CAMERA IN CONFLICT

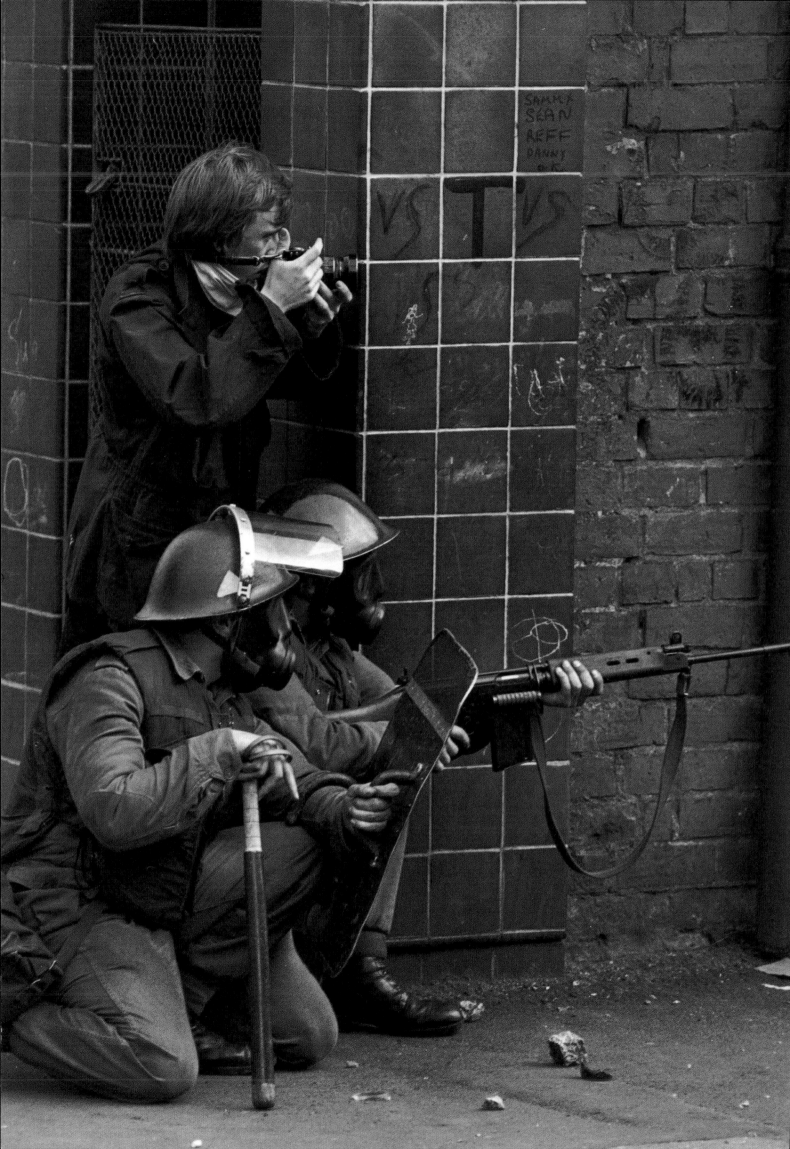

The Hulton Getty Picture Collection

CAMERA IN CONFLICT

Civil Disturbance

Innere Unruhen

Rébellion et Contestation

Nick Yapp

KÖNEMANN

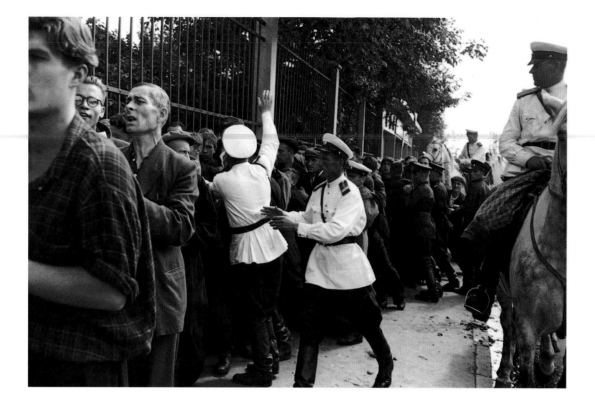

First published in 1996 by Könemann Verlagsgesellschaft mbH, Bonner Strasse 126, D-50968 Köln

© 1996 Könemann Verlagsgesellschaft mbH. Photographs © 1996 Hulton Getty Picture Collection Limited

All photographs from the Hulton Getty Picture Collection, London, with grateful acknowledgement to: Her Majesty The Queen,
Agence France Presse; The Associated Press; Steve Eason, Link Picture Library; The Mayibue Centre; Media Projects Inc.;
Mirror Syndication International; The Observer; Reuters; Sean Sexton

All rights reserved. No part of this publication may be reproduced, stored in a retrieval system, or transmitted in any form
or by any means, electronic, mechanical, photocopying, recording or otherwise, without prior permission in writing from the publishers.

This book was produced by The Hulton Getty Picture Collection Limited, Unique House, 21-31 Woodfield Road, London W9 2BA

For Könemann:
Production manager: Detlev Schaper
Managing editors: Sally Bald and Kristina Meier
Typesetting: Oliver Hessmann
German translation by Manfred Allié,
Ulrike Bischoff, Raingard Esser
French translation by Alice Boucher,
Véronique Brandner, Francine Rey

For Hulton Getty:
Art director: Michael Rand
Design: Ian Denning
Picture research: Leon Meyer
with Irene Lynch, Roger Syring
Project editor: Elisabeth Ingles
Production coordinator: Elisabeth Ihre

Colour separation: Imago. Printed and bound in France by Partenaires Fabrication

ISBN 3-89508-244-9

(Above) Russian police and militia manhandling the crowds at the Wolves v. Spartak football match in Moscow, August 1955.
(Frontispiece) A British army patrol and a press photographer in Northern Ireland, July 1970.

(Oben) Beim Fußballspiel Wolverhampton gegen Spartak Moskau im August 1955 halten russische Polizei und Miliz die Menge in Schach.
(Frontispiz) Britische Soldaten und ein Pressefotograf in Nordirland, Juli 1970.

(Au-dessus) Police et milice russes molmenant la foule lors du match de football qui opposait l'équipe
de Wolverhampton contre Spartak à Moscou en août 1955.
(Frontispice) Une patrouille de l'armée britannique et un photographe de presse en Irlande du Nord, juillet 1970.

Contents

Inhalt

Sommaire

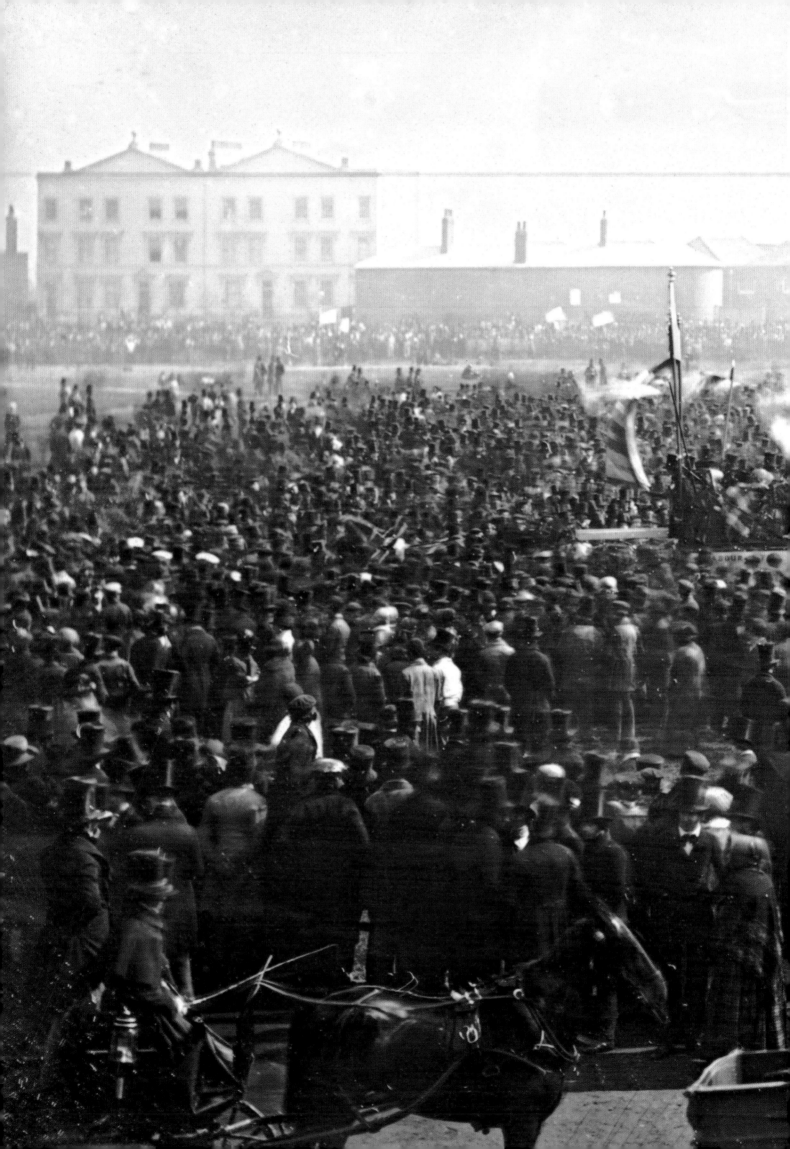

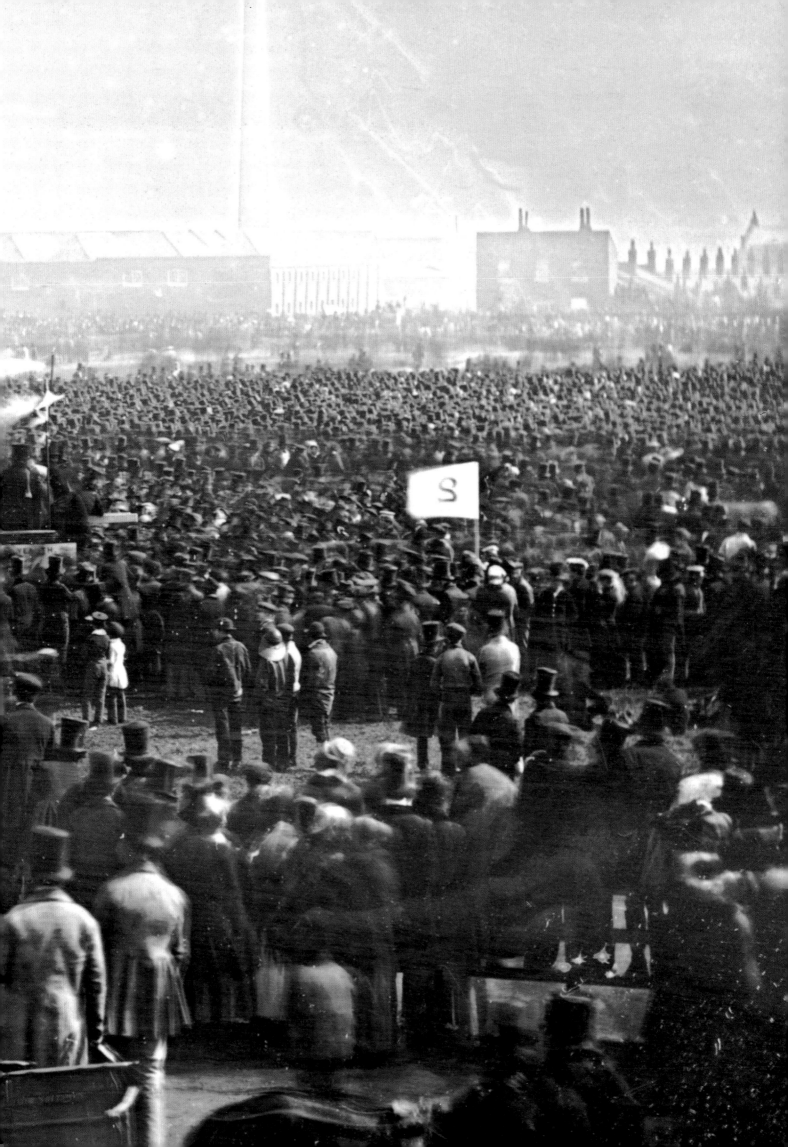

Introduction

On 10 April 1848 a crowd gathered at Kennington Common, on what was then the fringe of south-east London, to support the Chartist Movement. The Chartists were calling for political reform – annual elections, a secret ballot, universal suffrage. The police warned the leaders of the movement that they would not be allowed to march across any of the bridges to the north side of the Thames – the side on which stood the newly built Houses of Parliament. After a number of speeches, the rain fell and the demonstrators walked home.

The photograph of that event is probably the first ever picture of a crowd, and certainly the first visual record of protest. Although the aims of the Chartists appeared revolutionary to many, the meeting was orderly– had it been otherwise, a photograph might well have been out of the question.

Almost a century and a half later, the camera is ubiquitous, capturing defiance across the world – in Tiananmen Square, Trafalgar Square, Times Square. Cameramen and women have for years risked their equipment, their safety and sometimes their lives to reveal protest in its most violent forms. Some may argue that there are now protesters who respond to the presence of the camera by becoming more aggressive, more vicious, more uncontrolled. The technology is there to record frenzy, which is sometimes more effective and always more glamorous than peaceful demonstration could ever hope to be.

But to see the history of civil conflict as a forced march towards ever more physical confrontation would be a mistake. We don't have any pictures of Habsburg troops attacking Hungarian Nationalists, in the month before the Chartists met under those grey London skies, simply because the camera wasn't there. And even if it had been, any resulting photograph would have been a mere blur unless the action had been frozen for a minute or more. We do have pictures of Russian tanks on the streets of Budapest in 1956, and of the final moments of agony for members of the hated AVO (the Hungarian Secret Police), because cameras were there. But the vehemence and intensity of the protest on these two occasions would have been much the same.

The pictures in this book are about hope. Occasionally they are about the destruction of hope – the last seconds of life for someone who had hoped to change their part of the world, and failed, or of someone who had hoped to keep things as they were and was swept away in a social or political whirlwind. Sometimes they are about the fulfilment of hope – for a cause that may be good or bad. Often they are simply about hope itself – arms linked across the Champs-Elysées; a stone thrown in Soweto; a prophet standing at a microphone in Washington DC, centre of power of the most powerful nation the world has ever known; a truck bristling with bayonets in Petrograd as an old order is swept aside.

Heroes and villains parade, strut, ride the crest of a wave and draw their last breaths in these photographs. Hitler comes to power, in his wake the Fascist groupies from Britain and the United States who so longed to emulate Germany's *Führer*. Gandhi wears away what little patience British imperialists had: 'We're not pleasant in India,' says a character in E. M. Forster's *A Passage to India*, 'and we don't intend to be pleasant. We've something more important to do.' All over the world life can be unpleasant. Rabin is killed. North American natives survive. For 26 years, the camera all but loses sight of Nelson Mandela, until he returns to his land, his people, and power. The Black and Tan 'gangsters' – ex-Army men left with bits of uniform and nothing to do when the First World War ended – have their brief spell of gun-toting tyranny on the streets of Ireland. Police attack strikers, black youths, white youths, marchers, rioters and demonstrators, and everyone attacks the police. Suffragettes smash windows, Nazis smash windows, the IRA smash windows. Guns blaze, batons thump on heads and bodies, tear gas hangs heavy in the air, mutineers and martyrs hang from the gallows.

What did they all want? Freedom, of one kind or another. Freedom from colonial exploitation, dictatorship, a second-class life, political and religious oppression, hunger, want, racism, the threat of a nuclear holocaust. Freedom to vote, work, attend school, eat in a restaurant, strike, enjoy a landscape unspoilt by encroaching motorways, live in peace. But there are some images that have little to do with 'freedom'; studies of those who wanted only licence to lynch, burn and destroy at will; scenes of life in the Deep South, apartheid South Africa, the India of the British Raj, Amin's Uganda.

One perception of the last century and a half may be that what many of our ancestors wanted was democracy – that vaguely defined political system where people elect their government and life is impossible without the will of a consenting majority. In a way that's what the world has perhaps been stumbling towards. Voices are raised calling for 'Bread!', 'Land!', 'Freedom!' But nobody wants bread off the back of a truck for the rest of their life, and land seems unimportant to a miner or factory hand who is more interested in a fair day's pay for a fair day's work. Freedom, it is thought, can buy anything – including, sadly, the ability to enslave others.

And, far from protest ending with the coming of democracy, it is one of the features of democratic life. Most demonstrators in Western countries have been told at some time or another how lucky they are to be able to protest. Stalin would never have allowed dissenting crowds to march through Red Square; Mussolini would have dealt swiftly with

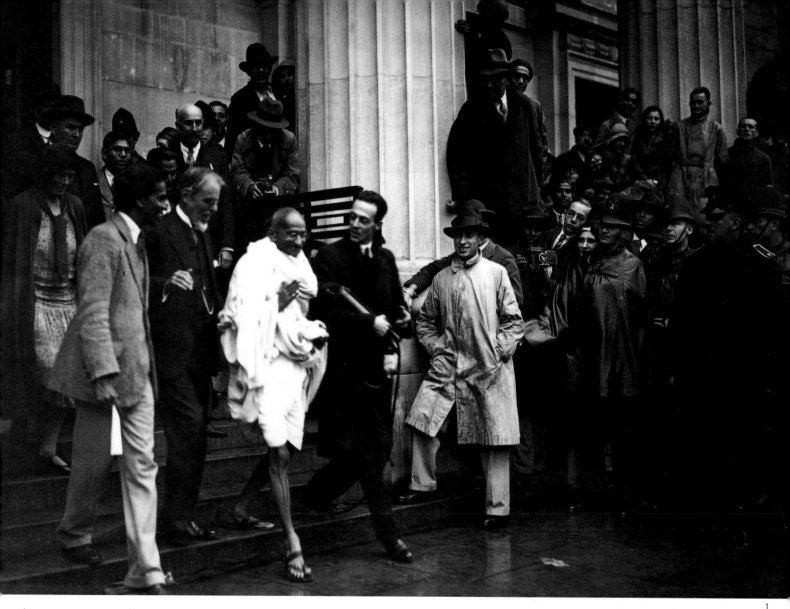

demonstrators in the Piazza Venezia. Mao Tse-tung and the Ayatollah Khomeini did not believe that voices should be raised in opposition to their will, anywhere.

But even in a democracy, there is still plenty to complain about. The issues may become smaller; the protest remains as intense as ever. Running battles are fought to maintain a footpath for ramblers, to stop a forest being felled, to assert the rights of one group of football fans to a few square metres of cold concrete, to do away with an unpopular tax, to stop the export of veal calves in wooden crates. Governments may speak soft words, but their troops and their police carry big sticks. Promises are as easily broken by elected representatives as by dictators. Words have always been the stock in trade of democracies, and they've always come cheap. When Chief Joseph of the Nez Percé gave up his nation's land in 1879, he was not fooled by the white men with whom he dealt. 'Good words will not give my people good health and stop them from dying,' he said. 'Good words will not get my people a home where they can live in peace and take care of themselves … I do not believe that the Great Spirit Chief gave one kind of men the right to tell another kind of men what they must do.'

It is that belief that has fuelled many a march.

And when people march together, when a black woman decides that the law saying she has to give up her seat on a bus

(Previous page) The Great Chartist Meeting on Kennington Common, 10 April 1848: the earliest photograph of a protest meeting. (1) The Indian nationalist leader Mahatma Gandhi leaving the Friends' Meeting House in London after the Round Table Conference in September 1931.

(Vorige Doppelseite) Die große Chartistenversammlung auf dem Kennington Common, 10. April 1848 – die erste Fotografie einer Protestversammlung. (1) Mahatma Gandhi, der Führer der indischen Unabhängigkeitsbewegung, verläßt nach einer Konferenz das Friend's Meeting House in London, September 1931.

(Page précédente) Grand rassemblement des chartistes à Kennington, le 10 avril 1848: la première photo d'une manifestation. (1) Le leader nationaliste indien, Mahatma Gandhi, quittant la Friend's Meeting House de Londres après une table ronde tenue en septembre 1931.

to a white man is a bad law, when a fanatic leaps on to the running board of a royal car and empties a revolver into the occupants, a part of our world is shaken. If cameras are there to record these events, the tremors are felt as far as the photograph can reach. This book is a collection of some of the best and worst in human endeavour during the last one hundred and fifty years. And, for good or ill, these are the events for which our grandparents and their grandparents must take responsibility. We may not always like what they did, but this is what has shaped our world.

Einführung

Am 10. April 1848 versammelte sich eine Menschenmenge auf dem Kennington Common am damaligen südwestlichen Stadtrand Londons, die die sogenannte »Chartisten«-Bewegung unterstützen wollte. Die Chartisten forderten politische Reformen – jährliche Wahlen, geheime Abstimmungen, allgemeines Wahlrecht. Die Polizei erklärte den Führern der Bewegung, daß jeglicher Übergang auf die Nordseite der Themse – auf der sich das neu erbaute Parlamentsgebäude befand – verboten sei. Nach einer Reihe von Reden begann es zu regnen, und die Demonstranten gingen nach Hause. Die Fotografie dieses Ereignisses ist möglicherweise die erste Aufnahme einer Menschenmenge und mit Sicherheit das erste bildliche Zeugnis einer Demonstration. Obwohl vielen die Forderungen der Chartisten als revolutionär erschienen, verlief das Treffen wohlgeordnet – andernfalls wäre eine Aufnahme wahrscheinlich unmöglich gewesen.

Fast eineinhalb Jahrhunderte später ist die Kamera überall dabei, um Widerstand und Protest auf der ganzen Welt festzuhalten – ob auf dem Tiananmen, dem »Platz des Himmlischen Friedens«, dem Trafalgar Square oder dem Times Square. Seit Jahrzehnten riskieren Kameramänner und -frauen ihre Ausrüstung, ihre Sicherheit und manchmal ihr Leben, um Protest in seiner gewaltsamsten Form festzuhalten. Gelegentlich wird argumentiert, daß Demonstranten auf die Gegenwart von Kameras mit größerer Aggressivität, Bösartigkeit und Unberechenbarkeit reagierten und daß die Technologie dazu benutzt würde, Ausschreitungen effektiver und in jedem Fall effekthaschender darzustellen, als friedliche Demonstrationen jemals sein könnten. Aber es wäre falsch, die Geschichte der zivilen Auseinandersetzungen als einen gewaltsamen Marsch in Richtung immer aggressiverer Konfrontation zu sehen. Nur weil keine Kamera zur Stelle war, haben wir keine Bilder von den Angriffen der habsburgischen Truppen auf die ungarischen Demonstranten einen Monat vor der Chartistenversammlung unter dem grauen Londoner Himmel. Und selbst wenn eine Kamera vor Ort gestanden hätte, wäre jedes Foto unscharf ausgefallen, da man die Ereignisse und Handlungen nicht einfach für eine oder

A demonstration against Fascism in Athens in 1944 ended with the shooting of two of the crowd by police. The bystanders are reacting to the presence of the camera.

Eine antifaschistische Demonstration in Athen 1944 endet mit der Erschießung zweier Demonstranten durch die Polizei. Die Umstehenden reagieren auf die Anwesenheit der Kamera.

En 1944, une manifestation contre le fascisme à Athènes se solda par deux morts. La police avait tiré sur la foule. Les témoins de l'agression ont remarqué la présence du photographe.

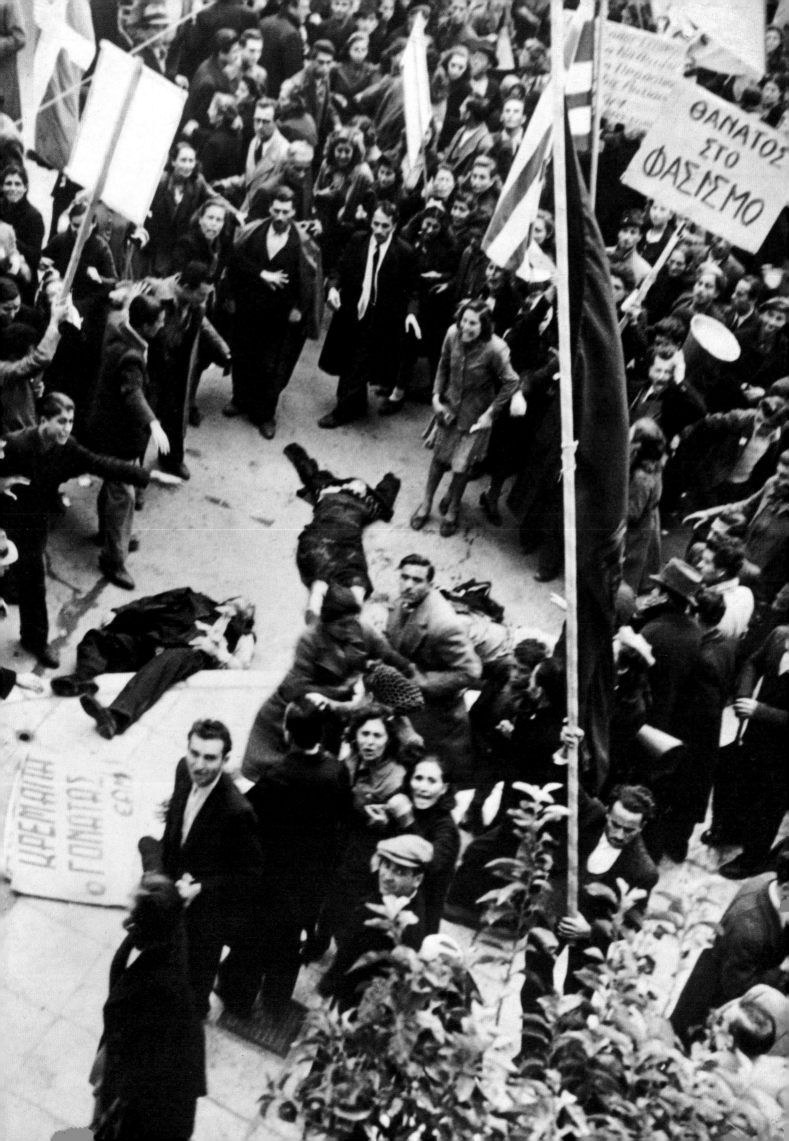

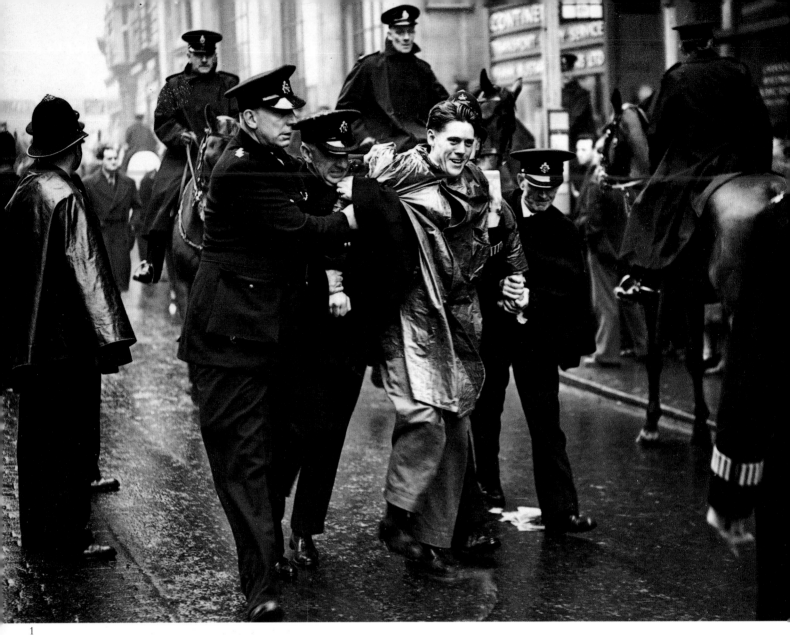

1

mehrere Minuten »einfrieren« konnte. Wir haben Bilder von russischen Panzern auf den Straßen von Budapest 1956 und von den letzten dramatischen Minuten der Mitglieder der verhaßten AVH (der ungarischen Geheimpolizei), weil die Kameras dort anwesend waren. Aber die Dramatik und die Intensität des Protestes bei beiden Gelegenheiten müssen sehr ähnlich ausgefallen sein.

Die Bilder in diesem Buch zeigen Hoffnung. Ursprünglich dokumentierten sie die Zerstörung von Hoffnung – die letzten Sekunden im Leben eines Menschen, der gehofft hatte, einen Teil der Welt zu verändern, und dabei scheiterte. Oder die letzten Augenblicke eines Mannes, der gehofft hatte, die Dinge beim alten belassen zu können, und vom sozialen oder politischen Wirbelwind der Zeit weggeweht wurde. Einige Bilder dokumentieren die Erfüllung einer Hoffnung – ob für eine gute oder eine schlechte Sache. Viele Bilder zeigen die Hoffnung selbst – eingehakte Menschen entlang den Champs-Élysées, ein Steinwurf in Soweto, ein Prophet vor einem Mikrophon in Washington DC, dem Zentrum der mächtigsten Nation der Welt, ein Lastwagen voller Bajonette in Petrograd, wo die alte Ordnung weggefegt wird.

Auf diesen Bildern marschieren oder stolzieren Helden oder Schurken; sie zeigen Augenblicke des Triumphes ebenso wie des Todes. Hitler ergreift die Macht, bewundert und

nachgeeifert von den faschistischen Nachahmern in Großbritannien und den Vereinigten Staaten, die es dem deutschen Führer so gerne gleichtun würden. Gandhi raubt den britischen Imperialisten den letzten Rest ihrer Geduld: »Wir sind nicht nett in Indien«, sagt eine Person in E. M. Forsters *A Passage to India,* »und wir haben auch nicht vor, nett zu sein. Wir haben Wichtigeres zu tun.« Auf der ganzen Welt kann das Leben unangenehm sein. Rabin wird ermordet. Nordamerikanische Indianer überleben. 26 Jahre lang verloren die Kameras Nelson Mandela aus den Augen, bis er in sein Land, zu seinem Volk und zur Macht zurückkehrt. Die Gangster der *Black and Tans,* ehemalige Armeeangehörige, die nach dem Ende des Ersten Weltkriegs nur noch Teile ihrer Uniform übrigbehielten, erlebten eine kurze Periode säbelrasselnder Tyrannei auf den Straßen Irlands. Die Polizei attackiert Streikende, schwarze und weiße Jugendliche, Marschierende, Randalierer und Demonstranten; und jeder ist gegen die Polizei. Suffragetten werfen Fensterscheiben ein, Nazis und die IRA ebenso. Gewehre rauchen, Schlagstöcke treffen Köpfe und Körper, Tränengas hängt schwer in der Luft, Meuterer und Märtyrer baumeln an ihren Galgen. Was war ihr Ziel? Freiheit in den verschiedensten Formen: Befreiung von kolonialer Ausbeutung, von der Diktatur, von einem Leben zweiter Klasse, religiöser Unterdrückung, Hunger, Entbeh-

rungen, Rassismus, der Bedrohung durch den nuklearen Holocaust. Wahlfreiheit, Freiheit der Arbeit, Freiheit, eine Schule zu besuchen, in einem Restaurant zu essen, zu streiken, eine Landschaft ohne den Eingriff von Autobahnen zu genießen, Freiheit, in Frieden zu leben. Aber es gibt auch Bilder, die mit »Freiheit« wenig zu tun haben: Studien derjenigen, die nur eine Lizenz zum Töten wollten, Bilder vom Leben in den amerikanischen Südstaaten, von der Apartheid in Südafrika, von Indien unter der britischen Herrschaft, von Amins Uganda.

Das große Ziel vieler unserer Vorfahren in den letzten einenhalb Jahrhunderten war die Demokratie – jenes vage definierte politische System, in dem die Menschen ihre Regierungen selbst wählen und der Alltag ohne die Zustimmung der Mehrheit nicht funktioniert. In gewisser Weise hat sich die Welt in diese Richtung bewegt. Menschen haben ihre Stimmen erhoben und nach »Brot!«, »Land!«, »Freiheit!« verlangt. Aber keiner will sein Leben lang Brot, das von einem Lastwagen verteilt wird, und Land bedeutet nichts für einen Minen- oder Fabrikarbeiter, der sich mehr für einen gerechten Tageslohn und bessere Arbeitsbedingungen interessiert. Freiheit, so heißt es, kann alles kaufen – leider auch die Möglichkeit, andere zu versklaven.

Aber der Protest hört nicht auf, wenn Demokratie erreicht ist: Protest ist ein Element des demokratischen Lebens. Viele Demonstranten der westlichen Welt haben bei der einen oder anderen Gelegenheit zu hören bekommen, daß sie sich glücklich schätzen sollten, überhaupt protestieren zu dürfen. Stalin hätte es niemals zugelassen, daß oppositionelle Massen über den Roten Platz marschieren, Mussolini hätte mit Demonstranten auf der Piazza Venezia kurzen Prozeß gemacht. Und Mao Tse-tung oder Ayatollah Khomeini glaubten nicht daran, daß irgendwo auf der Welt sich eine oppositionelle Stimme gegen ihren Willen erheben durfte.

Selbst in einer Demokratie gibt es noch viel Kritikwürdiges. Auch wenn der Anlaß geringfügiger ist, der Protest bleibt so intensiv wie eh und je: Wahre »Schlachten« werden um den Erhalt eines Wanderweges geschlagen, gegen die Abholzung eines Waldes, um die Rechte einer Gruppe von Fußballfans auf ein paar Quadratmeter kalten Betons, um die Abschaffung einer ungeliebten Steuer, um den Exportstopp von Mastkälbern in hölzernen Lattenverschlägen. Die Regierungen mögen zwar mit sanfter Zunge sprechen, aber ihre Polizei und ihre Soldaten tragen schwere Knüppel. Versprechen werden von gewählten Volksvertretern ebenso leicht gebrochen wie von Diktatoren. In Demokratien bildeten Worte stets das Grundkapital für Verhandlungen – und sie waren immer billig. Als Häuptling Joseph von den Nez-Perce 1879 das Land seines Stammes aufgab, ließ er sich von den Weißen, mit denen er verhandelte, nicht täuschen: »Gute Worte geben meinem Volk keine Gesundheit und schützen es nicht vor dem Tod«, sagte er. »Gute Worte geben meinem Volk kein Heim, in dem es in Frieden leben und sich selbst versorgen kann ... Ich glaube nicht, daß der Große Geist einer Sorte Menschen das Recht gegeben hat, den anderen vorzu-

schreiben, was sie zu tun haben.« Dieser Glaube hat viele Märsche in Gang gesetzt. Und wenn Menschen zusammen auf die Straße gehen, wenn eine schwarze Frau entscheidet, daß das Gesetz, welches ihr vorschreibt, ihren Platz in einem Bus für einen weißen Mann zu räumen, ein schlechtes Gesetz ist, wenn ein Fanatiker auf das Trittbrett einer königlichen Karosse springt und seinen Revolver auf die Insassen abfeuert, ist ein Teil unserer Welt erschüttert. Wenn Kameras dabei sind, um diese Ereignisse festzuhalten, verbreitet sich die Erschütterung so weit wie das Foto.

Dieses Buch ist eine Sammlung einiger der größten und der schrecklichsten menschlichen Taten der letzten 150 Jahre. Es sind die Ereignisse, die unsere Großeltern und deren Großeltern zu verantworten haben – im Guten wie im Bösen. Vielleicht heißen wir nicht alles gut, was sie getan haben, aber es hat unsere Welt geformt.

(1) An arrest in Whitehall, London, after a running fight between police and 2000 Communist marchers on May Day 1950. (2) Despite the good humour evident on the marchers' faces, the tanks rolled in and over 100 people were killed during this march by strikers in East Berlin, June 1953.

(1) Eine Verhaftung in Whitehall, London, nach einem Straßenkampf zwischen der Polizei und 2000 kommunistischen Demonstranten, 1. Mai 1950. (2) Trotz der fröhlichen Mienen der Streikenden wurde dieser Protestmarsch in Ostberlin im Juni 1953 von Panzern angegriffen, wobei über 100 Menschen ums Leben kamen.

(1) Arrestations à Whitehall, Londres, après une poursuite entre la police et 2000 manifestants communistes durant la manifestation du 1er mai 1950. (2) Malgré la bonne humeur évidente qui se reflète sur les visages, les chars entrèrent dans la ville et plus de 100 personnnes furent tuées au cours d'une manifestation organisée par des grévistes à Berlin-Est en juin 1953.

2

Introduction

Le 10 avril 1848, une foule se rassembla à Kennington, au sud-est de Londres, pour soutenir les chartistes qui revendiquaient une réforme politique: élections annuelles, scrutin secret, suffrage universel. La police avertit les dirigeants du mouvement qu'ils ne passeraient aucun des ponts menant sur la rive nord de la Tamise où se dressait le nouveau Parlement. Après nombre de discours, il se mit à pleuvoir et les manifestants rentrèrent chez eux.

La photo de cet événement est probablement la première jamais prise d'une foule, et certainement le premier document visuel d'une manifestation. Beaucoup jugeaient révolutionnaires les objectifs des chartistes; néanmoins, la réunion se déroula sans incident. Sinon, il aurait été impossible de prendre des photos.

Presque un siècle et demi plus tard, l'appareil photo est omniprésent – à Tiananmen Square, Trafalgar Square, Times Square. Depuis des années, les photographes, hommes et femmes, risquent leur équipement, leur sécurité et parfois leur vie pour montrer les formes les plus violentes de protestation. Certains affirmeront que les manifestants répondent à la présence de l'appareil photo par un déchaînement d'agressivité et de violence. La technologie est là pour témoigner d'une frénésie parfois plus efficace et toujours plus fascinante qu'une manifestation pacifique.

Toutefois, il serait faux de considérer l'histoire d'un conflit civil comme une marche forcée vers une confrontation toujours plus physique. Nous n'avons aucune photo des troupes des Habsbourg attaquant les nationalistes hongrois un mois avant la rencontre des chartistes sous le ciel gris de Londres, car il n'y avait pas d'appareil photo. Mais toute photo n'aurait donné qu'une image confuse, à moins de figer l'action pour une minute ou plus. Nous avons par contre des photos des chars russes dans les rues de Budapest en 1956 et de l'agonie des membres de l'AVO, la police secrète hongroise tant détestée. Mais dans les deux cas, la véhémence de la protestation fut probablement la même.

Le thème de ce livre est l'espoir. Ses photos illustrent parfois la destruction de l'espoir, les dernières secondes de la vie d'un homme qui avait espéré changer un peu le monde mais qui échoua, ou de celui qui avait espéré maintenir les choses telles qu'elles étaient et que balaya la tornade sociale ou politique. Elles traitent parfois d'un espoir réalisé, que la cause soit bonne ou mauvaise. Souvent, elles portent sur l'espoir lui-même: des gens bras dessus bras dessous sur les Champs-Elysées, une pierre jetée à Soweto, un prophète devant un micro à Washington DC, où se concentre la force de la nation la plus puissante qu'ait jamais connue le monde, un camion hérissé de baïonnettes à Petrograd alors qu'un ordre ancien s'écroule.

Héros et scélérats défilent, se pavanant, portés par la crête d'une vague, insufflant leur dernier soupir à ces photos. Hitler arrive au pouvoir, dans son sillage les groupies de Grande-Bretagne et des Etats-Unis qui meurent d'envie d'imiter le *Führer* allemand. Gandhi épuise le peu de patience qu'avaient les impérialistes britanniques: «Nous ne sommes pas aimables en Inde», dit un personnage dans *Un passage pour l'Inde* de E.M. Forster, «et nous n'avons pas l'intention d'être aimables. Nous avons plus important à faire». Partout dans le monde, la vie peut être désagréable. Rabin est assassiné. Les autochtones d'Amérique du Nord survivent. Il y a 26 ans, l'appareil photo perd pratiquement de vue Nelson Mandela jusqu'à ce qu'il

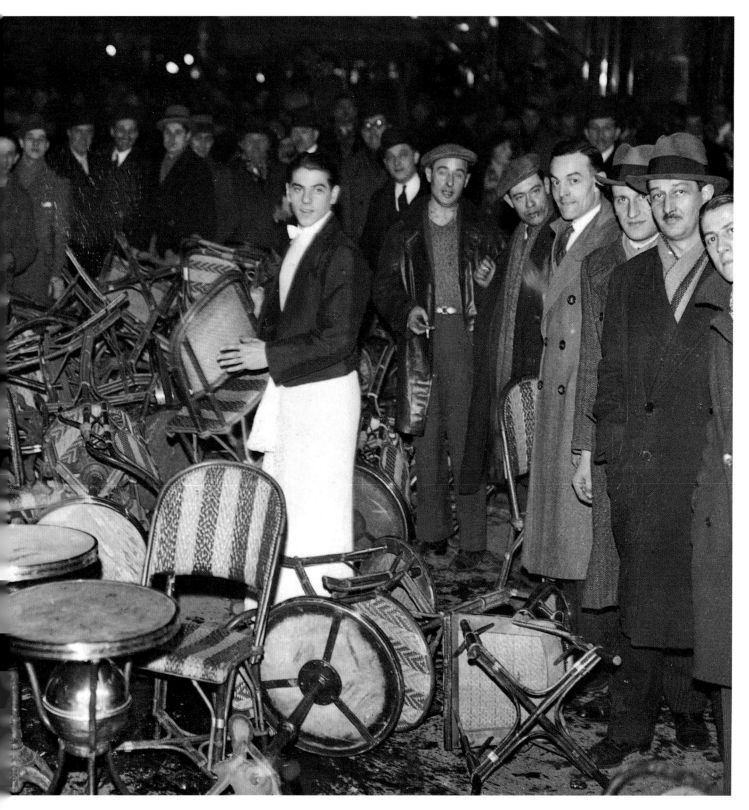

Serge Alexander Stavisky was a Russian-born French swindler who successfully floated fraudulent companies until it was revealed that he was handling bonds to the value of 500 million francs on behalf of the municipal pawnshop in Bayonne. The French Government was clearly implicated. There were widespread riots, many of them led by Fascists, in Paris on the night of 6 February 1934. Mobs wrecked hotels and restaurants, including the Café de la Paix in the Place de l'Opéra.

Serge Alexander Stavisky war ein französischer Hochstapler russischer Abstammung, der erfolgreich betrügerische Firmen gründete, bis enthüllt wurde, daß er auf die städtische Pfandleihe von Bayonne Aktien im Wert von 500 Millionen Francs ausgab. Die französische Regierung war tief in diesen Skandal verstrickt. In der Nacht des 6. Februar 1934 kam es in ganz Paris zu Unruhen, die größenteils von Faschisten angeführt wurden. Ein wütender Mob verwüstete Hotels und Restaurants, darunter auch das Café de la Paix am Place de l'Opéra.

Français d'origine russe, Serge Alexandre Stavisky était un escroc qui réussit à créer des compagnies frauduleuses avant que l'on s'aperçoive qu'il avait spéculé avec des bons d'une valeur de 500 millions de francs pour le compte d'un mont-de-piété de la ville de Bayonne. Le gouvernement français était de toute évidence impliqué. Il y eut plusieurs émeutes. Les fascistes en organisèrent plusieurs à Paris dans la nuit du 6 février 1934 au cours desquelles des casseurs saccagèrent hôtels et restaurants dont le Café de la Paix sur la Place de l'Opéra.

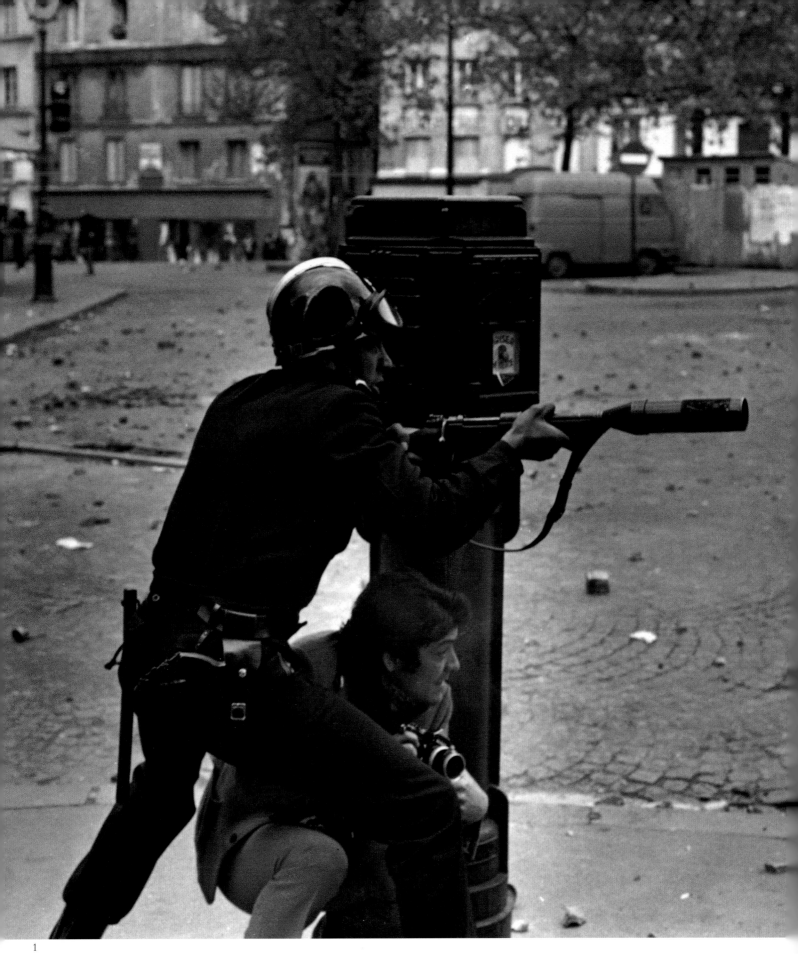

1

(1) During *Les Evénements* of May 1968 in Paris, a press photographer seizes the chance to take pictures under the protection of a riot policeman armed with a tear gas gun.
(2) Violence flares in a South African township, 1986: young men and boys flee as a car explodes.

(1) Während der Pariser Unruhen im Mai 1968 nutzt ein Fotograf die Möglichkeit zu Aufnahmen, geschützt von einem Bereitschaftspolizisten mit einem Tränengasgewehr.
(2) Ausbruch der Gewalt in einem südafrikanischen Township 1986: Junge Männer und Jungen fliehen, während ein Auto explodiert.

(1) Durant Les événements de mai 1968 à Paris, un photographe de presse eut la chance de pouvoir prendre ses photos sous la protection d'un policier armé d'un fusil à gaz lacrymogène. (2) Explosion de violence dans un ghetto d'Afrique du Sud en 1986: de jeunes hommes et des adolescents s'enfuient tandis qu'une voiture prend feu.

revienne dans son pays, auprès de son peuple et au pouvoir. Les «gangsters» du *Black and Tan,* anciens soldats laissés à la fin de la Première Guerre Mondiale dans des lambeaux d'uniforme et le désœuvrement, tyrannisent l'Irlande, revolver au poing. La police charge les grévistes, jeunes Noirs, jeunes Blancs, militants, manifestants et émeutiers et tout le monde attaque la police. Des Suffragettes font voler des vitres en éclat, les nazis de même, l'IRA aussi. Des fusils tirent, des matraques frappent, du gaz lacrymogène alourdit l'air, mutins et martyrs se balancent à la potence.

Que voulaient-ils, tous? La liberté, d'une manière ou d'une autre. Etre libérés de l'exploitation coloniale, de la dictature, d'une vie de deuxième classe, du joug politique et religieux, de la faim, de la misère, du racisme, de la menace d'un holocauste nucléaire. Etre libres de voter, de travailler, d'aller à l'école, de manger dans un restaurant, de faire la grève, de savourer un paysage épargné par des autoroutes dévoreuses, de vivre en paix. Mais certaines images n'ont pas grand-chose à voir avec la «liberté»: les activités de ceux qui ne voulaient qu'une autorisation de tuer, lyncher, brûler et détruire à leur guise, la vie dans le Sud profond des Etats-Unis, l'apartheid en Afrique du Sud, l'Inde du Rajah britannique, l'Ouganda d'Amin.

Pendant le dernier siècle et demi, nous avons peut-être perçu ce que nombre de nos ancêtres souhaitaient, la démocratie, ce système politique vaguement défini où les gens élisent leur gouvernement et où la vie est impossible sans le consentement de la majorité. C'est peut-être vers ce but que le monde titube. Des voix s'élèvent pour réclamer «pain», «terre», «liberté!». Mais personne ne veut de pain distribué du fond d'un camion toute sa vie, et la terre semble sans importance à un mineur ou un ouvrier d'usine qui s'intéresse plus à un salaire équivalent à son travail. On pense que la liberté peut tout acheter, même le droit d'asservir les autres, malheureusement.

En marge des protestations qui se terminèrent par l'avènement de la démocratie, voilà l'une des caractéristiques de la vie démocratique. Dans les pays occidentaux, on expliqua à la plupart des manifestants quelle chance ils avaient de pouvoir protester. Staline n'aurait jamais consenti à ce que les masses dissidentes traversent la Place Rouge; Mussolini aurait vite résolu le problème des manifestants sur la Piazza Venezia. Mao Tsé-Toung et l'ayatollah Khomeyni n'acceptaient pas que des voix s'élèvent pour s'opposer à leur volonté, où que ce fut.

Mais même dans une démocratie, on a encore beaucoup à se plaindre. Les problèmes s'amenuisent peut-être, la protestation demeure aussi vive. Des luttes continuelles sont menées pour conserver un chemin aux promeneurs, pour arrêter le déboisement d'une forêt, pour défendre les droits d'un groupe de supporters de football à quelques mètres carrés de béton froid, pour supprimer un impôt impopulaire, pour stopper l'exportation de veaux dans des caisses en bois. Les gouvernements ont beau parler gentiment, leurs troupes et leur police portent de grosses matraques. Les promesses sont aussi facilement rompues par les députés élus que par les dictateurs. Les mots ont toujours été les marchandises en stock des démocraties et ils ont toujours peu coûté. Lorsque le chef Joseph des Nez Percés abandonna ses terres en 1879, il ne fut pas dupé par l'homme blanc. «De bonnes paroles ne donneront pas la santé à mon peuple et ne l'empêcheront pas de mourir», dit-il. «De bonnes paroles ne donneront pas à mon peuple un foyer où il pourra vivre en paix… Je ne crois pas que le Grand Manitou ait donné à une espèce d'hommes le droit de dire à une autre ce qu'elle doit faire.»

Ce fut cette conviction qui souleva les masses.

Et quand les gens marchent ensemble, quand une femme noire décide que la loi qui l'oblige à céder sa place à un homme blanc dans un bus est une mauvaise loi, quand un fanatique saute sur le marchepied d'une voiture royale et vide un revolver sur ses occupants, une partie du monde est bouleversée. Les photos nous font ressentir les secousses qu'elles captent. Ce livre rassemble quelques-uns des meilleurs et des pires comportements humains pendant les dernières 150 années. Et, pour le meilleur ou pour le pire, ce sont des événements dont nos grands-parents et leurs grands-parents doivent assumer la responsabilité. Nous n'apprécions peut-être pas toujours ce qu'ils ont fait, mais c'est ce qui a formé notre monde.

2

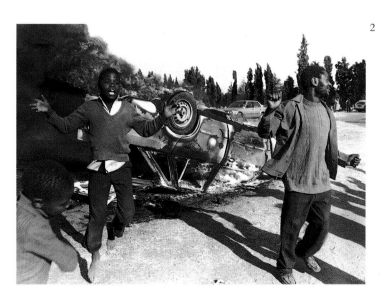

'All power to the Workers' and Soldiers' Soviets!' The Red Flag is carried through the streets of Berlin by armoured car on 1 December 1918.

»Alle Macht den Arbeiter- und Soldaten-räten!« Am 1. Dezember 1918 wird die Rote Fahne mit dem Panzerwagen durch Berlin getragen.

«Le pouvoir aux ouvriers et aux soldats soviétiques!» Le 1er décembre 1918, le Drapeau Rouge est promené à travers les rues de Berlin sur des voitures blindées.

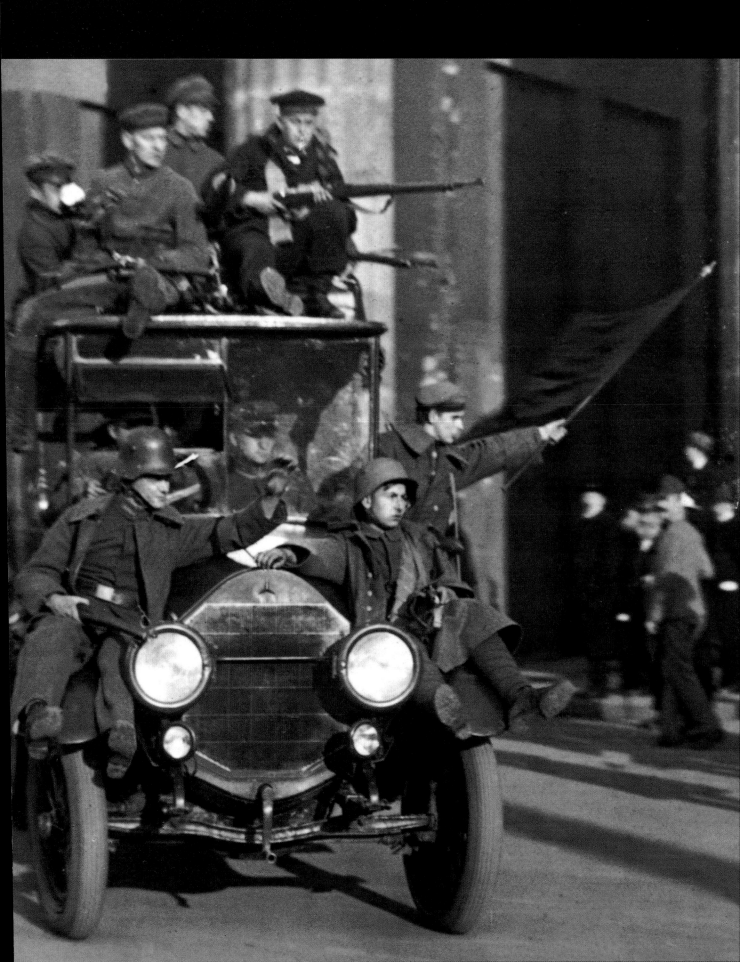

Women's Suffrage Movement

In the late 19th century, Europe and the United States, Australia and a handful of other countries struggled towards democracy. Few men had to fight as hard as almost all women for their basic rights to work, to vote, to own property, but perhaps those women who found themselves on the political battleground were the lucky ones. Three quarters of the world's women couldn't even protest against their traditional roles of looking after the home, hut or hovel and raising the family that so often starved and ailed in it.

In 1852, Florence Nightingale had despairingly written: 'Women are never supposed to have any occupation of sufficient importance not to be interrupted.' But, in the West at least, women's lives were dramatically changing. By the early 1900s there were 174,000 female shop assistants in Germany, 76,000 female local government officials in Britain, and the invention of the typewriter had led to a 25-fold increase in the number of women clerks in Europe.

Women could now go to university, join sports clubs, smoke in public, travel, and, in middle-class cases, live independently of men. But they couldn't vote. Many of their sex thought they shouldn't. In 1877, Mrs Sutherland Orr declared: 'The one fatal result of female emancipation is that … not only the power of love in women, but for either sex … will have passed away.'

Love or politics? Many middle- and upper-class women in Britain and the United States chose politics. The women who set fire to churches, chained themselves to the railings of important buildings, slashed famous paintings and smashed shop windows almost all came from 'good' families.

Im späten 19. Jahrhundert mühten sich Europa, die Vereinigten Staaten, Australien und eine Handvoll weiterer Länder um die Demokratie. Nur selten hatten Männer so hart wie die Mehrheit der Frauen um ihre Grundrechte zu kämpfen, um Wahlrecht, Recht auf Arbeit, Recht auf Eigentum; doch vielleicht waren die Frauen, die in die politische Schlacht zogen, noch die glücklichsten unter ihnen. Drei Viertel der weiblichen Weltbevölkerung hatten nicht einmal die Chance, gegen ihre traditionelle Rolle als Hüterin von Haus oder Hütte und als Betreuerin der Familie, die oft unter Krankheit und Hunger litt, aufzubegehren.

Noch 1852 schrieb Florence Nightingale verzweifelt: »Die Arbeiten, die Frauen tun, gelten nie als so wichtig, daß man sie nicht dabei stören darf.« Doch zumindest im Westen änderten sich die Lebensbedingungen der Frauen dramatisch. Anfang des 20. Jahrhunderts gab es in Deutschland 174000 Verkäuferinnen, in Großbritannien 76000 weibliche Verwaltungsangestellte, und seit der Erfindung der Schreibmaschine hatte sich die Zahl der Sekretärinnen in Europa verfünfundzwanzigfacht.

Frauen konnten nun Universitäten besuchen, Mitglied in Sportvereinen werden, in der Öffentlichkeit rauchen, allein reisen und zumindest in der Mittelschicht auch allein leben. Doch wählen durften sie nicht. Viele Frauen fanden es ganz in Ordnung so. 1877 verkündete Mrs. Sutherland Orr: »Die eine schlimme Folge der Emanzipation wird sein, daß nicht nur die Frauen die Fähigkeit zur Liebe verlieren, sondern daß beide Geschlechter gar nicht mehr wissen werden, was Liebe ist.«

Liebe oder Politik? Viele Frauen der mittleren und oberen Schichten in Großbritannien und den USA entschieden sich für die Politik. Die Frauen, die Kirchen in Brand setzten, sich an die Zäune von öffentlichen Gebäuden anketteten, mit

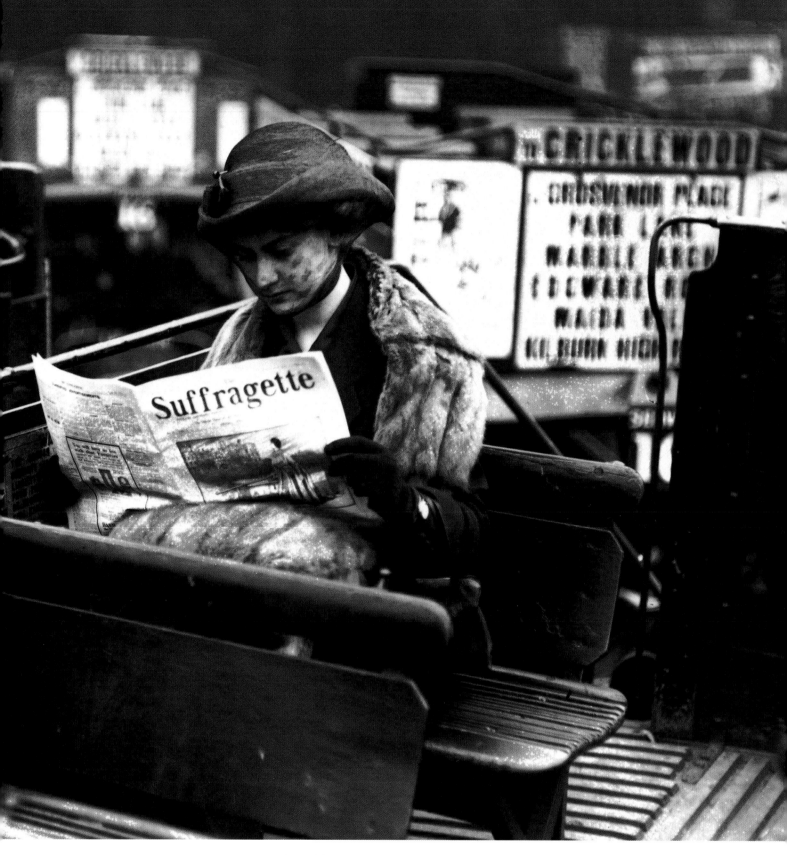

This publicity photograph was taken for *Suffragette*, edited by Christabel Pankhurst and first published in 1912. In the editor's words, the title stood 'as no other word for the independence, courage, public spirit and … humour which are the attributes of the really womanly woman'.

Dieses Werbefoto wurde für die Zeitschrift *Suffragette* aufgenommen, die erstmals 1912 erschien. Die Herausgeberin Christabel Pankhurst erklärte, sie habe den Titel gewählt, »weil kein anderes Wort so sehr die Unabhängigkeit, den Mut, das soziale Bewußtsein und … den Humor zum Ausdruck bringt – die Kennzeichen einer wirklich fraulichen Frau«.

Cette photographie publicitaire fut prise pour *Suffragette* – édité par Christabel Pankhurst –, elle fut publiée pour la première fois en 1912. Selon les termes de l'éditeur, le titre exprime «mieux que tout autre mot l'indépendance, le courage, l'esprit civique et … l'humour qui sont les attributs de la femme-femme».

(1) The first woman to take her seat in the British House of Commons: Lady Astor hears of her election victory at Plymouth, 1919. (2) 'Women require the vote more than men, since, being physically weaker, they are more dependent on law and society for protection' – John Stuart Mill with his stepdaughter, Helen Taylor.

(1) Die erste Frau im britischen Parlament: Lady Astor erfährt von ihrem Wahlsieg in Plymouth, 1919. (2) »Frauen brauchen das Wahlrecht mehr als Männer, denn da sie die körperlich Schwächeren sind, sind sie zu ihrem Schutz eher auf das Gesetz und die Gesellschaft angewiesen« – John Stuart Mill mit seiner Stieftochter Helen Taylor.

(1) La première femme à obtenir un siège à la Chambre des Communes britannique: Lady Astor apprend son élection à Plymouth, 1919. (2) «Les femmes ont davantage besoin que les hommes du vote en raison de leur faiblesse physique, les obligant à se mettre davantage sous la protection de la loi et de la société.» John Stuart Mill et sa belle-fille, Helen Taylor.

Messern auf berühmte Gemälde losgingen und Schaufensterscheiben einwarfen, kamen fast alle aus »guten« Familien.

A la fin du 19ᵉ siècle, l'Europe, les Etats-Unis, l'Australie et une poignée d'autres pays luttaient pour instaurer la démocratie. Peu d'hommes eurent à se battre avec le même acharnement que la majorité des femmes pour obtenir les droits fondamentaux au travail, au vote, à la propriété. Toutefois, ces pionnières des combats politiques furent des privilégiées, si l'on considère que les trois quarts des femmes n'étaient même pas en mesure de contester leurs rôles traditionnels: tenir la maison, la hutte ou le taudis et élever une famille, souvent dans des conditions misérables.

En 1852, Florence Nightingale écrivait ces lignes désespérées: «On considère toujours que les femmes accomplissent des travaux tellement mineurs qu'on peut en tout temps les déranger.» Pourtant, du moins en Occident, la vie des femmes était en train de subir un véritable bouleversement. Au début des années 1900, on comptait 174 000 vendeuses en Allemagne, 76 000 femmes étaient employées en Grande-Bretagne dans une administration et l'invention de la machine à écrire avait multiplié par 25 le nombre des secrétaires en Europe.

Les femmes pouvaient désormais fréquenter l'université, les clubs de sport, fumer en public, voyager et, dans les classes moyennes, vivre indépendamment des hommes. Mais elles n'avaient pas le droit de vote et nombreuses étaient celles qui ne le revendiquaient pas. En 1877, Mme Sutherland Orr déclarait: «L'une des conséquences fatales de l'émancipation des femmes est que … non seulement les femmes perdront le pouvoir de l'amour, mais que les deux sexes oublieront ce qu'est l'amour.»

Amour ou politique? Nombreuses furent les femmes des milieux moyens et aisés qui, en Grande-Bretagne, choisirent la politique. D'ailleurs, la plupart de celles qui mirent le feu aux églises, s'enchaînèrent aux grilles des édifices, déchirèrent des peintures célèbres ou brisèrent les vitrines des magasins, étaient issues de «bonnes» familles.

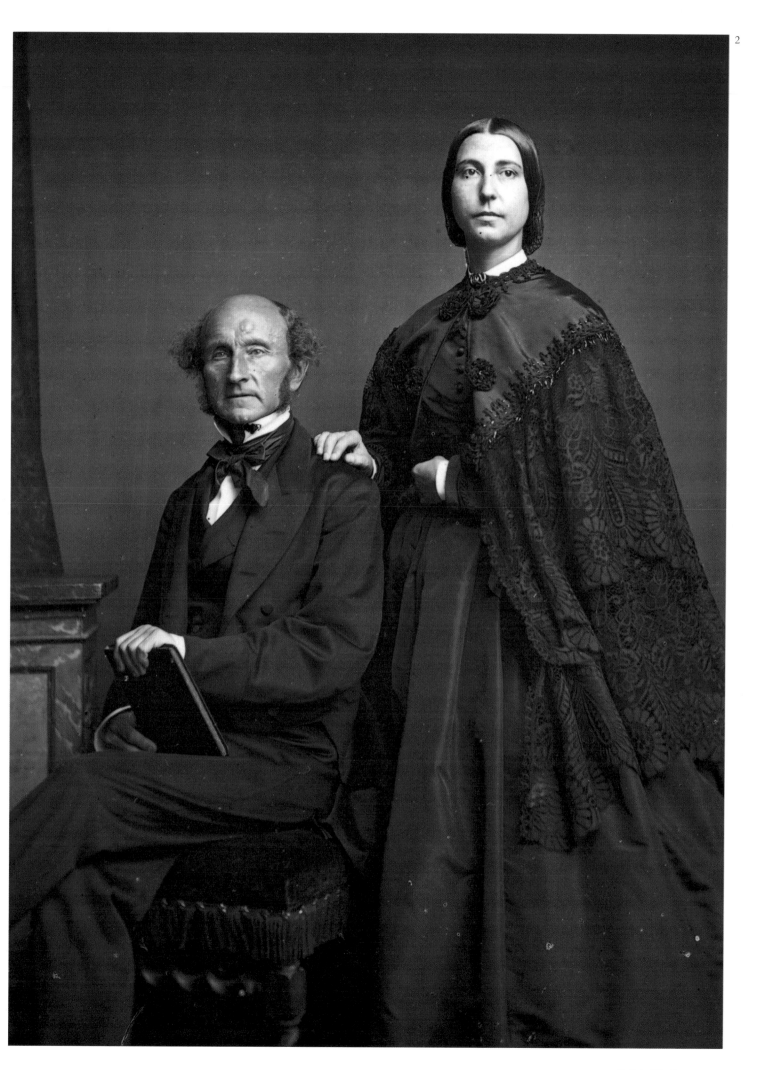

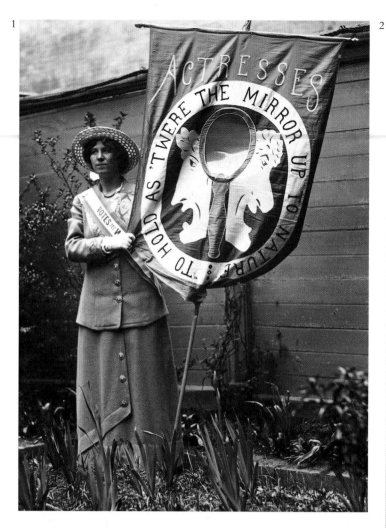

The Suffrage Movement

(1) Suffragettes demonstrate at the Metropolitan Opera House, New York. (2) The British Government condemned, August 1913. (3) The War is over, the fight goes on – suffragettes as pavement artists in March 1919. (4) The Women's Freedom League canvassing in Chelmsford during the 1908 election campaign. (5) The suffragettes found many inventive ways of getting their messages across.

Die Frauenbewegung

(1) Suffragetten demonstrieren vor der Metropolitan-Oper, New York. (2) Vorwürfe an die britische Regierung, August 1913. (3) Der Krieg ist vorüber, doch der Kampf geht weiter – Suffragetten als Pflastermalerinnen im März 1919. (4) Die *Women's Freedom League* beim Wahlkampf in Chelmsford, Großbritannien 1908. (5) Die Suffragetten waren sehr einfallsreich, wenn es darum ging, auf ihre Anliegen aufmerksam zu machen.

Mouvement des Suffragettes

(1) Les Suffragettes manifestent au Metropolitan Opera House, à New York. (2) Dénonciation du gouvernement britannique, août 1913. (3) La Guerre est finie, le combat continue – les Suffragettes en artistes des rues, mars 1919. (4) La *Women's Freedom League* (Ligue pour la Liberté des Femmes) faisant de la propagande à Chelmsford durant la campagne électorale de 1908. (5) L'imagination au service de la cause des Suffragettes!

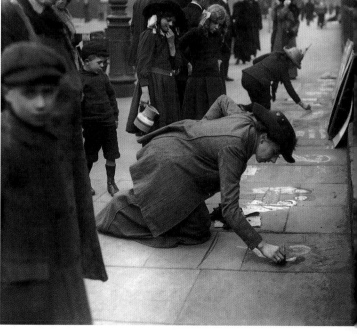

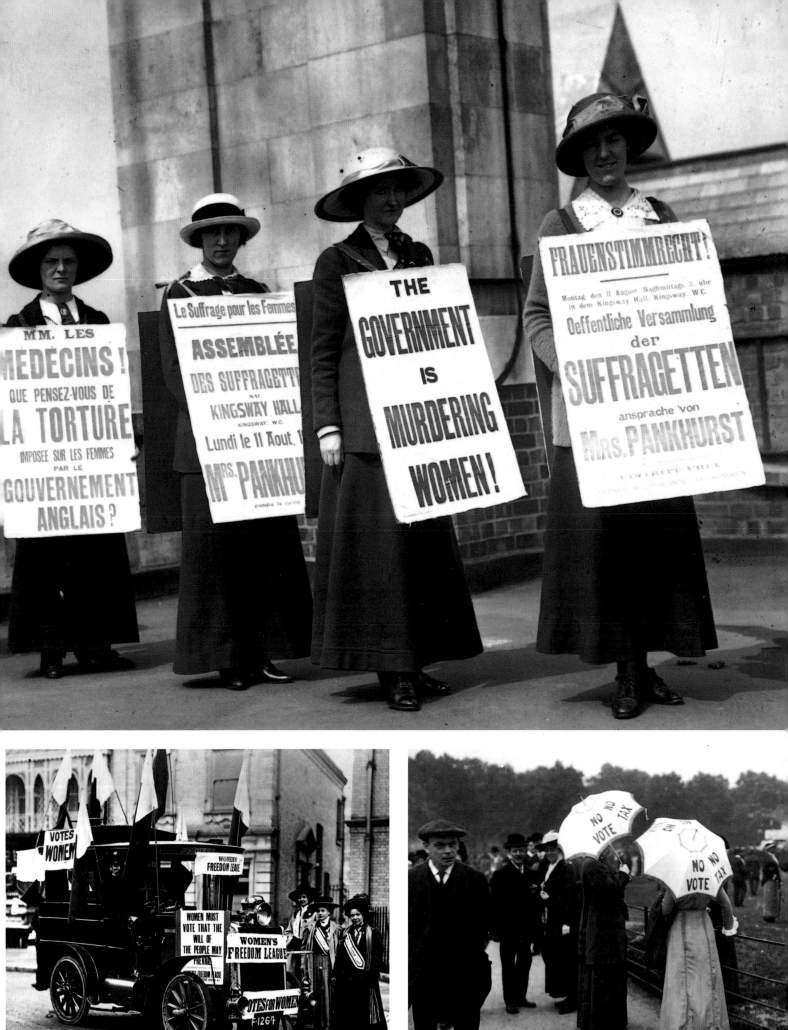

5

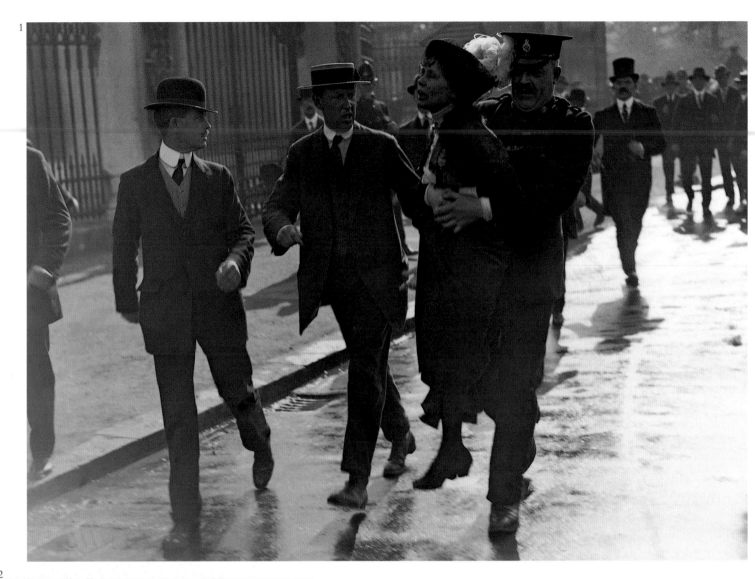

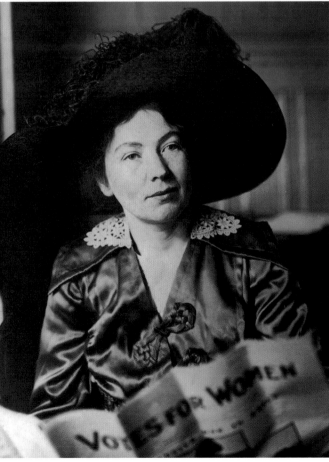

The Pankhursts

Mrs Emmeline Pankhurst (3) in the arms of a burly policeman after a suffragette demonstration at Buckingham Palace (1). A fellow militant described her as 'very frail and thin, but with the determination of Satan in the set of her jaw'. (2) Dame Christabel Pankhurst: 'We have at last got up steam and tasted the joy of battle. Our blood is up.' (Overleaf) Sylvia Pankhurst takes a break from painting the shopfront of the Women's Social Defence League in Bow Road, London, in 1912, to tell a group of young men about the fight for women's suffrage.

Die Pankhursts

Mrs. Emmeline Pankhurst (3) in den Armen eines kräftigen Polizisten nach einer Suffragettendemonstration vor dem Buckingham-Palast (1). Eine Mitstreiterin beschrieb sie als »sehr schmal und zerbrechlich, doch ihre zusammengepreßten Lippen zeugen von teuflischer Willenskraft«. (2) Dame Christabel Pankhurst: »Endlich haben wir Dampf genug, und die erste Schlacht ist geschlagen. Unser Blut ist in Wallung.« (Folgende Seite) Sylvia Pankhurst macht 1912 beim Anstrich des Ladens der *Women's Social Defence League* in der Londoner Bow Road eine Pause, um einer Gruppe junger Männer zu erklären, worum es der Frauenbewegung geht.

Les Pankhurst

Mme Emmeline Pankhurst (3) dans les bras d'un solide agent de police après une manifestation de Suffragettes à Buckingham Palace (1). Une camarade militante la décrit comme «très fragile et mince cependant que ses lèvres serrées expriment la détermination de Satan». (2) Dame Christabel Pankhurst: «Nous nous sommes enfin lancées et avons goûté aux joies du combat. Nous sommes en colère.» (Page suivante) Sylvia Pankhurst, alors en train de peindre la devanture de la *Women's Social Defence League* (Ligue pour la Protection Sociale des Femmes) sur Bow Road à Londres, en 1912, marque une pause pour expliquer à un groupe de jeunes hommes le combat des Suffragettes.

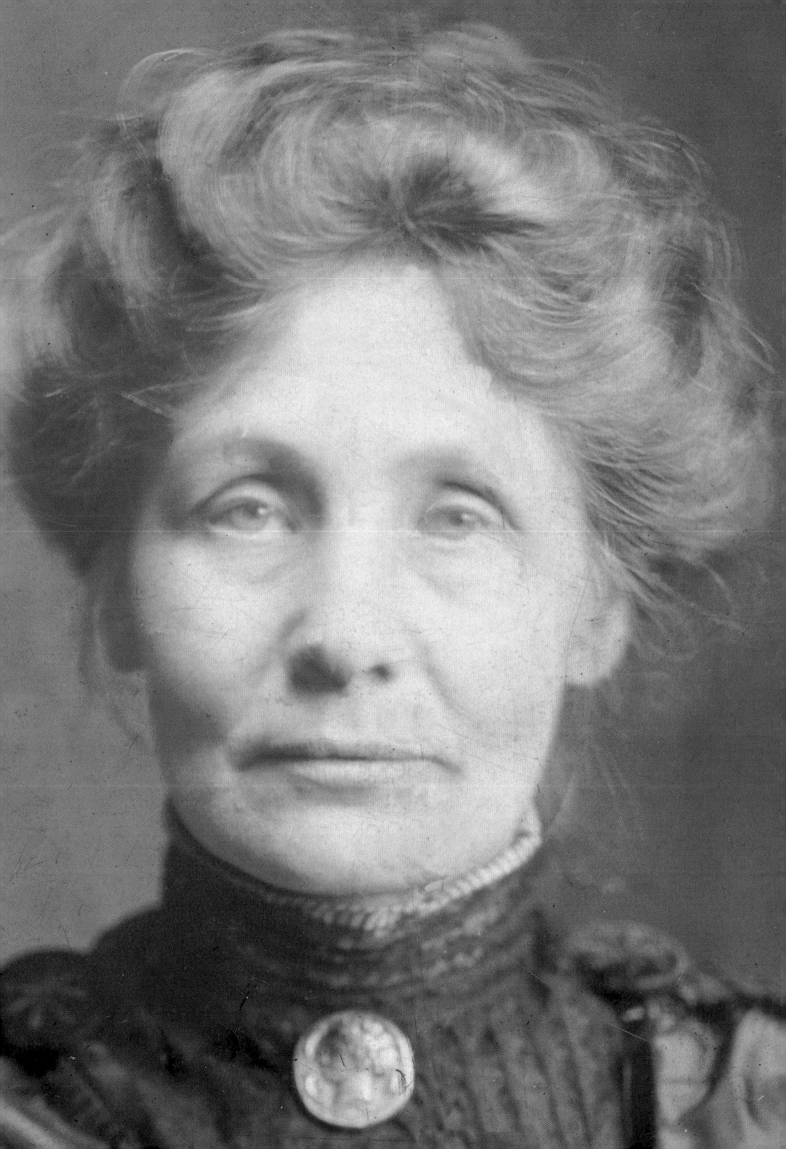

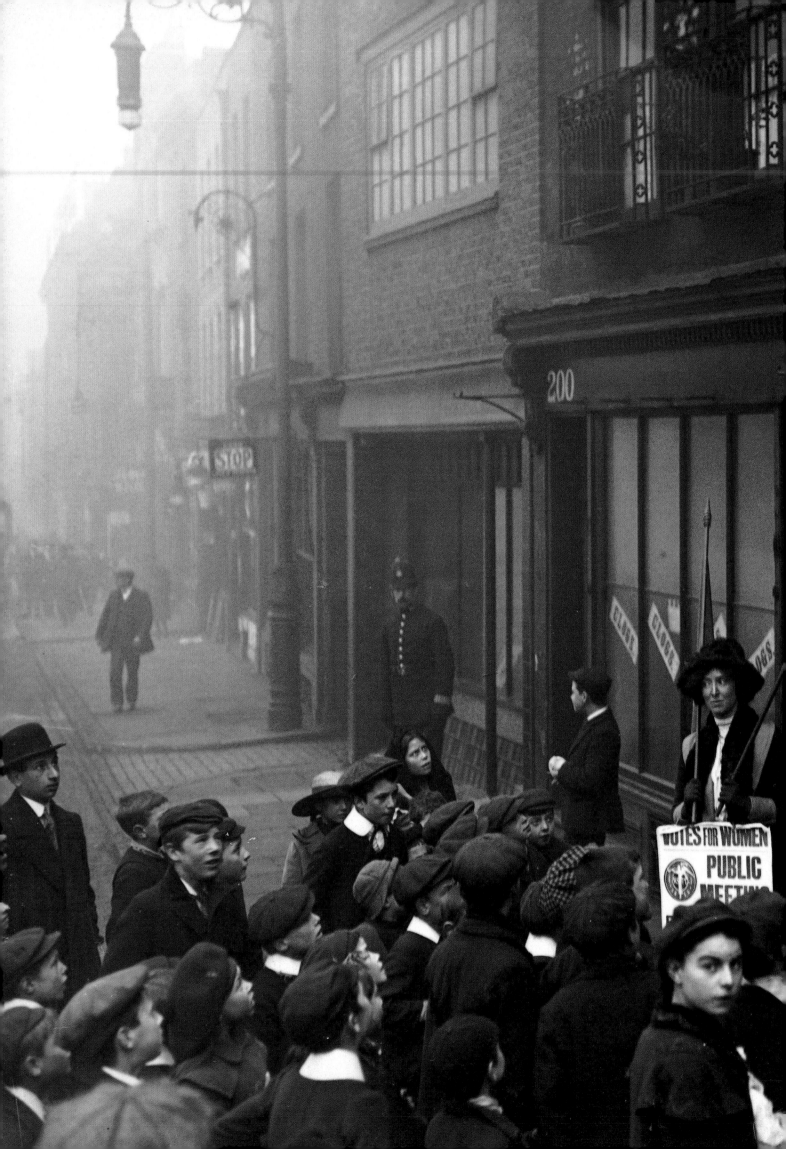

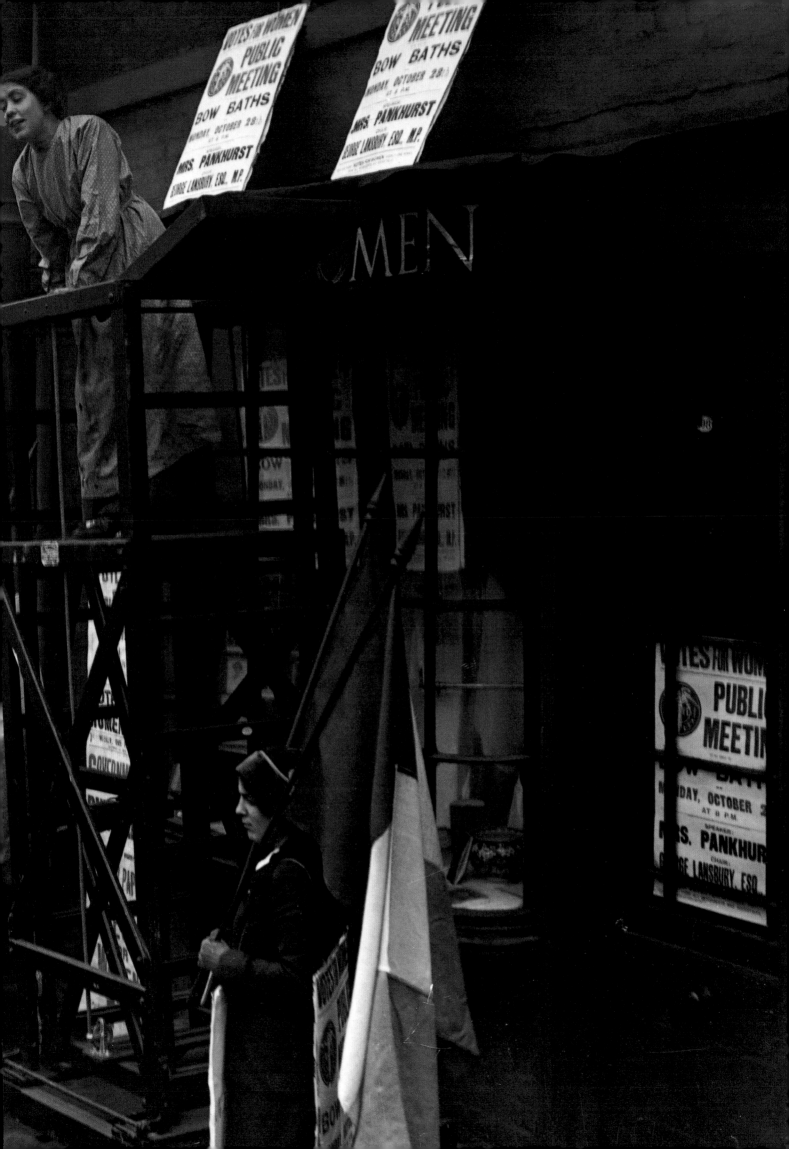

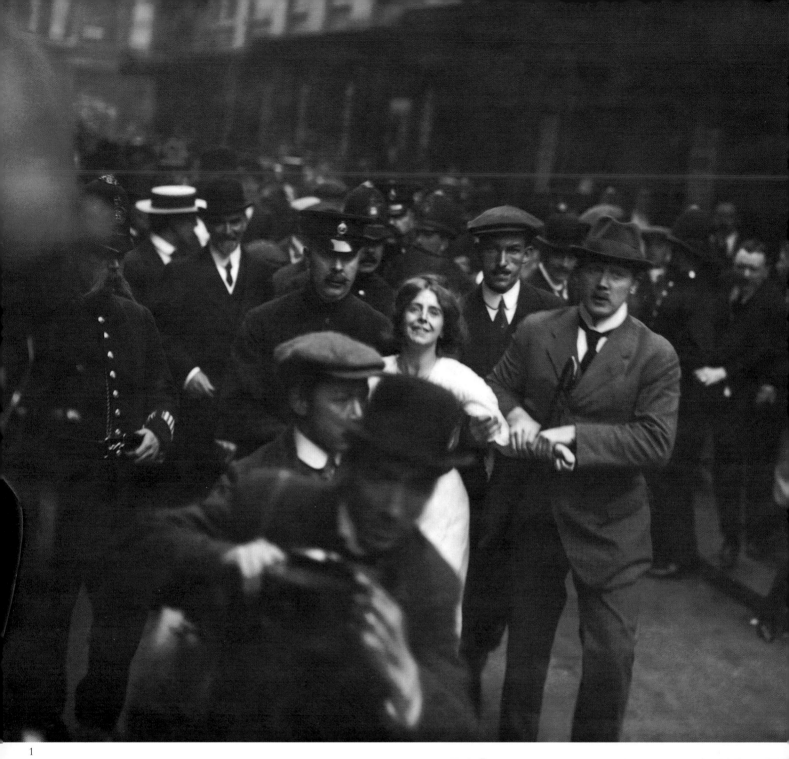

1

Violent Action
By 1913 the suffragettes had become more disruptive. (1) Annie Kenney
was accustomed to the routine of arrest, and came quietly and cheerfully.
(2) Others were more vociferously resistant. The demonstration at the
railings of Buckingham Palace in 1914 led to many arrests (3, 4, 5).

Militante Aktionen
1913 waren die Suffragetten bereits radikaler geworden. (1) Für Annie
Kenney war die Verhaftung schon Routine; sie läßt sich ruhig und guter
Dinge abführen. (2) Andere leisteten erbitterten Widerstand. Die Demon-
strationen vor dem Buckingham-Palast 1914 endeten mit zahlreichen
Festnahmen (3, 4, 5).

Action violente
En 1913, l'action des Suffragettes devint plus agressive. (1) Rodée à la
routine des arrestations, Annie Kenney se laissait emmener avec calme et
gaieté. (2) Les autres résistaient vigoureusement. La manifestation devant
les grilles de Buckingham Palace en 1914 provoqua de nombreuses
arrestations (3, 4, 5).

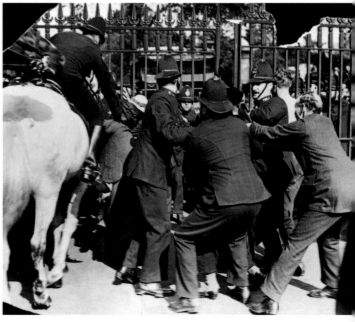

3

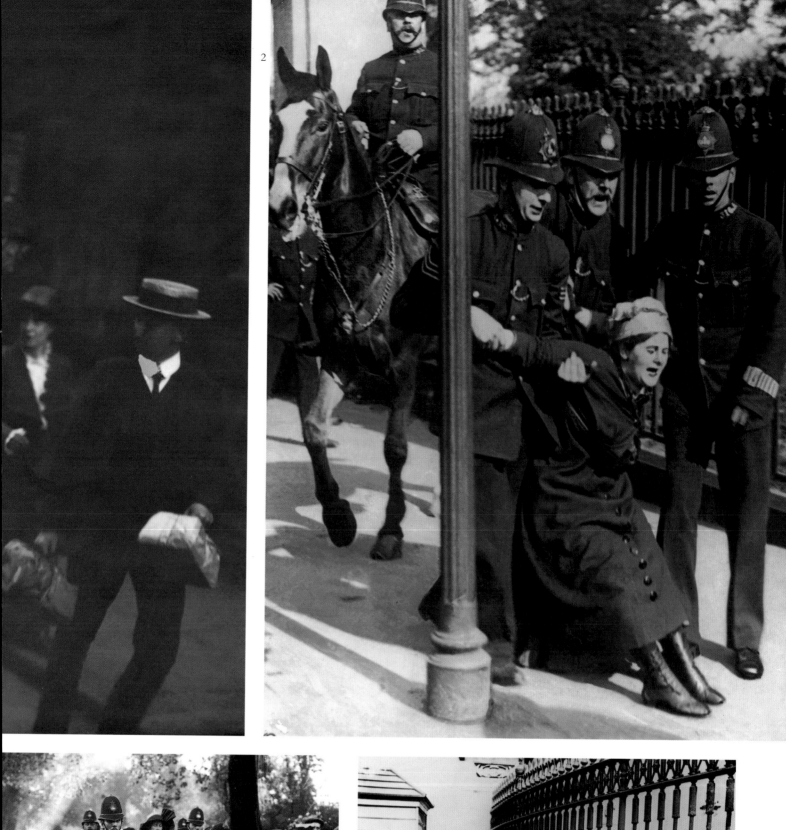

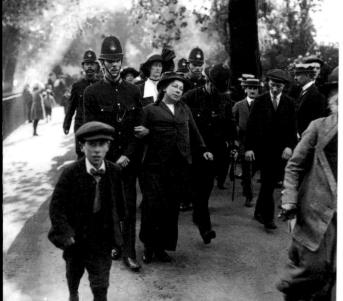

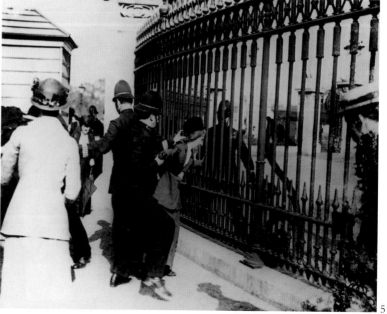

1

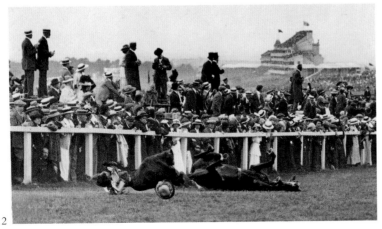

2

Martyr to the Cause

Emily Davison wrote: 'The glorious and indomitable Spirit of Liberty has but one further penalty within its power, the surrender of life itself, the supreme consummation of sacrifice.' (2) In 1913 she threw herself under the King's horse at the Derby. (1) Mrs Yates and Mary Lee guarding her coffin at Victoria Station, 14 June 1913. (3) The funeral procession. (Overleaf) In 1908 Mrs Baines addressed a mass rally in Trafalgar Square.

Eine Märtyrerin

Emily Davison schrieb: »Nur ein einziges kann der glorreiche und unbesiegbare Geist der Freiheit nun noch fordern – daß ich mein Leben gebe, das größte aller Opfer.« (2) 1913 warf sie sich beim Derby vor das Pferd des Königs. (1) Mrs. Yates und Mary Lee

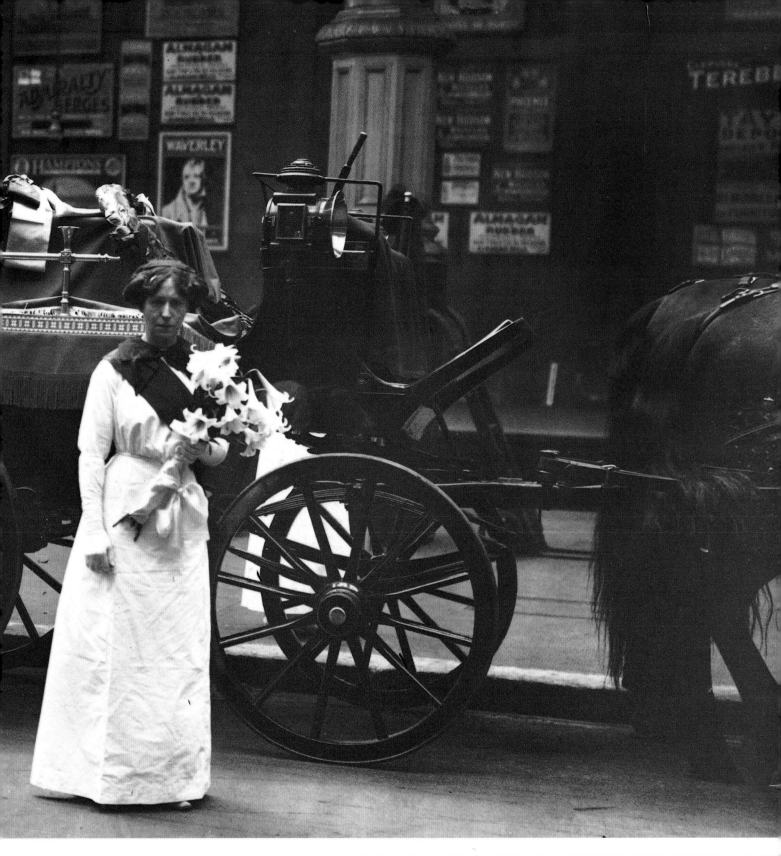

halten Wache an ihrem Sarg, Victoria Station, 14. Juni 1913.
(3) Der Trauerzug. (Folgende Seite) 1908 sprach Mrs. Baines bei
einer Großveranstaltung auf dem Trafalgar Square.

Martyre de la Cause

Emily Davison écrivait: «Le glorieux, l'invincible Esprit de Liberté
détient une arme ultime, la renonciation à la vie elle-même, apogée
suprême du sacrifice.» (2) En 1913, elle se jeta sous le cheval du
Roi au Derby. (1) Mme Yates et Mary Lee veillant son cercueil à la
gare Victoria, le 14 juin 1913. (3) Le cortège funèbre. (Page
suivante) En 1908, Mme Baines harangue un rassemblement
populaire à Trafalgar Square.

3

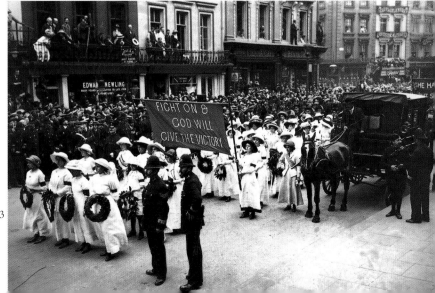

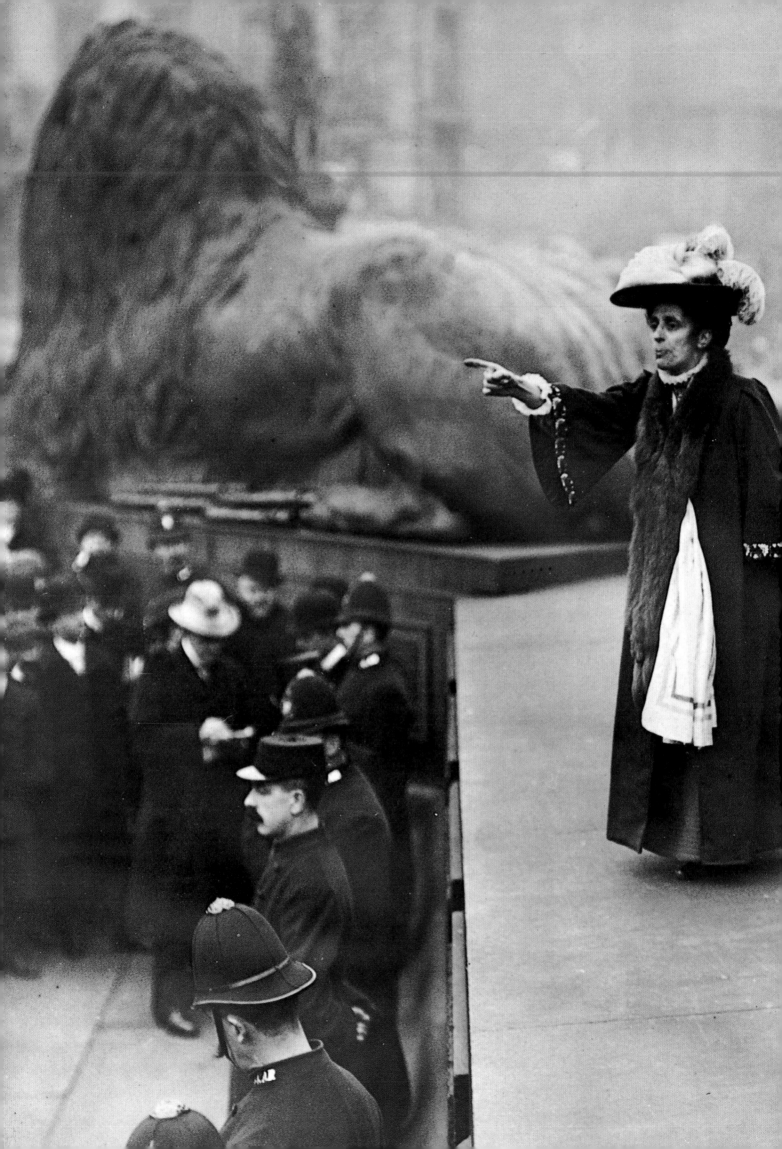

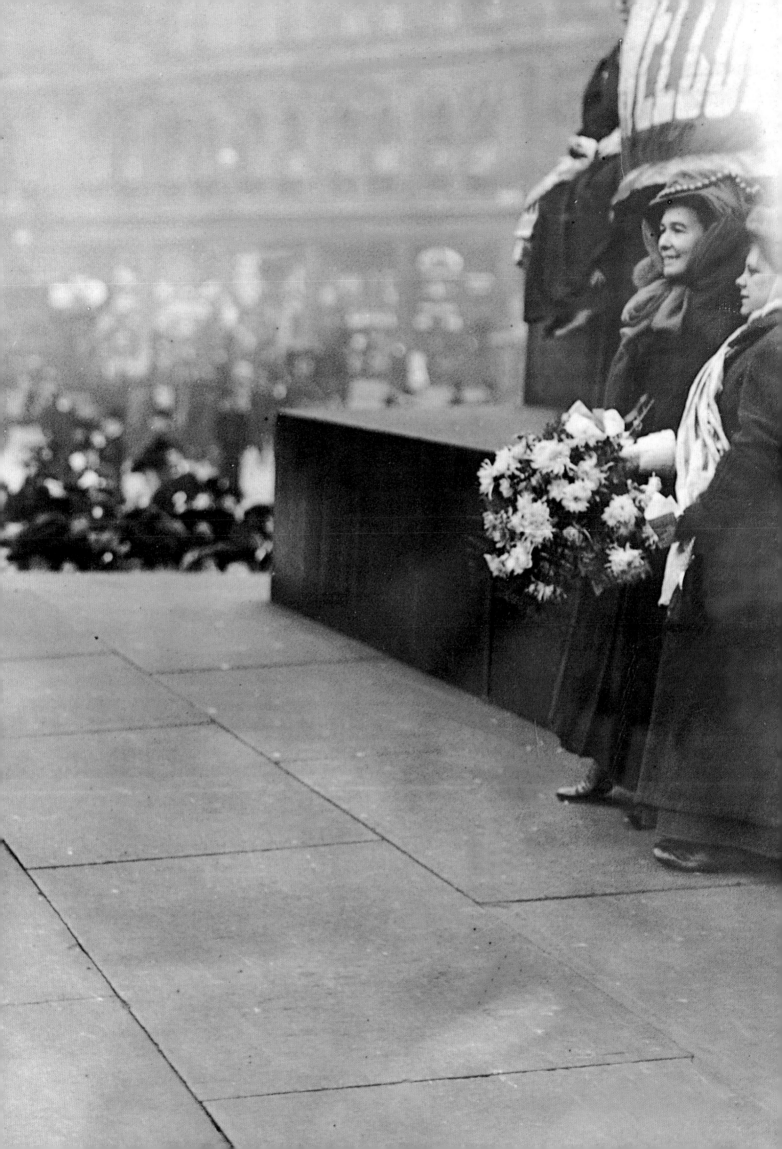

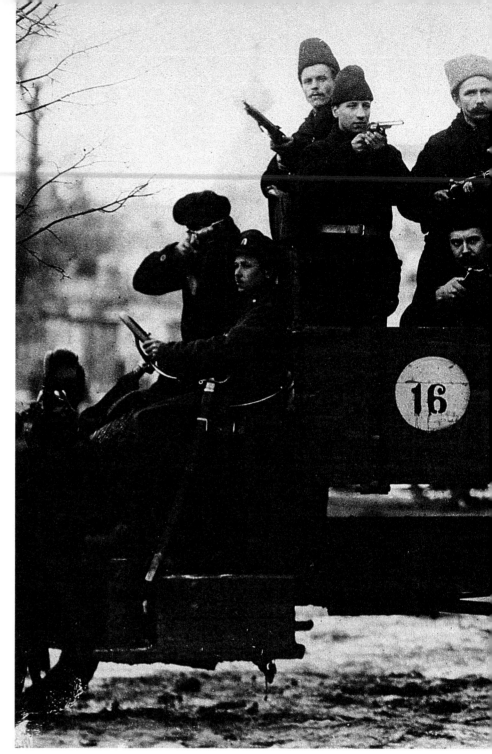

Armed Red Guards patrolling Petrograd in 1917: 'All these people were living on the slopes of a volcano which seemed to threaten to overwhelm them altogether' – Arthur Ransome, Russian correspondent of the *Daily News*.

Bewaffnete Rotgardisten patrouillieren in Petrograd, 1917: »All diese Menschen lebten am Rande eines Vulkans, der sie allesamt zu vernichten drohte« – Arthur Ransome, Rußlandkorrespondent der *Daily News*.

Les Gardes Rouges armés patrouillant dans Petrograd en 1917: «Tous ces gens vivent sur les flancs d'un volcan qui menace de les ensevelir tous» – Arthur Ransome, correspondant du *Daily News* en Russie.

The Red Menace

It didn't start with Marx and Engels. There had been fears that the masses might catch the heady scent of power in England in the Peasants' Revolt of 1381, in the French Revolution of 1789 and in Germany in 1834. But the opening words of the Communist Manifesto, published in seven languages, gave shape, identity and menace to the idea of political revolution: 'A spectre is haunting Europe – the spectre of Communism'.

Within weeks of its publication on 24 February 1848, the rulers of every state in Europe felt its effect. There was widespread agitation in Belgium, Italy, Britain, the Habsburg Empire, Poland, Spain and Russia. 'We are sitting on a volcano', Alexis de Tocqueville told the French Chamber of Deputies. A generation later, much of Paris was in the hands of the Communards. Two generations later came the Russian Revolution of 1905, a defeat for the revolutionaries but one which sowed the seeds of the Bolshevik victory of 1917.

Rosa Luxemburg looked forward to a revolution that was a spontaneous uprising of the workers. Lenin was prepared to push them faster than they might have wished to go. But despite the appalling slaughter and suffering of the First World War, in most countries revolution never came to the boil. The Spartacists had their day – or rather, month – in Germany. One employer described the French railway strike of 1920 as 'a civilian battle of the Marne'. Italian socialists threatened, but never recovered from Mussolini's March on Rome.

And so workers and bosses marched together into the Great Depression.

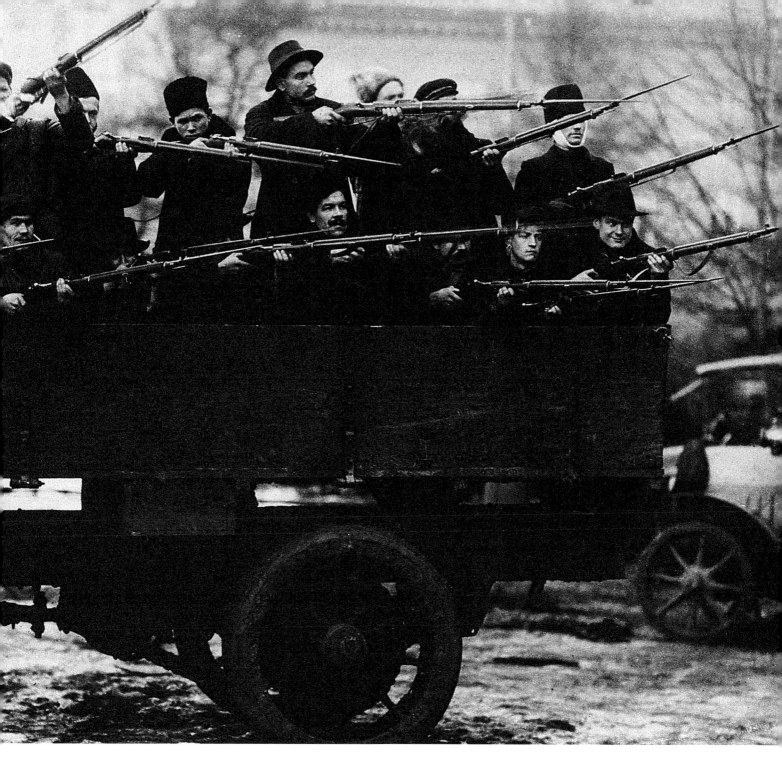

M arx und Engels waren nicht der Anfang. Die Angst, daß die Massen auf den berauschenden Geschmack der Macht kommen, hatte man in England schon beim Bauernaufstand von 1381, 1789 bei der Französischen Revolution und in Deutschland im Jahre 1834. Doch die ersten Worte des in sieben Sprachen veröffentlichten *Kommunistischen Manifests* gaben der Idee einer politischen Revolution Gestalt, Identität und Gewicht: »Ein Gespenst geht um in Europa – das Gespenst des Kommunismus.«

Das Manifest wurde am 24. Februar 1848 veröffentlicht, und es dauerte nur wenige Wochen, bis die Herrscher sämtlicher Staaten Europas seine Wirkung zu spüren bekamen. Es gab Agitationen in Belgien, Italien, Großbritannien, im Habsburger Reich, Polen, Spanien und Rußland. »Wir sitzen auf einem Vulkan«, sagte Alexis de Tocqueville der französischen Deputiertenkammer. Eine Generation später war ein Großteil von Paris in den Händen der Commune. Eine weitere

Generation später kam die russische Revolution von 1905, die zwar mit einer Niederlage der Revolutionäre endete, jedoch den Boden für den Sieg der Bolschewiki 1917 bereitete.

Rosa Luxemburg rechnete mit einem spontanen Arbeiteraufstand; Lenin wollte die Arbeiter weiter führen, als sie vielleicht von sich aus gegangen wären. Doch so entsetzlich das Leid und die Gemetzel des Ersten Weltkriegs auch waren, kam es doch in den meisten Ländern nicht zur Revolution. Einen Monat lang herrschten die Spartakisten in Deutschland; ein Industrieller bezeichnete den französischen Eisenbahnerstreik von 1920 als die »Marneschlacht der Zivilisten«; italienische Sozialisten trumpften auf, erholten sich jedoch nie von Mussolinis Marsch auf Rom.

Und so marschierten Arbeiter und Herren gemeinsam in die Weltwirtschaftskrise.

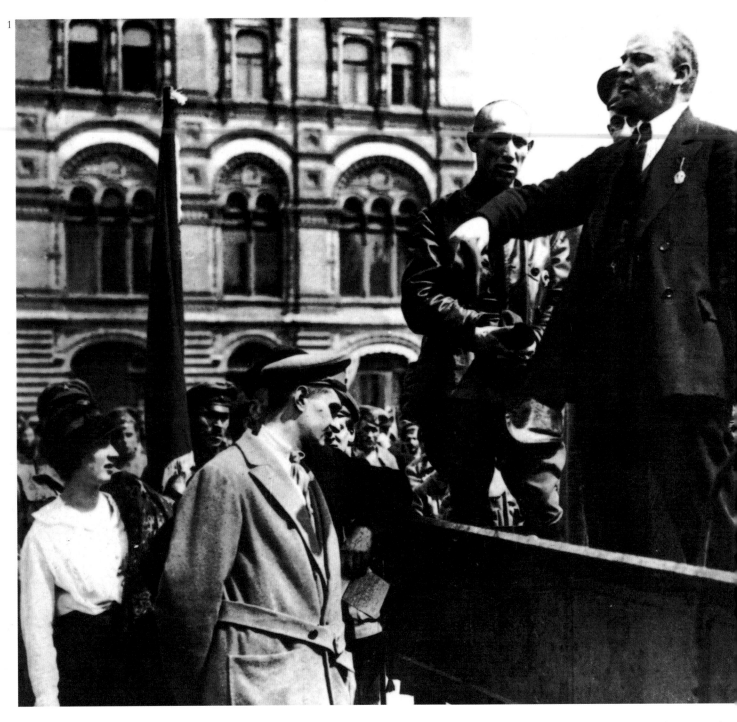

L'histoire commence bien avant Marx ou Engels. Il y a déjà longtemps que les masses s'étaient grisées de l'odeur du pouvoir. En Angleterre, les paysans avaient eu leur révolte en 1381. La France avait fait sa révolution en 1789 et l'Allemagne la sienne, en 1834. Les premières lignes du *Manifeste du Parti Communiste,* publié en sept langues, dessinaient les contours et donnaient une identité menaçante à l'idée de révolution politique. Un spectre hante l'Europe, et ce spectre a pour nom communisme.

Quelques semaines après sa publication, le 24 février 1848, tous les dirigeants d'Europe en ressentirent les effets. L'agitation grandissait en Belgique, en Italie, en Grande-Bretagne, dans l'empire des Habsbourg, en Pologne, en Espagne et en Russie. «Nous sommes assis sur un volcan», déclarait Alexis de Tocqueville à la Chambre des Députés. Une génération plus tard, les Communards avaient pris possession d'une grande partie de Paris. Deux générations plus tard, éclatait la Révolution Russe de 1905, qui se solda par un échec pour les révolutionnaires, mais prépara le terrain pour la victoire bolchévique en 1917.

Rosa Luxemburg attendait une révolution qui fut un soulèvement spontané des ouvriers. Lénine voulait, en dépit sans doute des aspirations réelles du peuple, précipiter le processus. Malgré l'hécatombe et les souffrances de la Première Guerre Mondiale, jamais, dans la plupart des pays, la révolution ne parvint à terme. Les Spartakistes eurent leur heure – plus exactement, leur mois – en Allemagne. La grève du rail de 1920 en France ressembla, selon les termes d'un patron, à «une bataille civile de la Marne». Un temps menaçants, les socialistes italiens ne se remirent jamais de la Marche sur Rome de Mussolini.

Et les ouvriers comme les patrons marchaient ensemble vers la Grande Dépression.

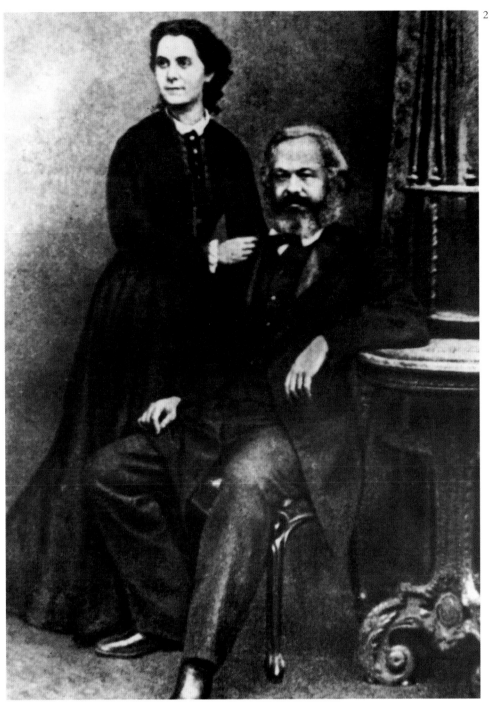

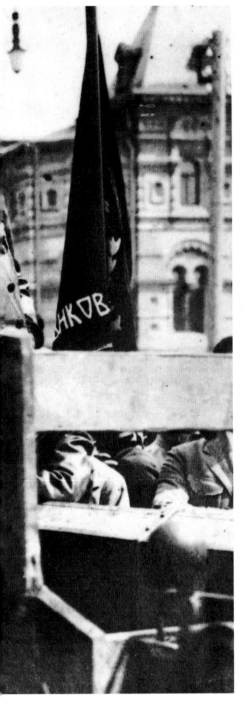

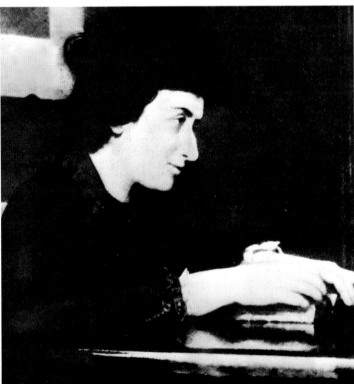

The brains behind the revolution: (1) Vladimir Ilyich Lenin; (2) Karl Marx, with his oldest and favourite daughter, Jenny; (3) Rosa Luxemburg, murdered by right-wing nationalists in Berlin, January 1919.

Die Köpfe der Revolution: (1) Wladimir Iljitsch Lenin; (2) Karl Marx mit seiner ältesten und liebsten Tochter Jenny; (3) Rosa Luxemburg, im Januar 1919 von rechtsgerichteten Freikorpsoffizieren ermordet.

Les cerveaux de la Révolution: (1) Vladimir Ilitch Lénine; (2) Karl Marx et sa fille aînée, sa préférée Jenny; (3) Rosa Luxemburg, assassinée par des nationalistes de droite à Berlin, en janvier 1919.

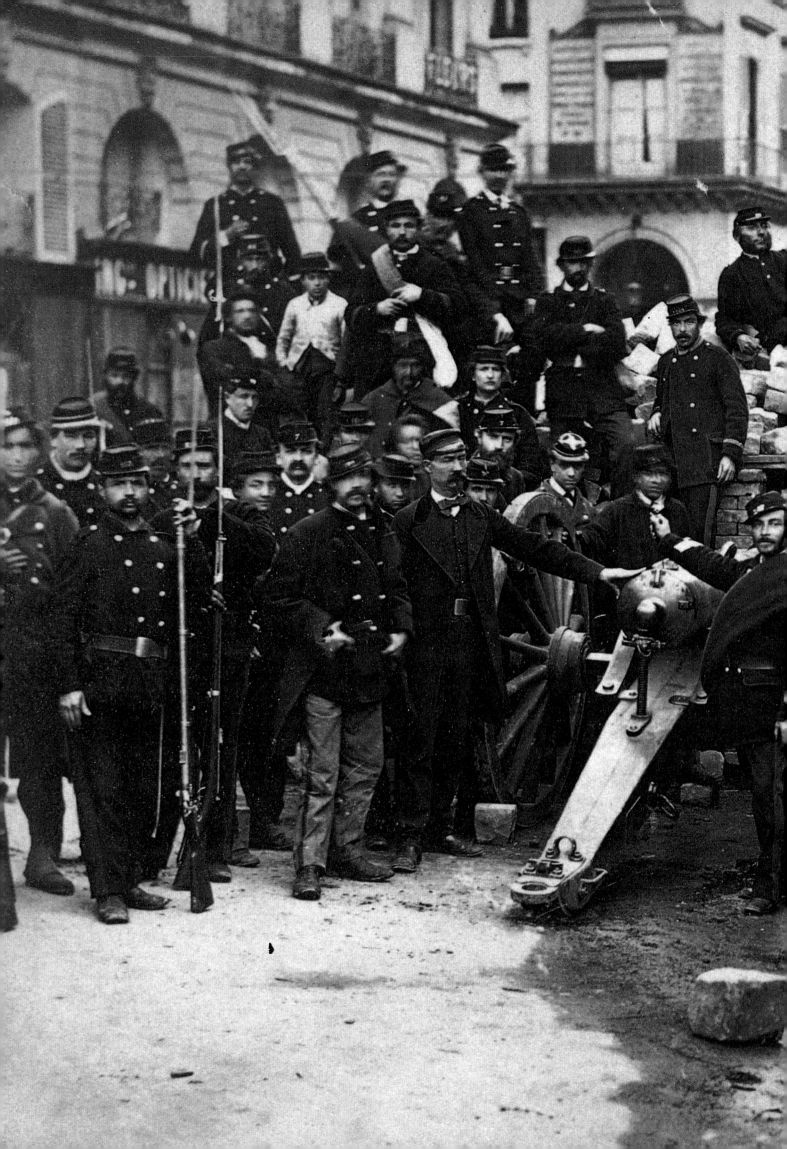

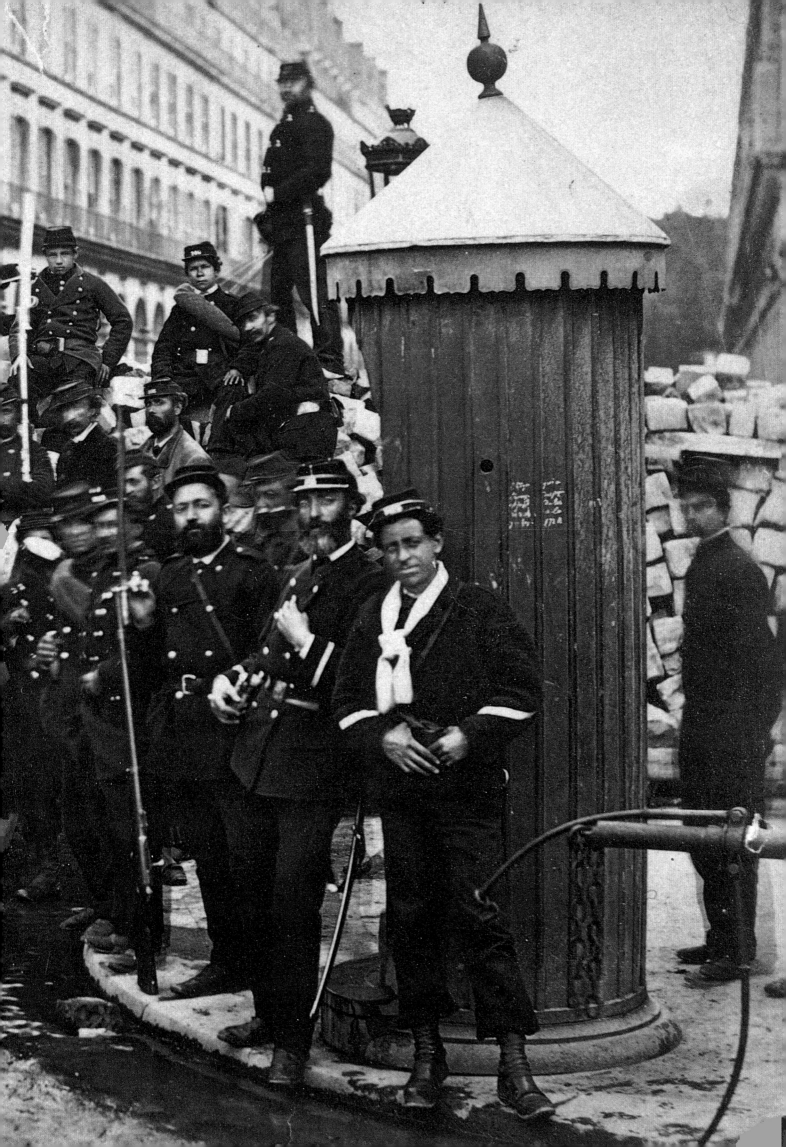

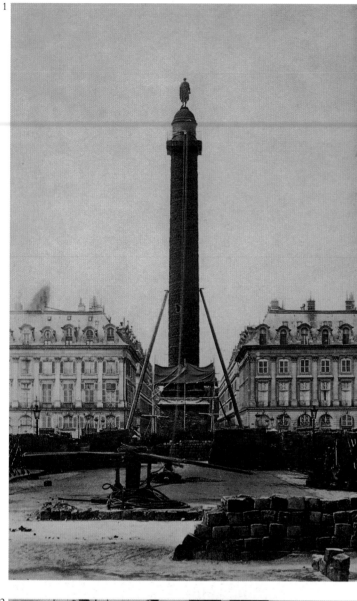

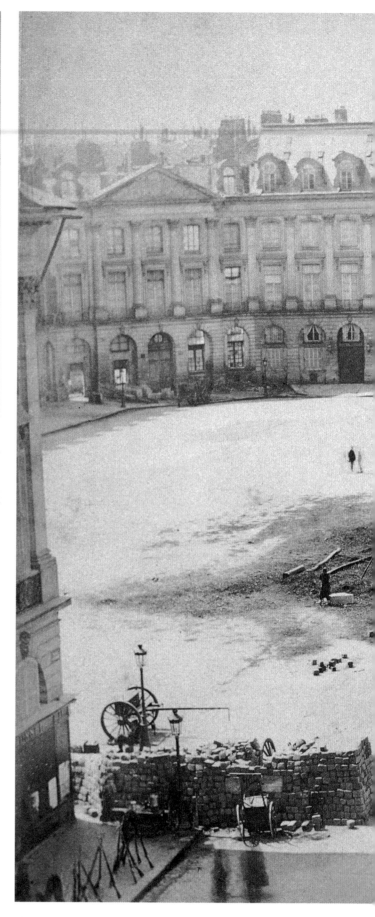

The Vendôme Column

(Previous page) National Guardsmen pose beside a barricade in the Place Vendôme, March 1871. (1) In May the 144-foot column commemorating Napoleon I was ritually demolished (3) in front of massed bands and a huge crowd. (2) The painter Courbet took no part in the proceedings but was later charged, and this faked photograph (his head marked 'X') was presented at his trial as evidence for the prosecution. He had to flee from France.

Die Vendôme-Säule

(Vorige Seite) Männer der Nationalgarde posieren an einer Barrikade auf der Place Vendôme, März 1871. (1) Im Mai wurde die Säule, deren 44 Meter langer Fries der Taten Napoleons I. gedenkt, von den Volksmassen rituell gestürzt (3). (2) Der Maler Courbet,

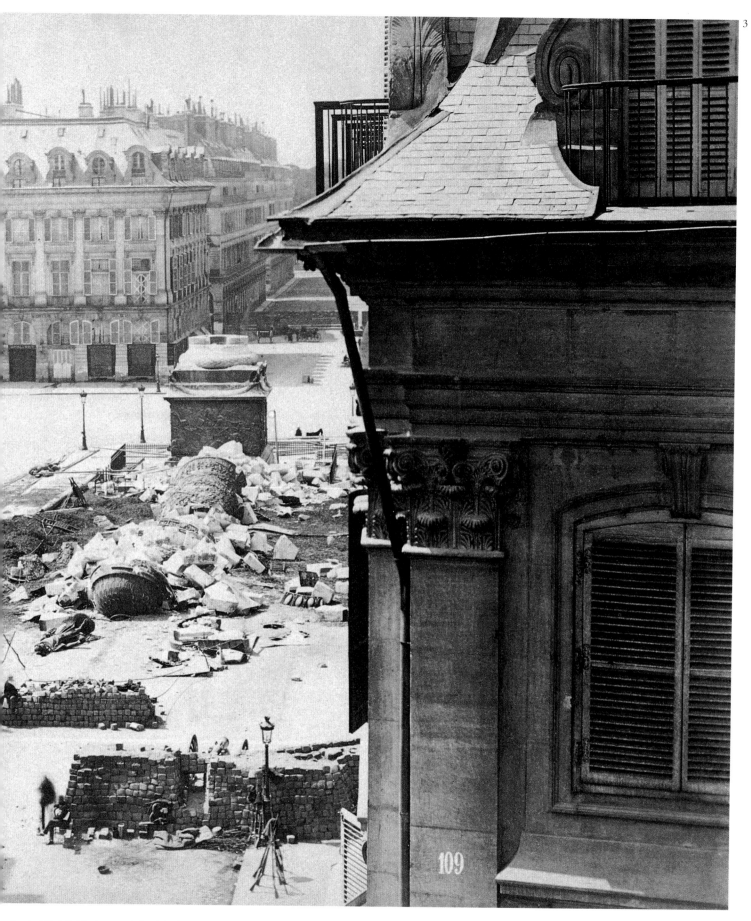

der in Wirklichkeit gar nicht dabeigewesen war, wurde später der Teilnahme angeklagt, und diese Fotomontage (sein Kopf mit einem Kreuz markiert) legte die Anklage vor Gericht als Beweis vor. Er mußte aus Frankreich fliehen.

La Colonne Vendôme
(Page précédente) Mars 1871, la Garde Nationale pose à côté d'une barricade sur la place Vendôme. (1) En mai, la colonne de 44 mètres dressée à la gloire de Napoléon Ier fut symboliquement démolie (3) devant une vaste foule et sous les yeux de la troupe.

(2) Le peintre Courbet, absent de cette manifestation, fut pourtant inculpé. Au cours de son procès, l'accusation se servit de cette photographie truquée (son visage est marqué d'un X) pour prouver sa culpabilité. Il fut contraint de quitter la France.

The Camera as a Weapon of Propaganda

An unrealistic reconstruction of the killing of hostages taken by the Communards on 26 May 1871. Everyone seems to be too well-dressed and composed to have been involved in weeks of bitter street fighting, and there is an unlikely atmosphere of calm and order. But such pictures did much to stir up hatred against the Commune.

Die Kamera als Propagandamittel

Eine unrealistisch gestellte Szene; die Ermordung von Geiseln durch Kommunarden am 26. Mai 1871. Alle sehen zu gut angezogen und zu ordentlich aus, als daß sie wochenlange erbitterte Straßenkämpfe hinter sich haben könnten, und es herrscht eine unglaubwürdige Stimmung von Ruhe und Ordnung. Doch gelang es tatsächlich, mit solchen Bildern den Haß gegen die Kommune zu schüren.

La photographie au service de la propagande

Une reconstitution invraisemblable du meurtre des otages pris par les Communards le 26 mai 1871. Les personnages sont trop soigneusement vêtus pour avoir subi des semaines d'âpres combats de rue, et il règne une atmosphère de calme et d'ordre assez factice. Ce type de photographies contribua largement à exacerber l'hostilité envers la Commune.

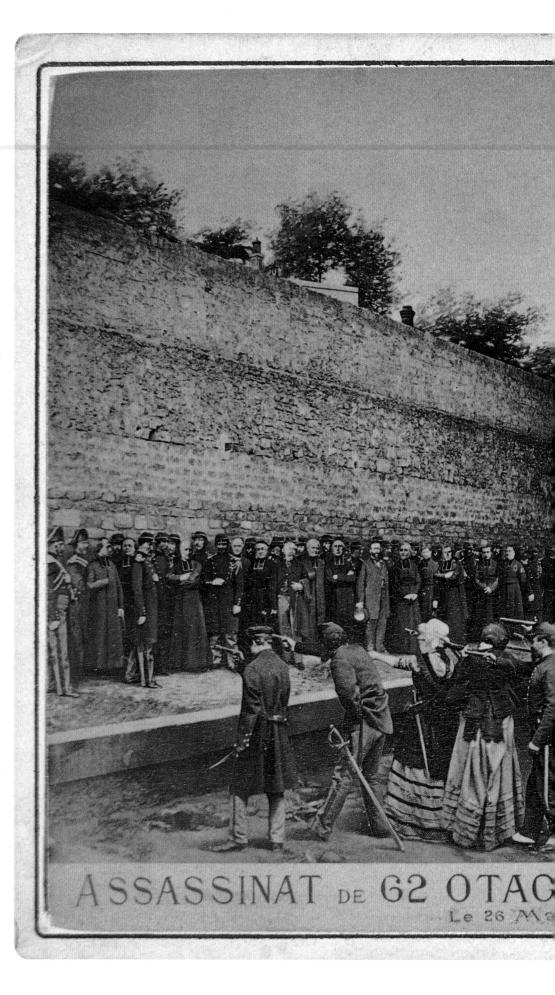

ASSASSINAT DE 62 OTAG
Le 26 Ma

RUE HAXO 85 . A BELLEVILLE .
à 5 heures du Soir

Album
24. Rue Taitbout, 24.
DEPOSE

Portrait
E. APPERT. PHOT. EXPERT
Reproduction interdite

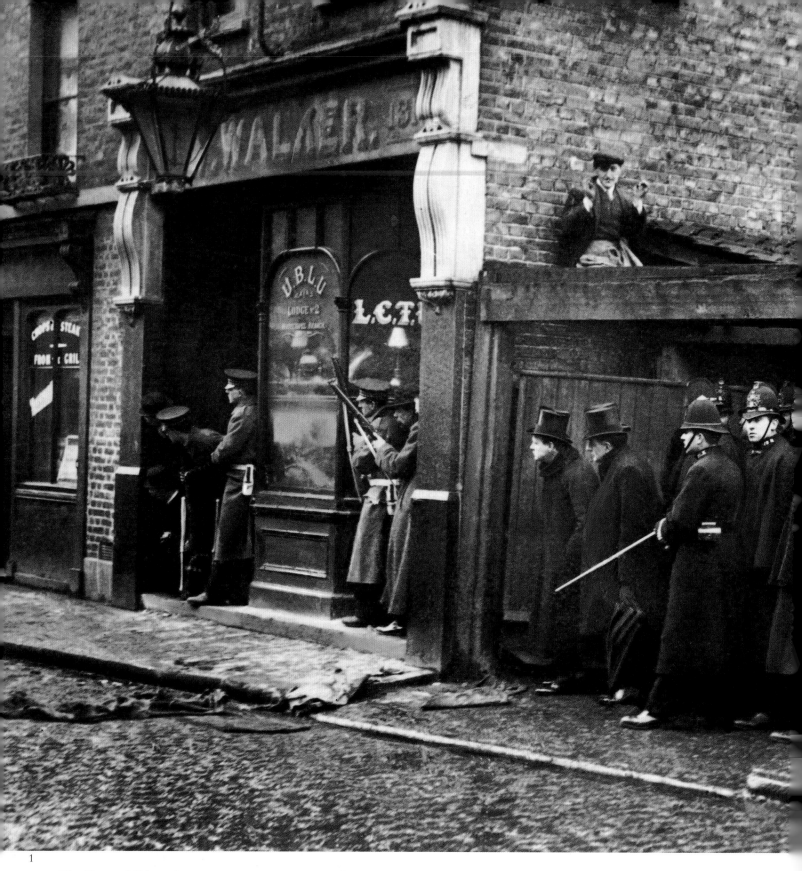

1

The Siege of Sidney Street

In December 1910 a gang of criminal anarchists were caught tunnelling into a jeweller's shop in the East End of London. They set fire to the building (3) and shot their way out, killing several policemen. (1) Scots Guards from the Tower of London and policemen armed with duck guns and rook rifles surrounded the house where three of the anarchists were trapped. Winston Churchill, then Home Secretary, visited the site (1, 2, in top hat). Legend has it that their leader, Peter the Painter, escaped.

Die Belagerung der Sidney Street

Im Dezember 1910 wurde eine Bande krimineller Anarchisten entdeckt, die einen Tunnel zu einem Juwelierladen im Londoner East End gegraben hatten. Sie setzten das Gebäude in Brand (3) und schossen sich dann den Weg frei, wobei mehrere Polizisten umkamen. (1) Leibgardisten aus dem Tower und Polizisten mit Entenflinten und Krähengewehren umstellten das Haus, in dem drei Anarchisten festsaßen. Winston Churchill, damals Innenminister, suchte den Ort des Geschehens auf (1, 2, mit Zylinder).

Der Legende nach soll der Anführer der Anarchisten, Peter the Painter, davongekommen sein.

Le siège de Sidney Street

En décembre 1910, un gang de malfaiteurs anarchistes fut arrêté alors qu'ils creusaient un tunnel pour s'introduire dans une bijouterie des quartiers est de Londres. Ils mirent le feu au bâtiment (3) et tirèrent pour couvrir leur fuite, tuant de nombreux policiers. (1) La Garde Ecossaise de la Tour de Londres et des policiers armés de

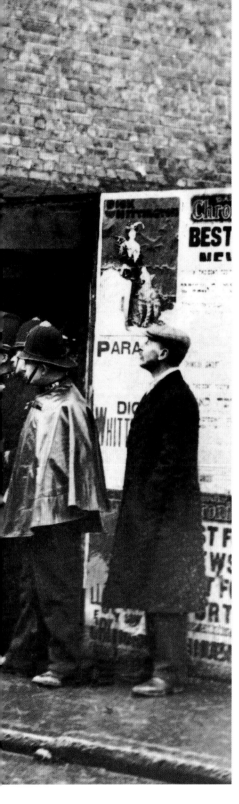

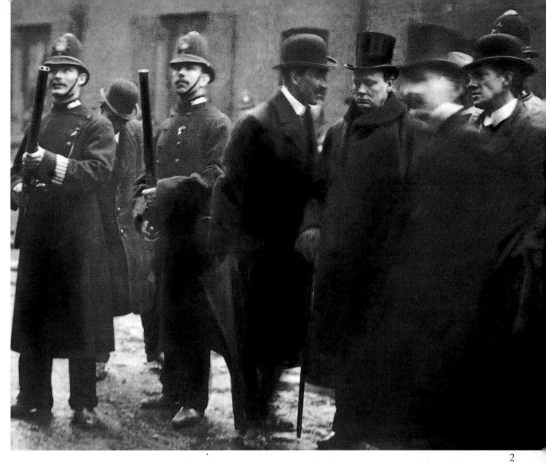

canardières et de carabines de chasse entou-
rèrent la maison où s'étaient retranchés trois
des anarchistes. Winston Churchill, alors
ministre de l'Intérieur, se rendit sur les lieux
(1, 2, en haut-de-forme). Selon la légende, le
chef du gang, Peter the Painter, se serait
échappé.

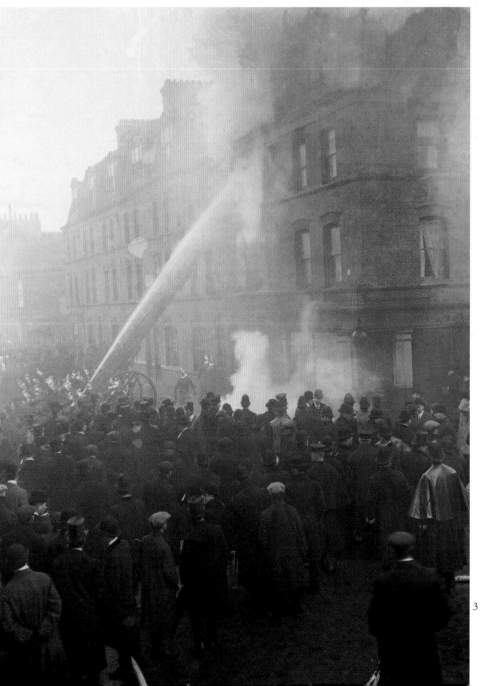

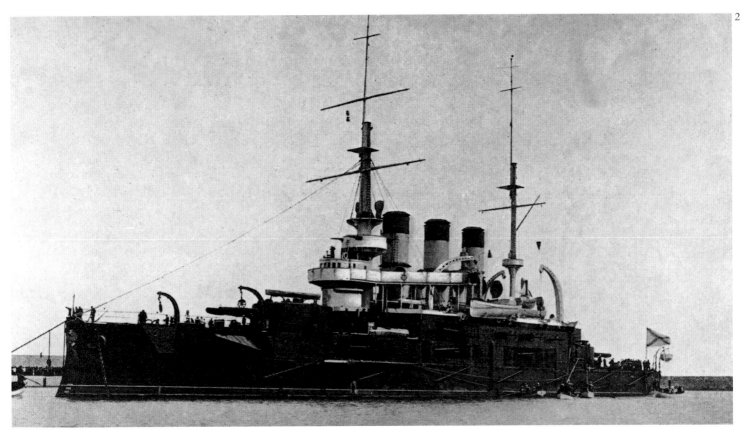

Battleship Potemkin

On 27 June 1905, the crew of the Russian battleship *Potemkin* (2), the most powerful ship in the Black Sea fleet, killed their captain and rose in mutiny while the ship was moored in Odessa harbour. Immediately a general strike was declared in the town in support of the mutineers. (3) Workers marched to demonstrate their solidarity. Like many of the revolutionary events of 1905, the mutiny spluttered and died. The crew sailed to Rumania, seeking asylum. (1) A month after the mutiny, they are breakfasting at a Rumanian hotel.

Panzerkreuzer Potemkin

Am 27. Juni 1905 meuterte die Besatzung des russischen Panzerkreuzers *Potemkin* (2) und tötete den Kapitän; das Schiff, das mächtigste der Schwarzmeerflotte, lag damals im Hafen von Odessa vor Anker. Sofort wurde in der Stadt zur Unterstützung der Meuterer ein Generalstreik ausgerufen. (3) Arbeiter marschierten, um ihre Solidarität zu demonstrieren. Wie so viele revolutionäre Ereignisse des Jahres 1905 erstarb der Aufstand schließlich. Die Mannschaft fuhr nach Rumänien und bat dort um Asyl. (1) Einen Monat nach dem Aufstand frühstücken sie in einem rumänischen Hotel.

Le cuirassé Potemkine

Le 27 juin 1905, le cuirassé russe *Potemkine* (2), le plus puissant navire de la flotte de la Mer Noire, mouillait dans le port d'Odessa; son équipage se mutina et tua le capitaine. Une grève générale de soutien à la mutinerie fut immédiatement déclenchée à Odessa. (3) Manifestation de solidarité des ouvriers. A l'instar de bien des événements révolutionnaires de 1905, la révolte échoua. Les mutinés firent voile vers la Roumanie pour demander l'asile. (1) Un mois après les événements, les marins prennent leur petit déjeuner dans un hôtel roumain.

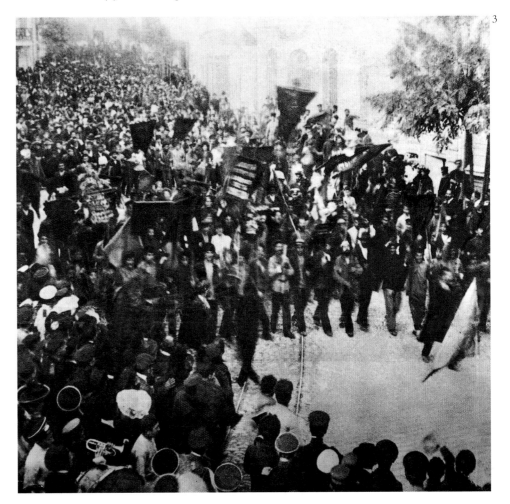

The October Revolution, 1917

(1) Soldiers and students lying in wait for the Petrograd police. 'The majority of Russians do not care one way or the other,' reported the British *Daily News*. 'The majority would acquiesce in anything that should give them bread, peace and some sort of order.' (2) The man who promised all three: Lenin leaves the First All Russian Congress on Education, August 1918. (3) Red Guards at Lenin and Trotsky's office.

Die Oktoberrevolution, 1917

(1) Soldaten und Studenten lauern der Petrograder Polizei auf. »Den meisten Russen ist vollkommen gleichgültig, welche Seite sich durchsetzt«, berichtete die britische *Daily News*. »Die meisten wären mit allem zufrieden, was ihnen Brot, Frieden und eine gewisse Ordnung bieten könnte.« (2) Der Mann, der diese drei Dinge versprach: Lenin beim Verlassen des Ersten Allrussischen Erziehungskongresses, August 1918. (3) Rotgardisten bewachen Lenins und Trotzkis Büro.

La Révolution d'Octobre, 1917

(1) Soldats et étudiants guettant la police de Petrograd. «La majorité des Russes ne s'y intéresse en aucune façon», rapporte le journal britannique *Daily News*. «La majorité souscrira à tout ce qui pourra lui fournir du pain, la paix et un certain ordre.» (2) L'homme qui promettait tout cela – Lénine – quitte le Premier Congrès de toute la Russie sur l'Education, août 1918. (3) Les Gardes Rouges devant les bureaux de Lénine et de Trotski.

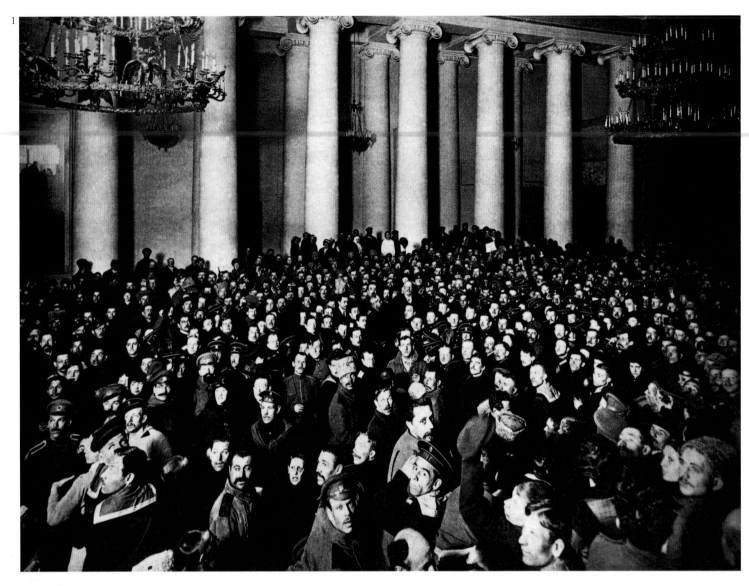

The Russian Revolution

It was the support of the military that carried the day for the Bolsheviks in the October Revolution. (1) An audience of mostly soldiers and sailors listen to a speech by Rodzhiansko in the Catherine Hall of the Tauride Palace, Petrograd. (2) The revolutionary organization begins to take over: verification of mandates to the Revolution. (3) Russian marines on an armoured car near the Smolny Palace, Moscow.

Die russische Revolution

Daß die Bolschewiki in der Oktoberrevolution den Sieg davontragen konnten, verdankten sie der Unterstützung durch das Militär. (1) Ein Publikum, das größtenteils aus Soldaten und Seeleuten besteht, lauscht einer Rede Rodschianskos im Katharinensaal des Taurischen Palasts in Petrograd. (2) Die revolutionären Institutionen übernehmen die Macht: Überprüfung der Revolutionsmandate. (3) Russische Marineinfanteristen auf einem Panzerwagen nicht weit vom Moskauer Smolny-Palast.

La Révolution Russe

Lors de la révolution d'octobre, le soutien des militaires aux Bolcheviks fut décisif. (1) Un public composé principalement de soldats et de marins écoutant un discours de Rodzhiansko dans la Salle Catherine du palais Tauride à Petrograd. (2) L'ordre révolutionnaire s'organise: vérification des mandats pour la Révolution. (3) Des marins russes sur une voiture blindée près du Palais Smolny à Moscou.

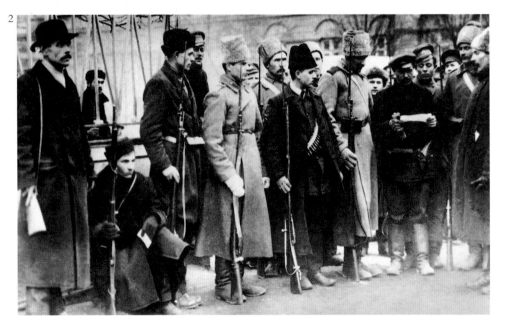

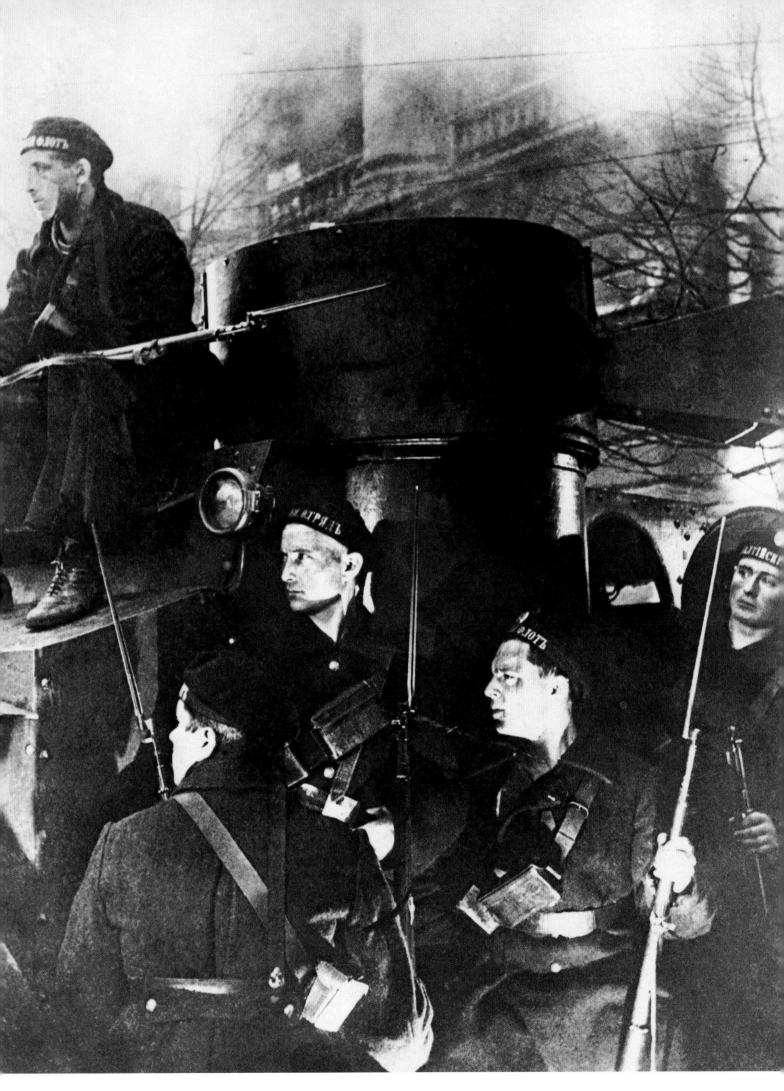

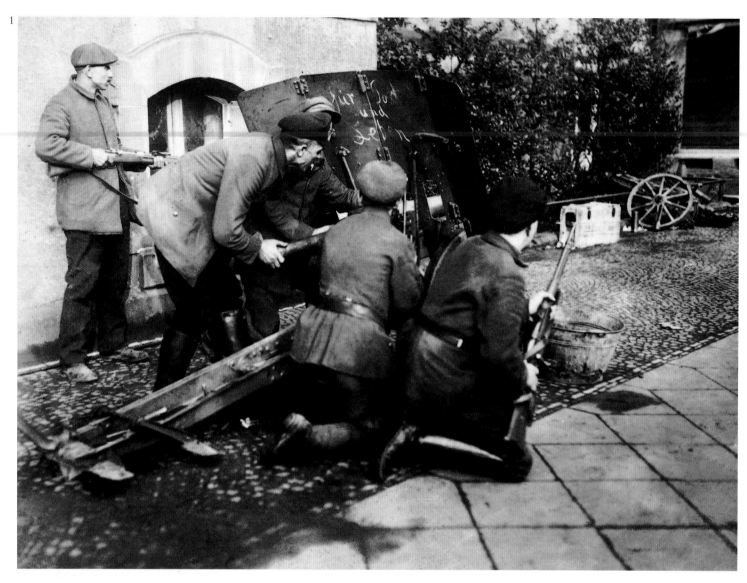

The German Revolution
9 November 1918, 'One of the most memorable and terrible days in German history'. It was a day that saw the abdication of the Kaiser, the collapse of the Imperial Army, troops of the Workers' and Soldiers' Council marching in Berlin along Unter den Linden (2), and shots exchanged between left- and right-wing factions around the Neptune Fountain (4). (3) In Hamburg, soldiers loyal to the government guarded shops against looters. (1) Communist troops in the Ruhr in April 1920 provoked the mobilization of the loyal German army, which, in turn, led to French occupation of the Ruhr.

Revolution in Deutschland
Der 9. November 1918, »einer der schreck-lichsten und denkwürdigsten Tage in der deutschen Geschichte«. Es war der Tag, an dem Kaiser Wilhelm abdankte, die kaiserliche Armee kapitulierte, in Berlin die Truppen der Arbeiter- und Soldatenräte Unter den Linden marschierten (2) und am Neptunbrunnen Schüsse zwischen links- und rechtsgerich-teten Splittergruppen fielen (4). (3) In Ham-burg schützten loyale Regierungstruppen die

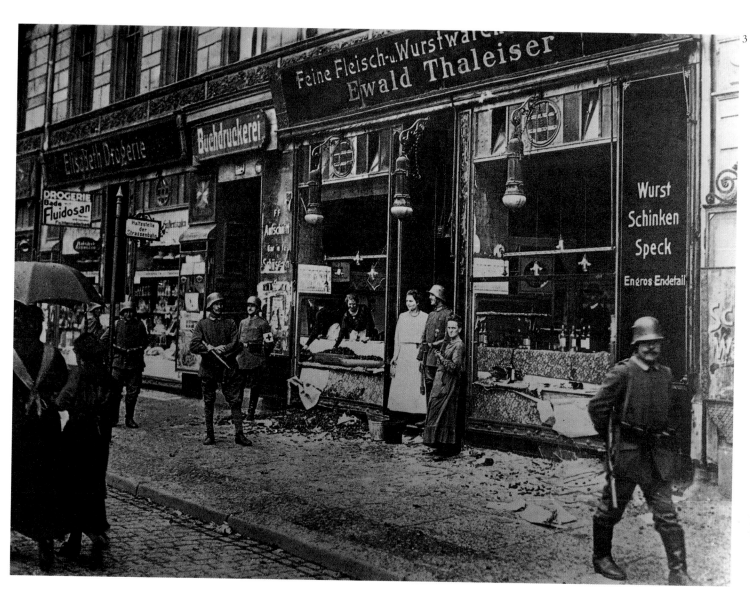

Läden vor Plünderern. (1) 1920 kam es zum
Kommunistenaufstand an der Ruhr, und in
der deutschen Armee wurde mobilgemacht,
was wiederum die französische Besetzung
des Ruhrgebiets nach sich zog.

La Révolution Allemande
9 novembre 1918, «l'un des jours de
l'Histoire de l'Allemagne les plus tristement
mémorables.» Ce jour-là vit l'abdication du
Kaiser, l'effondrement de l'Armée Impériale,
le défilé des troupes du Conseil des Ouvriers
et des Soldats sur Unter den Linden à Berlin
(2), des échanges de tirs enfin entre des
factions de droite et de gauche autour de la
fontaine Neptune (4). (3) A Hambourg, des
soldats fidèles au gouvernement protègent les
magasins des pilleurs. (1) En avril 1920, la
présence de troupes communistes dans la
Ruhr provoqua la mobilisation de l'armée
allemande gouvernementale et entraîna
l'occupation de la Ruhr par les Français.

Industrial Strife

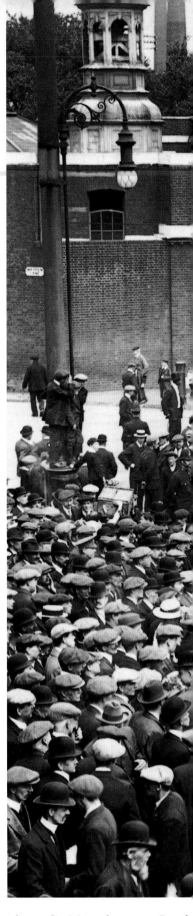

It was the age of the machine – driving people off the land and into the towns. Few went willingly, so it is perhaps not surprising that it was also the age of misery, confrontation and discontent. Workers who had been able to join together in trade unions – still illegal in many countries – could test their political and industrial muscle. They had little to lose. For the most part they were overworked, underpaid and poorly housed. Their employers, on the other hand, had much to lose if work came to a halt. This was the age of massive profits and dividends, increasing demand, new markets. Striking workers meant idle machines and that meant no income, no share in the rich bonanza of 19th-century trade and prosperity.

Some among the workers were men of vision. They saw all this, and the wealth and comfort that their toil was creating, and they saw no reason why they shouldn't share in it. If the bosses didn't give in peacefully and amicably to the workers' just demands – and few did – then maybe it would come to war of a kind. 'Workers feel that great social changes must come soon,' wrote Samuel Gompers, leader of the American Federation of Labour in 1909, 'that the curtain has been rung down on the comedy of government by, of and for the classes … and that the struggles of the toilers for their own shall take precedence over wars between nations.'

The battle lines were drawn. On the one side: the workers, in their caps and mufflers, their rough suits and heavy boots – millions of them. On the other: bosses, police, troops, bankers, all the trappings of the old order. When it came to a showdown, the workers could expect little outside help. 'Wherever miners stand, mates brave and true must be at hand,' chanted the German coalminers. Just occasionally a strike would proliferate – starting with the dockers who loaded and unloaded the ships on which world trade depended, then spreading to the transport and railway workers who moved the goods to and from the docks, and finally recruiting workers from other trades and industries. When this happened all hell was let loose in the great ports of Europe and the United States – Genoa, Barcelona, Amsterdam, New York, Marseilles.

Governments and employers were quick to respond. In 1910, 50,000 British dockers were fired for striking. The French government went further. When 150,000 railwaymen went on strike in France, they were all conscripted and placed under martial law. A year earlier pitched battles had been fought between strikers and state troopers at the Pressed Steel Car Company plant near Pittsburgh.

Four years later comparative peace returned to the industrial scene. In the United States Henry Ford began to pay his workers $5 a day, and in Europe millions of workers marched to war.

With the prospect of war looming, the strike at the Woolwich Arsenal in south-east London in July 1914 was seen as a real threat. The outbreak of the war a few weeks later resolved the situation as workers were drafted into the army.

Am Vorabend des bevorstehenden Krieges wurde der Streik im Woolwich Arsenal im südöstlichen London im Juli 1914 als eine echte Bedrohung gesehen. Der Ausbruch des Krieges ein paar Wochen später klärte die Situation, da die Arbeiter zur Armee eingezogen wurden.

Avec la menace d'une guerre imminente, la grève qui se propagea en juillet 1914 dans l'Arsenal Woolwich au sud-est de Londres fut considérée comme un véritable danger. Pourtant, quelques semaines plus tard, la situation se rétablit d'elle-même lorsque la guerre éclata: les ouvriers furent mobilisés.

Das Zeitalter der Maschine hatte die Menschen vom Land in die Städte getrieben. Nur die wenigsten gingen freiwillig, und so war das Maschinenzeitalter zugleich auch das Zeitalter von Elend, Unruhen und Unzufriedenheit. Dort, wo die Arbeiter sich schon in Gewerkschaften zusammenschließen konnten – vielerorts waren sie nach wie vor verboten –, zeigten sie Solidarität und Stärke. Zu verlieren hatten sie wenig. Die meisten von ihnen erhielten für lange Arbeitsstunden nur wenig Lohn und wohnten in ärmlichen

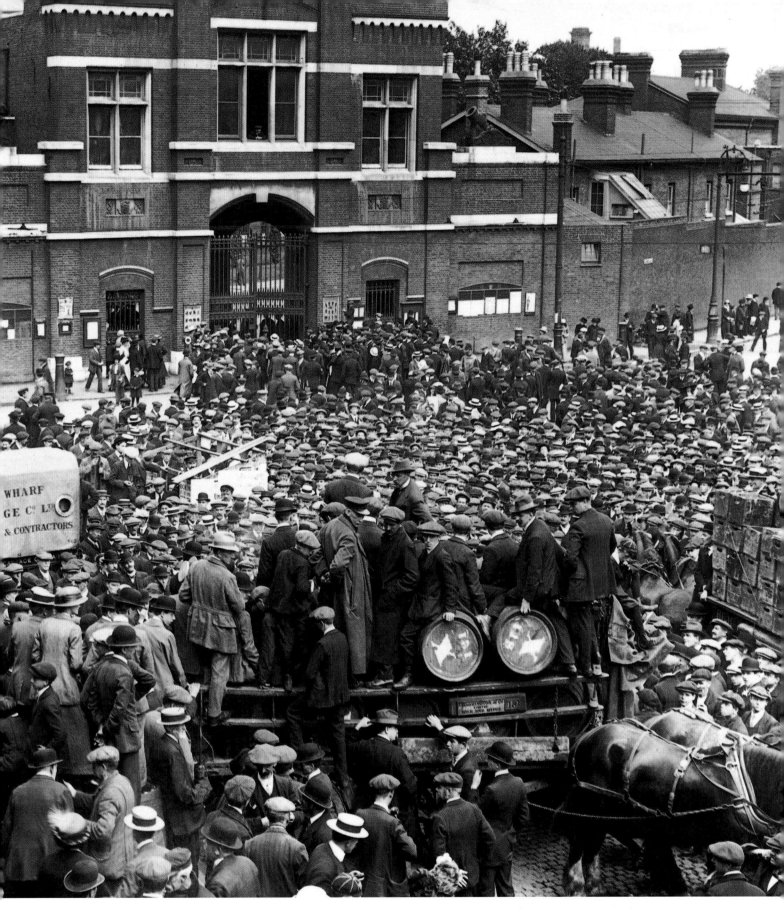

Behausungen. Ihre Arbeitgeber hingegen hatten viel zu verlieren, wenn die Arbeit eingestellt wurde. Es war ein Zeitalter gewaltiger Profite und Dividenden, wachsender Nachfrage und neuer Märkte. Streikende Arbeiter bedeuteten stillstehende Maschinen, und das bedeutete weniger Gewinn, einen kleineren Anteil an dem großen Kuchen, der für die Unternehmer des 19. Jahrhunderts zur Verteilung anstand.

Manche unter den Arbeitern waren klarsichtiger als andere. Sie durchschauten die Verhältnisse, sahen den Wohlstand und die Annehmlichkeiten, durch ihre Mühen geschaffen, und fanden, daß sie Anspruch auf einen Anteil daran hätten. Wenn die Industriellen nicht von sich aus auf die Forderungen der Arbeiter eingingen – und nur die wenigsten taten das –, dann mußte es eben zu Auseinandersetzungen kommen. »Die Arbeiter spüren, daß große gesellschaftliche Veränderungen bevorstehen«, schrieb Samuel Gompers, der Anführer der *American Federation of Labour* im Jahre 1909, »sie spüren, daß der letzte Akt der Komödie einer Herrschaft durch und für die

wohlhabenden Klassen gekommen ist … und daß der Kampf der Arbeiter um ihr Recht Vorrang vor dem Krieg zwischen den Nationen haben muß.«

Die Fronten waren also klar. Auf der einen Seite die Arbeiter mit ihren Mützen und Schals, den Anzügen aus grobem Stoff und den schweren Schuhen – Millionen davon. Auf der anderen die Bosse, die Polizei, das Militär, die Bankiers, alles, was zur alten Ordnung gehörte. Wenn es zur Auseinandersetzung kam, konnten die Arbeiter kaum auf Hilfe von außen hoffen. Die deutschen Bergarbeiter wußten ein Lied davon zu singen, daß sie ohne die Unterstützung ihrer Kameraden verloren waren. Ab und zu kam es vor, daß ein Streik um sich griff – er begann zum Beispiel bei den Hafenarbeitern, die die Schiffe be- und entluden, auf die der Welthandel angewiesen war, und sprang von da auf die Transport- und Eisenbahnarbeiter über, die gebraucht wurden, um die Waren zu den Docks und von dort fortzuschaffen, und am Ende kamen Arbeiter aus anderen Industrien und Gewerben hinzu. Bei solchen Streiks war in den großen Hafenstädten Europas und der Vereinigten Staaten die Hölle los – in Genua, Barcelona, Amsterdam, New York und Marseille.

Arbeitgeber und Regierungen reagierten schnell. 1910 wurden 50000 britische Hafenarbeiter entlassen, weil sie streikten. Die französische Regierung ging sogar noch weiter. Als 150000 französische Bahnarbeiter in Streik traten, wurden sie kurzerhand zum Militär eingezogen und unter Kriegsrecht gestellt. Ein Jahr zuvor war es bei der Pressed Steel Car Company nahe Pittsburgh zur offenen Schlacht zwischen Streikenden und Staatspolizei gekommen.

In den nächsten vier Jahren kehrte eine gewisse Ruhe ein. In Amerika zahlte Henry Ford seinen Arbeitern fünf Dollar pro Tag, und in Europa marschierten die Arbeiter zu Millionen in den Krieg.

Et vint le règne de la machine – qui provoqua l'exode des paysans vers les villes. Un exode à contrecœur; peu de gens avaient la volonté de partir de chez eux, ce qui explique sans doute la misère, les conflits, le mécontentement. Les ouvriers qui avaient su s'unir en syndicats – encore illégaux dans de nombreux pays – étaient en mesure d'éprouver leur force politique et sociale. Surexploités, sous-payés et misérablement logés pour la plupart, ils avaient peu à perdre. En revanche, les patrons avaient beaucoup à perdre en cas

d'arrêt du travail. A l'époque des profits et des bénéfices immenses, des marchés nouveaux et d'une demande en pleine expansion, la grève signifiait une immobilisation des machines, en clair ni recettes, ni participation à la florissante prospérité commerciale du 19ᵉ siècle.

Parmi les ouvriers se trouvaient des hommes lucides. Comprenant que leur labeur créait richesse et confort, ils ne voyaient aucune raison d'être exclus du partage. Si les patrons ne répondaient pas avec bienveillance aux justes revendications ouvrières – peu le firent –, sans doute faudrait-il recourir à la lutte. «Les ouvriers pressentent que de grands changements sociaux devront se produire rapidement» écrivait en 1909 Samuel Gompers, dirigeant de l'*American Federation of Labour* (Fédération Américaine du Travail), ajoutant «que la comédie du gouvernement avec, sur et pour les classes est finie … et que les luttes des travailleurs pour eux-mêmes doivent prendre le pas sur les guerres entre les nations.»

Le plan de bataille se dessinait. D'un côté: les ouvriers avec leur casquette et leur cache-col, leur tenue grossière et leurs lourdes bottes – des millions de travailleurs. De l'autre: les patrons, la police, les militaires, les banquiers, tous les tenants de l'ordre ancien. Quand l'épreuve de force eut lieu, les ouvriers ne pouvaient guère compter sur une aide extérieure. «Partout où se lèvent les mineurs, les copains courageux et sincères doivent se tenir prêts» chantaient les mineurs allemands. Ce fut presque par hasard que l'une de ces grèves se propagea. Elle commença par les dockers qui chargeaient et déchargeaient les navires dont dépendait le commerce mondial, elle atteignit ensuite les employés des transports et du chemin de fer qui apportaient et remportaient les marchandises des docks, et toucha finalement les ouvriers des autres domaines industriels et commerciaux. La pagaille fut gigantesque dans tous les grands ports d'Europe et des Etats-Unis – Gênes, Barcelone, Amsterdam, New York, Marseille.

La riposte des gouvernements et des patrons fut prompte. En 1910, 50000 dockers anglais furent licenciés pour avoir cessé le travail. Le gouvernement français alla plus loin, appelant sous les drapeaux les 150000 cheminots qui s'étaient mis en grève, et les plaçant de la sorte sous le coup de la loi martiale. Un an auparavant, grévistes et gendarmes s'affrontaient à l'usine automobile de la Pressed Steel Car Company des environs de Pittsburgh. Quatre ans plus tard, la scène industrielle retrouvait une paix relative. Aux Etats-Unis, Henry Ford commençait à payer ses ouvriers 5 dollars par jour, au même moment, des millions d'ouvriers européens marchaient vers la guerre.

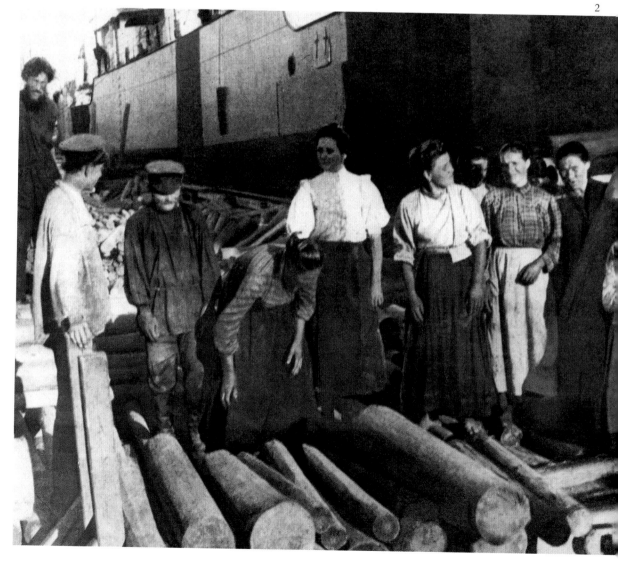

(1) During the Great Strike in South Africa, 1914, a citizens' defence force marches to protect the docks in Cape Town. (2) In the strike of August 1911 in St Petersburg women work alongside convicts to unload wood for pulping.

(1) Während des Großen Streiks 1914 in Südafrika marschiert eine Bürgerwehr zu den Docks in Kapstadt, um sie zu schützen. (2) Beim Streik im August 1911 in St. Petersburg laden Frauen zusammen mit Sträflingen Holz, das zu Brei verarbeitet werden soll, ab.

(1) Pendant la Grande Grève de 1914 en Afrique du Sud, une milice populaire marche sur les docks de Kapstadt pour les protéger. (2) Lors de la grève de Saint-Pétersbourg, en août 1911, des femmes aident les prisonniers à décharger le bois qui va être transformé en sciure.

Violent Protest

Trade unions flexed their industrial muscle in the years immediately preceding the First World War. (1) What began in Dublin as a tram-drivers' strike in September 1913 became a riot in which one man was killed and 500 were injured. (2) French police moved swiftly to break up a workers' meeting in the St Paul area of Paris. (3) Strikers positioned a locomotive across the tracks to halt railway traffic in northern France in October 1910. The strike spread. The French government arrested workers and the editors of left-wing newspapers, accusing them of fomenting national unrest.

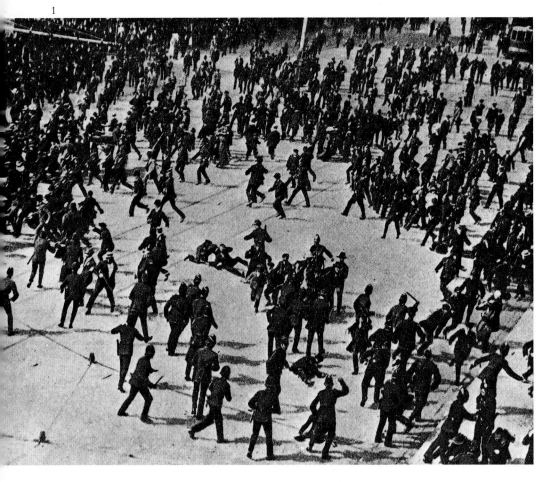

Gewaltsamer Protest

In den Jahren vor dem Ersten Weltkrieg ließen die Gewerkschaften ihre Muskeln spielen. (1) In Dublin weitete sich im September 1913 ein Streik der Straßenbahnfahrer zu einer Straßenschlacht aus, die einen Toten und 500 Verletzte forderte. (2) Die französische Polizei zögerte nicht lange, diese Arbeiterversammlung im Pariser St.-Paul-Viertel zu sprengen. (3) Streikende Bahnarbeiter haben im Oktober 1910 in Nordfrankreich den Schienenverkehr mit einer quergestellten Lokomotive zum Erliegen gebracht. Der Streik griff um sich. Die Polizei verhaftete Arbeiter und die Redakteure linksgerichteter Zeitungen, die sie der Unruhestiftung bezichtigte.

Contestation violente

Les syndicats éprouvèrent leur puissance dans les années qui précédèrent immédiatement la Première Guerre Mondiale. (1) Ce qui, à Dublin, avait commencé en septembre 1913 comme une grève des conducteurs de trams, se transforma en émeute. Bilan, un mort et 500 blessés. (2) La police française chargea pour briser une réunion d'ouvriers dans le quartier Saint-Paul à Paris. (3) Des grévistes installèrent une locomotive en travers des rails pour empêcher le trafic dans le Nord de la France en octobre 1910. Le mouvement s'amplifia. Le gouvernement français arrêta des travailleurs et des éditeurs de journaux de gauche, les accusant de fomenter une insurrection nationale.

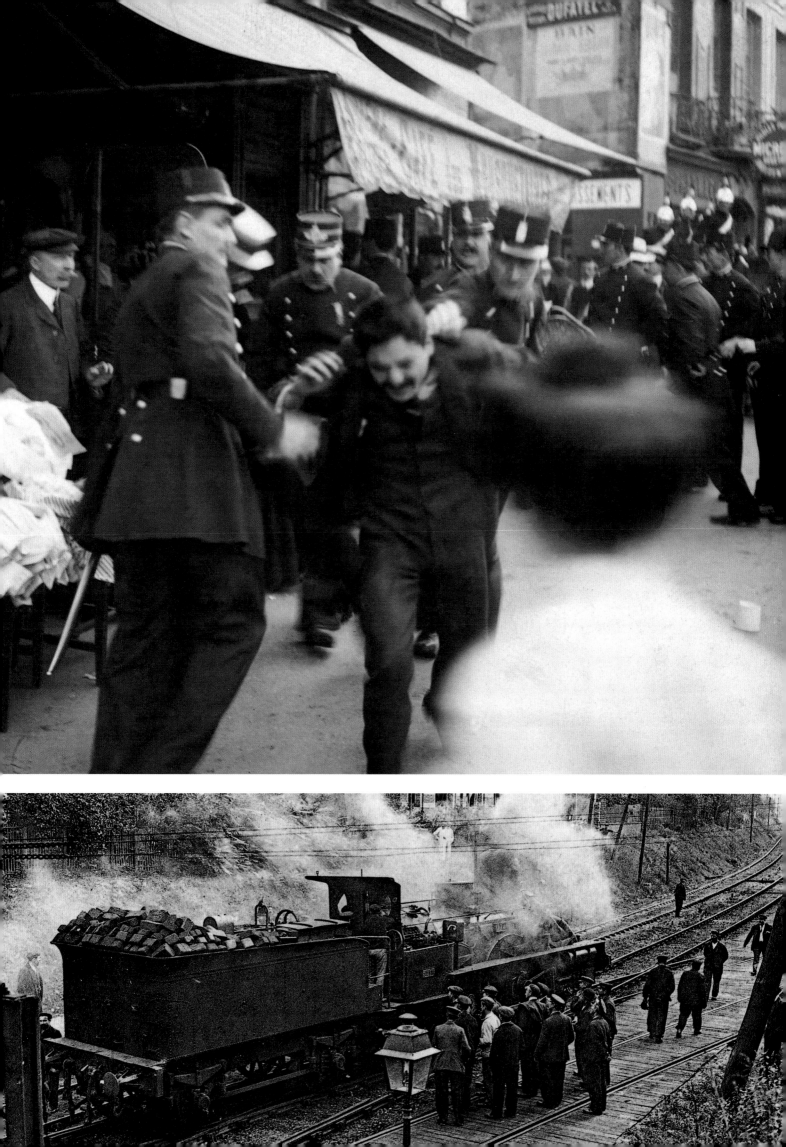

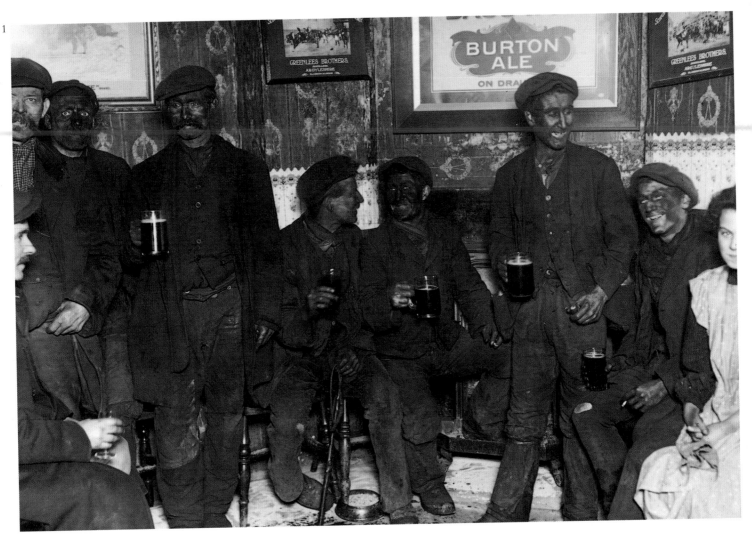

Peaceful Protest

(1) South Wales miners during the coal strike of February 1912. The picture appears posed – it is hard to see why miners on strike should be covered with coal dust. (2) The strike spread to the usually less militant tailors. (3) The police strike of 1919 was confined to London and Liverpool, and the Police Union, who had called the strike, was outlawed by the authorities. (4) Masked clerks of the NUC (National Union of Clerks) pause on their march to Hyde Park in September 1913.

Friedlicher Protest

(1) Südwalisische Kumpel beim Bergarbeiterstreik vom Februar 1912. Das Bild macht einen gestellten Eindruck – man weiß nicht, warum die Arbeiter voller Kohlestaub sind, wenn sie doch streiken. (2) Der Streik weitete sich auf die ansonsten weniger kämpferischen

chneider aus. (3) Der Polizistenstreik von
¹19 beschränkte sich auf London und
verpool; die Polizeigewerkschaft, die dazu
fgerufen hatte, wurde für ungesetzlich
klärt. (4) Maskierte gewerkschaftlich
ientierte Angestellte pausieren auf ihrem
Marsch zum Hyde Park, September 1913.

Contestation paisible
(1) Des mineurs du Sud du Pays de Galles,
durant la grève du charbon de février 1912.
Les photographies sont des mises en scène – il
est invraisemblable que des ouvriers en grève
soient recouverts de poussière noire. (2) La
grève s'étendit aux tailleurs, habituellement

moins militants. (3) La grève de la police en
1919 concerna seulement Londres et Liver-
pool, et le syndicat ayant appelé à la grève fut
déclaré illégal par les autorités. (4) Des em-
ployés masqués de la N.U.C. (syndicat des
employés) marquant une pause au cours de
leur défilé à Hyde Park en septembre 1913.

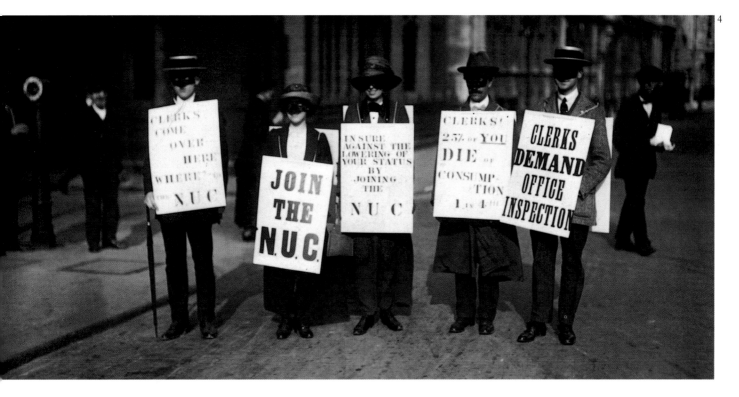

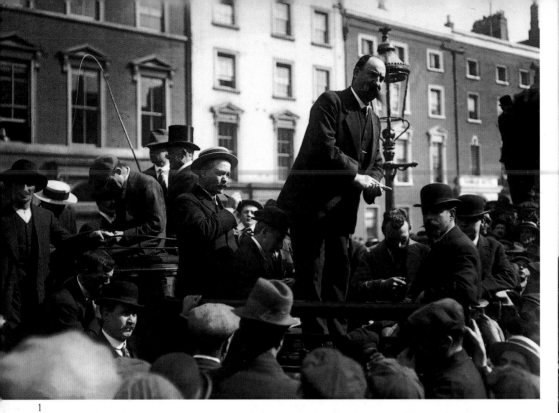

1

2

Friendly Persuasion

(1) A week before the riots in Dublin, Mr Brace MP addresses workers in the street. (2) In 1913, the British National Union of Railwaymen joined with the Miners' Federation and the Transport Workers' Federation to form the Triple Alliance. TWF pickets in Camberwell, London, try to persuade a colleague to join the motor bus strike, September 1913. (3) Keir Hardie (the white-haired figure under the banner), founder of the British Labour Party, at a tailors' rally in 1912. (4) In 1910, the British Government introduced an unemployment insurance scheme – unemployed women queue to register.

Freundliche Überredung

(1) Eine Woche vor den Unruhen in Dublin spricht der Parlamentsabgeordnete Brace zu Arbeitern auf der Straße. (2) 1913 schlossen die britischen Eisenbahner-, Bergbau- und Transportgewerkschaften einen Dreibund. Streikposten der Transportgewerkschaft wollen im September 1913 im Londoner Stadtteil Camberwell einen Kollegen dazu bewegen, sich dem Streik der Busfahrer anzuschließen. (3) Keir Hardie (der weiß-haarige Mann unter dem Banner), der Begründer der britischen Labour Party, bei einer Versammlung der Schneider im Jahre 1912. (4) 1910 führte die britische Regierung eine Arbeitslosenunterstützung ein – hier stehen arbeitslose Frauen an, um sich registrieren zu lassen.

Incitation amicale

(1) Une semaine avant les émeutes à Dublin M. Brace MP harangua les ouvriers dans la rue. (2) En 1913, la *British National Union of Railwaymen* se joint à la *Miners' Federation* et à la *Transport Workers' Federation* pour former la *Triple Alliance*. Des piquets de grève de la fédération des ouvriers du transport de Camberwell, à Londres, incitent un camarad à rejoindre la grève des autobus, septembre 1913. (3) Keir Hardie (silhouette à la cheve-lure blanche sous la bannière), fondateur du Parti Travailliste anglais, lors d'un rassemble-ment de tailleurs en 1912. (4) En 1910, le gouvernement britannique introduisit un régime d'assurance-chômage – chômeuses faisant la queue pour s'inscrire au chômage.

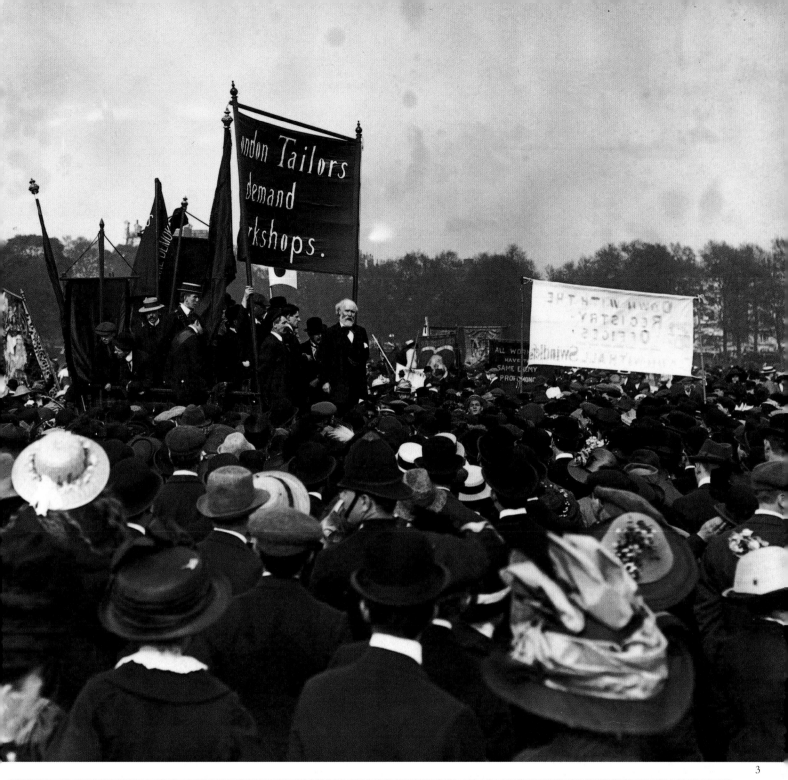

3

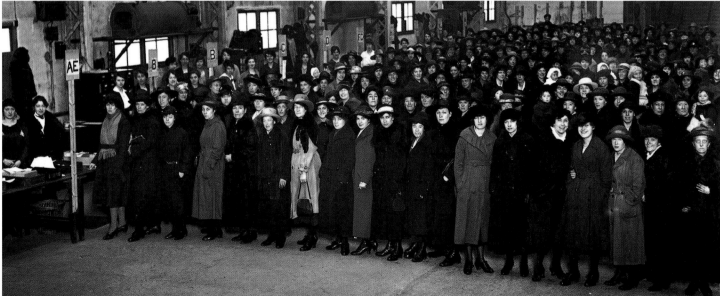

4

No voice raised in protest: all hands raised in salute. 80,000 German political leaders take the oath of allegiance to Hitler at a rally in the Lustgarten, Berlin.

Nicht eine einzige Proteststimme, nur die Hände heben sich zum Gruß. 80 000 deutsche Parteifunktionäre leisten bei einer Kundgebung im Berliner Lustgarten Hitler den Treueid.

Aucune contestation: toutes les mains se levèrent en un geste de salut unanime. 80 000 dirigeants politiques allemands font serment d'allégeance à Hitler lors d'un rassemblement du Lustgarten, Berlin.

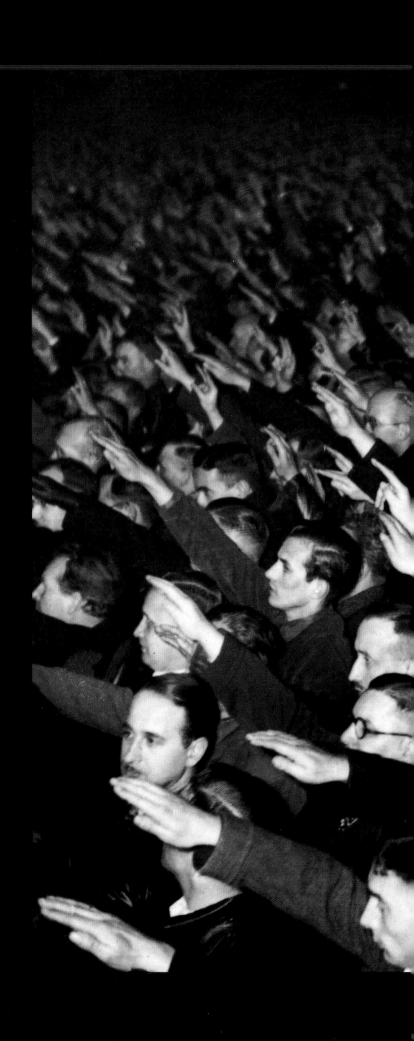

The Assurance of a Sleepwalker

On 10 January 1920, the Berlin publisher Harry Kessler wrote in his diary: 'Today the peace treaty was ratified in Paris; the war is over. A terrible time is beginning for Europe, the kind of humid stillness before a thunderstorm, which will probably end in an even more appalling explosion than the world war.'

He was right, and it didn't take long before the thunder began to roll. Fascism, Bolshevism, unemployment, devaluation, panic on the Stock Exchange, reparations, modern art … whose fault was it all? Perhaps the only thing that people felt good about in the sour and bitter years between the two World Wars was that there was always someone to blame – the capitalists, the Jews, the Russians, the warmongers, the appeasers, the old, the new, the young, the reactionary. The battle-lines were drawn between Left and Right as never before. Violence flared along grand and beautiful avenues and in dark alleyways. People's houses were invaded in the middle of the night and their lives destroyed. For Europe, India, the United States and the USSR it was the most bloody period of peace ever known.

Fortunes were lost as whole economies collapsed. In January 1921 there were 15.5 German marks to the US dollar. Two and a half years later, there were 160 million marks to the dollar; a tram ticket cost 10,000 marks and a cubic metre of gas 250,000 marks. Britain left the gold standard. Wall Street dived. Unemployment soared.

Whom to turn to in all this? Democracy just about survived in Britain, though Churchill mocked his government as living in a strange paradox, 'decided only to be undecided, resolved to be irresolute, adamant for drift, solid for fluidity, all-powerful to be impotent'. In the United States it took the passion and charm of Roosevelt and his New Deal to pull his country through. Others turned to the dictators of the Right (Hitler in Germany, Mussolini in Italy, Franco in Spain) or the Left (Stalin in the USSR). They were men of awesome sincerity, who honestly believed that they were saving their countries from disaster. They were also demagogues of the highest – or lowest – order, and, in the case of Hitler and Mussolini, powerful orators who commanded terrifying respect. *Mussolini ha sempre ragione* ('Mussolini is always right') was a slogan painted on many an Italian wall. 'That is the miracle of our age,' Hitler told Germany, 'that you have found me among so many millions!' And the millions believed him.

It was conflict that brought them to power, and conflict, or the fear of it, that sustained them. A little more violence on the streets of London and maybe Oswald Mosley's new Fascist party would have come to power in Britain. As it was, scuffles, fights and running battles broke out in almost every major city of the West. Factories, synagogues, offices, shops and private houses were firebombed. Within two summer weeks in 1922, Walther Rathenau, the German Foreign Minister, was assassinated; 30 people were killed in riots during a strike in Marion, USA; the Dublin Law Courts were blown up; and a British field marshal was shot down outside his London home by IRA gunmen.

Those who fought the battles on the streets were 'thugs' to their enemies, 'heroes' and 'martyrs' to their comrades, dupes to their masters. 'The broad mass of a nation will more easily fall victim to a big lie than a small one', wrote Hitler in *Mein Kampf*. But the masses on Left and Right had much in

'We'll keep the Red Flag flying here …' Supporters gathered at Bow Street Magistrates' Court, London, 1925, when 12 leading Communists were prosecuted under the Incitement to Mutiny Act. The judge offered to let them go if they renounced their political opinions. They didn't, and were sent to gaol.

»Ewig soll die Rote Fahne wehen …« Sympathisanten vor dem Gerichtsgebäude in der Londoner Bow Street, wo im Jahr 1925 zwölf führenden Kommunisten wegen Anstiftung zur Meuterei der Prozeß gemacht wurde. Der Richter bot den Angeklagten Freispruch an, wenn sie ihre politischen Überzeugungen widerriefen. Sie weigerten sich jedoch und erhielten eine Gefängnisstrafe.

«Le Drapeau Rouge flottera ici …» Militants rassemblés à la Cour des Magistrats sur Bow Street, à Londres en 1925, après l'inculpation de douze meneurs communistes pour incitation à la révolte. Le juge proposa de les relâcher s'ils renonçaient à leurs opinions politiques. Ils refusèrent et furent incarcérés.

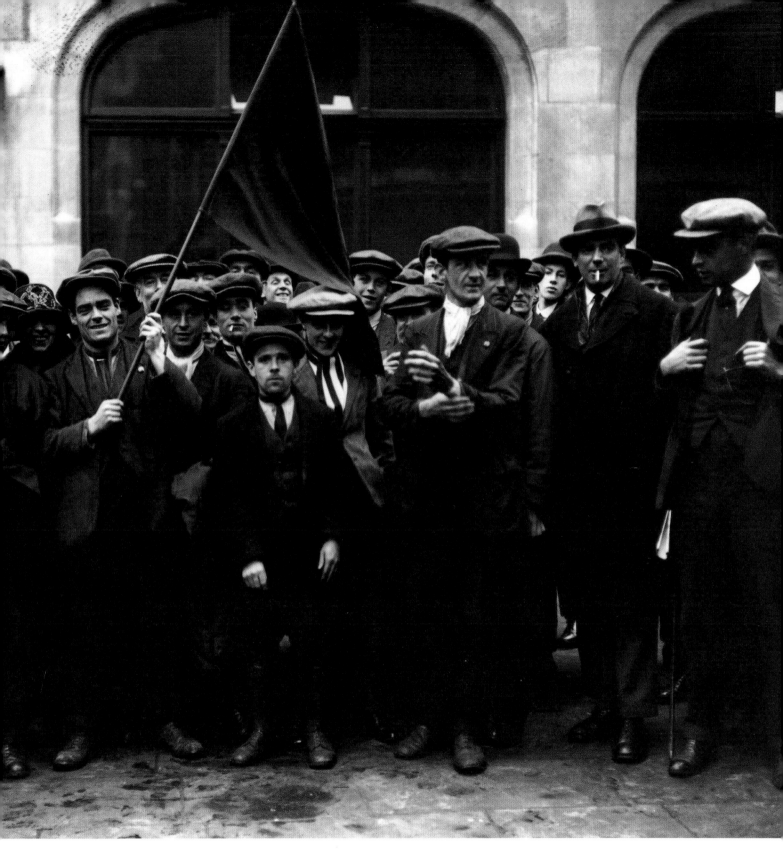

common. They were frightened, desperate, poor. The well-off seldom took to the streets – they had better things to do. Few people agitate on a full stomach. Liberals and democrats were shocked everywhere at what they saw – an absence of reason, the use of brute force and bullying tactics, a complete disregard for law. And, because most of the offenders were poor, the almost automatic reaction for many of the middle class was to blame the Communists.

And, all the while, the camera recorded the *putsch* and counter-*putsch*, the strikes, the lock-outs, the beatings and the burnings. From the mid-1920s onwards, the Ermanox plate camera and the 35-mm camera provided photographers with machines that were easily portable and gave far greater freedom of use. It was one of the few freedoms to survive.

'I go the way that Providence dictates with the assurance of a sleepwalker,' said Hitler. But Harry Kessler had had enough. On 8 March 1933 he left Berlin for Paris. He never returned, and died in exile in provincial France in December 1937. And on 1 September 1939, the unhappy and unruly peace came to an end.

Am 10. Januar 1920 notierte der Berliner Verleger Harry Graf Keßler in seinem Tagebuch: »Heute wurde der Friedensvertrag in Paris ratifiziert; der Krieg ist vorüber. Für Europa brechen schlimme Zeiten an, eine Art drückende Ruhe vor dem Sturm, die wohl mit einer noch gewaltigeren Eruption enden wird als der Weltkrieg.«

Er sollte recht behalten: Es dauerte nicht lange, bis der Donner zu grollen begann. Faschismus, Bolschewismus, Arbeitslosigkeit, Geldentwertung, Börsenkrach, Reparationszahlungen, moderne Kunst … wer trug Schuld an all dem? Der einzige Trost, der den Menschen in den bitteren Jahren zwischen den Weltkriegen blieb, war die Tatsache, daß es immer jemanden gab, den man für die Misere verantwortlich machen konnte – die Kapitalisten, die Juden, die Russen, die Kriegstreiber, die Beschwichtiger, das Alte, das Neue, die Jugend, die Reaktionäre. Linke und Rechte standen sich unversöhnlicher denn je gegenüber. Weder in prächtigen Alleen noch in finsteren Gassen war man sicher vor Gewalt. Mitten in der Nacht drangen Fremde in die Häuser der Menschen ein und töteten die Bewohner. Nie zuvor hatten Europa, Indien, die Vereinigten Staaten und die UdSSR einen derart blutigen Frieden erlebt.

Durch den Zusammenbruch ganzer Volkswirtschaften gingen private Vermögen verloren. Im Januar 1921 entsprach ein US-Dollar noch 15,50 Reichsmark. Zweieinhalb Jahre später betrug der Gegenwert 160 Millionen Reichsmark; eine Straßenbahnfahrkarte kostete 10 000 und ein Kubikmeter Gas 250 000 Reichsmark. Großbritannien gab den Goldstandard auf. Die Wall Street befand sich auf einer rasanten Talfahrt, während die Arbeitslosenzahlen schwindelnde Höhen erreichten.

Wer bot Halt in solchen Zeiten? In Großbritannien überlebte die Demokratie mit knapper Not, obwohl Churchill spottete, daß die britische Regierung eine seltsam paradoxe Politik betreibe, »zu nichts mehr entschlossen als zur Unentschlossenheit, mit aller Entschiedenheit unentschieden, zielstrebig ziellos, geradlinig schwankend und mit aller Kraft kraftlos«. In den Vereinigten Staaten bedurfte es der Überzeugungskraft und der Persönlichkeit eines Roosevelt mit seinem Reformprogramm des *New Deal,* um das Land aus der Krise zu retten. Andernorts hatten Diktatoren aus dem rechten (Hitler in Deutschland, Mussolini in Italien, Franco in Spanien) wie aus dem linken (Stalin in der UdSSR) Lager großen Zulauf. Sie waren Männer von ehrfurchtgebietender Offenheit, die ehrlich daran glaubten, ihre Länder vor einer Katastrophe zu retten. Sie waren Demagogen der schlimmsten Sorte, dazu – im Falle Hitlers und Mussolinis – brillante Redner, die ihren Zuhörern Angst und Respekt einflößten. Die Parole *Mussolini ha sempre ragione* (»Mussolini hat immer recht«) zierte so manche italienische Hauswand. Hitler sprach von einem Wunder, daß die Deutschen ihn unter so vielen Millionen gefunden hätten, und die Millionen glaubten ihm.

Durch Konflikte gelangten sie an die Macht, und durch Konflikte – oder die Angst davor – konnten sie sich an der Macht halten. Wenn es auf den Straßen von London auch nur

ein wenig mehr Gewalt gegeben hätte, dann wäre vielleich[t] auch Oswald Mosleys junge faschistische Partei in Groß[-] britannien an die Macht gekommen. Damals waren in fas[t] allen größeren Städten der westlichen Welt Raufereien, Hand[-] gemenge und kleinere Scharmützel an der Tagesordnung. E[s] gab Brandanschläge auf Fabriken, Synagogen, Büros, Läde[n] und Privathäuser. Innerhalb von nur zwei Wochen de[s] Sommers 1922 wurde der deutsche Außenminister Rathena[u] Opfer eines Attentats, kamen im amerikanischen Marion 3[?] Menschen bei Streikunruhen ums Leben, wurde da[s] Gerichtsgebäude von Dublin in die Luft gesprengt und ei[n] britischer Feldmarschall vor seinem Haus in London vo[n] IRA-Schützen niedergeschossen.

Diejenigen, die sich an den Auseinandersetzunge[n] beteiligten, galten ihren Feinden als »brutale Schläger«, ihre[n] Mitstreitern als »Helden« und »Märtyrer« und den Anführer[n] als Kanonenfutter. »Die breite Masse eines Volkes fällt eher au[f] eine große Lüge herein als auf eine kleine«, schrieb Hitler i[n] *Mein Kampf.* Doch ob sie nun Linke oder Rechte waren, di[e] Massen hatten viel gemein. Sie waren arm und voller Angs[t] und Verzweiflung. Die Wohlhabenden gingen nicht auf di[e] Straße – sie hatten Besseres zu tun. Wer agitiert, hat selte[n] einen vollen Magen. Liberale und Demokraten zeigten sic[h] allenthalben schockiert über das, was sie sahen – di[e] Unvernunft, die Gewalttätigkeit, die brutalen Einschüch[-] terungstaktiken, die völlige Mißachtung des Gesetzes. Und d[a] die Missetäter meistens arm waren, stand es in der Mittel[-] schicht meist außer Frage, daß die Kommunisten verant[-] wortlich waren.

Und stets waren Fotografen dabei und hielten Putsch un[d] Gegenputsch, Streiks und Aussperrungen, Schlägereien un[d] Brandanschläge im Bild fest. Seit Mitte der zwanziger Jahr[e] verfügten die Fotografen dank der Ermanox-Plattenkamer[a] und der Kleinbildkamera über leicht tragbare Apparate, di[e] ihnen weit größere Freiheit gestatteten. Es war eine de[r] wenigen Freiheiten, die nicht verlorengingen.

»Mit schlafwandlerischer Sicherheit beschreite ich de[n] Weg, den mir das Schicksal weist«, sagte Hitler. Doch Harr[y] Graf Keßler hatte genug gesehen. Am 8. März 1933 verließ e[r] Berlin und ging nach Paris, von wo er nicht mehr zurück[-] kehrte. Er starb Ende November 1937 im Exil in de[r] französischen Provinz. Am 1. September 1939 endete di[e] glücklose und chaotische Friedenszeit.

Le 20 janvier 1920, l'éditeur berlinois Harry Kessler nota[it] dans son journal intime: «Aujourd'hui vient d'être ratifi[é] à Paris le traité de paix; la guerre est finie. Une époque terribl[e] s'ouvre pour l'Europe. Les orages ne sont pas loin; l'atmo[-] sphère s'alourdit, l'explosion sera sans doute plus effroyabl[e] que la guerre mondiale.»

Il avait vu juste et il ne fallut guère attendre pour qu[e] l'orage commence à gronder. Fascisme, bolchevisme, chômag[e] dévaluation, panique à la Bourse, réparations, art moderne…[] à qui la faute? En ces années rudes et amères qui séparent le[s] deux Guerres Mondiales, les coupables ont toujours un nom[

les capitalistes, les juifs, les Russes, les bellicistes, les pacifistes, l'ordre ancien, le nouveau, les jeunes, les réactionnaires. La droite et la gauche s'affrontaient plus durement que jamais. La violence flambait sur les vastes et belles avenues, dans les sombres ruelles. Des maisons étaient envahies au milieu de la nuit, leurs habitants tués. L'Europe, l'Inde, les Etats-Unis et l'URSS vécurent la plus sanglante des périodes de paix.

L'économie entraîna dans son effondrement bien des fortunes. En janvier 1921, le dollar valait 15,5 marks allemands. Deux ans et demi plus tard, son cours passait à 160 millions de marks; un ticket de tram coûtait 10 000 marks et un mètre cube de gaz, 250 000 marks. La Grande-Bretagne abandonna l'étalon-or. Wall Street plongea. Le chômage atteignit des sommets.

Vers qui se tourner alors? En Grande-Bretagne, la démocratie survivait tant bien que mal alors que Churchill dénonçait cyniquement l'attitude paradoxale de son gouvernement, «décidé à être indécis, résolu à être irrésolu, inflexible dans la dérive, ferme dans les tergiversations, tout-puissant dans l'impuissance». Aux Etats-Unis, il fallut le charisme de Roosevelt et de son *New Deal* pour sortir le pays d'affaire. Les autres peuples se tournaient vers les dictateurs de droite (Hitler en Allemagne, Mussolini en Italie, Franco en Espagne) ou de gauche (Staline en URSS), des hommes d'une effrayante sincérité, qui estimaient en toute bonne foi sauver leur pays du désastre. Mais ces dirigeants étaient aussi des démagogues de premier – et de dernier – ordre et, dans le cas d'Hitler et de Mussolini, de puissants orateurs, imposant un terrifiant respect. *Mussolini ha sempre ragione* (Mussolini a toujours raison): ce slogan recouvrait les murs italiens. «C'est le miracle de notre époque», déclara Hitler à l'Allemagne, «que vous m'ayez trouvé moi, parmi des millions d'autres!» Et ces millions d'autres le crurent.

Parvenus sur le devant de la scène politique grâce aux conflits, la peur des conflits les y maintint. Il s'en fallut de peu – un échelon de plus dans la violence qui régnait alors à Londres – pour que le nouveau parti fasciste d'Oswald Mosley arrive au pouvoir en Angleterre. Rixes, combats, batailles rangées éclataient dans presque toutes les grandes villes occidentales. Usines, synagogues, bureaux, magasins et maisons étaient détruits par des incendies. Pendant l'été 1922, deux semaines suffirent à voir assassiné le Premier Ministre allemand, Walther Rathenau. Lors d'une grève à Marion, aux USA, 30 personnes trouvèrent la mort dans les émeutes; les cours de justice dublinoises étaient débordées; enfin un maréchal britannique fut exécuté devant sa maison londonienne par des tireurs de l'IRA.

«Gangsters» pour leurs ennemis, les combattants des rues étaient pour leurs camarades des «héros», des «martyrs» trahis par leurs maîtres. «Une vaste masse populaire sera plus facilement victime d'un mensonge énorme qu'une masse plus petite», écrivait Hitler dans *Mein Kampf*. Il faut noter qu'à cette époque les masses de droite et de gauche avaient beaucoup de choses en commun. Elles étaient terrorisées, désespérées, pauvres. Et si les gens aisés descendaient rarement dans la rue

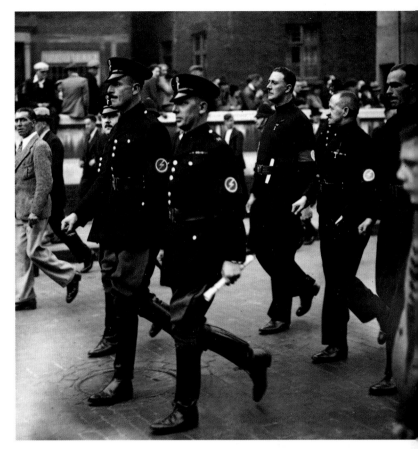

Oswald Mosley – with cap and moustache – leads his Blackshirts on an anti-Semitic march through London's East End in 1936. The march ended in the Battle of Cable Street.

Oswald Mosley – mit Mütze und Schnurrbart – führt seine Schwarzhemden 1936 auf einem antisemitischen Marsch durch das Londoner East End an. Der Marsch wuchs sich zur Schlacht in der Cable Street aus.

Oswald Mosley – avec casquette et moustache – à la tête de ses Chemises Noires lors d'un défilé antisémite dans les quartiers est de Londres en 1936. La manifestation s'acheva par la bataille de Cable Street.

(ils avaient mieux à faire, on s'agite rarement le ventre plein), libéraux et démocrates étaient choqués de ce qu'ils voyaient – absence de toute raison, recours à la force aveugle et aux procédés brutaux, mépris total de la loi. Comme les contestataires se recrutaient surtout parmi les pauvres, la classe moyenne réagissait spontanément en accusant les communistes.

Pendant ce temps, les clichés montraient les putsch et contre-putsch, les grèves, les lock-out, les bagarres et les incendies. Dès la seconde moitié des années 20, les photographes disposaient d'appareils portables plus faciles à manier, par exemple l'appareil à plaques photographiques Ermanox et l'appareil de 35 mm, qui leur conféraient une plus grande liberté d'action. Ce fut l'une des rares libertés qui ne se perdit pas.

«Je m'avance sur le chemin que dicte la providence avec l'assurance d'un somnambule» déclara Hitler. Harry Kessler cependant en avait vu assez. Le 8 mars 1933, il quittait Berlin pour Paris; il ne revint jamais et mourut en exil dans la province française en décembre 1937. Le 1er septembre 1939 s'achevait cette paix chaotique et difficile.

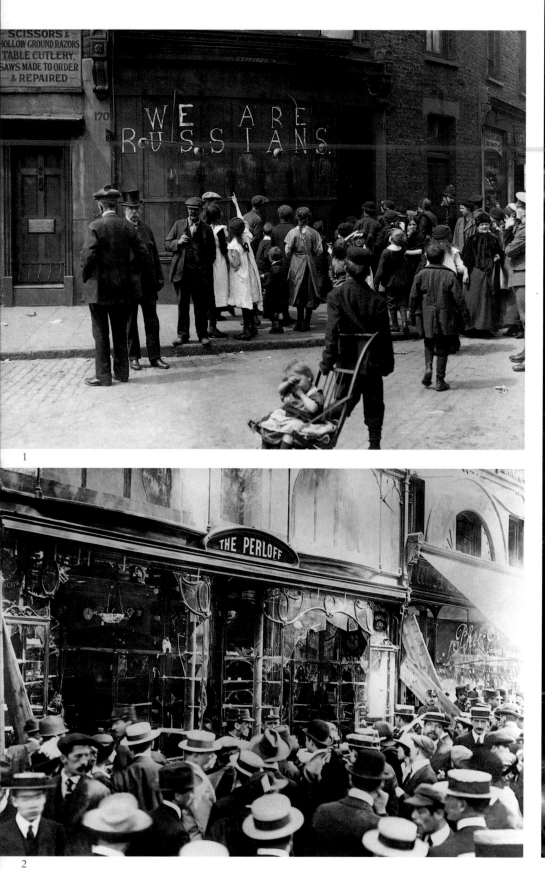

Anti-German Riots

The crude propaganda generated in words and pictures by both sides in the First World War took effect. By 1915 anti-German feelings reached a peak of hate in Britain and France, and the sinking of the liner SS *Lusitania* in May of that year sparked riots in London and Liverpool. Merely to speak in a 'foreign' accent invited suspicion – a shopkeeper hastens to profess his Russian background (1). Mobs smash the windows of a German restaurant in Paris (2) and a German shop in Poplar (3).

Antideutsche Unruhen

Die grobe Propaganda in Wort und Bild, deren sich beide Seiten im Ersten Weltkrieg bedienten, blieb nicht ohne Wirkung. 1915 erreichte die antideutsche Stimmung in Groß-britannien und Frankreich einen Höhepunkt, und nach der Versenkung der SS *Lusitania* im selben Jahr kam es in London und Liverpool zu Krawallen. Die bloße Tatsache, daß jemand einen »ausländischen« Akzent hatte, machte ihn bereits verdächtig – hier beeilt sich ein Ladenbesitzer darauf hinzuweisen, daß er aus Rußland stammt (1). Die Fensterscheiben eines deutschen Restaurants in Paris (2) und eines deutschen Geschäfts im Londoner Stadtteil Poplar (3) fallen dem Zorn der Massen zum Opfer.

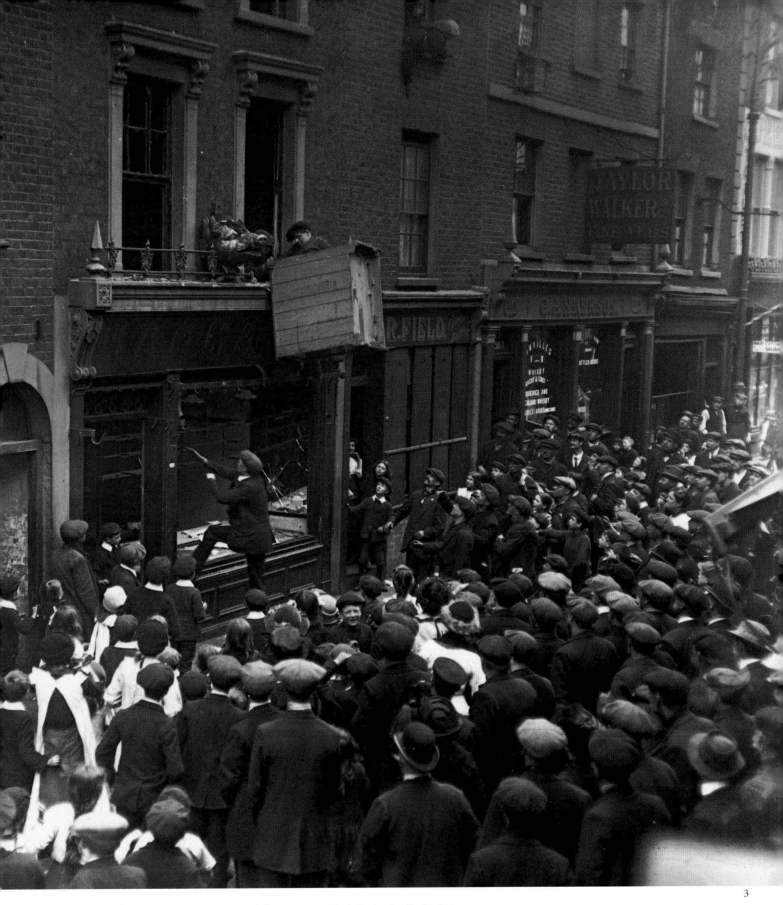

Émeutes anti-germaniques

Les deux camps issus de la Première Guerre Mondiale véhiculèrent une propagande éhontée qui finit par porter ses fruits. En 1915, les sentiments anti-allemands atteignaient leur paroxysme en Grande-Bretagne et en France; le naufrage du paquebot SS *Lusitania,* au mois de mai de la même année, déclencha des émeutes à Londres et à Liverpool. Un léger accent « étranger » suscitait la suspicion – un petit commerçant s'empresse de prouver ses origines russes. (1). A Paris, des foules brisent la devanture d'un restaurant allemand (2), et à Poplar, celle d'un magasin allemand (3).

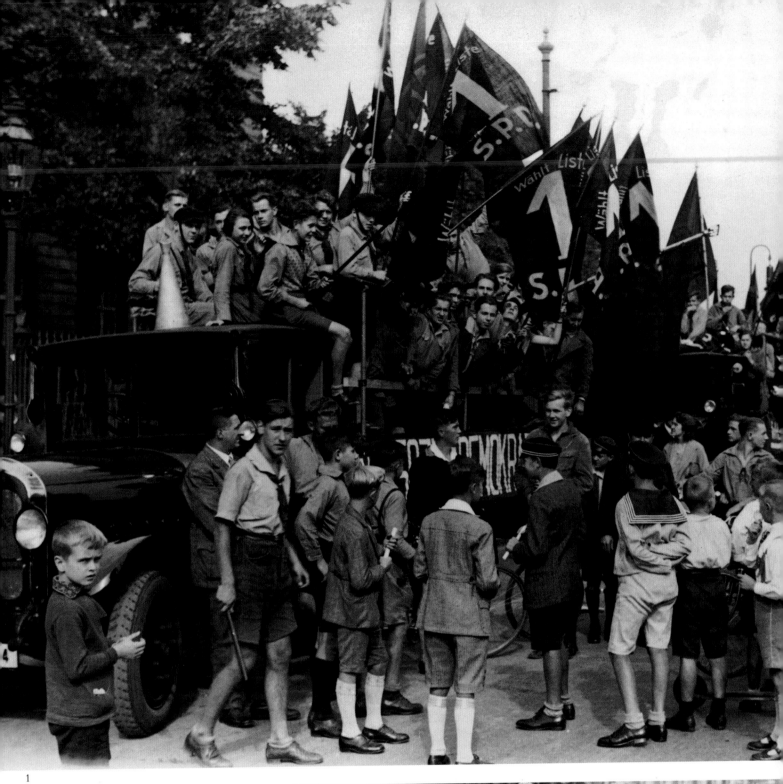

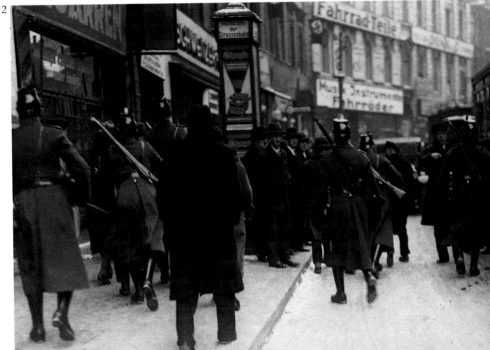

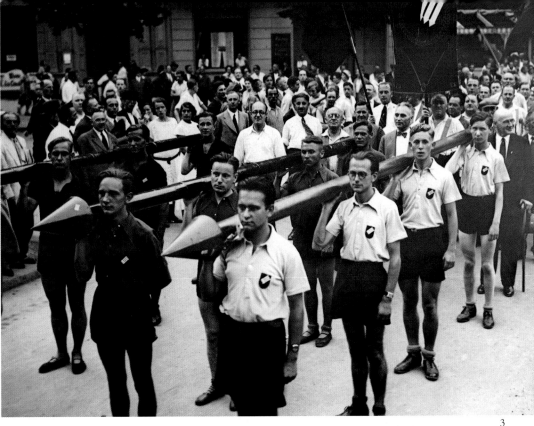

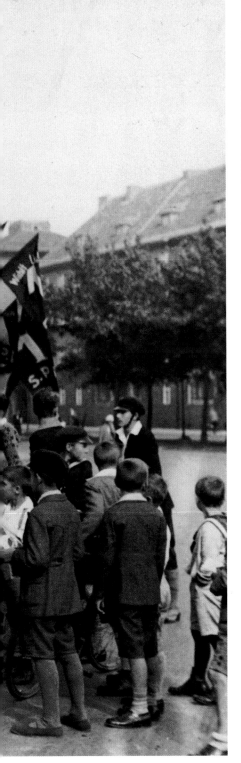

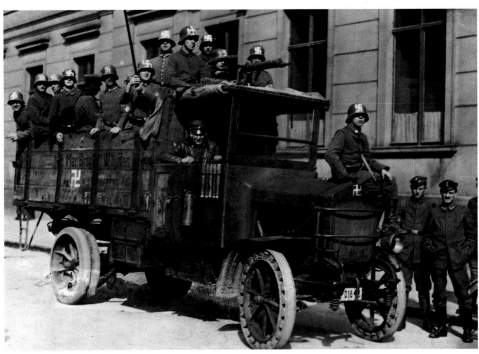

3

4

The Weimar Republic

(1) Members of the Social Democrat Party campaigning for votes in the elections to the Reichstag in September 1930. (2) Police move to protect a Nazi demonstration commemorating the death of Horst Wessel, January 1933. (3) The three arrows carried by members of the anti-Fascist 'Iron Front', at his rally in July 1932, were supposedly symbols of the powers that would destroy Adolf Hitler. (4) The swastika makes its first appearance in modern Germany – the Baltic brigade on their way to the Brandenburg Gate on 13 March 1920.

Die Weimarer Republik

(1) Mitglieder der Sozialdemokratischen Partei im Reichstagswahlkampf im September 1930. (2) Polizisten schützen eine national-sozialistische Kundgebung zum Gedenken an Horst Wessel im Januar 1933. (3) Die drei Pfeile, die die Mitglieder der antifaschistischen »Eisernen Front« bei dieser Kundgebung im Juli 1932 tragen, symbolisierten die Kräfte, die Adolf Hitler besiegen sollten. (4) Das Hakenkreuz hält Einzug in Deutschland – die Marinebrigade Ehrhardt auf dem Weg zum Brandenburger Tor am 13. März 1920.

La République de Weimar

(1) Membres du Parti Social Démocrate en campagne pour les élections au Reichstag de septembre 1930. (2) Police protégeant une manifestation nazie pour la commémoration de la mort de Horst Wessel, janvier 1933. (3) Juillet 1932, les membres du « Front de fer » antifasciste arborent les trois flèches symbolisant les forces sensées détruire Adolf Hitler. (4) Le 13 mars 1920, la croix gammée fait son apparition dans l'Allemagne moderne – « la Brigade Ehrhardt » en route vers la Porte de Brandebourg.

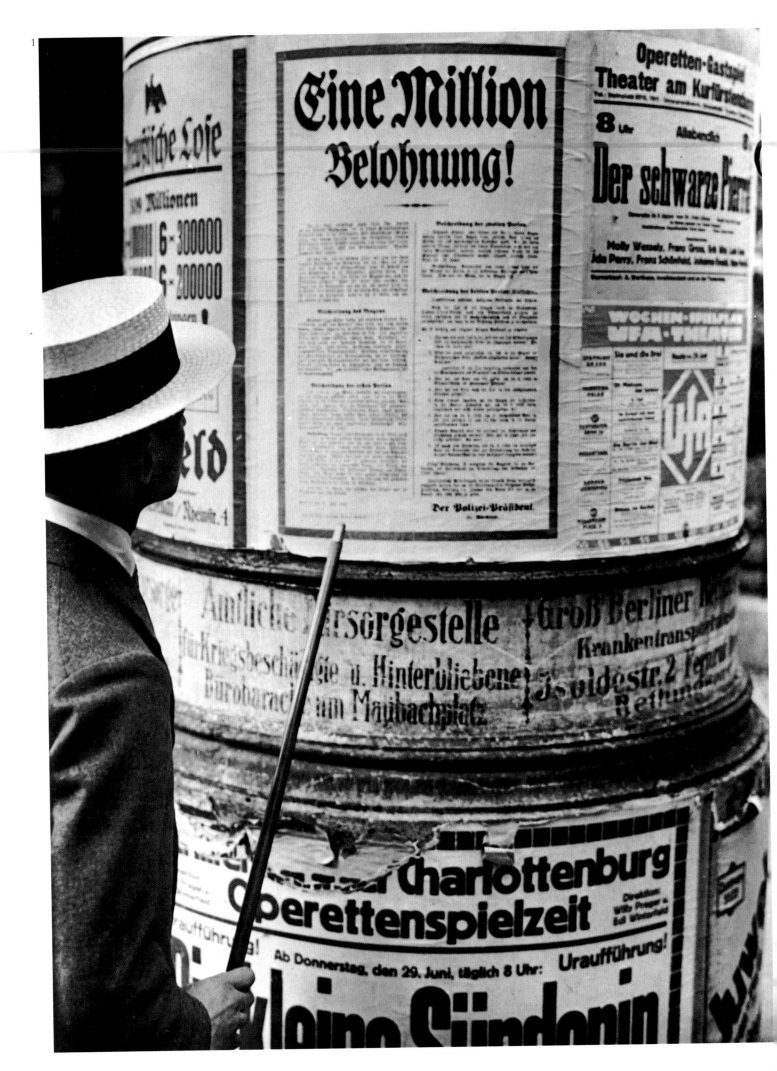

The Assassination of Rathenau

On 31 January 1922 Walther Rathenau wrote in his diary: 'What can one person alone do against an unfriendly world, with enemies at his back, aware of his limitations and weaknesses?' Six months later he was murdered. (1) Posters offered a reward of a million marks for the arrest of the assassins. (3) A million people mourned at Rathenau's funeral. (2) Democrats, socialists and Communists marked the second anniversary of his death.

Das Attentat auf Rathenau

Am 31. Januar 1922 schrieb Walther Rathenau in sein Tagebuch: »Was kann ein einzelner Mensch ausrichten in einer unfreundlichen Welt, wo hinter seinem Rücken Feinde lauern und seine Grenzen und Schwächen kennen?« Sechs Monate später wurde er ermordet. (1) Auf Plakaten wurde für die Ergreifung der Mörder eine Belohnung von einer Million Reichsmark ausgesetzt. (3) Eine Million Menschen trauerten bei Rathenaus Beisetzung. (2) Demokraten, Sozialisten und Kommunisten bei einer Feierstunde anläßlich seines zweiten Todestages.

L'assassinat de Rathenau

Le 31 janvier 1922, Walther Rathenau notait dans son journal intime: «Que peut faire un homme seul contre un monde hostile, menacé à l'arrière par des ennemis avertis de ses limites et de ses faiblesses?» Six mois plus tard, il était assassiné. (1) Affiches promettant une récompense d'un million de marks pour l'arrestation des assassins. (3) Un million de personnes en deuil lors des funérailles de Rathenau. (2) Démocrates, socialistes et communistes célèbrent le second anniversaire de sa mort.

Riots in Vienna

In July 1927, 89 people were killed and 600 injured in fights between Left and Right on the streets of Vienna. German newspapers suggested that Germany should annexe Austria to bring order to the country.

Unruhen in Wien

Im Juli 1927 gab es bei Straßenkämpfen zwischen linken und rechten Gruppierungen in Wien 89 Tote und 600 Verletzte. Deutsche Zeitungen regten an, Österreich zu annektieren, um die Ruhe im Land wiederherzustellen.

Emeutes à Vienne

Juillet 1927, bilan des affrontements entre la gauche et la droite dans les rues de Vienne: 89 morts et 600 blessés. Dans une perspective de rétablissement de l'ordre public, les journaux allemands suggérèrent l'annexion de l'Autriche par l'Allemagne.

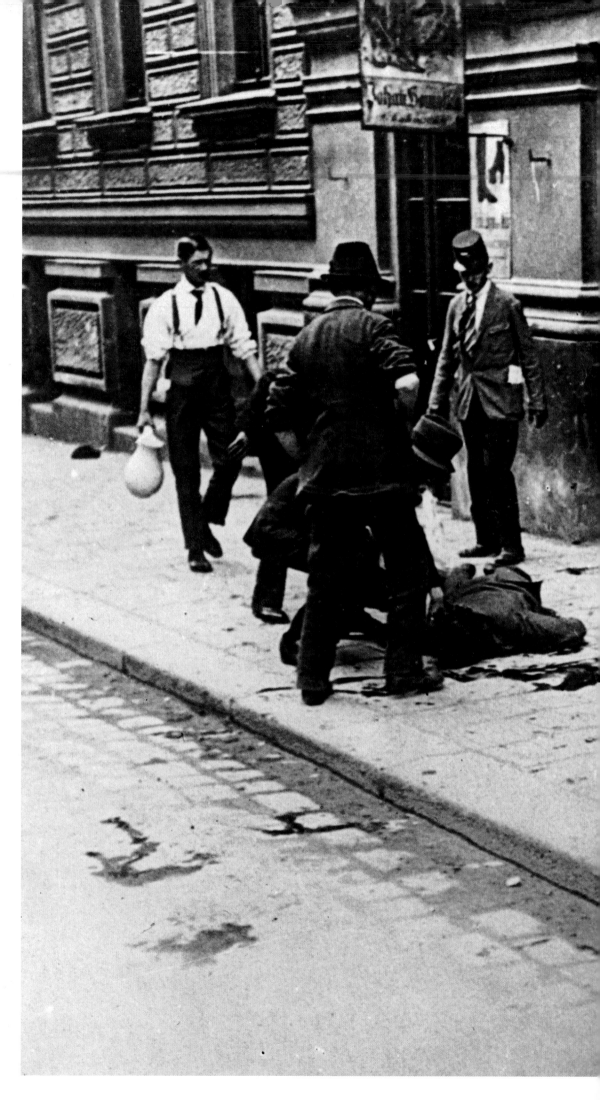

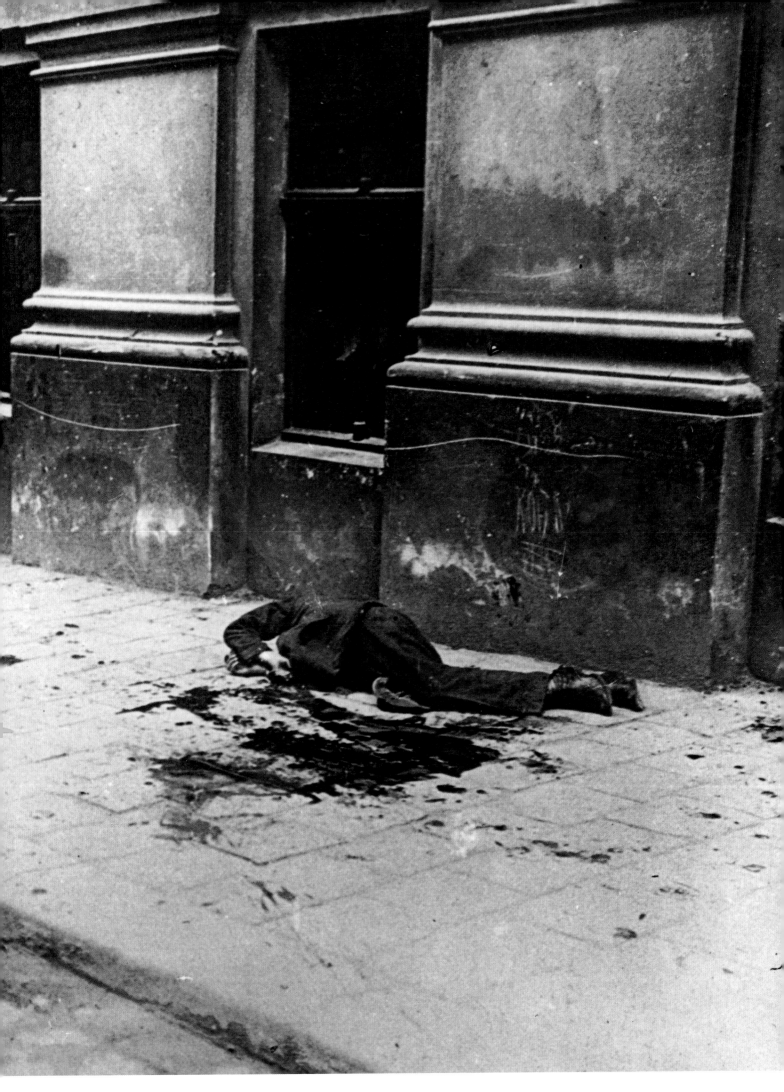

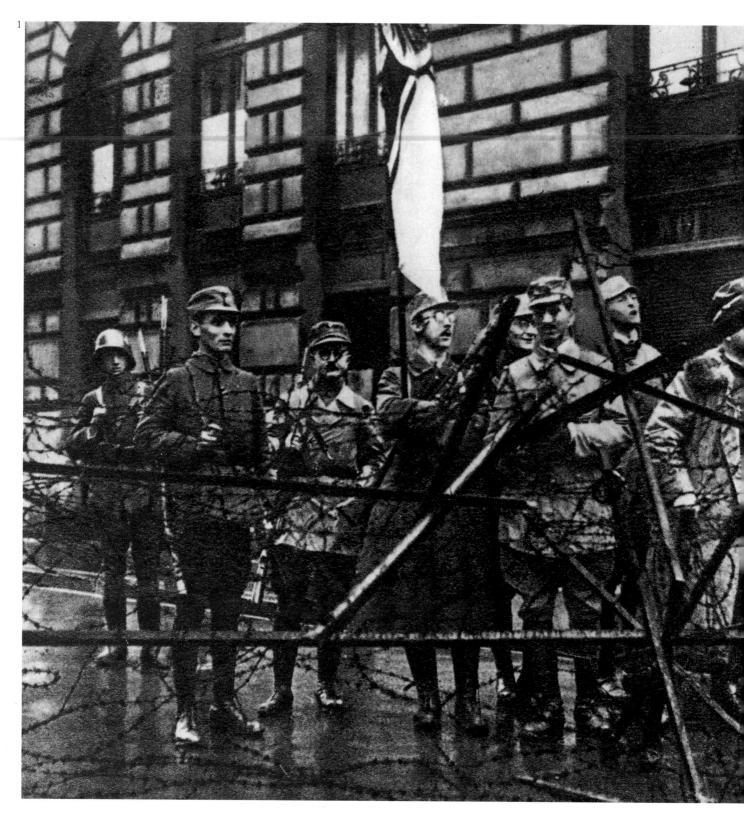

The *Putsch* that Failed

In November 1923 Hitler and Ludendorff staged their abortive Putsch. His followers – among them Heinrich Himmler, holding a Nazi banner (1) – took to the streets of Munich (2). (3) For a while the swastika flew over the Town Hall, but the *Putsch* failed. The British Ambassador later recorded in his memoirs that 'Hitler was tried for high treason … he was finally released after six months, thereafter falling into oblivion.'

Der fehlgeschlagene Putsch

Im November 1923 scheiterten Hitler und Ludendorff mit ihrem Putschversuch. Hitlers Gefolgsleute – unter ihnen Heinrich Himmler mit einer Hakenkreuzflagge (1) – marschierten durch die Straßen von München (2). (3) Vorübergehend wehte die Hakenkreuzflagge über dem Münchner Rathaus, doch der Putsch scheiterte. Der britische Botschafter schrieb darüber später in seinen Memoiren: »Hitler wurde wegen Hochverrats verurteilt … und schließlich nach sechs Monaten freigelassen. Danach geriet er in Vergessenheit.«

Echec d'un *Putsch*

En novembre 1923, Hitler et Ludendorff organisèrent un putsch qui fut un fiasco. Ses partisans – dont Heinrich Himmler, tenant une bannière nazie (1) – envahirent les rues de Munich (2). (3) La croix gammée flotta quelque temps au sommet de l'Hôtel de Ville, mais le *Putsch* échoua. L'ambassadeur britannique rapporta plus tard dans ses Mémoires, que «Hitler fut jugé pour haute trahison … il fut finalement libéré au bout de six mois, tombant ensuite dans l'oubli.»

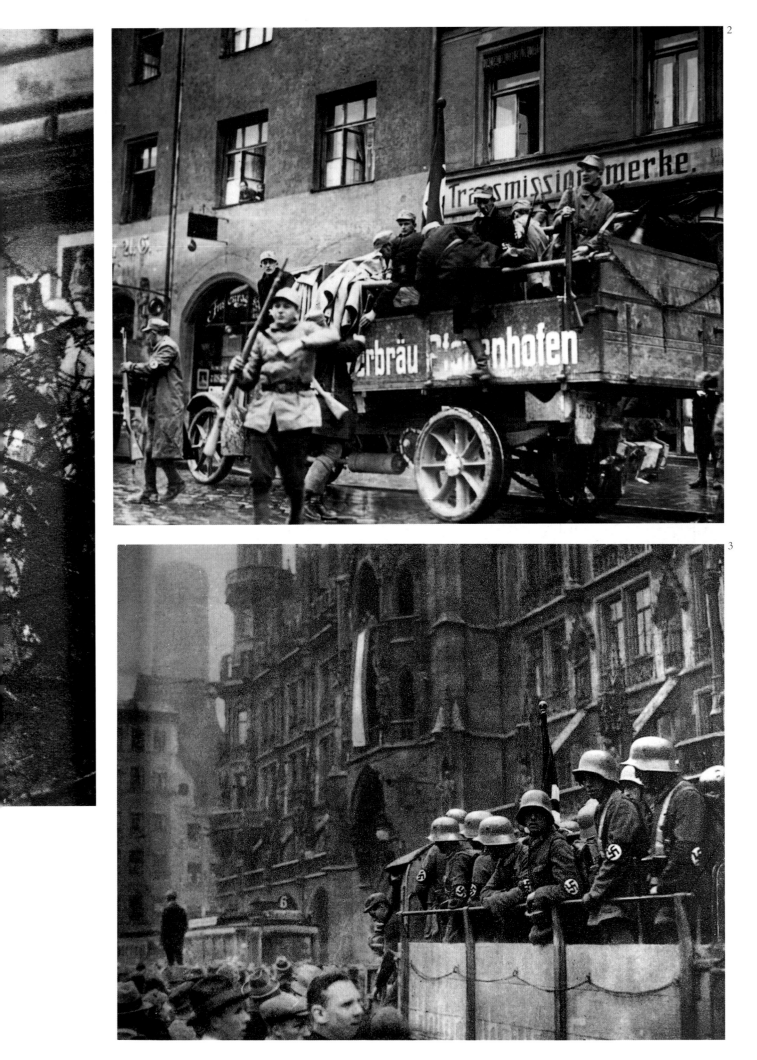

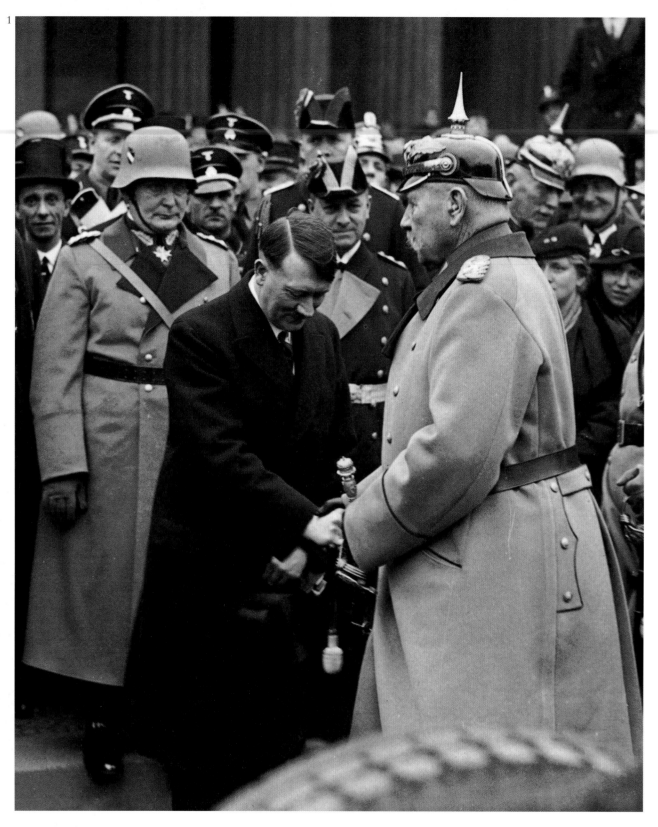

The Rise of Hitler

When Hitler and President Hindenburg first met in 1931 neither the 'Bohemian corporal' nor 'the dinosaur' was impressed with the other. But politically they needed each other, and in public (1) due deference was displayed by Hitler, while Hermann Göring (helmeted) looked on approvingly. (2) Within a couple of years, the legend of the *Führer* was being created as thousands of Berlin youth greeted him.

Der Aufstieg Hitlers

Als Hitler und Reichspräsident Hindenburg 1931 das erstemal zusammentrafen, war weder der »böhmische Gefreite« noch der »Dinosaurier« allzu begeistert von seinem Gegenüber. Politisch waren sie jedoch aufeinander angewiesen, und so zollte Hitler ihm unter den wohlwollenden Blicken Hermann Görings (mit Helm) in der Öffentlichkeit (1) den gebührenden Respekt. (2) Innerhalb von zwei Jahren entstand der Führermythos – hier wird Hitler von Tausenden Berliner Jugendlichen begrüßt.

L'avènement d'Hitler

En 1931, lors de la première rencontre entre Hitler et le président Hindenburg, le courant passait mal entre le «caporal bohémien» et le «dinosaure». Et pourtant, sur le plan politique, ils avaient besoin l'un de l'autre; (1) en public, Hitler faisait assaut de déférence à l'égard de son interlocuteur, sous l'œil approbateur de Hermann Göring (casqué). (2) En deux ans à peine, la légende du *Führer* prenait corps sous les acclamations de milliers de jeunes Berlinois.

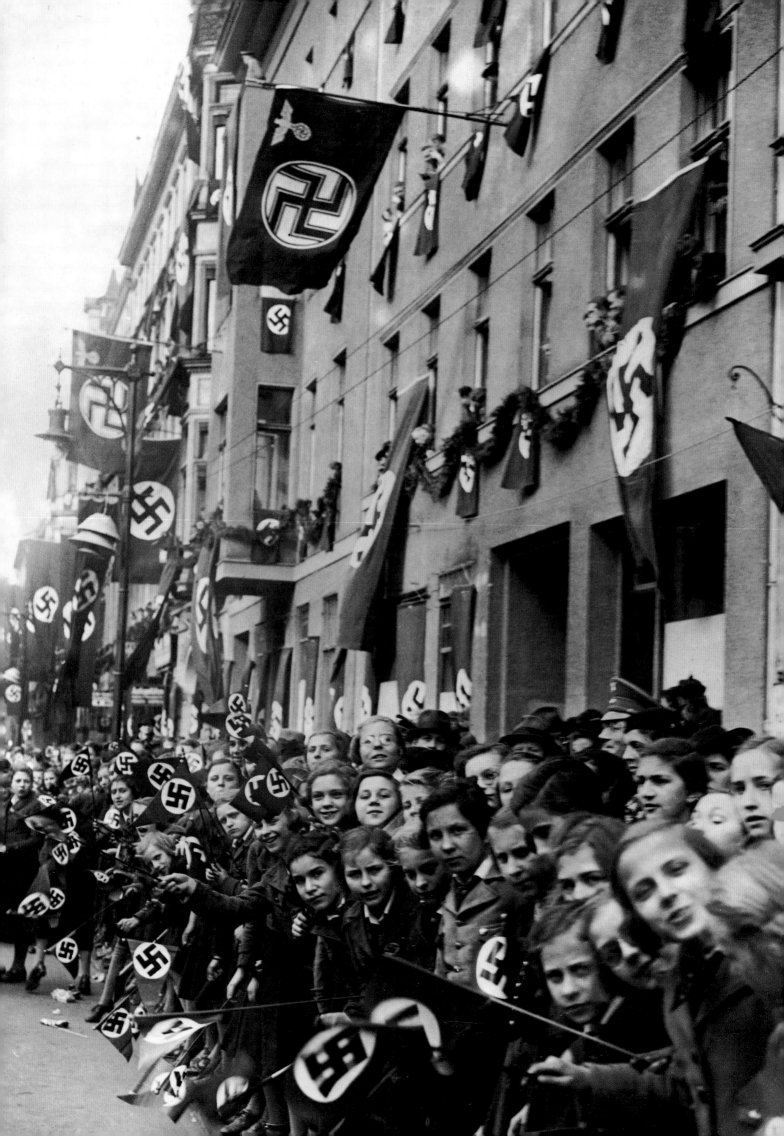

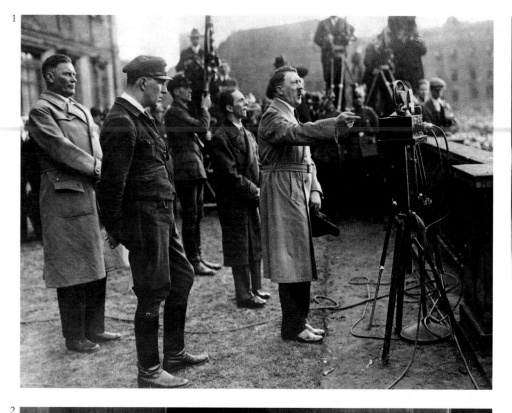

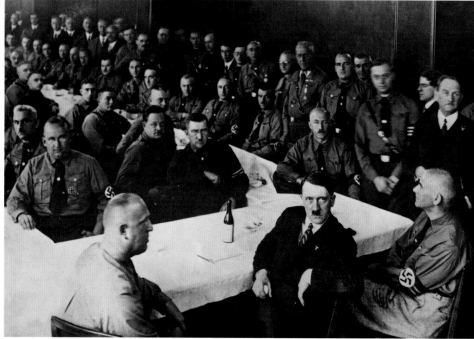

The Burning of the Books

'The voice isn't half as unsympathetic as you'd think,' wrote Erich Kästner. 'It smells a bit of the seat of the pants, unappetizing, but nothing more.' (1) Hitler makes an election speech, April 1932. (2) Hitler and Reichstag members of the National Socialist Party after their first conference. (3) The revival of a 'brutish medieval practice' – the Burning of the Books, 11 May 1933. Kästner stood by the bonfire in Berlin as his own works were thrown on to it, and heard Goebbels denounce them.

Bücherverbrennungen

»Die Stimme ist längst nicht so unsympathisch, wie man vielleicht denkt«, schrieb Erich Kästner. »Sie riecht ein bißchen nach Hosenboden, unappetitlich, nichts weiter.« (1) Hitler hält eine Wahlkampfrede im April 1932. (2) Hitler und Reichstagsabgeordnete der NSDAP nach ihrer ersten Besprechung.

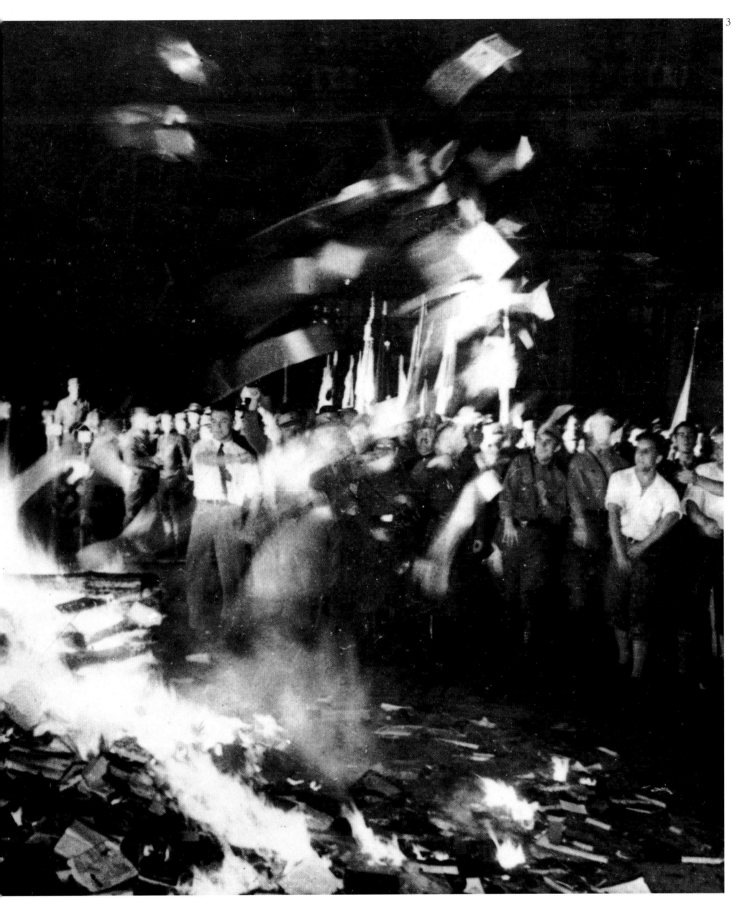

(3) Das finstere Mittelalter lebt wieder auf –
die »Verbrennung undeutschen Schrifttums«
am 11. Mai 1933. Kästner stand neben dem
Scheiterhaufen, als seine eigenen Werke in
Flammen aufgingen, und hörte, wie Goebbels
sie beschimpfte.

Livres et Autodafé.
«La voix n'est pas aussi antipathique que vous
pourriez le penser» écrivait Erich Kästner.
«Cela sent un peu le fond de culotte, rebutant,
mais sans plus.» (1) Avril 1932, Hitler en
plein discours électoral. (2) Hitler et les
membres du Parti National Socialiste après
leur première conférence. (3) La résurgence

d'«une pratique moyenâgeuse brutale»
– l'Autodafé des Livres, 11 mai 1933. Kästner
se tenait près du brasier berlinois tandis que
ses propres œuvres étaient jetées au feu et
qu'il écoutait Goebbels les dénoncer.

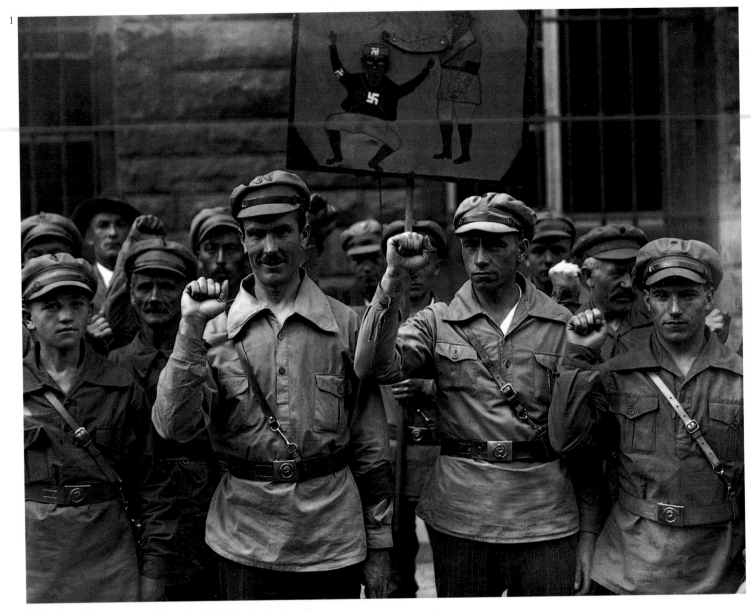

The German Elections

There were two elections in 1932. (1) In March, the Communist supporters of Ernst Thälmann polled 13 per cent of the votes. (3) In the run-up to the second election in April, placards proclaimed 'We want work and bread! Vote for Hitler!' The Nazis greatly increased their vote. (2) Berlin police queue to cast their votes in the election of March 1933, when the Nazis gained a majority in the Reichstag.

Wahlen in Deutschland

1932 fanden zwei Wahlen statt. (1) Bei der Reichspräsidentenwahl im März erzielte der Kommunist Ernst Thälmann 13 Prozent der Stimmen. (3) Im Vorfeld des zweiten Wahlgangs im April proklamierten die Plakate: »Wir wollen Arbeit und Brot! Wählt Hitler!« Hitler konnte seinen Stimmenanteil deutlich vergrößern. (2) Berliner Polizisten warten auf die Stimmabgabe bei den Reichstagswahlen im März 1933, bei denen die NSDAP stärkste Partei wurde.

Les élections allemandes

Il y eut deux élections en 1932. (1) En mars, les partisans communistes de Ernst Thälmann recueillirent 13 % des voix. (3) Dans la période qui précéda les secondes élections d'avril, des affiches proclamaient «Nous voulons du travail et du pain! Votez Hitler!» (2) Les voix en faveur des nazis augmentaient. Policiers de Berlin faisant la queue pour déposer leur bulletin de vote lors des élections de mars 1933 qui virent les nazis obtenir la majorité au Reichstag.

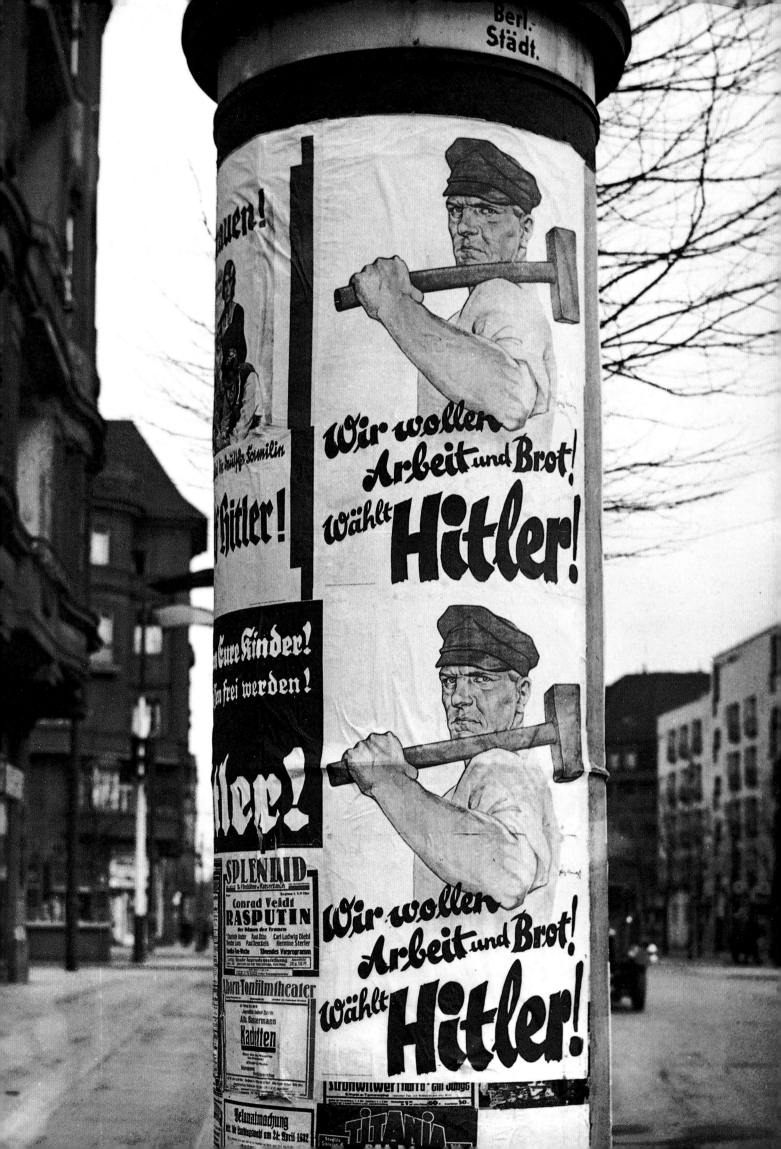

Italian Fascism

Resplendent in black shirts and immaculately creased trousers, Italian Fascists under Commander D'Amelio Mario await the arrival of their leader, Benito Mussolini. The date is December 1922, two months after the March on Rome. Mussolini was already threatening to make the nation Fascist ('*Fascistizzare la nazione*') by 'our fierce totalitarian will' ('*La nostra feroce volontà totalitaria*') – thus introducing into the 20th-century vocabulary two of its grimmest words.

Der italienische Faschismus

In schwarzen Hemden und Hosen mit makellosen Bügelfalten erwarten italienische Faschisten unter ihrem Kommandeur D'Amelio Mario die Ankunft ihres Führers Benito Mussolini. Die Aufnahme stammt vom Dezember 1922, zwei Monate nach dem Marsch auf Rom. Mussolini drohte bereits, die ganze Nation dem Faschismus zu unterwerfen (»*Fascistizzare la nazione*«), »mit gewaltigem, totalitärem Willen« (»*La nostra feroce volontà totalitaria*«) – und

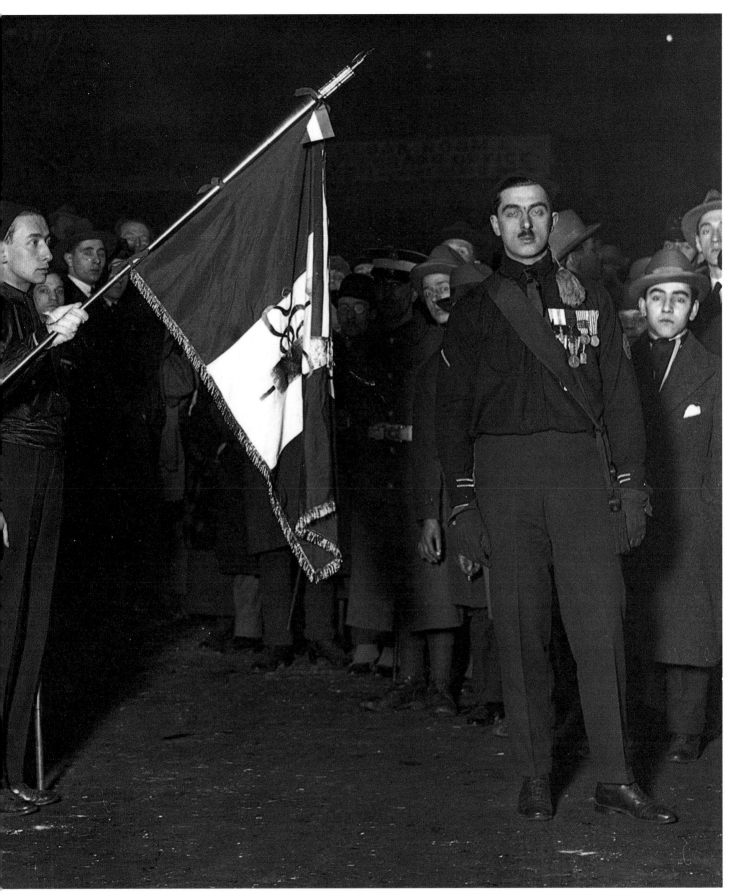

führte damit in die Sprache des 20. Jahrhunderts zwei ihrer schlimmsten Worte ein.

Le fascisme italien

Impeccables dans leurs chemises noires et leurs pantalons à plis, les fascistes italiens, dirigés par le commandant D'Amelio Mario, attendent l'arrivée de leur chef, Benito Mussolini. La scène se passait en décembre 1922, deux mois après la marche sur Rome. Mussolini menaçait

déjà de fasciser la nation («*Fascistizzare la nazione*») par «notre féroce volonté totalitaire» («*La nostra feroce voluntà totalitaria*») – introduisant ainsi dans le vocabulaire du 20ᵉ siècle deux de ses plus sinistres mots.

Kristallnacht

On the night of 9 November 1938 the windows of Jewish shops in Germany were smashed. (1) Two days later, passers-by in Friedrichstrasse appeared to approve. The reason for the violence against the Jews was the murder of Ernst vom Rath, Third Secretary at the German Embassy in Paris.

His assassin was a 17-year-old Polish Jew named Herschel Fiebel Grynspan (2), whose parents had been persecuted by the Nazis. Many synagogues, among them the one in Danzig (3), were set on fire.

»Reichskristallnacht«

In der Nacht des 9. November 1938 wurden die Fenster jüdischer Geschäfte in Deutschland eingeschlagen. (1) Zwei Tage später scheint dies bei Passanten in der Friedrichstraße Anklang zu finden. Der Anlaß für die antisemitischen Ausschreitungen war die Ermordung des Legationssekretärs an der deutschen Botschaft in Paris, Ernst vom Rath, durch einen siebzehnjährigen polnischen Juden namens Herschel Fiebel Grynspan (2), dessen Eltern von den Nazis verfolgt wurden. Zahlreiche Synagogen, darunter auch die in Danzig (3), gingen in Flammen auf.

Kristallnacht (La Nuit de Cristal)

Dans la nuit du 9 novembre 1938, les vitrines des magasins juifs furent brisées en Allemagne. (1) Deux jours plus tard, des passants approuvent les exactions sur la Friedrichstrasse. Le meurtre d'Ernst vom Rath, troisième secrétaire à l'ambassade d'Allemagne à Paris, déclencha la vague de violence contre les juifs. L'assassin était un juif polonais de 17 ans nommé Herschel Fiebel Grynspan (2), ses parents avaient été persécutés par les nazis. De nombreuses synagogues, dont celle de Danzig (3), furent incendiées.

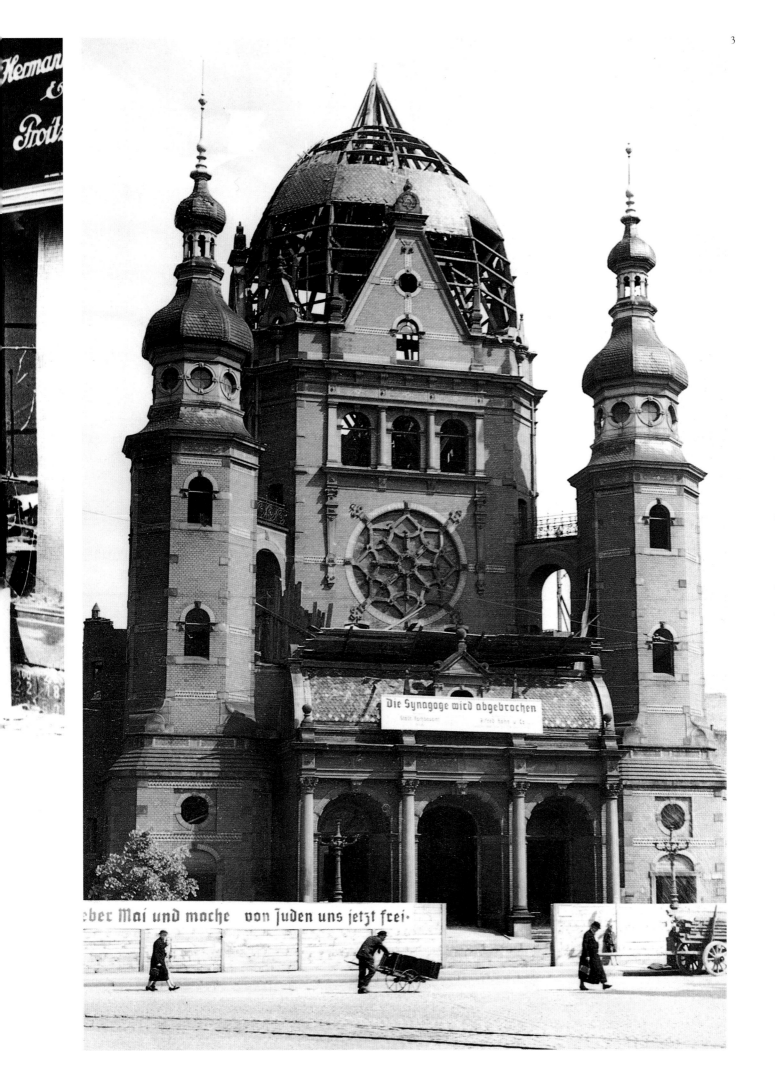

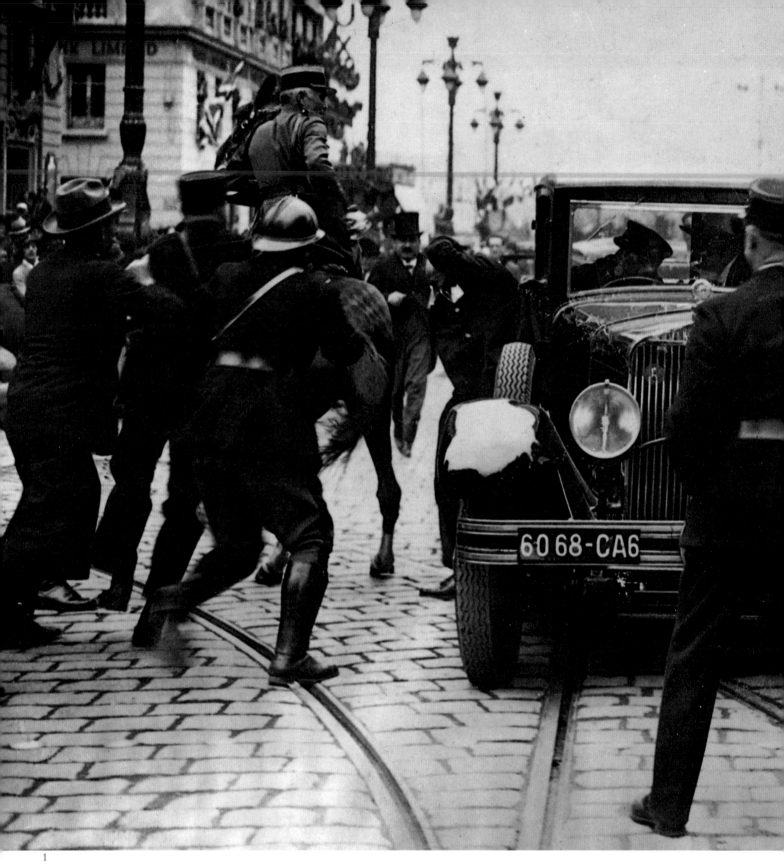

1

The Assassination of King Alexander
(1) 9 October 1934 – one of the most famous
assassination pictures of all time. The
chauffeur of the royal car holds the assassin
by the collar to prevent his escape, while Lt-
Colonel Poillet of the 41st Line Regiment
strikes at the Croatian gunman with his
sabre. Alexander of Yugoslavia (2, in uniform)
had only just arrived in Marseilles on a state
visit. Beside him was Louis Barthou, the
French Foreign Minister, who was also killed
by the assassin, Petrus Kaleman.
(3) Kaleman's body lies on the ground.

Die Ermordung König Alexanders

(1) 9. Oktober 1934 – eines der berühmtesten Attentatsfotos aller Zeiten. Der Chauffeur des königlichen Wagens hält den Attentäter Petrus Kaleman am Kragen fest, um ihn an der Flucht zu hindern, während Oberst Poillet vom 41. Linienregiment mit dem Säbel auf den kroatischen Schützen losgeht. Alexander von Jugoslawien (2, in Uniform) war gerade erst zu einem Staatsbesuch in Marseille eingetroffen. An seiner Seite saß der französische Außenminister Louis Barthou, der ebenfalls bei dem Attentat ums Leben kam. (3) Die Leiche Kalemans liegt auf dem Boden.

L'assassinat du roi Alexandre

(1) 9 octobre 1934 – l'une des plus célèbres photos d'assassinat de tous les temps. Le chauffeur de la voiture royale tient l'assassin par le cou pour l'empêcher de fuir, tandis que le colonel Poillet, du 41ᵉ Régiment de ligne, le frappe de son sabre. Alexandre de Yougoslavie (2, en uniforme) venait juste d'arriver à Marseille pour une visite d'Etat. Louis Barthou, ministre français des Affaires Etrangères était du voyage officiel, et fut également tué par le meurtrier croate, Petrus Kaleman. (3) Le corps de Kaleman gît à terre.

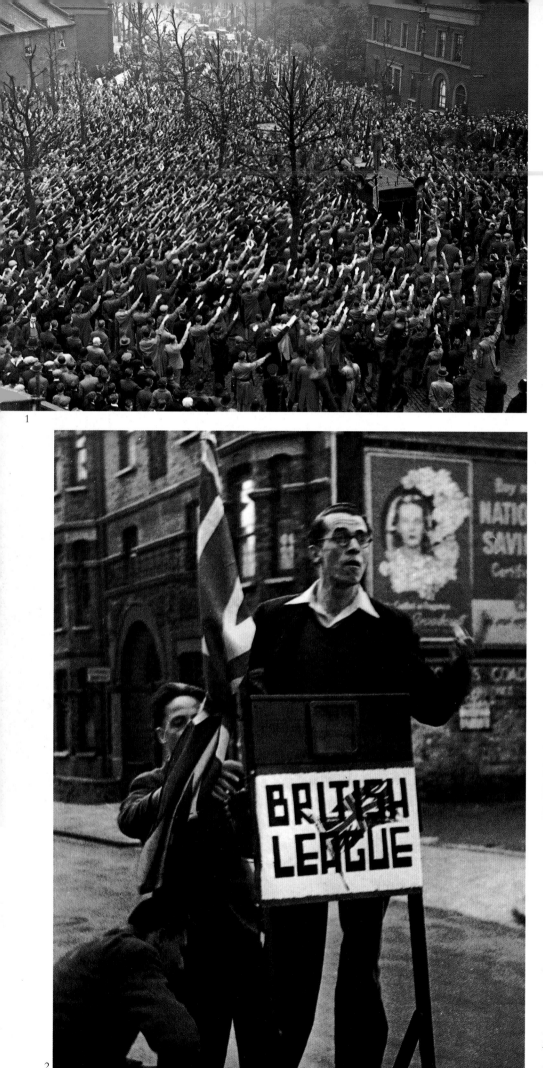

British Fascism

The leading figure was Sir Oswald Mosley, who left the Labour Party to found the British Union of Fascists. 'If I could have £250,000 and a press,' he said, ' I could sweep the country.' (1) Mosleyites salute their leader at a May Day demonstration in Bermondsey, London, in 1938. (2) There were other right-wing parties in Britain between the wars. Michael Ryan of the British League of ex-Servicemen seeks similarly disillusioned old soldiers in Brixton. (3) Mosley (centre) parades with his fellow Fascists, including William Joyce (extreme left), later to become notorious as Lord Haw-Haw during the

Second World War. Mosley was imprisoned; Joyce was executed for treason.

Der Faschismus in Großbritannien
An der Spitze der Bewegung stand der aus der *Labour Party* ausgetretene Begründer der *British Union of Fascists,* Sir Oswald Mosley, der behauptete, er brauche nur 250 000 Pfund und eine Druckerpresse, um das Land im Sturm zu erobern. (1) Mosley-Anhänger grüßen ihren Führer bei einer Mai-Demonstration im Londoner Stadtteil Bermondsey, 1938. (2) In der Zeit zwischen den Kriegen gab es in Großbritannien noch andere rechte Gruppierungen. Michael Ryan von der *British League of ex-Servicemen* sucht im Londoner Stadtteil Brixton nach ähnlich desillusionierten alten Soldaten. (3) Mosley (Mitte) mit faschistischen Gesinnungsgenossen, darunter William Joyce (ganz links), der berüchtigte Lord Haw-Haw. Mosley erhielt eine Gefängnisstrafe, Joyce wurde wegen Verrats hingerichtet.

Le fascisme britannique
La figure dominante du parti était Sir Oswald Mosley, qui quitta le Parti Travailliste pour fonder la *British Union of Fascists* (Union Fasciste britannique). «Si j'avais £250 000 et une imprimerie» déclara-t-il, «je pourrais couvrir le pays.» (1) Londres 1938, les Mosleyites saluent leur dirigeant lors d'une manifestation du Premier Mai à Bermondsey. (2) Dans la période de l'entre-deux-guerres, il existait d'autres partis de droite en Grande-Bretagne. Michael Ryan, de la *British League of ex-Servicemen* (Ligue britannique des Anciens Militaires) recrute chez les déçus de l'armée, à Brixton. (3) Mosley (au centre) parade avec ses militants fascistes, dont William Joyce (extrême gauche), qui se fera connaître sous le nom de Lord Haw-Haw pendant la Seconde Guerre Mondiale. Mosley fut emprisonné; Joyce exécuté pour trahison.

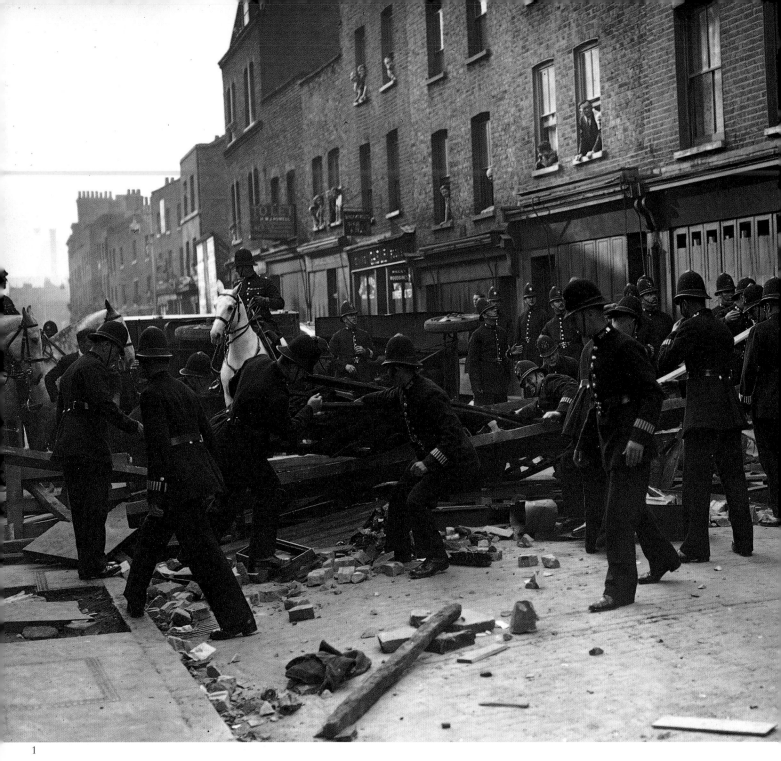

1

The Battle of Cable Street

On 4 October 1936, Mosley marched his followers into a predominantly Jewish area of East London. The Communist Party organized 100,000 people and built barricades to stop them. The police were instructed to help Mosley and his supporters, but the march finally had to be abandoned. (1) Police clear a path for Mosley by dismantling a barrier near Mark Lane, and (2) pursue counter-demonstrators along the streets of Bethnal Green. (3) Left- and right-wing scuffles continued until the outbreak of the Second World War – Fascists and Jews fight in Whitehall on 28 September 1938, during the Munich negotiations between Chamberlain and Hitler.

Die Schlacht in der Cable Street

Am 4. Oktober 1936 zogen Mosley-Anhänger in eine überwiegend von Juden bewohnte Gegend im Osten Londons. Die Kommunisten boten 100 000 Mann auf und errichteten Barrikaden, um sie aufzuhalten. Obwohl die Polizei Weisung hatte, Mosley und seine Anhänger zu unterstützen, mußte der Marsch schließlich doch abgebrochen werden. (1) Polizisten beseitigen eine Barrikade in der Nähe der Mark Lane, um Mosley den Weg freizumachen, und (2) verfolgen Gegendemonstranten durch die Straßen von Bethnal Green. (3) Die Kämpfe zwischen Rechten und Linken dauerten bis zum Ausbruch des Zweiten Weltkriegs an. Auseinandersetzungen zwischen Faschisten und Juden in Whitehall, 28. September 1938, während der Verhandlungen zum Münchner Abkommen zwischen Chamberlain und Hitler.

La bataille de Cable Street

Le 4 octobre 1936, Mosley entraîna ses partisans vers un quartier à dominante juive dans l'est de Londres. Le Parti Communiste rassembla 100 000 personnes et construisit des barricades pour les arrêter. La police reçut l'ordre de soutenir Mosley et ses troupes, qui durent cependant renoncer à leur défilé. (1) La police ouvre le passage à Mosley en démantelant une barricade près de Mark Lane, (2) et poursuit les contre-manifestants dans les rues de Bethnal Green. (3) Les affrontements droite-gauche continuèrent jusqu'à la Seconde Guerre Mondiale. Combats fascistes-juifs à Whitehall le 28 septembre 1938, au moment des négociations de Munich entre Chamberlain et Hitler.

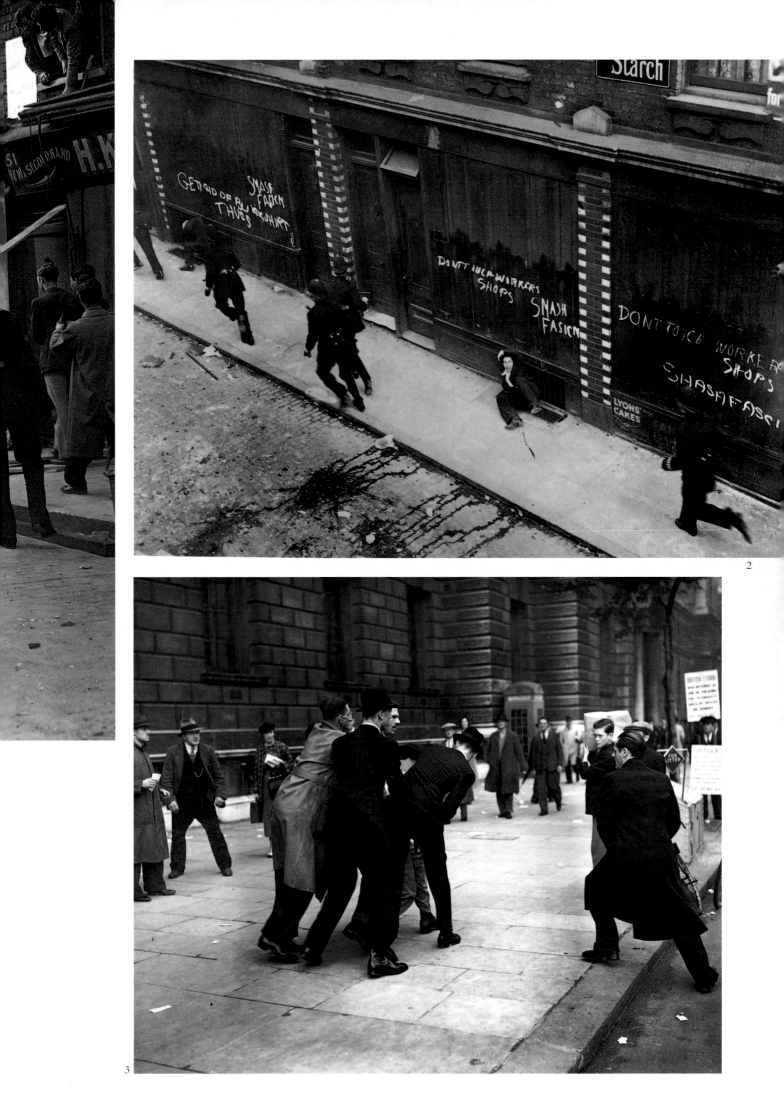

American Nazis

'It was a frightening tumult in Madison Square Garden, a rally of the German-American Bund, whose squat little leader goggled through thick lenses at his roaring flock' – Alistair Cooke did not enjoy his visit to cover the event. The meeting was organized by the Friends of the New Germany to protest at President Roosevelt's illegally imposed boycott of German goods.

Amerikanische Nazis

»Im Madison Square Garden herrschte ein beängstigender Tumult – eine Versammlung des ›Deutsch-Amerikanischen Bundes‹, dessen gedrungener Anführer die tobenden Massen durch dicke Brillengläser beobachtete« – der Berichterstatter Alistair Cooke konnte sein Unbehagen nicht verhehlen. Mit der Veranstaltung protestierten die »Freunde des Neuen Deutschland« gegen den von Präsident Roosevelt verhängten Boykott deutscher Waren.

Nazis américains

«Ce fut un effroyable tumulte à Madison Square Garden, le rassemblement du *German-American Bund* (Union Germano-Américaine). Petit et gros, son chef avait un regard globuleux derrière d'épaisses lunettes et il hypnotisait ses ouailles rugissantes» – Alistair Cooke, qui couvrit l'événement, n'apprécia guère de se trouver là. Le meeting était organisé par les *Friends of the New Germany* (les Amis de la Nouvelle Allemagne) pour protester contre le boycottage illégal des produits allemands imposé par le président Roosevelt.

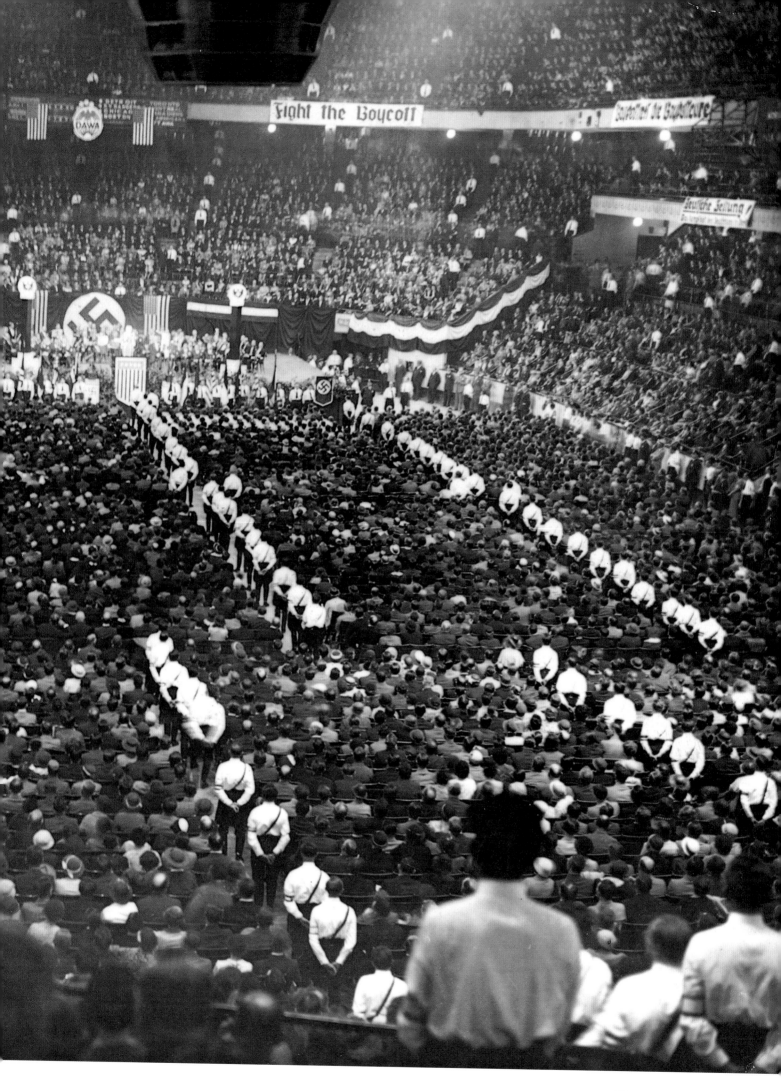

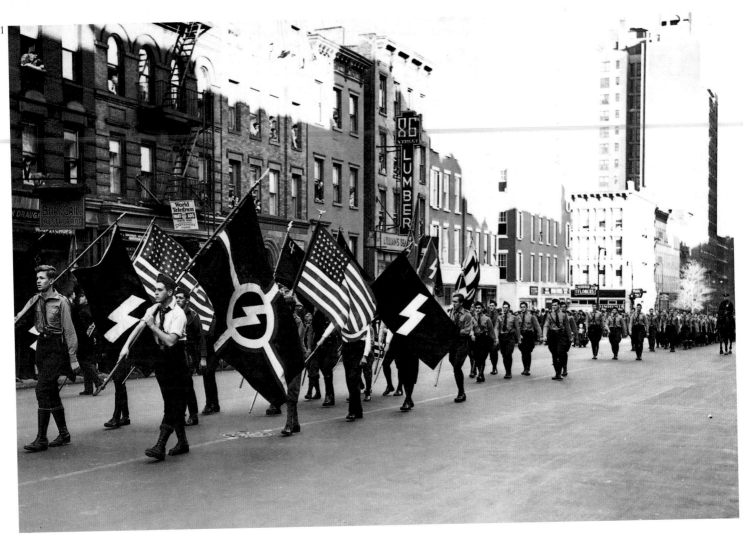

The German-American Bund

There were plenty of Americans who thought that the United States should stay clear of the impending war in the late 1930s. But there were some who believed the US should fight, on the Nazi side. (1, 2) On the day that the extermination of German Jewry was predicted, 800 members of the Bund paraded through New York. (3) John C.

Metcalfe, in the uniform of the Bund, appears before the House Committee investigating the Un-American Activities of the Bund in September 1938.

Der Deutsch-Amerikanische Bund

In den späten dreißiger Jahren fanden viele Amerikaner, die USA sollten sich aus dem drohenden Krieg heraushalten, während

andere für den Kampf plädierten – auf seiten der Nazis. (1, 2) An dem Tag, an dem die Ausrottung der deutschen Juden prophezeit wurde, marschierten 800 Mitglieder des Bundes durch New York. (3) Im September 1938 erscheint John C. Metcalfe in der Uniform des Bundes vor dem Ausschuß, der dessen unamerikanische Umtriebe untersuchen soll.

Le *German-American Bund* (Union Germano-Américaine)

Vers la fin des années 30, nombreux furent les Américains qui pensaient que les Etats-Unis devaient se tenir à l'écart de la guerre qui menaçait. En revanche, certains considéraient que leur pays aurait à s'engager, du côté nazi. (1, 2) Le jour où fut proclamée l'extermination de la communauté juive allemande, 800 membres du *German-American Bund* paradèrent dans New York. (3) Septembre 1938, John C. Metcalfe, en uniforme du Bund, comparaît devant la Commission de la Chambre qui enquêtait sur les activités anti-américaines du Bund.

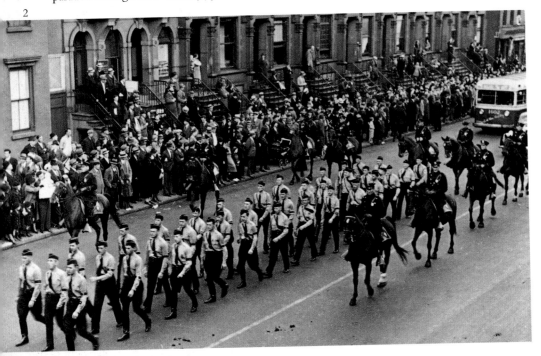

Industry and Unemployment

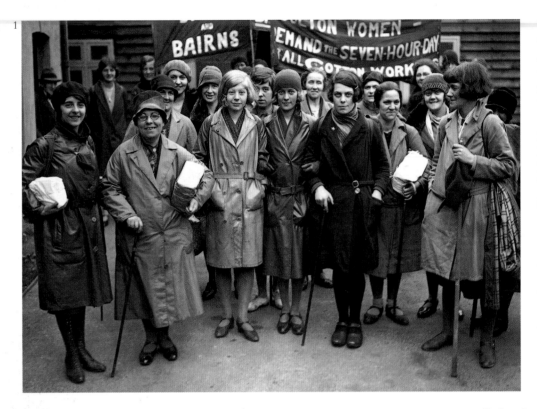

The fight for work: (1) unemployed women on a hunger march to London, April 1930. (2) Miners in Wigan during the General Strike of 1926, a time when resolute words did little to fill empty bellies.

Der Kampf um Arbeit: (1) Arbeitslose Frauen auf einem Hungermarsch nach London, April 1930. (2) Bergarbeiter in Wigan beim Generalstreik 1926 – energische Worte halfen wenig, um die leeren Bäuche zu füllen.

La lutte pour le travail: (1) Des chômeuses lors d'une marche de la faim à Londres, avril 1930. (2) Mineurs à Wigan durant la Grève Générale de 1926, époque où les discours aussi volontaires fussent-ils ne pouvaient remplir des ventres vides.

If you couldn't persuade the workers to take up arms, you could at least order them to lay down tools. Everyone, it seemed, was prepared to strike: miners, dockers, farm labourers – though they had most to lose, for their homes often went with their jobs – matchgirls, tailors, waitresses and even policemen.

Huge outdoor meetings were addressed by trade union leaders, who had sweated and suffered with their fellow workers in the engineering sheds and workshops of the world. The more important the industry involved, the more vicious the means by which bosses and owners sought to break any strike that halted production.

For a very small number of workers direct action was the answer. On the whole, strikers were not violent people, but the language of war invaded the industrial front. When French railway workers withdrew their labour in 1920, one employer prepared for what he called 'a civilian battle of the Marne'. In a sad echo of the Christmas Truce of 1914 on the Western Front, British strikers and police played football with each other in a period of major industrial unrest during the 1920s – and received the same official condemnation for so doing.

In Italy, Turin and Milan became centres of regular strikes and sit-ins. One leading industrialist solemnly announced that 'the future belongs to the organized classes', and was no doubt relieved when they turned out to be the Fascists rather than the Socialists.

In Britain, the culmination of unrest was the General Strike of 1926 – a brave move, but too late. Road transport was now so well developed that undergraduates, clerks and housewives could drive the buses that took the middle classes to work, and the trucks that ensured food supplies got through.

Employers in the United States saw Communist conspiracies in almost every industrial dispute, no matter how trivial. 'Big Bill' Haywood, founder of the Industrial Workers of the World, jumped bail in 1921 while awaiting trial on a charge of opposing the First World War. When he fled to Moscow it seemed evidence of management's worst fears. Certainly, the IWW were still seen as devils incarnate by most American industrialists and every attorney-general.

By 1928, Herbert Hoover was promising better times ahead and an end to poverty as he accepted the Republican Party nomination for the Presidency. 'A chicken in every pot, a car in every garage' was his platform slogan. Within 12 months the Wall Street stock-market had crashed and workers and bosses alike experienced a deepening depression throughout the industrial world.

The broken spirit of the age was caught in haunting popular songs such as *Buddy, Can You Spare a Dime?* and *Remember My Forgotten Man*, in films and books such as *How Green Was My Valley?* and *The Grapes of Wrath*. Once the Depression took hold, unemployment kept the workers in their place better than police batons and tear gas ever could do. But it took massive programmes of public works to get even a few thousand workers off the breadline, until a new world war appeared on the horizon.

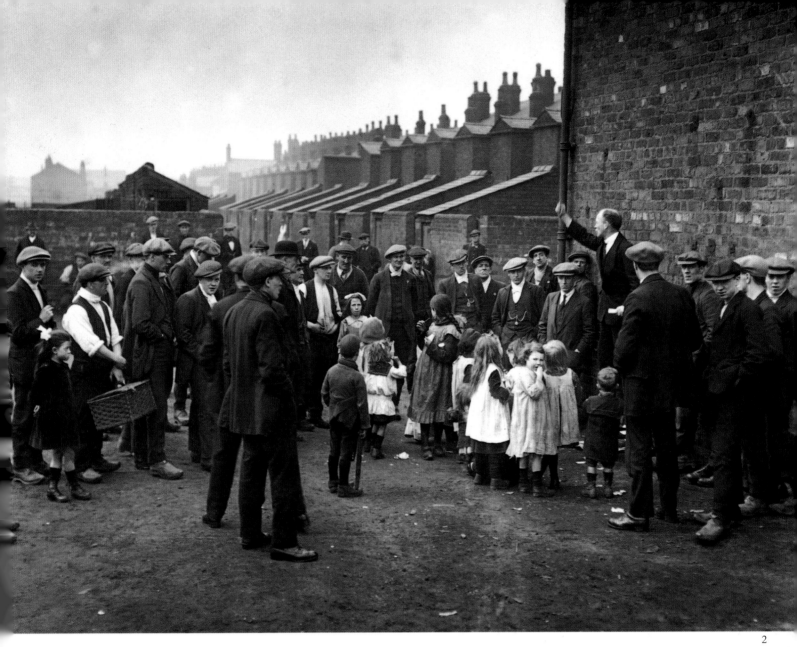

Wenn man die Arbeiter schon nicht dazu bringen konnte, zu den Waffen zu greifen, konnte man ihnen doch wenigstens befehlen, ihre Werkzeuge aus der Hand zu legen. Offenbar gab es keinen, der nicht bereit zum Streik war: Bergleute, Dock- und Landarbeiter – obwohl gerade sie am meisten zu verlieren hatten, denn sie erhielten mit der Arbeit oft auch Unterkunft –, Streichholzverkäuferinnen, Kellnerinnen, Schneider und sogar Polizisten.

Gewerkschaftsführer, die mit ihren Kameraden in den Werkstätten und Fabriken der Welt gearbeitet und gelitten hatten, sprachen vor gewaltigen Versammlungen unter freiem Himmel. Je bedeutender ein Industriezweig, desto gewaltsamer versuchten die Bosse und Eigentümer jeden Streik, der die Produktion stilllegte, zu brechen.

Nur für einen sehr geringen Teil der Arbeiter waren Handgreiflichkeiten die Antwort darauf. Alles in allem neigten die Streikenden nicht zur Gewalt, obwohl sich die Sprache des Krieges auch im Arbeitskampf breitmachte. Als die französischen Eisenbahner 1920 die Arbeit niederlegten, nannte ein Industrieller die zu erwartenden Auseinandersetzungen die »Marneschlacht der Zivilisten«. In den zwanziger Jahren, auf dem Höhepunkt der Arbeitskämpfe, spielten in Großbritannien Streikende und Polizisten miteinander Fußball, wofür sie wie die Soldaten beim Waffenstillstand an der Westfront zu Weihnachten 1914 dienstlich getadelt wurden.

In Italien waren in Turin und Mailand Streiks und Sitzblockaden an der Tagesordnung. Ein führender Industrieller verkündete grimmig, daß »die Zukunft den organisierten Klassen« gehöre, und zweifellos war er erleichtert, daß die Zukunft ihm die Faschisten und nicht den Sozialismus bescherte.

In Großbritannien gipfelten die Unruhen im Generalstreik des Jahres 1926 – ein mutiger Schritt, der jedoch zu spät kam. Das Verkehrswesen war inzwischen so weit entwickelt, daß Studenten, Büroangestellte und Hausfrauen die Busse fahren konnten, mit denen die Mittelschicht zur Arbeit kam, ebenso die Lastwagen, die ihnen Lebensmittel brachten.

Arbeitgeber in den Vereinigten Staaten witterten in praktisch jedem Arbeitskampf, so unbedeutend er auch sein mochte, eine kommunistische Verschwörung. »Big Bill« Haywood, Begründer der *Industrial Workers of the World,* floh 1921, als er wegen Aufwiegelung zum Widerstand gegen den Ersten Weltkrieg angeklagt werden sollte, nach Moskau, was die schlimmsten Befürchtungen des amerikanischen Kapitals nur bestätigte. Für die meisten amerikanischen Industriellen und jeden Staatsanwalt war die IWW jedenfalls der Teufel in Person.

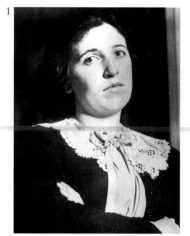

1928 versprach Herbert Hoover, der Präsidentschafts-
kandidat der Republikaner, daß es wieder aufwärts ginge
und die Armut bald ein Ende hätte. »Ein Huhn in jedem
Kochtopf, ein Auto in jeder Garage« war sein Slogan. Es sollte
kein Jahr mehr bis zum großen Börsenkrach an der Wall Street
dauern, und die Bosse ebenso wie die Arbeiter rutschten
immer tiefer in die Wirtschaftskrise.

Die niedergeschlagene Stimmung des Zeitalters hielten
Lieder fest, die bis heute populär geblieben sind, Lieder
wie *Buddy, Can You Spare a Dime?* oder *Remember My Forgotten
Man,* und Filme und Bücher wie *So grün war mein
Tal* oder *Früchte des Zorns.* Als die Wirtschaftskrise sich erst
einmal festgesetzt hatte, hielt die Arbeitslosigkeit die Arbeiter
besser an ihrem Platz, als Schlagstöcke und Tränengas es
jemals gekonnt hätten. Mit ihren massiven Arbeitsbeschaf-
fungsprogrammen konnten die Regierungen wenigstens ein
paar tausend Arbeitslose von der Straße holen, bis dann am
Horizont ein neuer Weltkrieg heraufzog.

Si l'on ne parvient pas à convaincre les ouvriers de prendre
les armes, on peut au moins leur ordonner de déposer les
outils. Chacun, apparemment, était prêt à faire grève: mineurs,
dockers, cultivateurs – quoiqu'ils aient presque tout à perdre,
leur foyer se confondant souvent avec leur travail – allu-
mettières, tailleurs, serveuses, voire policiers.

Les dirigeants des syndicats, qui avaient trimé aux côtés de
leurs camarades ouvriers dans les ateliers de construction
mécanique et les fabriques du monde entier, organisèrent de
vastes meetings en plein air. Plus l'industrie touchée était
importante, plus les moyens auxquels recouraient les patrons
ou les propriétaires pour briser tout arrêt de travail
immobilisant la production, étaient brutaux.

Cependant, si un petit nombre d'ouvriers choisissait de
répondre par l'action directe, globalement, les grévistes
n'étaient pas violents, bien que le vocabulaire guerrier appa-
raissait aussi dans le quotidien de la lutte ouvrière. Lorsque les
cheminots français firent grève en 1920, un industriel appela
«bataille civile de la Marne» les confrontations qui devaient

Strike leaders, strike-breakers: in the United States, heartland of capitalism, strikes often led to bitter and violent struggles between unions and employers. (1) Elizabeth Flynn led the waiters' strike in New York in January 1913. (2) William D. ('Big Bill') Haywood was the founder of the Industrial Workers of the World. This portrait was taken in Moscow, where he retreated to write his memoirs in 1924. (3) 200 police were needed to escort 'blacklegs' through mass pickets at the Federal Screw Works in April 1938.

Streikführer, Streikbrecher: In den Vereinigten Staaten, der Hochburg des Kapitalismus, führten Streiks oft zu erbitterten und brutalen Kämpfen zwischen Gewerkschaftlern und Industriellen. (1) Elizabeth Flynn führte den Streik der New Yorker Kellner im Januar 1913 an. (2) William D. (»Big Bill«) Haywood war der Gründer der *Industrial Workers of the World*. Das Porträt entstand in Moskau, wo er 1924 Zuflucht gesucht hatte, um seine Memoiren zu schreiben. (3) 200 Polizisten eskortieren Streikbrecher durch ein Großaufgebot von Streikposten vor den Federal Screw Works, April 1938.

Meneurs et briseurs de grèves: aux Etats-Unis, berceau du capitalisme, les grèves dégénéraient souvent en luttes âpres et violentes entre syndicats et patrons. (1) Elizabeth Flynn conduit la grève des serveurs à New York en janvier 1913. (2) William D. («Big Bill») Haywood fut le fondateur de l'*Industrial Workers of the World* (Ouvriers Industriels du Monde). Ce portrait fut pris à Moscou, où il se retira pour écrire ses mémoires en 1924. (3) 200 policiers furent requis pour escorter les «briseurs de grève» à travers la masse des piquets de grève à l'Industrial Screw Works (Ateliers de vis industrielles) en avril 1938.

s'ensuivre. A l'époque des grands conflits sociaux qui agitaient les années 1920, grévistes et policiers britanniques organisèrent une partie de football. Faisant tristement écho à la Trêve de Noël sur le front occidental, en 1914, une même sanction officielle condamna les deux partis.

En Italie, Turin et Milan furent régulièrement le théâtre de grèves et de manifestations. Un important industriel qui déclarait solennellement que «le futur appartient aux classes organisées», fut certainement soulagé lorsqu'elles s'avérèrent être fascistes plutôt que socialistes.

En Grande-Bretagne, les troubles culminèrent au moment de la Grève Générale de 1926 – mouvement courageux mais trop tardif. Les transports routiers s'étaient alors si bien développés que les étudiants, les employés et les ménagères pouvaient conduire les bus qui emmenaient les classes moyennes au travail, et les camions qui assuraient la livraison des produits alimentaires.

Aux Etats-Unis, les employeurs décelaient des conspirations communistes dans presque chaque conflit social, aussi insignifiant soit-il. «Big Bill» Haywood, fondateur de la *Industrial Workers of the World* (Ouvriers Industriels du Monde) fut libéré sous caution en 1921, en attendant que s'ouvrît son procès pour opposition à la Première Guerre Mondiale, et plongea dans la clandestinité. Les patrons virent dans sa fuite pour Moscou la confirmation de leurs pires craintes. Assurément, la IWW continuait à incarner le démon pour la plupart des industriels comme pour l'ensemble des procureurs généraux américains.

En 1928, alors qu'il était nommé candidat à la présidence par le Parti Républicain, Herbert Hoover promit des temps meilleurs et la fin de la misère. «Une poule dans chaque marmite, une voiture dans chaque garage» proclamait son slogan. En 12 mois, la bourse de Wall Street s'effondrait, la dépression touchait l'ensemble du monde industriel, frappant les patrons comme les ouvriers.

De lancinants chants populaires traduisirent le désespoir de cette période: *Buddy, can you spare a dime?* (Buddy, t'as pas un sou?) et *Remember my forgotten man* (souviens-toi de mon homme oublié), dans des films et livres tels que *Quelle était verte ma vallée* et *Les Raisins de la Colère*. Lorsque s'abattit la Dépression, le chômage maintint, plus efficacement que les matraques et les gaz lacrymogènes, les ouvriers à leur place. Cependant, de massifs programmes de travaux publics furent nécessaires pour éviter à quelques milliers d'ouvriers de sombrer au-dessous du seuil de pauvreté, jusqu'à ce qu'un monde nouveau se profile à l'horizon.

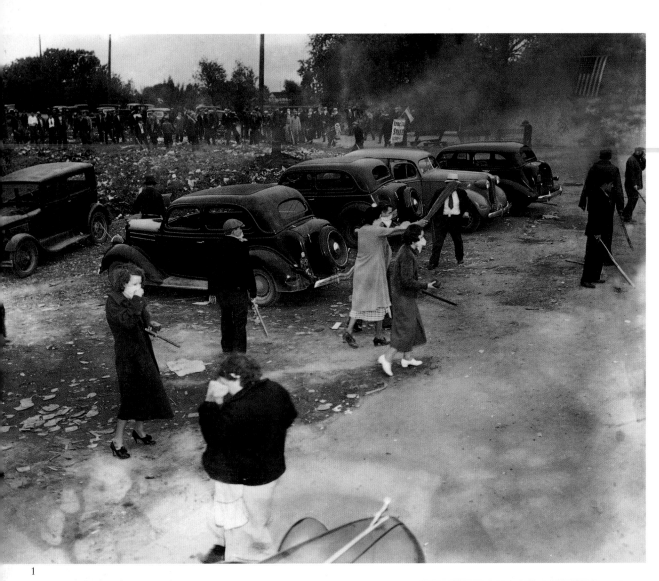

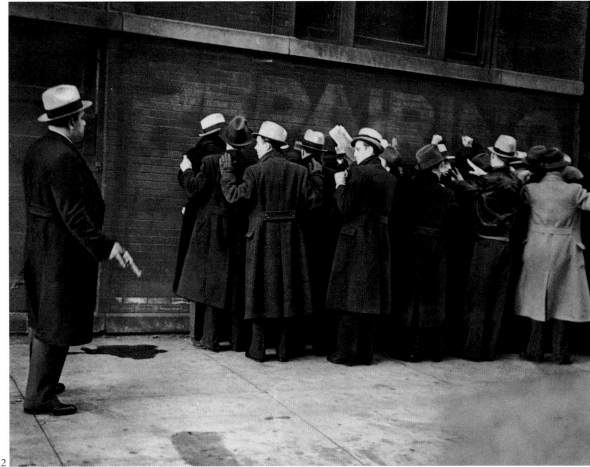

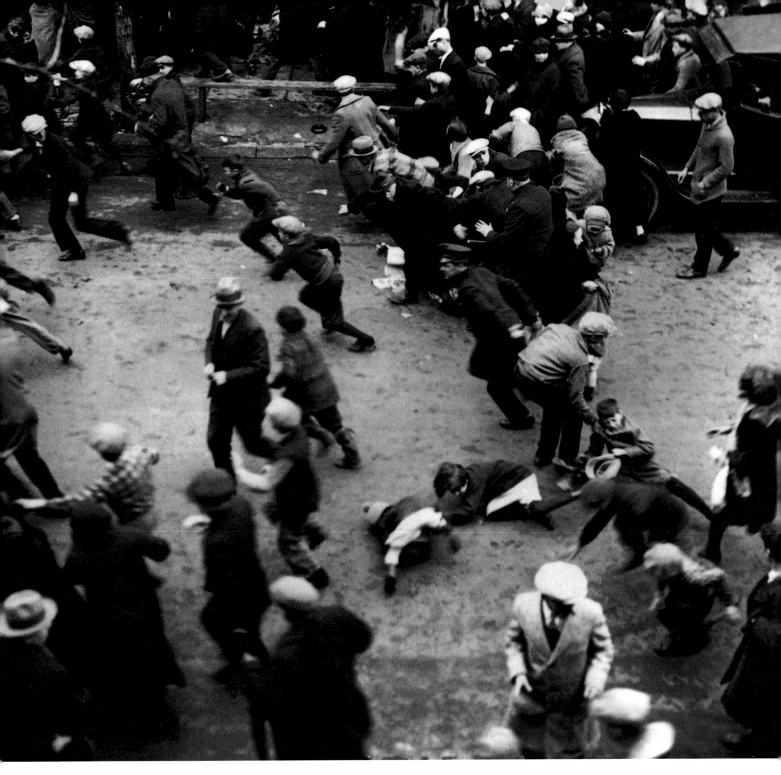

Strikes in the US

The 1930s saw the worst of times. The Wall Street stock-market crashed, millions were unemployed, poor farming methods turned fertile land into dustbowls. Clashes between bosses and workers led to scenes reminiscent of the popular gangster movies of the time. (1) Women pickets face tear gas at the Newton Steel Company strike in Monroe, Michigan, in June 1937. (2) Not the St Valentine's Day Massacre, but a plainclothes policeman keeping gun and eye on striking cab-drivers in Chicago, November 1937. (3) Women and children were injured when police baton-charged strikers at the Gera Mills in Passaic, New Jersey, April 1926.

Streiks in den USA

Die 1930er Jahre waren die schlimmsten. Die Wall-Street-Börse brach zusammen, Millionen waren ohne Arbeit, rücksichtslose Anbaumethoden verwandelten fruchtbares Land in Wüste. Die Auseinandersetzungen zwischen Arbeitern und ihren Bossen führten zu Szenen, die oft an die populären Gangsterfilme der Zeit erinnerten. (1) Weibliche Streikposten vor der Newton Steel Company, Monroe, Michigan, werden im Juni 1937 mit Tränengas angegriffen. (2) Nicht das Massaker am Valentinstag, sondern ein Polizist in Zivil, der ein Auge und seine Waffe auf streikende Taxifahrer in Chicago richtet, November 1937. (3) Als die Polizei im April 1926 vor den Gera Mills in Passaic, New Jersey, mit Schlagstöcken auf streikende Arbeiter losging, kamen auch Frauen und Kinder zu Schaden.

Grèves aux Etats-Unis

Les années 30 furent une période terrible. La bourse de Wall Street s'effondra, il y eut des millions de chômeurs, les méthodes rudimentaires des cultivateurs transformèrent les terres fertiles en déserts de poussière. Les confrontations entre patrons et ouvriers donnèrent lieu à des scènes dignes des films populaires de gangsters de l'époque. (1) Des femmes grévistes affrontent les gaz lacrymogènes lors de la grève de la Newton Steel Company (aciérie), à Monroe, Michigan, en juin 1937. (2) Ce n'est pas l'Hécatombe de la Saint-Valentin, mais un policier en civil surveillant, arme au poing, les chauffeurs de taxi en grève à Chicago, novembre 1937. (3) En avril 1926, les policiers chargèrent à la matraque les grévistes à Gera Mills à Passaic, New Jersey, blessant des femmes et des enfants.

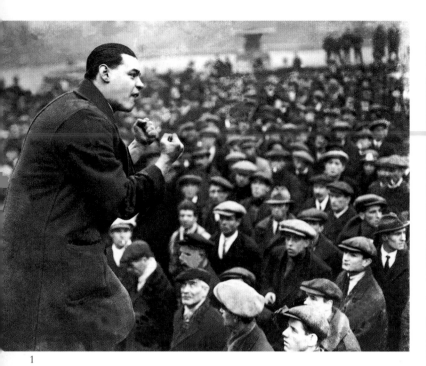

The Jarrow Marchers

In Britain, the unemployed marched and listened and sent in petitions, but little was done to ease the hardship for millions of families. (1) Wal Hannington addresses a crowd of unemployed in Trafalgar Square. Hannington was a Communist, described by George Orwell as a poor speaker, 'using all the padding and clichés of the Socialist orator'. (2) Unemployed shipyard workers from the North-East marched over 200 miles from Jarrow to London in October 1936, to present a petition to the Government. The mouth organs were supplied by a newspaper. (3) Marchers prepare to leave Jarrow. (4) The petition is presented. It achieved nothing. Only the rush to war rekindled the British economy.

Die »Jarrow Marchers«

In England marschierten die Arbeitslosen, kamen zu Kundgebungen und reichten Petitionen ein, doch es geschah kaum etwas, um die Not von Millionen Familien zu lindern. (1) Wal Hannington spricht vor einer Arbeitslosenversammlung auf dem Trafalgar Square. George Orwell zufolge war der Kommunist Hannington kein großer Redner; »er bringt sämtliche typischen Floskeln und Klischees des Sozialismus«. (2) Arbeitslose Werftarbeiter aus dem englischen Nordosten marschierten im Oktober 1936 über 300 Kilometer von Jarrow nach London, um der Regierung ihre Petition zu überbringen. Die Mundharmonikas hatte eine Zeitung gestiftet. (3) Teilnehmer des Marsches vor dem Aufbruch aus Jarrow. (4) Die Bittschrift wird überreicht. Sie erreichte nichts. Erst die Rüstung für einen neuen Krieg brachte die britische Wirtschaft wieder in Gang.

Les manifestants de Jarrow

En dépit des manifestations, des discours, des pétitions organisés par les chômeurs en Grande-Bretagne, peu fut fait pour soulager la misère qui touchait des millions de familles. (1) Wal Hannington harangue une foule de chômeurs à Trafalgar Square. Hannington était un communiste que George Orwell décrivit comme un piètre tribun, «recourant à la langue de bois et aux clichés des socialistes». (2) En octobre 1936, privés de travail, les ouvriers des chantiers navals du Nord-Est organisèrent une marche de plus de 300 kilomètres, de Jarrow à Londres, pour présenter leur pétition au gouvernement. Un journal fournit les harmonicas. (3) Les manifestants se préparent à quitter Jarrow. (4) Présentation de la pétition, sans résultat. Seule la course à l'armement redonna de la vigueur à l'économie anglaise.

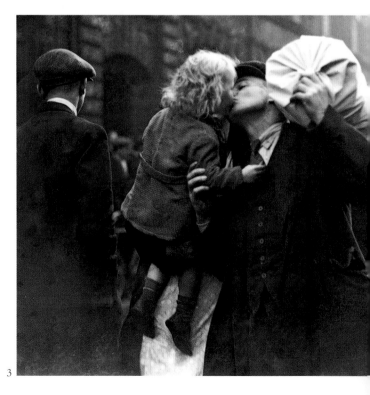

2

4

The General Strike

In 1926 Stanley Baldwin, the British Prime Minister, announced: 'All workers in this country have got to take a reduction in wages.' Coal-owners were quick to cut miners' wages. The miners went on strike, and were joined by railway and transport workers; for nine days much of Britain was brought to a standstill. The only buses, trams or trains that ran were staffed by students, middle-class volunteers or a few 'blacklegs'. (1) Oxford University students parade as special police constables. (2) A 'bright young thing' prepares to drive a train. (3) Volunteers await tours of duty as bus or train crews. (4) A student conductor helps run a London bus.

Der Generalstreik

1926 verkündete der britische Premier Stanley Baldwin: »Jeder Arbeiter dieses Landes wird Minderungen seines Einkommens hinnehmen müssen.« Die Zechenbesitzer zögerten nicht lange und kürzten die Löhne der Bergarbeiter. Die Bergleute traten in Streik, und die Eisenbahner und Transportarbeiter schlossen sich an; neun Tage lang kam der Verkehr in Großbritannien fast ganz zum Erliegen. Wo noch Busse, Straßenbahnen

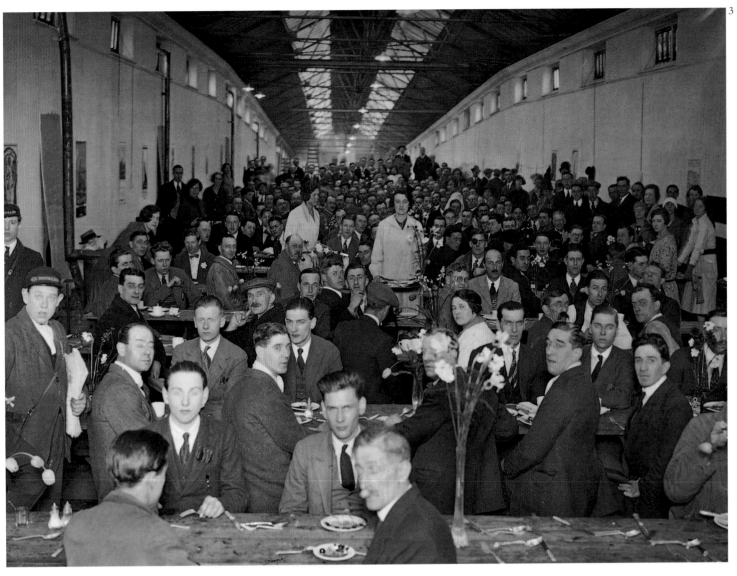

oder Züge fuhren, waren sie mit Studenten, Freiwilligen aus der Mittelschicht und einigen wenigen Streikbrechern bemannt.
(1) Studenten der Universität Oxford wurden zur Polizei verpflichtet. (2) Eine »Tochter aus gutem Hause« versucht sich als Zugführer. (3) Freiwillige warten auf den Einsatz in Bussen und Bahnen. (4) Ein Student hilft auf einem Londoner Bus als Schaffner aus.

La Grève Générale

En 1926, le Premier Ministre britannique, Stanley Baldwin, annonçait: «Tous les travailleurs de ce pays doivent accepter une réduction de salaire.» Les propriétaires de mines de charbon s'empressèrent de diminuer la paie des mineurs. Ceux-ci se mirent en grève, rejoints par les cheminots et les ouvriers du transport; la Grande-Bretagne fut presque entièrement paralysée pendant neuf jours. Les quelques bus, trams ou trains étaient conduits par des étudiants, des volontaires ou des briseurs de grève. (1) Etudiants d'Oxford en agents de police spéciaux. (2) Une «vive et jeune créature» se prépare à conduire un train. (3) Des volontaires attendent leur tour. (4) Un étudiant assure le service de contrôleur dans un bus londonien.

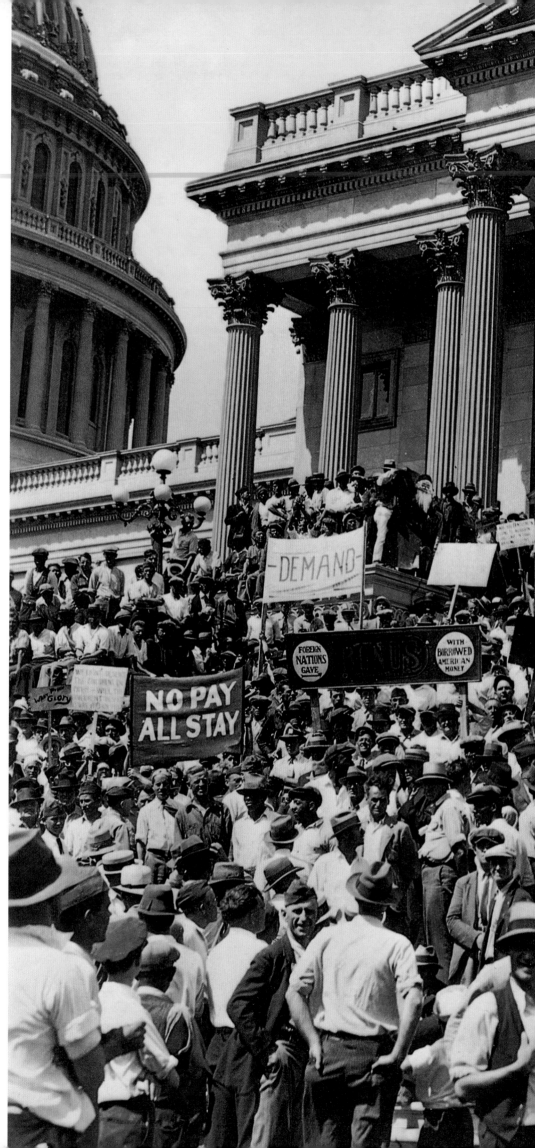

The Bonus Army

For three months in the spring and early summer of 1932, thousands of veterans of the First World War gathered in Washington DC to demand payment of a war bonus that Congress had promised them. The men became known as the 'Bonus Army', and they came from all over the United States. Each day they staged a quiet, orderly but massed vigil on the steps of the Capitol, while the Senate debated their case. A Republican Senator, Edward Eslick, died on the floor of the House while pleading the cause of the Bonus Army.

Die »Bonus Army«

Drei Monate lang im Frühjahr und Frühsommer 1932 waren Tausende amerikanischer Veteranen des Ersten Weltkriegs in Washington DC versammelt, um die Zahlung einer Entschädigung *(war bonus)* zu fordern, die der Kongreß ihnen versprochen hatte. Die Männer, die aus allen Teilen der Vereinigten Staaten zusammengekommen waren, wurden unter dem Namen *»Bonus Army«* bekannt. Tag für Tag hielten sie eine schweigende, geordnete und doch drohende Wache vor dem Kapitol ab, wo der Senat ihren Fall debattierte. Ein republikanischer Senator, Edward Eslick, brach, während er sich für die Sache der Soldaten einsetzte, am Rednerpult tot zusammen.

L'Armée de la Prime
(Bonus Army)

Entre le printemps et le début de l'été 1932, des milliers de vétérans de la Première Guerre Mondiale, venus des quatre coins du pays, se rassemblèrent à Washington DC, pour exiger le paiement d'une prime de guerre promise par le Congrès. Chaque jour, tandis que le Sénat débattait de cette revendication, l'«Armée de la Prime» – comme on la surnomma par la suite –, organisa, dans le calme et la dignité, des veillées massives sur les marches du Capitole. Le sénateur républicain Edward Eslick mourut à la Chambre en plaidant la cause de l'Armée de la Prime.

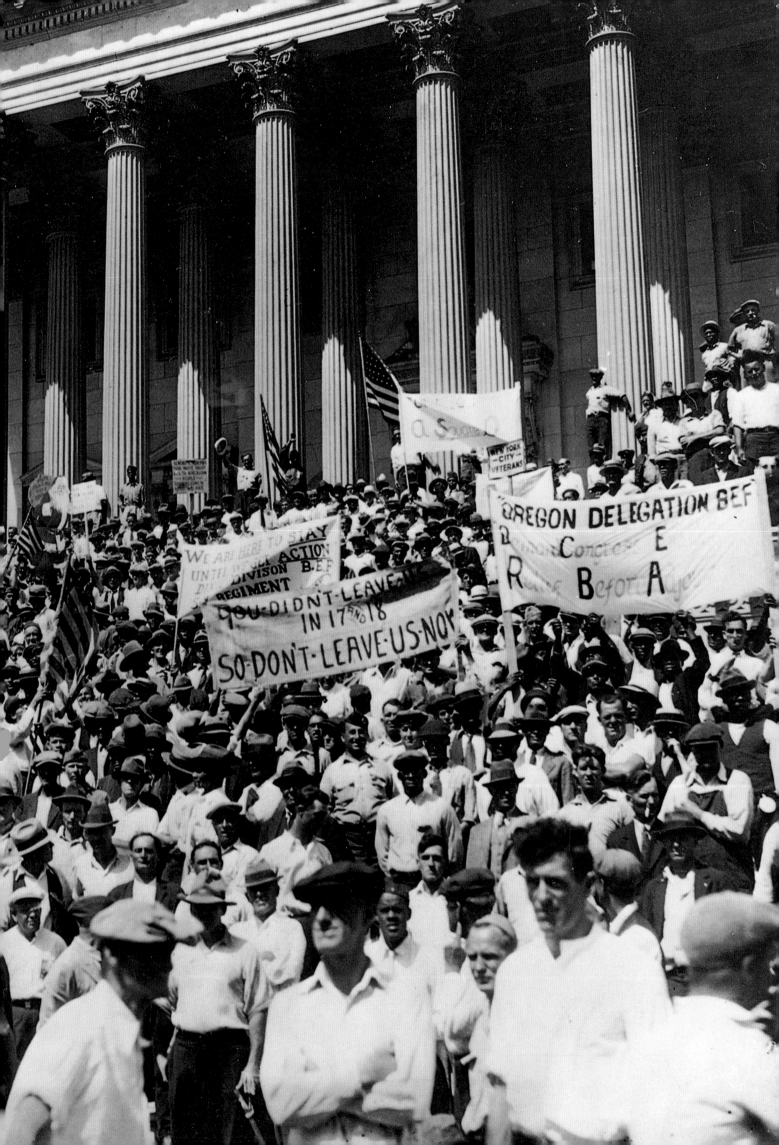

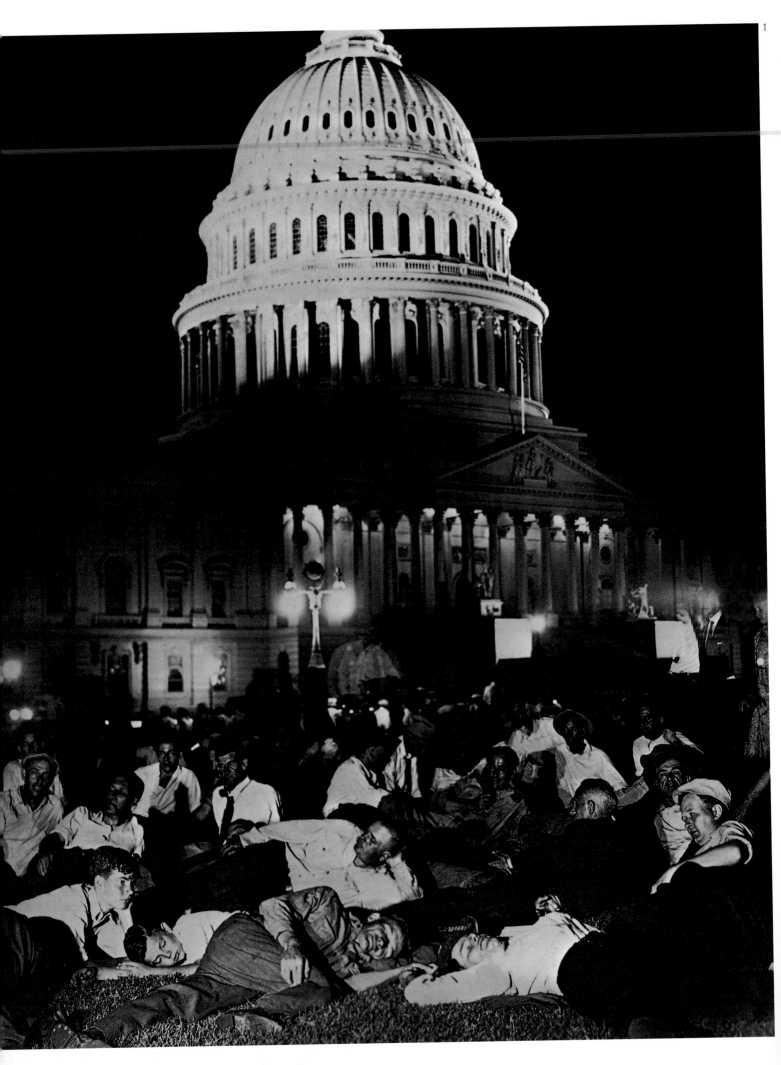

116 *Uneasy Peace*

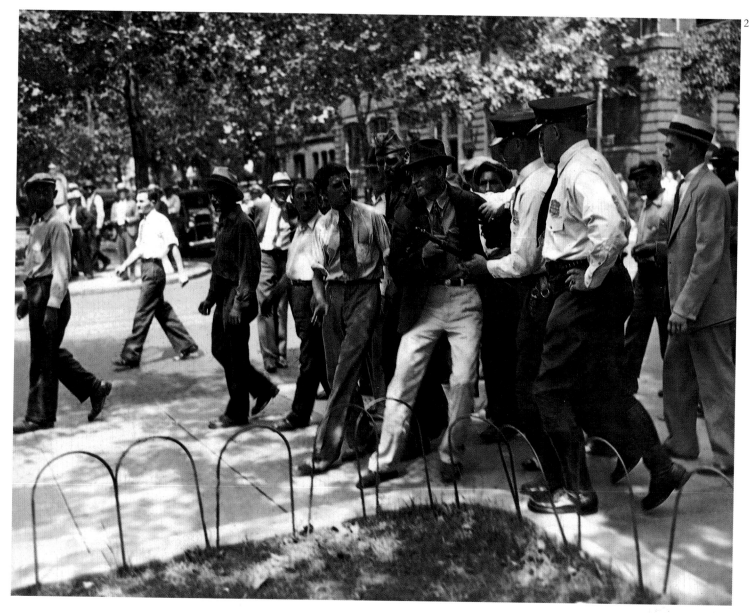

The End of the Bonus Army

(1) Night after night, the Bonus Army camped on the lawns of the Capitol. Finally, President Hoover ordered federal troops to evict them, blaming Communist infiltration. (2) John Page, the leader, was arrested and charged with parading without a permit. The troops were commanded by Generals Douglas MacArthur (3, on left) and Dwight D. Eisenhower.

Das Ende der *Bonus Army*

(1) Nacht für Nacht kampierte die *Bonus Army* auf dem Rasen des Kapitols. Das Ende kam schnell und überraschend. Unter dem Vorwand, sie seien mit Kommunisten infiltriert, ließ Präsident Hoover Bundestruppen kommen, die sie vertrieben. (2) Der Anführer John Page wurde verhaftet und des unerlaubten Aufmarschs angeklagt. Die Bundestruppen standen unter dem Kommando von General Douglas MacArthur (3, links) und Dwight D. Eisenhower.

La fin de l'Armée de la Prime

(1) Nuit après nuit, l'Armée de la Prime campait sur les pelouses du Capitole. Le dénouement fut rapide. Prétextant une infiltration communiste, le président Hoover ordonna aux troupes fédérales de les chasser. (2) L'armée manifestant sans autorisation, son chef, John Page, fut arrêté. Les troupes étaient sous les ordres des généraux Douglas MacArthur (3, sur la gauche) et Dwight D. Eisenhower.

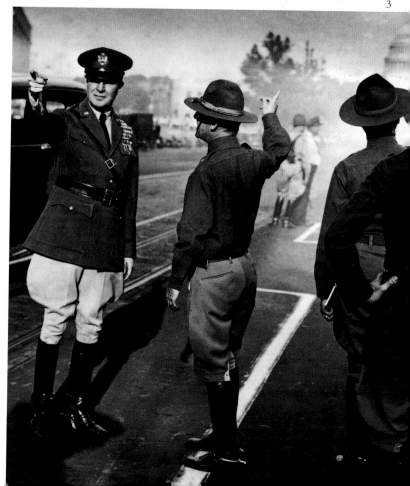

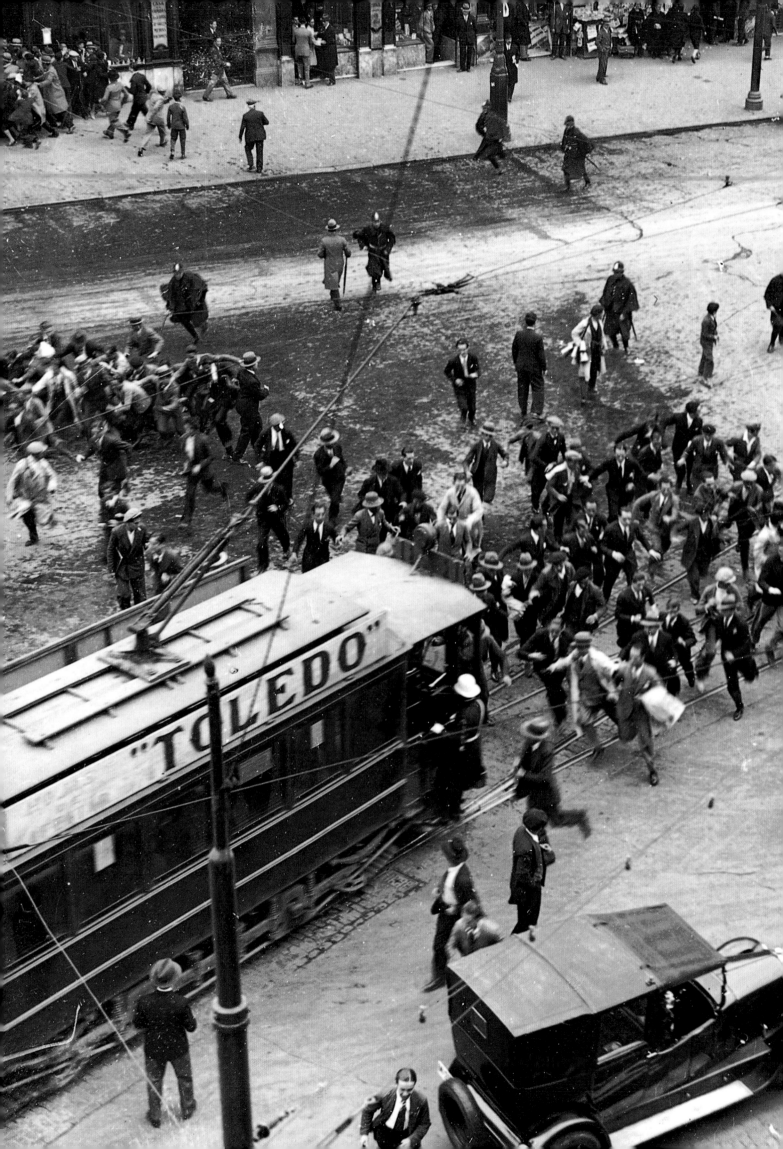

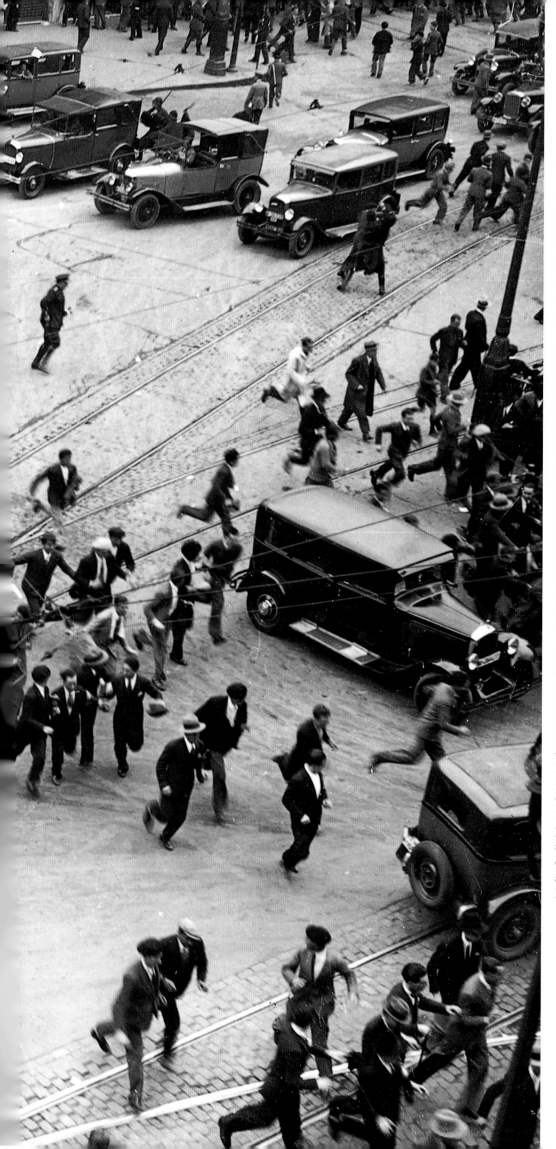

Spain in the 1930s

In April 1931 the Spanish Republic came into being, following the collapse of the right-wing military government of Primo de Rivera and the rapid departure by night of King Alfonso XIII. The Republicans won an enormous victory in the elections for the Cortes, and crowds burst excitedly onto the streets as the results were announced. A hint of the nightmare that was to come for Spain can be seen in the actions of the uniformed police in this picture. The old order of control in Spain was not going to give up without a struggle.

Spanien in den 30er Jahren

Im April 1931 schlug nach dem Zusammenbruch der rechtsgerichteten Militärregierung Primo de Rivera und der eiligen nächtlichen Abreise König Alfonsos XIII. die Geburtsstunde der spanischen Republik. In den Wahlen zur Cortes konnten die Republikaner einen überwältigenden Sieg verbuchen, und überall liefen die Menschen begeistert auf die Straße, als die Ergebnisse verkündet wurden. Eine erste Ahnung der Greuel, die kommen sollten, vermittelt dieses Bild mit seinen uniformierten Polizisten. Die alten Kräfte Spaniens würden nicht kampflos aufgeben.

L'Espagne dans les années 30

En avril 1931, la proclamation de la République espagnole suivait l'effondrement du gouvernement militaire de droite dirigé par Primo de Rivera et la fuite nocturne du roi Alfonso XIII. Les Républicains remportèrent une victoire sans précédent aux élections des Cortes, et le peuple en liesse descendit dans la rue pour fêter les résultats. Cependant, la présence de policiers en uniforme sur la photo annonce le cauchemar qui attendait l'Espagne – l'ordre ancien n'abandonnerait pas sans lutter.

Muslim refugees swarm over a train about to leave Delhi for Pakistan in the first two weeks of independence. To stay meant risking death. 'They got their Pakistan,' said one Hindu, 'now let them go to it.'

In den ersten zwei Wochen nach der Unabhängigkeit drängen sich in Delhi Muslims in Scharen auf einen Zug nach Pakistan. Bleiben hieß den Tod riskieren. »Sie haben ihr Pakistan, jetzt laßt sie dahin gehen«, meinte ein Hindu.

A Delhi, dans les deux semaines qui suivent l'indépendance, des réfugiés musulmans prennent d'assaut un train en partance pour le Pakistan. Rester pouvait signifier la mort. «Ils ont eu leur Pakistan» dit un Hindou, «maintenant qu'ils partent.»

Lowering the Flag

For four centuries the European powers plundered, invaded and annexed the rest of the world. They took spices from the East, slaves from Africa, tea from India, cotton from the Americas, sugar from the West Indies and gold from wherever it could be wrested from the ground. The Portuguese began the contest, searching Asia for ivory, cinnamon and precious stones. The Spanish, Dutch, French and British were quick to join in, scouring the coastlines of Africa and India, eager for trade, though piracy is perhaps a more accurate word.

Once Columbus and the Conquistadors had discovered the whole new world of the Americas in the early 16th century, the contest changed character. Traders became settlers, settlers became colonists. The European powers discovered that there was more profit to be made by harnessing the labour of the native populations, and taking back any wages they earned by selling them European manufactured goods. In trade terms, the imperialists had hit the jackpot. It was now simply a question of guarding what had been seized against the depredations of any and every imperial rival. When the dust and smoke of the Napoleonic wars settled, it was apparent that the British sat in control of India, the southern tip of Africa, most of the West Indies, Canada, New Zealand and Australia; the Spanish held much of central and southern America; the Dutch had the East Indies; the French had north Africa and parts of south-east Asia; and that the Portuguese had very little left.

But there was still the vast interior of Africa to be grabbed. In the late 19th century Britain, France, Germany, Italy and Belgium sent boats steaming up the great rivers of the Dark Continent: the Nile, the Niger, the Congo, the Zambezi. At first the white pioneers encountered trouble only from the indigenous population, the Zulus, the Matabele, the Sudanese. But by the late 1890s the Europeans were bumping into each other, hauling down each other's sun-faded flags from outpost and fortress, making shows of strength and threatening to turn confrontation into conflict.

The First World War sorted out many of these problems, and for the first half of the 20th century the map of the world – apart from some temporary re-drafting in Europe – remained set in its red, yellow and blue imperial colours.

But everywhere there was thunderous unrest. India was one of the first to break free from servitude. Stalin had long thought it was ridiculous that 'a few hundred Englishmen should dominate India'. By the 1940s the Quit India Movement was irresistible. Lord Mountbatten, the last Viceroy, was sent out with orders to hand India to the Indians: 'We have come to make it over to you,' he told Gandhi.

South Africa went next, brusquely asserting its independence from Britain. Then, in rapid succession, came the Suez Crisis, the *Enosis* movement in Cyprus, the French débâcle in Indo-China, and freedom fighting in Aden, Malay and Algeria. By 1960 even conservatives among the British admitted that the days of imperial glory were over. And so, in time, the Congo, Kenya, Tunisia, French Guinea, Togoland Madagascar, Ghana, Zimbabwe, Chad, the Central African Republic, Dahomey, Nigeria, Upper Volta, Katanga and dozens of other countries became independent.

The birth pangs of many of the new republics were long and painful. The terrorist struggles that preceded independence were often immediately superseded by civil war. But it is difficult to see how the process could have been avoided or altered – perhaps it could only have been accelerated.

When Gandhi visited England in 1930, he was just halfway down the gangway from his ship in Southampton when a reporter asked him: 'Mr Gandhi, what do you think of modern civilization?' And Gandhi replied: 'That would be a good idea.'

Vier Jahrhunderte lang plünderten, überfielen und besetzten die europäischen Mächte den Rest der Welt. Sie holten Gewürze aus dem Fernen Osten, Sklaven aus Afrika Tee aus Indien, Baumwolle aus Amerika, Zucker aus Westindien und Gold aus allen Ländern, deren Boden es hergab Den Auftakt zu diesem Wettstreit machten die Portugiesen, die in Asien nach Elfenbein, Zimt und Edelsteinen suchten. Doch schon bald beteiligten sich auch die Spanier, Niederländer, Franzosen und Briten an den Streifzügen durch die Küstengebiete Afrikas und Indiens, fieberhaft auf der Suche nach Handelsmöglichkeiten, obwohl Piraterie vielleicht wohl das treffendere Wort wäre.

Nachdem Kolumbus und die Conquistadores zu Beginn des 16. Jahrhunderts die Neue Welt, also Nord- und Südamerika, entdeckt hatten, erfuhr dieser Wettstreit eine Wandlung. Aus Händlern wurden Siedler, aus Siedlern Kolonialherren. Den europäischen Mächten kam die Erkenntnis, daß sie mehr Profit machen konnten, wenn sie die Arbeitskraft der Einheimischen für sich einspannten und sich den Lohn, den sie ihnen womöglich zahlten, zurückholten, indem sie ihnen Waren aus europäischer Manufaktur verkauften. Was den Handel anging, hatten die Imperialisten das große Los gezogen. Nun ging es nur noch darum, das Gewonnene gegen die Raubzüge aller imperialistischen Rivalen zu schützen. Als sich der Staub und Rauch der napoleonischen Kriege gelegt hatten, zeigte sich, daß die Briten die Herrschaft über Indien, die Südspitze Afrikas, den größten Teil der Westindischen Inseln, Kanada, Neuseeland und Australien besaßen; die Spanier beherrschten den größten Teil Mittel- und Süd-

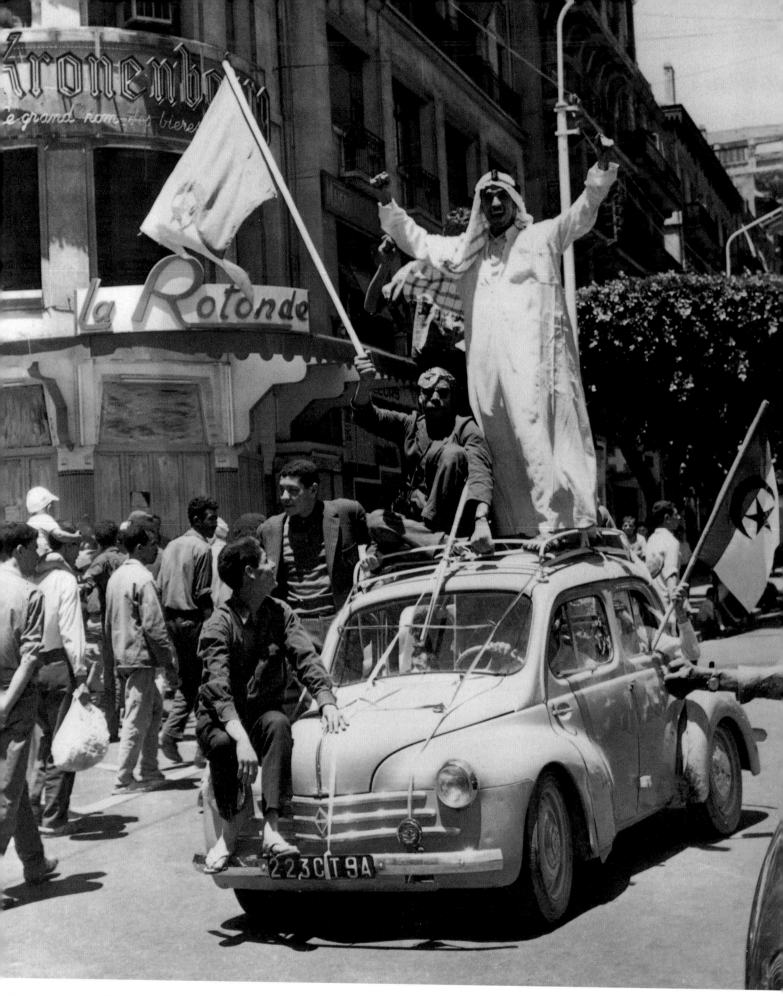

Muslims celebrate Algerian independence and the formation of Ben Khedda's provisional government in the summer of 1962.

Im Sommer 1962 feiern Muslims die Unabhängigkeit Algeriens und die Bildung der provisorischen Regierung Ben Kheddas.

Au cours de l'été 1962, des musulmans célèbrent l'indépendance de l'Algérie ainsi que la formation du gouvernement provisoire de Ben Khedda.

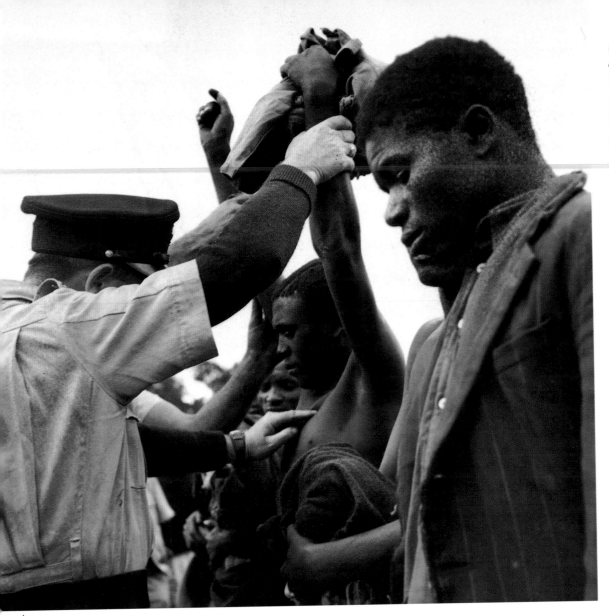

(1) British police in Kenya examine suspects for the seven initiation cuts on the body that marked a member of the Mau Mau terrorist organisation, 1952. (2) Africans demonstrate in Dar Es Salaam against American aid to the Tshombe regime in the Congo, August 1964.

(1) Britische Polizisten in Kenia untersuchen Verdächtige auf die sieben Einschnitte in der Haut, das Erkennungszeichen der Mitglieder der terroristischen Mau-Mau-Bewegung, 1952. (2) Afrikaner demonstieren in Daressalam gegen die amerikanische Unterstützung für das Tschombé-Regime im Kongo, August 1964.

(1) Au Kenya, la police britannique recherche sur le corps de suspects les sept incisions caractéristiques de l'initiation des membres de l'organisation terroriste Mau-Mau. (2) Août 1964: des manifestants africains protestent à Dar Es-Salaam contre l'aide américaine au régime Tchombé au Congo.

1

amerikas; die Niederländer besaßen Ostindien; die Franzosen hatten Nordafrika und Teile Südostasiens; und den Portugiesen war nur sehr wenig geblieben.

Nach wie vor galt es jedoch, das weite Binnenland Afrikas zu erobern. Ende des 19. Jahrhunderts sandten Großbritannien, Frankreich, Deutschland, Italien und Belgien Dampfschiffe die großen Flußläufe des Schwarzen Kontinents stromaufwärts: auf den Nil, den Niger, den Kongo, den Sambesi. Anfangs stießen die weißen Pioniere lediglich auf den Widerstand der Ureinwohner, der Zulu, der Matabele, der Sudanesen. Doch um die Jahrhundertwende kam es zu Zusammenstößen zwischen den Europäern, die sich gegenseitig die sonnengebleichten Flaggen von vorgeschobenen Stützpunkten und Festungen holten, ihre Stärke demonstrierten und drohten, die Konfrontation in einen offenen Konflikt umschlagen zu lassen.

Viele dieser Probleme löste der Erste Weltkrieg; so behielt die Weltkarte während der ersten Hälfte des 20. Jahrhunderts ihre Einteilung in die jeweiligen Landesfarben der Weltmächte weitgehend bei, abgesehen von vorübergehenden Grenzverschiebungen innerhalb Europas.

Überall wurde jedoch schwelende Unruhe laut. Als erstes befreite sich Indien aus der Knechtschaft. Schon lange hatte Stalin gemeint, daß die Herrschaft einiger hundert Engländer über Indien lächerlich sei. In den vierziger Jahren unseres Jahrhunderts war die Unabhängigkeitsbewegung *Quit India Movement* nicht mehr aufzuhalten. Lord Mountbatten, der letzte Vizekönig, erhielt den Auftrag, Indien an die Inder zu übergeben: »Wir sind gekommen, es Ihnen zu übertragen«, erklärte er Gandhi.

Als nächstes erklärte Südafrika schroff seine Unabhängigkeit von Großbritannien. In rascher Folge kam es zur Suez-Krise, zur *Enosis*-Bewegung auf Zypern, zum französischen Debakel in Indochina und zu Freiheitskämpfen in Aden, Malaya und Algerien. Zu Beginn der sechziger Jahre räumten selbst konservative Briten ein, daß die glorreichen Tage des *British Empire* zu Ende waren. Und so erlangten mit der Zeit der Kongo, Kenia, Tunesien, Französisch Guinea, Togo, Madagaskar, Ghana, Simbabwe, Tschad, die Republik Zentralafrika, Dahomey, Nigeria, Obervolta, Katanga und Dutzende anderer Länder ihre Unabhängigkeit.

Viele der neuen Republiken mußten langwierige und schmerzhafte Geburtswehen durchmachen. Oft gingen die Freiheitskämpfe, die der Unabhängigkeit vorausgingen, nahtlos in einen Bürgerkrieg über. Man kann sich allerdings nur schwer vorstellen, wie man diesen Prozeß hätte vermeiden oder ändern können – vielleicht hätte man ihn lediglich beschleunigen können.

Als Gandhi 1930 bei seinem Englandbesuch die Gangway seines Schiffes in Southampton zur Hälfte überschritten hatte, fragte ihn ein Reporter: »Mr. Gandhi, was halten Sie von der modernen Zivilisation?« Gandhi antwortete: »Das wäre eine gute Idee.«

Quatre siècles durant, les puissance européennes pillèrent, envahirent et annexèrent le reste du monde. Elles prirent les épices de l'Orient, les esclaves d'Afrique, le thé de l'Inde, le coton d'Amérique, le sucre des Antilles et l'or de toutes les régions qui en recelaient. Les Portugais amorcèrent le mouvement en important d'Asie l'ivoire, la cannelle et les pierres précieuses. Prompts à suivre, les Espagnols, les Hollandais, les Français et les Anglais écumèrent les côtes africaines, avides de commerces – «pillages» serait sans doute ici plus approprié – en tout genre.

Après la découverte du Nouveau Monde par Christophe Colomb et les Conquistadors, les conquêtes prirent un sens différent. Les marchands devinrent des colons, les colons des colonisateurs. Les Européens surent rapidement tirer profit des indigènes: ils exploitaient leur travail et récupéraient leurs salaires en leur vendant les produits manufacturés qu'ils importaient. En termes commerciaux, les impérialistes avaient touché le jackpot. Il ne s'agissait pas seulement de protéger de la convoitise des rivaux impérialistes ce qui avait été conquis. Lorsque s'apaisa enfin le fracas des guerres napoléoniennes, il apparut alors que les Britanniques contrôlaient l'Inde, la pointe sud de l'Afrique, la plupart des Antilles, le Canada, la Nouvelle-Zélande et l'Australie; que les Espagnols possédaient une grande partie de l'Amérique Centrale et du Sud; que les Hollandais détenaient les Indes Orientales et les Français le nord de l'Afrique ainsi que certaines régions du Sud-Est asiatique; qu'enfin, il ne restait pas grand-chose aux Portugais.

Cependant, les vastes terres intérieures de l'Afrique s'offraient encore à la convoitise. A la fin du 19ᵉ siècle, la Grande-Bretagne, la France, l'Allemagne, l'Italie et la Belgique envoyèrent leurs navires sur les grands fleuves du continent noir: le Nil, le Niger, le Congo, le Zambèze. D'abord occupés à combattre les peuples indigènes, Zoulous, Matabélé et Soudanais, les Européens en vinrent dès la fin des années 1890 à s'affronter entre eux – les drapeaux décolorés par le soleil valsèrent alors au sommet des avant-postes ou des forts au rythme des escarmouches qui menacèrent de dégénérer en véritable conflit.

La Première Guerre Mondiale permit de résoudre nombre de problèmes, et dans la première moitié du 20ᵉ siècle, la carte du monde – en dehors de quelques modifications temporaires en Europe – conserva ses couleurs impériales rouge, jaune et bleu.

La révolte pourtant commençait à gronder un peu partout. L'Inde fut la première à secouer le joug de la servitude. Longtemps, Staline trouva ridicule que «quelques centaines d'Anglais puissent dominer l'Inde». Les années 1940 furent dominées par le *Quit India Movement* (Campagne «Quit India»). Lord Mountbatten, le dernier vice-roi, fut envoyé avec pour mission de restituer l'Inde aux Indiens: «Nous sommes venus pour vous la rendre» déclara-t-il à Gandhi.

Puis ce fut au tour de l'Afrique du Sud, qui s'émancipa brutalement de la domination anglaise. Les événements s'enchaînèrent rapidement: la crise de Suez, le mouvement *Enosis* à Chypre, la débâcle française en Indochine, les luttes de libération à Aden, en Malaisie et en Algérie. En 1960, les conservateurs britanniques eux-mêmes reconnaissaient que les jours de gloire de l'impérialisme étaient passés. Ainsi, l'un après l'autre, le Congo, le Kenya, la Tunisie, la Guinée française, le Togo, Madagascar, le Ghana, le Zimbabwe, le Tchad, la République de Centre-Afrique, le Dahomey, le Nigeria, la Haute-Volta, le Katanga et des douzaines d'autres pays, affirmèrent leur indépendance.

L'avènement de nombre de ces nouvelles républiques fut long et douloureux. Aux luttes terroristes pour l'indépendance succédait souvent presque immédiatement la guerre civile. Il est néanmoins difficile d'imaginer qu'un tel processus ait pu être évité ou modifié – sans doute aurait-il pu être accéléré.

Arrivant à Southampton pour une visite en Angleterre en 1930, Gandhi se trouvait à peine à mi-chemin de la passerelle du navire qu'un journaliste lui demanda: «M. Gandhi, que pensez-vous de la civilisation moderne?» Gandhi répliqua: «Ce serait une bonne idée.»

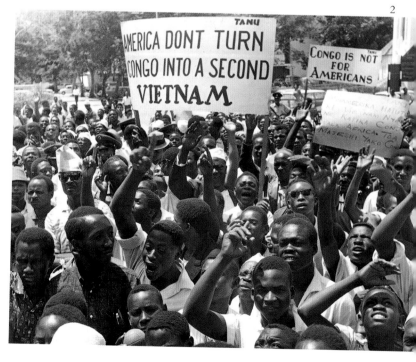

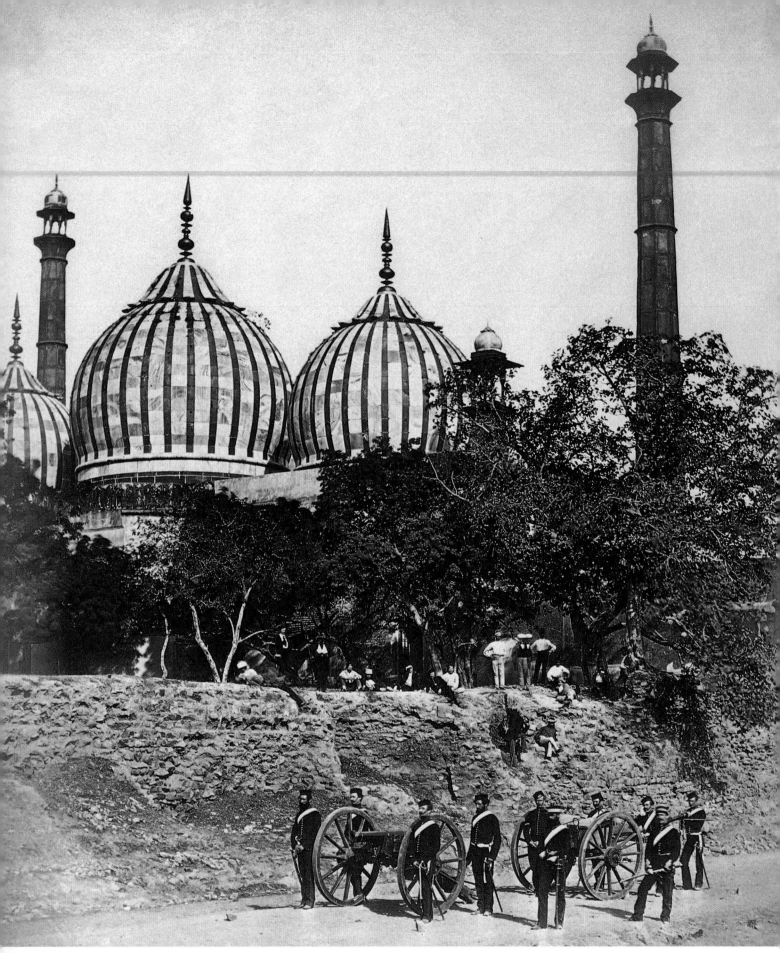

The Indian Mutiny

The mutiny began in Delhi on 11 May 1857, when a crowd invaded the palace of Bahadur Shah Zafur and implored him to lead them against the British. (1) To the Muslims who worshipped at the Khynabee Gate Mosque, Bahadur was the true ruler of all India. His boat in the shape of a fish (2) was kept on the banks of the river Jumna. (3) One of the first cities to follow Delhi's mutinous example was Lucknow. When Sir Colin Campbell lifted the siege of the city, mutineers exploded mines to destroy the Chuttra Munzil Palace.

Aufstand in Indien

Der Aufstand brach am 11. Mai 1857 in Delhi aus, als eine Menschenmenge in den Palast des Bahadur Shah Zafur eindrang und ihn ersuchte, sie gegen die Briten zu führen. (1) Für die Muslime, die die Khynabee-Gate-Moschee besuchten, war Bahadur der wahre Herrscher ganz Indiens. Sein Schiff in Form

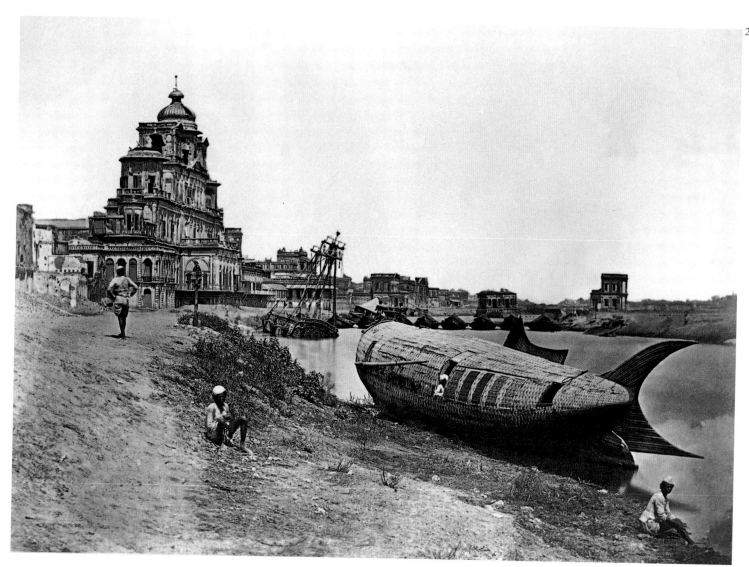

eines Fisches (2) lag am Ufer des Flusses Jumna. (3) Als eine der ersten Städte folgte Lucknow dem Beispiel des Aufstandes von Delhi. Als Sir Colin Campbell die Belagerung der Stadt aufhob, sprengten Aufständische den Chuttra-Munzil-Palast.

La Mutinerie Indienne

Le 11 mai 1857 à Delhi, une foule envahit le palais de Bahadur Shah Zafur pour le supplier de mener la lutte contre les Anglais, marquant le début de la mutinerie. (1) Pour les Musulmans qui accomplissaient leurs dévotions à la mosquée de Khynabee Gate, Bahadur représentait le souverain légitime de l'Inde. Son bateau en forme de poisson (2) était amarré sur les berges de la rivière Jumna. (3) Lucknow fut l'une des premières villes à suivre l'exemple de la mutinerie de Delhi. Lorsque Sir Colin Campbell leva le siège de la ville, les mutinés firent exploser des mines qui détruisirent le palais de Chuttra Munzil.

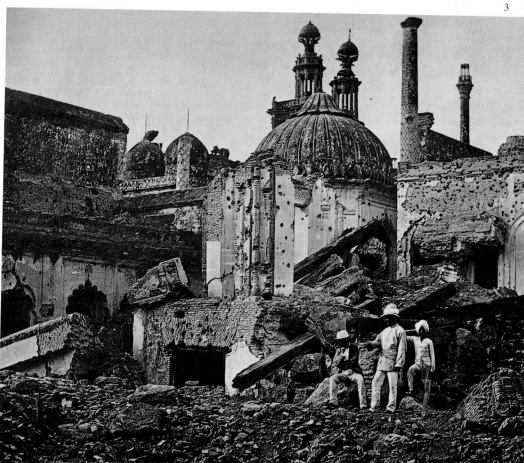

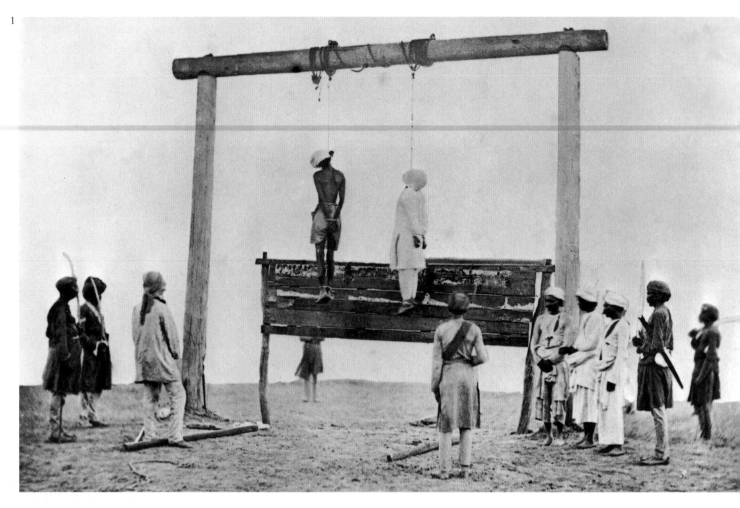

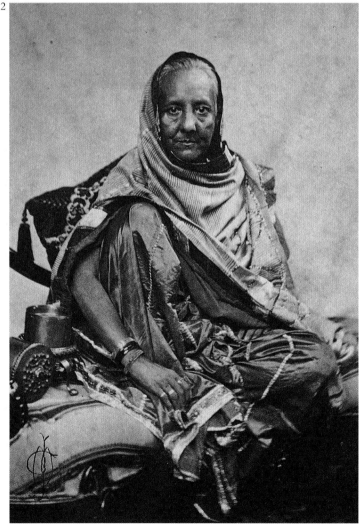

The End of the Mutiny

It was a struggle in which the British and the mutineers traded atrocities. (1) When the mutiny was finally crushed in 1859, many of the mutineers were hanged, or in some cases strapped to the mouths of cannons and blown to pieces. Bahadur, tried for rebellion, was described by his prosecuting counsel as 'a shrivelled impersonation of malignity'. He and his wives, among them the Queen of Delhi (2), were exiled to Rangoon. (3) Among the fiercest fighters in the Indian Army, the Sikhs remained loyal to the British.

Das Endes des Aufstandes

Auf seiten der Briten wie auch der Aufständischen kam es bei diesem Kampf zu Grausamkeiten. (1) Nach der endgültigen Niederschlagung des Aufstandes 1859 wurden viele Aufständische gehenkt oder in einigen Fällen vor eine Kanonenmündung gebunden und zerfetzt. Bahadur wurde wegen Rebellion vor Gericht gestellt und vom Vertreter der Anklage als »verkümmerte Verkörperung des Bösen« bezeichnet. Man verbannte ihn und seine Frauen, unter ihnen auch die Mogulin von Delhi (2), nach Rangun. (3) Die Sikhs, die zu den erbittertsten Kämpfern in der indischen Armee gehörten, hielten den Briten die Treue.

La fin de la mutinerie

Au cours de cette lutte, les Anglais et les insurgés firent assaut d'atrocités. (1) En 1859, la mutinerie fut finalement écrasée, et de nombreux rebelles furent pendus ou, dans certains cas, attachés sur la bouche des canons et déchiquetés. Qualifié par l'accusation de «caricature flétrie de la malfaisance», Bahadur fut jugé pour trahison et exilé, en compagnie de ses femmes, dont la reine de Delhi (2), à Rangoon. (3) Combattants d'une rare férocité, les Sikhs demeurèrent fidèles aux Britanniques.

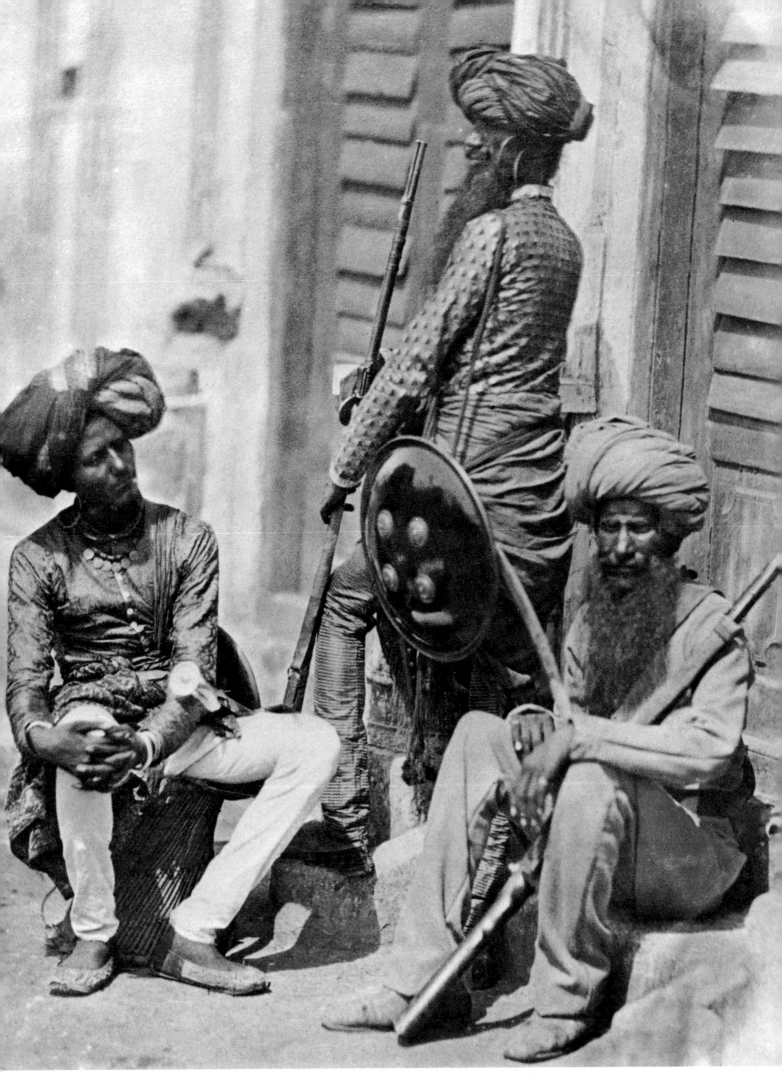

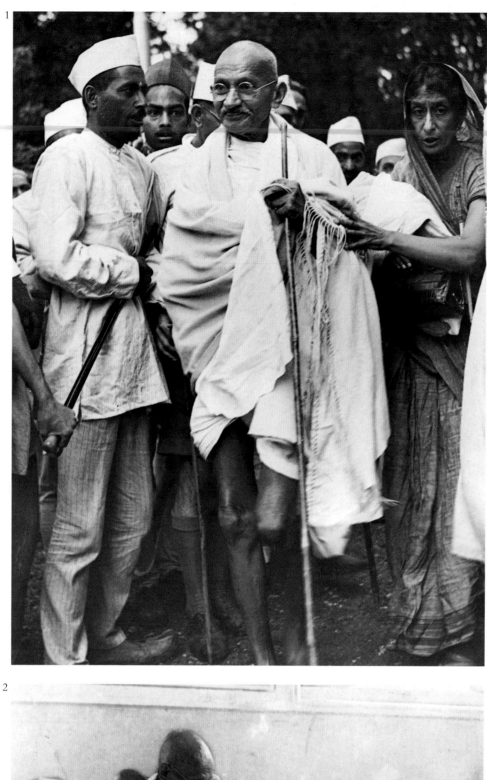

Gandhi

Mahatma Gandhi as a young man had served with the British Army. He regarded it as his mission to free India from the British, and several times fasted (2) in protest against British rule. He had so much influence that it became virtually impossible for the British to act without consulting him. (1) In 1939 he was invited to Simla for talks with the Viceroy. Gandhi visited England in 1931, where he met Charlie Chaplin and Bernard Shaw, and took tea with King George V and Queen Mary. (3) Here, in humbler

surroundings, he is talking with women in Darwen, Lancashire.

Gandhi

Mahatma Gandhi hatte als junger Mann in der britischen Armee gedient. Er sah es als seine Mission an, Indien von den Briten zu befreien, und trat mehrmals aus Protest gegen die britische Herrschaft in den Hungerstreik (2). Sein Einfluß war so groß, daß es den Briten fast unmöglich wurde, etwas zu tun, ohne ihn zu konsultieren. (1) 1939 lud man ihn nach Simla zu

Gesprächen mit dem Vizekönig ein. Gandhi besuchte 1931 England, wo er mit Charlie Chaplin und Bernard Shaw zusammentraf und mit König George V. und Queen Mary Tee trank. (3) Hier spricht er in bescheidenerer Umgebung mit Frauen in Darwen, Lancashire.

Gandhi

Jeune homme, le Mahatma Gandhi avait servi dans l'armée britannique. Considérant qu'il avait pour mission de libérer l'Inde, il manifesta, par de nombreux jeûnes, (2) son

opposition à la domination anglaise. Son influence était telle qu'il devint de fait impossible aux Anglais d'agir sans le consulter. (1) En 1939, il eut une entrevue avec le vice-roi à Simla. En 1931, il se rendit en Angleterre où il rencontra Charlie Chaplin et Bernard Shaw, et prit le thé en compagnie du roi George V et de la reine Mary. (3) Il converse ici avec des femmes d'un quartier très modeste à Darwen, dans le Lancashire.

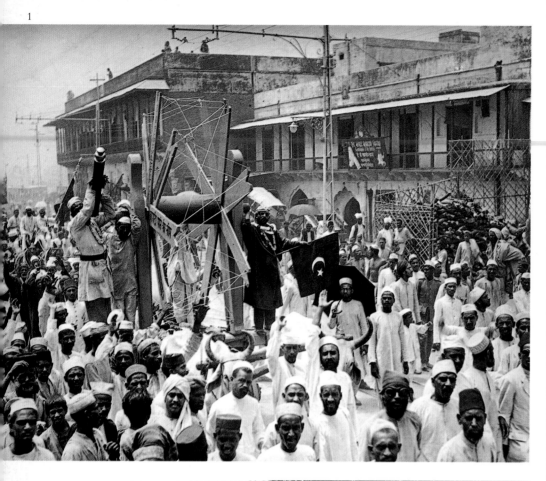

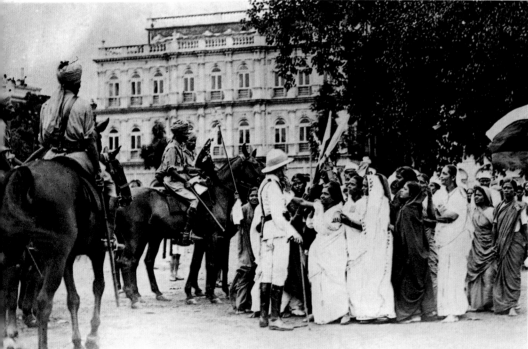

The followers of Gandhi

The strength of Gandhi was his ability to present politics in a way that the masses could understand, through symbols: symbolic marches, protests and images. (1) In July 1922, marchers protesting at Gandhi's imprisonment carried a spinning wheel representing the village economy of India. (2) In July 1930 the police broke up a meeting of the National Militia of the Congress Party in Bombay. At this time, over 100,000 Indian patriots – including Nehru and Gandhi – were in prison. 'May I congratulate you,' wrote Nehru to Gandhi, 'on the new India you have created by your magic touch?' (3) Protesting shop owners and workers, carrying placards reading 'Wreck this Slave Constitution'.

Die Anhänger Gandhis

Gandhis Stärke lag in seiner Fähigkeit, der Masse Politik verständlich nahezubringen, nämlich in Symbolen: symbolischen Demonstrationen, Protesten und Bildern. (1) Im Juli 1922 trugen Demonstranten, die gegen Gandhis Inhaftierung protestierten, ein Spinnrad als Symbol für die dörflichen Wirtschaftsstrukturen Indiens. (2) Im Juli 1930 löste die Polizei eine Versammlung der Nationalmiliz der Kongreßpartei in Bombay

auf. Damals waren über hunderttausend indische Patrioten im Gefängnis, unter ihnen auch Nehru und Gandhi. »Darf ich Ihnen zu dem neuen Indien gratulieren, das Ihr Charisma geschaffen hat,« schrieb Nehru an Gandhi. (3) Protestierende Ladenbesitzer und Arbeiter tragen Plakate mit der Aufschrift »Nieder mit der Sklavenverfassung«.

Les disciples de Gandhi

La force de Gandhi résidait dans sa capacité à présenter la politique en des termes compréhensibles pour les masses. Il recourait aux symboles: marches, actions de protestations, images emblématiques. (1) En juillet 1922, les manifestants qui protestaient contre l'incarcération de Gandhi apportèrent un rouet qui incarnait l'économie villageoise de l'Inde. (2) En juillet 1930, la police dispersa un meeting de la Milice Nationale du Parti du Congrès à Bombay. A l'époque, plus de 100 000 patriotes indiens – dont Nehru et Gandhi – furent emprisonnés. Nehru écrivit à Gandhi: «Permettez-moi de vous féliciter de cette Inde nouvelle créée par votre charisme.» (3) Commerçants et ouvriers brandissant des affiches proclamant «Abolissez cette Constitution esclavagiste.»

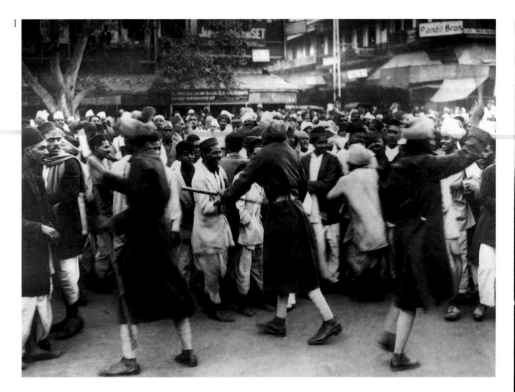

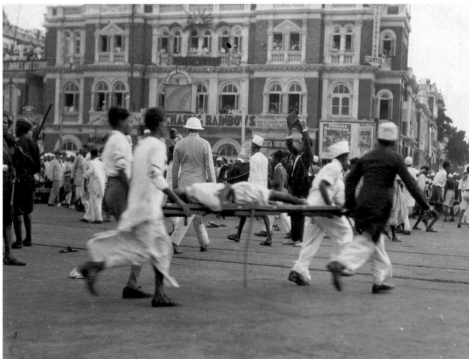

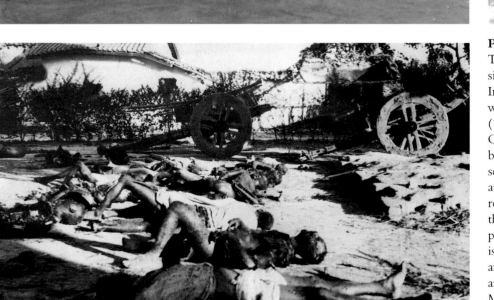

Persistent Protest

Tempers began to flare, mostly on the British side. 'I am quite satisfied with my views on India,' said Winston Churchill, 'and I don't want them disturbed by any bloody Indians.' (1, 2) Political demonstrations by the Congress Party in the 1930s were broken up by the police in Delhi and Bombay. (3) More seriously, police fired on followers of Gandhi at Chauri Chaura. According to official reports, the 'mob' retaliated by setting fire to the police station and 'throwing 21 policemen and inspectors into the fire'. This is the officially authorised photograph of the aftermath of the event. (4) In March 1931 another demonstration at the Esplanade Maidan in Bombay was broken up by police,

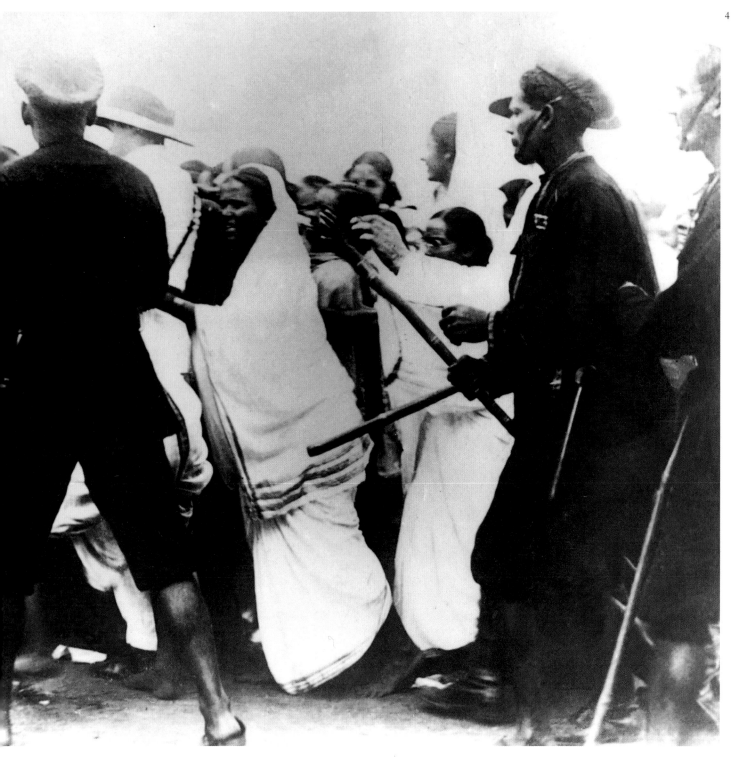

who were 'forced to charge many of the law-breakers with lathis'.

Anhaltende Proteste

Die Gemüter erhitzten sich, besonders auf britischer Seite. »Ich bin mit meinen Ansichten über Indien ganz zufrieden«, erklärte Winston Churchill, »und ich möchte darin nicht von verfluchten Indern gestört werden.« (1, 2) In den dreißiger Jahren löste die Polizei politische Demonstrationen der Kongreßpartei in Delhi und Bombay auf. (3) Die Lage spitzte sich zu, als die Polizei in Chauri Chaura auf Anhänger Gandhis schoß. Offiziellen Berichten zufolge antwortete der »Mob« darauf, indem er die Polizeistation in Brand setzte und »21 Polizisten und

Inspektoren ins Feuer warf«. Das ist das offiziell autorisierte Foto zu den Folgen des Vorfalls. (4) Im März 1931 wurde eine weitere Demonstration auf der Esplanade Maidan in Bombay von der Polizei aufgelöst, die »gezwungen war, mit eisenbeschlagenen Knüppeln gegen viele der Gesetzesbrecher vorzugehen«.

La révolte continue

Le mécontentement grandissait, surtout du côté britannique. « Je suis relativement satisfait par mes positions sur l'Inde », déclara Winston Churchill, « et ne permettrai à aucun Indien barbare de les perturber. » (1,2) Au cours des années 1930, les manifestations politiques du Parti du Congrès à Delhi et

Bombay furent dispersées par la police. (3) Plus tragiquement, les policiers ouvrirent le feu sur les disciples de Gandhi à Chauri Chaura. Selon les rapports officiels, la «populace» répliqua en incendiant un poste de police et en «jetant 21 policiers et inspecteurs dans le feu.» Voici la photographie officiellement autorisée au lendemain de l'événement. (4) En mars 1931, la police, «contrainte de charger les hors-la-loi avec des bâtons ferrés», mit fin à une autre manifestation à l'Esplanade de Maidan à Bombay.

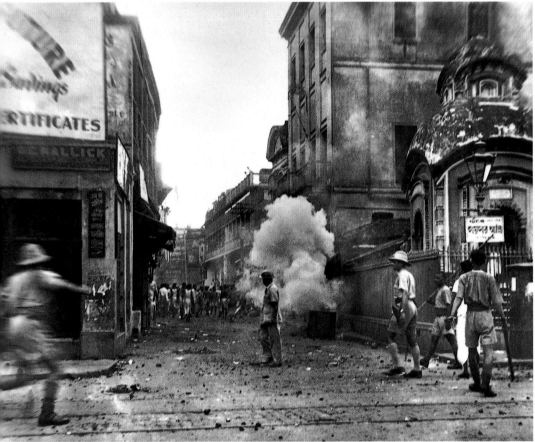

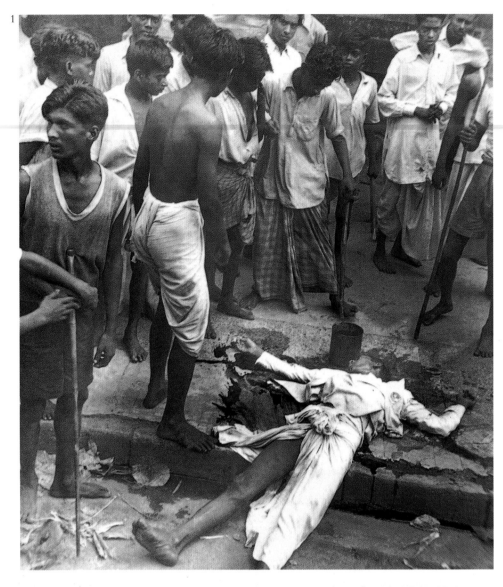

The Partition Riots

By 1946 the British Labour Government had decided that British rule in India should end quickly. It was decided to create two independent countries: India and Pakistan. But in the run-up to independence and for years afterwards, fighting flared between the two religions. (1) Muslims, armed with lathis, surround a dead Hindu. At least 2,000 people were killed in the communal riots in Calcutta in August 1946. (2) When a crowd tried to set fire to a Hindu temple, police used tear gas. (3) The following month,

looters took advantage of riots in Bombay to help themselves from shops.

Unruhen anläßlich der Teilung

1946 beschloß die britische Labour-Regierung, die britische Herrschaft in Indien zu beenden, und zwar rasch. Man beschloß, zwei unabhängige Länder zu schaffen: Indien und Pakistan. In der Vorbereitungszeit auf die Unabhängigkeit und noch Jahre danach flammten immer wieder Kämpfe zwischen den beiden Religionen auf. (1) Eine mit eisenbeschlagenen Knüppeln bewaffnete Gruppe Muslime umringt einen toten Hindu. Die Unruhen im August 1946 in Kalkutta forderten mindestens 2000 Menschenleben. (2) Als eine Menschenmenge versuchte, einen Hindu-Tempel anzuzünden, setzte die Polizei Tränengas ein. (3) In den folgenden Monaten nutzten Plünderer die Unruhen in Bombay, um sich in Geschäften selbst zu bedienen.

Les émeutes de la Partition

En 1946, le gouvernement travailliste anglais décida de mettre rapidement terme à la domination britannique en Inde. La solution consista à créer deux pays indépendants: l'Inde et le Pakistan. Cependant, le processus d'indépendance fut émaillé de combats entre les deux religions. (1) Un attroupement de musulmans armés de bambous ferrés, entourent un hindou mort. Les émeutes à Calcutta en août 1946 se soldèrent par plus de 2000 morts. (2) Pour empêcher la foule d'incendier un temple hindou, la police recourut aux gaz lacrymogènes. (3) Le mois suivant, les pilleurs profitèrent des troubles à Bombay pour dévaliser les magasins.

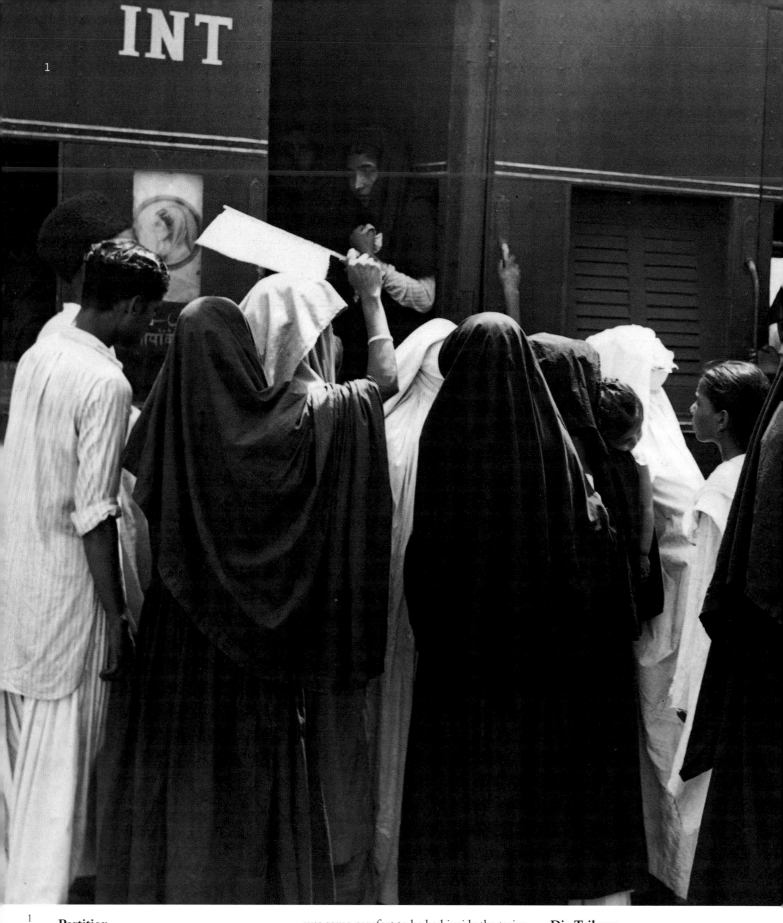

1

Partition

Gandhi had always claimed that he would rather have chaos than British rule, but he agreed with Jinnah, the Muslim leader, that partition was essential to safeguard the interests of such a divided population. And so 11 million people left their homes to join their fellow Hindus or fellow Muslims. Mostly they travelled on foot, but those that could went by rail. For the better-off, there was some comfort to be had inside the trains that rattled from Karachi to Bombay, from Calcutta to Dacca. (1) Muslim women board a train bound for Pakistan. (2) Muslim National Guards stand to attention as the train departs. (3) Muslim crowds gather at New Delhi Station.

Die Teilung

Gandhi hatte immer erklärt, ein Chaos sei ihm lieber als die britische Herrschaft, aber er war sich mit Muslimführer Jinnah einig, daß eine Teilung unausweichlich war, um die Interessen einer derart gespaltenen Bevölkerung zu schützen. Und so verließen 11 Millionen Menschen ihre Heimat, um zu ihren hinduistischen oder muslimischen Glaubensbrüdern zu ziehen. Meist machten

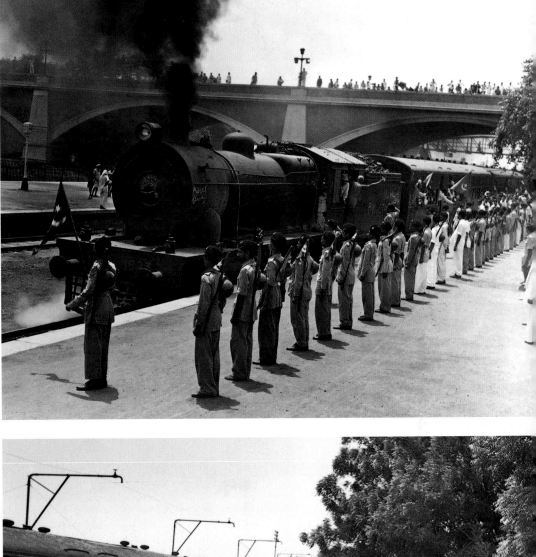

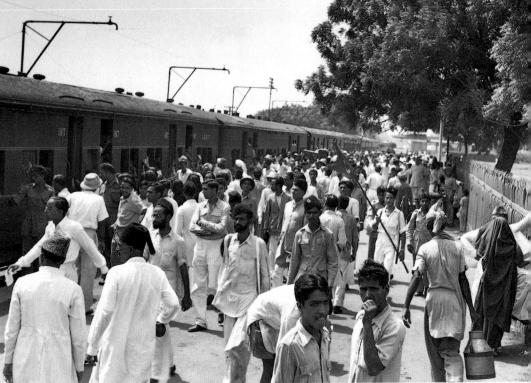

sie sich zu Fuß auf den Weg, doch wer konnte, nahm die Eisenbahn. Für die Reicheren gab es einen gewissen Komfort in den Zügen, die von Karatschi nach Bombay, von Kalkutta nach Dakka ratterten. (1) Muslimische Frauen steigen in einen Zug nach Pakistan. (2) Muslimische Nationalgardisten stehen bei Abfahrt des Zuges in Habachtstellung. (3) Muslime drängen sich in Scharen auf dem Bahnhof von Neu-Delhi.

Partition

Bien qu'ayant toujours affirmé préférer le chaos à la domination britannique, Gandhi reconnut néanmoins, en accord avec le chef musulman Jinnah, que la Partition était essentielle pour sauvegarder les intérêts d'une population si divisée. C'est ainsi que 11 millions de personnes quittèrent leur foyer pour rejoindre leurs compatriotes hindous ou musulmans. La majorité voyagea à pied, ceux qui le pouvaient empruntèrent les lignes ferroviaires. Il était plus sécurisant pour les Indiens aisés de circuler dans les trains qui reliaient en cahotant Karachi à Bombay, Calcutta à Dacca. (1) Musulmanes montant à bord d'un train en direction du Pakistan. (2) Gardes Nationaux musulmans au garde-à-vous au départ du train. (3) Foule musulmane rassemblée à la gare de New Delhi.

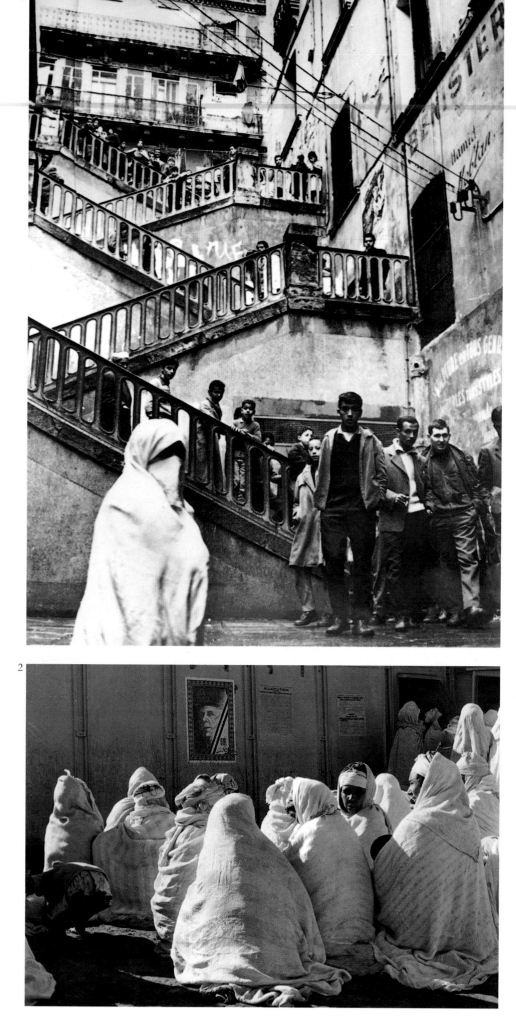

L'Algérie libre

'In all of Algeria', said de Gaulle, 'there are only Frenchmen – with the same rights and the same duties.' It wasn't what the white settlers wanted to hear. When de Gaulle visited Tizi-Ouzou in December 1960 (3), he forced his way through crowds of booing Europeans to shake hands with the Muslims. (1) After years of fighting, the French and the National Liberation Front (FLN) agreed on a ceasefire in March 1962, and the Casbah in Algiers was opened to foreigners for the first time. Three months later, 99.72 per cent of Algerians voted for independence. (2) At a

village near Tiaret, Muslim women await their turn to vote.

L'Algérie libre

»In ganz Algerien gibt es nur Franzosen mit denselben Rechten und Pflichten«, erklärte de Gaulle. Das war es nicht, was die weißen Siedler hören wollten. (3) Als de Gaulle im Dezember 1960 Tizi-Ouzou besuchte, bahnte er sich einen Weg durch die Menge der buhrufenden Europäer, um den Muslimen die Hand zu reichen. (1) Nach Jahren des Kampfes schlossen die Franzosen und die Nationale Befreiungsfront (FLN) im März 1962 einen Waffenstillstand, und zum erstenmal wurde die Kasba in Algier für Ausländer geöffnet. Drei Monate später stimmten 99,72 Prozent der Algerier in einem Referendum für die Unabhängigkeit. (2) Muslimische Frauen warten in einem Dorf bei Tiaret auf ihre Stimmabgabe.

L'Algérie libre

«Dans toute l'Algérie», déclara de Gaulle, «il n'y a que des Français – avec les mêmes droits et les mêmes devoirs». Ce n'était pas ce que les colons blancs voulaient entendre. Visitant Tizi-Ouzou en décembre 1960 (3), de Gaulle se fraya un chemin parmi la foule des Européens qui le huaient pour aller serrer les mains des musulmans. (1) Après des années de combats, les Français et le Front de Libération Nationale (FLN) s'accordèrent sur un cessez-le-feu en mars 1962, et pour la première fois, la Casbah d'Alger fut ouverte aux étrangers. Trois mois plus tard, lors du référendum, 99,72 % des Algériens choisissaient l'indépendance. (2) Dans un village près de Tiaret, des musulmanes attendent leur tour de vote.

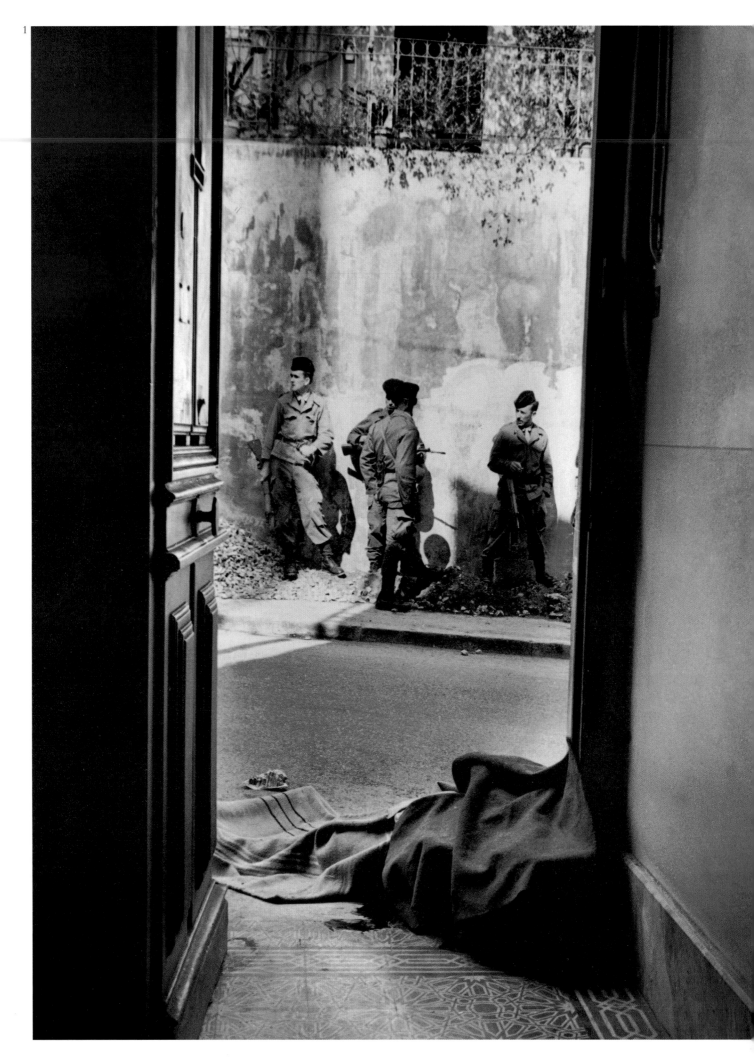

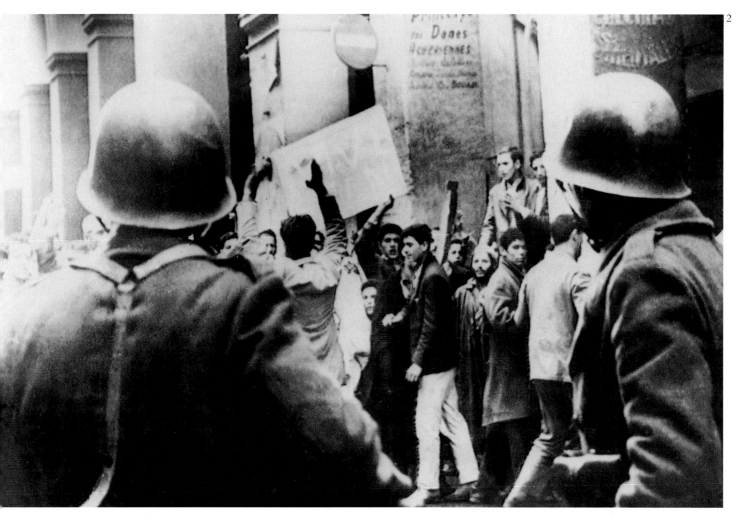

L'Algérie française

The struggle for independence had been bitter and bloody. For 15 years both sides had shown little mercy. In the cities, French troops were often the victims of snipers and gunmen. Reprisals were swift and harsh. Executions of rebel leaders provoked more violence. (1) In the week before the ceasefire was signed, Roger Jonchy was shot while working with French paratroopers in Algiers. A blanket covers his body while security forces across the street appear helpless. (2) The Casbah was often the flash-point for violence. (3) Muslims who could not satisfy security troops as to their identity or business were rounded up and interned.

L'Algérie française

Erbittert und blutig war der Kampf um die Unabhängigkeit verlaufen. 15 Jahre lang hatte es auf beiden Seiten kaum Erbarmen gegeben. In den Städten wurden die französischen Truppen oft Opfer von Heckenschützen und Freischärlern. Sie antworteten umgehend mit harten Vergeltungsmaßnahmen. Die Exekution der Rebellenführer provozierte weitere Gewalt. (1) In der Woche vor Unterzeichnung des Waffenstillstandes wurde Roger Jonchy bei der Arbeit mit französischen Fallschirmjägern in Algier erschossen. Eine Decke verhüllt seinen Leichnam; die Sicherheitskräfte auf der anderen Straßenseite wirken hilflos. (2) Oft flammte in der Kasba Gewalt auf. (3) Muslime, die sich vor den Sicherheitskräften nicht ausweisen oder erklären konnten, wurden zusammengetrieben und interniert.

L'Algérie française

La lutte pour la libération fut rude et sanglante. Durant quinze ans, les deux partis s'affrontèrent sans pitié. Dans les villes, les troupes françaises étaient souvent la cible de terroristes et de tireurs embusqués. Les représailles étaient immédiates et cruelles. Les exécutions des chefs rebelles provoquaient une recrudescence de la violence. (1) Dans la semaine qui précéda la signature du cessez-le-feu, Robert Jonchy fut tué par balles alors qu'il travaillait avec des parachutistes français en Algérie. Une couverture recouvre son corps tandis que les forces de sécurité, de l'autre côté de la rue, semblent désemparées. (2) La Casbah était fréquemment le théâtre d'affrontements. (3) Les musulmans qui ne pouvaient justifier face aux troupes de sécurité de leur identité ou de leur travail, étaient rassemblés et internés.

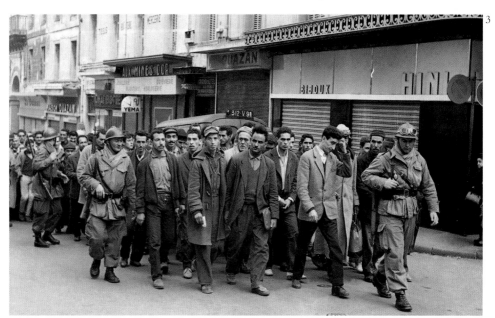

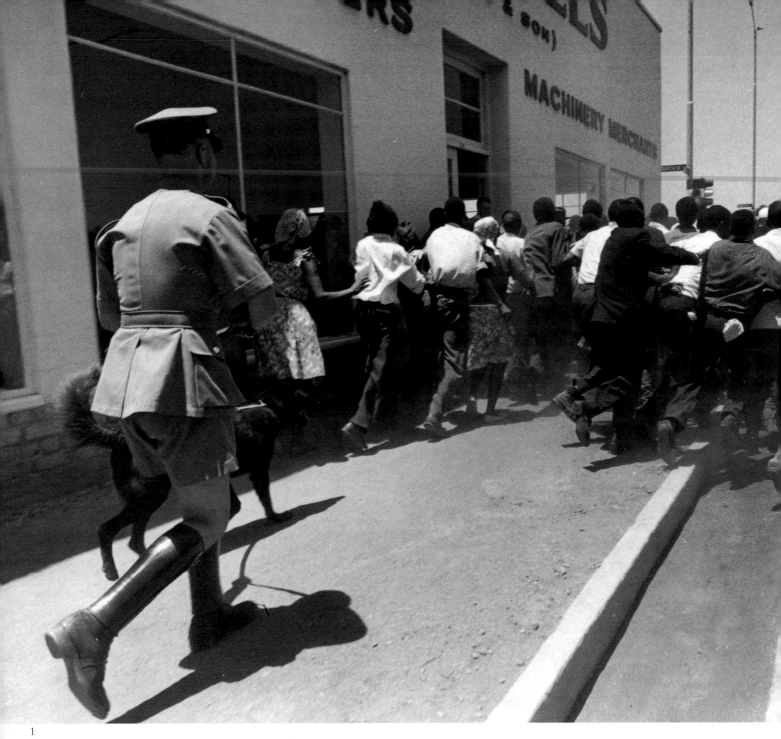

1

Rhodesia

The battle for control of Rhodesia was
initially between Britain and the white
Rhodesians. (1) In November 1965, Ian
Smith, Rhodesia's Prime Minister,
announced that he wanted independence and
permanent white rule – which meant the rule
of force. (2) This was the famous 'Unilateral
Declaration of Independence' – UDI –
proclaimed by the *Rhodesia Herald*. The
headline reads: 'Rhodesia Goes It Alone …
Censorship is Imposed'. (3) Smith's
supporters were the hard-line white farmers,
who saw the Union Jack as a symbol of their
race, rather than as a symbol of British rule.

Rhodesien

Anfangs kämpften Briten und weiße
Rhodesier um die Vorherrschaft in
Rhodesien. (1) Im November 1965
verkündete Ian Smith, Premierminister von
Rhodesien, er wolle Unabhängigkeit und
eine dauerhafte Herrschaft der Weißen – und
das bedeutete Gewaltherrschaft. (2) Das war
die berühmte »Einseitige Unabhängigkeits-
erklärung«, die vom *Rhodesia Herald*
proklamiert wurde. Die Schlagzeile lautet:
»Rhodesien geht seinen Weg allein – Zensur
verhängt.« (3) Smith fand Unterstützung bei
den weißen Farmern, die für eine harte Linie
eintraten und den Union Jack eher als
Symbol ihrer Rasse denn als Symbol
britischer Herrschaft sahen.

La Rhodésie

La lutte pour le contrôle du pays mit
initialement aux prises la Grande-Bretagne et
les Blancs de Rhodésie. (1) En novembre
1965, le Premier Ministre de Rhodésie, Ian
Smith, réclama l'indépendance et l'instaura-
tion d'un pouvoir blanc permanent – en
d'autres termes, de la loi du plus fort. (2) Ce
fut la célèbre *« Unilateral Declaration of
Independance »* (Déclaration Unilatérale
d'Indépendance – UDI) proclamée par le
Rhodesia Herald. La manchette annonçait: « La
Rhodésie fait cavalier seul… La censure est
imposée. » (3) Smith était soutenu par les
planteurs blancs extrémistes qui considéraient
le *Union Jack* (drapeau du Royaume-Uni)
comme le symbole, non pas de la domination
britannique, mais de leur race.

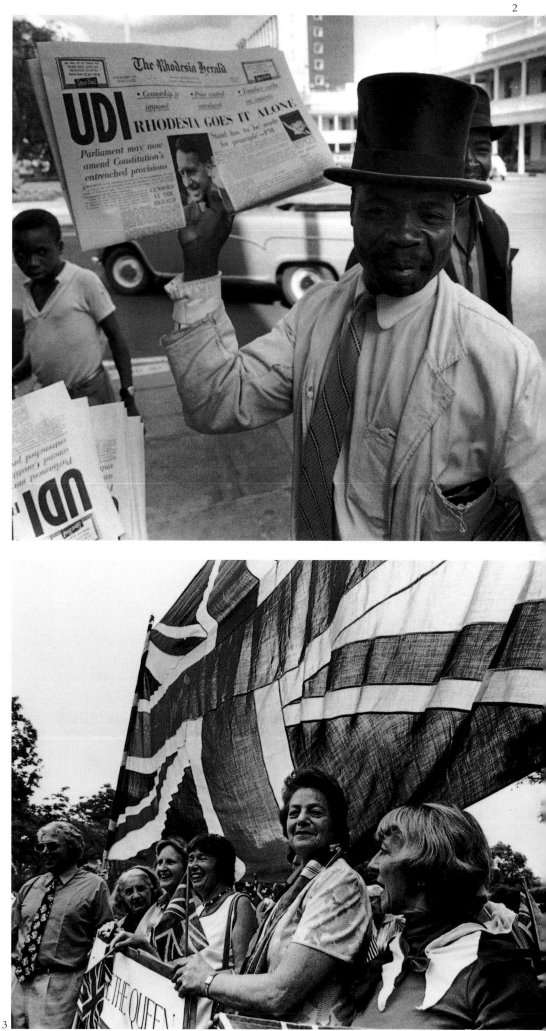

3

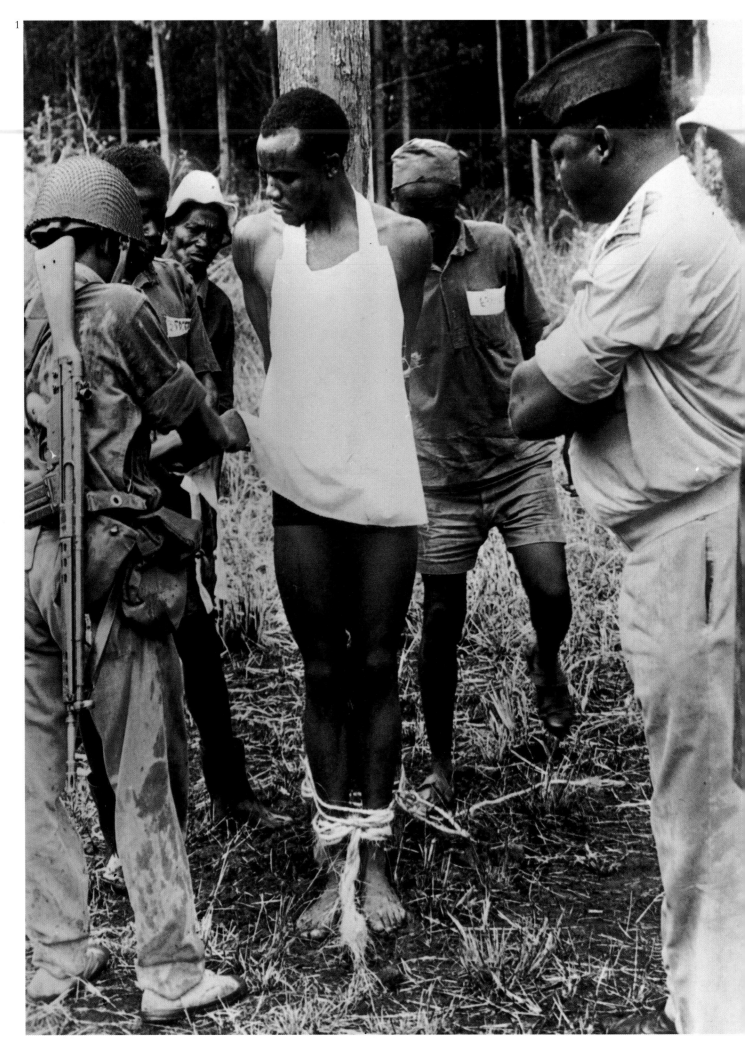

146 *Imperial Retreat*

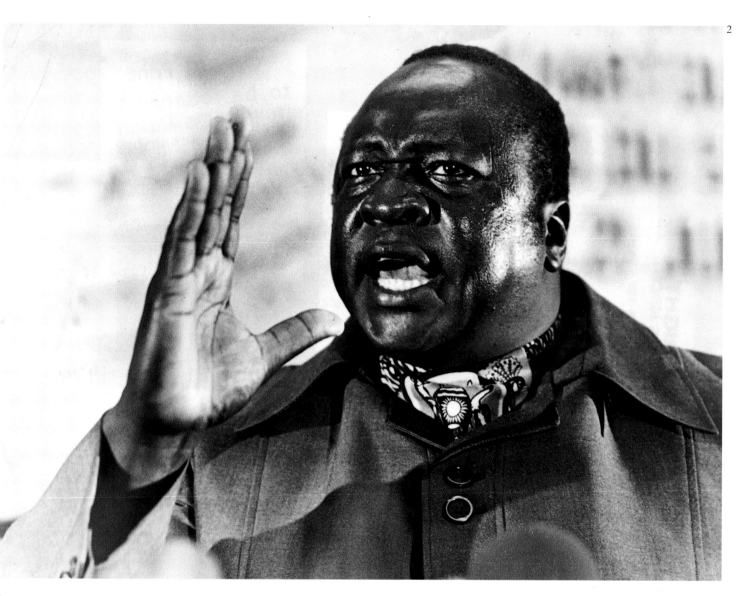

Uganda

Al Hajji Field Marshal Dr Idi Amin Dada, VC, DSO, MC, CBE (2), seized power in January 1971. There followed eight years of hell for Uganda. Amin's cruelty and excesses became legendary. (1) Alleged 'criminals' were stripped and publicly executed, among them Tom Masaba, an ex-officer of the Ugandan Army. Amin was driven from Uganda by Tanzanian forces in 1979. (3) The bodies of some of his followers hanging from their wrecked machine gun.

Uganda

Der hochdekorierte Offizier Al Hajji Feldmarschall Dr. Idi Amin Dada (2) ergriff im Januar 1971 die Macht im Land. Es folgten acht Jahre der Hölle in Uganda: Amins Grausamkeit und Exzesse waren unvorstellbar. (1) Angebliche »Kriminelle« wurden entkleidet und öffentlich hingerichtet, unter ihnen Tom Masaba, Ex-Offizier der ugandischen Armee. 1979 vertrieben die Streitkräfte Tansanias Idi Amin aus Uganda. (3) Die Leichen einiger seiner Anhänger auf ihrem zerstörten Kanonenfahrzeug.

Ouganda

Idi Amin Dada – Dr., Maréchal, Croix de Victoria, *Distinguish Service of Order* (légion d'honneur britannique), *Master of Ceremony* (Maître des Cérémonies) et Compagnon de l'Empire britannique – (2) prit le pouvoir en janvier 1971. Huit années d'enfer s'ensuivirent pour l'Ouganda. (1) Les supposés «criminels» étaient dénudés et exécutés. L'un d'eux, Tom Masaba, était un ancien officier de l'armée ougandaise. Amin fut chassé d'Ouganda par les forces tanzaniennes en 1979. (3) Des partisans d'Amin Dada pendus sur les mitrailleuses détruites.

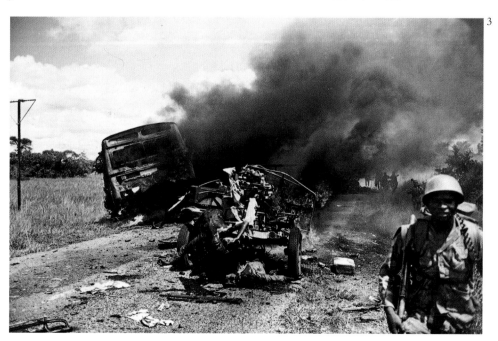

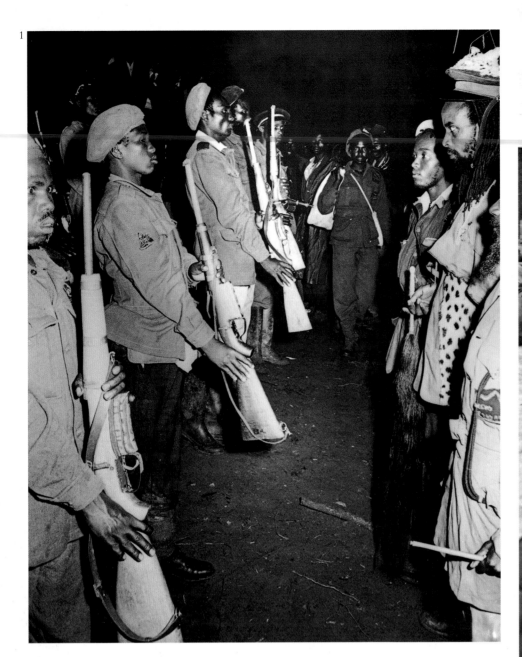

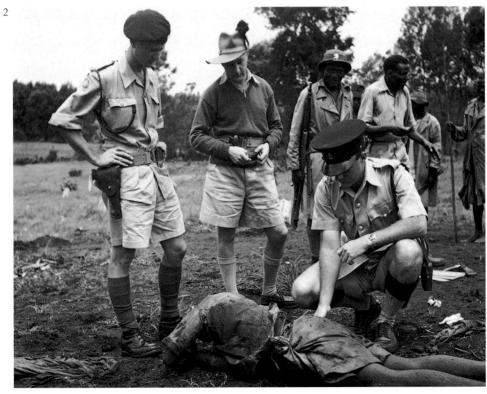

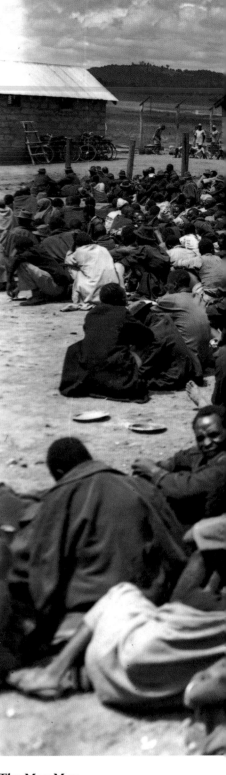

The Mau Mau

The wind of change was often a destructive wind. In East African Kenya, the struggle for independence from British rule took 11 bloody years. (1) The Mau Mau freedom fighters – 'terrorists' to the British – were members of the Kikuyu tribe, dedicated to driving white farmers from the rich heartland of Kenya. (2) They were daring and merciless, attacking first isolated farms and police outposts, and later the vast camps where Mau Mau suspects were imprisoned, such as this at Thompson Falls. (3) In the three years up to January 1956, over 10,000

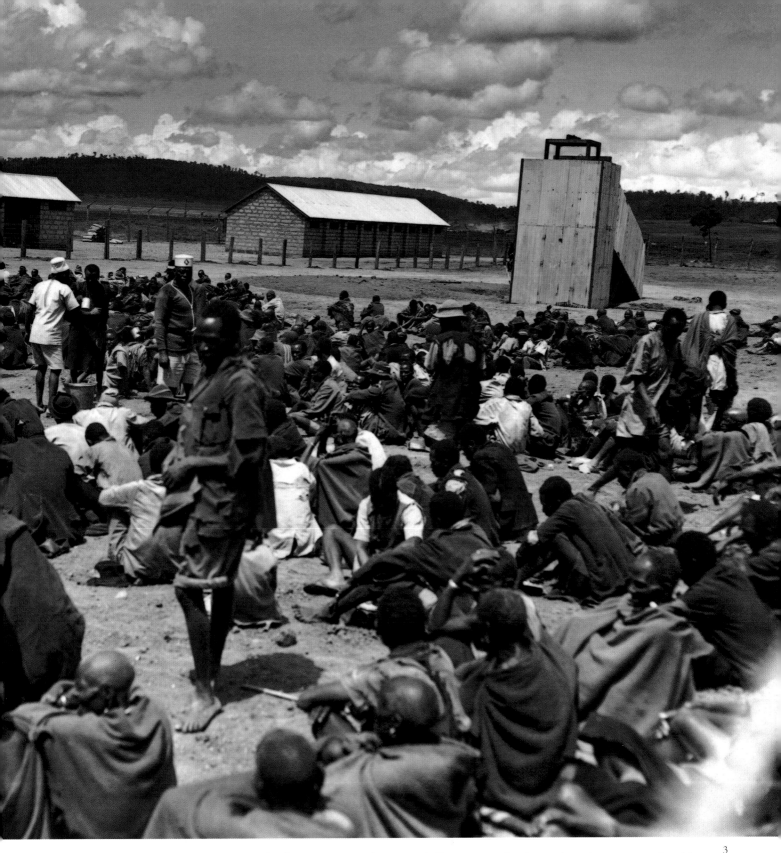

Mau Mau lost their lives, many of them on the gallows (right background of picture).

Die Mau-Mau-Bewegung

Der neue Wind war oft zerstörerisch. Im ostafrikanischen Kenia dauerte der Kampf um die Unabhängigkeit von der britischen Herrschaft elf lange, blutige Jahre. (1) Die Mau-Mau-Freiheitskämpfer – für die Briten »Terroristen« – gehörten den Kikuyu an, einem Volk, das entschlossen war, die weißen Farmer aus dem fruchtbaren Herzland Kenias zu vertreiben. (2) Sie waren unerschrocken und erbarmungslos, griffen abgelegene Farmen

und Polizeiposten an und später auch die riesigen Gefangenenlager mit mutmaßlichen Mau-Mau-Kämpfern wie zum Beispiel dieses Lager in Thompson Falls. (3) In den drei Jahren bis Januar 1956 ließen über 10 000 Mau Mau ihr Leben, viele von ihnen am Galgen (rechter Bildhintergrund).

Les Mau-Mau

Les bouleversements sont parfois d'une rare violence. En Afrique de l'Est, le Kenya ne parvint à chasser les Anglais qu'au terme de 11 années de luttes sanglantes. (1) Les Mau-Mau, combattants de la liberté ou «terroristes»

selon leurs adversaires, appartenaient à la tribu Kikuyu, chauffeurs traditionnels des grands fermiers blancs des riches terres centrales du pays. (2) Audacieux et impitoyables, ils attaquèrent d'abord les fermes isolées et les avant-postes de police, puis les vastes camps où étaient internés les suspects Mau-Mau, tel que Thompson Falls. (3) Durant les trois années qui précédèrent janvier 1956, plus de 10 000 Mau-Mau perdirent la vie, finissant pour la plupart sur la potence (arrière-plan à droite sur la photographie).

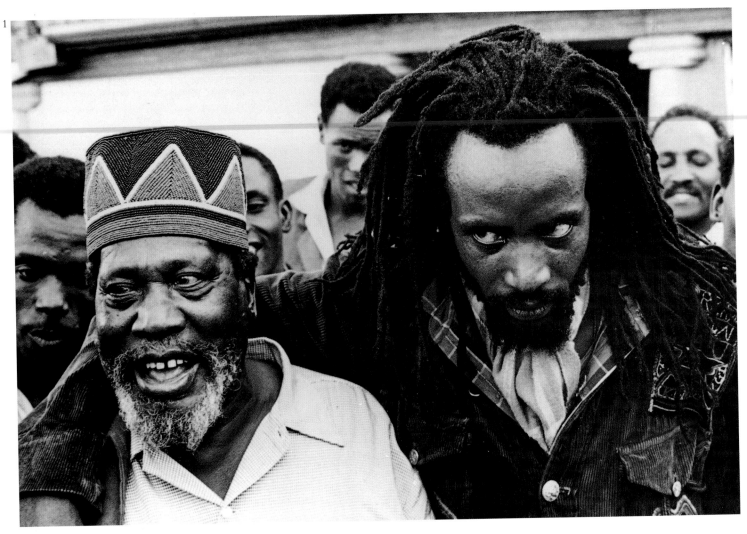

Kenyatta

(1) The leader of the movement for Kenyan independence was Jomo 'Burning Spear' Kenyatta, seen here with his guerrilla commander, Mwariama, in 1961, shortly after Kenyatta's release from nine years' imprisonment. (2) In April 1953, Kenyatta and fellow defendants at the Kapenguria Trial were accused of assisting and inspiring the Mau Mau. Kenyatta's imprisonment – with hard labour – did little to calm the situation. (3) The words on the poster call for 'Freedom' and 'Unity'.

Kenyatta

(1) Der Führer der Unabhängigkeitsbewegung Kenias war Jomo »Brennender Speer« Kenyatta, hier 1961 kurz nach seiner Freilassung aus neunjähriger Haft mit seinem Guerillakommandeur Mwariama. (2) Im April 1953 wurden Kenyatta und seine Mitangeklagten beim Kapenguria-Prozeß der Beihilfe und Anstiftung der Mau Mau beschuldigt. Kenyattas Haft – unter Zwangsarbeit – trug nicht gerade zur Beruhigung der Lage bei. (3) Die Worte auf dem Plakat fordern »Freiheit« und »Einheit«.

Kenyatta

(1) Jomo Kenyatta, surnommé «Lance brûlante», que l'on voit ici avec son chef de guérilla, Mwariama, en 1961, peu après sa libération au terme de neuf années de prison, était le leader du mouvement pour l'indépendance du Kenya. (2) En avril 1953, au cours du procès de Kapenguria, Kenyatta et ses défenseurs furent accusés d'aider et d'inspirer l'action des Mau-Mau. L'emprisonnement de Kenyatta – assorti d'une peine de travaux forcés – n'apaisa pas, loin de là, la situation. (3) L'affiche appelle à la «Liberté» et «Unité.»

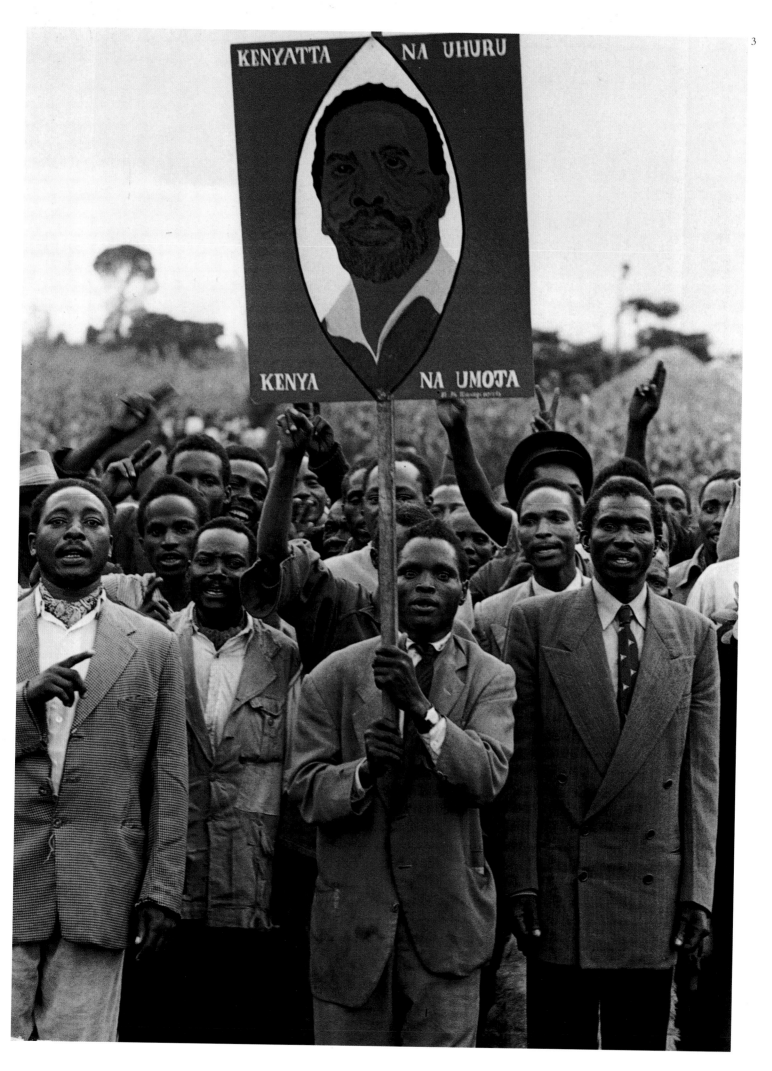

The scene is a park in Rhodesia, 1964. It took another 30 years to bring an end to the odious farce of 'separate development' in South Africa.

Diese Aufnahme entstand 1964 in einem Park in Rhodesien. Südafrika brauchte noch dreißig Jahre, um der abscheulichen Farce der »separaten Entwicklung« ein Ende zu setzen.

La scène se passe dans un parc de Rhodésie en 1964. Ce ne fut que 30 années plus tard que s'acheva l'odieuse farce du «développement séparé» en Afrique du Sud.

The Patience of the Oppressed

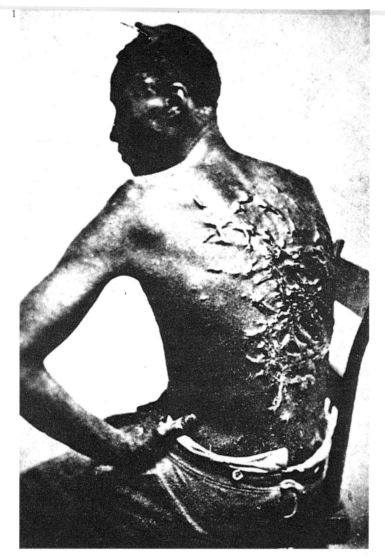

On 3 January 1956, the night a bomb was thrown into the home of Martin Luther King Jr, a black American said to a white policeman who was attempting to push him aside: 'I ain't gonna move nowhere … you white folks is always pushin' us around. Now you got your .38 and I got mine; so let's battle it out.'

That the struggle between black and white – in the US and in South Africa – so seldom came to a pitched battle owes much to the patience of the oppressed. By the mid-1950s, 90 years after the passage of the Thirteenth Amendment of the Constitution in 1865 freeing slaves, little had been done to put an end to the beatings, lynchings and subjugation of the black American. Then Rosa Parks, a National Association for the Advancement of Colored People organiser and a seamstress from Montgomery, Alabama, refused to give up her seat on a bus to a white man. 'When the driver saw that I was sitting there,' she later recalled, 'he asked if I was going to stand up. I told him no, I wasn't. He said: "Well, if you don't stand up I'm going to have you arrested." I told him to go and have me arrested.' It was as simple as that, but the US would never be the same again.

For so began the non-violent process of boycotts, marches, sit-ins, demonstrations and strikes that gradually dismembered the segregation-besotted Southern way of life. It was a slow process, many believed too slow. In the words of Robert F Williams, a black activist who became a fugitive from American justice: 'Non-violence is a very potent weapon when the opponent is civilized, but … no repellent for a sadist.' Malcolm X put it more strongly – to him every white man was a devil: 'Think of how it was on *your* slave fore-parents' bloody, sweaty backs that he built his empire that's today the richest of all nations, where his evil and his greed cause him to be hated round the world!'

The country where whites did all they could to make themselves hated was South Africa. Apartheid – so-called separate development – was written into that beautiful country's constitution; indeed, the South African Republic was founded on exploitation of the blacks. The United States imported its second-class citizens: the Afrikaners took the native population and made them second-class. In most other ways both countries ran parallel systems of ill-treatment. Blacks held the worst jobs, lived in the poorest slums and shanty towns, were allowed minimal education. Again, the wonder is that they were so patient for so long. At the Rivonia Trial in April 1964, Nelson Mandela explained from the dock how Umkonto were prepared to reject guerrilla warfare, terrorism and open revolution in their fight for basic human rights: 'We hope, even at this late hour … that we will bring the Government and its supporters to their senses before it is too late … before matters reach the desperate stage of civil war.'

Mandela's final words at that trial were: 'I have cherished the ideal of a democratic and free society in which all persons live together in harmony and with equal opportunities.' The words could have been those of Abraham Lincoln, a hundred years earlier. That they still needed to be uttered reveals how long and painful the journey to justice had been, and was yet to be.

But in all this, from Wounded Knee to Soweto, the camera had an essential part to play. When pictures of the massacre at Sharpeville in 1960 were wired round the world, too many saw too much for the South African Government to survive – in the long run. When television cameras revealed the vicious attack by state troopers and Sheriff James G. Clark Jr's deputies on a peaceful civil rights march, hundreds of thousands from an entire continent were shocked into action.

Another wonder is that it took the agents and instigators so long to realize that the camera is perhaps mightier than the sword.

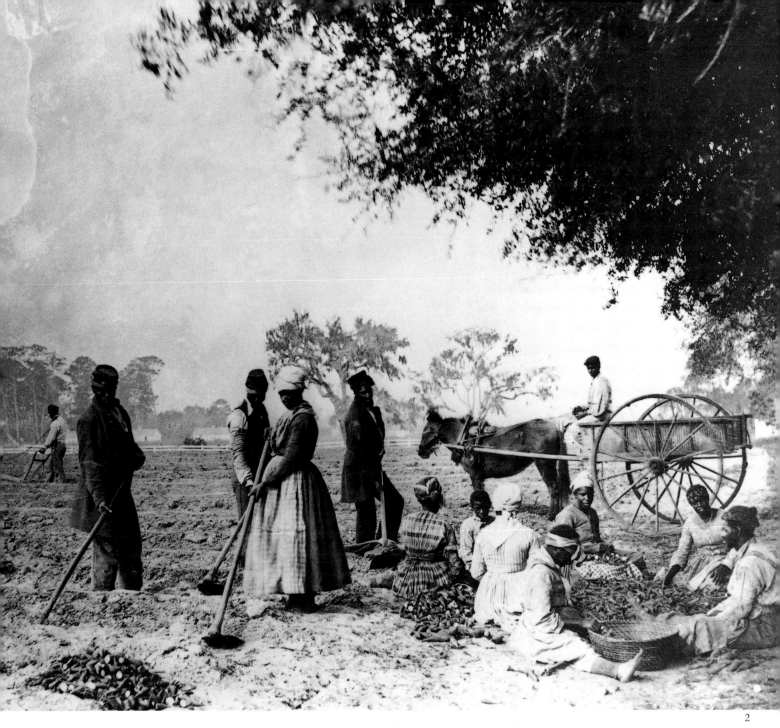

Als in der Nacht des 3. Januar 1956 eine Bombe in das Haus von Martin Luther King jr. geworfen wurde, erklärte ein schwarzer Amerikaner einem weißen Polizisten, der versuchte, ihn beiseite zu schieben: »Ich rühr' mich nicht vom Fleck … ständig schubst ihr Weißen uns rum. Du hast deine 38er, und ich hab' meine; laß uns die Sache ausfechten.«

Daß die Auseinandersetzungen zwischen Schwarz und Weiß in den USA und in Südafrika sich so selten zu einem Kampf zuspitzten, ist großenteils der Geduld der Unterdrückten zu verdanken. In den neunzig Jahren von der Verabschiedung des Dreizehnten Zusatzartikels zur amerikanischen Verfassung 1865, der die Sklaven befreite, bis zur Mitte der fünfziger Jahre war wenig geschehen, um die Unterdrückung, die Lynchjustiz und die Tätlichkeiten gegen schwarze Amerikaner zu beenden. Bis Rosa Parks, eine Organisatorin der *National Association for the Advancement of Colored People* und Näherin aus Montgomery, Alabama, sich weigerte, ihren Sitzplatz im Bus einem weißen Mann zu überlassen. »Als der Fahrer sah, daß ich da saß, fragte er, ob ich

(1) The unacceptable side of Dixie: the scarred back of a slave after a whipping. (2) An image of the Old South, the acceptable face of Dixie: Negroes planting sweet potatoes on James Hopkinson's plantation, Edisto Island, North Carolina, in 1862.

(1) Das unannehmbare Gesicht des alten Südens: Der von Peitschenhieben vernarbte Rücken eines Sklaven. (2) Ein Bild des Alten Südens, das das annehmbare Gesicht der Südstaaten zeigt: Schwarze pflanzen Süßkartoffeln auf der Plantage von James Hopkinson, Edisto Island, North Carolina, 1862.

(2) Image du Vieux Sud – la face présentable de Dixie: des nègres plantant des patates douces sur la propriété de James Hopkinson, à Edito Island, Caroline du Nord, en 1862. (1) L'autre face: le dos écorché d'un esclave fouetté.

Slums und Elendsvierteln und erhielten nur ein Minimum an Schulbildung. Auch hier ist es ein Wunder, daß sie so lange Geduld hatten. Im April 1964 erklärte Nelson Mandela beim Rivonia-Prozeß auf der Anklagebank, daß die Bewegung Umkhonto bereit sei, in ihrem Kampf für grundlegende Menschenrechte auf Guerillakrieg, Terrorismus und offene Revolution zu verzichten: »Selbst zu diesem späten Zeitpunkt hoffen wir noch …, daß wir die Regierung und ihre Anhänger zur Vernunft bringen, bevor es zu spät ist …, bevor die Lage das verzweifelte Stadium des Bürgerkrieges erreicht.«

Mandelas abschließende Worte bei diesem Prozeß lauteten »Ich halte am Ideal einer demokratischen und freien Gesellschaft fest, in der alle Menschen in Harmonie und Chancengleichheit zusammenleben.« Diese Worte hätten auch hundert Jahre früher von Abraham Lincoln stammen können. Daß sie immer noch gesagt werden mußten, zeigt wie lang und schmerzlich der Weg zur Gerechtigkeit war und noch werden sollte.

Doch in alldem, vom Wounded Knee bis Soweto, spielte die Kamera eine entscheidende Rolle. Als 1960 Aufnahmen vom Massaker in Sharpeville um die Welt gingen, sahen zu viele Menschen zu viel, als daß die Regierung Südafrikas es – langfristig – hätte überstehen können. Als Fernsehkameras zeigten, wie Staatspolizei und die Stellvertreter von Sheriff James G. Clark brutal gegen friedliche Demonstranten eines Bürgerrechtsmarsches vorgingen, brachte der Schock Hunderttausende eines ganzen Kontinents dazu, aktiv zu werden.

Ein weiteres Wunder ist, daß die Handelnden und die Anführer so lange für die Erkenntnis gebraucht haben, daß die Kamera vielleicht eine mächtigere Waffe ist als das Schwert.

aufstehen würde. Ich sagte, das würde ich nicht tun«, erinnerte sie sich später. »Er sagte: ›Gut, wenn Sie nicht aufstehen, lasse ich Sie festnehmen.‹ Ich sagte: ›Gehen Sie und lassen Sie mich festnehmen.‹« So einfach war das, aber die USA sollten nie wieder die gleichen sein.

Denn so begann der gewaltlose Prozeß der Boykotts, Protestmärsche, Sit-ins, Demonstrationen und Streiks, der nach und nach die von besessener Rassentrennung durchdrungene Lebensweise der Südstaaten zermürben sollte. Es war ein langwieriger Prozeß, der vielen zu langsam erschien. Robert F. Williams, ein schwarzer Aktivist, der später vor der amerikanischen Justiz flüchten mußte, sagte: »Gewaltlosigkeit ist eine mächtige Waffe, wenn der Gegner zivilisiert ist, aber … keine Abschreckung für einen Sadisten.« Malcolm X drückte es krasser aus – für ihn war jeder Weiße ein Teufel: »Denkt daran, daß er auf den blutigen, verschwitzten Rücken eurer versklavten Vorfahren sein Weltreich aufgebaut hat, das heute das reichste der Welt ist, wo man ihn überall wegen seiner Bösartigkeit und Gier haßt!«

Das Land, in dem Weiße alles unternahmen, um sich verhaßt zu machen, war Südafrika. Die Apartheid – die sogenannte separate Entwicklung – war in der Verfassung dieses schönen Landes festgeschrieben; die Republik Südafrika gründete sich auf die Ausbeutung der Schwarzen. Während die Vereinigten Staaten ihre Bürger zweiter Klasse importiert hatten, machten die Afrikander die einheimische Bevölkerung zu Bürgern zweiter Klasse. In anderer Hinsicht waren sich beide Länder in ihren Systemen der Benachteiligung und Willkür großenteils gleich. Schwarze bekamen die schlechtesten Arbeitsplätze, lebten in den armseligsten

La nuit du 3 janvier 1956, alors qu'une bombe venait d'exploser dans la maison de Martin Luther King Jr, un Noir américain lança à un policier blanc qui tentait de le repousser: «J'peux aller nulle part … vous les Blancs, vous nous marchez toujours sur les pieds. Maintenant t'as ton 38 et j'ai le mien; viens, on va s'expliquer.»

Que la lutte entre les Noirs et les Blancs – aux Etats-Unis et en Afrique du Sud – ait si rarement dégénéré en affrontements directs, doit beaucoup à la patience des opprimés Jusqu'au milieu des années 1950, pendant près d'un siècle entre l'adoption du Treizième Amendement et la Constitution de 1865 qui libéra les esclaves, rien ou presque ne fut entrepris pour mettre fin aux passages à tabac, aux lynchages et au statut inférieur des Noirs américains. Puis vint le jour où Rosa Parks, organisatrice de la *National Association for the Advancement of Colored People* (Association Nationale pour la Promotion des Gens de Couleur) et couturière de Montgomery, en Alabama, refusa de céder son siège à un Blanc dans le bus. «Lorsque le conducteur vit que j'étais assise là» rapporta-t-elle plus tard, «il me demanda de me lever. Je refusai. Il dit: ›Bon, si tu ne te lèves pas, je vais te faire arrêter.‹ Je lui répondis d'agir à sa guise.» Incident routinier qui pourtant allait changer la face des Etats-Unis.

Race on the street: in apartheid South Africa, all black citizens had to carry an identity card or pass. (1) Enforcement of the Pass laws controlled the movement and employment of blacks. (2) A Civil Rights demonstration in the US in the 1960s.

Rassenzugehörigkeit auf der Straße: Alle schwarzen Bürger mußten im Südafrika der Apartheid Personalausweis oder Paß bei sich tragen. (1) Über die Paßgesetze ließen sich die Bewegungen und Arbeitsverhältnisse der Schwarzen kontrollieren. (2) Eine Bürgerrechtsdemonstration in den USA während der sechziger Jahre.

Discrimination dans la rue: En Afrique du Sud, l'apartheid exigeait que tous les citoyens noirs portent une carte d'identité ou un laissez-passer. (1) Le système législatif des laissez-passer permettait de contrôler les déplacements et les emplois des Noirs. (2) Manifestation pour les Droits Civils aux Etats-Unis dans les années 1960.

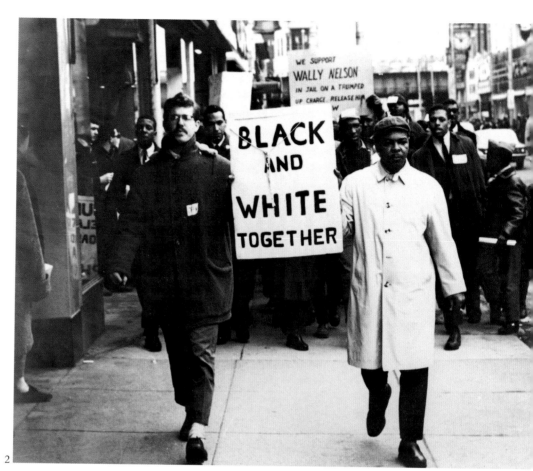

2

Ce fut le début d'une série d'actions non-violentes – boycotts, défilés, sit-ins, manifestations et grèves – qui, graduellement, démantela l'absurde système ségrégationniste du Sud. Processus trop lent pour certains: pour Robert F. Williams, militant noir plus tard recherché par la justice américaine, «La non-violence est une arme très puissante lorsque l'adversaire est civilisé, mais... sans efficacité face à un sadique.» Ce que Malcolm X affirmait plus violemment – pour lui, tout homme blanc incarnait le diable: «Pense que c'est sur le dos en sueur et en sang de tes ancêtres esclaves qu'il a construit son empire, aujourd'hui le plus riche de toutes les nations, tandis que sa malignité et sa cupidité le font haïr dans le monde entier!»

En Afrique du Sud, les Blancs s'acharnèrent à susciter la haine. L'Apartheid – autrement dit le «développement séparé» – était inscrit dans la constitution de ce magnifique pays; en effet, la République Sud-Africaine était fondée sur l'exploitation des Noirs. A la différence des Etats-Unis qui les importaient, les Afrikaners constituaient leurs citoyens de seconde zone à partir des populations indigènes. Les deux pays instaurèrent, à leur façon, des systèmes répressifs. Les Noirs accomplissaient les pires travaux, vivaient dans des taudis et bidonvilles insalubres, ne recevaient qu'une éducation minimale. Pourquoi encore une fois, une telle patience? Au procès de Rivonia, en avril 1964, Nelson Mandela, sur le banc des accusés, expliqua comment les Umkhonto étaient prêts à renoncer à la guérilla, au terrorisme et à lancer la révolution pour obtenir de bénéficier des Droits de l'Homme: «Nous espérons, encore maintenant ... amener le gouvernement et ses partisans à la raison avant qu'il ne soit

trop tard ... avant que la situation n'atteigne le stade désespéré de la guerre civile.»

«J'ai caressé l'idéal d'une société libre et démocratique dans laquelle toutes les personnes vivront ensemble en harmonie et avec les mêmes chances.» Telles furent les dernières paroles de Mandela lors du procès – elles auraient pu être celles d'Abraham Lincoln, une centaine d'années plus tôt. Qu'il ait fallu une nouvelle fois les exprimer prouvait combien long et douloureux avait été, et continuait à l'être, le chemin de la justice.

Cependant, de Wounded Knee à Soweto, la photographie joua un rôle essentiel. En 1960, les images du massacre de Sharpeville en 1960 firent le tour du monde, provoquant une prise de conscience préjudiciable à la survie du gouvernement sud-africain – à long terme. De même, la retransmission télévisée de l'assaut révoltant lancé par les gendarmes et les adjoints du shérif James G. Clark Jr., sur une marche pacifique pour les droits civils provoqua-t-elle l'indignation durable de centaines de milliers de personnes sur l'ensemble du continent.

Pourquoi également fallut-il tant de temps aux responsables et à leurs agents pour réaliser que l'image est sans doute plus puissante que les mots?

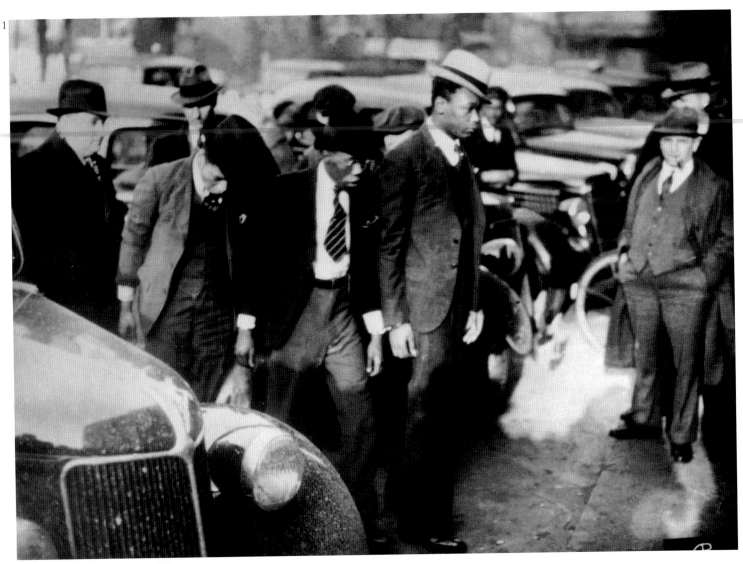

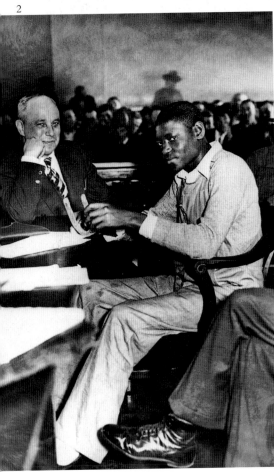

The Scottsboro Boys

In 1931, nine black youths were accused of assaulting two white girls on a train in Scottsboro, Alabama. Normally such a charge would have meant a death sentence, but the case received enormous press coverage – which probably saved their lives. (1) Three of the defendants arrive at Birmingham Jail – from left to right, Eugene Williams, Olen Montgomery and Andy Wright. (2) Haywood Patterson, another defendant, with his attorney, a lucky horseshoe and a rabbit's foot. (3) Patterson, second from right, rolling dice in Decatur Jail, awaiting retrial. His sentence was commuted from death to 75 years.

Die Jungs von Scottsboro

1931 wurden neun schwarze Jugendliche beschuldigt, zwei weiße Mädchen in einem Zug in Scottsboro, Alabama, überfallen zu haben. Normalerweise hätte eine solche Beschuldigung an einem solchen Ort den Tod durch Lynchjustiz oder den elektrischen Stuhl bedeutet, der Fall erregte jedoch in der Presse erhebliche Aufmerksamkeit – was ihnen vermutlich das Leben rettete. (1) Drei der Angeklagten treffen im Gefängnis Birmingham ein; von links: Eugene Williams, Olen Montgomery und Andy Wright. (2) Haywood Patterson, ein weiterer Angeklagter, vor Gericht mit seinem Anwalt, einem Hufeisen und einer Kaninchenpfote als Glücksbringer. (3) Patterson (zweiter von rechts) beim Würfelspiel im Gefängnis Decatur, während er auf seine Berufungsverhandlung wartet. Bei seinem ersten Prozeß hatte man ihn zum Tode verurteilt; in der Berufungsverhandlung wurde er zu 75 Jahren Gefängnis verurteilt.

Les Garçons de Scottsboro

En 1931, neuf jeunes Noirs furent accusés d'avoir agressé deux jeunes filles blanches dans un train à Scottsboro, dans l'Alabama. En temps normal, une telle accusation en un tel lieu aurait signifié la mort par lynchage public ou la chaise électrique, mais le cas bénéficia d'une large couverture médiatique – ce qui probablement leur sauva la vie. (1) Trois des prévenus arrivent à la prison de Birmingham – de gauche à droite, Eugene Williams, Olen Montgomery et Andy Wright. (2) Dans la salle d'audience, Haywood Patterson, autre prévenu, assisté de son avocat, et muni d'un fer à cheval porte-bonheur et d'une patte de lapin. (3) Patterson, second sur la droite, jouant aux dés à la prison de Decatur, en attendant son nouveau procès. Le premier procès avait conclu à la mort; le second aboutit à 75 ans d'emprisonnement.

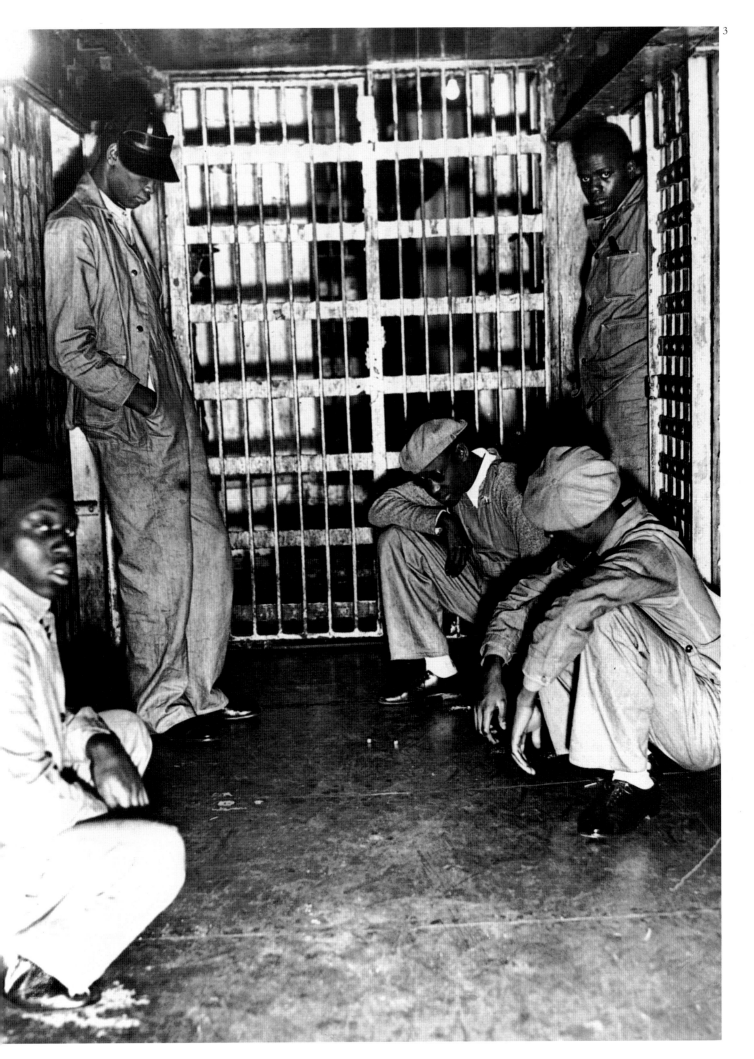

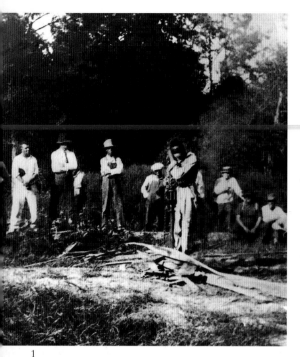

1

Lynch Law

Brutal lynchings – often of the innocent –
were horrifyingly common incidents in the
southern United States, even after the
Second World War. (1) J. D. Ivy covers his
face with his hands as he is burnt at the stake
by a lynch mob in Memphis, Tennessee, in
1925. (2) Bigots gather to gloat at two victims
of lynch law in the Deep South. (Overleaf)
The Ku Klux Klan was refounded in 1915, to
maintain white supremacy and foster race
hatred.

Lynchjustiz

Brutale Fälle von Lynchjustiz – der oft
Unschuldige zum Opfer fielen – waren in
den Südstaaten der USA erschreckend
verbreitet, selbst noch nach dem Zweiten
Weltkrieg. (1) J. D. Ivy bedeckt sein Gesicht
mit den Händen, während der Mob in
Memphis, Tennessee, ihn 1925 auf dem
Scheiterhaufen verbrennt. (2) Selbstgerechte
Gaffer rotten sich zusammen, um zwei
Opfer der Lynchjustiz im Tiefen Süden
hämisch anzugaffen. (Nächste Seite) Der Ku-
Klux-Klan wurde 1915 neu gegründet, um
die weiße Vorherrschaft aufrechtzuerhalten
und Rassenhaß zu schüren.

La loi du lynchage

Les lynchages – d'innocents la plupart du
temps –, actes bestiaux et atroces, étaient
courants dans le sud des Etats-Unis, même
après la Seconde Guerre Mondiale. (1) Brûlé
vif par la foule à Memphis, dans le Tennessee,
en 1925, J.D. Ivy, sur le bûcher, se cache le
visage dans les mains. (2) Des fanatiques
expriment leur joie devant deux victimes de
la loi du lynchage dans le Sud profond des
Etats-Unis. (Page suivante) Le Ku Klux Klan,
qui voulait maintenir la suprématie blanche
et attisait la haine raciale, fut refondé en 1915. 2

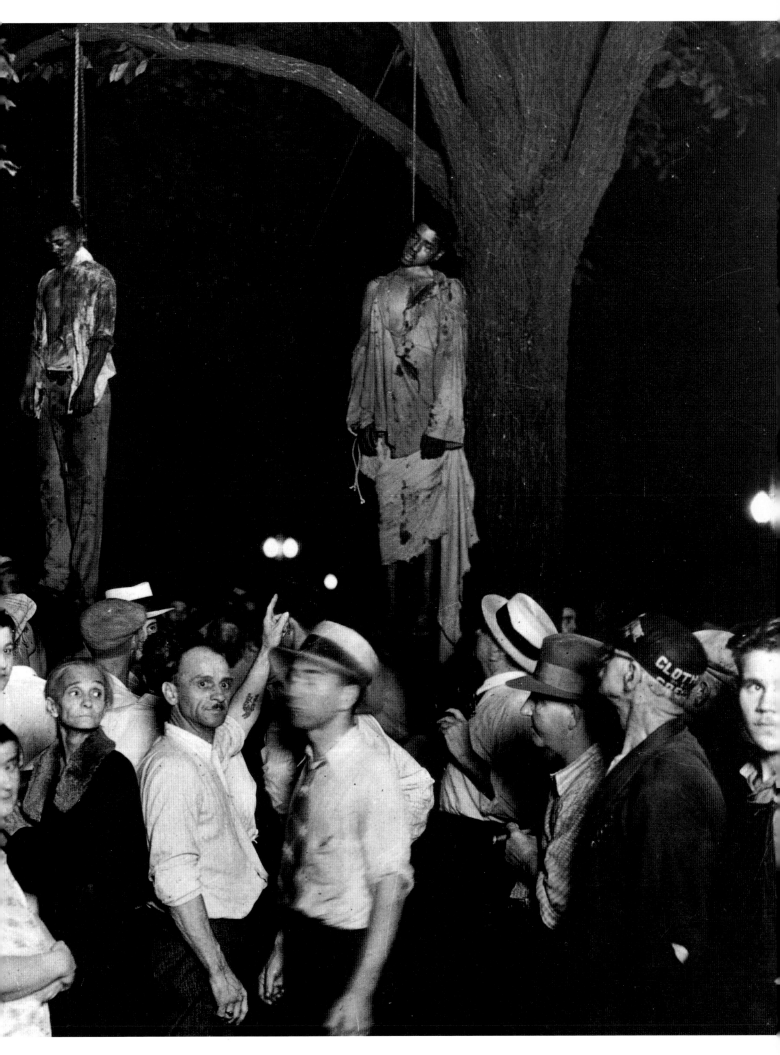

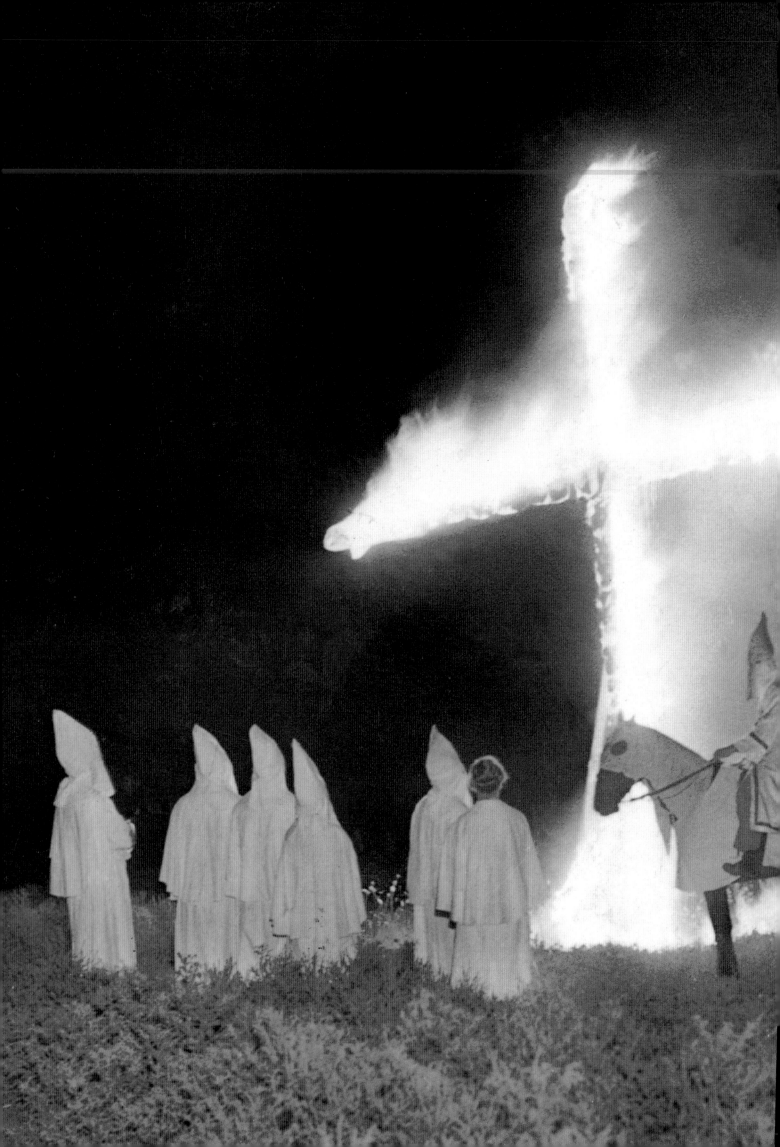

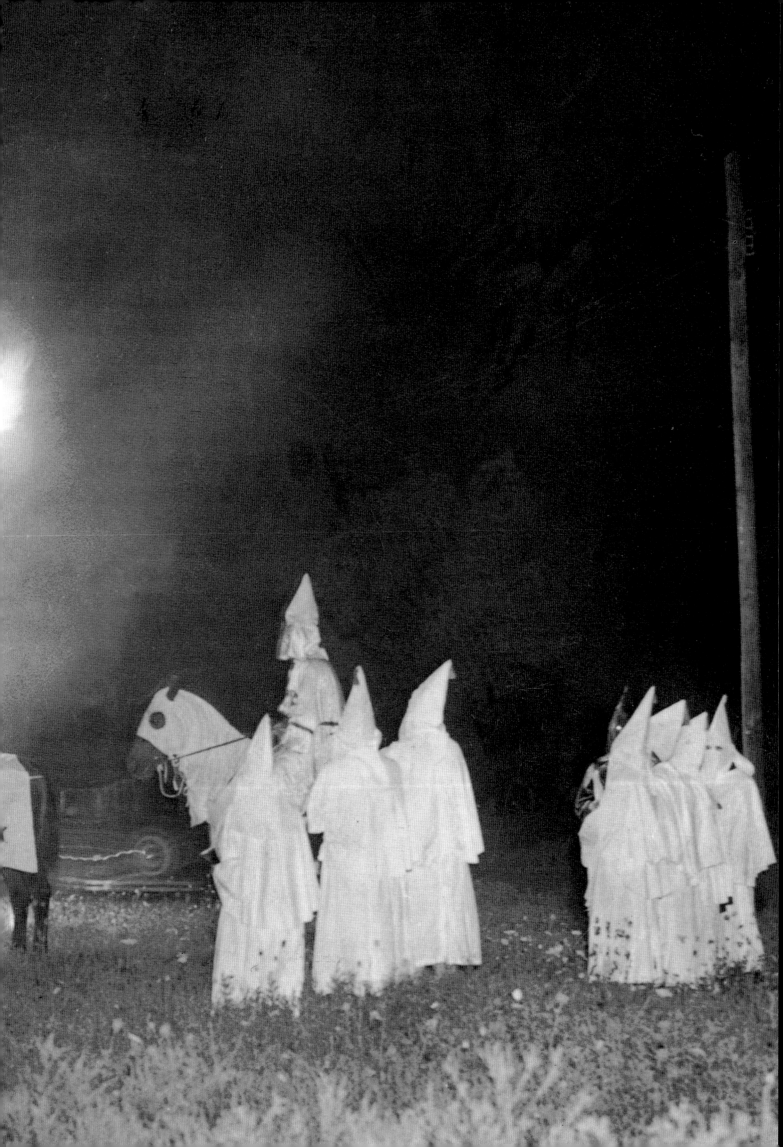

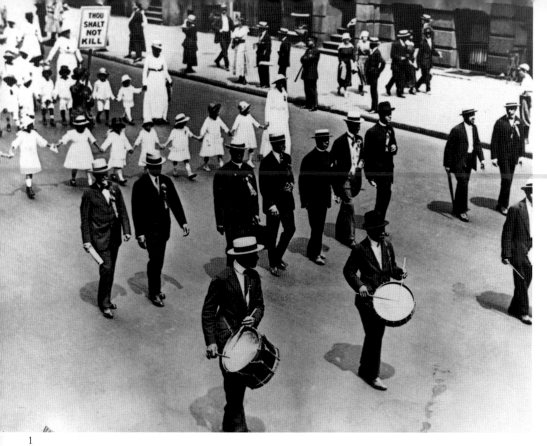

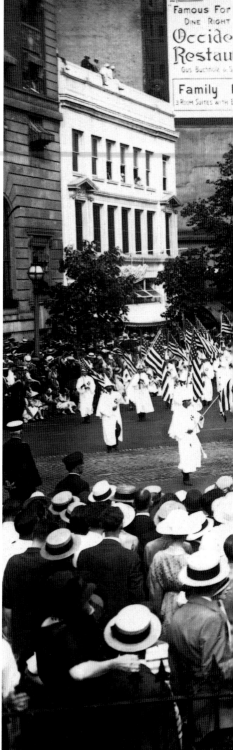

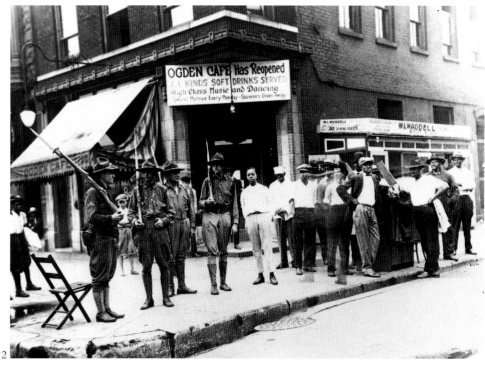

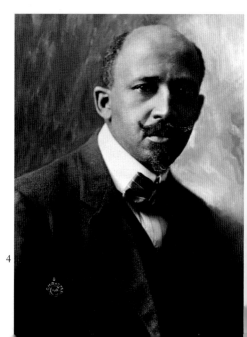

A Nation Divided

(1) In July 1917, the newly formed National Association for the Advancement of Colored People marched in a peaceful protest to promote anti-lynching laws. (2) Troops called out to quell race riots in Chicago in July 1919 were told: 'Draw no color line. A white rioter is as dangerous as a Negro rioter'. (3) At the height of their power, 40,000 members of the Ku Klux Klan parade down Pennsylvania Avenue, Washington DC, July 1925. W. E. B. Du Bois (4) and Booker T. Washington (5), Harvard-educated Afro-Americans who urged black Americans to organize. 'The time seems more than ripe,' wrote Du Bois in 1905, 'for determined and aggressive action on the part of men who believe in Negro freedom and growth.'

Eine gespaltene Nation

(1) Im Juli 1917 veranstaltete die neu gegründete *National Association for the Advancement of Colored People* einen friedlichen Protestmarsch für eine Gesetzgebung gegen Lynchjustiz. (2) Polizeitruppen, die im Juli 1919 aufgeboten wurden, um Rassenunruhen in Chicago niederzuschlagen, erhielten die Anweisung: »Zieht keine Trennlinie nach der Hautfarbe. Ein weißer Unruhestifter ist ebenso gefährlich wie ein schwarzer Unruhestifter.« (3) Auf dem Höhepunkt ihrer Macht paradieren im Juli

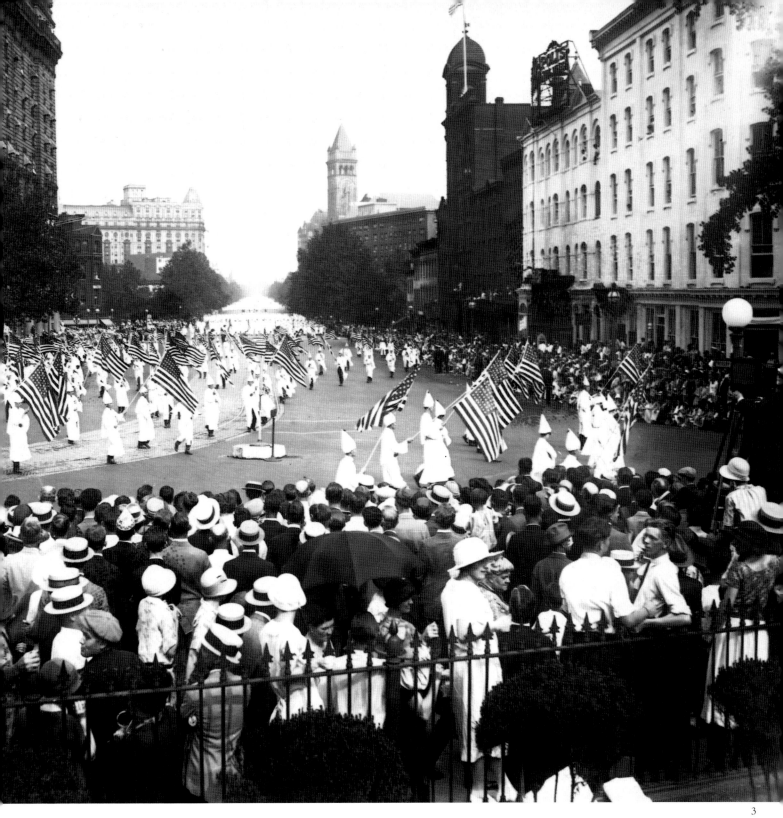

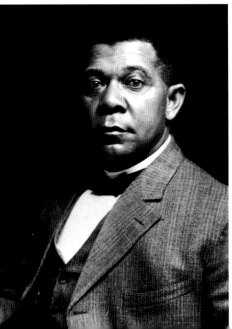

1925 40 000 Mitglieder des Ku-Klux-Klan über die Pennsylvania Avenue in Washington, DC. W. E. B. Du Bois (4) und Booker T. Washington (5), zwei Afroamerikaner, die in Harvard studiert hatten und schwarze Amerikaner aufriefen, sich zu organisieren: »Die Zeit ist mehr als reif, daß Männer, die an Freiheit und Entwicklung der Neger glauben, entschlossen und aggressiv zur Tat schreiten«, schrieb Du Bois 1905.

Une nation divisée

(1) En juillet 1917, la toute nouvelle *National Association of Coloured People* (Association Nationale des Gens de Couleur), défila pacifiquement pour réclamer des lois anti-lynchage. (2) Les policiers appelés pour réprimer des émeutes raciales à Chicago en juillet 1919 reçurent le conseil suivant: « Ne faites aucune distinction de couleur. Un manifestant blanc est aussi dangereux qu'un manifestant noir. » (3) Au faîte de leur puissance, 40 000 membres du Ku Klux Klan paradent sur Pennsylvania Avenue, Washington DC, en juillet 1925. W. E. B. Du Bois (4) et Booker T. Washington (5), deux Afro-Américains de Harvard qui incitèrent les Noirs américains à s'organiser. « Le temps semble plus que venu, » écrivait Du Bois en 1905, «pour une action déterminée et offensive de la part d'hommes qui croient à la liberté et à la promotion des Noirs. »

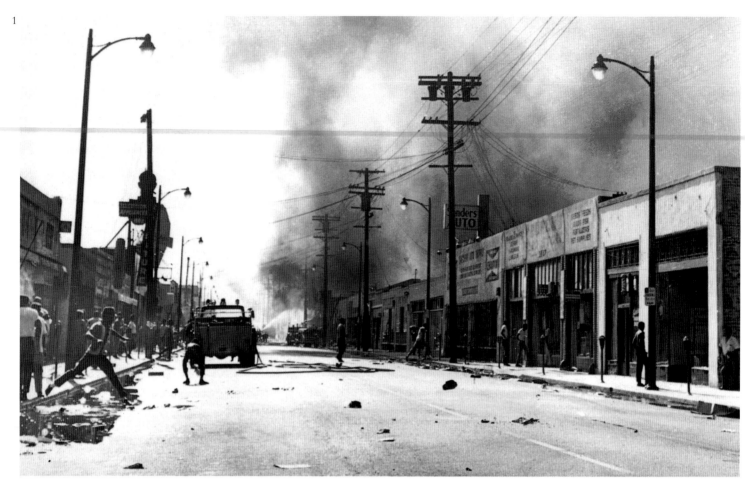

Forty Years On

The Second World War did much to raise the political consciousness of black Americans, especially those men and women who served in the armed forces. After the Civil Rights campaigns of the 1950s, the battle was on for political rights – in areas of the South more than 90 per cent of black Americans had been prevented from registering to vote. By 1965, tension between black and white had reached breaking point in cities all over the United States: Newark, Detroit, and (1) the Watts district of Los Angeles. (3) Extreme police force, usually white, was used to arrest those suspected of rioting, and (2) looters were often shot in the act.

Vierzig Jahre später

Der Zweite Weltkrieg trug erheblich dazu bei, das politische Bewußtsein schwarzer Amerikaner zu schärfen, zumal bei Männern und Frauen, die in den Streitkräften gedient hatten. Nach den Bürgerrechtskampagnen der fünfziger Jahre entbrannte der Kampf um politische Rechte; in einigen Gegenden der Südstaaten wurden mehr als 90 Prozent der schwarzen Amerikaner daran gehindert, sich zu den Wahlen eintragen zu lassen. Bis 1965 hatten die Spannungen zwischen Schwarzen und Weißen in vielen Städten der USA den Zerreißpunkt erreicht: in Newark, Detroit und (1) im Watts District von Los Angeles. (3) Vornehmlich weiße Beamte setzten extreme Polizeigewalt ein, um mutmaßliche Unruhestifter festzunehmen, und Plünderer wurden oft auf frischer Tat erschossen (2).

Quarante ans plus tard

La Seconde Guerre Mondiale contribua largement à la prise de conscience politique des Noirs américains, notamment chez les hommes et les femmes qui servirent dans les forces armées. Aux campagnes pour les droits civils dans les années 1950 succédèrent celles pour les droits politiques – dans des régions comme le Sud, plus de 90 % des Noirs américains n'avaient pu voter. En 1965, la tension entre les Noirs et les Blancs avait atteint le point de rupture dans nombre de villes à travers les Etats-Unis: Newark, Detroit et (1) le district de Watts à Los Angeles. (3) Une force de police spéciale, habituellement blanche, était requise pour arrêter ceux qui étaient soupçonnés de provoquer des émeutes et (2) les pilleurs étaient souvent abattus en pleine action.

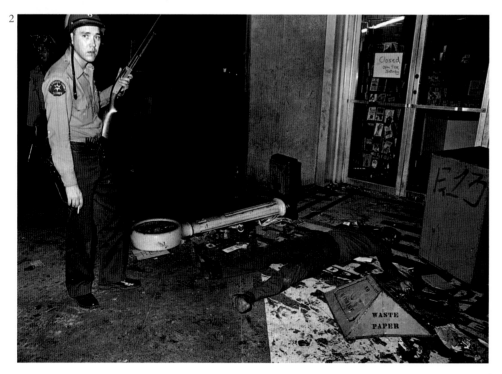

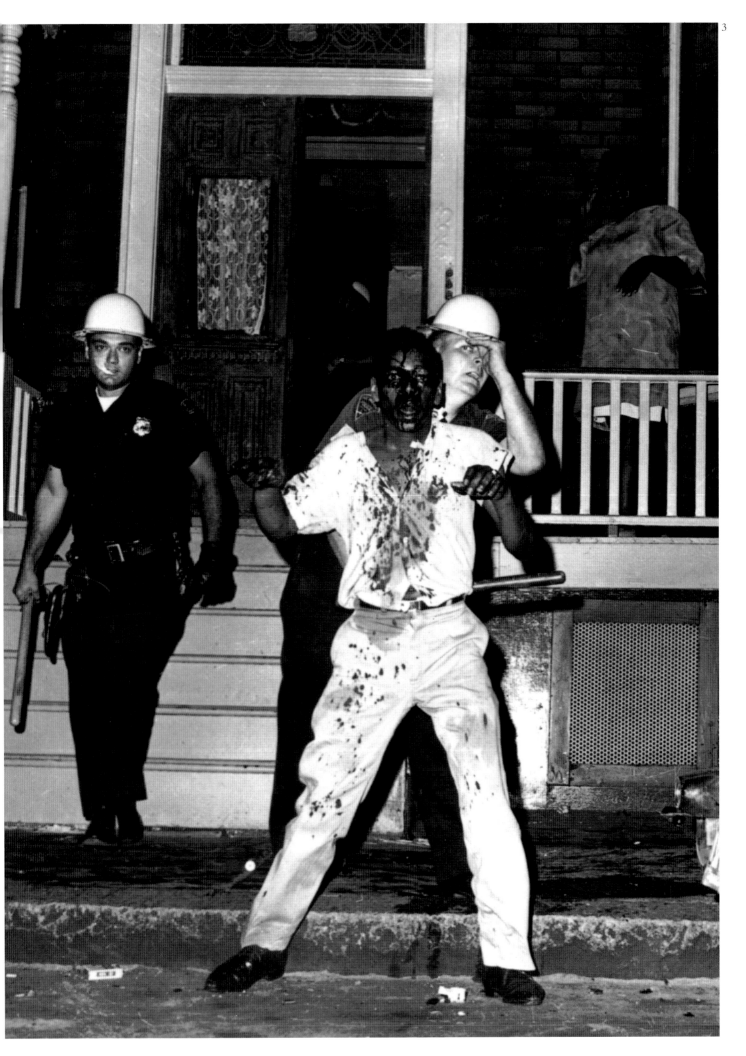

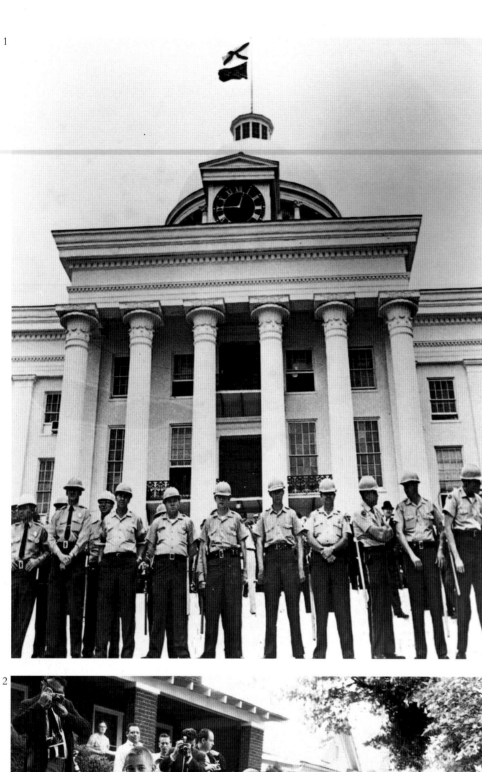

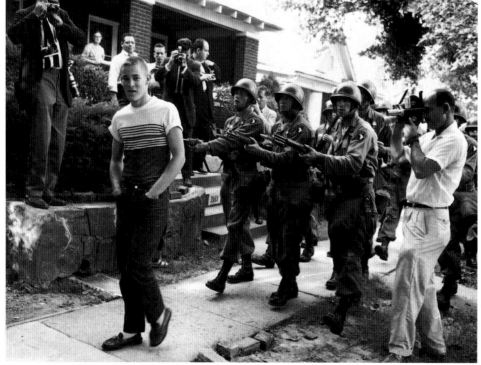

Civil Rights

After the success of the de-segregation campaigns in public transport, focus shifted to diners, rest-rooms and education. In March 1965 Martin Luther King Jnr led the first march from Selma, Alabama, to Montgomery, but the marchers never reached the State Capitol and were violently beaten back. (1) The second march triumphantly entered Montgomery, to find the Capitol heavily guarded. (2) It took 1,000 paratroopers and 10,000 of the Arkansas National Guard to convince white students and others that black students had the right to enter the Little Rock Central High School

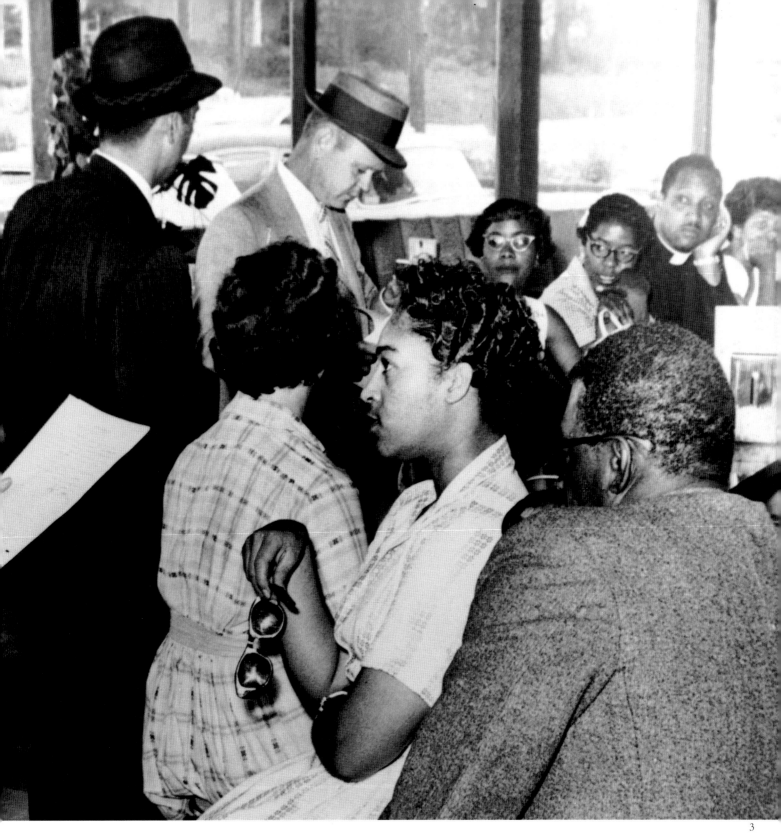

in September 1957. (3) Blacks and whites join in a sit-in protest at Rockville, Maryland.

Bürgerrechte

Nach dem Erfolg der Kampagnen zur Aufhebung der Rassentrennung in den öffentlichen Verkehrsmitteln verlagerte sich der Schwerpunkt auf Lokale, Toiletten und Schulen. Im März 1965 führte Martin Luther King jr. den ersten Protestmarsch von Selma, Alabama, nach Montgomery; die Demonstranten erreichten jedoch die Hauptstadt des Bundesstaates nicht, sondern wurden gewaltsam zurückgeschlagen. (1) Der zweite Protestmarsch zog triumphierend in Montgomery ein und stieß in der Hauptstadt des Bundesstaates auf ein starkes Polizeiaufgebot. (2) Im September 1957 mußten 1000 Fallschirmjäger und 10 000 Männer der Arkansas National Guards weiße Studenten und andere Weiße davon überzeugen, daß schwarze Studenten das Recht hatten, die Little Rock Central High School zu besuchen. (3) Schwarze und Weiße beteiligen sich an einem Sit-in in Rockville, Maryland.

Droits Civils

Après le succès des campagnes de déségrégation dans les transports publics, l'attention se concentra sur les restaurants, les toilettes publiques et l'éducation. En mars 1965, Martin Luther King Jr. mena la première marche de Selma, Alabama, à Montgomery mais les manifestants, violemment dispersés, n'atteignirent jamais le Capitole. (1) Le second défilé pénétra triomphalement à Montgomery, et se heurta à un Capitole sévèrement gardé. (2) Il fallut 1000 parachutistes et 10 000 membres de la Garde Nationale d'Arkansas pour convaincre, en septembre 1957, les étudiants blancs et la foule que les Noirs avaient le droit d'entrer à l'université de Little Rock. (3) Blancs et Noirs unis lors d'un sit-in de protestation à Rockville, Maryland.

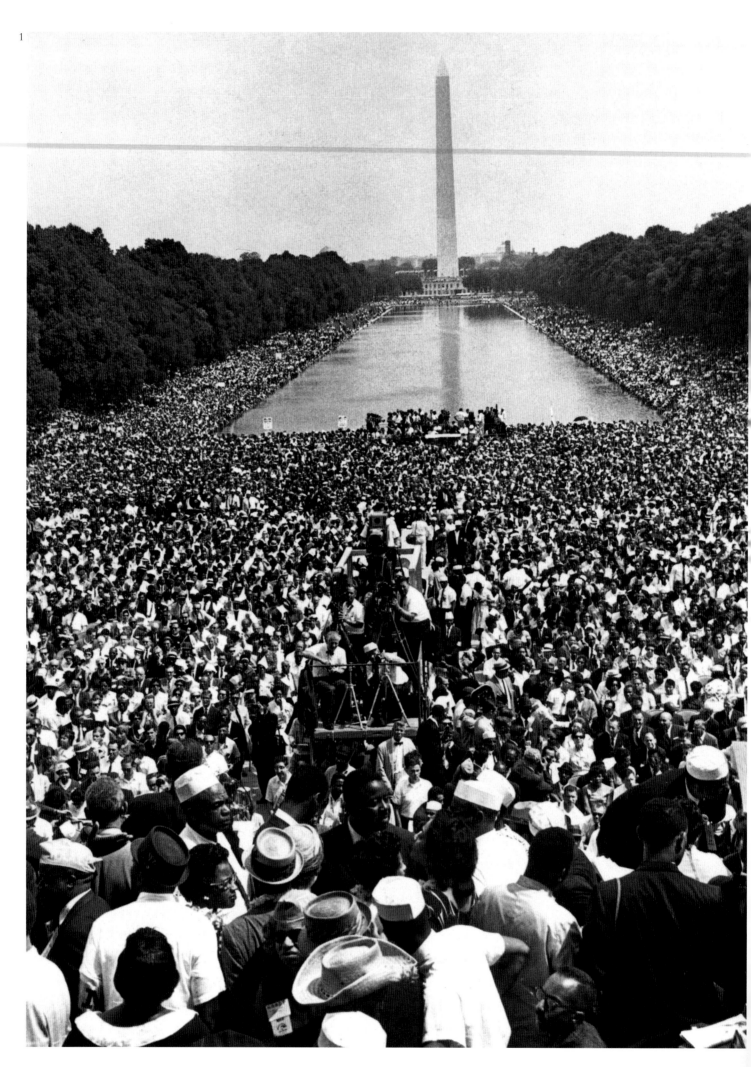

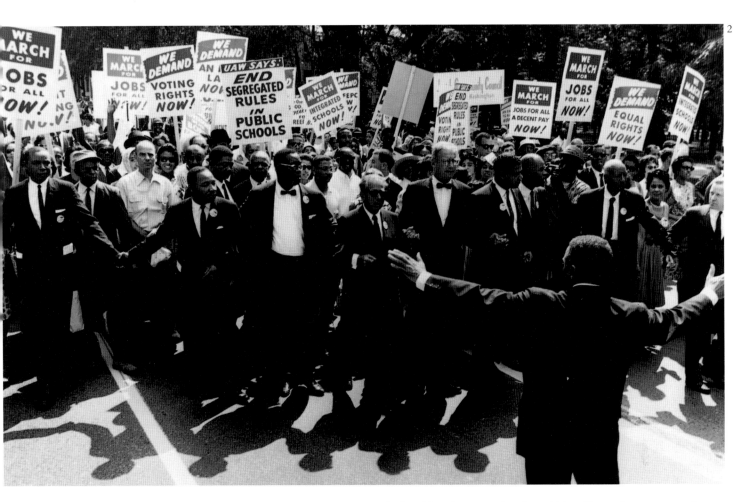

The March on Washington

(1) In August 1963, 200,000 protesters gathered at the Washington Monument. (2) They demanded equal rights for 20 million black Americans to education, jobs and the vote. President Kennedy's administration, fearful of revolution, encouraged moderate civil rights leaders to join the march and the event passed off peacefully, much to Malcolm X's fury. He regarded Kennedy's action as hijacking the march, and referred to it as 'The Farce on Washington'. (3) Martin Luther King Jr addresses crowds at the Lincoln Memorial. After the march, Kennedy promised to press Congress to pass the Civil Rights Bill and eliminate discrimination in education.

Der Marsch auf Washington

(1) Im August 1963 versammelten sich 200 000 Demonstranten am Washington Monument. (2) Sie forderten für 20 Millionen schwarze Amerikaner gleiches Recht auf Bildung, Arbeit und Wahlrecht. Die Regierung unter Präsident Kennedy bewegte aus Angst vor einer Revolution gemäßigte Führer der Bürgerrechtsbewegung, an dem Protestmarsch teilzunehmen, und so verlief die Demonstration sehr zu Malcom X' Verärgerung friedlich. Er war der Meinung, daß Kennedy den Marsch für sich vereinnahmt hatte, und bezeichnete ihn als »die Farce von Washington«. (3) Martin Luther King jr. spricht vor dem Lincoln Memorial zur Menge. Nach dem Marsch versprach Kennedy, den Kongreß zur Verabschiedung der Bürgerrechtsgesetze und zur Abschaffung der Diskriminierung im Bildungswesen zu drängen.

La marche sur Washington

(1) En août 1963, 200 000 manifestants se rassemblèrent au Monument de Washington. (2) Ils réclamaient des droits égaux pour les 20 millions de Noirs américains dans les domaines de l'éducation, du travail et du vote. Craignant une révolution, l'administration du président Kennedy encouragea les dirigeants modérés du mouvement pour les droits civils à participer à la manifestation qui se déroula pacifiquement – trop à la grande colère de Malcolm X pour qui Kennedy avait réussi à en détourner le sens et qui qualifia l'événement de «farce de Washington.» (3) Martin Luther King Jr. harangue la foule au Mémorial de Lincoln. Suite à la manifestation, Kennedy promit d'inciter le Congrès à adopter le Projet de Loi sur les Droits Civils et à interdire la discrimination dans les écoles.

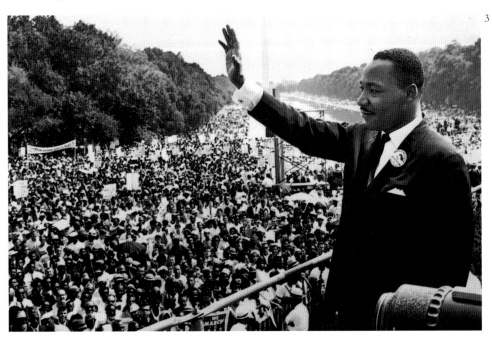

Paul Krüger

'Oom Paul', as he was called by the Afrikaners, was a lifelong opponent of British rule in South Africa. He trekked with the Boers to Natal, the Orange Free State, and finally Transvaal, and led them in both the first and second wars against the British in 1881 and 1899 respectively. He has perhaps best been described by James Morris: 'A coarse man, a man of spittoons and pipe-smoke, homespun philosophies on the stoep, religious bigotry ... but he moved among his people like a prophet.'

Paul Krüger

»Oom Paul«, wie die Afrikander ihn nannten, war zeit seines Lebens ein Gegner der britischen Herrschaft in Südafrika. Er zog mit den Buren nach Natal, in den Oranjefreistaat und schließlich nach Transvaal und führte sie im ersten und im zweiten Burenkrieg 1881 und 1899 gegen die Briten an. Am besten hat ihn vielleicht James Morris beschrieben: »Ein rauher Mann, ein Mann der Spucknäpfe und des Pfeifenrauchs, der auf der Veranda hausgesponnenen Philosophien, der religiösen Bigotterie ..., aber unter seinen Landsleuten trat er auf wie ein Prophet.«

Paul Krüger

«Oncle Paul», ainsi que l'appelaient les Afrikaners, s'opposa toujours à la domination britannique. Accompagnant les Boers dans leurs expéditions vers le Natal, l'Etat libre d'Orange, et enfin le Transvaal, il les entraîna dans les deux guerres contre les Britanniques, respectivement en 1881 et 1899. James Morris donna sans doute de lui la meilleure description: «Un homme grossier, un homme qui crachait et fumait la pipe, professait des philosophies de vérandas ..., un fanatisme religieux ... mais il marchait à côté de son peuple tel un prophète.»

LEO . WEINTHAL . PH

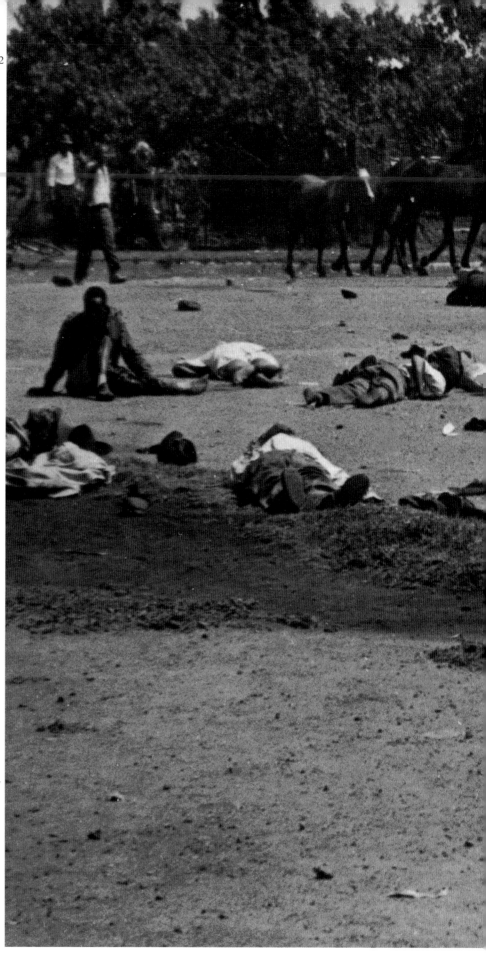

The Sharpeville Massacre

In December 1959, the South African Minister of Defence reportedly told army officers: 'We are arming to shoot down the black masses.' When a black crowd resisted removal from a settlement at Windhoek, police opened fire and killed 14 of them. On 20 March 1960, Robert Sobukwe of the Pan-Africanist Congress called for a non-violent campaign against the Pass Laws: 'We are not going to fight, insult or provoke the police in their lawful duties. Nobody is carrying knives or any dangerous weapons tomorrow.' When 5,000 demonstrators gathered at Sharpeville, on the outskirts of Johannesburg, police killed 69 and injured 180 (2). The dead were unceremoniously removed by police (1).

Das Massaker von Sharpeville

Im Dezember 1959 soll der südafrikanische Verteidigungsminister zu seinen Armeeoffizieren gesagt haben: »Wir rüsten uns, die schwarzen Massen abzuknallen.« Als die schwarze Menge Widerstand gegen die Räumung einer Siedlung in Windhoek leistete, eröffnete die Polizei das Feuer und erschoß 14 Menschen. Am 20. März 1960 rief Robert Sobukwe vom Panafrikanischen Kongreß zu einer gewaltlosen Kampagne gegen die Paßgesetze auf: »Wir werden uns der Polizei bei der Ausübung ihrer gesetzmäßigen Pflicht nicht widersetzen, sie nicht beleidigen oder provozieren. Niemand trägt morgen Messer oder sonstige gefährliche Waffen.« Als sich 5000 Demonstranten in Sharpeville am Rand von Johannisburg versammelten, tötete die Polizei 69 und verletzte 180 von ihnen (2). Die Leichen der Getöteten wurden von der Polizei pietätlos weggeschafft (1).

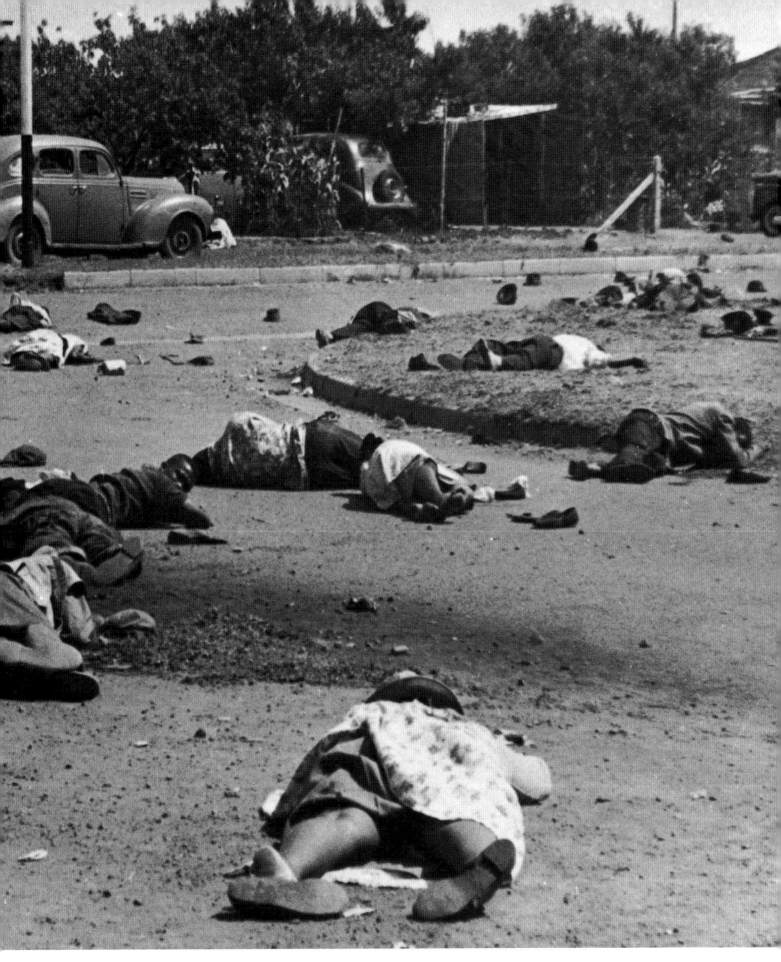

Le massacre de Sharpeville

En décembre 1959, le ministre sud-africain de la Défense aurait déclaré aux officiers de l'armée: «Nous nous armons pour tuer les masses noires.» Lors de la résistance qu'opposa une foule noire au déplacement forcé d'une colonie à Windhoek, la police ouvrit le feu et tua 14 personnes. Le 20 mars 1960, Robert Sobukwe du Congrès Pan-Africain appela à une campagne non-violente contre le régime des laissez-passer: «Nous n'allons pas combattre, insulter ou provoquer la police en exercice légal. Personne ne portera de couteaux ou d'armes demain.»

Lorsque les 5000 manifestants se rassemblèrent à Sharpeville, sur les abords de Johannesburg, la police abattit 69 personnes et en blessa 180 autres (2). Les morts furent enlevés sans ménagement par la police (1).

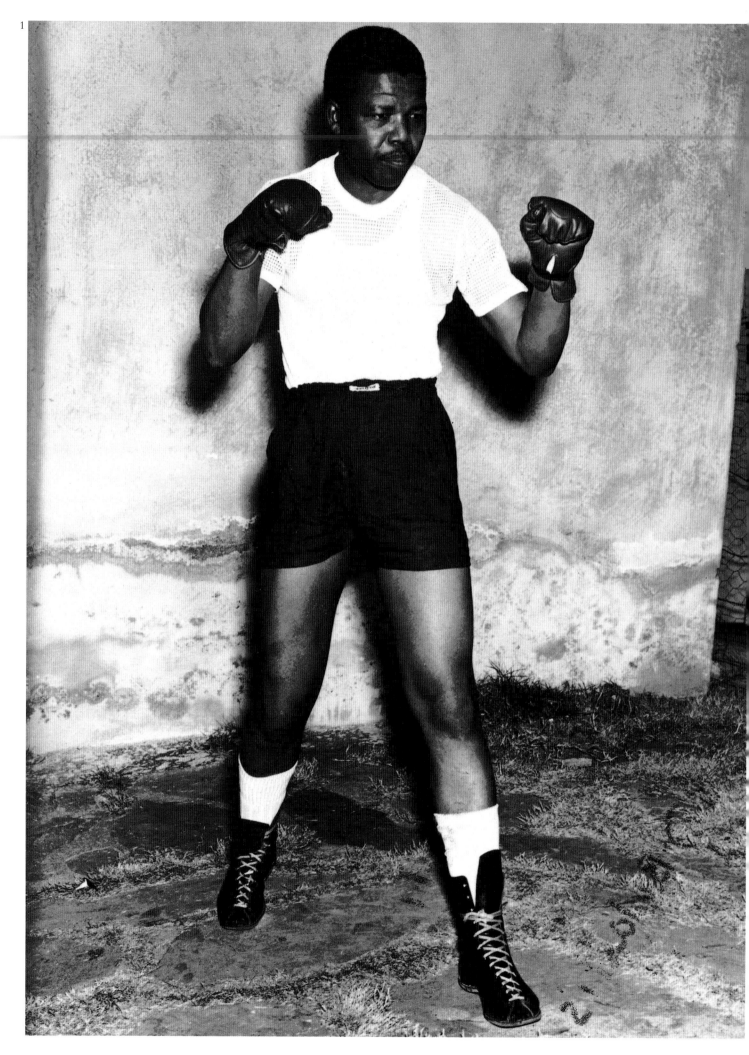

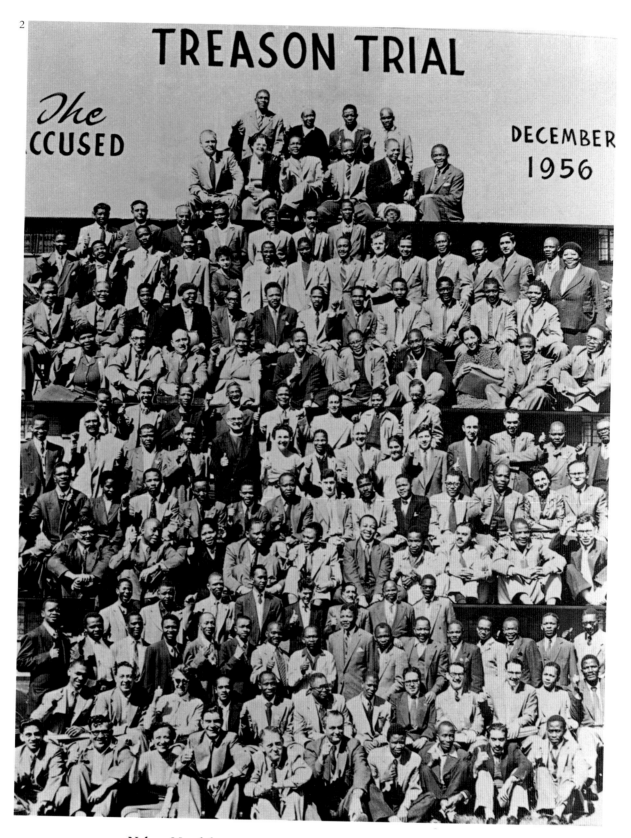

TREASON TRIAL

The
ACCUSED

DECEMBER
1956

Nelson Mandela

(1) In his youth Nelson Mandela took up boxing: 'I trained in a desultory way, and only years later, when I had put on a few more pounds, did I begin to box in earnest'. He was more interested in ballroom dancing; one of his early heroes was Victor Sylvester, the British dance-band leader. (2) In December 1956, Mandela and 143 others were arrested for treason. Mandela is third row up, eighth from the right.

Nelson Mandela

(1) In seiner Jugend begann Nelson Mandela zu boxen: »Ich trainierte planlos, und erst Jahre später, als ich etwas Gewicht zugelegt hatte, begann ich ernsthaft zu boxen.« Das Tanzen interessierte ihn mehr; eins seiner frühen Idole war Victor Sylvester, der britische Leiter einer Tanzband. (2) Im Dezember 1956 wurde Mandela mit 143 anderen wegen Verrats festgenommen. Mandela steht in der dritten Reihe von unten als achter von rechts.

Nelson Mandela

(1) Dans sa jeunesse, Nelson Mandela apprit la boxe: « Je m'entraînais sans méthode, et ce ne fut que des années plus tard, lorsque je pris quelques kilos de plus, que je commençai sérieusement la boxe. » Les salles de danse l'intéressaient nettement plus; l'un de ses premiers héros fut Victor Sylvester, le chef d'un orchestre de danse anglais. (2) En décembre 1956, Mandela et 143 autres personnes furent arrêtés pour trahison. Mandela se trouve au troisième rang, le huitième à partir de la droite.

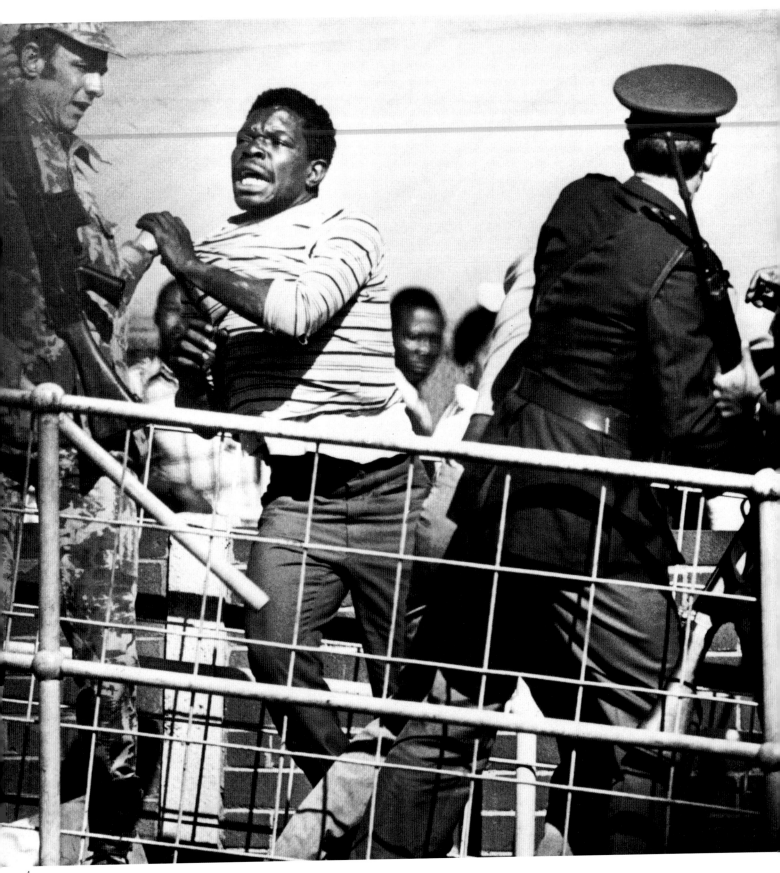

1

Soweto

In 1976 the South African Government introduced Afrikaans as the language of instruction in secondary schools. Few teachers could speak it: hardly any pupils could understand it. They called for a boycott of schools in protest. On 16 June parents and pupils rallied together at Soweto. Police fired on the children. And so began the Soweto riots in which 100 people were killed and over 1,000 injured, and the entire township was wrecked. Some of the worst violence occurred on 21 June. (1) Police clash with rioters. (2) A beer hall is set on fire – nearby is a burnt-out bus. (3) Rioters gather behind hastily constructed road-blocks.

Soweto

1976 führte die südafrikanische Regierung Afrikaans als Unterrichtssprache in weiterbildenden Schulen ein. Nur wenige Lehrer sprachen diese Sprache, und kaum ein Schüler verstand sie. Sie riefen aus Protest zu einem Schulboykott auf. Am 16. Juni scharten sich Eltern und Schüler in Soweto zusammen. Die Polizei schoß auf die Kinder. So begannen die Unruhen von Soweto, bei

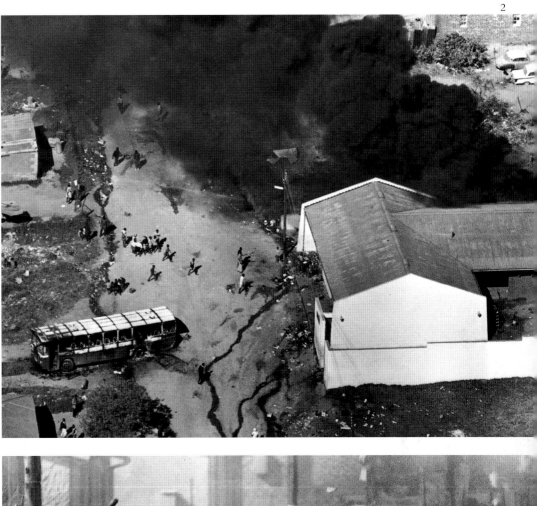

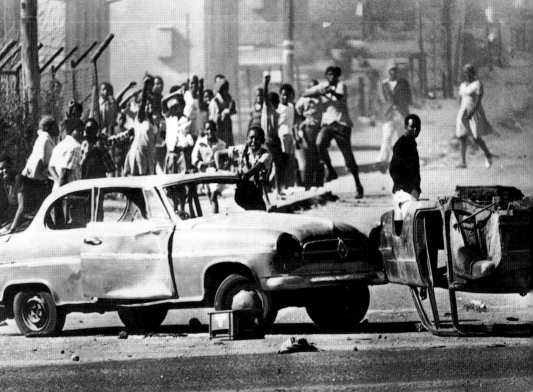

lenen 100 Menschen getötet, über 1000
verletzt und der gesamte Stadtteil verwüstet
wurden. Zu den schlimmsten Ausschreitun-
gen kam es am 21. Juni. (1) Zusammenstöße
zwischen Polizei und Demonstranten.
(2) Ein Bierlokal wird in Brand gesetzt –
daneben ein ausgebrannter Bus. (3) Demon-
stranten verschanzen sich hinter eilig errich-
teten Straßensperren.

Soweto

En 1976, le gouvernement sud-africain
introduisit l'afrikaans comme langue officielle
dans les établissements d'enseignement
secondaire. Peu de professeurs le parlaient:
encore moins d'élèves le comprenaient. Ils
protestèrent en appelant à un boycott des
écoles. Le 16 juin, les parents et les élèves se
rassemblèrent à Soweto. La police fit feu sur
les enfants. Ainsi commencèrent les émeutes

de Soweto au cours desquelles 100 personnes
trouvèrent la mort et plus de 1000 autres
furent blessées, tandis que l'ensemble de la
commune était dévastée. L'un des heurts les
plus terribles se produisit le 21 juin.
(1) Affrontement entre la police et les mani-
festants. (2) Un entrepôt de bière est incendié
– à côté un bus calciné. (3) Les émeutiers se
regroupent derrière des barrages routiers
élevés à la hâte.

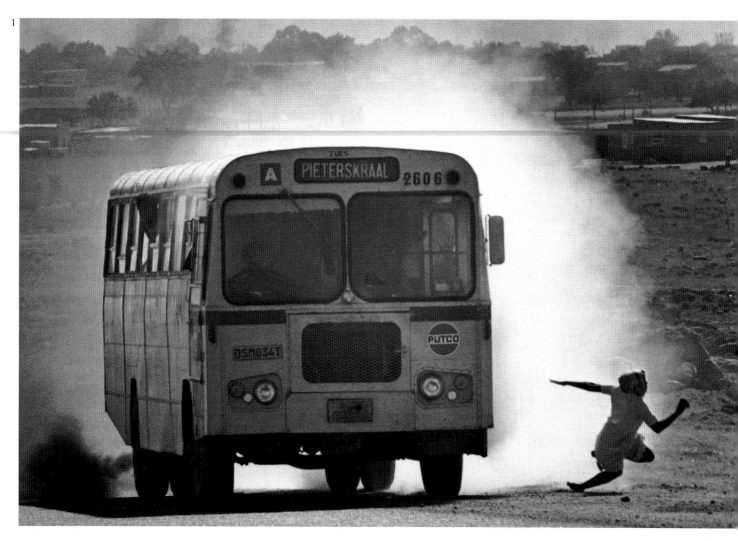

South Africa

(1) In October 1986 police used tear gas to break up a meeting on the homelands' independence – here a woman falls from a gas-filled bus. (2) In March 1986 they beat protesting students. (3) During his 26 years in prison (1964-90) Mandela continued to be the leading figure in South African politics. His supporters carry his poster at the funeral following the police killing of seven African National Congress members in Capetown, 1986. (Overleaf) During the presidential campaign in April 1994, ANC supporters perch on a pro-Mandela billboard in South Africa's first ever multi-racial elections.

Südafrika

(1) Im Oktober 1986 setzte die Polizei Tränengas ein, um eine Versammlung zur Unabhängigkeit der Homelands aufzulösen – hier fällt gerade eine Frau aus einem Bus voller Tränengas. (2) Im März 1986 schlug die Polizei auf protestierende Studenten ein. (3) Auch während seiner sechsundzwanzigjährigen Haft (1964-90) blieb Nelson Mandela die führende Persönlichkeit in der Politik Südafrikas. Seine Anhänger führten sein Bild bei der Beerdigung von sieben Mitgliedern des Afrikanischen Nationalkongresses mit, die 1986 in Kapstadt von der Polizei erschossen wurden. (Nächste Seite) Während der Präsidentschaftswahlen im April 1994 – die erste Wahl in Südafrika, an der alle Rassen beteiligt waren – sitzen ANC-Anhänger auf einem Wahlplakat für Mandela.

Afrique du Sud

(1) En octobre 1986, la police utilisa les gaz lacrymogènes pour disperser un meeting sur l'indépendance des homelands – ici, une femme tombe d'un bus empli de gaz. (2) En mars 1986, ils frappèrent des étudiants qui manifestaient. (3) Tout au long de ses 26 années d'incarcération (1964-90), Mandela ne cessa de dominer la scène politique sud-africaine. Ses partisans portent son image lors des funérailles des sept membres du Congrès National Africain abattus par la police à Capetown, en 1986. (Page suivante) Au cours de la campagne présidentielle d'avril 1994, les fidèles de l'ANC brandissent un panneau pro-Mandela pour les toutes premières élections multiraciales.

2

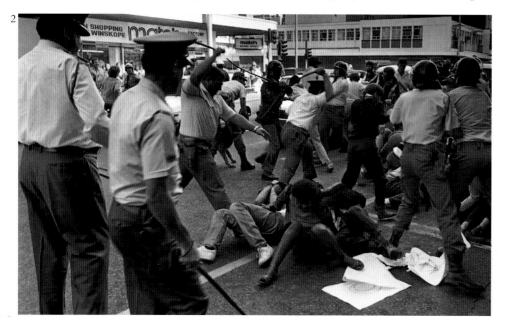

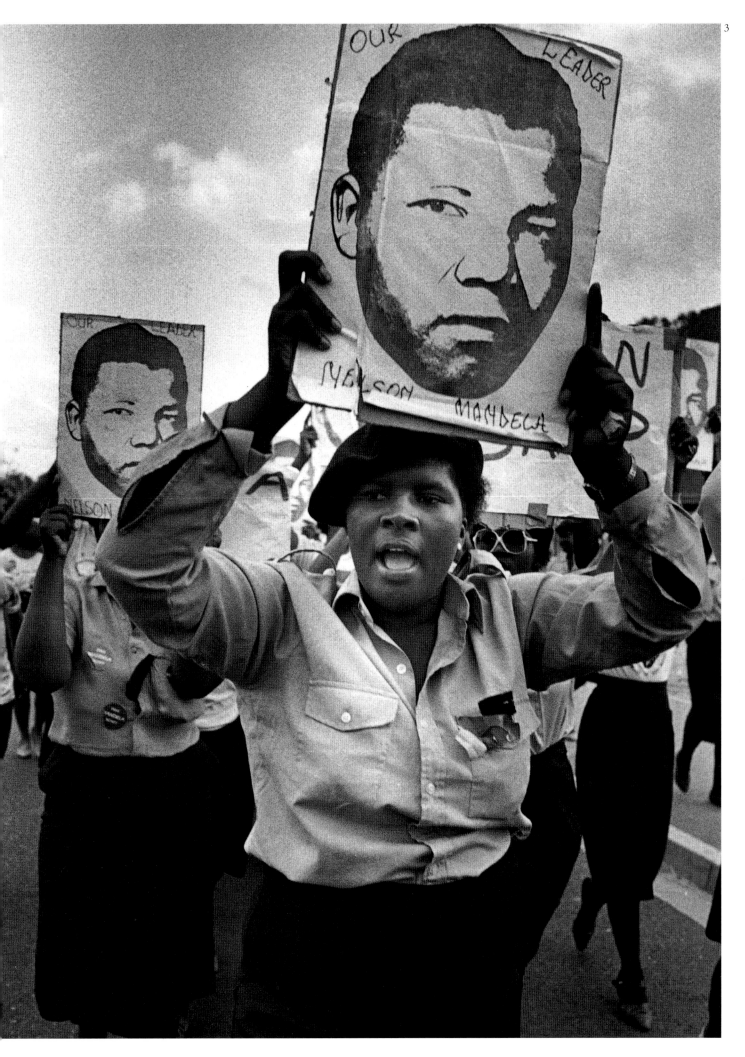

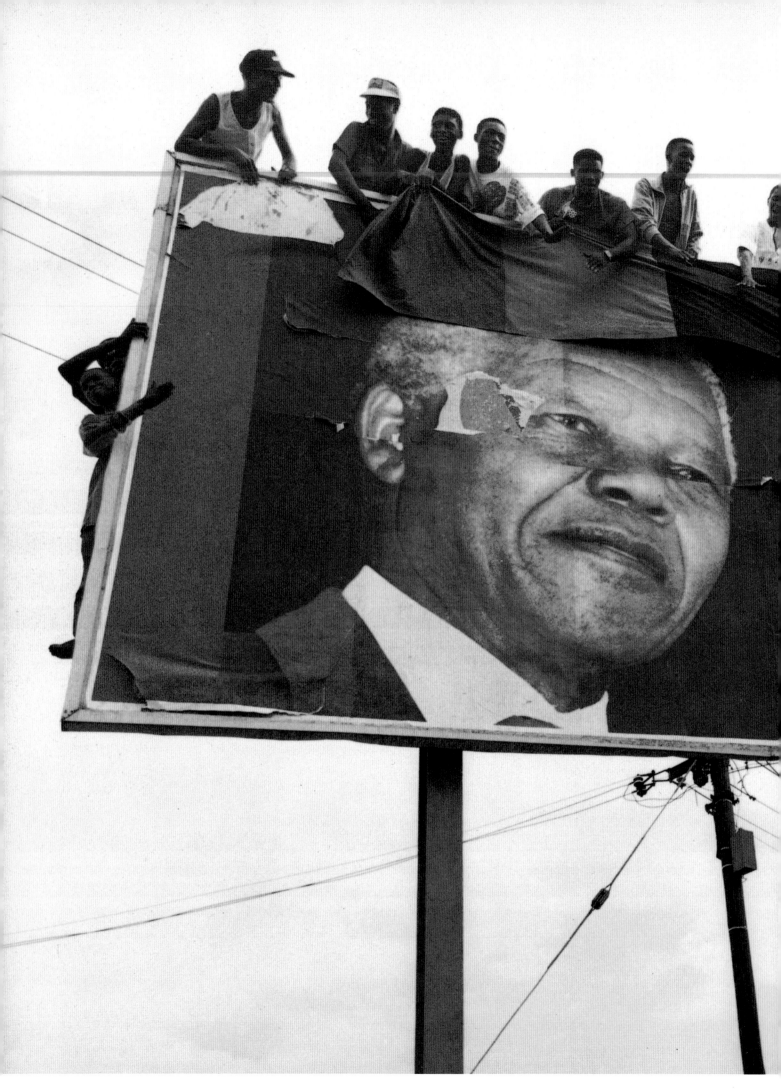

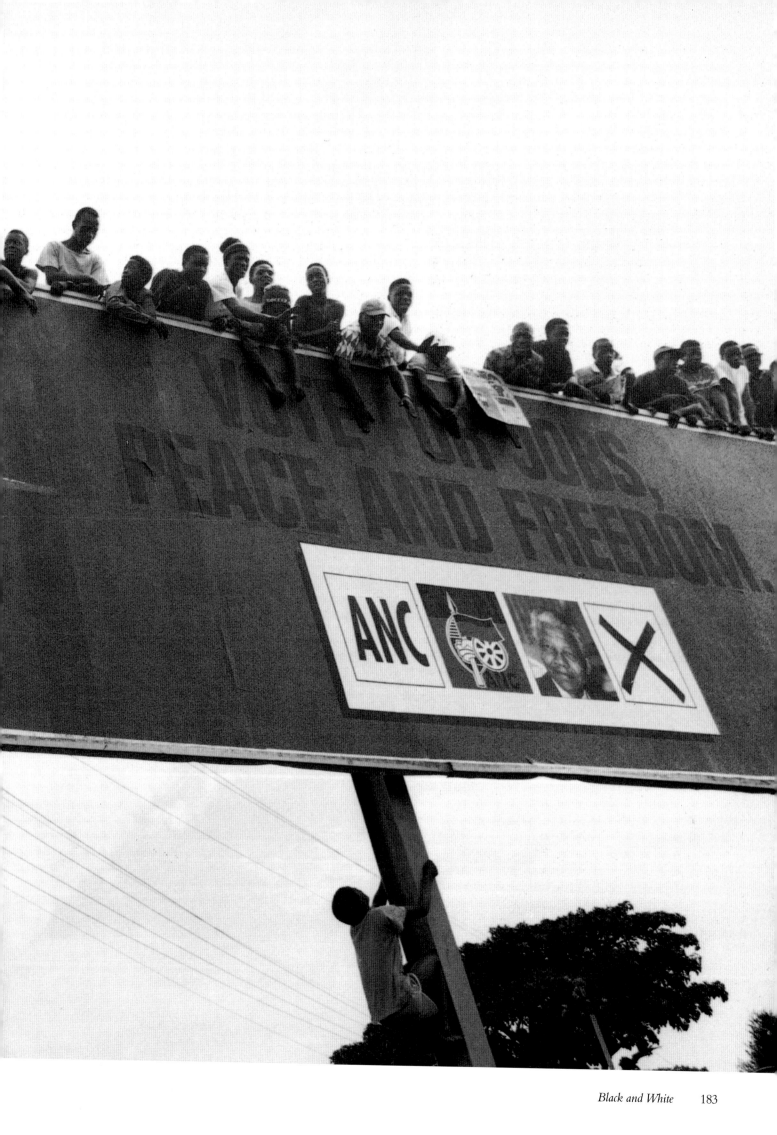

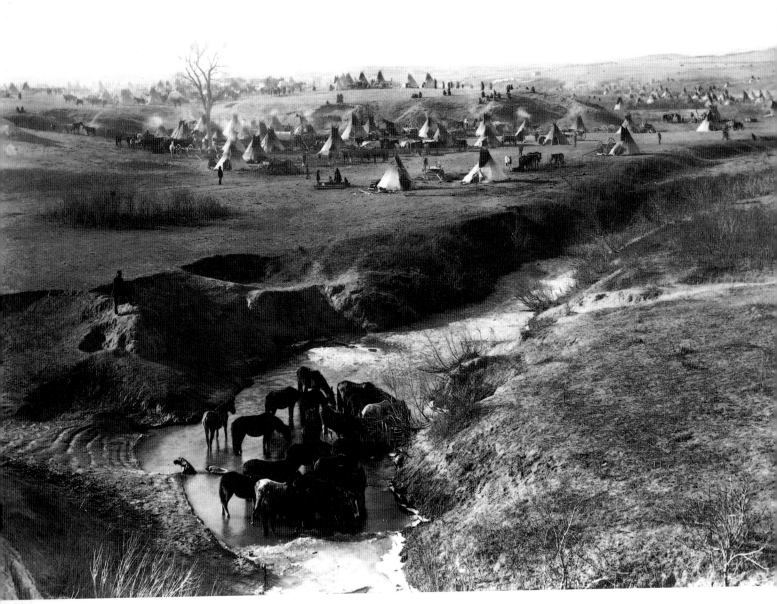

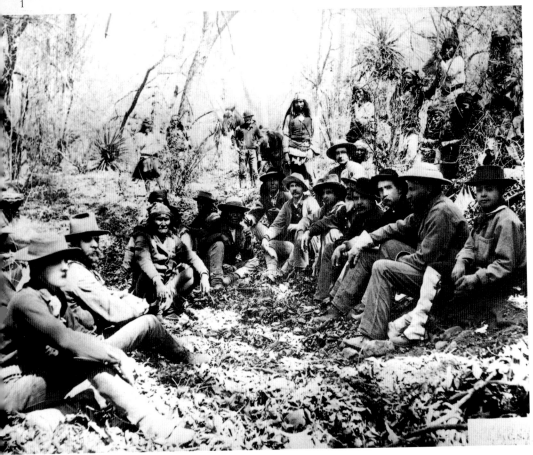

Bury My Heart at Wounded Knee

When the Sioux annihilated Custer and his command at the Little Big Horn in 1876, they signed their own death warrant. Ten years later, the Ghost Dance Movement appeared to threaten a revival of Sioux pride. It produced visions and dreams of dead warriors rising again. (1) The Sioux were massacred at Wounded Knee, South Dakota on 29 December 1890. (3) Their bodies were flung into mass graves. (2) General George Crook and his staff meet with Apache chiefs. It was Crook who accepted Cochise's surrender in 1871. (4) Indian prisoners at Fort Mansion, 1875. The warrior seated, centre, is Wohaw.

Begrabt mein Herz
an der Biegung des Flusses

Als die Sioux 1876 General Custer und seine Truppe am Little Big Horn vernichtend schlugen, unterschrieben sie ihr eigenes Todesurteil. Zehn Jahre später schien der Sioux-Stolz unter der Bewegung der Geistertänzer zu neuem Leben erwacht. Sie produzierte Visionen und Träume von toten Kriegern, die wiederauferstanden. (1) Am 29. Dezember 1890 kam es am Wounded Knee in

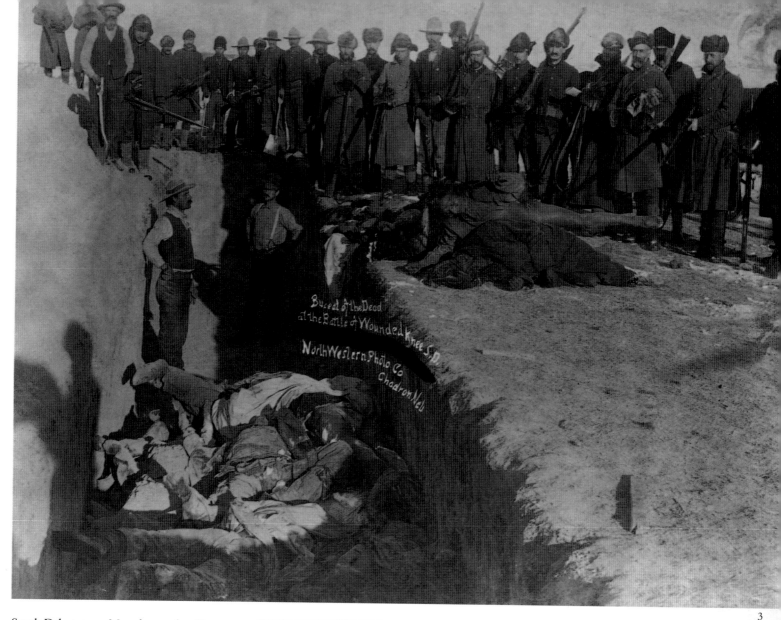

South Dakota zum Massaker an den Sioux.
(3) Ihre Leichen wurden in Massengräber
geworfen. (2) General George Crook und
sein Stab treffen sich mit Apachen-Häuptlin-
gen. Crook hatte 1871 die Kapitulation von
Cochise entgegengenommen. (4) Gefangene
Indianer in Fort Mansion, 1875. Der Krieger
in der Mitte ist Wohaw.

Enterre mon cœur
En écrasant Custer et ses troupes à Little Big
Horn en 1876, les Sioux signèrent leur
propre arrêt de mort. Dix ans plus tard, le
Ghost Dance Movement (Mouvement de la
Danse Fantôme), basé sur des rêves et des
visions de guerriers morts ressuscitant,
émergeait pour affirmer la renaissance de
l'identité sioux. (1) Les Sioux furent
massacrés à Wounded Knee, dans le sud du
Dakota, le 29 décembre 1890. (3) Leurs corps
furent jetés dans un charnier. (2) Le général
George Crook et son état-major rencontrent
les chefs Apaches. Ce fut Crook qui accepta
la reddition de Cochise en 1871.
(4) Prisonniers indiens au Fort Mansion,
1875. Le guerrier assis au centre est Wohaw.

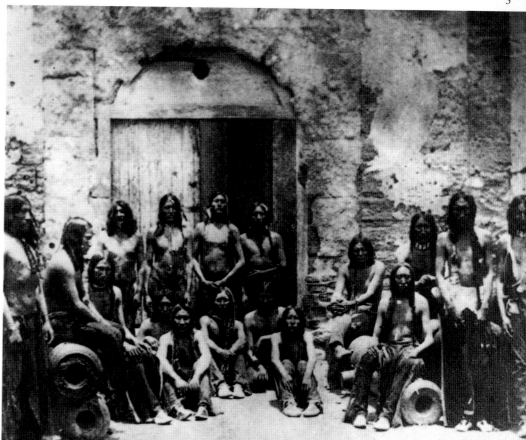

4

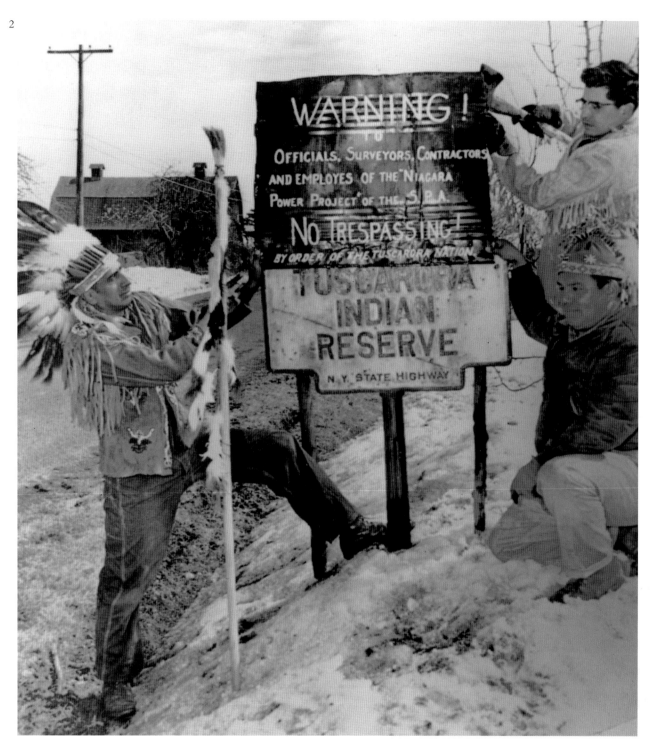

The Native Americans

As black Americans became more assertive in the 1950s, so, too, native Americans began to fight for their civil and political rights. In January 1958, 500 Lumbee Indians raided and broke up a Ku Klux Klan rally in Lumberton, North Carolina. (1) They display a captured Klan flag. (2) In the 1960s the New York Power Authority took land granted 'for ever' from the Tuscarora Indians. The Tuscaroras fought all the way to the Supreme Court, only to lose by one vote. 'Some things are worth more than money,' the dissenting judges said. 'Great nations, like great men, should keep their word.'

Die Ureinwohner Amerikas

Als in den fünfziger Jahren die schwarzen Amerikaner selbstbewußter für ihre Rechte eintraten, begannen auch die Ureinwohner für ihre bürgerlichen und politischen Rechte zu kämpfen. Im Januar 1958 sprengten 500 Lumbee-Indianer eine Versammlung des Ku-Klux-Klan in Lumberton, North Carolina. (1) Sie zeigen eine eroberte Klan-Flagge. (2) In den sechziger Jahren nahmen die New Yorker Stadtwerke den Tuscarora-Indianern Land fort, das man ihnen »für immer« zugestanden hatte. Die Tuscaroras gingen dagegen bis zum Obersten Gerichtshof und verloren wegen einer Stimme. »Manche Dinge sind mehr wert als Geld«, erklärten die überstimmten Richter. »Große Nationen sollten ebenso wie große Männer Wort halten.«

Les Indiens d'Amérique

Encouragés par les revendications des Noirs américains dans les années 1950, les Amérindiens entreprirent de lutter pour leurs propres droits civils et politiques. En janvier 1958, 500 Indiens prirent d'assaut et dispersèrent un rassemblement du Ku Klux Klan à Lumberton, en Caroline du Nord. (1) Ils exhibent un drapeau du KKK. (2) Dans les années 1960, le *New York Power Authority* s'empara des terres concédées « pour toujours » aux Indiens Tuscarora qui défendirent leurs droits jusque devant la Cour Suprême, où ils ne perdirent que d'une seule voix. « Il y a des choses de plus grande valeur que l'argent » déclarèrent les juges mis en minorité. « Les grandes nations, comme les grands hommes, devraient savoir tenir leur parole. »

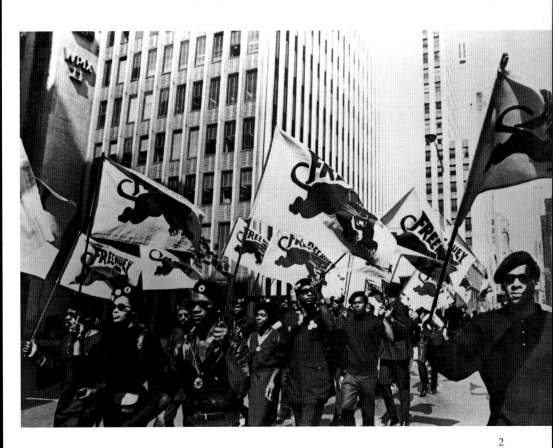

2

Malcolm X

(1) '"Conservatism" in America's politics means "Let's keep the niggers in their place." And "Liberalism" means "Let's keep the kneegrows in their place – but tell them we'll treat them a little better."' Malcolm X addresses Black Muslims in Newark, New Jersey. The Messenger, the Honourable Elijah Muhammud, sits behind him.
(2) Black Panthers, 'the Children of Malcolm', march to a news conference in New York to protest at the trial of one of their members, Huey P. Newton, in July 1968. Newton was later convicted of the voluntary manslaughter of an Oakland policeman.

Malcolm X

(1) »›Konservatismus‹ heißt in der amerikani-schen Politik: ›Halten wir die Nigger auf ih-rem Platz.‹ Und ›Liberalismus‹ heißt: ›Halten wir die *kneegrows* auf ihrem Platz – aber sagt ihnen, daß wir sie etwas besser behandeln werden.«« Malcolm X hält eine Rede vor den *Black Muslims* in Newark, New Jersey. Messenger Elijah Muhammud sitzt hinter ihm. (2) Im Juli 1968 marschieren *Black*

Panthers, die »Kinder Malcolms«, zu einer Pressekonferenz in New York, um gegen den Prozeß gegen eins ihrer Mitglieder, Huey P. Newton, zu protestieren. Newton wurde später wegen Mordes an einem Polizisten aus Oakland verurteilt.

Malcolm X

(1) «‹Conservatisme› en politique américaine, signifie ‹laissons les nègres à leur place.› Et ‹libéralisme› veut dire ‹laissons les *kneegrows* à leur place – mais dites-leur que nous les traiterons un peu mieux»». Malcolm X harangue les *Blacks Muslims* à Newark, New Jersey. Le Messager, l'Honorable Elijah Muhammud, est assis derrière lui. (2) Les *Black Panthers,* les «Enfants de Malcolm», en route vers une conférence de presse à New York pour protester contre le procès de l'un de leurs membres, Huey P. Newton, en juillet 1968. Newton fut par la suite convaincu d'homicide volontaire sur un policier d'Oakland.

1

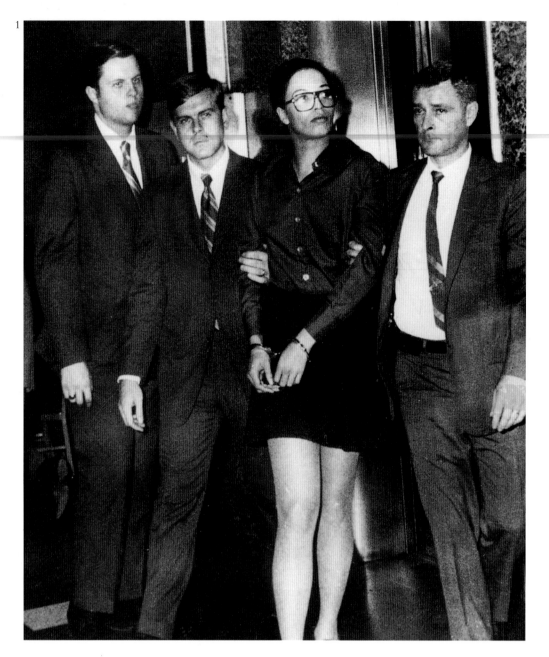

Black Protest

Despite the progress made by the Civil Rights Movement in the United States, many political groups still protested against the treatment of black Americans in the late 1960s and early 1970s. (1) Angela Davis, an Assistant Professor of Philosophy at the University of California, was arrested in New York and charged with implication in the escape of three black prisoners from the Marin County Courthouse. (2) Tommie Smith (right arm raised) and John Carlos (left arm raised), respectively gold and bronze medallists in the Men's 200 Metres at the 1968 Mexico City Olympic Games, give the Black Power salute. They were subsequently suspended from the team.

Schwarzer Protest

Trotz der Fortschritte, die die Bürgerrechtsbewegung in den Vereinigten Staaten erzielte, protestierten Ende der sechziger und Anfang der siebziger Jahre immer noch viele politische Gruppen gegen die Behandlung schwarzer Amerikaner. (1) Angela Davis, Dozentin für Philosophie an der University of California, wurde in New York verhaftet und der Fluchthilfe für drei schwarze Häftlinge aus dem Marin County Courthouse beschuldigt. (2) Tommie Smith (mit erhobenem rechtem Arm) und John Carlos (mit erhobenem linkem Arm), Gold- und Bronzemedaillengewinner im 200-Meter-Lauf der Männer bei der Olympiade 1968 in Mexico City, zeigten bei der Siegerehrung die Faust, den Gruß der Black Panther. Daraufhin wurden sie von der Olympiamannschaft ausgeschlossen.

Révolte Noire

En dépit des progrès accomplis par le Mouvement des Droits Civils aux Etats-Unis, de nombreux groupes politiques dénonçaient encore le traitement infligé aux Noirs américains à la fin des années 1960 et au début des années 1970. (1) Angela Davis, maître assistant en philosophie à l'université de Caroline, fut arrêtée à New York et accusée d'être impliquée dans l'évasion de trois prisonniers noirs du tribunal du comté de Marin. (2) Tommie Smith (bras droit levé) et John Carlos (bras gauche levé), respectivement médailles d'or et de bronze au deux cent mètres hommes aux Jeux Olympiques de Mexico en 1968, exécutent le salut du Black Power. Par la suite, ils furent suspendus de l'équipe.

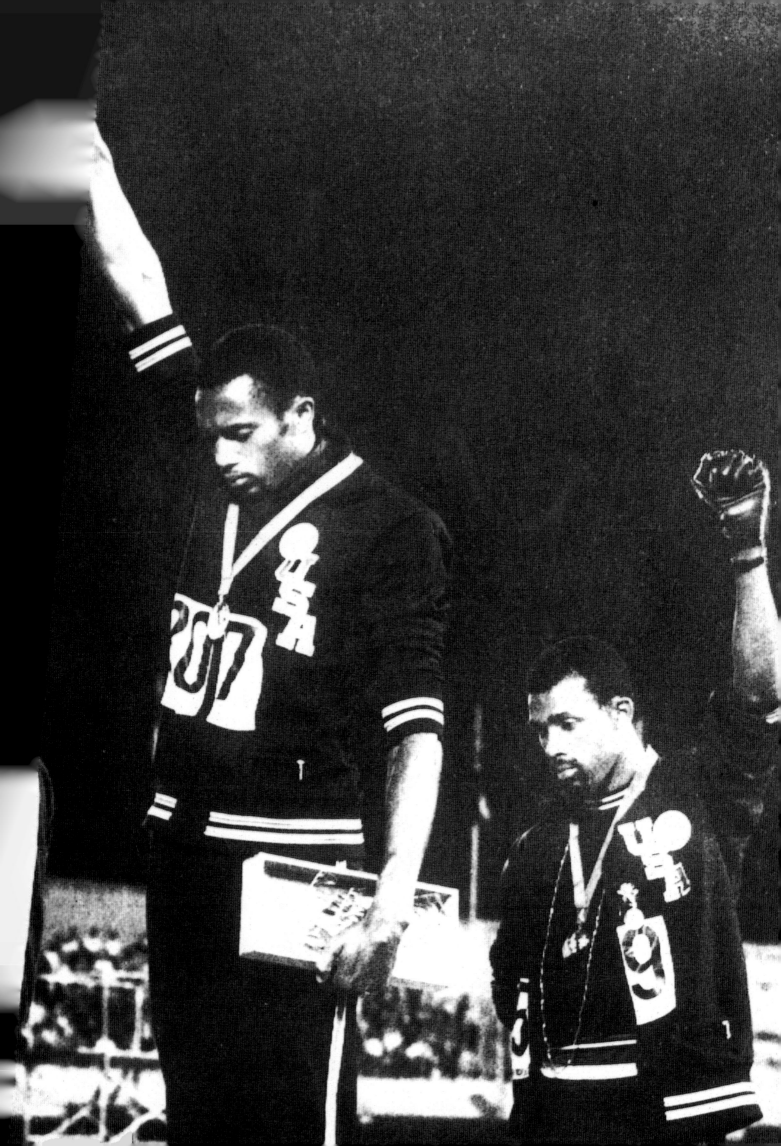

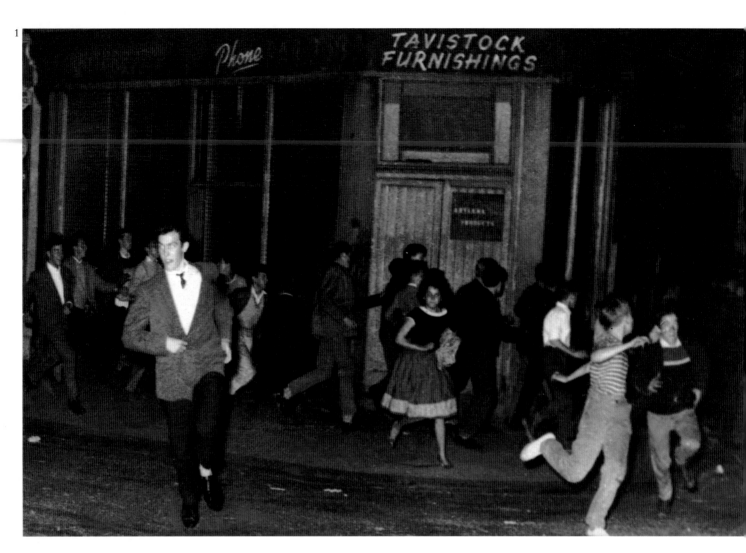

Notting Hill Riots

The thousands of West Indians who had been encouraged to immigrate to Britain in the 1950s had a cold welcome. Getting a job or somewhere to live was never easy, and, in the areas of London where many of them settled, there was often hostility from local people. (1) Some of the worst race riots in Britain took place in Notting Hill in September 1958, largely provoked by white youths. (2) Police attempt to break up a white demonstration, and (3) search a black youth.

Unruhen in Notting Hill

Die Tausende von Immigranten von den Westindischen Inseln, die man in den fünfziger Jahren zur Einwanderung nach Großbritannien ermutigt hatte, wurden kühl empfangen. Arbeit oder Unterkunft zu finden war schwer, und in den Stadtvierteln von London, in denen sie sich niederließen, stießen sie oft auf Feindseligkeit bei den Einheimischen. (1) Einige der schlimmsten Rassenunruhen in Großbritannien brachen im September 1958 in Notting Hill aus, überwiegend provoziert durch weiße Jugendliche. (2) Die Polizei versucht, eine Demonstration von Weißen aufzulösen, und durchsucht einen schwarzen Jugendlichen (3).

Emeutes de Notting Hill

Les milliers d'Antillais encouragés à immigrer en Grande-Bretagne dans les années 1950 furent fraîchement accueillis. Trouver du travail ou un logement n'était jamais facile, et, dans les quartiers de Londres où nombre d'entre eux s'établirent, ils étaient souvent en butte à l'hostilité de la population locale. (1) L'une des pires émeutes raciales de Grande-Bretagne, principalement provoquée par des jeunes Blancs, eut lieu à Notting Hill en septembre 1958. (2) La police tente de disperser une manifestation blanche et (3) fouille un jeune Noir.

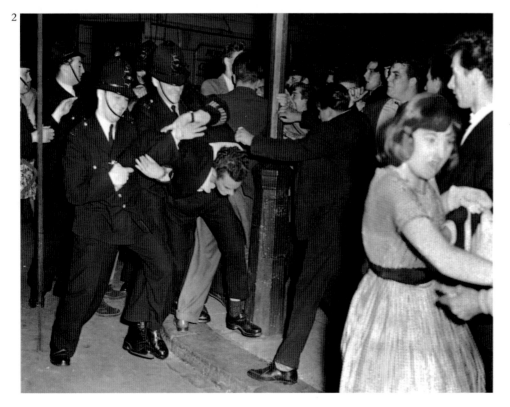

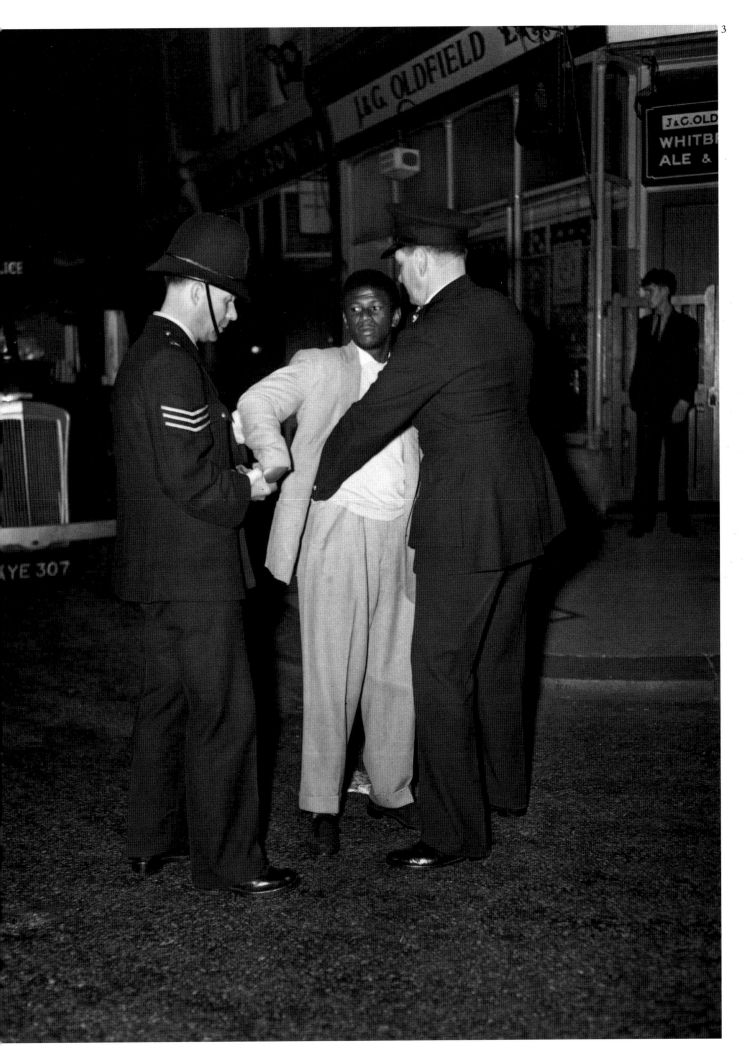

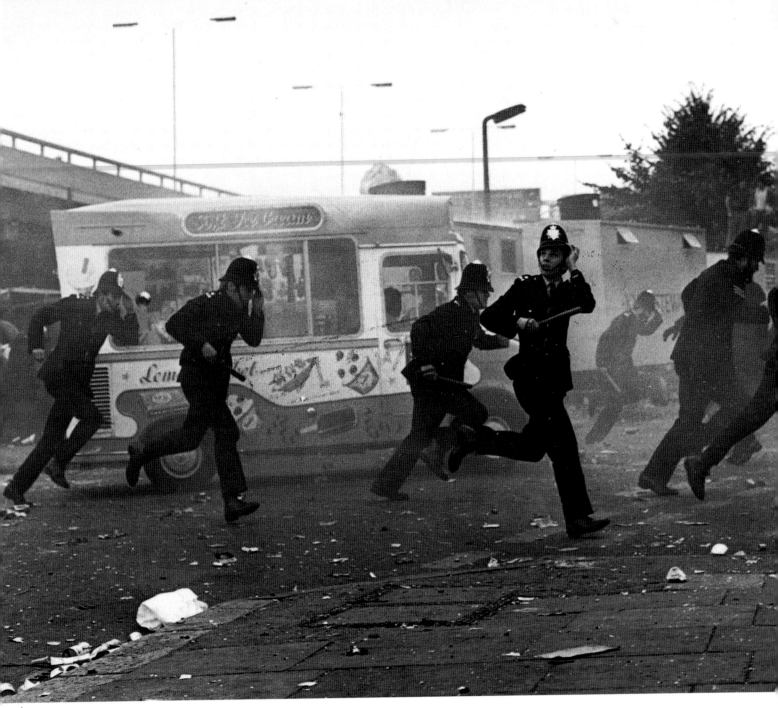

1

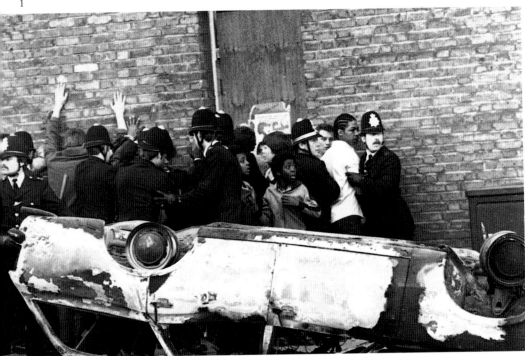

2

City Troubles

There were several summers of discontent in London and Liverpool during the 1970s and 1980s. (1) In 1976 police were again on the streets of Notting Hill, with truncheons at the ready, in the days before riot shields were issued. (3) An anti-police march in August 1981 led to vicious fighting in the Toxteth area of Liverpool. (2, 4) One of the worst riots followed a stabbing incident in Brixton, London, in April 1981. With high unemployment and years of tension between black residents and the police, Brixton suddenly exploded into pitched battles between rioters and police. Shops were looted, houses and cars set on fire. It was a foretaste of what was to come in other British cities such as Bristol and Liverpool.

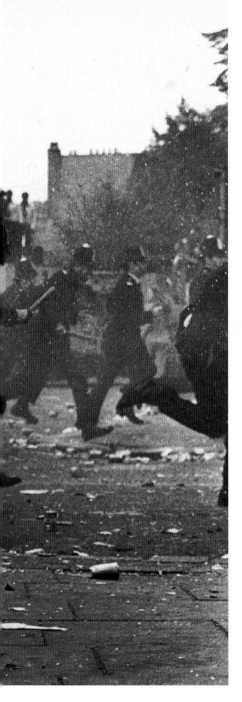

Troubles en ville

Londres et Liverpool connurent de nombreux étés chauds dans les années 1970 et 1980.
(1) En 1976, la police se retrouvait de nouveau dans les rues de Notting Hill, matraques au poing, avant de recourir aux boucliers. (3) Un défilé anti-police en août 1981 provoqua d'horribles combats dans le quartier de Toxteth à Liverpool. (2, 4) L'une des pires émeutes se produisit à la suite d'une rixe au couteau à Brixton, Londres, en avril 1981. Marqué par un chômage élevé et des années de tension entre les résidents noirs et la police, Brixton devint le théâtre d'affrontements entre émeutiers et policiers. Les magasins furent pillés, les maisons et les voitures incendiées. C'était un avant-goût de ce que devaient connaître d'autres villes telles que Bristol et Liverpool.

Unruhen in den Städten

In den siebziger und achtziger Jahren kam es wiederholt im Sommer zu Unruhen in London und Liverpool. (1) 1976 war die Polizei erneut auf den Straßen von Notting Hill im Einsatz, Schlagstöcke parat – Schutzschilde gab es damals noch nicht. (3) Eine Demonstration gegen die Polizei führte im August 1981 zu gewaltsamen Auseinandersetzungen im Viertel Toxteth in Liverpool. (2, 4) Nach einer Messerstecherei kam es im April 1981 in Brixton, London, zu einer der schlimmsten Unruhen. Angesichts hoher Arbeitslosigkeit brachen nach jahrelangen Spannungen zwischen schwarzen Einwohnern und der Polizei in Brixton explosionsartig gewaltsame Kämpfe zwischen Randalierern und der Polizei aus. Geschäfte wurden geplündert, Häuser und Autos in Brand gesetzt. Ein Vorgeschmack auf das, was in anderen britischen Großstädten wie Bristol und Liverpool noch kommen sollte.

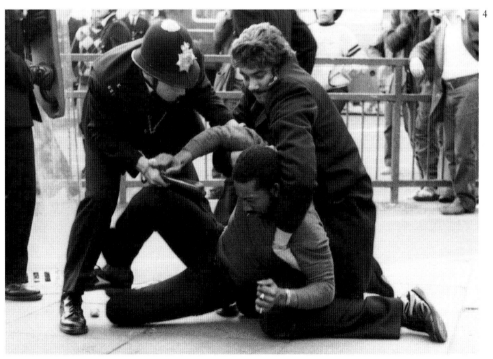

In the Summer of 'Sixty-eight, Paris
students and sympathizers parade in
Montparnasse on 1 June to assert
their opposition to the Gaullist
regime. Two days earlier, de Gaulle
had vowed to use force, if necessary,
to prevent a Communist dictatorship.

Am 1. Juni des 68er-Sommers
marschieren Pariser Studenten und
Sympathisanten auf den Mont-
parnasse, um ihren Widerstand gegen
die gaullistische Regierung zu
demonstrieren. Zwei Tage vorher
hatte de Gaulle geschworen, notfalls
Gewalt anzuwenden, um eine
kommunistische Diktatur zu
verhindern.

Pendant l'été 1968, étudiants et
sympathisants parisiens défilent à
Montparnasse le 1er juin pour appuyer
leur opposition au régime gaulliste.
Deux jours plus tôt, de Gaulle avait
juré de recourir à la force, si
nécessaire, pour éviter une dictature
communiste.

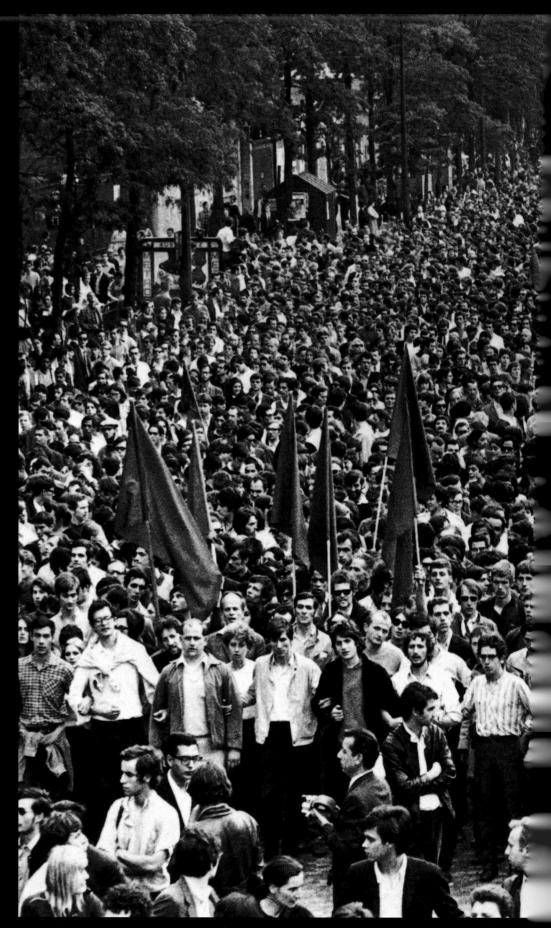

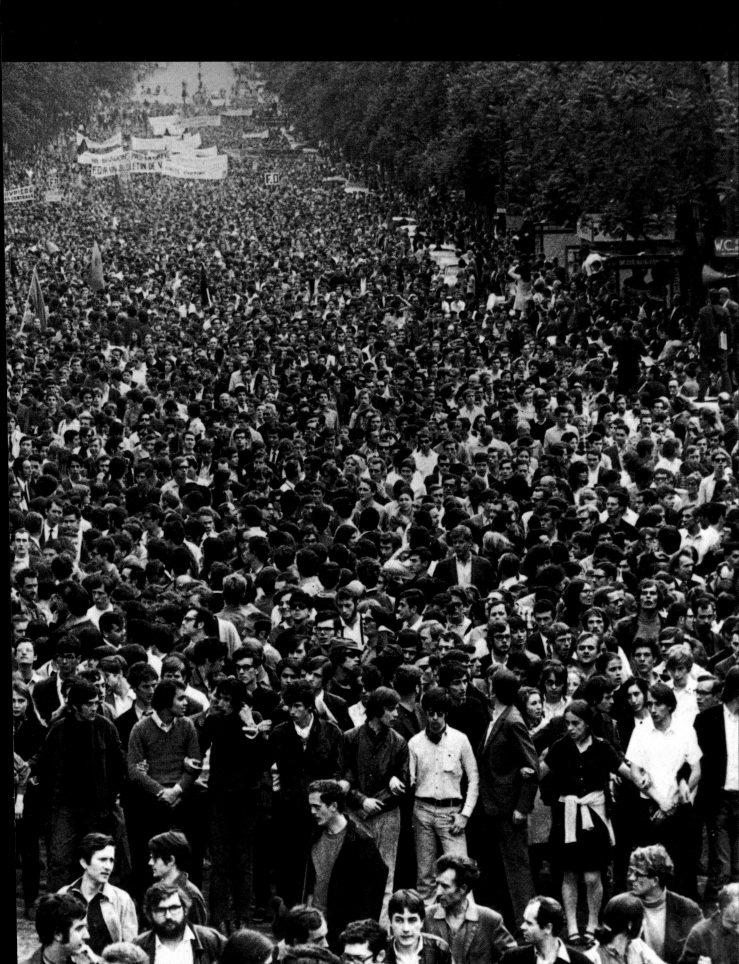

The Power of the People

Nothing frightens those in authority more than the sight (and sound) of a great mass of people gathered together in protest. In the 18th and 19th centuries, the London or Paris mob terrified kings and ministers alike, reminding them of the worst excesses of the French Revolution. When thousands take to the streets it's a sign that they want something done, and a signal to the forces of control, good or bad, that hasty and extreme action will have to be taken to prevent the masses having their way.

Communism and capitalism both had their hundreds of thousands of marching critics in the second half of the 20th century. In the Soviet bloc the demands were for greater freedom for the satellite states of Eastern Europe, for more democracy, for a freer press and radio. In the West, the demands were for an end to the Vietnam war, to nuclear weapons, to the Suez invasion of 1956, to what often appeared a lurch too far to the political Right. In the long run neither democracy nor totalitarianism can assume a comfortable ride in office – people have a habit of coming together to amplify their own individual voices in the throaty chanting of a crowd. 'What do we want?' Well, it could be anything – better pay, better conditions, a fairer tax system, freedom from the threat of a nuclear holocaust, more independence, an end to tyranny. 'When do we want it?' 'Now' – *always* 'now'.

But it's in the long run that the masses often get their way. Hungary in the 1990s is a very different place from that of 1956. The Prague Spring of 1968 took over 30 years to blossom. In the end, those Americans who burnt their draft cards and ran the gauntlet of tear gas and water cannons lived to see the United States pull out of Vietnam. In Britain, the hated poll tax was eventually wiped from the statute book. Even for those French workers and students who so passionately hoped to bring down their republic in 1968 there were a few crumbs of comfort. On 21 April 1969, De Gaulle resigned and slipped away to spend the rest of his days at Colombey-les-Deux-Eglises.

And the modern mass has often found new allies in the press photographs, film and television cameras that record their actions. The pictures that came out of Budapest in 1956 may not have stirred Western governments into action, but they certainly caused a great many fellow travellers throughout the West to desert the Communist cause. And the faith of those that stayed within the Party was further tested by photographs from Prague 12 years later. When Soviet troops stormed the Czechoslovakian national radio station, transmissions ceased with the announcement: 'These may be the last reports you will hear because technical facilities in our hands are insufficient.' But in newspapers the images of unarmed civilians facing mighty tanks went round the world.

Hundreds of thousands of East Berliners gather by the ruins of the Reichstag in an anti-Communist demonstration, September 1948. The demonstration took place at the height of the American air-lift to West Berlin.

Hunderttausende Ostberliner versammeln sich im September 1948 vor den Ruinen des Reichstags zu einer antikommunistischen Demonstration. Die Kundgebung fand auf dem Höhepunkt der amerikanischen Luftbrücke nach Westberlin statt.

En septembre 1948, des centaines de milliers de gens se rassemblent à Berlin-Est près des ruines du Reichstag pour une manifestation anti-communiste. Le pont aérien américain avec Berlin-Ouest est à son apogée.

'The people united, will never be defeated.' Variations on this theme echoed down the streets of Europe and America. Who were the people? Who linked arms and marched through Berlin, Paris, London or Washington DC? Before the Second World War they had been the politically militant of Left or Right, Communists and Fascists; or the unemployed, seeking an active and welcome change from shuffling along in dole queue or breadline. After the war, they were almost anyone: teachers, students, bus drivers, salesmen and women, intellectuals, anarchists, factory workers, mothers and fathers with babies in push-chairs, priests, nuns, shopkeepers and labourers.

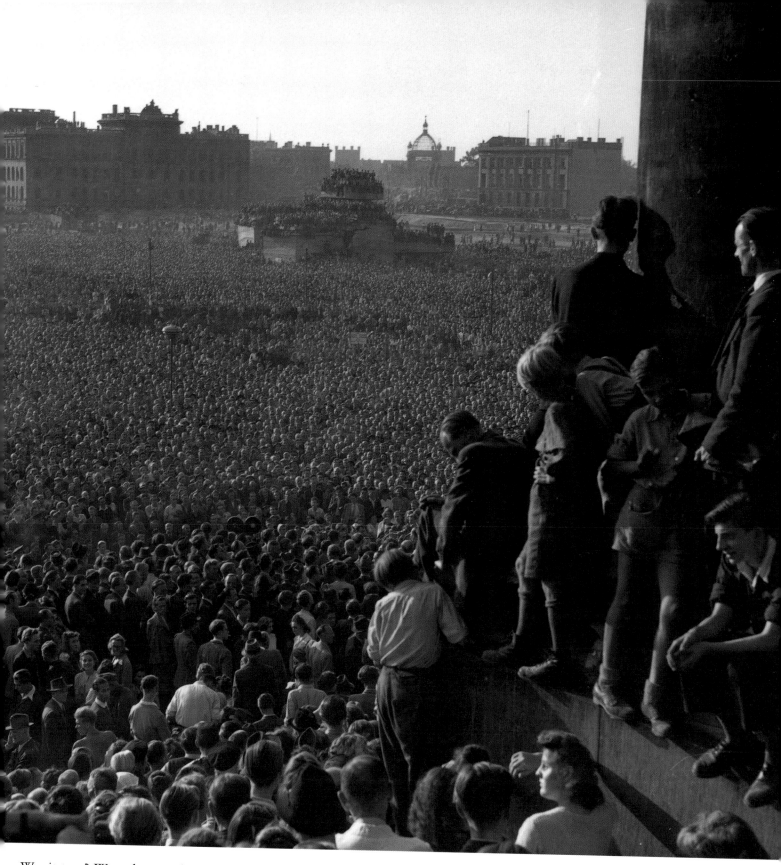

Was it true? Were the people, united, assured of success? Perhaps – when they kept up the pressure, rode the storm of repression and didn't lose hope, then the masses on the march had considerable influence. But hope can die, and when it did t was often all too easy to limp away from a demonstration eeling that the real political battles were being fought lsewhere, behind closed doors.

Nichts erschreckt die Machthaber mehr als der Anblick (und der Lärm) von Menschenmassen, die sich zum Protest versammelt haben. Im 18. und 19. Jahrhundert versetzte der Mob sowohl in London als auch in Paris durch die Erinnerungen an die schlimmen Auswüchse der Französischen Revolution Könige und Minister gleichermaßen in Angst und Schrecken. Wenn Tausende auf die Straße gehen, ist dies ein Zeichen dafür, daß etwas geschehen soll. Für die Ordnungskräfte – ob gut oder böse – ist es das Signal für schnelle und extreme Maßnahmen, um zu verhindern, daß die Massen sich durchsetzen.

In der zweiten Hälfte des 20. Jahrhunderts hatten sowohl der Kommunismus als auch der Kapitalismus Hunderttausende demonstrierender Kritiker. Im sowjetischen Block forderte man mehr Freiheit für die Satellitenstaaten in Osteuropa, mehr Demokratie und größere Presse- und Rundfunkfreiheit. Im Westen konzentrierten sich die Forderungen auf das Ende des Vietnamkriegs, gegen Nuklearwaffen, gegen die Suez-Invasion von 1956 und gegen einen befürchteten Rechtsruck in der Politik. Auf lange Sicht gesehen ist weder die Demokratie noch der Totalitarismus ein Garant für eine ruhige Amtszeit – Menschen haben die Gewohnheit, sich mit anderen zusammenzutun und ihre eigenen Stimmen durch das heisere Skandieren in der Masse zu verstärken. »Was wollen wir?« kann so gut wie alles bedeuten – bessere Bezahlung, bessere Bedingungen, ein gerechteres Steuersystem, Freiheit von der Angst vor einem nuklearen Holocaust, größere Unabhängigkeit, ein Ende der Tyrannei. »Wann wollen wir das?« – »Sofort« – immer »sofort«.

Langfristig setzten die Massen häufig ihren Willen durch. Ungarn ist in den neunziger Jahren ein anderes Land als 1956. Es dauerte über 30 Jahre, bis die Knospen des Prager Frühlings erblühten. Am Ende erlebten jene Amerikaner, die ihren Einberufungsbefehl verbrannt hatten und zwischen Tränengas und Wasserwerfern Spießruten laufen mußten, den Rückzug der amerikanischen Truppen aus Vietnam. In Großbritannien wurde die verhaßte Kopfsteuer schließlich aus dem Gesetz gestrichen. Selbst für die französischen Arbeiter und Studenten, die 1968 so leidenschaftlich den Fall der Republik herbeigewünscht hatten, gab es eine kleine Genugtuung: Am 21. April 1969 trat de Gaulle zurück und verbrachte seinen Lebensabend zurückgezogen in Colombey-les-Deux-Eglises.

In den Pressefotografen fanden die Menschenmassen unserer Zeit vielfach neue Verbündete. Die Bilder der Ereignisse in Budapest 1956 haben die westlichen Regierungen vielleicht nicht zum Handeln, aber viele Sympathisanten des Kommunismus zur Umkehr bewegt. Zwölf Jahre später stellten die Bilder aus Prag die Überzeugung der verbliebenen Anhänger erneut auf eine harte Probe. Als die sowjetischen Truppen den nationalen Radiosender der Tschechoslowakei stürmten, endete die Übertragung mit den Worten: »Dies sind vielleicht die letzten Berichte, die Sie hören werden, da uns nur unzureichende technische Mittel zur Verfügung stehen.« Aber in den Zeitungen der ganzen Welt erschienen die Bilder von unbewaffneten Zivilisten, die sich mächtigen Panzern entgegenstellten.

»Menschen, die zusammenstehen, werden niemals besiegt werden.« Variationen dieses Themas waren in den Straßen Europas und Amerikas zu hören. Wer waren diese Menschen? Wer hakte sich unter und marschierte durch Berlin, Paris, London oder Washington? Vor dem Zweiten Weltkrieg waren es rechte oder linke politische Extremisten, Kommunisten oder Faschisten; oder die Arbeitslosen, die eine aktive und willkommene Abwechslung vom Schlangestehen vor dem Sozialamt oder den Suppenküchen suchten. Nach dem Krieg waren es fast alle: Lehrer, Studenten, Busfahrer, Verkäufer und

Verkäuferinnen, Intellektuelle, Anarchisten, Fabrikarbeiter, Mütter und Väter mit Kinderwagen, Priester, Nonnen, Ladenbesitzer und Arbeiter.

Stimmt es wirklich? Wurden die Menschen, die zusammenstanden, niemals besiegt? Vielleicht – wenn sie den Druck aufrechterhalten konnten, den Sturm der Unterdrückung meisterten und die Hoffnung nicht aufgaben, hatten die Massen häufig bemerkenswerten Einfluß. Aber die Hoffnung kann sterben, und wenn das geschah, war es oft nur zu einfach, sich mit dem Gefühl aus der Demonstration davonzumachen, daß die wirklichen politischen Gefechte an anderer Stelle, hinter verschlossenen Türen ausgetragen wurden.

Rien n'effraie plus les autorités que la vue (et le bruit) d'une masse de gens réunis pour protester. Aux XVIIIe et XIXe siècles, la populace de Londres ou de Paris terrifia rois et ministres, leur rappelant les pires excès de la Révolution française. Quand des milliers de gens descendent dans les rues, c'est le signe qu'ils veulent un changement, et pour les forces de contrôle, bonnes ou mauvaises, c'est le signal que des mesures rapides et rigoureuses doivent être prises pour éviter la progression des masses.

Communisme et capitalisme eurent tous deux leurs centaines de milliers de manifestants détracteurs dans la seconde moitié du XXe siècle. Dans le bloc soviétique, on réclamait plus de liberté pour les états satellites de l'Europe de l'Est, plus de démocratie, plus de liberté pour la presse et la radio. A l'Ouest, on exigeait la fin de la guerre du Vietnam, des armes nucléaires, de l'invasion de Suez en 1956. A la longue ni la démocratie ni le totalitarisme ne peuvent s'installer confortablement au pouvoir; la foule a l'habitude de s'unir pour scander à tue-tête des slogans gutturaux. «Que voulons nous?» Ce pourrait être n'importe quoi, un meilleur salaire, de meilleures conditions, un système fiscal plus équitable, l'élimination de la menace d'un holocauste nucléaire, plus d'indépendance, la fin de la tyrannie. «Quand le voulons nous?» «Maintenant», toujours «maintenant».

A la longue, les masses arrivent à leur but. La Hongrie des années 1990 est très différente de celle de 1956. Le Printemps de Prague de 1968 a mis plus de 30 ans à s'épanouir. A la fin ces Américains qui brûlèrent leur ordre d'incorporation et foncèrent à travers les gaz lacrymogènes et les lances d'arrosage ne vivaient plus que pour voir les Etats-Unis se retirer du Vietnam. En Grande-Bretagne, les impôts locaux furent finalement rayés du code. Même pour ces ouvriers et étudiants français espérant avec tant d'ardeur faire chuter leur république en 1968, il y eut quelques brins de réconfort. Le 21 avril 1969, de Gaulle renonça et alla passer le reste de ses jours à Colombey-les-Deux-Églises.

Les masses modernes ont souvent trouvé de nouveaux alliés parmi les photographes de presse, les cameramen de film et de télévision qui documentent leurs actions. Les images venues de Budapest en 1956 n'ont peut-être pas incité les gouvernements occidentaux à agir, mais elles ont certainement

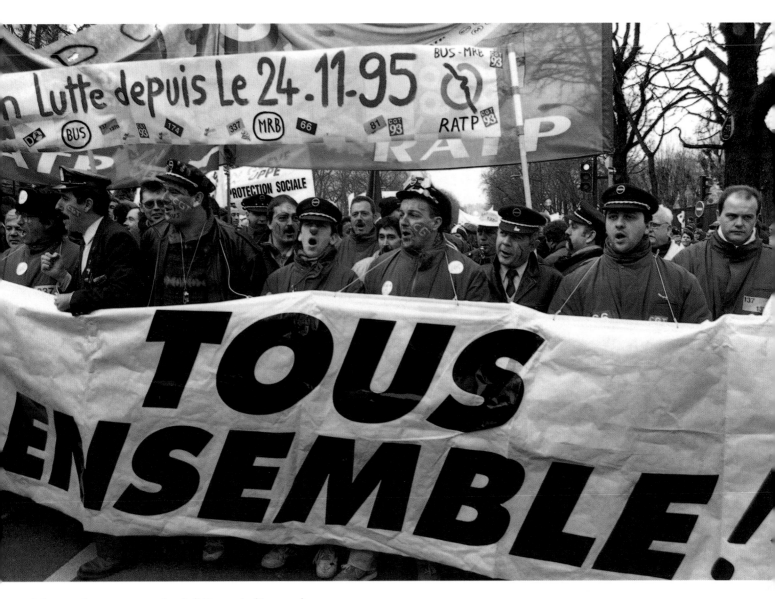

oussé de nombreux camarades à l'Ouest à déserter la cause communiste. Et la foi de ceux qui restèrent au sein du parti fut ncore mise à l'épreuve par les photos de Prague, 12 ans plus ard. Quand les troupes soviétiques prirent d'assaut la station le radio nationale, la diffusion fut interrompue par ces mots: Ce sera peut-être le dernier bulletin que vous entendrez, car 'équipement technique à notre disposition est insuffisant.» Mais dans les journaux, les images de civils non armés face aux hars puissants firent le tour du monde.

«Les peuples unis ne seront jamais vaincus.» Des ariations sur ce thème retentirent dans les rues d'Europe et l'Amérique. Qui étaient ces peuples? Qui marchait bras lessus bras dessous à travers Berlin, Paris, Londres ou Washington DC? Avant la Seconde Guerre Mondiale, ils vaient été militants de droite ou de gauche, communistes ou ascistes, ou chômeurs en quête d'un changement effectif our ne plus faire la queue pour des vivres ou un emploi. Après la guerre, ils en étaient tous: enseignants, étudiants, hauffeurs de bus, vendeurs et vendeuses, représentants, ntellectuels, anarchistes, ouvriers d'usine, pères et mères avec les bébés dans des poussettes, prêtres, religieuses, ommerçants et travailleurs agricoles.

Etait-ce vrai? Les peuples étaient-ils unis, sûrs de gagner? Peut-être, si les masses continuaient à faire pression, à tenir

The essence of mass movement: 'All together!' Metro workers march in Paris after three weeks of a strike by public sector workers, December 1995.

Die Grundlage jeder Massenbewegung: »Alle zusammen!« Metro-Arbeiter demonstrieren in Paris nach einem dreiwöchigen Streik im öffentlichen Dienst, Dezember 1995.

L'essence du mouvement de masse: «Tous ensemble!» Des employés de la RATP défilent à Paris après trois semaines de grève dans le secteur public. Décembre 1995.

tête à la répression et à ne pas perdre espoir, alors leur influence serait considérable. Mais l'espoir peut mourir et dans ce cas, il était souvent facile de s'esquiver en sentant que les vraies luttes politiques étaient menées ailleurs, derrière des portes closes.

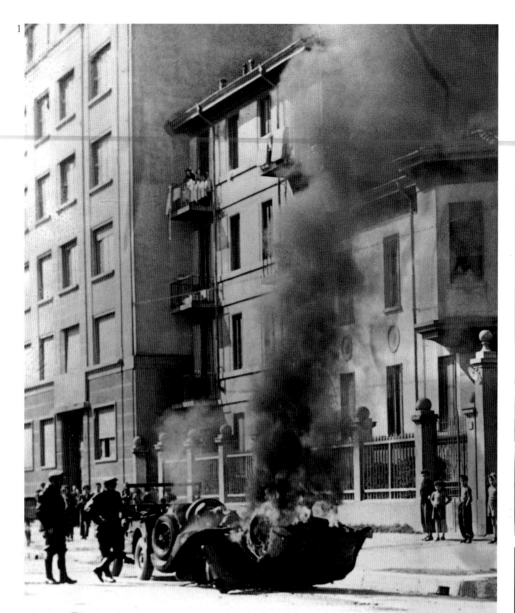

Peacetime Struggles

After the Second World War Europe was shaken by civil war in Greece, a Communist coup in Czechoslovakia, the Soviet blockade of Berlin, and political and social unrest almost everywhere. In March 1950 police and troops throughout Italy fought workers when the General Confederation of Labour called a national strike against the government's repressive emergency measures. (1) In Milan Communists set fire to a car that carried a notice urging workers not to join the strike. (2) In September 1948 French Communists clashed with Gaullists in Grenoble during a visit by General de Gaulle. (3) In the mid-1950s scenes reminiscent of the 1930s returned as employers called in police to

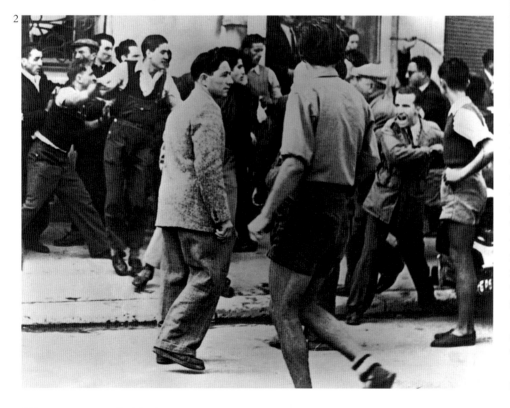

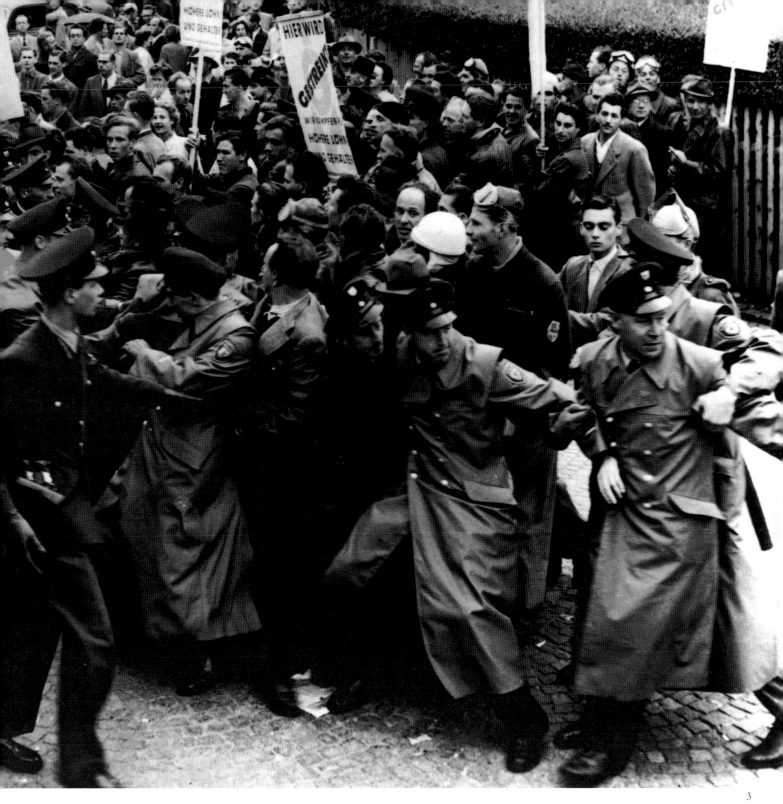

rotect 'blackleg' labour, as in this metal-
workers' strike in Munich, August 1954.

Unruhen in Friedenszeiten

Nach dem Zweiten Weltkrieg wurde Europa
vom Bürgerkrieg in Griechenland, von der
kommunistischen Machtübernahme in der
Tschechoslowakei, der sowjetischen Blockade
Berlins sowie politischen und sozialen
Unruhen in fast allen anderen Regionen
erschüttert. Im März 1950 kämpften Polizei
und Armee überall in Italien gegen Arbeiter,
nachdem die Generalversammlung der
Arbeiterschaft einen nationalen Streik gegen
die repressiven Notstandsmaßnahmen der
Regierung ausgerufen hatte. (1) In Mailand
stecken Kommunisten ein Auto in Brand, an

dem ein Aufruf zum Boykott des Streiks
angebracht war. (2) Im September 1948
gerieten in Grenoble während eines Besuchs
von General de Gaulle französische
Kommunisten und Gaullisten aneinander.
(3) Szenen, die an die dreißiger Jahre
erinnern: Bei diesem Metallarbeiterstreik in
München im August 1954 rufen die
Arbeitgeber zum Schutz von Streikbrechern
die Polizei.

Luttes en temps de paix

Après la Seconde Guerre Mondiale, l'Europe
fut secouée par une guerre civile en Grèce,
un coup d'Etat communiste en Tchéco-
slovaquie, le blocus soviétique de Berlin et
des remous politiques et sociaux presque

partout. En mars 1950, la police et les troupes
italiennes affrontèrent les ouvriers dans tout
le pays quand la Confédération Générale du
Travail appela à une grève nationale contre les
mesures répressives d'urgence du gouverne-
ment. (1) A Milan, des communistes mirent
feu à une voiture portant une affiche incitant
les ouvriers à ne pas se joindre à la grève.
(2) En septembre 1948, des communistes
français se heurtèrent aux Gaullistes à
Grenoble pendant la visite du Général de
Gaulle. (3) Certaines images des années 50
rappellent des scènes des années 30, par
exemple lorsque des employés appelèrent la
police pour protéger les briseurs de grève
durant la grève des métallurgistes à Munich
en août 1954.

The East Berlin Uprising

On 17 June 1953 the East German government announced an increase in production quotas for construction workers. The next day 50,000 workers took to the streets in protest. The Soviet Embassy was attacked, the Red Flag was burnt, and one of East Germany's deputy premiers was dragged from his car and assaulted. For a couple of days the red, gold and black flag of West Germany was seen in the streets. Then came the Soviet tanks, clearing the city and sealing the border between East and West Berlin. It was a little like shutting the stable door after the horse had bolted, for 300,000 Germans had crossed into West Berlin during the previous 12 months.

Der Arbeiteraufstand in Ostberlin

Am 17. Juni 1953 verkündete die ostdeutsche Regierung eine Steigerung der Produktions-quoten für Bauarbeiter. Daraufhin protestierten am nächsten Tag 50 000 Arbeiter auf den Straßen. Die sowjetische Botschaft wurde angegriffen, die rote Fahne verbrannt, und ein Vertreter des Ministerpräsidenten wurde aus seinem Auto gezerrt und überfallen. Ein paar Tage lang wehte die schwarzrotgoldene Flagge der Bundes-republik auf den Straßen. Dann kamen die sowjetischen Panzer. Sie räumten die Stadt und riegelten die Grenze zwischen Ost- und Westberlin ab. Es war, als hätte man die Stalltür hinter einem durchgegangenen Pferd verschlossen, denn in den vorangegangenen 12 Monaten hatten sich 300 000 Deutsche nach Westberlin abgesetzt.

La révolte à Berlin-Est

Le 17 juin 1953, le gouvernement est-allemand annonça une augmentation des quotas de production pour les ouvriers du bâtiment. Le lendemain, 50 000 ouvriers descendirent dans les rues pour protester. L'ambassade soviétique fut attaquée, le drapeau rouge brûlé, et l'un des députés est-allemand fut tiré de sa voiture et agressé. Pendant deux jours le drapeau rouge, or, noir de l'Allemagne de l'Ouest apparut dans les rues. Puis, les chars soviétiques arrivèrent, dégageant les rues et colmatant la frontière entre Berlin-Est et Ouest. On ferma pour ainsi dire la porte de l'écurie après que le cheval se fût emballé, car 300 000 Allemands étaient passés à Berlin-Ouest pendant les 12 mois précédents.

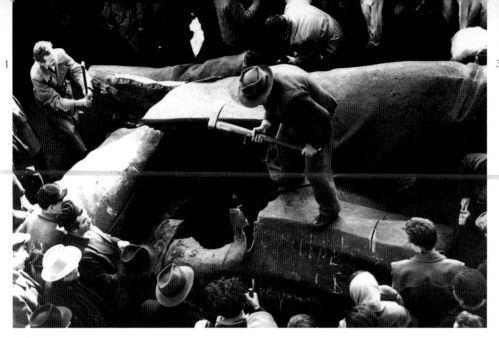

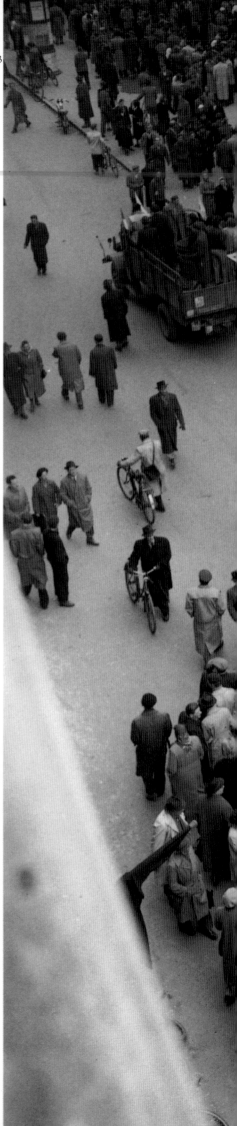

Hungary 1956

On 23 October 1956 Hungarian students demonstrated against their Stalinist First Secretary Mátyás Rakosi. The AVH (secret police) fired on them. Hungarians rose in protest. Khrushchev forced Rakosi to resign, but sent in Soviet tanks once it was clear that Imre Nagy, the Hungarian Premier, was considering leaving the Warsaw Pact. (1) Hungarian nationalists demolish the vast statue of Stalin. (2) Suspected members of the AVH are summarily executed. (3) Once again, the Red Flag is burnt.

Ungarn 1956

Am 23. Oktober 1956 demonstrierten ungarische Studenten gegen den Stalinisten und Ersten Sekretär Mátyás Rákosi. Als die AVH (Geheimpolizei) das Feuer auf sie eröffnete, kam es zu einem Aufstand in Ungarn. Chruschtschow zwang Rákosi zum Rücktritt, schickte aber sowjetische Panzer, als klar wurde, daß der ungarische Präsident

Imre Nagy daran dachte, den Warschauer Pakt zu verlassen. (1) Ungarische Nationalisten zerstören eine große Statue Stalins. (2) Mutmaßliche Mitglieder der AVH werden kurzerhand erschossen. (3) Noch einmal wird die rote Fahne verbrannt.

Hongrie, 1956

Le 23 octobre 1956, des étudiants hongrois manifestèrent contre leur Premier Secrétaire staliniste Mátyás Rakosi. L'AVH (police secrète) tira. Les Hongrois se soulevèrent. Khrouchtchev obligea Rakosi à démissionner, mais envoya des chars soviétiques quand il fut clair que Imre Nagy, le Premier Ministre hongrois, quitterait le Pacte de Varsovie. (1) Les nationalistes hongrois démolissent la grande statue de Staline. (2) Des membres suspects de l'AVH sont exécutés sommairement. (3) Une fois de plus, le drapeau rouge est brûlé.

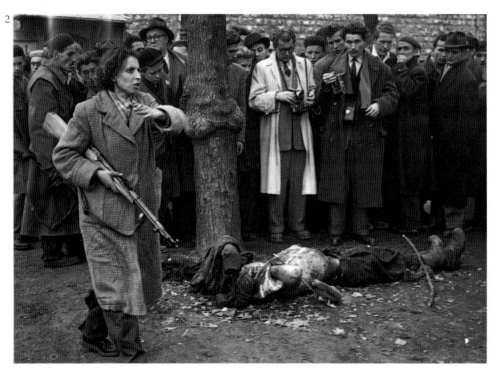

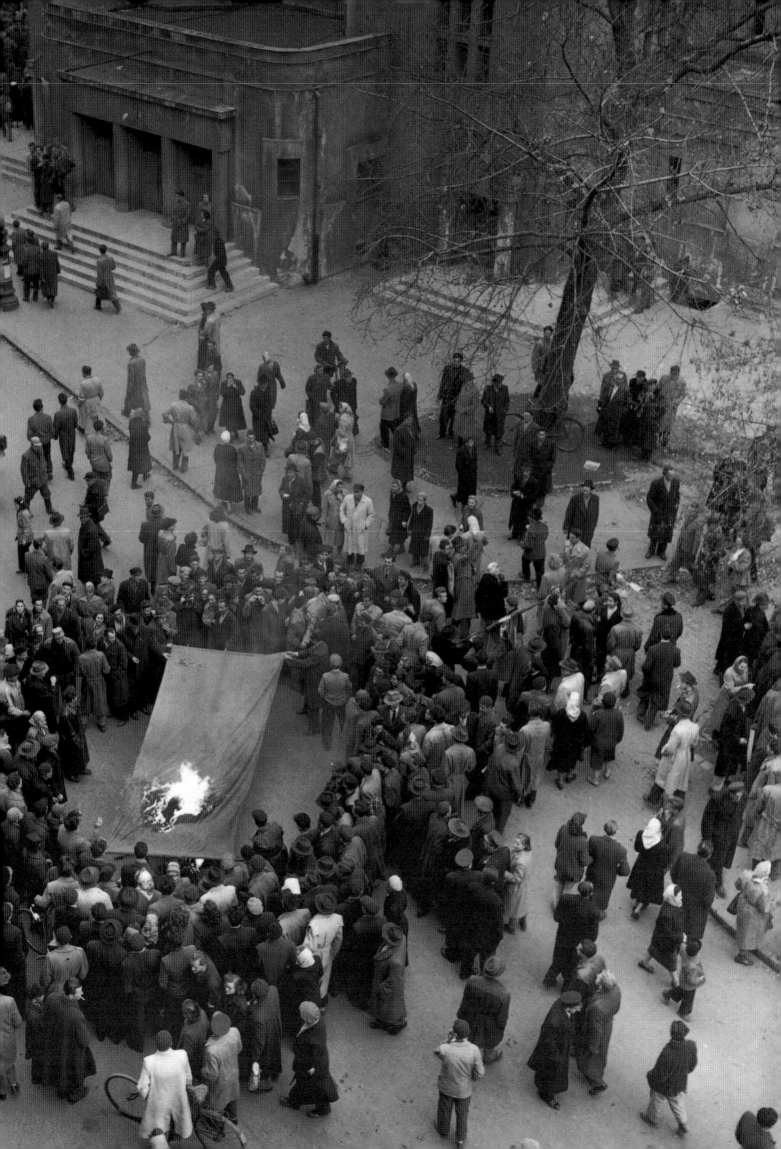

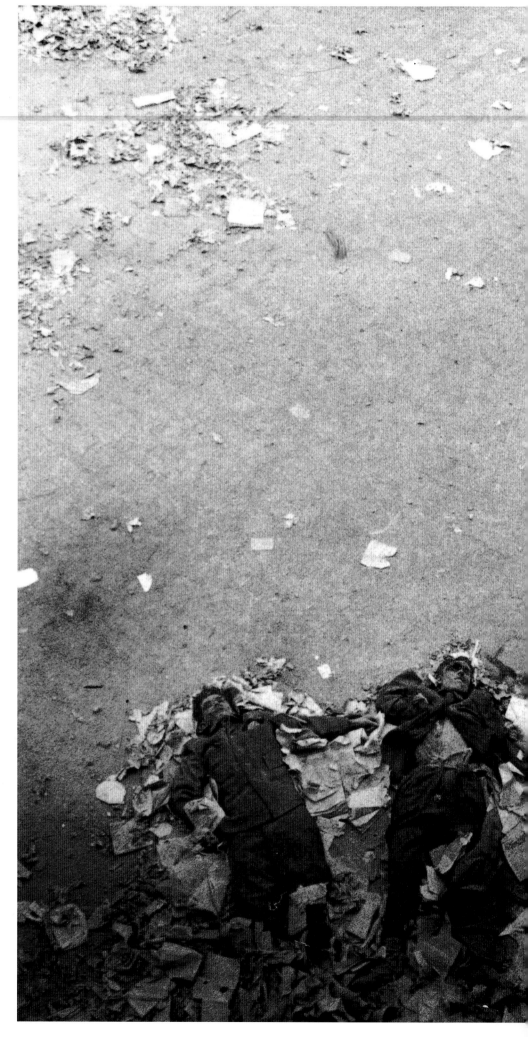

End of the AVH

'The secret police lie twisted in the gutter,' wrote an eye-witness, 'their faces dark masks of dust and blood, blank eyes staring at the day. Somebody has tried to put them into some kind of line, God knows who, for the Hungarians thronging the streets will not touch the corpse of an AVH man, not even to close the eyes or straighten a neck.'

Das Ende der AVH

»Die Geheimpolizisten liegen mit verrenkten Gliedern in der Gosse«, schrieb ein Augenzeuge, »ihre Gesichter sind dunkle Masken aus Staub und Blut, mit leeren Augen, die in den Himmel starren. Irgend jemand hat versucht, sie in eine Art Reihe zu bringen – Gott weiß wer, denn die Ungarn, die sich in den Straßen drängen, rühren die Leiche eines AVH-Mannes nicht an, noch nicht einmal, um seine Augen zu schließen oder den Kopf gerade zu betten.«

La fin de l'AVH

«La police secrète gît disloquée dans le caniveau», écrivit un témoin oculaire, «leurs visages comme des masques noirs de poussière et de sang, les yeux vides et fixes. Quelqu'un a essayé de les allonger en rang, Dieu sait qui, car les Hongrois se pressant dans les rues ne toucheront jamais le corps d'un membre de l'AVH, même pas pour lui fermer les yeux ou lui redresser la tête.»

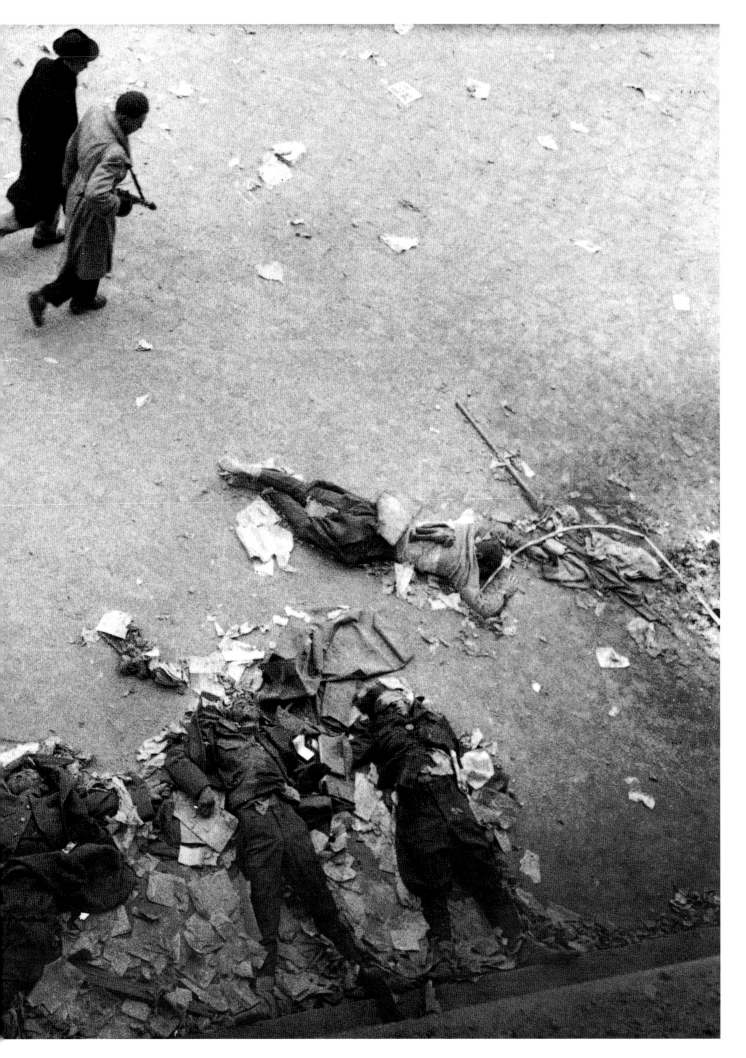

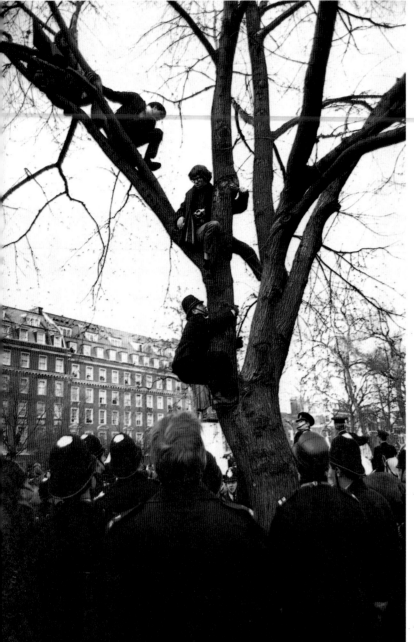

1

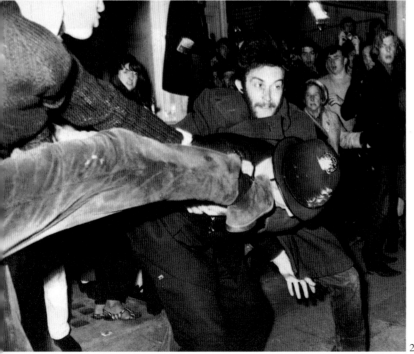

2

Vietnam Protest

The US intervention in the Vietnam War was
ill-timed. Most of their Western allies were in
no mood for war, like a great number of
Americans themselves, for the war was
regarded as 'unwinnable'. Young and old alike
were horrified at the use of napalm, at the
tales of torture and murder by US troops, at
the barbarity of the South Vietnamese
regime. (3) And wherever violence flared at
protest meetings, cameras were there to
record any excessive force used by police or
troops in the US, or (1, 2) by protesters
themselves in Grosvenor Square, London.

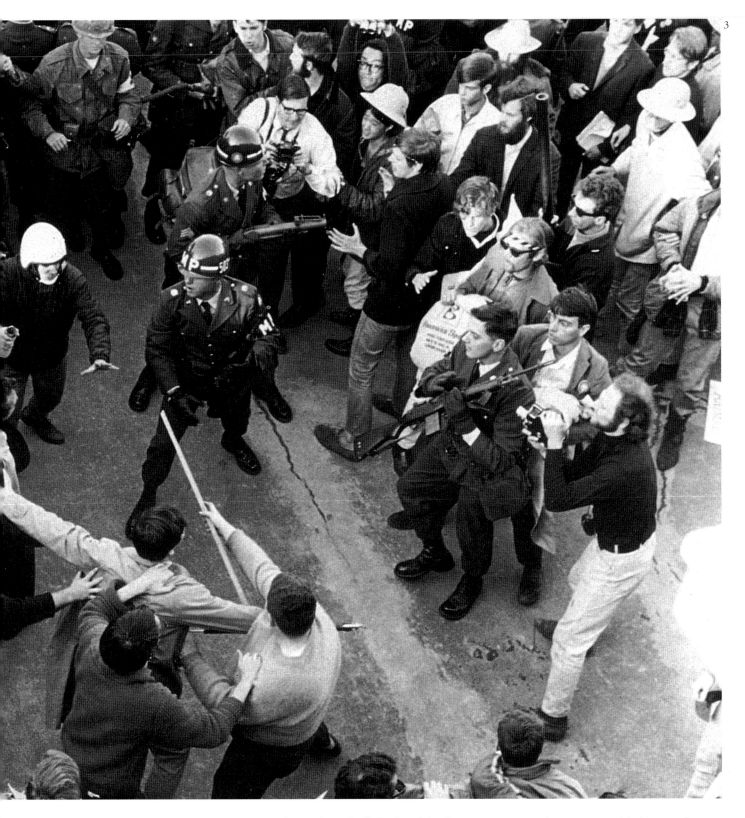

Vietnam-Protest

Die amerikanische Intervention in Vietnam kam zu einem schlechten Zeitpunkt. Die meisten westlichen Verbündeten waren nicht in Kriegsstimmung, ebensowenig viele Amerikaner selbst, da dieser Krieg als »nicht zu gewinnen« galt. Alt und Jung zeigten sich gleichermaßen geschockt vom Einsatz von Napalm, von den Nachrichten über Folter und Morde durch US-Truppen und von der Grausamkeit des südvietnamesischen Regimes. (3) Wo immer bei den Protestaktionen Aggressionen aufflackerten, waren die Kameras dabei, um übermäßige Gewalt-

anwendung seitens der Polizei und der Armee in den USA oder (1, 2) der Demonstranten ihrerseits festzuhalten, wie hier am Grosvenor Square in London.

Protestations contre le Vietnam

L'intervention américaine dans la guerre du Vietnam fut intempestive. La plupart de ses alliés occidentaux n'était pas d'humeur belliqueuse, comme un grand nombre d'Américains eux-mêmes, car la guerre était considérée comme «ingagnable». Jeunes et vieux étaient horrifiés par l'utilisation de napalm, par les récits de tortures et de

meurtres des troupes américaines, par la barbarie du régime sud-vietnamien. (3) Et partout où la violence éclatait durant des manifestations, les caméras étaient là pour saisir tout excès de force de la part de la police ou des troupes en Amérique ou (1, 2) des manifestants eux-mêmes à Grosvenor Square à Londres.

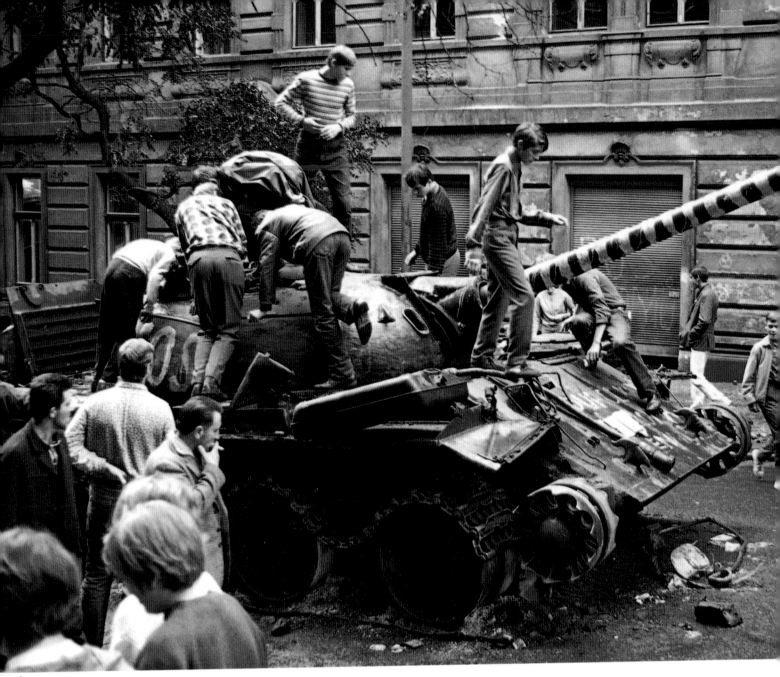

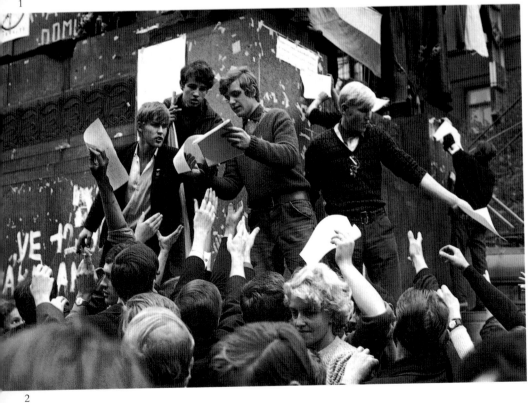

1

2

The Prague Spring

Early in 1968 President Novotny of Czechoslovakia told his people that 'the last few years are a blot on our post-war existence'. Popular support increased for the Communist Party leader Alexander Dubček's attempts to move towards 'socialism with a human face'. And, again, the Red Flag was burnt. But the threat to move to a multi-party system was too much for Soviet President Brezhnev. (3, 4) By late summer Soviet tanks and troops were in Prague. (1) Though some of the tanks were attacked and destroyed by Czechs with their bare hands, the rising was virtually over. (2) While there was still hope, students distributed underground literature in Wenceslas Square, Prague, September 1968. (Overleaf) On 16 January 1969 a 21-year-old Czech student, Jan Palach, publicly burnt himself to death in protest at the Soviet occupation of his country. Two weeks later thousands of mourners filed past his coffin in the grounds of the Charles University.

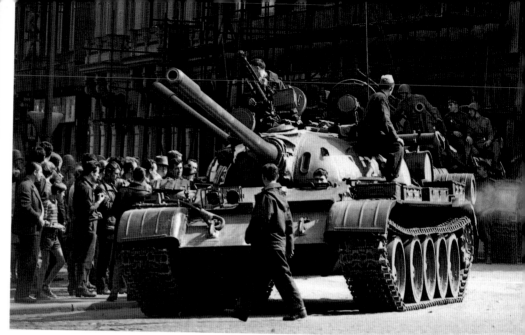

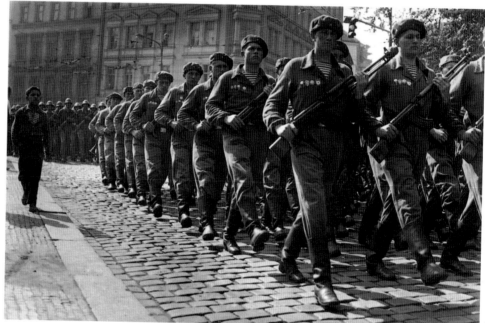

Der Prager Frühling

Anfang 1968 erklärte der tschechische Prasident Novotny seinem Volk: »Die letzten Jahre sind ein Schandfleck für unsere Nachkriegsgeschichte.« Der von Alexander Dubček, dem Führer der Kommunistischen Partei, angestrebte »Sozialismus mit menschlichem Antlitz« fand zunehmend Unterstützung. Und wieder wurde die rote Fahne verbrannt. Aber die Schritte hin zu einem Mehrparteiensystem waren eine zu starke Bedrohung für den sowjetischen Präsidenten Breschnew. (3, 4) Im Spätsommer standen Panzer und Truppen in Prag. (1) Obwohl einige Panzer von den Tschechen mit bloßen Händen angegriffen und zerstört wurden, war der Aufstand praktisch beendet. (2) Als noch Hoffnung bestand, verteilten Studenten Untergrund-Literatur auf dem Wenzelsplatz, Prag, September 1968. (Folgende Doppelseite) Am 16. Januar 1969 verbrannte sich der 21jährige Student Jan Palach öffentlich, um damit gegen die sowjetische Besetzung seines Landes zu protestieren. Zwei Wochen später defilierten Tausende von Trauernden in der Karlsuniversität an seinem Sarg vorbei.

Le Printemps de Prague

Au début de l'année 1968, Novotny, le Président de la Tchécoslovaquie, déclara à son peuple que «les dernières années souillent notre existence d'après-guerre». Le peuple soutenait de plus en plus les tentatives d'Alexander Dubček, chef du Parti Communiste, vers «un socialisme à face humaine». Et, de nouveau, le drapeau rouge fut brûlé. Mais la menace d'en arriver à un système multipartite était trop forte pour le Président soviétique Brejnev. (3,4) A la fin de l'été, les chars et les troupes soviétiques étaient à Prague. (1) Bien que quelques chars aient été attaqués et détruits à mains nues par les Tchèques, la révolte était pratiquement terminée. (2) Espérant encore, des étudiants distribuaient des tracts place Wenceslas à Prague en septembre 1968. (Page suivante) Le 16 janvier 1969, un étudiant tchèque de 21 ans, Jan Palach, s'immola pour protester contre l'occupation soviétique. Deux semaines plus tard, des milliers de sympathisants défilèrent devant son cercueil dans le parc de l'Université Charles.

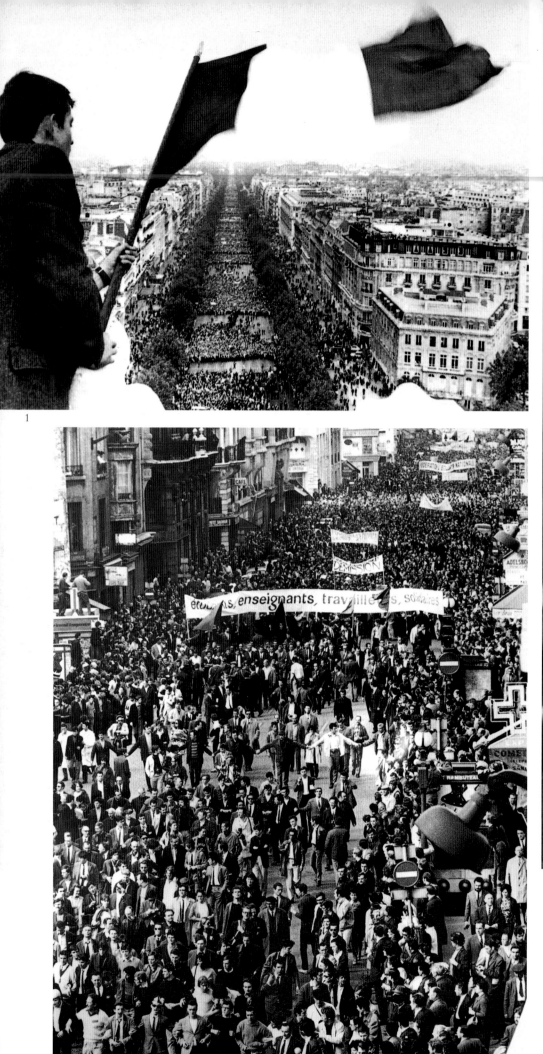

Summer of '68

'On ne peut rassembler les Français que sous le coup de la peur' ('One can only unite the French under the threat of danger'), said de Gaulle, and there was plenty of danger and plenty of unity in 1968. (1) The tricolour flies high over marching crowds. (2) Arms linked, students and workers swarm down the boulevards of Paris. (3) Daniel Cohn-Bendit (Danny the Red) holds forth at the Gare de l'Est in the heady days of May.

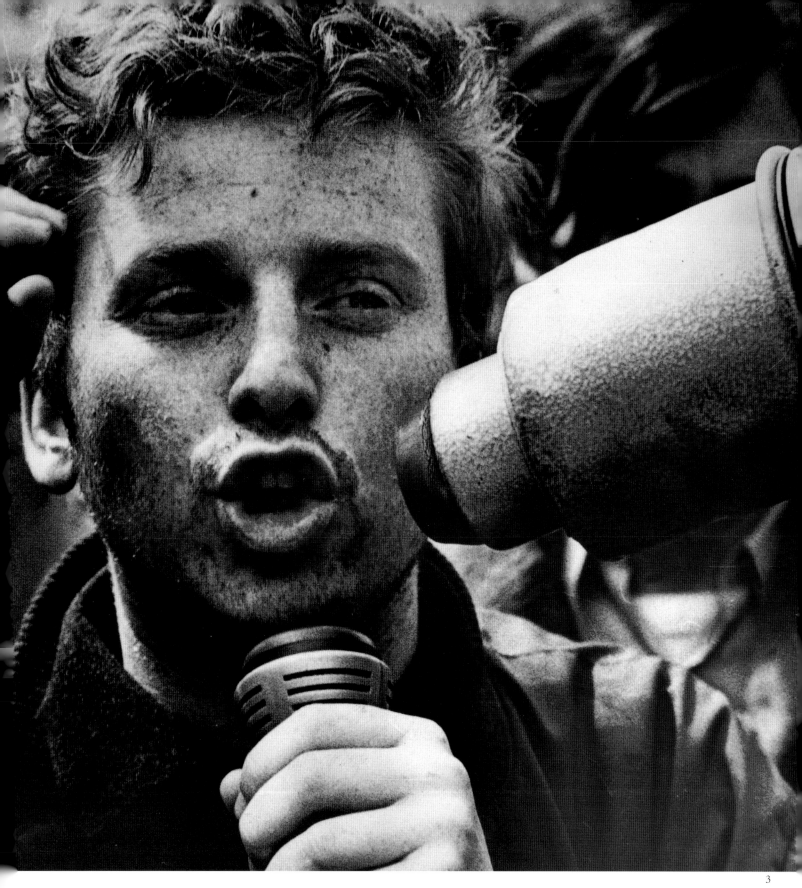

Der 68er-Sommer

»*On ne peut rassembler les Français que sous le coup de la peur*« (»Die Franzosen kann man nur unter drohender Gefahr vereinigen«), sagte De Gaulle – und 1968 gab es viel Gefahr und viel Einigkeit. (1) Die Trikolore flattert hoch über den marschierenden Massen. (2) Untergehakt ziehen Studenten und Arbeiter über die Pariser Boulevards. (3) Daniel Cohn-Bendit (der »Rote Dany«) als Wortführer in den rauschhaften Tagen im Mai auf dem Gare de l'Est.

L'été 1968

«On ne peut rassembler les Français que sous le coup de la peur», a dit de Gaulle, et il y a beaucoup de danger et beaucoup d'unité en 1968. (1) Le drapeau tricolore flotte haut au-dessus des masses qui défilent. (2) Bras dessus bras dessous, une foule d'étudiants et d'ouvriers descend les boulevards de Paris. (3) Daniel Cohn-Bendit (Dany le Rouge) fait un discours à la Gare de l'Est pendant les grisantes journées de mai.

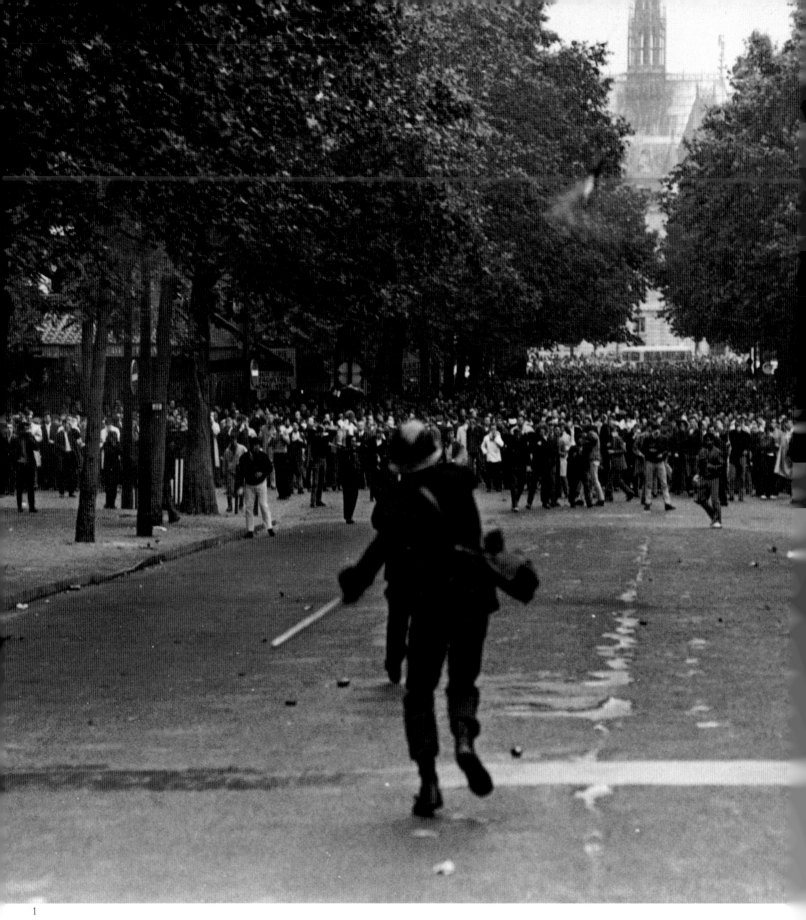

1

Authority responds

(1) Outnumbered but better armed, the police had orders to crush what seemed to many revolution on the streets of Paris. (3) The students occupied the Sorbonne until it was cleared by the police on 18 June. There followed running battles through the streets around the university. Police charge a group of retreating students in the Boulevard St Michel. (2) A casualty is led away.

Die Obrigkeit reagiert

(1) Die zahlenmäßig unterlegene, aber besser bewaffnete Polizei erhielt die Anweisung, die für viele »revolutionären« Ereignisse auf den Straßen von Paris zu zerschlagen. (3) Am 18. Juni stürmt die Polizei die von den Studenten besetzte Sorbonne. Daraufhin kommt es zu Straßenschlachten rund um die Universität. Auf dem Boulevard St. Michel geht die Polizei gegen eine Gruppe fliehender Studenten vor. (2) Ein Verletzter wird abtransportiert.

Réponses des autorités

(1) Surpassée en nombre mais mieux armée, la police avait ordre d'écraser ce que beaucoup considéraient comme une révolution dans les rues de Paris. (3) Les étudiants occupèrent la Sorbonne jusqu'à ce qu'elle soit vidée par la police le 18 juin. Des luttes continuelles

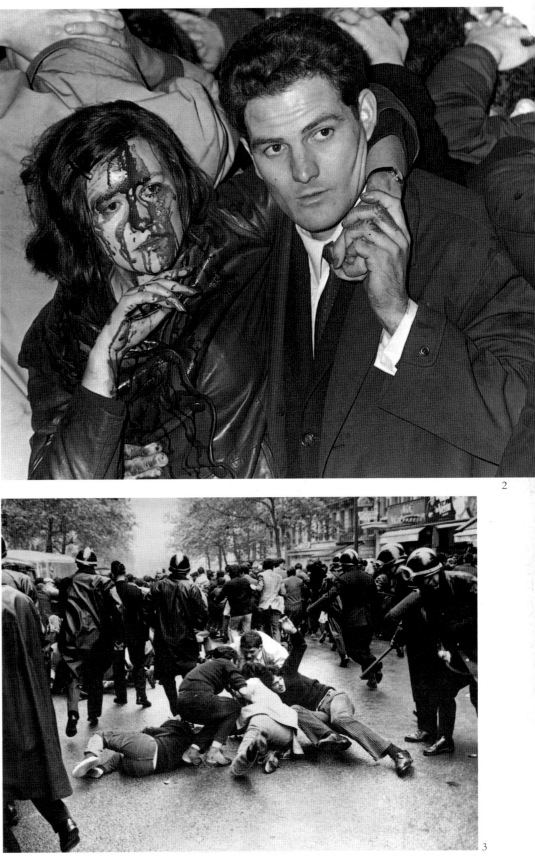

'ensuivirent dans les rues entourant
'université. Boulevard Saint Michel, la police
harge un groupe d'étudiants qui bat en
etraite. (2) On emmène un blessé.

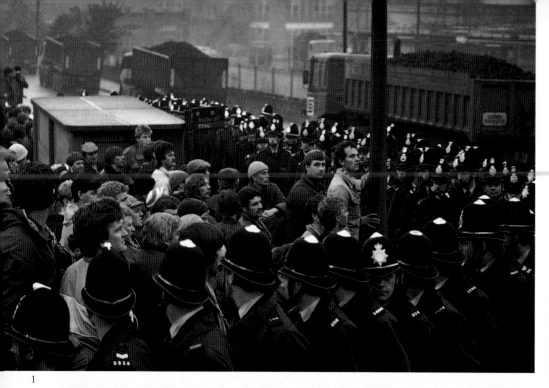

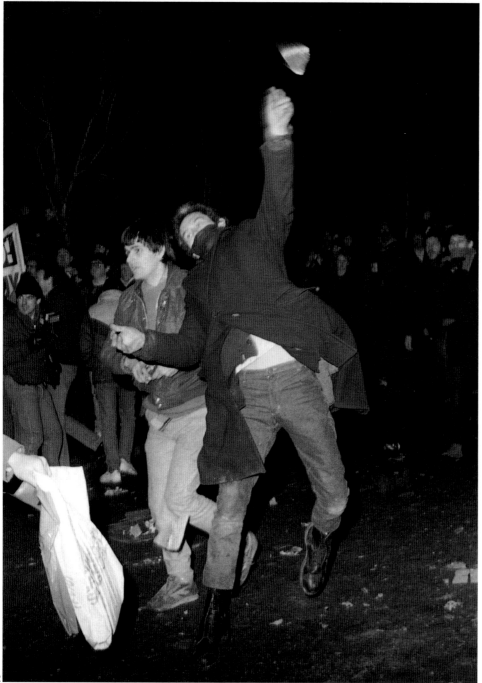

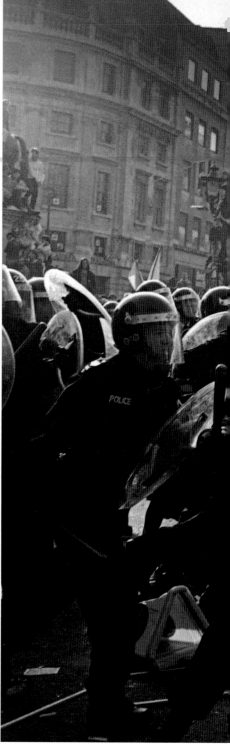

An End to English Reticence

Though lacking a revolutionary tradition, the English were roused into action by several issues in the late 20th century. (1) The longest-running battle was in support of the coalminers from March 1984 to the spring of 1985, a time when Britain was bitterly divided. Never before had so many police appeared on the streets, and some alleged that many of those in police uniforms were really troops in disguise. (2) In the 1987 Battle of Wapping, printworkers and their supporters fought to preserve the traditional but doomed working structure in the newspaper industry. (3) The most violent protest was that in Trafalgar Square, London, on 31 March 1990 300,000 people gathered to protest against the poll tax. Fighting between police and protesters was vicious.

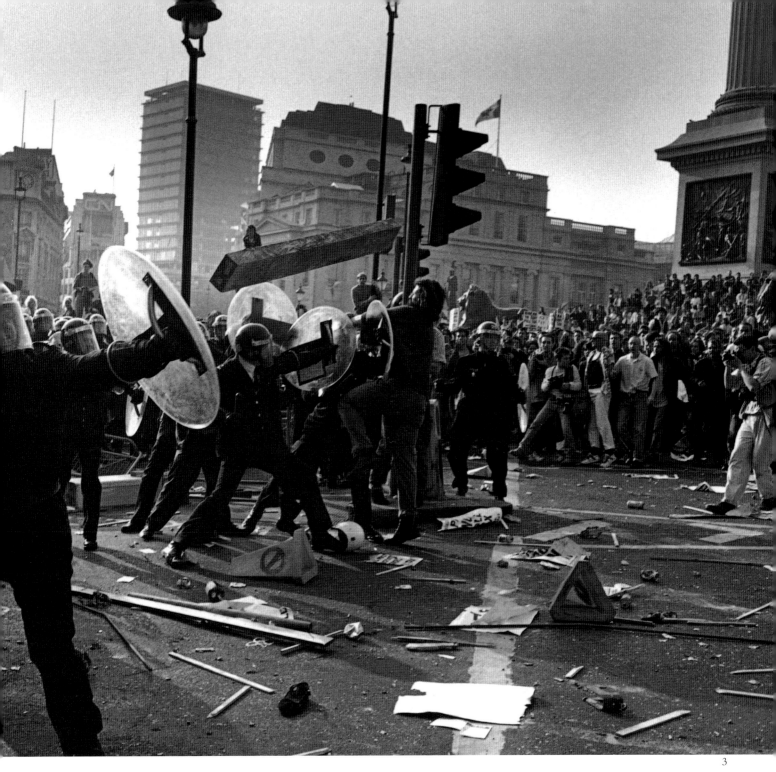

3

Das Ende der britischen Zurückhaltung

Obwohl sie auf keine revolutionäre Tradition zurückblicken konnten, wurden auch die Briten aktiv – aufgeschreckt durch mehrere Vorfälle im späten 20. Jahrhundert. (2) In der Schlacht von Wapping 1987 kämpften Drucker und ihre Mitstreiter für den Erhalt ihrer herkömmlichen, jedoch überholten Arbeitsstrukturen in der Druckindustrie. (1) Die längste Schlacht wurde um die Unterstützung der Bergarbeiter von März 1984 bis zum Frühjahr 1985 geschlagen – eine Zeit, in der Großbritannien bitter gespalten war. Nie zuvor gab es so viel Polizei auf den Straßen, und man vermutete sogar, daß viele Männer in Polizeiuniform getarnte Armeeangehörige seien. (3) Der gewaltsamste Protest fand am 31. März 1990 auf dem Trafalgar Square statt. 300 000

Menschen hatten sich dort versammelt, um gegen die *Poll Tax* – die »Kopfsteuer« – zu demonstrieren. Dabei kam es zu blutigen Gefechten zwischen Polizei und Protestierenden.

La fin de la réticence anglaise

Bien que n'ayant pas de tradition révolutionnaire, les Anglais furent poussés à l'action par plusieurs controverses à la fin du XXᵉ siècle. (1) La lutte la plus longue fut menée pour soutenir les mineurs, de mars 1984 au printemps 1985, période de cruelle division en Grande-Bretagne. Jamais encore, autant de forces de police n'avaient envahi les rues, et certains prétendirent que beaucoup de ceux qui portaient l'uniforme de la police étaient en réalité des troupes déguisées. (2) En 1987, à la bataille de Wapping, des ouvriers

d'imprimerie et leurs alliés luttèrent furieusement pour conserver leurs méthodes de travail traditionnelles, mais devenues complètement obsolètes. (3) La plus violente protestation fut celle de Trafalgar Square à Londres le 31 mars 1990. 300 000 personnes protestèrent contre les impôts locaux. Les combats entre la police et les manifestants furent sauvages.

Seoul 1995

The form and place of protest may change, but not the methods of dealing with it. (3) An elderly South Korean Woman weeps as police prevent her reaching the Japanese Embassy in Seoul to demand an official apology for Japan's wartime atrocities in Korea. (1) South Korean police fire tear gas at students seeking the prosecution of former President Chun Doo Hwan for the brutal way he suppressed the pro-democracy uprising of May 1980. This was one of a series of riots throughout the 1980s and 1990s in Korea. (2) Riot police charge students in a similar demonstration, November 1995.

Seoul 1995

Die Schauplätze und die Art des Protestes ändern sich, nicht aber die Methoden, ihm zu begegnen. (3) Eine ältere Südkoreanerin weint, weil sie von der Polizei daran gehindert wird, in der japanische Botschaft eine offizielle Entschuldigung für die japanischen Greueltaten im Koreakrieg einzufordern. (1) Die südkoreanische Polizei feuert Tränengas auf Studenten, die die gerichtliche Verfolgung des früheren Präsidenten Chun Doo Hwan für sein brutales Vorgehen gegen den prodemokratischen Aufstand vom Mai 1980 verlangen – eine von vielen Unruhen in Korea in den achtziger und neunziger Jahren. (2) Ein Überfallkommando geht auf einer ähnlichen Demonstration gegen Studenten vor, November 1995.

Séoul, 1995

La forme et l'endroit de la protestation peuvent changer, pas les méthodes. (3) Une Coréenne du Sud pleure quand la police l'empêche d'atteindre l'ambassade japonaise à Séoul pour réclamer des excuses officielles suite aux atrocités commises en Corée par le Japon durant la guerre. (1) La police de la Corée du Sud répand du gaz lacrymogène sur les étudiants demandant la mise en accusation de l'ancien Président Chun Doo-Hwan pour la brutalité avec laquelle il réprima la révolte démocratique en mai 1980. Ce fut l'une des séries d'émeutes durant les années 1980 et 1990 en Corée. (2) La police charge des étudiants au cours d'une manifestation semblable en novembre 1995.

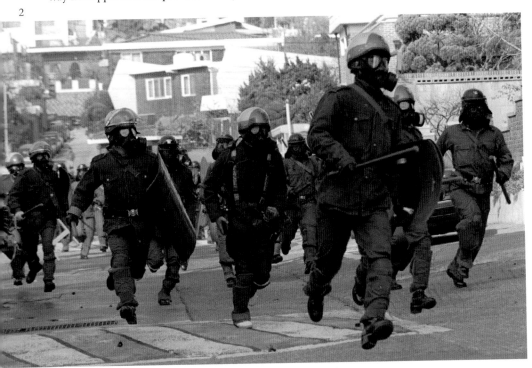

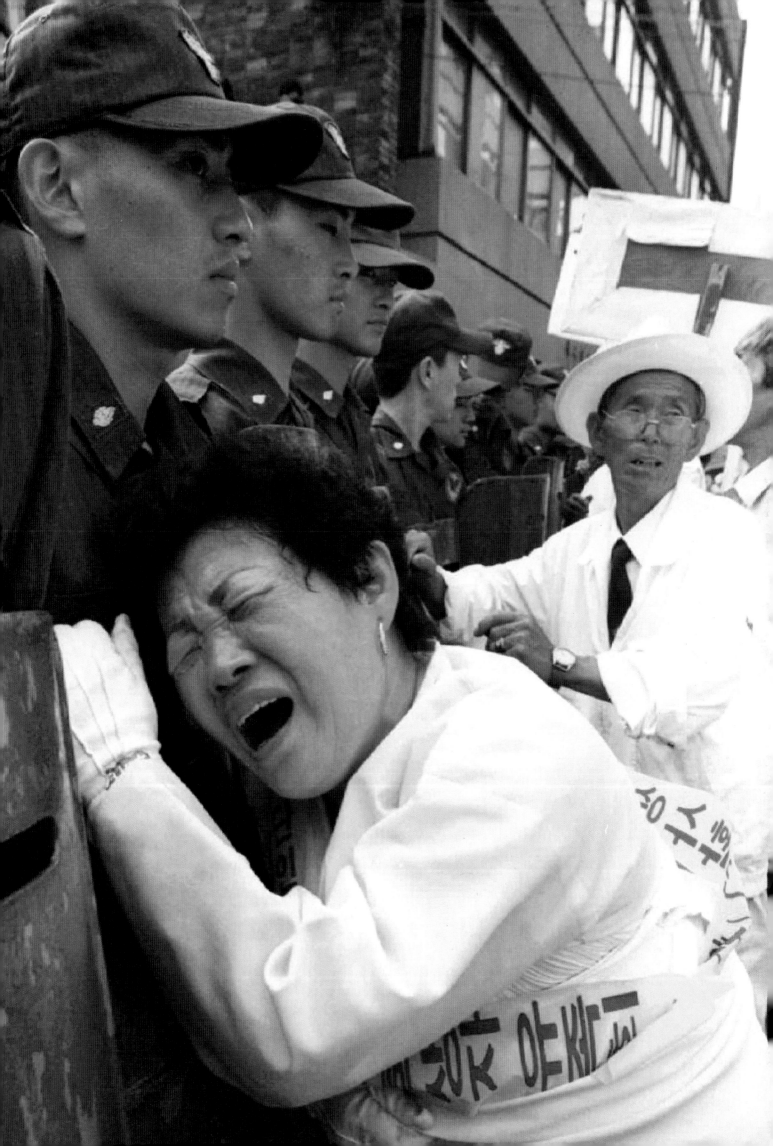

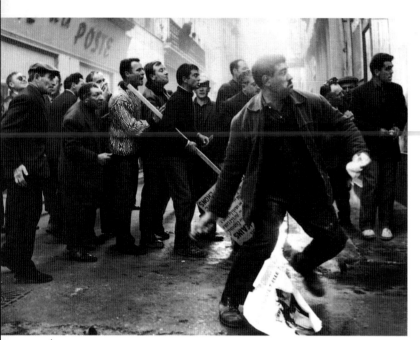

1

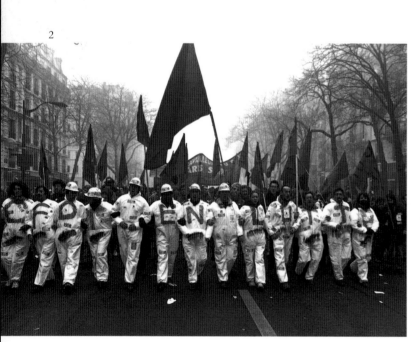

2

French Resistance

In France protest may occasionally have the grandeur of an operatic production coupled with the regularity of physical exercise, but it is always heartfelt. In March 1967 thousands of wine producers from the Midi region protested against the threat to their livelihood from cheap Algerian wine. (1) Here they return the CS gas cylinders thrown at them by the CRS. (2) A generation later, the CGT delegation leads a march during the French national strike in 1995. (3) In December 1995, a million people throughout France demonstrated against Prime Minister Juppé's proposed cuts in welfare.

Der Widerstand in Frankreich

In Frankreich haben Protestaktionen gelegentlich den Charakter von Operninszenierungen, verbunden mit regelmäßiger körperlicher Bewegung, immer aber tief und ehrlich empfunden. Im März 1967 protestierten Tausende von Winzern des Midi gegen die Bedrohung ihrer Existenz durch billigen algerischen Wein. (1) Auf diesem Bild werfen sie die CS-Gas-Zylinder zurück, mit denen die staatliche Sicherheitspolizei CRS gefeuert hatte. (2) Eine Generation später führt eine Delegation der Gewerkschaft CGT eine Demonstration während des landesweiten Streiks 1995 an. (3) Im Dezember 1995 protestierten eine Million Menschen gegen die von Premierminister Juppé vorgesehenen Sozialkürzungen.

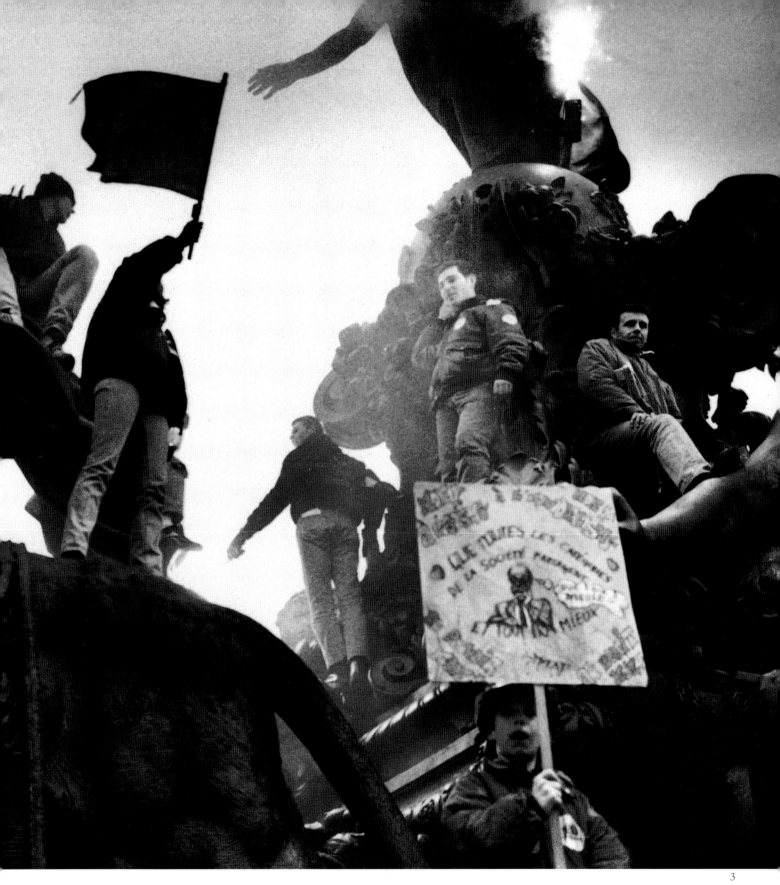

Résistance française

En France, la protestation peut parfois avoir l'ampleur d'une mise en
scène d'opéra, menée avec la régularité d'un exercice physique, mais
elle vient toujours du cœur. En mars 1967, des milliers de viticulteurs
du Midi protestèrent contre le vin algérien bon marché qui menaçait
leur existence. (1) Ils renversent ici les barriques d'essence que leur
avaient jetées les CRS. (2) Une génération plus tard, la délégation de
la CGT défile pendant la grève nationale française en 1995. (3) En
décembre 1995, un million de personnes manifeste dans toute la
France contre la réforme de la Sécurité Sociale proposée par le
Premier Ministre Juppé.

Solidarity

Lech Walesa began working at the Gdansk shipyard in 1967 at the age of twenty-four. Three years later he was arrested for his trade union activities. He led the Gdansk strike in 1980 and was a founder of Solidarity, the Polish independent trade union movement. (1) Walesa holds his union card proudly aloft during a vote at the 1981 Solidarity Congress. (3) Members of Solidarity demonstrate outside the Courts in Warsaw, November 1980. (2) A portrait of Pope John Paul II adorns the fence of the Lenin Shipyards, Gdansk in August 1980.

Solidarität

1967, im Alter von 24 Jahren, begann Lech Walesa seine Arbeit auf der Danziger Schiffswerft. Drei Jahre später wurde er wegen seiner gewerkschaftlichen Aktivitäten verhaftet. Er führte den Danziger Streik 1980 an und war Gründer der polnischen unabhängigen Gewerkschaftsbewegung Solidarität. (1) Während einer Abstimmung auf dem Kongreß der Solidarität 1981 hält Walesa stolz seine Mitgliedskarte hoch. (3) Mitglieder der Solidarität demonstrieren im November 1980 vor dem Warschauer Gericht. (2) Ein Bild von Papst Johannes Paul II. schmückt den Zaun der Lenin-Werft, Danzig, im August 1980.

Solidarité

Lech Walesa commença à travailler sur le chantier naval de Gdansk en 1967 à l'âge de 24 ans. Trois ans plus tard, il fut arrêté pour activités syndicalistes. Il mena la grève de Gdansk en 1980 et fonda Solidarność, le syndicat indépendant polonais. (1) Walesa brandit fièrement sa carte de membre du syndicat pendant un vote au Congrès en 1981. (3) Des membres de Solidarność manifestent devant les tribunaux de Varsovie en novembre 1980. (2) Un portrait du pape Jean Paul II orne la barrière du chantier naval Lénine à Gdansk en août 1980.

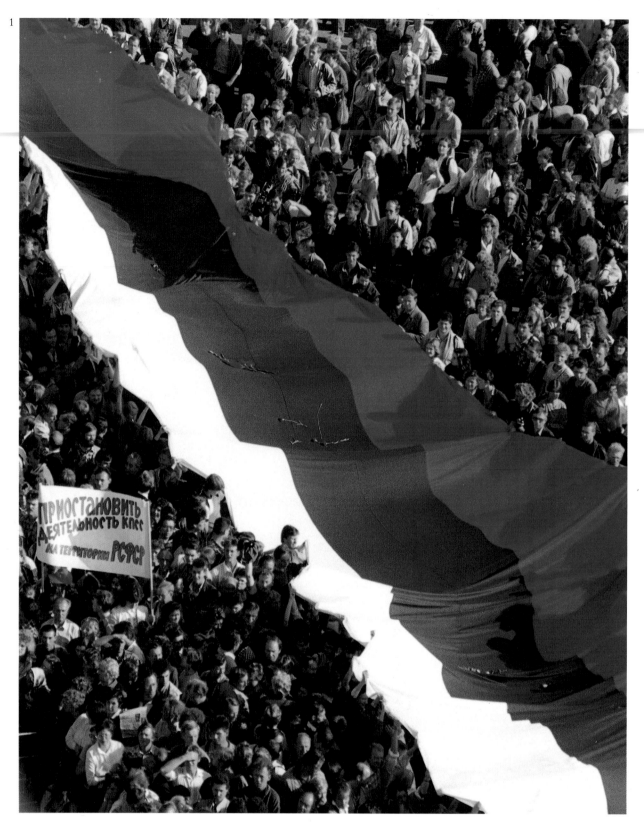

The Second Russian Revolution
Three months after the Berlin Wall came
down, the Baltic republics of Estonia, Latvia
and Lithuania fought to break free from
Soviet control. In January 1991 thirteen
civilians were killed when Soviet troops fired
on a crowd in Vilnius, Lithuania. (2) A group
of Lithuanians try to stop a Russian tank
from crushing a fallen protester. (1) Jubilant
Muscovites celebrate the failure of the hard-
line coup to oust Mikhail Gorbachev, August
1991.

Die Zweite Russische Revolution
Drei Monate nach dem Fall der Berliner
Mauer kämpften Estland, Lettland und Litau-
en um die Unabhängigkeit von sowjetischer
Kontrolle. Im Januar 1991 starben 13 Zivilisten,
als sowjetische Truppen eine Menschenmenge
in Vilnius, Litauen, beschossen. (2) Eine
Gruppe Litauer versucht, einen russischen
Panzer davon abzuhalten, einen gestürzten
Demonstranten zu überrollen. (1) Jubelnde
Moskauer feiern das Scheitern eines von
»Hardlinern« initiierten Staatsstreichs gegen
Michail Gorbatschow, August 1991.

La seconde révolution russe
Trois mois après la chute du mur de Berlin,
les républiques baltiques d'Estonie, de
Lettonie et de Lituanie combattirent pour se
libérer du contrôle soviétique. En janvier
1991, treize civils furent tués quand les
troupes soviétiques ouvrirent le feu sur la
foule à Vilnius en Lituanie. (2) Un groupe de
Lituaniens essaie d'empêcher un char russe
d'écraser un manifestant à terre. (1) Des
moscovites en liesse célèbrent l'échec du rud
coup d'Etat pour renverser Mikhaïl
Gorbatchev en août 1991.

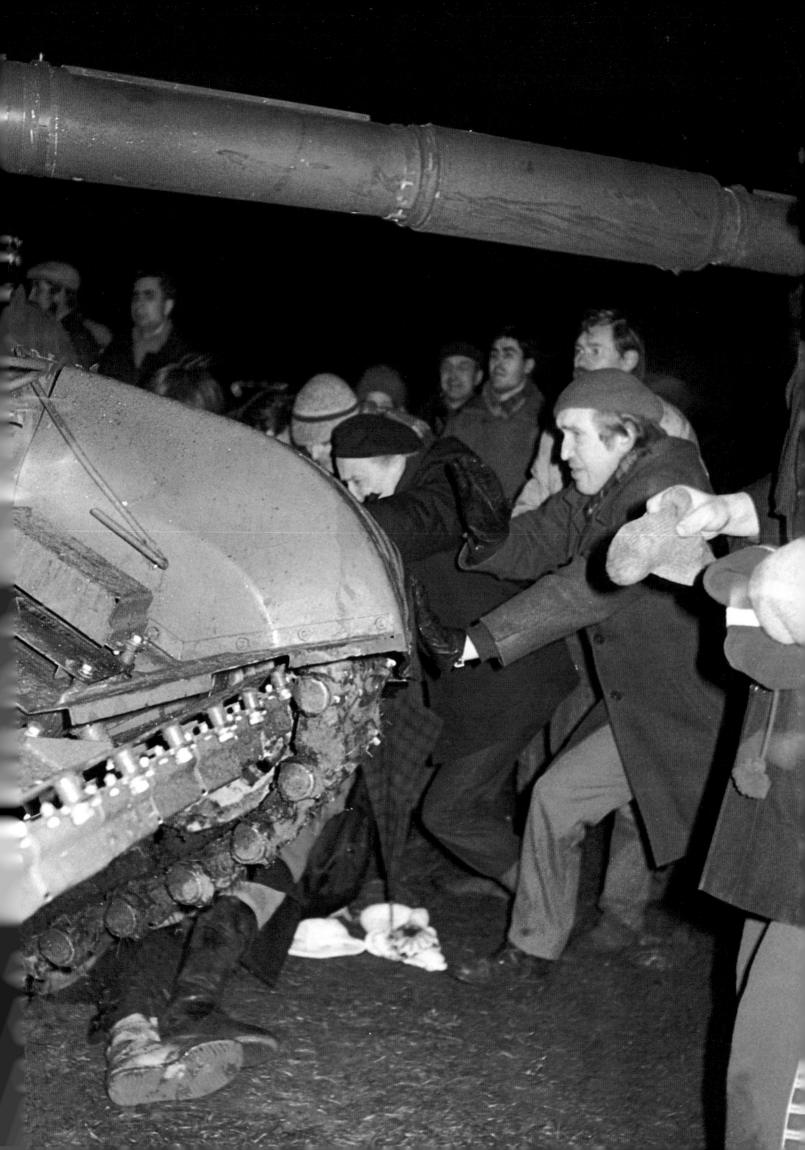

Dublin, 1922. For once the British are
not the enemy. Republicans and Free
Staters fight in the streets.

Dublin 1922. Ausnahmsweise sind
nicht die Briten die Feinde:
Republikaner und Freistaatler
kämpfen in den Straßen.

Dublin, 1922. Pour une fois, ce ne
sont pas les Britanniques qui sont les
ennemis. Combats de rue entre
Républicains et partisans de l'Etat
libre d'Irlande.

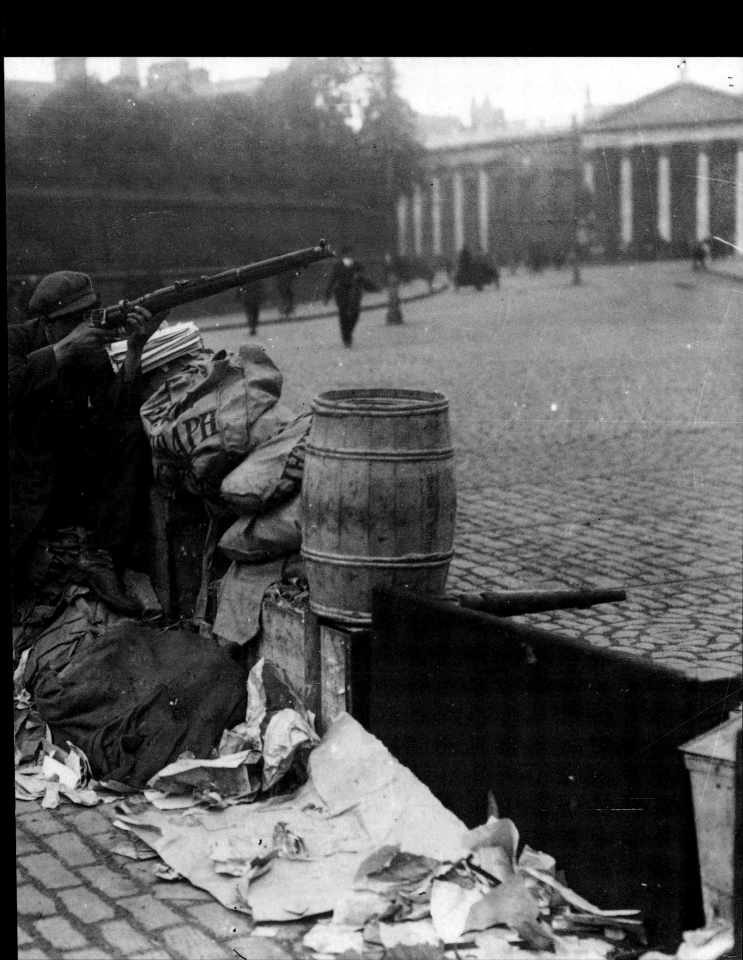

Brothers at War

With the exception of Switzerland, home of land-locked valleys and security-locked vaults, hardly a country in the world escaped some kind of armed uprising or revolution in the 150 years from the middle of the 19th to the end of the 20th century. Some nations were born of war – Germany, Italy, Israel. Others survived only through the blood-letting of civil war, like some ancient leech at its awful work – the United States, Spain, Russia, China. Many had to fight their way to independence – Cyprus, Zimbabwe, Mexico. And one nation, at least, disappeared in the shelled ruins of a broken federation – Yugoslavia.

Of all countries torn apart by the forces of history, Ireland suffered longest. The British hold over what George Bernard Shaw labelled 'John Bull's Other Island' was always precarious, and no colonial power behaves at its best when it feels insecure. But there were two historical events which made sure that the bomb and bullet would long tear Ireland asunder. The first was the repopulation of Northern Ireland with Scottish Lowland Presbyterians and English Protestants after the Flight of the Earls in the 1640s, which guaranteed sectarian rivalry thereafter. The second was the abolition of the Irish Parliament in 1800, which brought Irish MPs to Westminster and enmeshed Irish politics in British power struggles.

Three years after this forced Act of Union, Robert Emmet and a small band of Irish Nationalists unsuccessfully tried to capture Dublin Castle. They had been promised aid by Napoleon Bonaparte: it never materialised. In the confusion of the botched attack, an innocent judge – one of few – was killed. Emmet was charged with treason. At his trial he uttered the words which have confirmed the spirit of rebellion in generation after generation of fellow-patriots: 'When my country takes its place among the nations of the world, then, and not until then, let my epitaph be written.' He was hanged the next day. Two hundred years later the nation of Ireland, as Emmet and his successors envisaged it, has yet to take its rightful place in the world.

There have been heroes and villains on both sides in those two hundred years: men such as Terence MacSwiney, Lord Mayor of Cork, whose death in an English jail after 74 days on hunger strike made headlines round the world; or Edward Carson, who so vehemently opposed Home Rule for Ireland that he armed Ulster and all but precipitated a civil war. And there were those who were perhaps both hero and villain: men like Roger Casement and Michael Collins.

Of course, it's as easy to blame the great powers of the world for such tragedies as it is to blame the boss of a company for what goes wrong on the factory floor. Whom should we blame for the woes of Palestine, a land so rich and so sacred to Jew, Christian and Muslim alike? Over 50 years ago

Sir Edward Carson, surrounded by Union Jacks, addresses an Orange demonstration in 1914. Carson, the leader of the Irish Unionists and founder of the Ulster Volunteers, believed that the sword was mightier than the pen when it came to opposing Home Rule for Ireland.

Sir Edward Carson, umringt von britischen Union-Jack-Flaggen, spricht bei einer Oranier-Demonstration 1914. Carson, Führer der irischen Unionisten und Gründer der »Ulster Volunteers«, war davon überzeugt, daß beim Widerstand gegen die irische Selbstbestimmung die Macht des Schwertes stärker sein würde als die der Feder.

1914, devant une foule d'Orangistes, Sir Edward Carson, debout sur une estrade couverte de drapeaux britanniques, prit la parole. Pour Carson, chef des Unionistes de l'Irlande du Nord et fondateur des Volontaires de l'Ulster, les armes étaient plus fortes que les mots quand il s'agissait de s'opposer à l'autonomie pour l'Irlande.

the Anglo-US Commission on Palestine recommended a continuation of the British Mandate that had run since 1920 and the immediate admission of 100,000 Jews – refugees from the hunger and chaos of post-war Europe. Richard Crossman, a British member of that Commission, said that he did not 'conceive of an Arab and a Jewish state, but of one state exclusively Arab and one at the beginning 50-50 Jew and Arab, later achieving a Jewish majority'. Ten months later, British troops pulled out of Palestine, the state of Israel came into being, and bitter fighting began. It is still going on today.

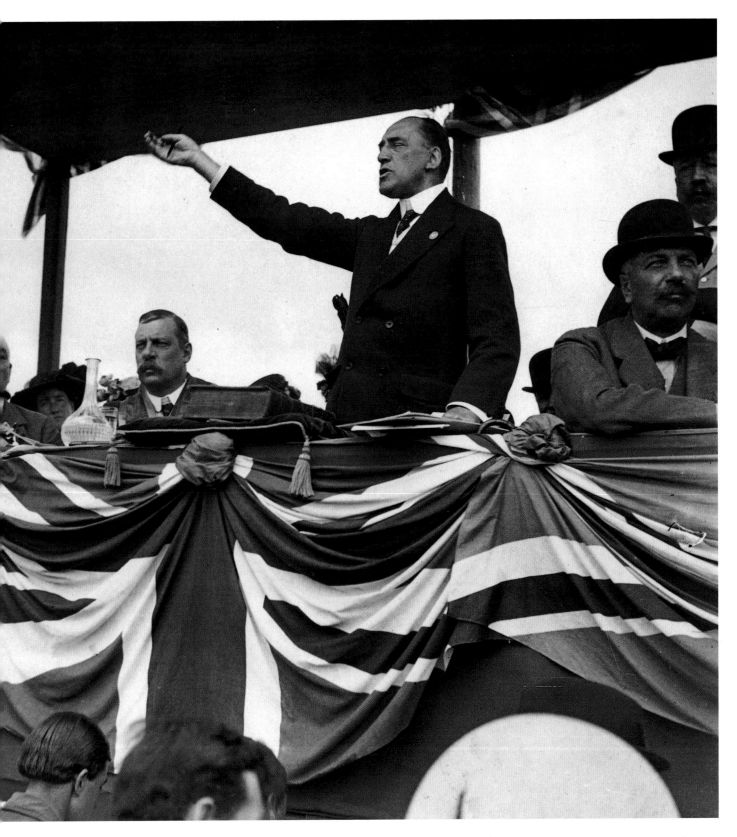

While Zionist bombs wrecked trains and hotels in the Holy Land, all-out civil war finally ended in China, when Mao Tse-tung's Communists drove the Nationalists of Chiang Kai-shek on to the offshore island of Formosa. For 60 years or more the only parts of China free from warlord or brigand, revolution or slavery, had been those in the hands of the foreign 'devils', the concessionary areas in the ports and cities along China's seaboard. The new regime brought an end to fighting and foreign exploitation, but little peace of mind. Two generations of Communist control have still not convinced some Chinese that Marxism is for all, as the dramatic events in Tiananmen Square testified.

As Mao enjoyed his last few years as the revered father of the People's Republic of China, ten thousand miles away Salvador Allende led Chile in a brief and painful burst of democracy. In September 1973 he was driven from office by a military coup that had US backing and massive CIA and ITT involvement. In his last speech, Allende vowed that he would teach 'a lesson in the ignominious history of those with strength but no reason.'

It is a lesson that the strong find difficult to learn.

Jewish refugees arrive at a British camp in Cyprus on their way to Palestine, 1947.

Jüdische Flüchtlinge auf ihrem Weg nach Palästina bei der Ankunft in einem britischen Lager auf Zypern, 1947.

1937, arrivée de réfugiés juifs dans un camp britannique à Chypre, étape sur leur route vers la Palestine.

Mit Ausnahme der Schweiz, der Heimat der tiefen Täler und der Nummernkonten, ist in den letzten 150 Jahren – von der Mitte des 19. bis zum Ende des 20. Jahrhunderts – kaum ein Land von Aufstand oder Revolution verschont geblieben. Einige Nationen entstanden erst durch Kriege – Deutschland, Italien, Israel. Andere haben nur durch den Aderlaß des Bürgerkriegs überlebt – die Vereinigten Staaten, Spanien, Rußland, China. Viele mußten sich ihren Weg zur Unabhängigkeit erkämpfen – Zypern, Simbabwe, Mexiko. Und mindestens eine Nation verschwand in den ausgebombten Ruinen einer zerbrochenen Föderation – Jugoslawien.

Von allen Ländern, die durch die Macht der Geschichte auseinandergerissen wurden, litt Irland am längsten. Der britische Zugriff auf »John Bulls andere Insel« (George Bernard Shaw) war immer unsicher, und keine Kolonialmacht zeigt sich von ihrer besten Seite, wenn sie sich unsicher fühlt. Aber es gab zwei historische Ereignisse, die festschrieben, daß Irland auf lange Zeit von Bomben und Kugeln auseinandergerissen würde. Das erste war die Ansiedlung südschottischer Presbyterianer und englischer Protestanten in Nordirland nach dem sogenannten »Flight of the Earls« um 1640. Damit waren sektiererische Rivalitäten während der folgenden Jahrhunderte garantiert. Das zweite Ereignis betraf die Abschaffung des irischen Parlaments 1800, die dazu führte, daß irische Parlamentsmitglieder nun in Westminster vertreten waren und die irische Politik Teil des britischen Machtkampfes wurde.

Drei Jahre nach diesem aufgezwungenen »Act of Union« versuchten Robert Emmet und eine kleine Truppe irischer Nationalisten erfolglos, Dublin Castle einzunehmen. Napo-leon Bonaparte hatte ihnen Unterstützung versprochen, die aber niemals eintraf. Im Chaos des mißlungenen Angriffs kam einer der wenigen unschuldigen Richter ums Leben. Emmet wurde des Verrats angeklagt. Bei seinem Prozeß sprach er die Worte, die den Geist der Rebellion über Generationen gleichgesinnter Patrioten festschrieben: »Wenn mein Land seinen Platz unter den Nationen der Welt einnimmt, dann, und erst dann soll mein Grabspruch geschrieben werden.« Am nächsten Tag wurde Emmet gehenkt. Zweihundert Jahre später ist der gerechte Platz der irischen Nation in der Welt, der Emmet und seinen Nachfolgern vorschwebte, noch immer nicht besetzt.

In diesen zweihundert Jahren gab es Helden und Schurken auf beiden Seiten: Männer wie Terence MacSwiney, Bürgermeister von Cork, dessen Tod in einem englischen Gefängnis nach 74 Tagen Hungerstreik auf der ganzen Welt für Schlagzeilen sorgte; oder Edward Carson, der so vehement gegen die Selbstbestimmung Irlands eingestellt war, daß er die Provinz Ulster bewaffnete und beinahe einen Bürgerkrieg heraufbeschwor. Und dann gab es diejenigen, die vielleicht beides waren, Helden und Schurken – Männer wie Roger Casement und Michael Collins.

Natürlich ist es einfach, die Großmächte der Welt für solche Tragödien verantwortlich zu machen – wie den Chef einer Firma dafür, was in der Fabrikhalle vorgeht. Wem sollen wir die Schuld für die Wunden in Palästina geben, einem Land, das so reich und für Juden, Christen und Moslems gleichermaßen heilig ist? Vor mehr als 50 Jahren befürwortete die anglo-amerikanische Kommission für Palästina eine Verlängerung des britischen Mandats, das seit 1920 bestand, sowie die sofortige Aufnahme von 100000 Juden – Flüchtlinge des Hungers und des Chaos im Nachkriegseuropa. Richard Crossman, ein britisches Mitglied der Kommission, sagte, daß er sich »keinen arabischen und jüdischen Staat« vorstelle, »sondern einen Staat ausschließlich für Araber und einen, der zunächst zur Hälfte von Arabern und zur Hälfte von Juden, später aber von einer jüdischen Mehrheit bewohnt werden soll«. Zehn Monate später zogen sich die britischen Truppen aus Palästina zurück, der Staat Israel wurde gegründet, und die bitteren Kämpfe begannen. Sie dauern bis zum heutigen Tage an.

Während zionistische Bomben Züge und Hotels im Heiligen Land zerstörten, ging der Bürgerkrieg in China zu Ende, nachdem Mao Tse-tungs Kommunisten die Nationalisten unter Tschiang Kai-schek auf die Insel Formosa vor der Küste getrieben hatten. Für mehr als 60 Jahre waren nur solche Gebiete Chinas frei von Kriegsherren oder Banditen, Revolution oder Sklaverei, die sich in der Hand der ausländischen »Teufel« befanden – die konzessionierten Häfen und Städte entlang der chinesischen Küste. Die neue Regierung beendete die Kämpfe und die ausländische Ausbeutung, brachte aber keinen inneren Frieden. Zwei Generationen kommunistischer Kontrolle haben einige Chinesen immer noch nicht davon überzeugt, daß Marxismus für alle da ist, wie die dramatischen Ereignisse

1989 auf dem Tiananmen-Platz, dem »Platz des Himmlischen Friedens«, verdeutlichen.

Während Mao seine letzten Jahre als verehrter Vater der Volksrepublik China genoß, führte fünfzehntausend Kilometer weit entfernt Salvador Allende Chile zu einem kurzen und schmerzhaften Aufbruch in die Demokratie. Im September 1973 wurde er durch einen Militärputsch aus dem Amt getrieben, den die USA unterstützten und an dem CIA und ITT massiv beteiligt waren. In seiner letzten Rede schwor Allende, er würde »der schändlichen Geschichte derer, die Macht, aber keine Vernunft besitzen«, eine Lektion erteilen.

Es ist eine Lektion, die die Starken nur schwer lernen.

A l'exception de la Suisse, pays aux frontières fermées et aux coffres-forts inviolables, il n'est pour ainsi dire aucun pays au monde qui ne connaîtra pas de soulèvement armé ou de révolution entre 1850 et la fin de notre siècle. De la guerre sont nées des nations comme l'Allemagne, l'Italie et Israël. D'autres ont survécu, non sans avoir traversé une guerre civile meurtrière, telle une sangsue à l'œuvre. C'est le cas des Etats-Unis, de l'Espagne, de la Russie, de la Chine. Beaucoup de pays se battront pour sauvegarder leur indépendance, comme Chypre, le Zimbabwe et le Mexique. Mais une nation au moins disparaîtra: la Yougoslavie, ensevelie sous les ruines d'une fédération brisée.

De tous les pays que les forces de l'histoire ont déchirés, l'Irlande est le pays qui aura souffert le plus longtemps. L'emprise britannique sur «la deuxième île de John Bull», pour citer George Bernard Shaw, a toujours été précaire et aucune puissance coloniale ne se comporte bien quand elle se sait en péril. Deux événements historiques peuvent expliquer pourquoi, pendant longtemps encore, les bombes allaient déchirer l'Irlande. Le premier remonte aux années 1640, quand des Presbytériens écossais et des Protestants anglais s'installèrent en Irlande du Nord après la Fuite des Comtes. De cette émigration naquit une rivalité durable entre les communautés religieuses. Le deuxième événement fut l'abolition du Parlement irlandais en 1800, qui obligea les Irlandais à siéger dorénavant à Westminster, liant ainsi le destin politique de l'Irlande à la lutte pour le pouvoir menée par la Grande-Bretagne.

Trois ans après la signature forcée de l'Acte d'Union, Robert Emmet et un petit groupe d'Irlandais nationalistes tentèrent sans succès de prendre le Château de Dublin. Napoléon Bonaparte leur avait promis de l'aide, mais celle-ci n'arrivera jamais. Dans la confusion de cette attaque manquée, un juge innocent – une des seules victimes – fut tué. Emmet fut accusé de trahison. Lors du procès, il fit une déclaration qui animera, pendant des générations, l'esprit de révolte de ses compatriotes: «Lorsque mon pays aura sa place parmi les nations du monde, alors, et à ce moment-là seulement, pourra-t-on écrire mon épitaphe.» Il fut pendu le jour suivant. Deux cents ans plus tard, la nation irlandaise, telle que Emmet et ses successeurs l'avait imaginée, n'avait toujours pas acquis la juste place qui lui revenait.

Deux siècles plus tard, on peut compter des héros et des traîtres dans chaque camp. Il y avait des hommes comme Terence MacSwiney, le maire de Cork, dont la mort, dans une prison anglaise après 74 jours de grève de la faim, fit la une des journaux du monde entier, et d'autres comme Edward Carson, un farouche opposant à la *Home Rule,* l'autonomie pour l'Irlande, qui arma la Province de l'Ulster et faillit précipiter son pays dans la guerre civile. Il y eut aussi des hommes qui furent les deux à la fois, des héros et des traîtres, comme Roger Casement et Michael Collins.

Il est certes aussi facile de rejeter la responsabilité de ces tragédies sur les grandes puissances de ce monde que de condamner le dirigeant d'une société pour une production défaillante. A qui attribuer la responsabilité des malheurs de la Palestine, une terre si riche et si sacrée à la fois pour les Juifs, les Chrétiens et les Musulmans? Un demi-siècle plus tôt, la Commission anglo-américaine pour la Palestine préconisait la prolongation du mandat britannique mis en place dès 1920 et l'accueil immédiat de 100 000 Juifs, réfugiés de la faim et du chaos de l'Europe de l'après-guerre. Richard Crossman, un des membres de la Commission, déclara qu'il fallait concevoir «non pas un Etat à la fois arabe et juif, mais un Etat exclusivement arabe et un Etat qui, au début, serait moitié arabe, moitié juif, avant de parvenir à une majorité juive». Dix mois plus tard, les troupes britanniques se retirèrent de la Palestine. Ce fut la naissance de l'Etat d'Israël et le début d'une âpre lutte qui se poursuit jusqu'à nos jours.

Tandis que les bombes sionistes détruisaient trains et hôtels en Terre Sainte, la guerre civile qui ravageait la Chine cessa enfin. Les Communistes de Mao Tsé-Toung avaient repoussé les Nationalistes de Tchang Kaï-Chek sur l'île de Formose. Pendant plus de 60 ans, les seules régions de la Chine à avoir été épargnées par les seigneurs de la guerre ou les brigands, la révolution ou l'esclavage, furent celles se trouvant aux mains des «diables» étrangers, à savoir les concessions dans les ports et villes situés sur les côtes de la Mer de Chine. Le nouveau régime mit un terme aux combats et à l'exploitation étrangère, sans pour autant parvenir à instaurer le calme et la paix. Deux générations de pouvoir communiste n'ont toujours pas su convaincre un petit nombre de Chinois que le marxisme était pour tout le monde, comme l'ont prouvé les événements tragiques de la Place Tiananmen, en 1989.

Alors que Mao jouit, à la fin de sa vie, du titre de père vénéré de la République de Chine, à des milliers de kilomètres de là, au Chili, Salvador Allende tenta une percée démocratique qui sera brève et douloureuse. En septembre 1973, il fut renversé par un coup d'état militaire soutenu par les Etats-Unis et où la CIA et l'ITT étaient fortement impliqués. Dans son dernier discours, Allende fit vœu de donner une «leçon à ceux dont l'histoire honteuse s'est faite par la force et non par la raison».

C'est une leçon que les plus puissants peinent à apprendre.

The Fenian Brotherhood

The Fenians were the forerunners of the Irish Republican Brotherhood, founded in 1858 in the United States. The Fenians believed in direct action to get an independent Ireland and soon provided martyrs for the cause. One of their bolder – and less successful – exploits was to invade Canada in May 1866. The aim was to capture Canada and hold it as hostage for Irish freedom. The invasion was unsuccessful, and the invaders were arrested. The dates on the slates held by the two prisoners would suggest that James Donaghy and Hugh McGrishan were involved in this desperate enterprise.

Die Bruderschaft der Fenier

Die Fenier, die Vorläufer der Irisch-Republikanischen Bruderschaft, wurden 1858 in den Vereinigten Staaten gegründet. Sie glaubten, mit Gewalt die Unabhängigkeit Irlands erreichen zu können, und schon bald gab es Märtyrer für ihre Sache. Eine ihrer verwegeneren – und weniger erfolgreichen – Aktionen war der Plan einer Invasion Kanadas im Mai 1866. Das Ziel war die

Besetzung Kanadas, das dann gegen die Freiheit Irlands eingetauscht werden sollte. Die Invasion scheiterte, und die Angreifer wurden verhaftet. Die Angaben auf den Tafeln, die die beiden Gefangenen tragen, deuten darauf hin, daß James Donaghy und Hugh McGrishan an dieser verzweifelten Aktion beteiligt waren.

La Fraternité des Fenians

Les Fenians furent les précurseurs de la Fraternité République Irlandaise, fondée aux Etats-Unis en 1858, et prônaient l'action directe pour obtenir l'indépendance de l'Irlande. Très vite, des martyrs tomberont pour la cause. Un de leurs exploits le plus courageux, et aussi le moins réussi, fut l'invasion du Canada en mai 1866. Leur but était de prendre ce pays en otage pour obtenir

la libération de l'Irlande. L'invasion échoua et les membres de l'expédition furent arrêtés. A en croire les dates qui sont inscrites sur les ardoises de ces deux prisonniers, James Donaghy et Hugh McGrishan étaient impliqués dans cette entreprise désespérée.

Captain Boycott

n 1880 Charles Parnell, President of the
rish Land League, urged that anyone taking
ver a farm from which the previous tenants
ad been evicted should be shunned by his
eers. (1) Captain Boycott, a land agent, was
he first to be so treated; his name passing
nto the English language. (2) After
rganizing a rent strike in Tipperary, Father
Humphries was shadowed by the
onstabulary.

Captain Boycott

1880 forderte Charles Stuart Parnell, der
Präsident der Irischen Landliga, daß jeder, der
eine Farm übernehmen wollte, deren
vorheriger Eigentümer vertrieben worden
war, »von seinen Freunden gemieden werden
solle«. (1) Charles Boycott, ein Gutsverwal-
ter, war der erste, dem diese Behandlung
widerfuhr – und sein Name ging in die
englische Sprache ein. (2) Pfarrer Humphries
organisierte einen Mietstreik in Tipperary
und wurde daraufhin von der Polizei
beschattet.

Le Capitaine Boycott

(1) En 1880, Charles Parnell, président de la
Irish Land League, déclara que toute personne
qui reprendrait une ferme dont les précédents
locataires avaient été expulsés «devait être
tenu à l'écart par les siens». Boycott, un
régisseur terrien, fut le premier à enfreindre
le mot d'ordre et à être mis au ban. C'est
ainsi que son nom entra dans la langue
anglaise. (2) Le Père Humphries avait
organisé une grève des loyers à Tipperary et
tous ses faits et gestes furent désormais
surveillés par la police.

2

Sir Roger Casement

In April 1916, Casement, formerly of the British Consular Service, came from Germany to prevent the Easter Rising, which he knew would fail without German help. But he was arrested (2), charged with treason and found guilty. To silence his supporters, sections of his diary, in which he recorded his homosexual activities, were leaked. (1) A large crowd gathered at Pentonville where he was hanged on 3 August 1916.

Sir Roger Casement

Im April 1916 reiste Casement, ehemaliger Mitarbeiter des britischen Konsulardienstes, von Deutschland nach Irland, um den Oster-aufstand zu verhindern. Er wußte, daß die Rebellion ohne deutsche Hilfe scheitern würde. Er wurde jedoch festgenommen (2), des Verrats angeklagt und verurteilt. Um seine Anhänger zum Schweigen zu bringen, veröffentlichte man Teile seines Tagebuchs über seine homosexuellen Aktivitäten. (1) Eine große Menschenmenge versammelte sich in Pentonville, wo Casement am 3. August 1916 gehenkt wurde.

Sir Roger Casement

Avril 1916, Casement, ancien membre du service consulaire britannique, arrivait d'Alle-magne pour empêcher les Pâques sanglantes car il savait que, sans le soutien des Alle-mands, elles échoueraient. Mais il fut arrêté (2), accusé de trahison et déclaré coupable. Pour faire taire ses partisans, des extraits de son journal intime, dans lequel il relatait ses aventures homosexuelles, furent divulgués. (1) Une grande foule se réunit à Pentonville le jour de sa pendaison, le 3 août 1916.

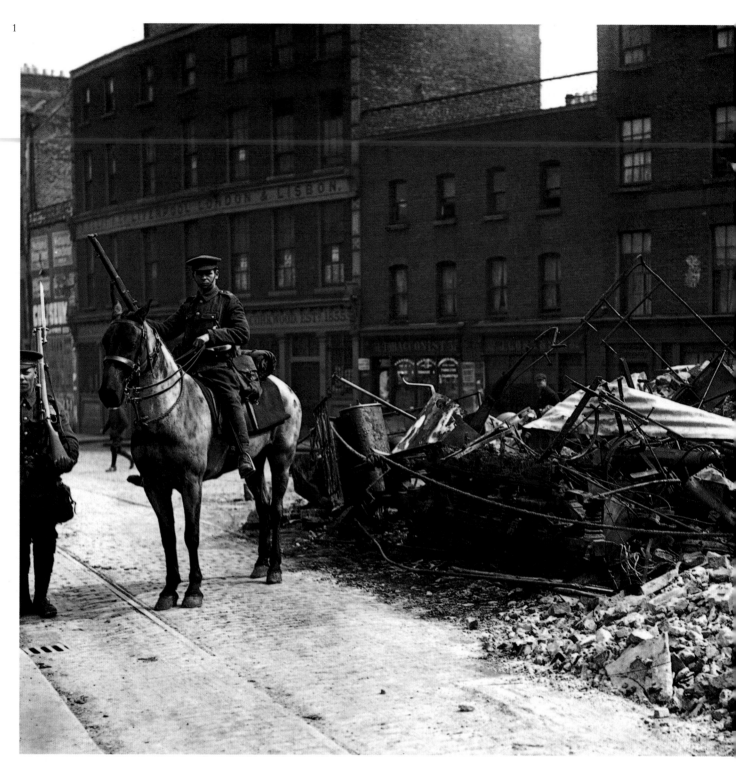

The Easter Rising

On Easter Monday 1916, a body of Irish
Volunteers and members of the Irish Citizen
Army took control of the General Post Office
in Sackville Street, Dublin. The 150 men
were commanded by Patrick Pearse and
James Connolly. They were poorly armed
and carried enough sandwiches for one week.
From the steps of the GPO Pearse
proclaimed the Irish Republic. He expected
the rising to fail, but hoped it would set in
motion greater revolutionary efforts.
(1) Tramcars were used as barricades in the
street fighting that followed. (2) The GPO
itself was gutted. (3) After Pearse and his men
surrendered, the poor searched for food and
fuel in the ruins. Pearse and Connolly were

both executed by firing squads – Connolly
had to be tied to a chair as he had been
wounded and was unable to stand.

Der Osteraufstand

Am Ostermontag 1916 besetzten Mitglieder
der *Irish Volunteers* und der »Irischen
Bürgerarmee« das Hauptpostamt auf der
Sackville Street in Dublin. Die 150 Männer
wurden von Patrick Pearse und James
Connolly angeführt. Sie waren schlecht
bewaffnet und führten einen Brotvorrat für
eine Woche bei sich. Auf den Stufen des
Hauptpostamtes rief Pearse die Irische
Republik aus. Er rechnete mit dem Scheitern
des Aufstands, hoffte aber, daß er größere
revolutionäre Bewegungen in Gang setzen

würde. (1) In den folgenden Kämpfen
dienten Straßenbahnen häufig als Barrikaden
(2) Das Hauptpostamt brannte völlig aus.
(3) Nachdem Pearse und seine Männer sich
ergeben hatten, suchten die Armen in den
Ruinen nach Lebensmitteln und Brennstoff.
Pearse und Connolly wurden von einem
Exekutionskommando erschossen. Da
Connolly wegen Verwundung dabei nicht
stehen konnte, wurde er auf einem Stuhl
festgebunden.

Les Pâques sanglantes

Le lundi de Pâques 1916, un groupe de
Volontaires irlandais et des membres de
l'Armée des citoyens irlandais s'empara de la
poste principale de Dublin, à Sackville Street

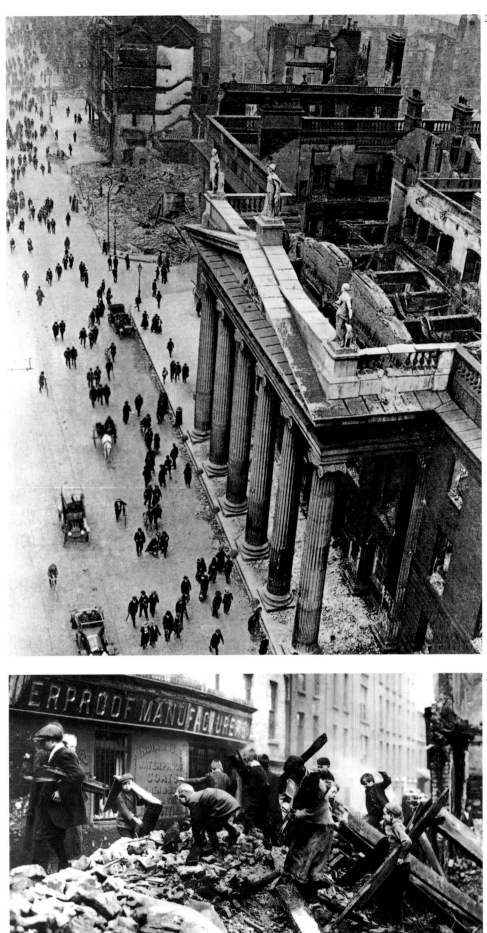

Les 150 hommes étaient sous les ordres de Patrick Pearse et James Connolly. Ils étaient peu armés et avaient assez de provisions pour tenir une semaine. Du haut des escaliers de la poste, Pearse proclama la République d'Irlande. Il s'attendait à ce que le soulèvement échoue mais espérait qu'il donnerait l'élan à de plus grands mouvements révolutionnaires. (1) Les trams furent utilisés comme barricades durant les échauffourées qui s'ensuivirent. (2) Pillage de la poste. (3) Pauvres à la recherche de nourriture et de charbon après la reddition de Pearse et de ses hommes. Exécution de Pearse et Connolly par un peloton. Blessé et incapable de se tenir debout, Connolly fut attaché sur une chaise.

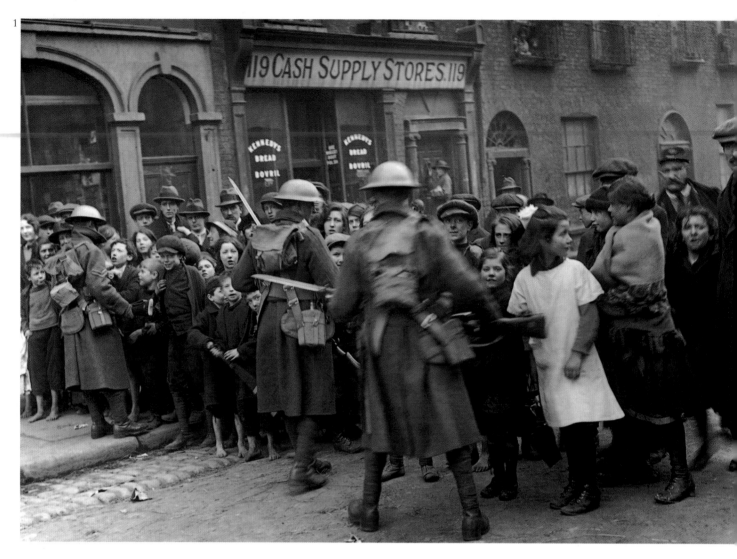

The Black and Tans

By 1920 Ireland was in uproar. The new leaders of the republican movement – Eamon de Valera and Michael Collins – maintained the armed struggle against (1) British troops, (2) the police, and (3) the infamous Black and Tans. Here two members of the Black and Tans search a suspect who may well have been lucky that a camera had arrived on the scene. His comrade, lying on the road behind, was not so fortunate. Asquith, leader of the Opposition in the British House of Commons, said: 'There are things being done in Ireland which would disgrace the blackest annals of the lowest despotism in Europe.'

Die *Black and Tans*

1920 wurde Irland von Aufständen erschüttert. Die neuen Führer der republikanischen Bewegung – Eamon de Valera und Michael Collins – kämpften mit Waffengewalt gegen (1) britische Truppen, (2) die Polizei und (3) die berüchtigten *Black and Tans* – eine Polizeispezialtruppe aus ehemaligen englischen Armeeangehörigen. Hier durchsuchen zwei Mitglieder der *Black and Tans* einen Verdächtigen, der wohl nur darum noch lebt weil ein Kameramann dazukam. Sein Kamerad, der hinter ihm auf der Straße liegt, hatte nicht so viel Glück. Der Oppositionsführer im britischen Unterhaus, Asquith, kommentierte: »Es geschehen Dinge in Irland, die die dunkelsten Annalen des niedrigsten Despotismus in Europa noch beschämen würden.«

Les *Black and Tans*

En 1920, l'Irlande traversa une période de grande agitation. Les nouveaux chefs du mouvement républicain, Eamon de Valera et Michael Collins, maintinrent la lutte armée contre (1) les troupes britanniques, (2) la police et (3) les infâmes *Black and Tans* (divisions spéciales composées d'anciens militaires anglais). Deux membres des *Black and Tans* fouillent un suspect dont la vie fut peut-être sauvée par le photographe témoin de la scène. Son camarade, gisant un peu plu loin sur la route, n'a pas eu cette chance. Pour Asquith, chef de l'opposition à la Chambre des communes britannique, «ce qui se passe en Irlande fait honte aux périodes les plus noires du plus vil des despotismes qu'ait pu connaître l'Europe».

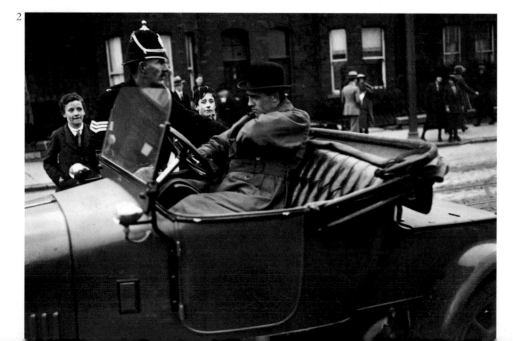

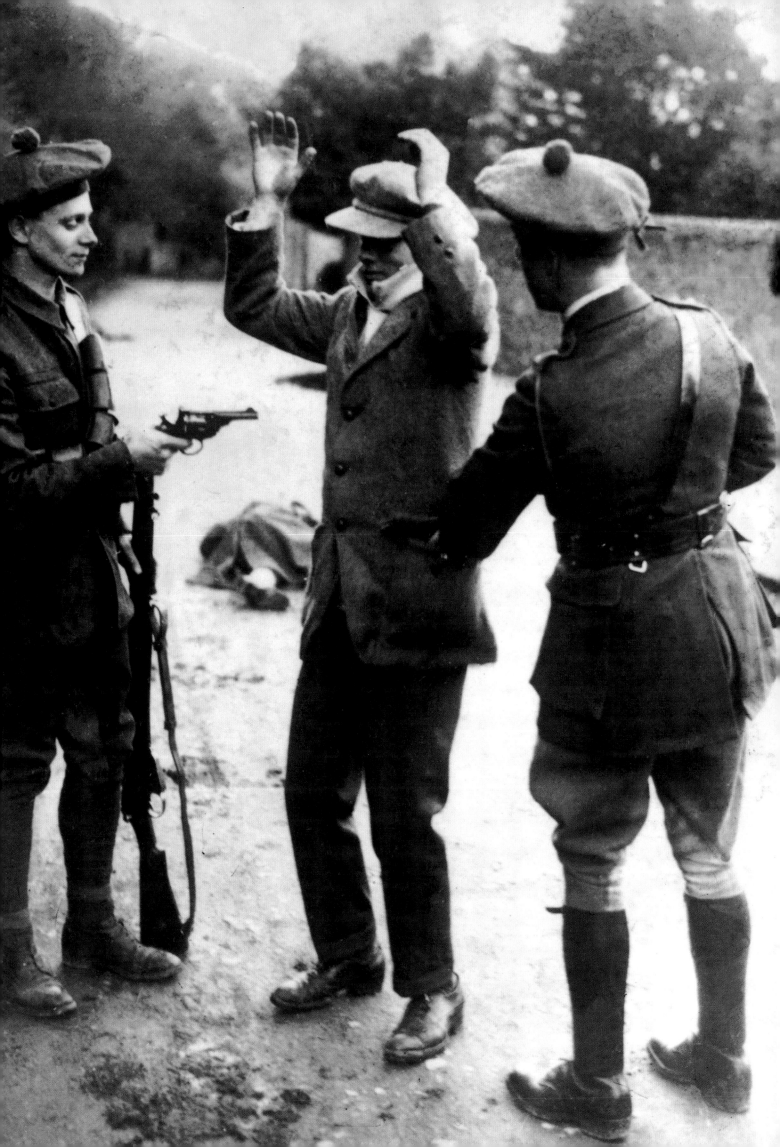

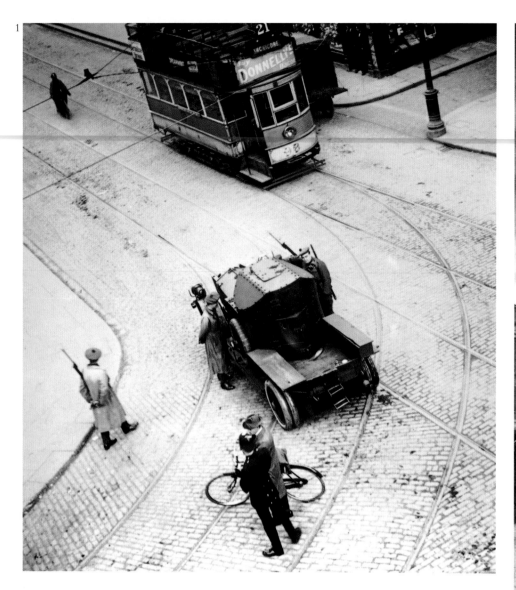

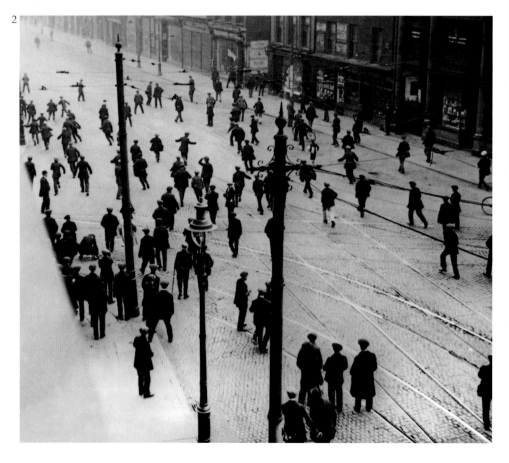

The Irish Split

In 1918 Sinn Fein set up their own Parliament or *Dáil* in Dublin. Their plan was to achieve independence by non-violent means. The IRB had other ideas, and created the Irish Republican Army, under the command of Michael Collins. (1) The IRA was poorly armed but well organized; the British had to bring armoured Crossley tenders to the streets of Dublin to keep order. (2) When a strike was called by Republicans in September 1920, shipyard workers were attacked on their way to work. (3) The IRA's Dublin Brigade captured and destroyed the Customs House in May 1921.

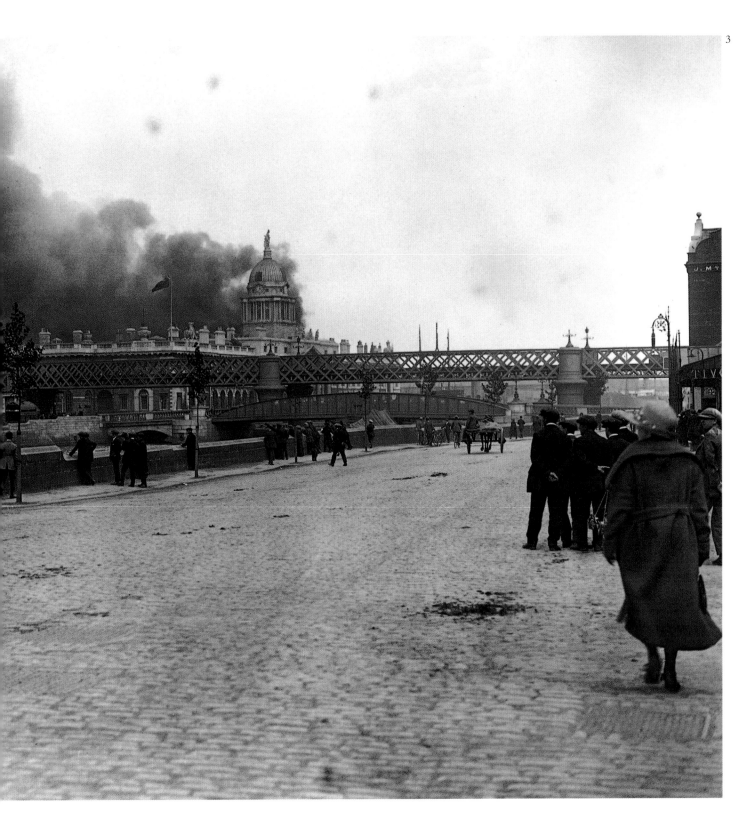

Die Teilung Irlands

1918 gründet die Sinn Fein ihr eigenes Parlament, den *Dáil,* in Dublin. Die Unabhängigkeit sollte nach ihren Vorstellungen mit gewaltfreien Mitteln erreicht werden. Im Gegensatz dazu gründete die IRB (*Irish Republican Brotherhood*) die Irisch-Republikanische Armee unter der Führung von Michael Collins. (1) Die IRA war schlecht bewaffnet, aber gut organisiert; die Briten mußten Crossley-Panzerwagen in den Straßen von Dublin auffahren, um die Ordnung aufrechtzuerhalten. (2) Nachdem die Republikaner im September 1920 einen Streik ausgerufen hatten, werden Dock-arbeiter auf ihrem Weg zur Arbeit angegriffen. (3) Die Dubliner Brigade der IRA besetzt und zerstört das Zollhaus im Mai 1921.

Le partage de l'Irlande

En 1918, le Sinn Fein mit en place son propre Parlement, le *Dáil,* à Dublin. Son intention était de parvenir à l'indépendance sans avoir recours à la violence. La Fraternité République Irlandaise avait d'autres vues et créa l'I.R.A., l'Armée Républicaine Irlandaise, dirigée par Michael Collins. (1) L'I.R.A. était sous-équipée mais bien organisée. Les Britanniques durent faire venir des véhicules blindés, les Crossley, pour maintenir l'ordre dans les rues de Dublin. (2) Septembre 1920, appel à la grève des Républicains. Des ouvriers du chantier naval furent attaqués alors qu'ils se rendaient à leur travail. (3) Mai 1921, la Brigade de Dublin de l'I.R.A. s'empara du Bureau des douanes et le détruisit.

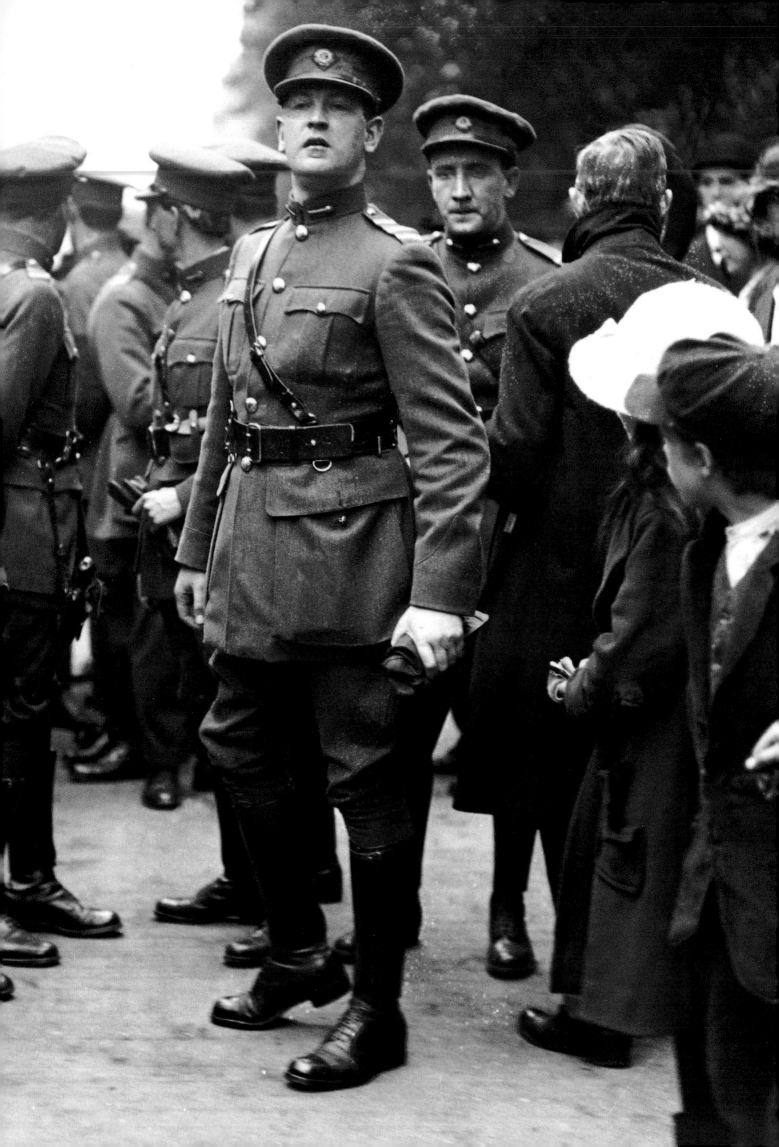

Free State or Republic?

De Valera (2) believed in a Republic of all Ireland, while Arthur Griffith and Collins saw an Irish Free State of the 26 southern counties as a stepping stone. By signing the Treaty establishing the Free State, Collins knew he was signing his own death warrant. In August 1922 Griffith died of a heart attack. (1) Collins attended his funeral. Less than a week later Collins himself was dead, shot by the IRA in an ambush in County Cork. (3) His body was brought to Dublin to lie in state. (Overleaf) At the launching of the Irish Free State in March 1922, Michael Collins addresses the Dublin crowd.

Freistaat oder Republik?

De Valera (2) glaubte an eine gesamtirische Republik. Arthur Griffith und Collins sahen dagegen in einem irischen Freistaat aus den 26 südlichen Provinzen einen ersten Schritt zur irischen Unabhängigkeit. Collins wußte, daß er mit dem Vertrag zur Gründung des Freistaates sein Todesurteil unterschrieb. Im August 1922 starb Griffith an einem Herzanfall. (1) Collins nahm an der Beerdigung teil. Weniger als eine Woche später wurde er bei einem Attentat der IRA in der Grafschaft Cork erschossen. (3) Man brachte seinen Leichnam nach Dublin, wo er feierlich aufgebahrt wurde. (Folgende Doppelseite) Bei der Proklamation des irischen Freistaates im März 1922 spricht Michael Collins zu einer Menschenmenge in Dublin.

Etat indépendant ou République?

De Valera (2) croyait en une république pour l'ensemble de l'Irlande tandis que Arthur Griffith et Collins considéraient que la création d'un Etat libre d'Irlande, composé des 26 comtés du Sud du pays, représentait un premier pas vers l'indépendance. En août 1922, Griffith mourut d'une crise cardiaque. (1) Collins se rendit à ses funérailles. Moins d'une semaine plus tard, Collins mourut après être tombé dans une embuscade dressée par l'I.R.A. dans le Comté de Cork. (3) Son corps fut ramené à Dublin et exposé solennellement. (Page suivante) Mars 1922, à l'inauguration de l'Etat libre d'Irlande, Michael Collins s'adressa aux Dublinois.

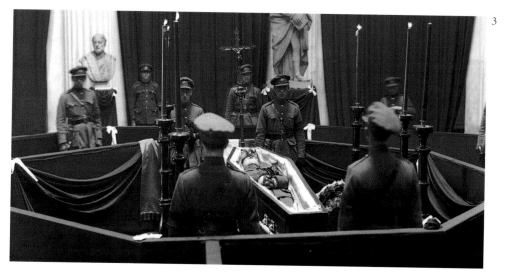

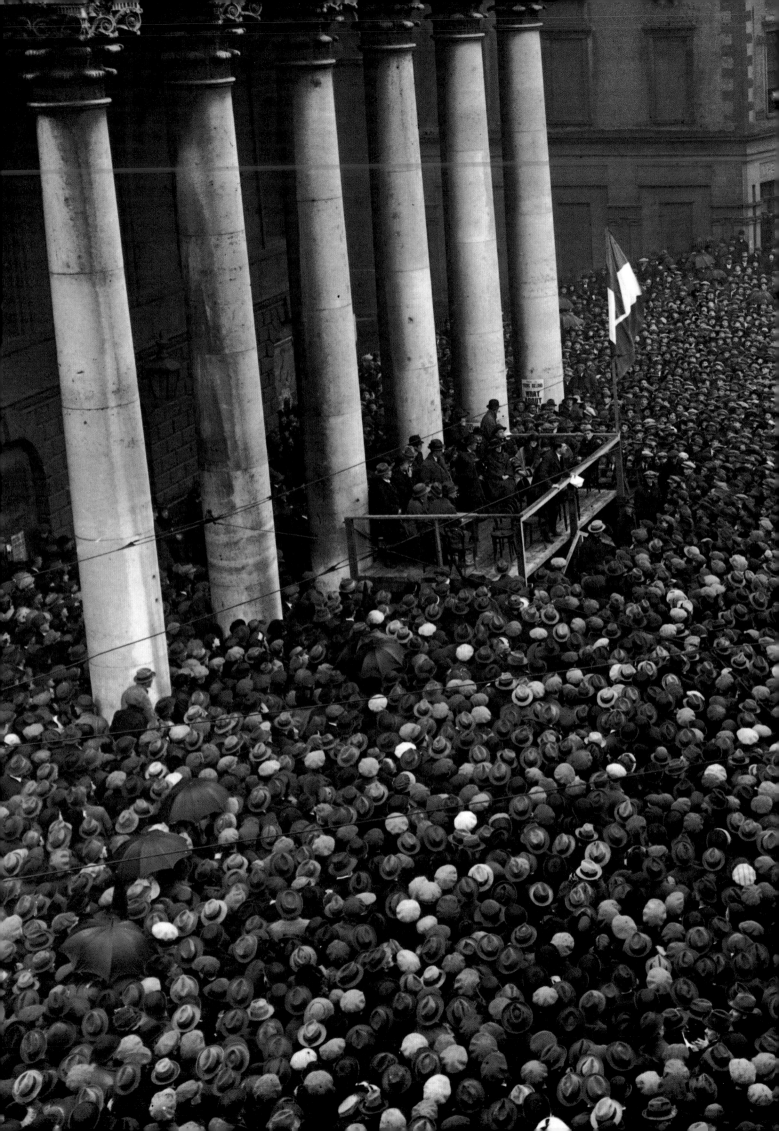

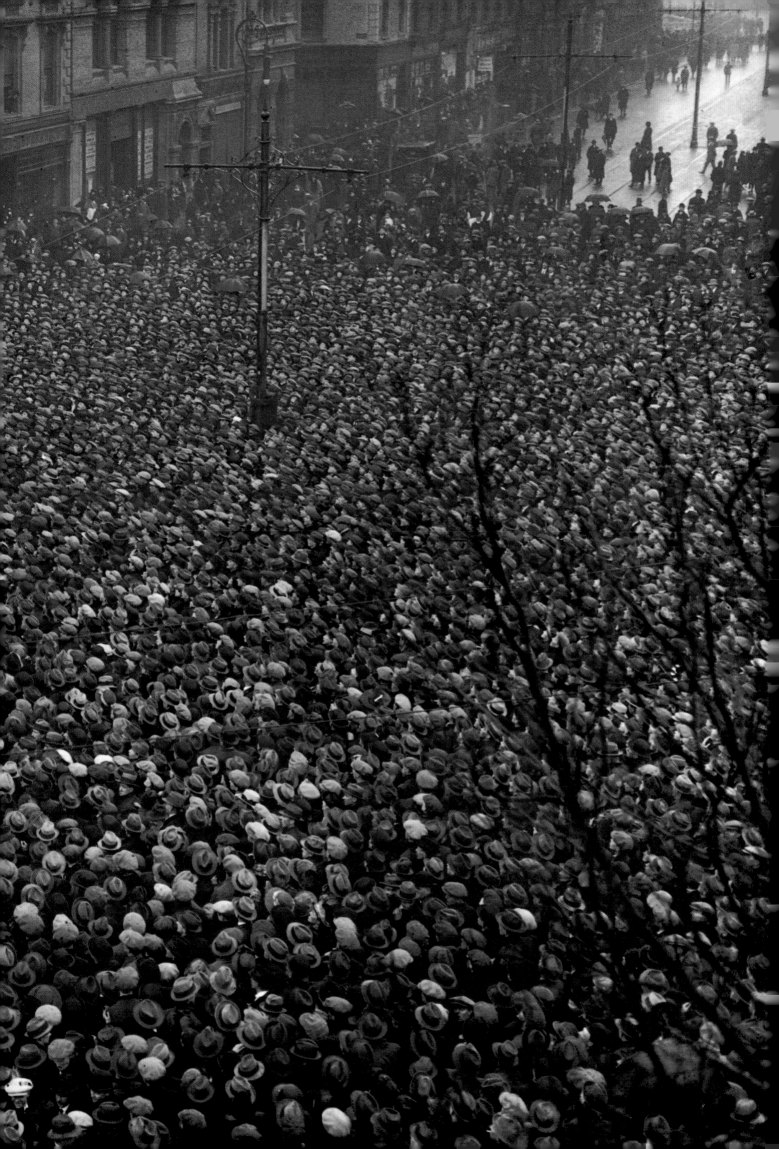

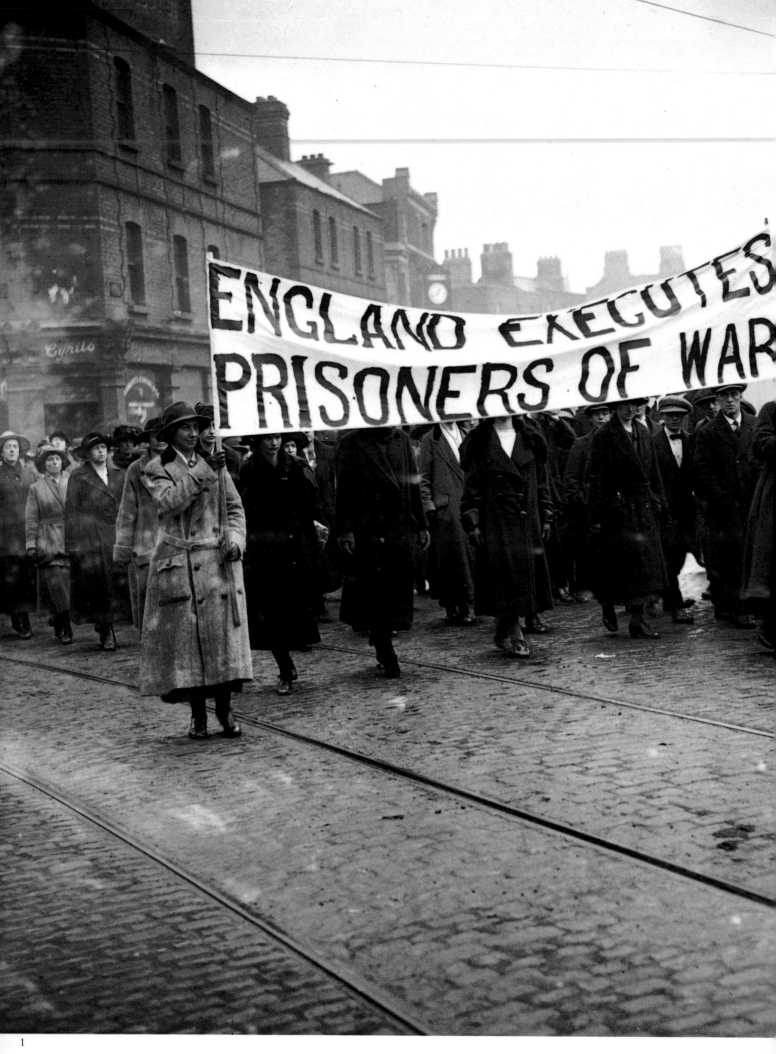

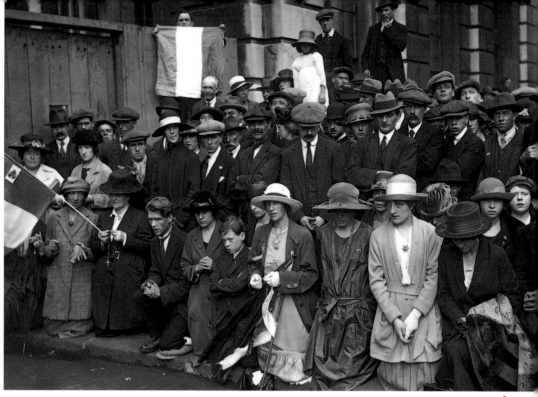

Towards Peace in Ireland

(1) When the British began hanging IRA volunteers as murderers, Republicans took to the streets of Dublin. Temporary gates were erected in Whitehall, London, in October 1921, while negotiations took place between Sinn Fein and the British Government.
(2) Crowds gather to pray for peace. (3) In July another crowd awaits news of the truce.

Irland auf dem Weg zum Frieden

(1) Als die Briten begannen, Freiwillige der IRA als Mörder aufzuhängen, gingen die Republikaner auf die Straße. Im Oktober 1921 wurden in Whitehall, London, für die Verhandlungen zwischen Sinn Fein und der britischen Regierung Gitter errichtet.

(2) Menschenmengen beten für den Frieden.
(3) Im Juli erwartet eine Menschenmenge Nachrichten über den Waffenstillstand.

Vers la paix en Irlande

(1) Lorsque les Britanniques commencèrent à pendre des volontaires de l'I.R.A., les Républicains descendirent en masse dans les rues de Dublin. Octobre 1921, des barrières provisoires furent élevées devant le Whitehall à Londres pendant les négociations entre le Sinn Fein et le gouvernement britannique.
(2) Rassemblements pour prier pour la paix.
(3) Juillet 1921, la foule, à nouveau réunie, attendait la nouvelle annonçant la signature de la trêve par Lloyd George et de Valera.

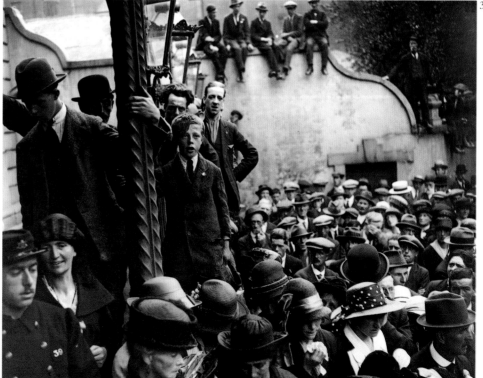

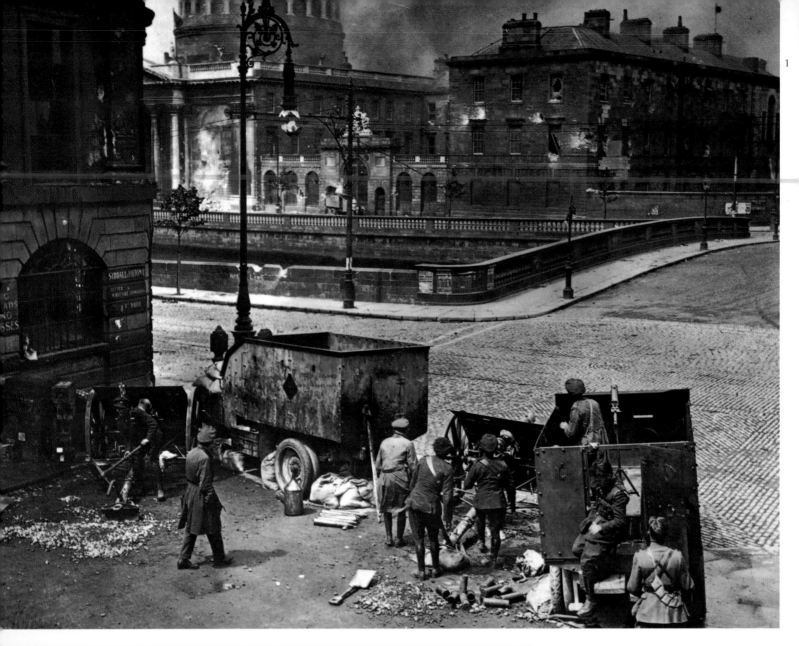

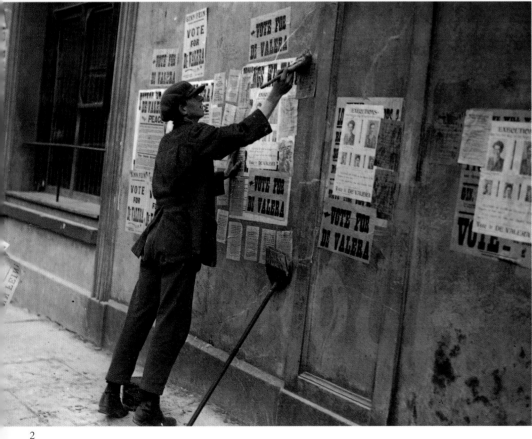

Civil War in Ireland

After the Free State Treaty, Irishmen fought each other. (1) At the Four Courts in Dublin, July 1922, the uniformed Free State Army used British artillery to attack the Republican IRA. (3) Non-uniformed IRA members defiantly patrol Dublin streets in the same month. (4) Free State troops fire on Republicans. In April 1923 de Valera called off action and stood for election to a parliament he had originally refused to recognize. The moment he set foot on an election platform he was arrested. (2) Election posters are pasted over with arrest notices.

Bürgerkrieg in Irland

Nach Unterzeichnung des Vertrags über den Freistaat kämpften die Iren gegeneinander. (1) Die Freistaatsarmee (in Uniform) beschießt mit Hilfe britischer Artillerie die republikanische IRA. (3) Mitglieder der IRA in Zivil patrouillieren im Juli 1922 heraus-fordernd durch die Straßen von Dublin. (4) Freistaattruppen feuern auf die IRA. Im April 1923 beendete de Valera die Aktionen der IRA und kandidierte für die Parlaments-

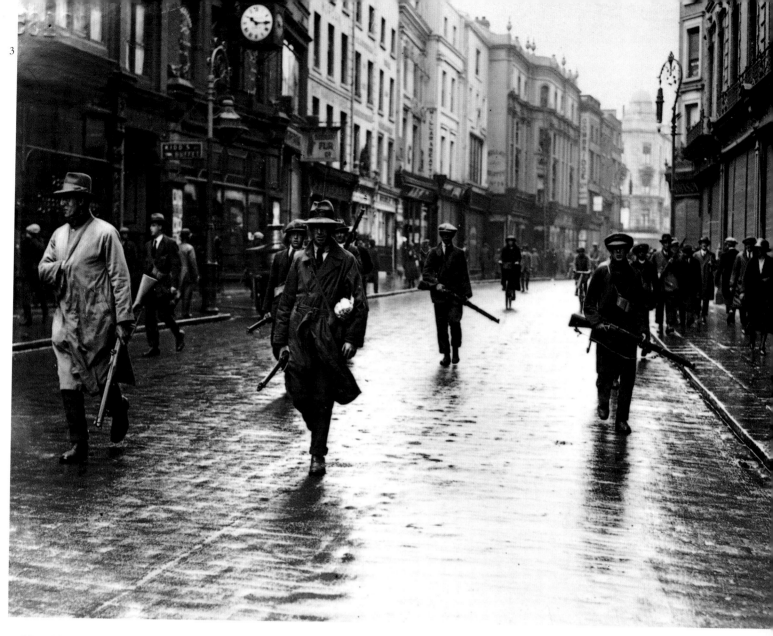

wahlen. Als er im Wahlkampf erstmals
auftrat, wurde er von Vertretern des Freistaats
verhaftet. (2) Wahlplakate werden mit der
Nachricht von seiner Verhaftung überklebt.

Guerre civile en Irlande

Après la signature du Traité de l'Etat libre
d'Irlande, les Irlandais se battirent les uns
contre les autres. (1) L'Armée de l'Etat libre
(en uniformes) se servit de l'artillerie
britannique pour attaquer les Républicains de
l'I.R.A. (3) Juillet 1922, des membres de
l'I.R.A. en civil patrouillèrent avec
ostentation dans les rues de Dublin. (4) Des
soldats de l'Etat libre tirèrent sur l'I.R.A. en
plein cœur de la ville. Avril 1923, de Valera
exigea la fin de l'action de l'I.R.A et se
présenta à l'élection du Parlement, qu'il avait
pourtant initialement refusé de reconnaître.
A peine avait-il mis le pied sur une plate-
forme électorale qu'il fut arrêté. (2) Des
tracts électoraux furent recouverts par des
tracts annonçant son arrestation.

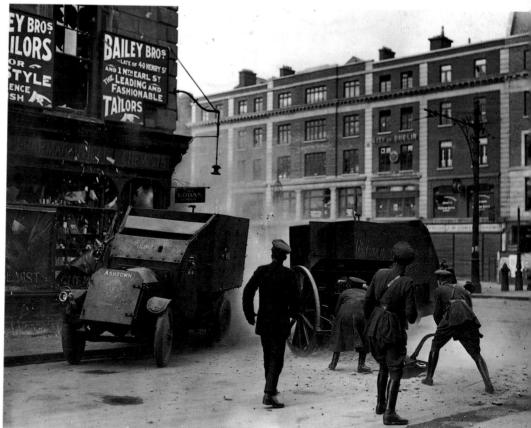

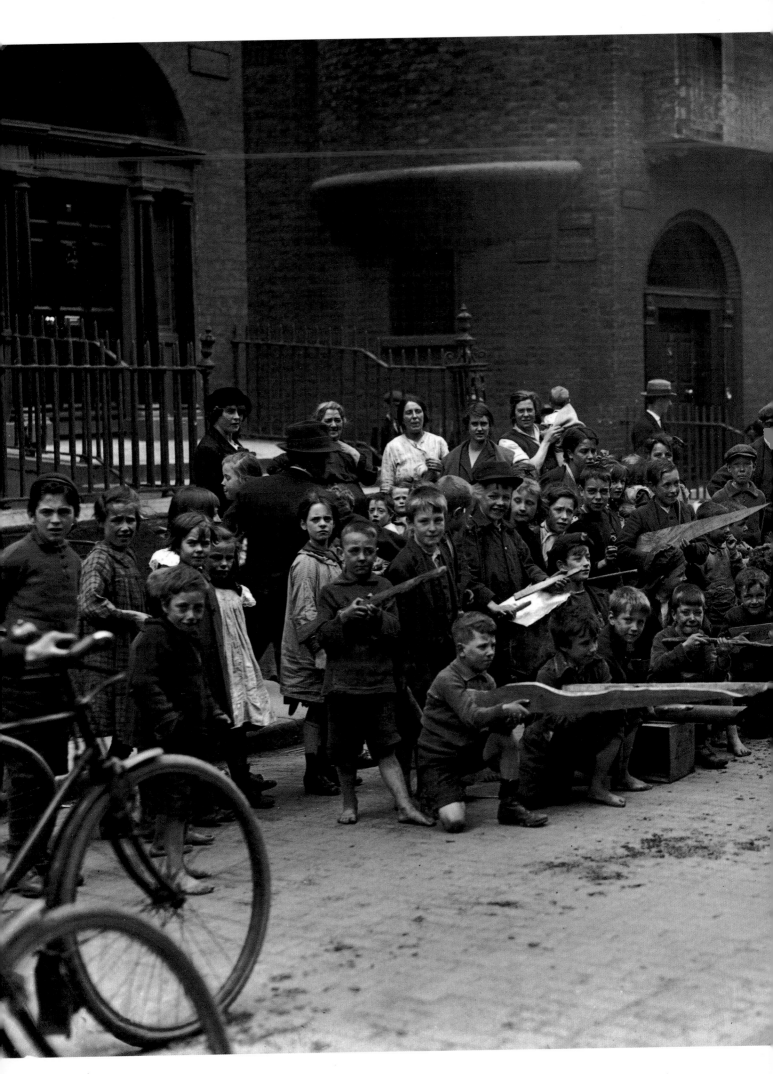

The Next Generation

When this photograph was taken in Dublin in July 1922, the IRA had lost much of its support. De Valera was in hiding and the republican Irregulars had left Dublin and taken to the hills. Many in Dublin had wearied of the war and were more interested in Clery's, a large new department store in Sackville Street. But the fighting wasn't over. Members of the *Dáil* were assassinated and the execution of IRA prisoners continued. These children had lived all their lives amid fighting – some may well have become members of the next generation of the IRA.

Die nächste Generation

Als diese Aufnahme im Juli 1922 in Dublin gemacht wurde, hatte die IRA viel von ihrer Unterstützung verloren. De Valera tauchte unter, die republikanischen Freischärler verließen Dublin und zogen sich in die Berge zurück. Viele Dubliner waren kriegsmüde und mehr an Clery's, dem neuen Warenhaus auf der Sackville Street, interessiert. Dennoch war kein Ende der Kämpfe in Sicht: Mitglieder des *Dáil* wurden ermordet und die Exekution von IRA-Gefangenen fortgesetzt. Diese Kinder haben ihr ganzes Leben während der Kämpfe verbracht – und einige von ihnen sind möglicherweise IRA-Mitglieder der nächsten Generation geworden.

La deuxième génération

A l'époque où cette photo fut prise à Dublin, juillet 1922, l'I.R.A. avait perdu un grand nombre de ses partisans. De Valera se cachait et les Irregulars républicains avaient quitté Dublin pour se réfugier dans les collines. A Dublin, nombre de gens étaient lassés de la guerre et bien plus intéressés par l'ouverture de Clery's, un grand magasin à Sackville Street. Mais la lutte n'était pas terminée pour autant. Des membres du *Dáil* furent assassinés et l'exécution des prisonniers de l'I.R.A. se poursuivit. Ces enfants n'ont connu que la guerre. Il est probable que, parmi eux, certains soient devenus des membres de l'I.R.A. de la deuxième génération.

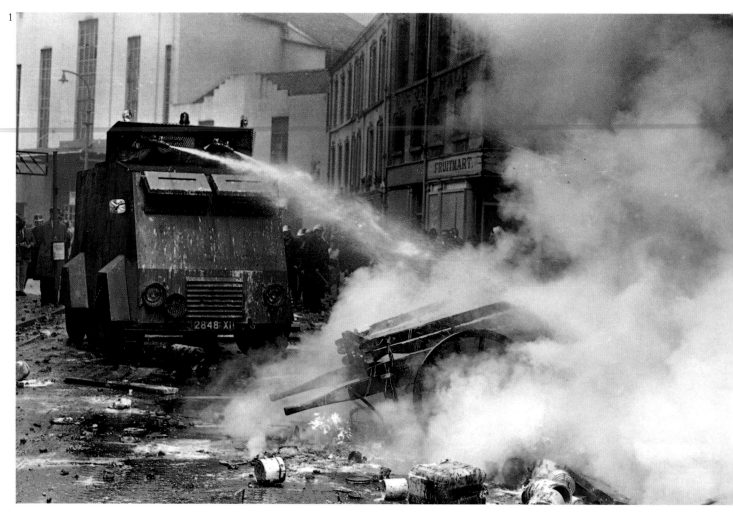

The Troubles

(1) On 11 August 1969 the Protestant Orange Order's Apprentice Boys' March was prevented by barricades from entering the Catholic Bogside area of Belfast. (3) The Royal Ulster Constabulary were pelted with stones and petrol bombs. In two days six people were killed and 87 injured. (2) British troops arrived, here patrolling the Falls Road area. (4) Any incident was sure to have several witnesses.

Die Unruhen

(1) Am 11. August 1969 errichteten die katholischen Bewohner der Bogside in Belfast Barrikaden, um die Parade der *Protestant Orange Order's Apprentice Boys* am Einmarsch in ihr Stadtviertel zu hindern. (3) Die *Royal Ulster Constabulary* wurde mit Steinen und Benzinbomben angegriffen. Innerhalb der nächsten zwei Tage starben bei Straßenschlachten sechs Menschen, 87 erlitten Verletzungen. (2) Britische Truppen wurden nach Belfast verlegt; hier eine Patrouille auf der Falls Road. (4) Jeder Zwischenfall wurde mit Sicherheit von mehreren Augenzeugen beobachtet.

Les Troubles

11 août 1969, manifestation des *Derry Apprentice Boys* de l'Ordre d'Orange protestant. (1) Les habitants catholiques du quartier de Bogside dressèrent des barricades pour stopper les manifestants et la police. (3) Les policiers du R.U.C. (*Royal Ulster Constabulary*) furent accueillis par des jets de pierres et des cocktails Molotov. Au cours de deux jours d'émeutes, six personnes furent tuées et 87 autres blessées. Arrivée des troupes britanniques à Belfast. (2) Elles furent aussitôt déployées sur Falls Road. (4) Chacune de leurs interventions se fit sous les yeux de plusieurs témoins.

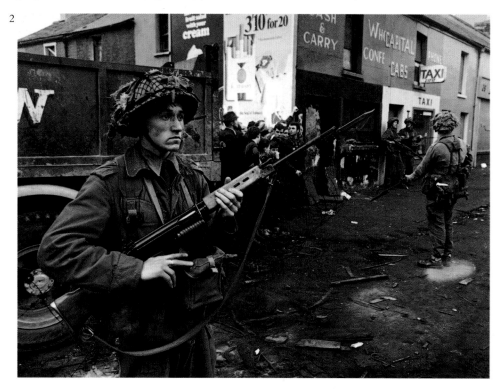

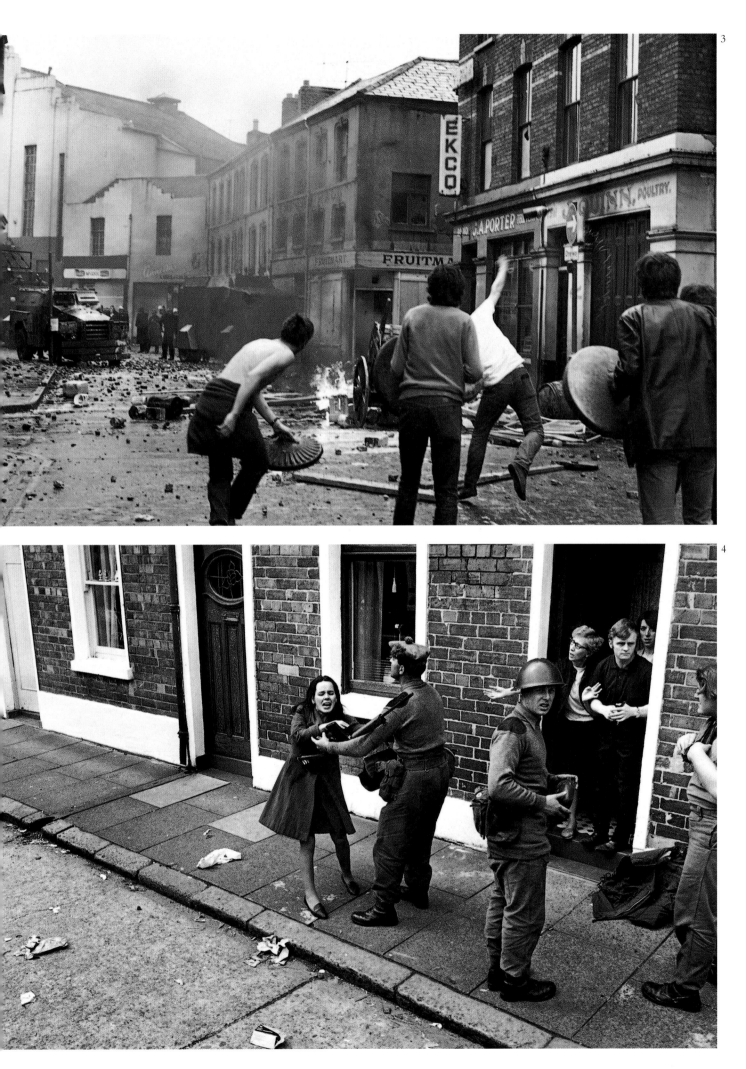

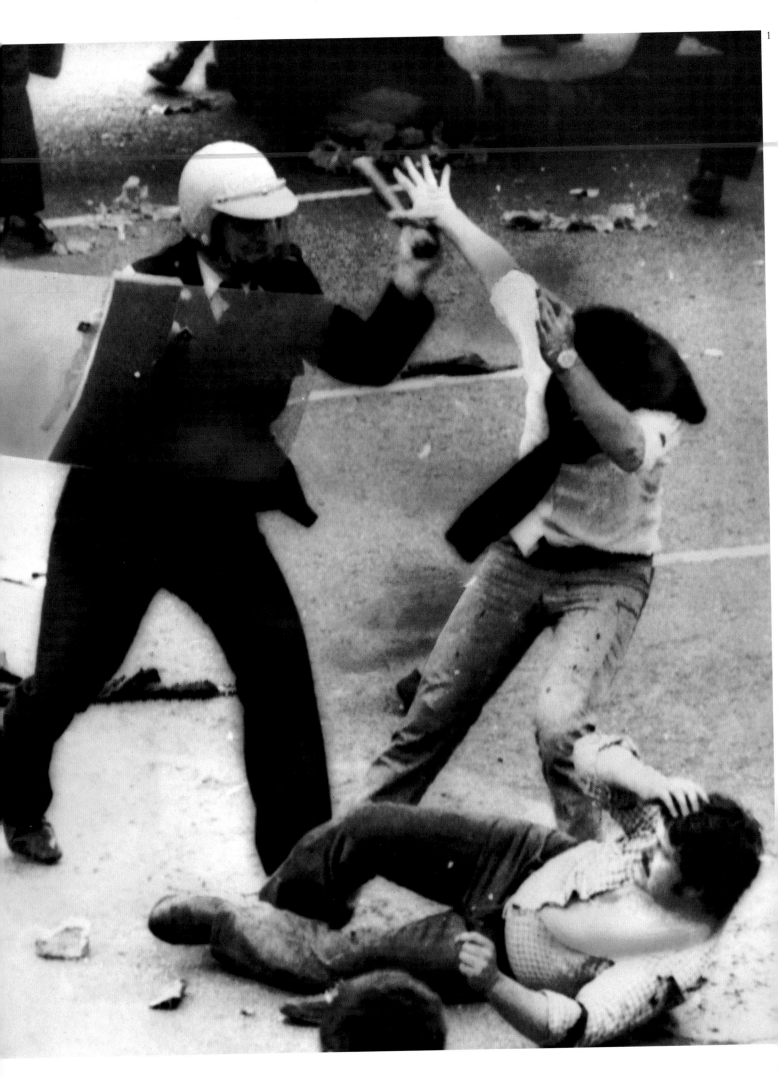

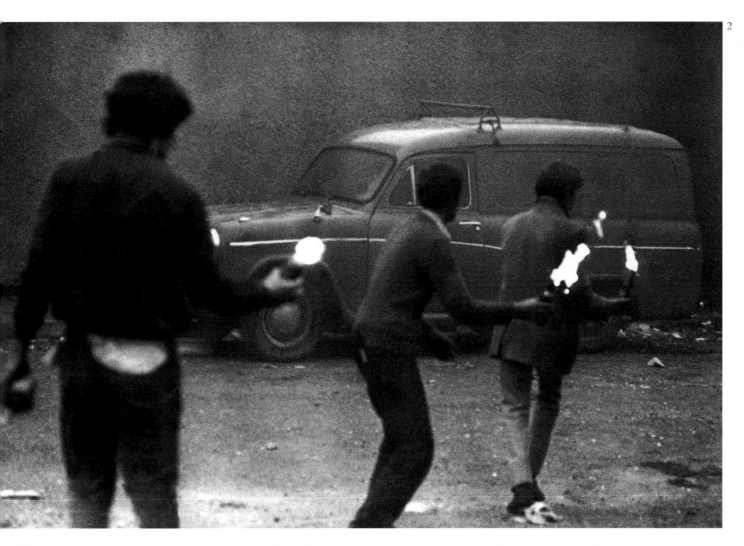

Dublin and Derry

Fighting on the streets was not confined to Northern Ireland. (1) In July 1981 a member of the Dublin *Gárda* (police) attacks one of the thousands of demonstrators marching on the British Embassy: 'We didn't need gas, rubber bullets or water cannons, just the strong arm of the law'. (2) Young petrol bombers take aim in Derry, a picture by Italian photographer Fulvio Grimaldi in October 1971. Children were often in the thick of the action. (3) A teenager is arrested, threatened and hurried away by British troops.

Dublin und Derry

Die Straßenkämpfe beschränkten sich nicht nur auf Nordirland. (1) Im Juli 1981 greift ein Mitglied der Dubliner *Gárda* (Polizei) einen von mehreren tausend Demonstranten an, die zur britischen Botschaft marschierten: »Wir brauchten kein Gas, keine Gummi-geschosse oder Wasserwerfer, nur den starken Arm des Gesetzes.« (2) In Derry nehmen junge Bombenwerfer ihr Ziel in Angriff. Das Bild machte der junge italienische Fotograf Fulvio Grimaldi im Oktober 1971. Oft waren Kinder mitten im Geschehen. (3) Ein Teen-ager wird von britischen Soldaten verhaftet, bedroht und abgeführt.

Dublin et Derry

Les échauffourées ne se limitèrent pas à l'Irlande du Nord. (1) Juillet 1981, un policier de la Dublin *Gárda* chargea un des milliers de manifestants qui se dirigeaient vers l'ambassade britannique: «Nous n'avions pas besoin de gaz lacrymogène, de balles en caoutchouc ou de canons à eau, seulement d'une arme forte, la loi.» (2) Derry, octobre 1971, jeunes sur le point de lancer des cocktails Molotov, cliché du photographe italien Fulvio Grimaldi. Les enfants se retrouvaient souvent en plein cœur de l'action. (3) Adolescent arrêté, menacé puis emmené par des soldats britanniques.

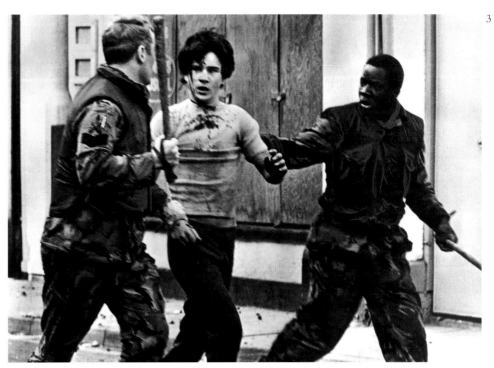

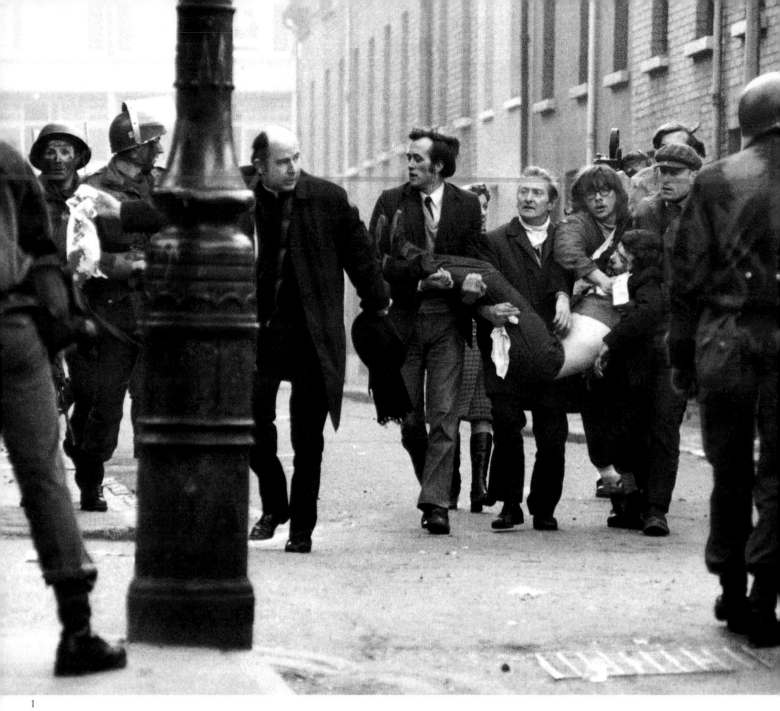

Bloody Sunday

On 30 January 1972 residents of Derry marched in protest at the internment of over eight men from their city, without charge or trial. Ten thousand people joined the march, defying a ban on such demonstrations. (3) At Rossville Street the marchers encountered army barricades. Some of the marchers threw stones and bottles. The soldiers fired rubber bullets, and used tear gas and water cannons. Then the Paras rushed into Rossville Street and the killing began. Thirteen marchers were shot dead. (1) Father Daly holds a white handkerchief to gain passage for one of the casualties through army lines, and (2) gives the last rites to one of those killed. (4) Later in the day troops round up other demonstrators.

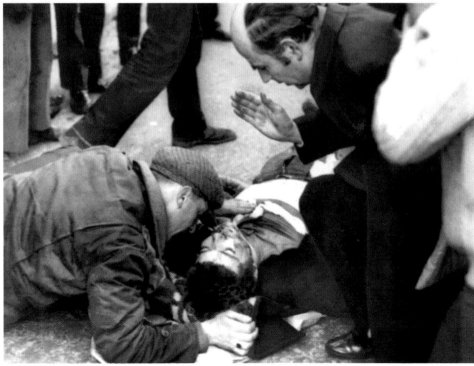

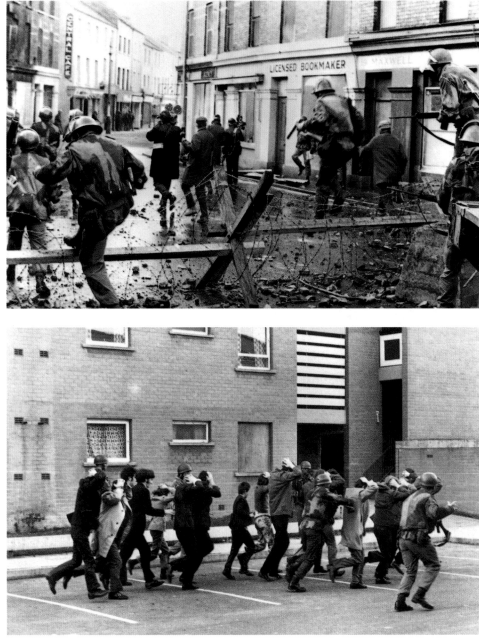

Blutiger Sonntag

Am 30. Januar 1972 demonstrierten Einwohner von Derry gegen die Verhaftung einiger Männer der Stadt, die ohne Haftbefehl vorgenommen worden war. Zehntausend Menschen mißachteten das herrschende Demonstrationsverbot und schlossen sich dem Marsch an. (3) Auf der Rossville Street trafen sie auf Armeebarrikaden. Einige Demonstranten warfen Steine und Flaschen. Die Soldaten antworteten mit Gummigeschossen und setzten Tränengas und Wasserwerfer ein. Als Fallschirmjäger die Rossville Street stürmten, begann ein Blutbad: Dreizehn Demonstranten wurden erschossen. (1) Pfarrer Daly schwenkt ein weißes Taschentuch, um durch die Armeelinien zu den Verwundeten vorzudringen, und (2) erteilt einem der Getöteten die Letzte Ölung. (4) Im Verlauf des Tages trieben die Truppen weitere Demonstranten zusammen.

Bloody Sunday

Le 30 janvier 1972, manifestation des habitants de Derry après l'incarcération de huit des leurs, sans motif ou procès. Dix mille personnes participèrent à la manifestation, défiant l'interdiction de tels rassemblements. (3) Quand les manifestants arrivèrent à Rossville Street, l'armée avait dressé des barbelés. Quelques manifestants jetèrent des pierres et des bouteilles. Les soldats répliquèrent avec des balles en caoutchouc, des gaz lacrymogènes et des canons à eau. Arrivèrent alors les Paras et ce fut le début de la tuerie. Treize manifestants furent abattus. (1) Le Père Daly brandit un mouchoir blanc pour permettre l'évacuation d'un blessé de l'autre côté des lignes de l'armée et (2) donna l'extrême-onction à l'un des morts. (4) Plus tard dans la journée, d'autres manifestants furent emmenés par les soldats.

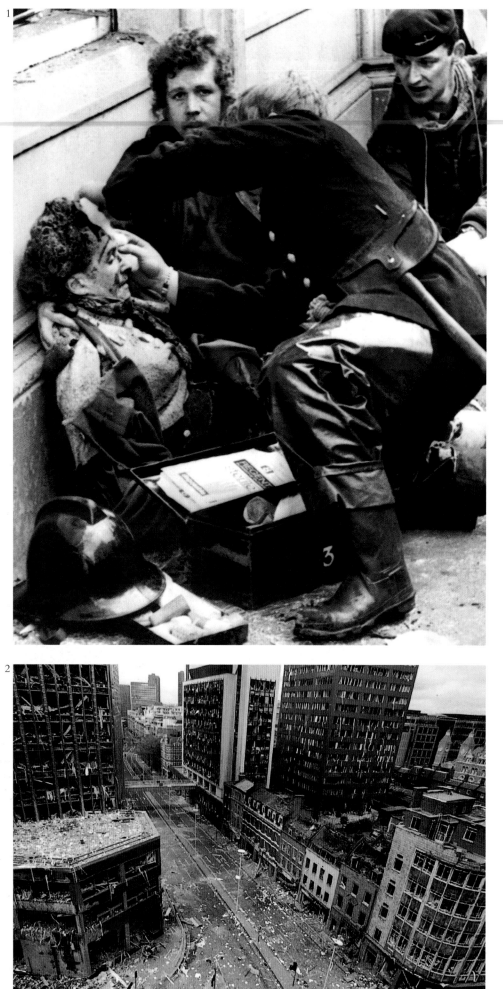

The Bombing Campaigns

When they resumed active duty in the 1970s the IRA concentrated on a bombing campaign to create fear and disruption in Northern Ireland and on the British mainland. Their targets were not always military, or even political. (1) Six people were killed and 146 injured when a bomb exploded in Donegal Street, Belfast, on 21 March 1972. (3) The IRA attacked Downing Street on two occasions. This car bomb exploded in Whitehall. (2) One of the most effective bombs was that which exploded in the heart of the City of London in April 1993. Entire office blocks were shattered.

Die Bombenkampagnen

Als die IRA in den siebziger Jahren ihre Aktionen wiederaufnahm, konzentrierte sie sich auf eine Bombenstrategie, die Angst und Unruhe in Nordirland und auf der britischen Insel erzeugen sollte. Dabei waren ihre Ziele nicht immer militärisch oder politisch. (1) Bei einer Bombenexplosion auf der Donegal Street in Belfast kamen am 21. März 1972 sechs Menschen ums Leben, 146 wurden verletzt. (3) Zweimal griff die IRA Downing Street an. Diese Autobombe explodierte in Whitehall. (2) Eine der größten Bombenexplosionen ereignete sich im April 1993 im Herzen der Londoner City. Ganze Büroblocks wurden zerstört.

Série d'attentats à la bombe

A la reprise de ses activités dans les années 1970, l'I.R.A. lança une vague d'attentats à la bombe en Irlande et sur le sol britannique pour créer un climat de peur et d'incertitude. Leurs cibles ne seront pas forcément militaires ou même politiques. (1) Le 21 mar 1972, six personnes furent tuées et 146 blessées lors de l'explosion d'une bombe à Belfast, Donegal Street. (3) L'I.R.A. visa Downing Street à deux reprises. Attentat à la voiture piégée à Whitehall. (2) Avril 1993, une bombe, l'une des plus dévastatrices, explosa au cœur de la City de Londres. Des immeubles de bureaux furent entièrement détruits.

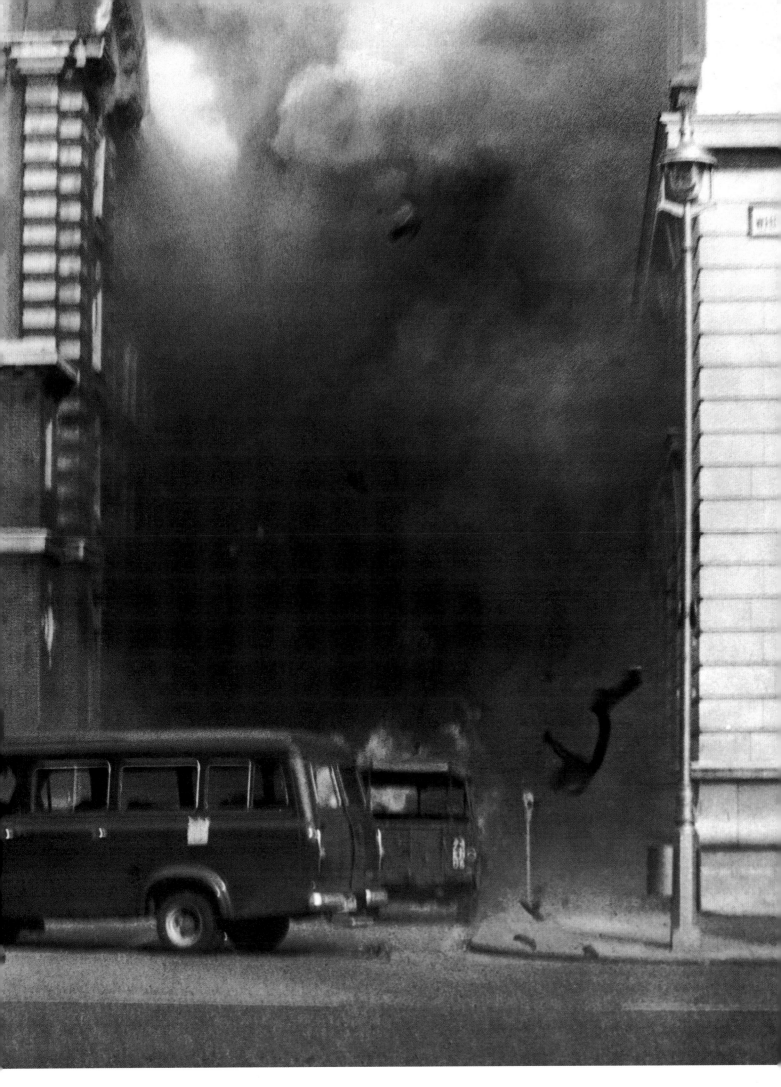

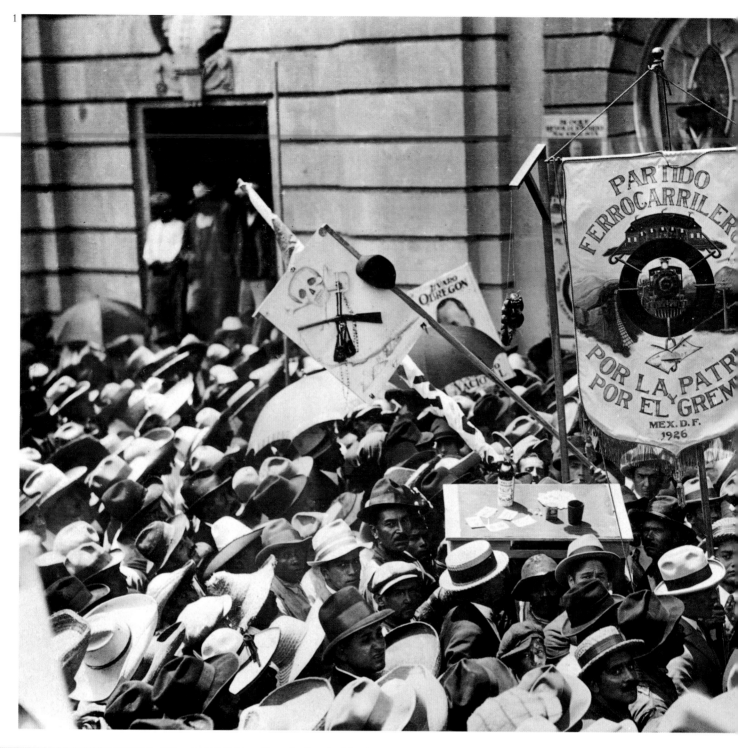

Revolution in Mexico

For the first 30 years of the 20th century, Mexico was in an almost constant state of revolution or civil war. (1) There was some hope of peace when President Obregon was re-elected in 1928, but he was assassinated a few weeks later. Mexican presidents often called on the United States for support against rebel groups. They fought for the restoration of land that had been taken from them and leased to foreign interests. (2) In 1916 it took 4000 American troops under General Pershing to defeat Pancho Villa and his rebel army. (3) Emilio Zapata was the leader of another rebel group.

Revolution in Mexiko

In den ersten 30 Jahren des 20. Jahrhunderts herrschten in Mexiko fast ununterbrochen Revolutionsunruhen oder Bürgerkrieg. (1) Nach der Wiederwahl Präsident Obregons 1928 gab es berechtigte Friedenshoffnungen; kurz danach wurde er jedoch ermordet. Häufig baten mexikanische Präsidenten die Vereinigten Staaten um Hilfe gegen Rebellengruppen. Diese kämpften um die Rückgewinnung ihres Landes, das ihnen weggenommen und an ausländische Interessenten verpachtet worden war. (2) 1916 wurden 4000 amerikanische Soldaten unter Führung General Pershings gegen Pancho Villa und seine Rebellenarmee eingesetzt. (3) Emilio Zapata, Anführer einer weiteren Rebellengruppe.

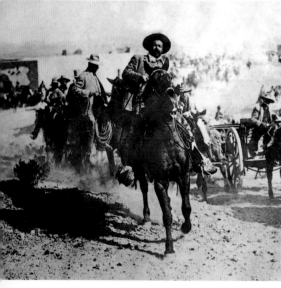

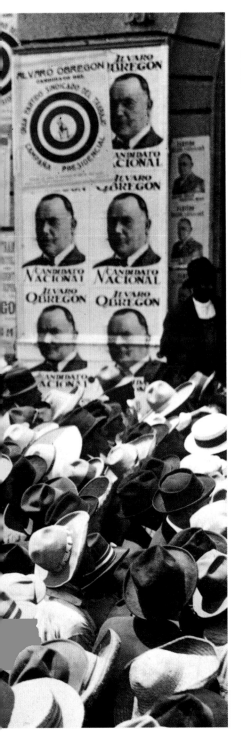

Révolution au Mexique

De 1900 à 1930, le Mexique était presque toujours en révolution ou plongé dans la guerre civile. (1) Espoirs de paix après la ré-élection du Président Obregon en 1928, mais il fut assassiné quelques semaines plus tard. Les Présidents mexicains firent souvent appel aux Etats-Unis pour obtenir leur soutien dans la lutte contre les groupes de rebelles qui se battaient pour la reconquête des terrains dont ils avaient été privés et qui avaient été alloués à des intérêts étrangers. (2) 1916, il faudra 4000 soldats américains, sous le commandement du Général Pershing, pour venir à bout de Pancho Villa et de son armée de rebelles. (3) Emilio Zapata était le chef d'une autre organisation rebelle.

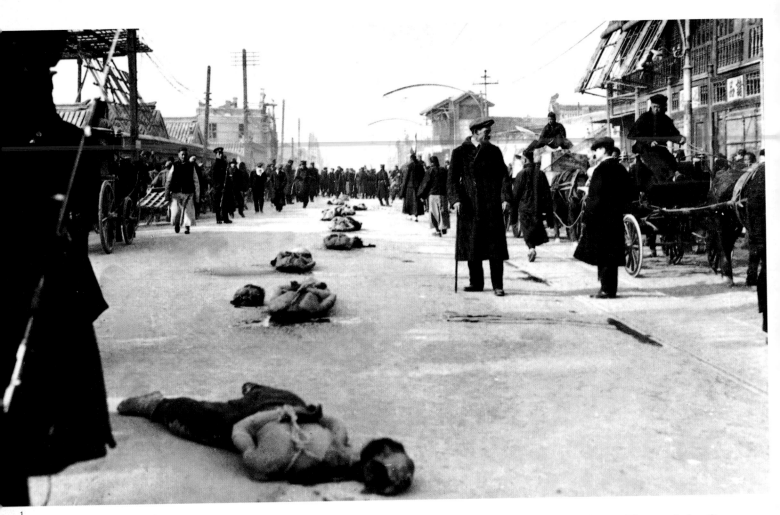

The Boxer Rebellion

In 1900 the Boxers ('Fists of Righteous Harmony') rebelled against the Imperial Chinese Government, demanding an end to European and Christian influence in China. The rising spread from Peking to Nanking and Canton, and foreign legations were attacked. The United States, Germany, France, Britain and Russia sent in troops and the rising was ruthlessly crushed within a few months. Punishment was swift and public. (1) Bodies of those executed lay in the streets as a warning to others. The Western troops stayed in China, policing the international ports. (2) A mixed group of Chinese, Indian and European officers pose for the camera in Tientsin in 1912. (3) A Boxer leader is beheaded.

Der Boxeraufstand

Im Jahre 1900 rebellierten die Boxer (»Fäuste der Gerechten Harmonie«) gegen die Kaiserliche chinesische Regierung. Sie forderten ein Ende des europäischen und christlichen Einflusses in China. Der Aufstand verbreitete sich von Peking nach Nanking und Kanton, wobei ausländische Vertretungen angegriffen wurden. Die Vereinigten Staaten, Deutschland, Frankreich, Großbritannien und Rußland entsandten Truppen, und innerhalb weniger Monate wurde der Aufstand schonungslos niedergeschlagen. Die Bestrafungen folgten schnell und in aller Öffentlichkeit. (1) Die Leichen der Hingerichteten liegen als Warnung für andere auf den Straßen. Die westlichen Truppen blieben in China stationiert und überwachten die internationalen Häfen. (2) Eine gemischte Gruppe chinesischer, indischer und europäischer Offiziere läßt sich 1912 in Tientsin fotografieren. (3) Ein Boxerführer wird geköpft.

La Révolte des Boxers

En 1900, les Boxers («Poings de justice») se soulevèrent contre le gouvernement impérial chinois pour mettre un terme à l'influence européenne et chrétienne en Chine. Le soulèvement se propagea dans tout le pays, de Pékin à Nankin et Canton. Des légations étrangères furent attaquées. Les Etats-Unis, l'Allemagne, la France, la Grande-Bretagne et la Russie envoyèrent des troupes. Le mouvement sera, en l'espace de quelques mois, durement réprimé. Le châtiment était immédiat et avait lieu en public. (1) Les cadavres de rebelles décapités furent laissés dans les rues en guise d'avertissement. Les troupes occidentales restèrent en Chine et contrôlèrent les ports internationaux. (2) T'ien-tsin, 1912, un groupe d'officiers chinois, indiens et européens pose devant l'appareil. (3) Décapitation d'un chef des Boxers.

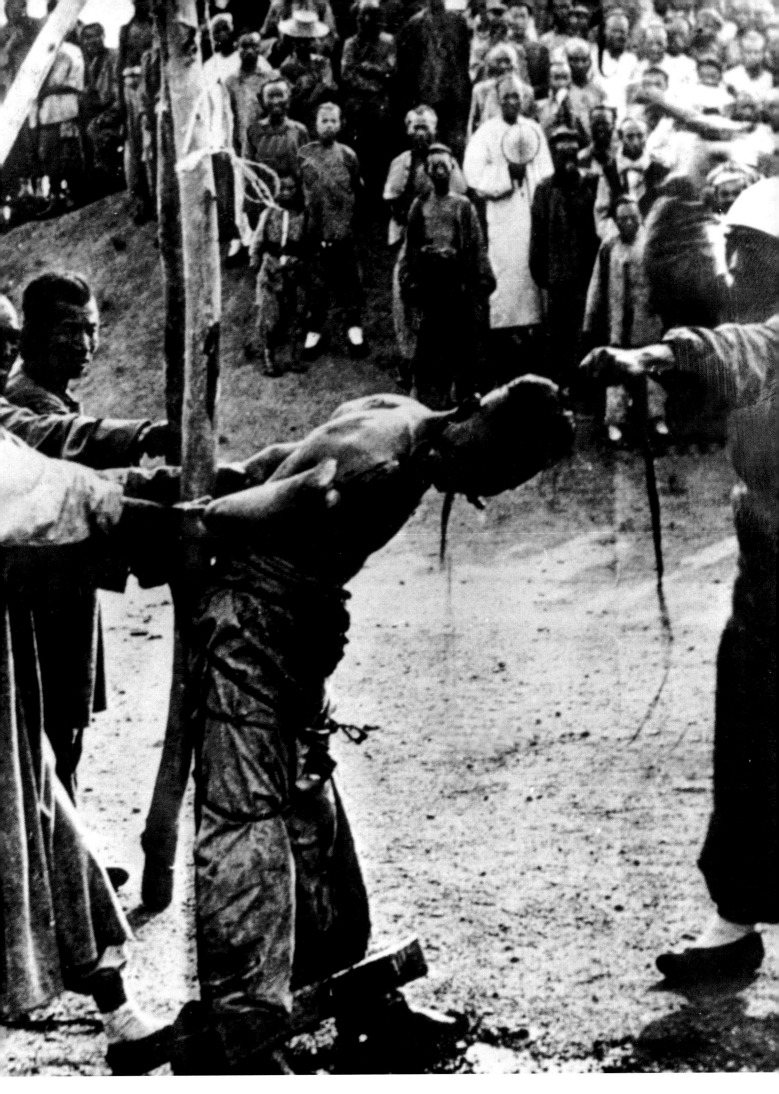

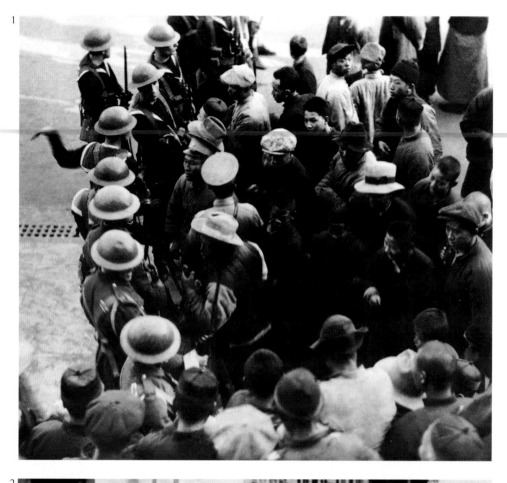

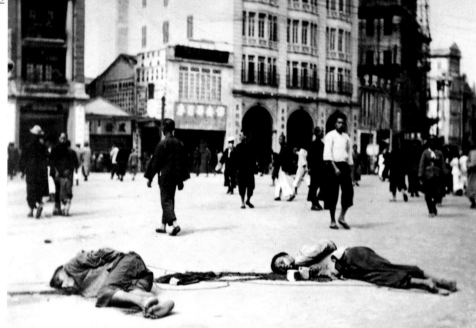

Civil War in China

In 1926 General Chiang Kai-shek, leader of the Kwomintang, set out to unify China by military force. The following year Nationalist protests against foreigners again broke out in Peking, Hankow, Shanghai and Canton. British and American garrisons were reinforced to guard the legations and concessions. (1) British marines attempt to maintain order in Hankow, January 1927. (3) Mobs invade the British Concession in the same city. This was one of the first photographs of the threat to Western privileges in China to reach Britain. It was received with horror. At first Chinese Communists allied themselves with Chiang, under orders from Stalin. In April 1927, however, Chiang suddenly moved against them. Fighting between Nationalists and Communists was bitter. (2) When the Communists were defeated in Canton, the bodies of those slaughtered were left in the streets.

Bürgerkrieg in China

1926 beschloß General Tschiang Kai-schek, Führer der Kuomintang, China mit Militärgewalt zu vereinigen. Im folgenden Jahr brachen in Peking, Hankou, Schanghai und Kanton erneut nationalistische Proteste gegen Ausländer aus. Britische und amerikanische Garnisonen wurden verstärkt, um die Botschaften und diplomatischen Vertretungen zu schützen. (1) Britische Marineinfanterie versucht in Hankou die Ordnung aufrechtzuerhalten, Januar 1927. (3) Eine aufgebrachte Menge dringt in die britische Vertretung

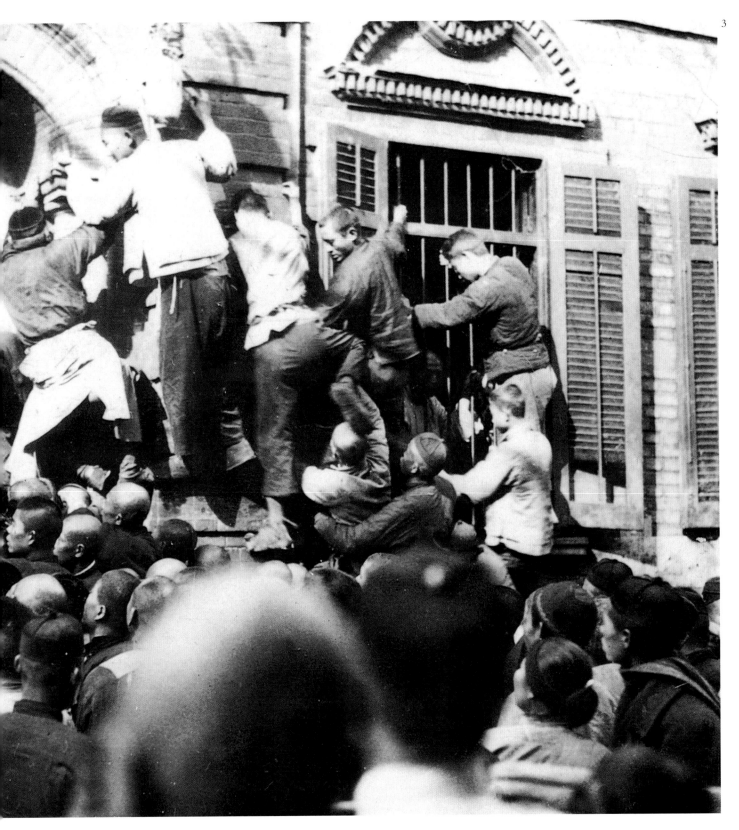

der Stadt ein. Dies war eines der ersten Fotos, auf denen die Bedrohung der westlichen Privilegien in China bis nach Großbritannien vordrang. Es wurde mit Entsetzen aufgenommen. Zunächst arbeiteten die chinesischen Kommunisten auf Anordnung Stalins mit Tschiang Kai-schek zusammen. Aber im April 1927 wandte sich Tschiang plötzlich gegen sie. Die Kämpfe zwischen Nationalisten und Kommunisten waren grausam. (2) Nach der Niederlage der Kommunisten in Kanton wurden die Leichen der Ermordeten auf den Straßen zurückgelassen.

La Guerre civile en Chine

En 1926, le Général Tchang Kaï-chek, chef du Guomindang, tenta d'unifier la Chine par la force militaire. L'année suivante, de nouvelles manifestations de Nationalistes eurent lieu à Pékin, Hankou, Shanghai et Canton. Renforcement des garnisons britanniques et américaines pour défendre les légations et les concessions. (1) Janvier 1927, des soldats de la marine britannique tentèrent de maintenir l'ordre à Hankou. (3) La foule envahit la concession britannique de la ville. C'est l'une des premières photos montrant la

menace qui pesait sur les privilèges occidentaux à être publiée en Grande-Bretagne. Elle suscita l'effroi. Sous les ordres de Staline, les communistes chinois s'allieront avec Tchang Kaï-chek. Mais, en avril 1927, celui-ci se retourna subitement contre eux. La lutte entre Nationalistes et Communistes sera âpre. (2) Défaite des Communistes à Canton. Les corps furent abandonnés dans les rues.

Shanghai

A British outpost on the Soochow Creek, Shanghai, in 1927. The British were there to protect the International Settlement, a rich area of shops, cinemas, night clubs and restaurants with a population of 750,000, including 30,000 foreigners. Across the Creek is part of Chinese Shanghai – crowded, noisy, filthy and poor. Each year some 25,000 bodies of those who had died from cold or starvation were collected from the streets of the city. The original caption to this picture explained that the Chinese refuse boats used the Creek to collect the city's rubbish and that 'the atmosphere is most objectionable to the British soldiers'.

Schanghai

Ein britischer Vorposten auf dem Suchau-Fluß in Schanghai 1927. Die Briten waren dort stationiert, um das Internationale Viertel zu schützen – eine wohlhabende Gegend mit Geschäften, Kinos, Nachtclubs und Restaurants und einer Einwohnerzahl von 750 000 Menschen, darunter 30 000 Ausländer. Jenseits des Flusses liegt der chinesische Teil Schanghais – überfüllt, laut, schmutzig und arm. Jedes Jahr wurden etwa 25 000 Leichen eingesammelt, Menschen, die in den Straßen der Stadt an Kälte und Hunger gestorben waren. Die Originalunterschrift unter dem Foto berichtet, daß die chinesischen Abfallkähne den Fluß als Müllabladeplatz benutzten. Die Atmosphäre »ist für britische Soldaten äußerst widrig«.

Shanghai

Shanghai, 1927, avant-poste britannique sur la Crique de Sou-tcheou. Les Britanniques étaient là pour protéger l'International Settlement, un quartier prospère et riche en magasins, cinémas, boîtes de nuit et restaurants comptant 750 000 habitants, dont 30 000 étrangers. De l'autre côté de la crique, il y avait le Shanghai chinois, peuplé, bruyant, sale et pauvre. Chaque année, on ramassait plus de 25 000 cadavres de personnes mortes de faim ou de froid dans les rues de la ville. La légende d'origine de cette photo expliquait que les bateaux-poubelles chinois utilisaient la Crique de Sou-tcheou pour ramasser les ordures de la ville rendant «l'air nauséabond pour les soldats britanniques».

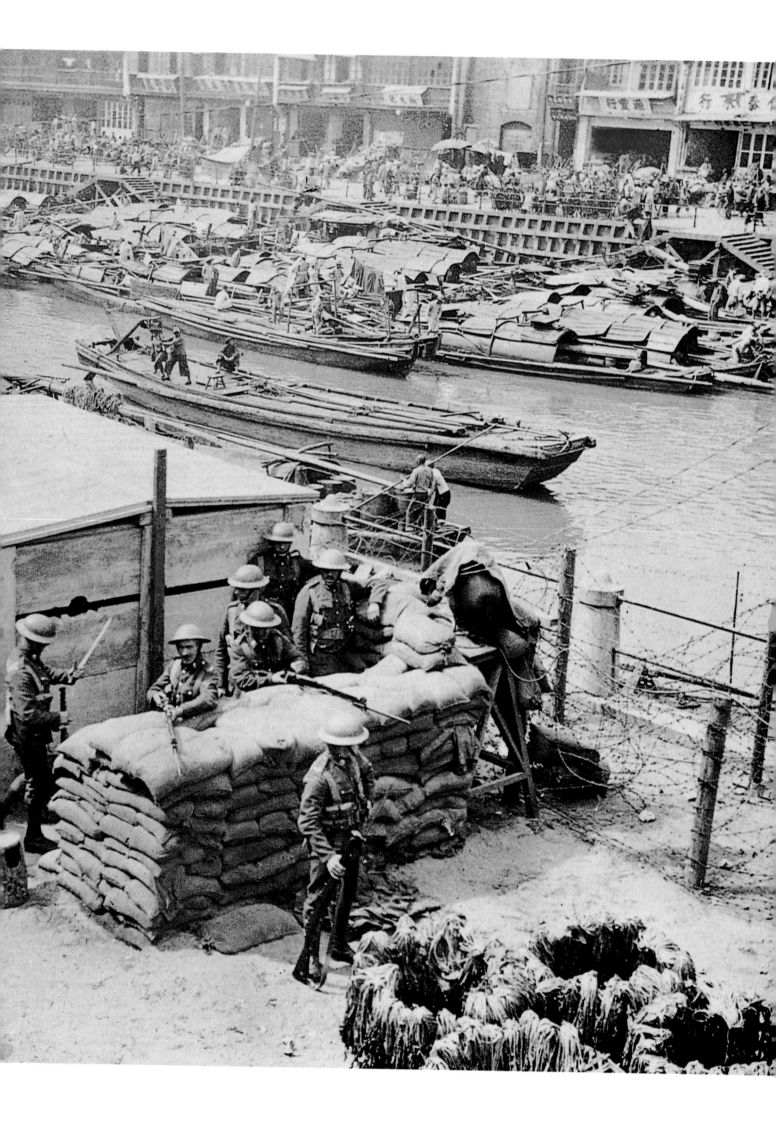

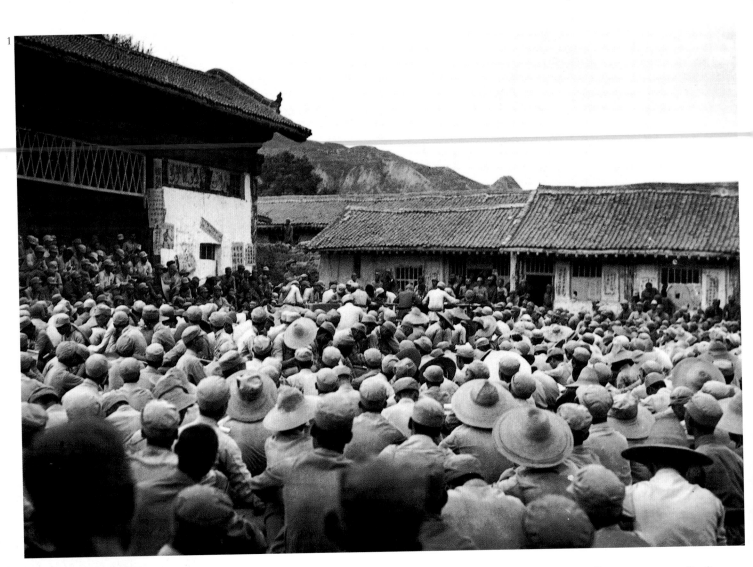

The Chinese Revolution

When they were defeated by Chiang's Nationalist forces, the Communists withdrew and regrouped. An uneasy alliance between the two sides prevailed once the Japanese invaded China in 1935. (2) Under the leadership of Mao Tse-tung, the Communists embarked on their Long March to north-west China. (1) Here they established a university in the caves at Kangdah, where Mao and Party workers re-educated the peasantry in Communist ideology and 'rectification'. The speaker appears to be Mao himself. Only five women took part in the Long March, but women held important posts at Kangdah. (3) A young woman conducts songs of resistance.

Die chinesische Revolution

Nach ihrer Niederlage gegen Tschiangs Nationalisten zogen sich die Kommunisten zurück und formierten sich neu. Nach der japanischen Invasion Chinas 1935 hielten beide Seiten einen brüchigen Waffenstill-stand. (2) Unter der Führung von Mao Tse-tung begannen die Kommunisten ihren »Langen Marsch« nach Nordwestchina. (1) Dort richteten sie in den Höhlen von Kangdah eine Universität ein, an der Mao und seine Parteigenossen ein Umerziehungs- und »Richtigstellungsprogramm« für die Bauern durchführten, ganz im Sinne der kommunistischen Ideologie. Der Sprecher scheint Mao selbst zu sein. Nur fünf Frauen nahmen am »Langen Marsch« teil; in Kangdah besetzten Frauen jedoch wichtige Stellen. (3) Eine junge Frau dirigiert Widerstandslieder.

La révolution chinoise

Vaincus par les forces nationalistes de Tchang Kaï-chek, les Communistes battirent en retraite et se regroupèrent. Après l'invasion de la Chine par les Japonais en 1935, une fragile alliance fut conclue entre Nationalistes et Communistes. (2) Sous la direction de Mao Tsé-Toung, les Communistes entamèrent la Longue Marche vers le nord-ouest de la Chine. (1) Création d'une université dans les grottes de Kangdah. Rééducation des paysans par Mao et les travailleurs du parti, conformément à l'idéologie communiste et la campagne de «rectification». Discours donné par Mao en personne. Cinq femmes seulement participèrent à la Longue Marche. Mais, à Kangdah, les femmes se virent confier des postes importants. (3) Jeune femme faisant répéter des chants de la résistance.

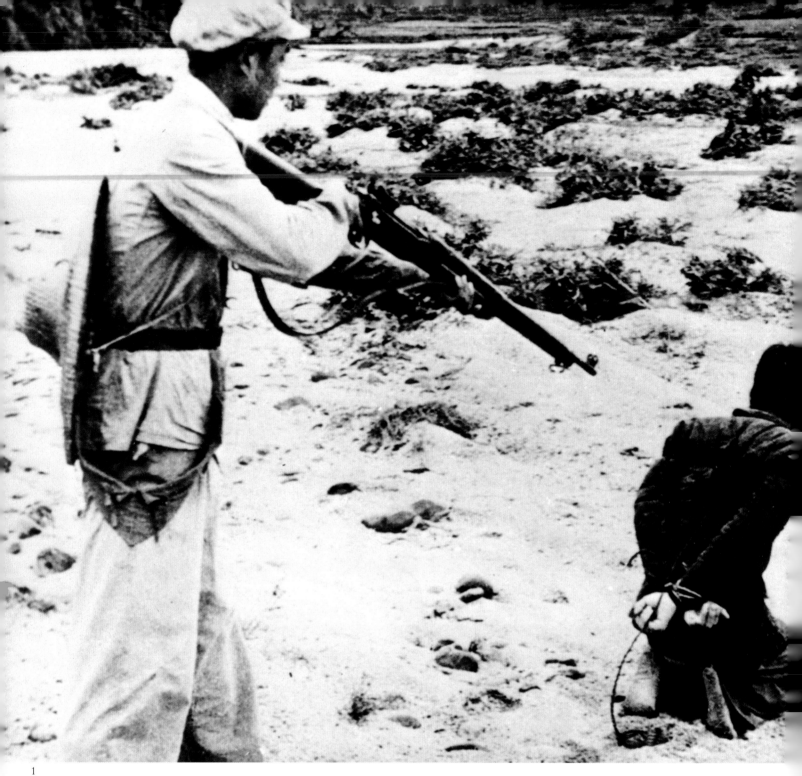

1

Communist China

Following the defeat of Japan in 1945, Mao
Tse-tung and the Communists quickly
shattered Chiang Kai-shek's forces. Chiang
retreated to Formosa (Taiwan), leaving the
entire Chinese mainland in Communist
hands. (1) Those regarded by the
Communists as enemies of the new regime,
especially unrepentant landowners of the old
system, were executed. Mao's influence
declined in the early 1960s, after the failure
of the 'Great Leap Forward'. (4) The
Cultural Revolution of 1966 to 1969,
however, re-established his control. Teenage
girls of the Red Guard perform rifle drill in
Peking in January 1967. (3) Young people
recruited to help farmers with the harvest
read the 'Thoughts of Mao' before setting to
work. (2) Red Guards carry portraits of Mao

as they parade through Peking to the Soviet
Embassy in August 1966 to protest at 'Soviet
Revisionism'.

Das kommunistische China

Nach der Niederlage der Japaner 1945
konnten Mao und seine Kommunisten in
kurzer Zeit Tschiangs Truppen ausschalten.
Tschiang zog sich nach Formosa (Taiwan)
zurück; das gesamte chinesische Festland
blieb in der Hand der Kommunisten.
(1) Wen die Kommunisten als Feinde des
neuen Regimes betrachteten – darunter vor
allem die reuelosen Landbesitzer des alten
Systems –, der wurde hingerichtet. Nach
dem Scheitern des »Großen Sprungs nach
vorn« in den frühen 60er Jahren verlor Mao
an Einfluß. (4) Die Kulturrevolution von
1966 bis 1969 festigte seine Position jedoch

erneut. Junge Mädchen der Roten Garden
beim Drill am Gewehr im Januar 1967.
(3) Junge Leute, die als Erntehelfer rekrutiert
wurden, lesen vor Arbeitsbeginn die »Gedan-
ken Maos«. (2) Bei einem Protestmarsch
gegen den »sowjetischen Revisionismus« zur
sowjetische Botschaft in Peking im August
1966 tragen Mitglieder der Roten Garde
Portraits von Mao.

La Chine communiste

Après la défaite du Japon en 1945, Mao et les
Communistes parvinrent rapidement à bout
des armées de Tchang Kaï-chek. Celui-ci se
retira sur l'île de Formose (Taiwan), laissant
tout le continent chinois aux mains des
Communistes. (1) Exécution des personnes
que les Communistes jugeaient hostiles au
nouveau régime, en particulier les propriétai-

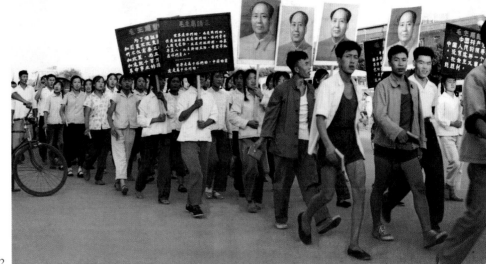

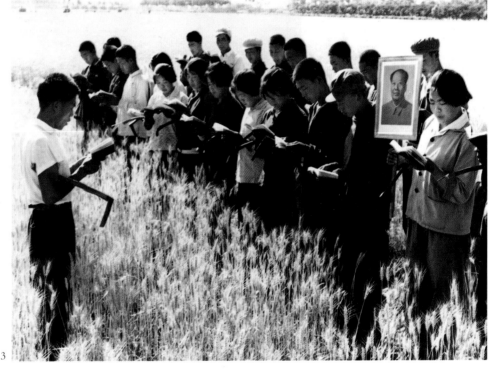

es terriens non repentis de l'ancien régime.
Mao perdit de son influence au début des
années 60 après l'échec de la campagne du
«Grand Bond en avant». (4) Mais la
Révolution culturelle menée de 1966 à 1969
ui permit de rétablir son autorité. Janvier
1967 à Pékin, des adolescentes de la Garde
rouge s'entraînent à manier le fusil. (3) Des
eunes gens, recrutés pour aider les paysans
au moment des récoltes, lisent le «Petit Livre
rouge» avant de se mettre au travail.
(2) Août 1966, des Gardes rouges portant des
portraits de Mao défilent dans Pékin jusqu'à
l'ambassade soviétique pour protester contre
le «révisionnisme soviétique».

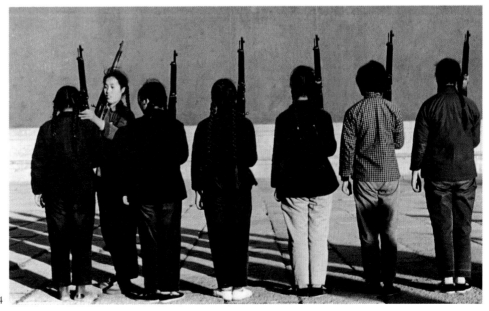

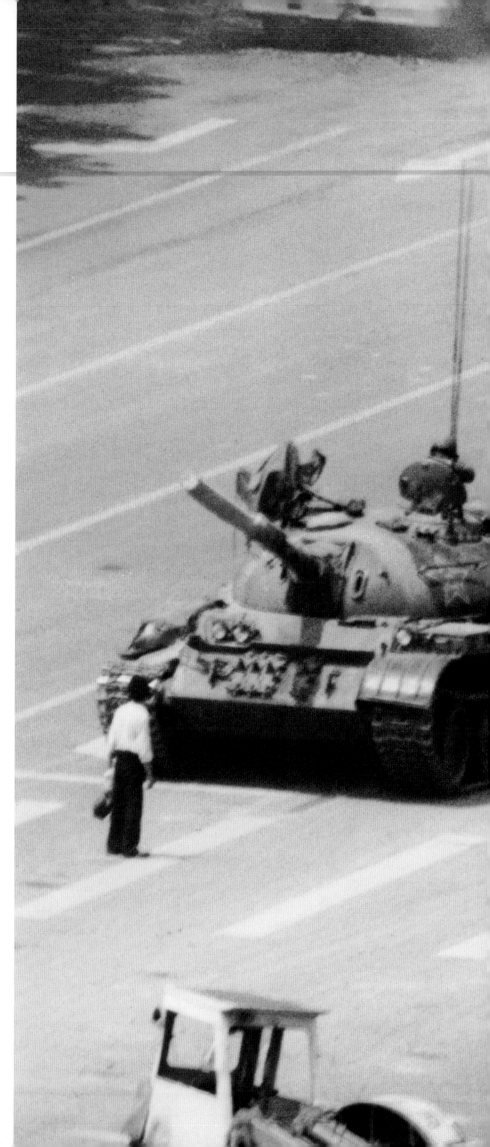

Tiananmen Square

Perhaps the most famous protest of all time. An unidentified Chinese civilian faces the Government's military might in Peking, June 1989. The protest began when thousands of pro-democracy hunger strikers occupied the square in May. The Chinese Government was momentarily split, but the hardliners under Li Peng won the day, and the tanks were sent in. After the crackdown, in which hundreds were killed, arrested demonstrators were paraded on television as criminals. This photograph, however, was suppressed in China.

Der Tiananmen-Platz

Die vielleicht bekannteste Protestaktion aller Zeiten. Ein unbekannter chinesischer Bürger stellt sich der Militärmacht in Peking entgegen, Juni 1989. Der Protest begann mit der Besetzung des Platzes durch Tausende prodemokratischer Hungerstreikende. Die politische Führung war zeitweilig gespalten, aber die Hardliner unter Li Peng gewannen die Oberhand: Panzer wurden aufgefahren. Nach der Niederschlagung mit Hunderten Todesopfern wurden festgenommene Demonstranten im Fernsehen als Verbrecher vorgeführt. Dieses Foto durfte in China nicht veröffentlicht werden.

La Place de Tiananmen

Peut-être le mouvement de protestation le plus célèbre de tous les temps. Juin 1989, à Pékin, un Chinois non identifié défia la puissance militaire du gouvernement. Le mouvement débuta en mai lorsque des milliers de grévistes de la faim en faveur de la démocratie occupèrent la place. Le gouvernement chinois fut momentanément divisé mais l'aile dure de Li Peng l'emporta et les chars furent envoyés contre les manifestants. Après la répression, au cours de laquelle des centaines de personnes furent tuées, les manifestants qui avaient été arrêtés furent montrés à la télévision comme des criminels. Cette photo, cependant, sera interdite en Chine.

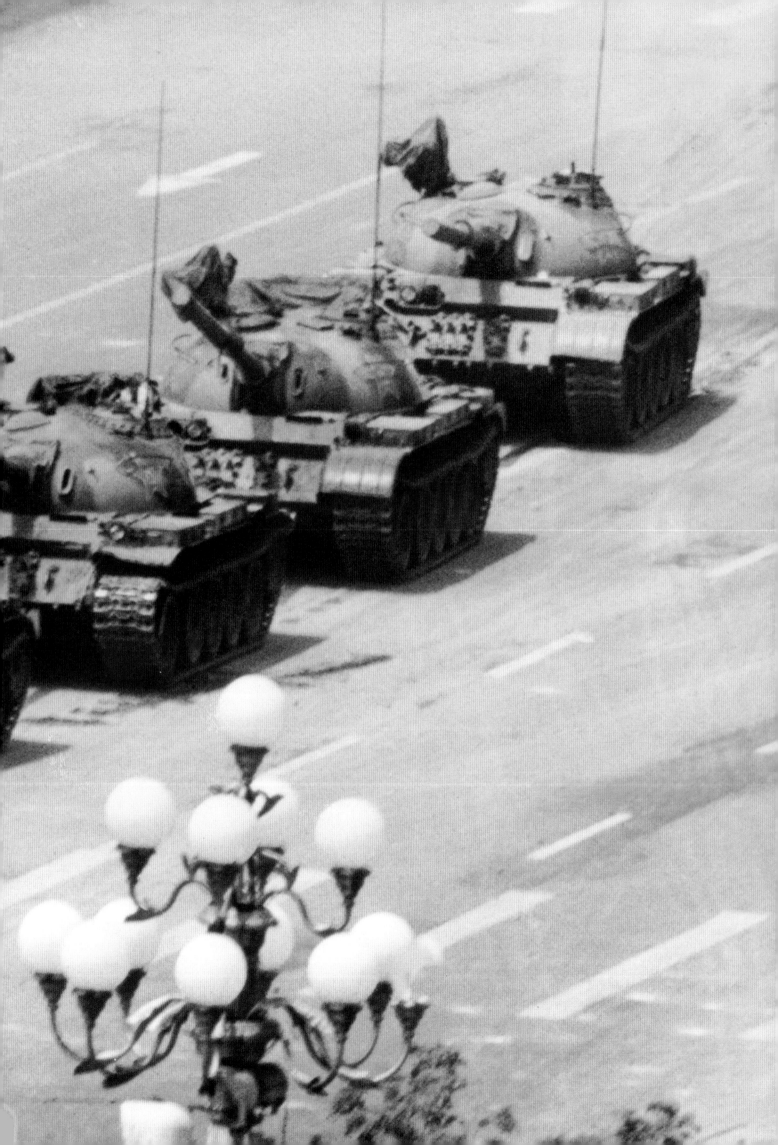

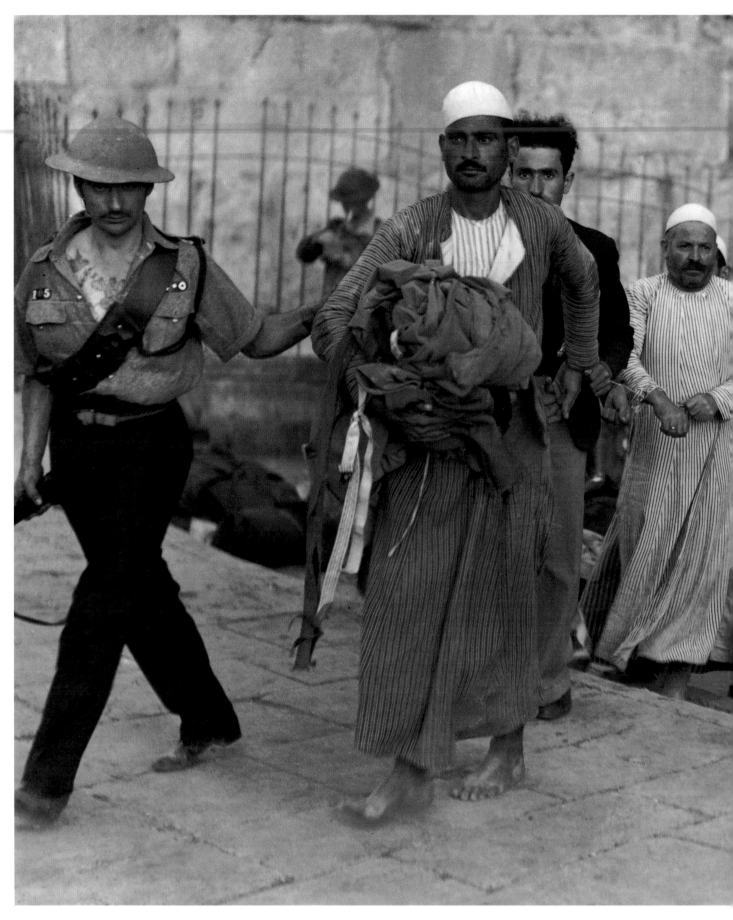

Palestine

The British Mandate over Palestine had little
support. The Arabs wanted independence:
the Zionists wanted the land as their national
home. In 1938 Arab rebels briefly occupied
the Old City of Jerusalem, but were captured
by British troops. The box of Heinz Baked

Beans, 'with pork and tomato sauce', may
have been basic rations to the British, but
probably did little to promote good relations
with either Jews or Muslims.

Palästina

Das britische Mandat über Palästina fand
wenig Unterstützung: Die Araber strebten
nach Unabhängigkeit, während die Zionisten
das Land als ihre nationale Heimat
beanspruchten. 1938 besetzten arabische
Rebellen für kurze Zeit die Jerusalemer

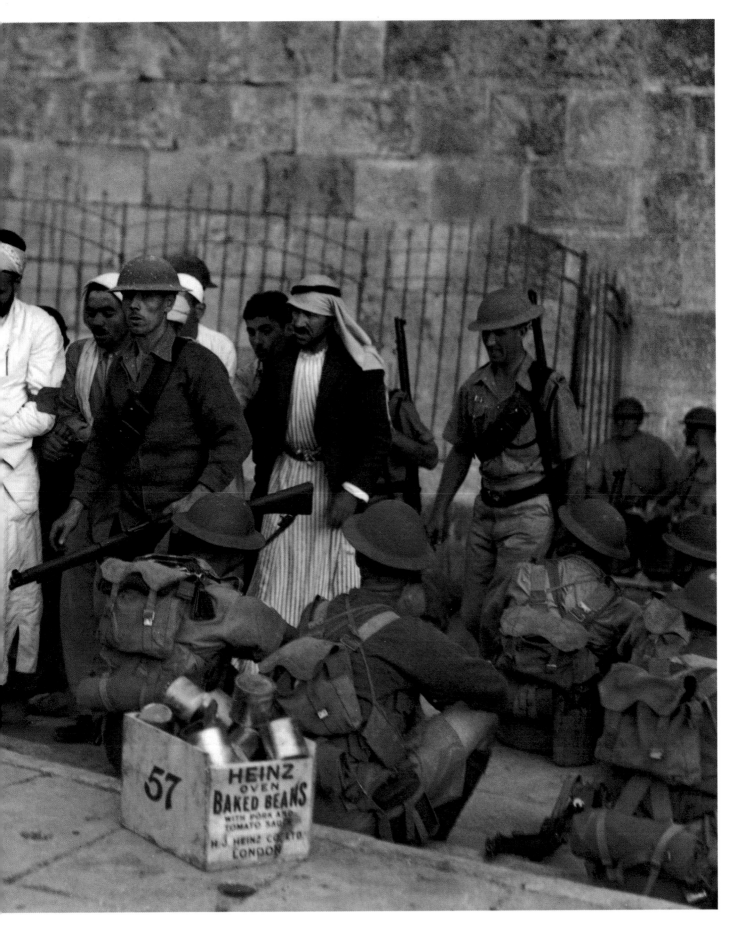

Altstadt; sie wurden jedoch von britischen Truppen gefangengenommen. Das Paket Heinz *Baked Beans,* »mit Schweinefleisch und Tomatensauce«, gehörte zur Grundration der Briten, trug aber wahrscheinlich wenig dazu bei, die Beziehungen mit Juden und Moslems zu fördern.

La Palestine

Le mandat britannique en Palestine obtint peu de soutien. Les Arabes réclamaient l'indépendance et les Sionistes voulaient faire de cette terre leur patrie. En 1938, des rebelles arabes occupèrent brièvement la vieille ville de Jérusalem avant d'être arrêtés par des soldats britanniques. Cette caisse remplie de Heinz *Baked Beans,* haricots, porc et sauce tomate, ne contenait pour les Britanniques que de simples provisions de base, mais ne contribua guère à entretenir de bonnes relations avec les Juifs ou les Arabes.

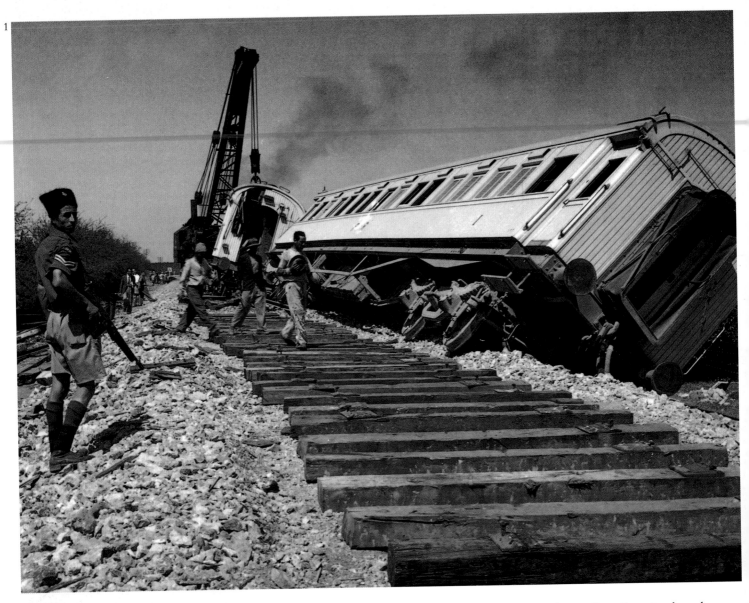

Zionist Terrorism

The Jews made up roughly a third of the population of Palestine – enough to make life almost impossible for the British, against whom the Zionists waged a ceaseless war of terrorism from 1945 onwards. (1) In April 1947 five British soldiers were among 11 people killed when terrorists blew up a Cairo-Haifa troop train. (2) Twenty-two people were killed in a single day in March 1947, which produced a strict curfew in Jerusalem and searches of the locals. (3) The destruction of the King David Hotel, Jerusalem, the British HQ, 1946; 91 died. It was the beginning of the end of the British Mandate.

Zionistischer Terror

Die Juden stellten etwa ein Drittel der Bevöl-kerung Palästinas – genug, um den Briten, gegen die die Zionisten seit 1945 einen ständigen Guerillakrieg führten, das Leben fast unmöglich zu machen. (1) Fünf britische Soldaten waren unter den elf Opfern eines Terrorangriffs auf einen Truppenzug zwischen Kairo und Haifa. (2) An einem einzigen Tag im März 1947 wurden 22 Menschen getötet, was zu einer strikten Sperrstunde und Leibesvisitationen führte. (3) Die Zerstörung des King-David-Hotels, des britischen Hauptquartiers, 1946: 91 Menschen starben. Es war der Anfang vom Ende des britischen Mandats.

Le terrorisme sioniste

Les Juifs représentaient à peu près un tiers de la population de la Palestine, un nombre assez élevé pour rendre la vie impossible aux Britanniques. Dès 1945 et sans relâche, les Sionistes menèrent une guerre terroriste contre la puissance mandataire. (1) En avril 1945, cinq soldats britanniques figurèrent parmi les 11 victimes du train que les terroristes firent exploser sur la ligne Le Caire-Haïfa. (2) Mars 1947, vingt-deux personnes furent tuées dans une seule journée. A Jérusalem, le couvre-feu fut décrété et les habitants firent l'objet de fouilles. (3) 1946, la destruction de l'hôtel King David, le Q.G. britannique, fit 91 victimes. Ce fut le début de la fin du mandat britannique.

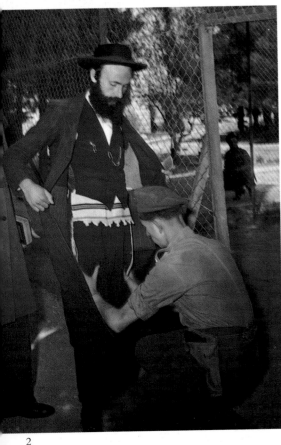

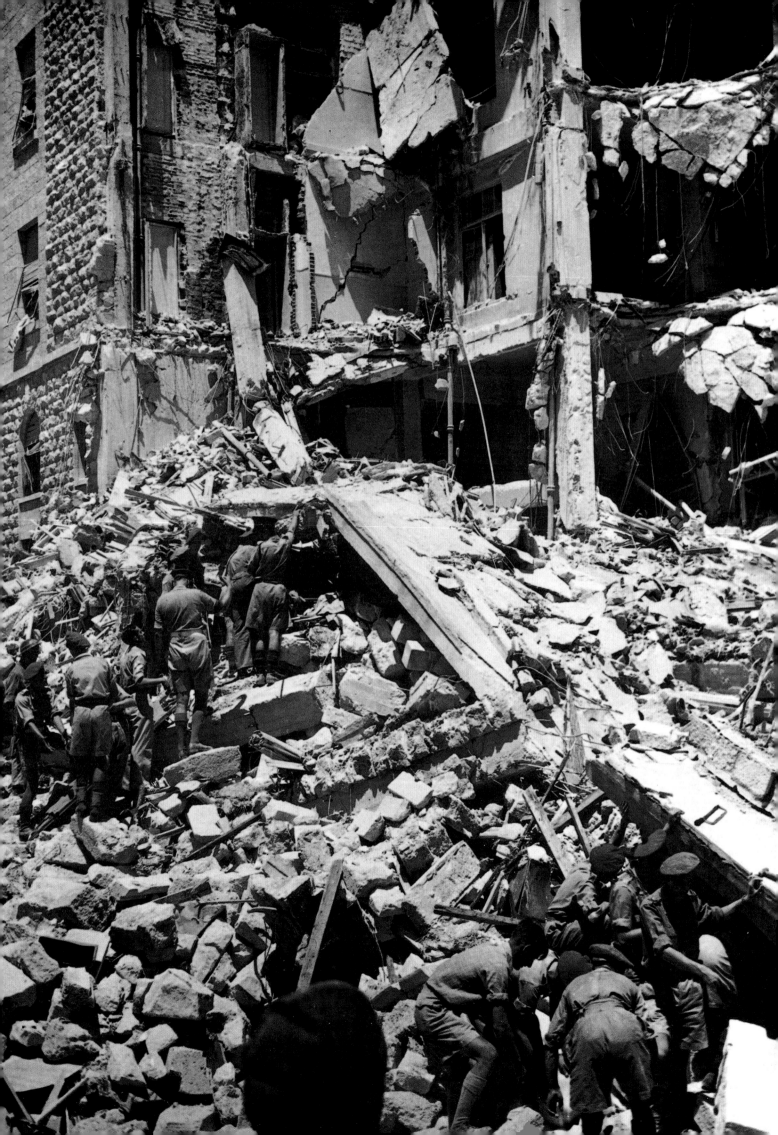

1

2

Jewish Settlement

In the 1930s, the British were in the Middle East largely to safeguard their oil interests. The Jews were there to claim their homeland. By 1945 the British were opposed by three separate Jewish armed forces: the Stern Gang, the Irgun, and (1, 3) the Haganah. (2) In remote parts of Palestine, the Jews protected their settlements by building stockades and observation towers, such as this at Upper Hanita.

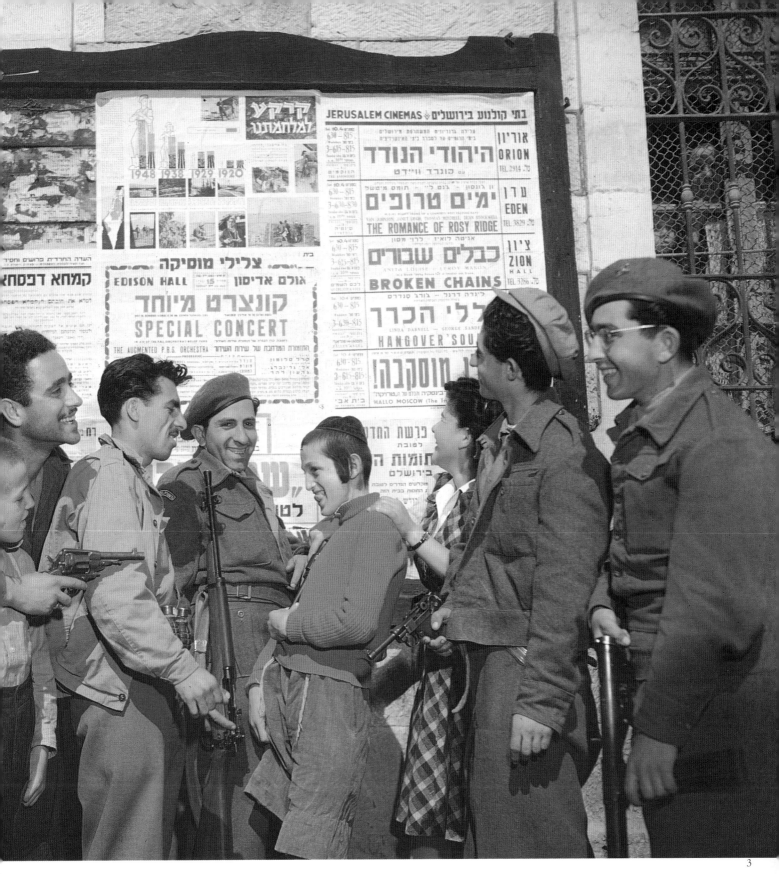

Jüdische Siedlungen

In den dreißiger Jahren waren die Briten vor
allem zur Wahrung ihrer Ölinteressen im
Nahen Osten, während die Juden dort ihr
Heimatland in Anspruch nehmen wollten.
1945 sahen sich die Briten drei verschie-
denen bewaffneten jüdischen Truppen
gegenüber: der Stern Gang, der Irgun und
(1, 3) der Haganah. (2) In den abgelegeneren
Teilen Palästinas, wie hier in Ober-Hanita,
schützten die Juden ihre Siedlungen mit
Palisaden und Wachtürmen.

Les colonies juives

Dans les années 30, les Britanniques en poste
au Moyen-Orient y étaient principalement
pour sauvegarder leurs intérêts pétroliers. Les
Juifs étaient là pour revendiquer leur patrie.
En 1945, trois organisations juives menèrent
une lutte armée contre les Britanniques: le
groupe Stern, l'Irgoun et (1, 3) la Haganah.
(2) Dans certaines régions isolées de la
Palestine, les Juifs construisirent des
palissades et des miradors pour protéger leurs
colonies juives, comme celle du kibboutz
Hanita.

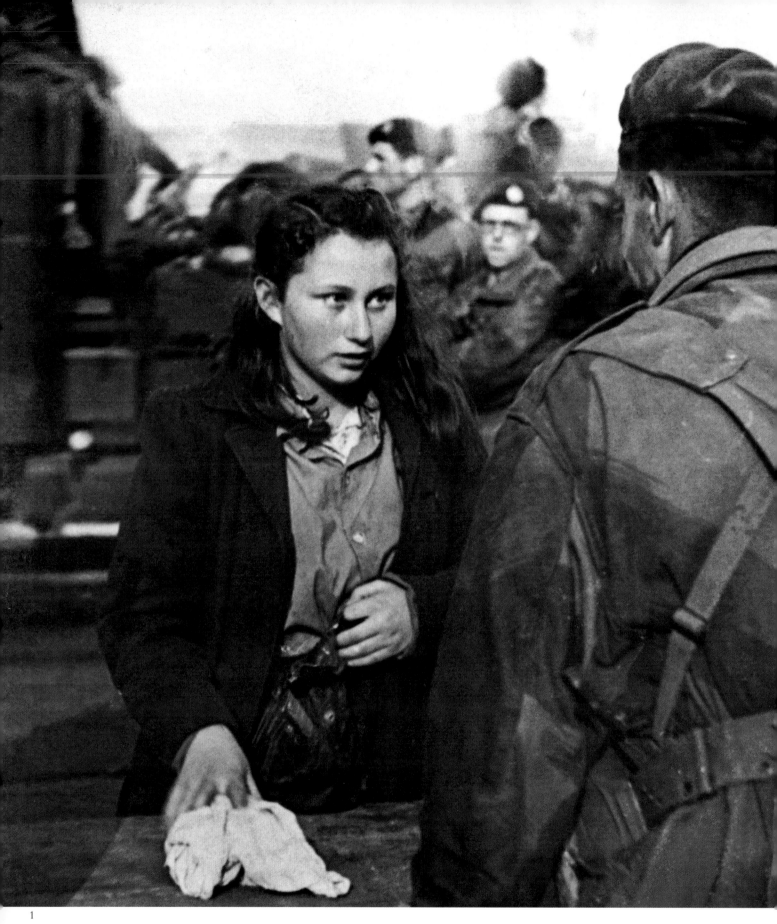

1

Exodus

When peace returned to a Europe in ruins in 1945, thousands of Jews, refugees from camps and persecution, arrived in Palestine, most of them illegally. (1) They came to their homeland, to be met by red tape and troops, like this Jewish girl in Haifa. The ships in which they sailed were intercepted and turned back. (2) One of the first ships to arrive was the *Haviva Reik* in June 1946, with

a banner bearing the words 'Keep the Gates Open – We Are Not the Last'. The ship, carrying 450 refugees, broke down 120 miles from Palestine, and was towed to Haifa. (3) Conditions on the refugee boats were appalling, but that mattered little to those who sailed in them.

Exodus

Nachdem 1945 Frieden im zerstörten Europa eingezogen war, kamen Tausende von Juden als Flüchtlinge der Lager und der Verfolgung nach Palästina, die meisten von ihnen illegal. (1) Endlich in ihrem Heimatland, sahen sie sich, wie dieses jüdische Mädchen in Haifa, Absperrungsbändern und Truppen gegenüber. Die Schiffe, auf denen sie reisten, wurden abgefangen und mußten umkehren.

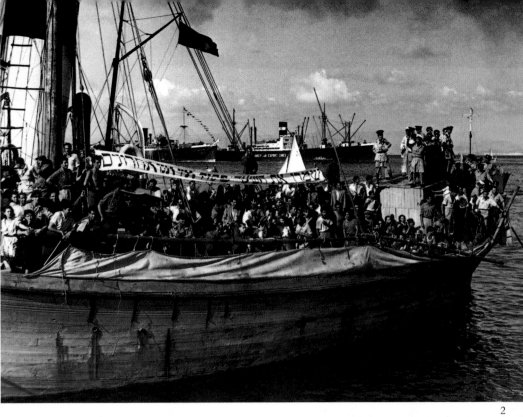

(2) Eines der ersten Schiffe war die *Haviva Reik,* die im Juni 1946 eintraf. Sie trug ein Banner mit den Worten: »Haltet die Tore offen – wir sind nicht die letzten.« Das Schiff mit 450 Flüchtlingen hatte 200 Kilometer vor Palästina eine Panne und mußte nach Haifa geschleppt werden. (3) Die Bedingungen auf den Flüchtlingsschiffen waren erschreckend, aber das berührte die Passagiere wenig.

L'exode

En 1945, quand l'Europe en ruine retrouva la paix, des milliers de Juifs ayant survécu aux camps et à la persécution arrivèrent en Palestine, pour la plupart illégalement. (1) Ils atteignirent la Terre Promise et, comme cette jeune Juive à Haïfa, furent accueillis par des fonctionnaires et des soldats. Les bateaux dans lesquels ils s'étaient embarqués furent interceptés et durent faire demi-tour. (2) Juin

1946, un des premiers bateaux à arriver fut le *Haviva Reik.* Une bannière proclamait «Gardez les barrières ouvertes, nous ne sommes pas les derniers». Le bateau, avec 450 réfugiés à bord, tomba en panne à quelque 200 kilomètres de la Palestine et fut remorqué jusqu'à Haïfa. (3) Les conditions de vie sur les bateaux de réfugiés étaient épouvantables mais cela importait peu aux passagers.

The Intifada

When the British pulled out of Palestine in 1948, they bequeathed a bitter legacy to the Jews and Arabs of that country. For almost fifty years relations have been untrusting at best, vicious at their worst. (1) An Arab uses his sling-shot to hurl stones at Israeli border guards in a Palestinian refugee camp, February 1994. (2) A wounded woman is treated after a Hamas suicide bomber blew himself up in a Tel Aviv street, March 1996. (3) A week earlier dozens were killed when another suicide bomber attacked a Jerusalem bus.

Die Intifada

Seit die Briten 1948 Palästina verlassen hatten, waren die Beziehungen zwischen Juden und Arabern bestenfalls von Mißtrauen, schlimmstenfalls von Terror geprägt. (1) Februar 1994: Ein Araber in einem palästinensischen Flüchtlingscamp wirft mit einer Schleuder Steine auf israelische Grenzschützer. (2) Eine Verletzte wird behandelt, nachdem sich ein Hamas-Selbstmörder im März 1996 in Tel Aviv in die Luft gesprengt hat. (3) Eine Woche zuvor starben Dutzende bei einem Selbstmordangriff auf einen Jerusalemer Bus.

L'Intifada

Quand les Britanniques se retirèrent de la Palestine en 1948, ils laissèrent un héritage amer aux Juifs et aux Arabes de ce pays. Pendant près de cinquante ans, leurs relations furent au mieux empreintes de méfiance, au pire de haine. (1) Février 1994, dans un camp de réfugiés palestiniens, un Arabe attaque au lance-pierres les Israéliens postés à la limite du camp. (2) Mars 1996, une femme, blessée dans l'attentat-suicide d'un membre du Hamas, lui-même tué dans l'explosion, fut soignée dans une rue de Tel Aviv. (3) Une semaine plus tôt, des dizaines de personnes furent tuées lors d'un autre attentat-suicide contre un bus à Jérusalem.

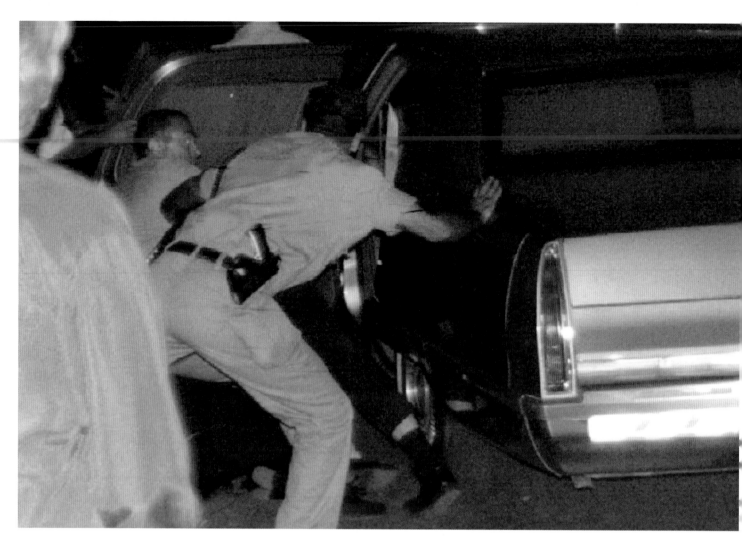

The Shooting of Rabin

On 4 November 1995 Yitzhak Rabin, Prime Minister of Israel, was assassinated by a Zionist extremist after a peace rally. (1) His slumped body is half-hidden by the Israeli policeman. Rabin's death shocked the world, but some Israelis approved the murder. (2) A copy of the 'Song of Peace', covered in Rabin's blood. (3) Rabin's successor, Shimon Peres, at a memorial tribute to Rabin in New York, in December 1995.

Die Ermordung Rabins

Am 4. November 1995 wurde der israelische Premierminister Yitzhak Rabin nach seiner Teilnahme an einer Friedensdemonstration von einem zionistischen Extremisten erschossen. (1) Hinter dem israelischen Polizisten kann man seinen zusammengesackten Körper erkennen. Rabins Tod erschütterte die Welt, allerdings begrüßten in Israel auch einige Menschen den Mord. (2) Eine mit Rabins Blut verschmierte Kopie des »Friedensliedes«. (3) Rabins Nachfolger, Shimon Peres, während einer Gedenkveranstaltung für Rabin in New York, Dezember 1995.

L'assassinat de Rabin

Le 4 novembre 1995, alors qu'il quittait un rassemblement pour la paix, Itzhak Rabin, le Premier Ministre d'Israël, fut assassiné par un extrémiste sioniste de 23 ans. (1) Derrière le policier israélien (centre), on peut voir son corps gisant à terre. La mort de Rabin choqua le monde entier, même si certains en Israël approuvèrent le meurtre. (2) Une copie du «Chant pour la paix», couverte du sang de Rabin, fut exposée à l'entrée du cimetière militaire du Mont Herzl où repose Rabin. (3) Le 10 décembre 1995, à New York, le successeur de Rabin, Shimon Perès, prononça un discours lors d'une cérémonie en hommage à son prédécesseur.

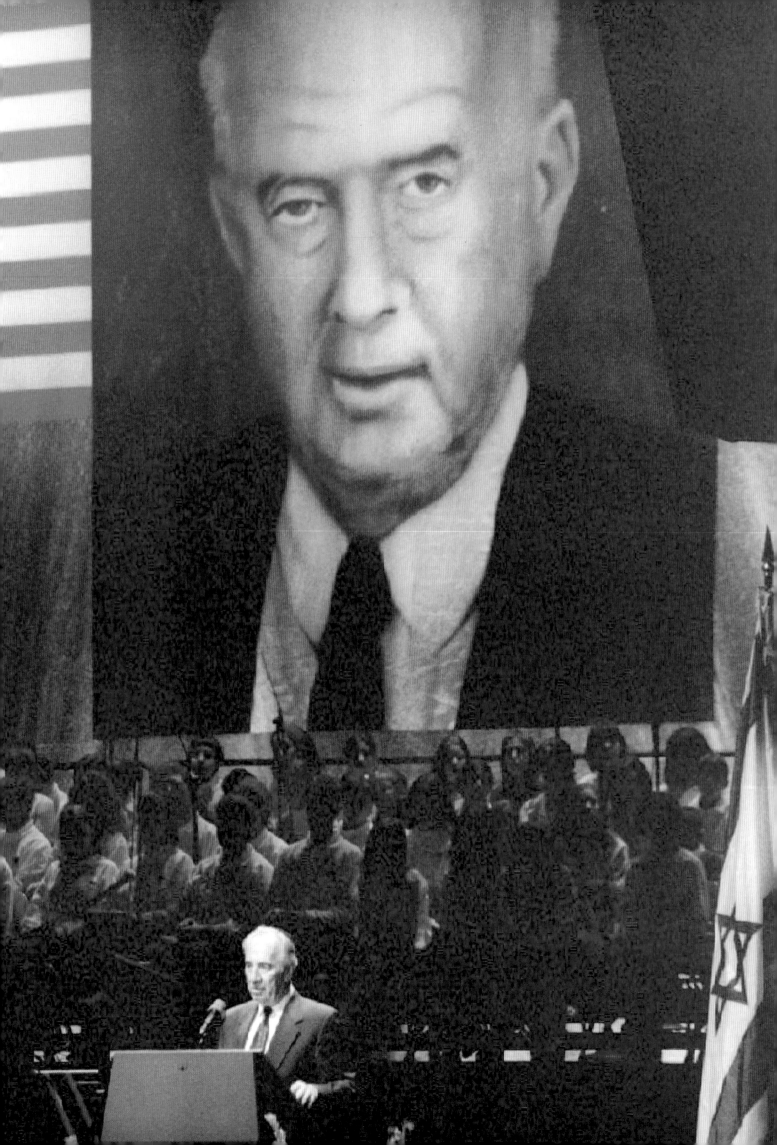

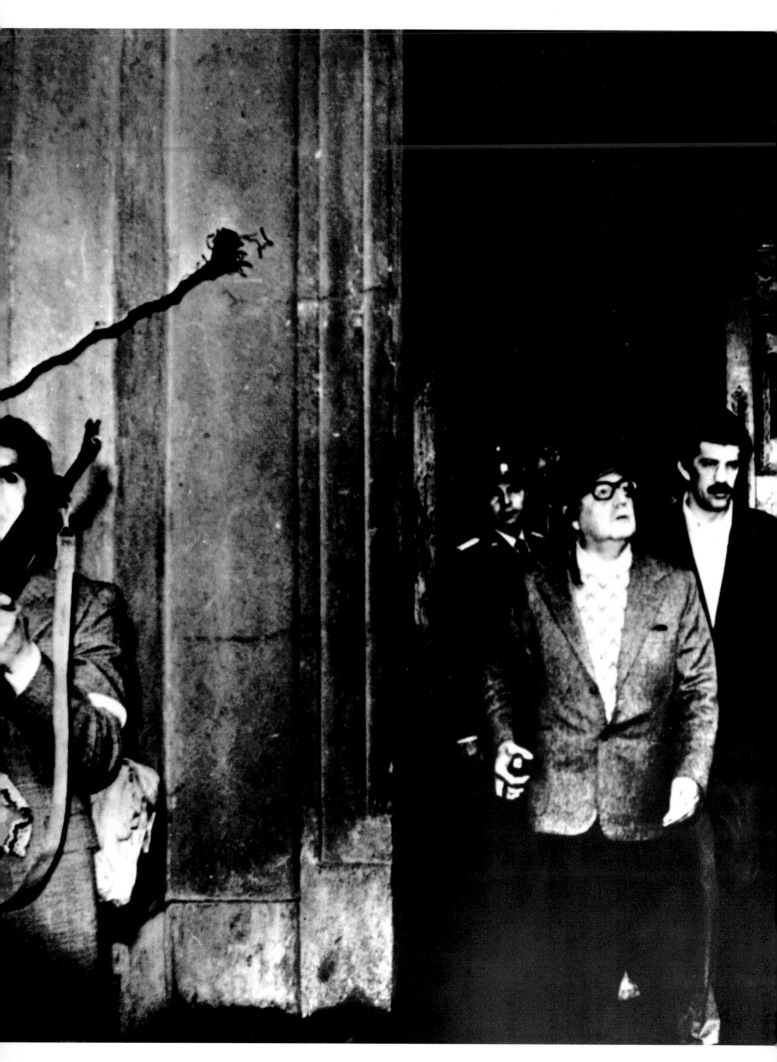

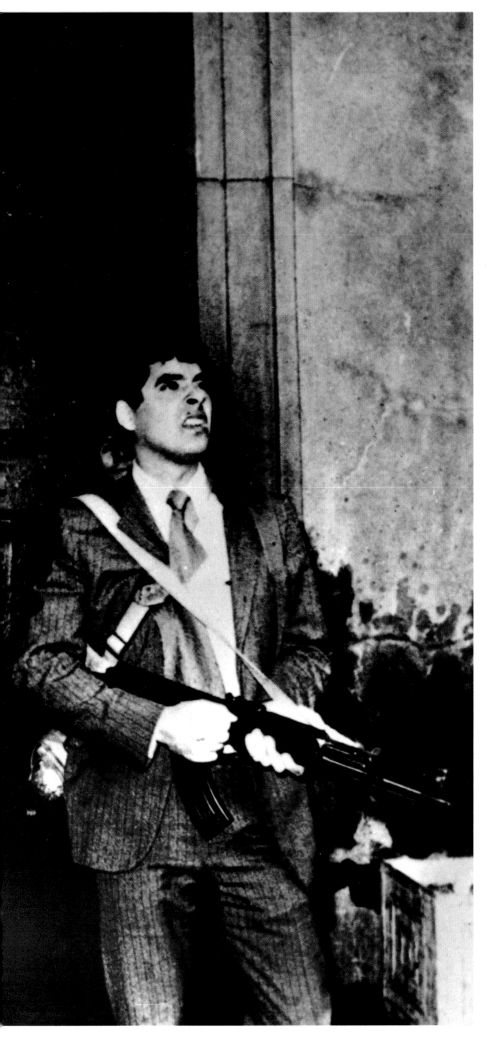

The Last Hours of Democracy
This picture of President Salvador Allende of Chile was taken shortly before he died, on 11 September 1973. Leaders of the military coup that ousted Allende claimed that he committed suicide. His supporters say he was shot by police. Within the next month a further 2000 Chileans were killed by the Junta.

Die letzten Stunden der Demokratie
Dieses Bild von Präsident Salvador Allende in Chile wurde kurz vor seinem Tod am 11. September 1973 aufgenommen. Führer des Militärputsches, durch den Allende gestürzt wurde, gaben an, er habe Selbstmord begangen. Seine Anhänger behaupten, er sei von der Polizei erschossen worden. Innerhalb des nächsten Monats wurden weitere 2000 Chilenen von der Junta ermordet.

Les dernières heures de la démocratie
Cette photo du Président chilien Salvador Allende fut prise peu de temps avant sa mort le 11 septembre 1973. Les chefs du coup d'état militaire qui avait renversé Allende prétendirent qu'il s'était suicidé. Ses partisans affirmèrent qu'il avait été tué par la police. Le mois suivant, 2000 Chiliens seront tués par la junte.

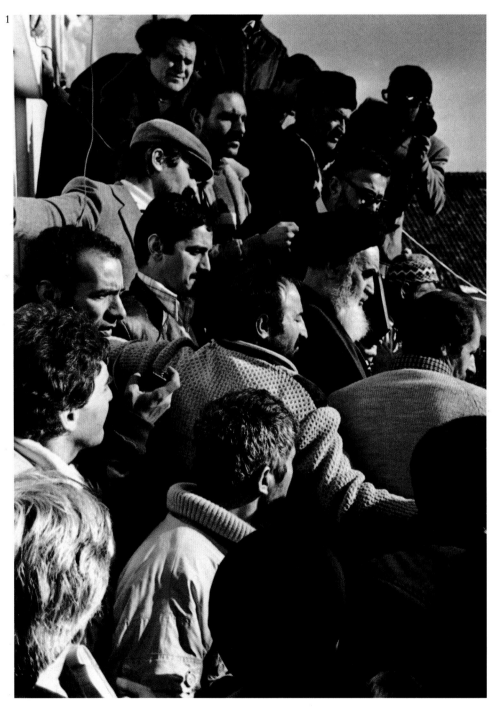

The Ayatollah

(1) When the Shah fled Iran in January 1979, the way was opened for the return of the Ayatollah Khomeini to return after 15 years exile in Paris. For a while the Iranian Prime Minister, Shahpur Bakhtiar, resisted the establishment of an Islamic Republic, but the army was divided in its loyalties and Bakhtiar himself was forced to flee. 'A great Satan has fled in ignominy', delared Khomeini.

(2) When the Ayatollah died, ten years later, three million mourners crowded the streets of Teheran.

Der Ayatollah

(1) Mit der Flucht des Schahs aus dem Iran im Januar 1979 war nach 15jährigem Exil in Paris der Weg frei für die Rückkehr Ayatollah Khomeinis. Nur kurz widersetzte sich der iranische Premierminister Shapur Bakhtiar der Errichtung einer islamischen Republik, aber seine Armee war gespalten, Bakhtiar selbst mußte fliehen. »Ein großer Satan ist in Schande geflohen«, erklärte Khomeini.

(2) Als der Ayatollah zehn Jahre später starb, versammelten sich drei Millionen Trauernde auf den Straßen von Teheran.

L'Ayatollah

(1) Après la fuite du Chah d'Iran en janvier 1979, la voie fut libre pour permettre le retour de l'Ayatollah Khomeiny après 15 ans d'exil à Paris. Pendant quelque temps, le Premier Ministre iranien, Chapour Bakhtiar, parvint à résister à la création d'une République islamique, mais l'armée était divisée et Bakhtiar fut obligé de fuir. «Un grand Satan s'est couvert de honte en prenant la fuite», déclara Khomeiny. (2) A la mort de l'Ayatollah, dix ans plus tard, trois millions de personnes en deuil descendirent dans les rues de Téhéran.

In September 1970, Palestinian gunmen took fifty hostages when they hijacked five civilian planes at Dawson's Field, a desert airstrip in northern Jordan. Among the planes they took over were a BOAC DC-10 and a Swissair DC-8. In the intense heat of the desert, negotiations were sweaty and tense, but the resolution of the 'outrage' was better than many had feared. After releasing the hostages, the terrorists simply blew up the planes.

Im September 1970 kaperten palästinensische Terroristen fünf Zivilflugzeuge auf dem Flughafen Dawson's Field in Nordjordanien und nahmen 50 Geiseln. Zu den entführten Flugzeugen gehörten eine DC-10 der BOAC und eine DC-8 der Swissair. In der glühenden Wüstenhitze zogen sich die Verhandlungen zäh und zermürbend dahin, aber das Ende dieser »Gewalttat« verlief friedlicher als von vielen erwartet: Nach der Freilassung der Gefangenen sprengten die Terroristen einfach die Flugzeuge.

Septembre 1970, des Palestiniens armés retiennent 50 personnes en otages après le détournement de 5 avions civils sur la piste de Dawson, un aéroport dans le désert du nord de la Jordanie. Parmi les appareils détournés, il y a un DC-10 de la BOAC et un DC-8 de la Swissair. Sous la chaleur accablante du désert, les négociations sont longues et tendues mais les conséquences de l'opération sont moins graves que ce que l'on aurait pu craindre. Après avoir libéré les otages, les terroristes font exploser les appareils.

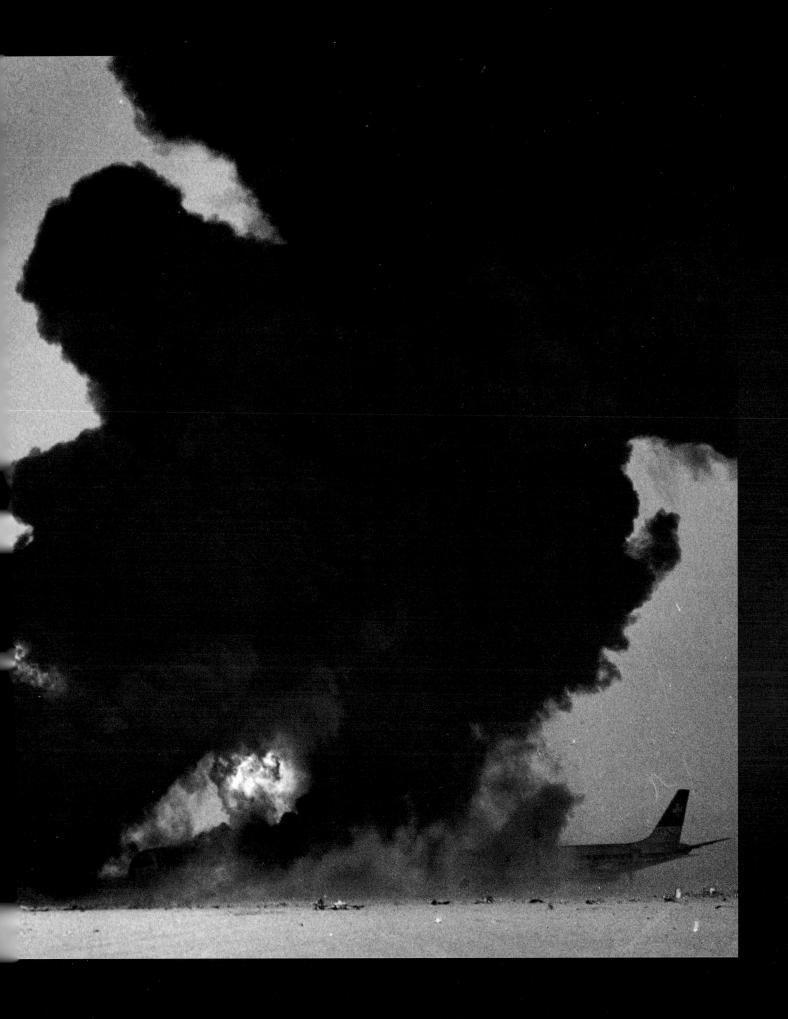

By Bomb and Bullet

The 1970s and 1980s saw a huge increase in hijacking as a method of protest and a means of highlighting a cause or grievance. Boats, planes and buses were all seized by terrorists. The South Moluccan separatist groups hijacked both a train and two buildings. In December 1975 they occupied the Indonesian Consulate in Amsterdam and commandeered a train ninety miles outside the city. Two years later they seized a Dutch school.

Planes were particularly susceptible to hijacking: Entebbe, Mogadishu (1977), Larnaca, Cyprus (1978), Beirut (1985), Malta and Rome (1985) being just some of the ultimate destinations for flights that had been taken over. Airports and railway stations became targets for several attacks: New York (1975), Bologna (1980), Montreal (1984), Rome (twice) and Vienna (1985). Even boats were no longer safe – the *Achille Lauro* was hijacked by Palestinian supporters of the PLO in October 1985.

In the face of this spate of terrorism, governments divided into those who avowed that they would never deal with terrorists; those who accepted that they had to; and those that said they wouldn't, but did. The United States tried a variety of methods in an age when US embassies around the world were probably the least safe places to be. The most serious attacks on US embassies were in Iran (1979), San Salvador (1981), and Beirut (1983 and 1984). The siege of the Libyan Embassy in London (1984) began when a group demonstrated in the street outside against Colonel Gaddafi. Shots were fired and a policewoman was killed. Who fired the shot, and where it came from, may never be discovered, but at the time it was believed to have come from the embassy.

In this atmosphere of almost constant violence, the technological revolution made it easier for governments to spy on their enemies and their own people. It also made it easier for dissenters who believed in direct action to get their message across. Television companies and newspaper editors may have condemned embassy sieges and plane hijackings, but they were always hungry for dramatic pictures of such events.

New armies appeared – owing allegiance not to a nation, but to a belief. Some, like the PLO, had their roots in an age-old quarrel. Others, like the Symbionese Liberation Army, were new on the scene. The SLA was a small-time organisation of left-wing extremists who gained world attention in February 1974. They kidnapped Patty Hearst, a 19-year-old art student at Berkeley University, California – but, more significantly, the heir to the Hearst newspaper and publishing millions. Hearst's kidnappers demanded that two million dollars' worth of food be given to the poor before they would open negotiations for her release. Her father, Randolph Hearst, paid the money. The SLA then demanded a further

Wrecked train, wrecked dreams: the Dublin-Belfast Express, the train that symbolically brought together Ulster and the Irish Republic, is shattered by a terrorist bomb.

Zerstörter Zug, zerstörte Träume: Der Dublin-Belfast-Express, der Ulster und die Irische Republik symbolisch miteinander verband, wurde durch einen terroristischen Bombenanschlag zerstört.

Un train détruit, des rêves anéantis: une bombe explose dans l'express de la ligne Dublin-Belfast, le train qui réunit symboliquement l'Ulster à la République d'Irlande.

four million dollars' worth of food for her release. The story then turned upside down. Patty Hearst joined the SLA, armed herself with an automatic rifle and raided a bank. For her the story had as happy an ending as possible – a short jail sentence. For the few members of the SLA it ended in tragedy. For the poor – well, at least they had something to eat.

Perhaps the most horrifying terrorist attack of all was that on the Israeli athletes at the Olympic Village in Munich in September 1972. Black September guerrillas, the group that had hijacked a Belgian airliner a few months earlier, broke into the Israeli quarters, killing two members of the team. By next morning some 12,000 police were surrounding the building. The terrorists demanded the release of 200 Palestinian prisoners in Israeli jails and safe passage out of Germany. During the tense negotiations, a hooded figure occasionally appeared on one of the balconies. Just before midnight the guerrillas and nine hostages were flown by helicopter to

Munich airport, where a plane was purportedly waiting to take them to Cairo. German sharpshooters then opened fire. Four of the guerrillas, all Israeli hostages, and a German police officer were killed.

The attack ushered in a violent age when, for many, bomb and bullet replaced words.

In den siebziger und achtziger Jahren kam es zunehmend zu Flugzeugentführungen und Geiselnahmen als Protest oder als Methode, um eine Sache oder ein Anliegen in den Mittelpunkt öffentlichen Interesses zu rücken. Terroristen kaperten Schiffe, Flugzeuge und Busse. Separatistengruppen der Südmolukker brachten einen Zug und zwei Gebäude mit Insassen in ihre Gewalt. Im Dezember 1975 besetzten sie das Indonesische Konsulat in Amsterdam und einen Zug 150 Kilometer vor der Stadt. Zwei Jahre später brachten sie eine niederländische Schule in ihre Gewalt.

Flugzeuge waren besonders anfällig für Entführungen: Entebbe, Mogadischu (1977), Larnaka, Zypern (1978), Beirut (1985), Malta und Rom (1985) waren nur einige der Orte, an denen Fluzeugentführungen endeten. Flugzeuge und Bahnhöfe wurden zu Zielen mehrerer Anschläge: New York (1975), Bologna (1980), Montreal (1984), Rom (zweimal) und Wien (1985). Selbst Schiffe waren nicht mehr sicher: Im Oktober 1985 kaperten palästinensische Anhänger der PLO die *Achille Lauro*.

Angesichts dieser Flut von Terroranschlägen spalteten sich die Regierungen in jene, die schworen, niemals mit Terroristen zu verhandeln, jene, die akzeptieren, daß ihnen nichts anderes übrigblieb, und solche, die vorgaben, es nicht zu tun, es aber dennoch taten. Die Vereinigten Staaten probierten es in einer Zeit, in der US-Botschaften auf der ganzen Welt zu den wohl unsichersten Orten gehörten, mit verschiedenen Methoden. Die schwersten Anschläge auf US-

Botschaften gab es im Iran (1979), in San Salvador (1981) und in Beirut (1983 und 1984). In London kam es zur Belagerung der libyschen Botschaft (1984), als eine Gruppe Demonstranten auf der Straße vor dem Gebäude gegen Oberst Gaddafi protestierte. Schüsse fielen, und eine Polizistin wurde getötet. Wer den Schuß abgab und woher er kam, wird vielleicht nie geklärt, doch nahm man damals an, daß aus der Botschaft geschossen worden war.

In dieser Atmosphäre fast andauernder Gewalt machte die technologische Revolution es den Staaten leichter, ihre Feinde und auch ihr eigenes Volk zu überwachen. Ebenso konnten Andersdenkende, die an die direkte Aktion glaubten, ihre Botschaften ebenfalls leichter an die Öffentlichkeit bringen. Fernsehgesellschaften und Zeitungsverleger mochten die Botschaftsbesetzungen und Flugzeugentführungen zwar verdammen, stürzten sich aber immer gierig auf die dramatischen Bilder solcher Vorfälle.

Neue Armeen schlossen sich zusammen, die nicht einem Staat, sondern einem Glauben verpflichtet waren. Einige, wie die PLO, wurzelten in uralten Konflikten. Andere, wie die *Symbionese Liberation Army,* erschienen neu auf der Bildfläche. Die SLA war eine kurzlebige Organisation linker Extremisten, die im Februar 1974 weltweite Aufmerksamkeit erregte, als sie Patty Hearst, neunzehnjährige Kunststudentin an der Universität von Berkeley, Kalifornien, und, was wichtiger war, Millionenerbin des Zeitungs- und Verlagskonzerns der Familie Hearst, entführte. Ihre Entführer verlangten, daß man Lebensmittel im Wert von zwei Millionen Dollar an Arme verteilte, ehe sie zu Verhandlungen über ihre Freilassung bereit seien. Ihr Vater, Randolph Hearst, bezahlte das Geld. Daraufhin forderte die SLA weitere Lebensmittel im Wert von vier Millionen Dollar für ihre Freilassung. Dann verkehrte sich die ganze Geschichte. Patty Hearst trat der SLA bei und überfiel, mit einem Automatikgewehr bewaffnet, eine Bank. Die ganze Geschichte endete für sie so gut, wie es unter diesen Umständen nur möglich war: Sie erhielt eine kurze Gefängnisstrafe. Für einige Mitglieder der SLA endete sie in einer Tragödie. Und für die Armen – nun ja, zumindest hatten sie etwas zu essen.

Der vielleicht abscheulichste Terroranschlag war der gegen die israelischen Athleten im olympischen Dorf von München im September 1972. Guerillas der Gruppe »Schwarzer September«, die einige Monate vorher eine belgische Linienmaschine entführt hatten, brachen in das israelische Quartier ein und töteten zwei Mitglieder der Olympiamannschaft. Am nächsten Morgen war das Gebäude von gut 12 000 Polizisten umstellt. Die Terroristen verlangten die Freilassung von 200 palästinensischen Gefangenen aus israelischen Gefängnissen und freies Geleit aus Deutschland. Während der zähen Verhandlungen erschien von Zeit zu Zeit eine maskierte Gestalt auf einem der Balkons. Kurz vor Mitternacht flog man die Guerillas und neun Geiseln mit dem Hubschrauber auf einen Flugplatz bei München, wo angeblich ein Flugzeug nach Kairo für sie bereitstand. Dann eröffneten deutsche Scharfschützen das Feuer. Vier der

Guerillas, alle israelischen Geiseln und ein deutscher Polizi: wurden getötet.

Dieses Ereignis war der Beginn einer Ära der Gewalt, i der Bomben und Schußwaffen für viele die Worte ersetzten.

Au cours des années 70 et 80, les prises d'otages s multiplièrent. Elles devinrent une forme de protestatio et un moyen d'attirer l'attention sur une cause ou un injustice. Les terroristes s'emparèrent de bateaux, d'avions ε de bus. En décembre 1975, des séparatistes moluques retirer en otage un train et deux immeubles simultanément. Il occupèrent le consulat d'Indonésie à Amsterdam et réquisi tionnèrent un train à cent cinquante kilomètres hors de la ville Deux ans plus tard, ils s'emparèrent d'une école.

Les avions devinrent une cible privilégiée pour le terroristes. Entebbe, Mogadishio (1977), Larnaca à Chypr (1978), Beyrouth (1985), Malte et Rome (1985) furent l destination finale des avions détournés. Plusieurs attentat furent commis dans des aéroports et des gares: New Yor (1975), Bologne (1980), Montréal (1984), Rome (deux fois) e Vienne (1985). Même les bateaux n'étaient plus des lieux sûrs En octore 1985, l'*Achille Lauro* fut détourné par des Palestinien membres de l'OLP.

Face à cette recrudescence du terrorisme, l'attitude de gouvernements était partagée. Certains déclarèrent qu'ils n traiteraient jamais avec les terroristes. D'autres reconnaissèren avoir été contraints de le faire. Enfin, il y eut ceux qu affirmèrent n'avoir jamais traité avec les terroristes mais qui l firent néanmoins. Les Etats-Unis employèrent diverse méthodes alors que les ambassades américaines n'étaient plu des lieux sûrs. Les attaques les plus graves furent menée contre les ambassades américaines en Iran (1979), à Sai Salvador (1981) et à Beyrouth (1983 et 1984). L'occupation d l'ambassade libyenne à Londres (1984) commença tandis que dans la rue, un groupe de manifestants protestait contre le colonel Khadafi. Des coups de feu partirent et une femm policier fut tuée. Qui tira le coup de feu et d'où? On ne l saura peut-être jamais mais, à l'époque, tout le monde pensai qu'il avait été tiré depuis l'ambassade.

Dans ce climat de violence quasi perpétuelle, la révolutior technologique facilita la tâche des gouvernements qui vou laient espionner leurs ennemis et leurs propres populations Elle permit aussi aux dissidents, qui croyaient en une actior directe, de faire passer leurs messages plus simplement. Si le chaînes de télévision et les rédacteurs en chef des journaux no manquaient pas de condamner l'occupation d'une ambassad et les détournements d'avion, ils restaient malgré tout à l'affû d'images spectaculaires de ces événements.

Des armées nouvelles firent leur apparition. Elles no prêtaient plus serment à une nation mais à une croyance Certaines, comme l'OLP, avaient leurs racines dans un confli ancien. D'autres, comme l'Armée de Libération Symbionèse (ALS), entrèrent en scène. L'ALS était une organisatior d'extrême gauche de troisième ordre qui retint l'attention di monde entier en février 1974 après avoir enlevé Patty Hearst

The remains of the Alfred
Murrah Federal Building in
Oklahoma City, April 1995,
after a truck bomb had ripped
the offices apart and killed over
a hundred people.

Die Überreste des Alfred P.
Murrah Federal Building in
Oklahoma City, nachdem im April
1995 eine Autobombe die
Büroräume zerstört und über
hundert Menschen getötet hatte.

Avril 1995 à Oklahoma City, ruines
du bâtiment fédéral Alfred P.
Murrah après l'explosion d'un
camion piégé qui éventre
l'immeuble de bureaux et fait une
centaine de victimes.

Cette étudiante en art à l'Université de Berkeley en Californie, âgée de 19 ans, n'était autre que l'héritière du magnat de la presse Hearst dont les journaux se vendaient à des millions d'exemplaires. Les ravisseurs de Patricia Hearst exigèrent, avant d'entamer les négociations pour sa libération, que soit distribué aux pauvres l'équivalent de deux millions de dollars en nourriture. Son père, Randolph Hearst, paya cette somme. L'ALS exigea alors quatre millions de dollars en nourriture en échange de sa liberté. Mais la situation se renversa. Patty Hearst s'engagea dans l'ALS, prit les armes et, armée d'une mitraillette, dévalisa une banque. Pour elle, l'histoire se termina plutôt bien. Elle ne fut condamnée qu'à une faible peine de prison. Pour les quelques membres de l'ALS, la fin fut tragique. Quant aux pauvres, ils eurent au moins quelque chose à manger.

L'acte terroriste le plus choquant de tous est peut-être celui qui fut perpétré à l'encontre des athlètes israéliens au village olympique de Munich en septembre 1972. Le commando Septembre Noir, l'organisation qui avait détourné un avion

belge quelques mois plus tôt, fit irruption dans le quartier israélien et tua deux athlètes. Le lendemain, à l'aube, 12 000 policiers encerclaient le bâtiment. Les terroristes exigèrent la libération de 200 prisonniers palestiniens des prisons israéliennes et l'assurance de pouvoir quitter librement l'Allemagne. Pendant les négociations très tendues, un visage cagoulé apparaissait de temps à autre au balcon. Peu avant minuit, le commando et neuf otages furent évacués par hélicoptère vers l'aéroport de Munich où un avion était censé les emmener au Caire. Les tireurs d'élite allemands ouvrirent le feu. Quatre terroristes, tous les otages israéliens et un officier de police allemand furent tués.

Ce fut le début d'une ère de violence durant laquelle, pour beaucoup, les bombes et les balles allaient remplacer les mots.

Women Terrorists

The press never quite knew what to call them – one moment they were the queens of hijacking or urban warfare, next moment they were terrorist scum. (1) Leila Khaled was a Palestinian who became notorious in the early 1970s as a hijacker of planes. (2) Patty Hearst was kidnapped by the Symbionese Liberation Army in February 1974, but later joined her kidnappers in a bank raid. She was arrested by the FBI in September 1975, and served 22 months of a seven-year gaol sentence. (3) Ulrike Meinhof was one eponymous half of the Baader-Meinhof gang of the 1970s.

Weibliche Terroristen

Die Presse wußte nie genau, wie sie sie nennen sollte – Königinnen der Entführer oder terroristischer Abschaum. (1) Die Palästinenserin Leila Khaled wurde zu Beginn der siebziger Jahre als Flugzeug-entführerin berühmt. (2) Patty Hearst wurde im Februar 1974 von der *Symbionese Liberation Army* entführt, überfiel aber später gemein-sam mit ihren Kidnappern eine Bank. Nach ihrer Verhaftung durch das FBI im Septem-ber 1975 verurteilte man sie zu sieben Jahren Gefängnis, von denen sie 22 Monate absaß. (3) Ulrike Meinhof, einer der beiden Namensgeber der Baader-Meinhof-Gruppe in den siebziger Jahren.

Les femmes terroristes

La presse n'a jamais su comment les désigner: tantôt reines du détournement ou de la guérilla urbaine, tantôt rebuts du terrorisme. (1) Au début des années 70, la Palestinienne Leila Khaled devient célèbre en détournant des avions. (2) Février 1974, Patty Hearst est enlevée par l'Armée de Libération Symbio-nèse mais, par la suite, se range aux côtés de ses ravisseurs et les aide à dévaliser une banque. Elle est arrêtée par le FBI en septem-bre 1975 et passe 22 mois en prison alors qu'elle a été condamnée à une peine de 7 ans. (3) Ulrike Meinhof est la moitié éponyme de la bande à Baader-Meinhof des années 70.

Terrorist Hostages

(1) Black September guerrillas broke into the Munich Olympic Village in 1972, killed two members of the Israeli team and took nine others hostage. A deal was made to fly the guerrillas to Cairo, but it wasn't kept. A pitched battle took place on the tarmac at Munich Airport. All the Israeli hostages were killed. (2) By 1978, the Red Brigade hoped that terrorism would become a mass phenomenon and destroy the Republic in Italy. This was their 'strategy of annihilation'. Their main enemy was now 'social democracy'. Aldo Moro was the leader of the Christian Democrat Party. He was kidnapped and held prisoner for 54 days. Moro behaved with courage and dignity, though he wrote several letters to his family and colleagues, begging them to secure his release. On 9 May 1978, the Red Brigade killed him, placed his body in the boot of a car and left the car in the Via Caetani, in the heart of Rome.

Geiseln des Terrors

(1) Guerillas der Gruppe »Schwarzer September« brachen 1972 in München in das Olympische Dorf ein, töteten zwei Mitglieder der israelischen Mannschaft und nahmen neun weitere als Geiseln. Angeblich sollte für die Terroristen eine Maschine nach Kairo bereitstehen, aber das Versprechen wurde nicht eingehalten. Auf dem Rollfeld des Münchener Flughafens kam es zu einer regelrechten Feldschlacht, bei der sämtliche

israelische Geiseln starben. (2) Um 1978 hoffte die Rote Brigade, daß Terrorismus zum Massenphänomen werden und die Republik Italien zerschlagen würde. Das war ihre »Vernichtungsstrategie«. Ihr Hauptfeind war nun die »Sozialdemokratie«. Aldo Moro war Vorsitzender der Christlich-Demokratischen Partei. Er wurde von der Roten Brigade entführt und 54 Tage gefangengehalten. Moro zeigte in seinem Verhalten Mut und Würde, obwohl er mehrere Briefe an seine Familie und Kollegen schrieb und

1

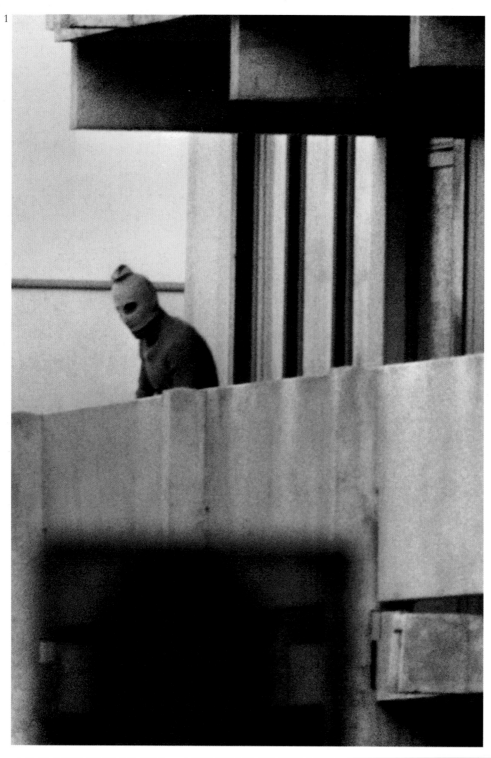

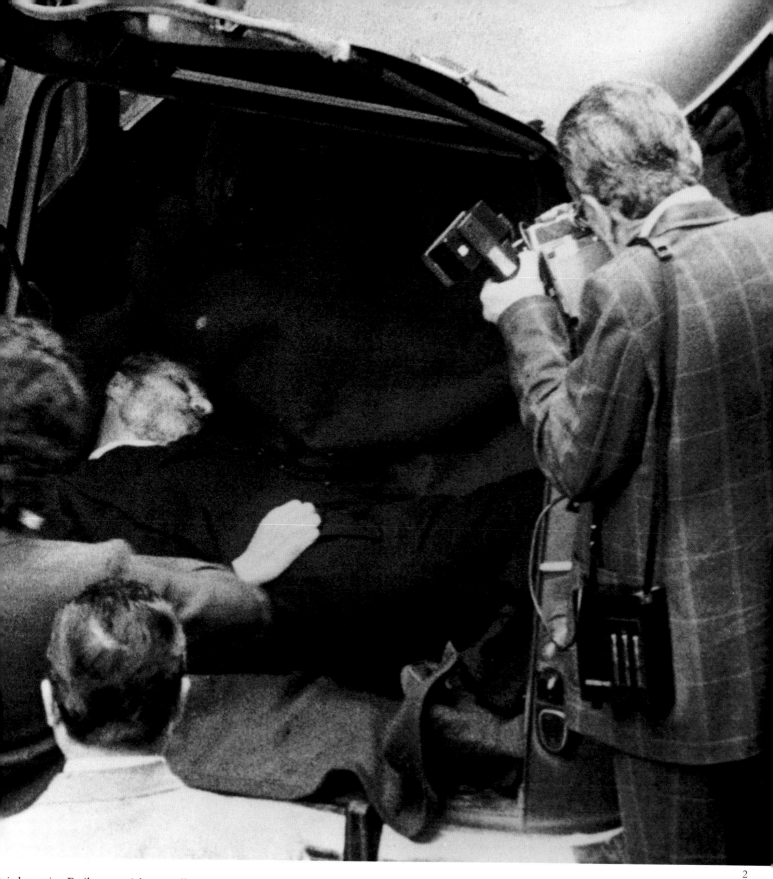

...sie bat, seine Freilassung sicherzustellen. Am 9. Mai 1978 tötete die Rote Brigade Moro, legte seine Leiche in den Kofferraum eines Wagens und ließ ihn in der Via Caetani, mitten in Rom, stehen.

Les preneurs d'otages

(1) En 1972, le commando Septembre Noir fait irruption dans le village olympique de Munich, tue deux membres de l'équipe israélienne et prend en otage sept autres athlètes. Un accord est conclu permettant aux terroristes de s'envoler pour le Caire mais il n'est pas respecté. Une véritable bataille se livre sur le tarmac de l'aéroport de Munich. Tous les otages israéliens sont tués. (2) En 1978, les Brigades Rouges espèrent que le terrorisme devienne un phénomène de masse et détruise la République italienne. C'est leur «stratégie d'anéantissement». Leur principal ennemi est désormais la «social-démocratie». Aldo Moro, président de la démocratie chrétienne, est enlevé et retenu prisonnier pendant 54 jours. Moro fait preuve de courage et de dignité. Mais, dans ses lettres à sa famille et ses confrères, il les supplie de tout faire pour permettre sa libération. Le 9 mai 1978, il est tué par les Brigades Rouges qui déposent son corps dans le coffre d'une voiture abandonnée sur la Via Caetani, en plein centre de Rome.

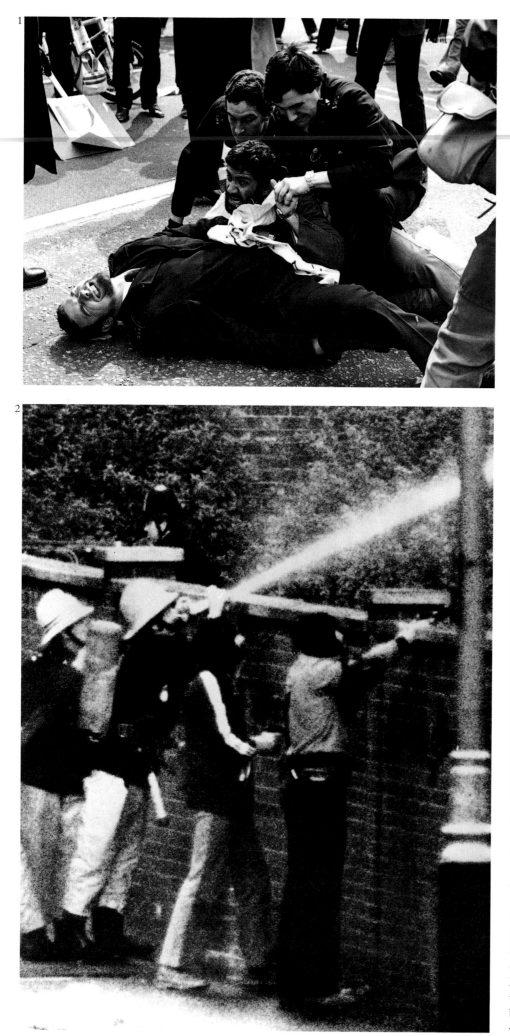

The Iranian Embassy Siege

Filmed and televised as though it was part of a Hollywood blockbuster, the SAS assault on the Iranian Embassy in London in May 1980 was seen by millions. The siege lasted five days after gunmen from Iran's Arab minority took nineteen hostages, most of them members of the staff. (1) Supporters of the Iranian Government then attacked members of the police who were surrounding the Embassy. (2) When the gunmen shot two of the hostages, tear gas was fired into the building, and (3) the SAS stormed the rooms where the hostages were held.

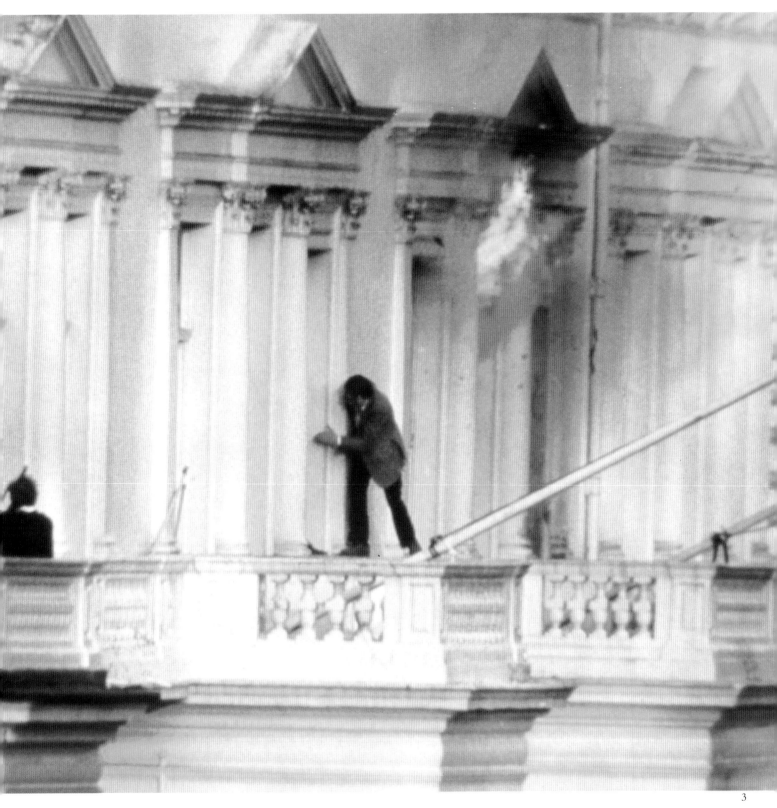

Die Belagerung der iranischen Botschaft
Die Erstürmung der iranischen Botschaft in London durch die britische Antiterror-Einheit SAS im Mai 1980 wurde wie ein Hollywood-Kassenknüller gefilmt und von Millionen weltweit am Fernsehen verfolgt. Nachdem bewaffnete Anhänger der arabischen Minderheit im Iran die Botschaft besetzt und 19 Geiseln genommen hatten, kam es zu einer fünftägigen Belagerung des Gebäudes. (1) Anhänger der iranischen Regierung griffen Mitglieder der Polizei an, die die Botschaft umstellte. (2) Als die Terroristen zwei Geiseln erschossen, feuerte man Tränengas in das Gebäude; dann (3) stürmte die SAS die Räume, in denen die Geiseln festgehalten wurden.

Le siège de l'ambassade d'Iran
Mai 1980, filmé et retransmis à la télévision comme s'il s'agissait d'un grand film hollywoodien, l'assaut lancé par les hommes du SAS (ndt: équivalent britannique du GIGN français) sur l'ambassade iranienne est regardé par des millions de personnes. Le siège a duré cinq jours après que des terroristes, membres d'une minorité arabe en Iran, aient retenu dix-neuf personnes en otages, des employés de l'ambassade pour la plupart. (1) Des partisans du gouvernement iranien agressent des policiers qui encerclent l'ambassade, (2) des grenades lacrymogènes sont tirées à l'intérieur du bâtiment après l'élimination de deux otages par les terroristes et (3) les hommes du SAS prennent d'assaut les pièces où sont retenus les otages.

Issue Politics

Issues were not hard to come by after the end of the Second World War. All over the world people struggled to save the whale, save the countryside, even to save the entire planet. They monitored discharge from factories, imports and exports, nuclear waste, air pollution, food additives and the treatment of animals. They surrounded military camps and power stations, printing works and offices. They were often impressive in their numbers, their dignity and their determination.

Mighty armies sprang up, who never armed themselves at all. In Europe and the United States, those who wished to ban the Bomb – and everyone knew which bomb they meant – hoped to win the day by sheer weight of numbers. Perhaps they did, though the collapse of the Soviet Union and the end of the Cold War was given as the reason why some of the bombs were at least disarmed.

Greenpeace had one simple aim – to save the world. They believed in peaceful but direct confrontation – abseiling down parliament buildings, sailing into nuclear bomb testing zones, placing themselves in the sights of harpoonists on whaling ships. They made many friends, but also enemies powerful and dangerous enough to sink the *Rainbow Warrior*, one of the Greenpeace ships, and kill two of its crew.

There were also hordes of ragged irregulars – people who came together for a short time only, while the cause in which they so passionately believed was in the headlines. Unlikely alliances between vegetarians, pensioners, animal lovers and the unemployed picketed the entrances to docks and harbours to ban the export of veal calves and other livestock. And, on the other side of the water, farmers blockaded ports and barricaded roads to stop the import of the same livestock – for totally different reasons.

In some cases it didn't seem difficult to work out which side was right. The white racist groups who were led by the evil and supported by the gullible remained on the sidelines of politics in most countries, though the good sense of the majority of any population could never be taken for granted. Victims varied. In Germany it was the Turkish immigrants; in France, the Arabs from North Africa; in Britain, the Pakistani and Bangladeshi; in the United States, the Mexicans who crept across the border into California by night, and were hustled back to Mexico by day. In the case of other issues it was harder to see which group of demonstrators had the more moral ground – an end to abortion, or a woman's right to choose?

In the heart of Middle England, women from all over the world besieged the USAF Air Base at Greenham Common, demanding that the cruise missiles which were menacingly paraded there – but never fired – be sent back home. It was one of the best publicized of all protests, both supporters and

Women of all ages and backgrounds came together to protest at the storage of American missiles at Greenham Common. Many brought their children as a symbol of the future they were trying to protect.

Frauen aller Altersgruppen und Gesellschaftsschichten versammelten sich zum Protest vor dem amerikanischen Raketenlager im englischen Greenham Common. Viele von ihnen brachten ihre Kinder mit – als Symbol einer Zukunft, die sie zu schützen versuchten.

Des femmes de tous âges et de toutes origines se sont réunies pour protester contre le stockage de missiles américains à Greenham Common. Un grand nombre d'entre elles ont emmené leurs enfants, symboles du futur qu'elles tentent de protéger.

detractors being fascinated by the mixture of gentleness (decking the perimeter fence in knitted decorations) and forcefulness of the protest (demolishing the same fence a few days later).

French farmers could be regularly relied upon to find an issue that demanded a tractor blockade of Paris, or the burning of consignments of lamb on the highway, or, in one delightfully imaginative protest, the construction of a pyramid of fruit and vegetables but a potato's throw from the more famous Pyramid outside the Louvre.

But they all marched and counter-marched, seeking to ban anything from fox-hunting to nuclear power, from personal persecution to war itself. Total victory was hard to achieve – the best that most could hope for was some small advance, a headline or two, and a picture on a front page.

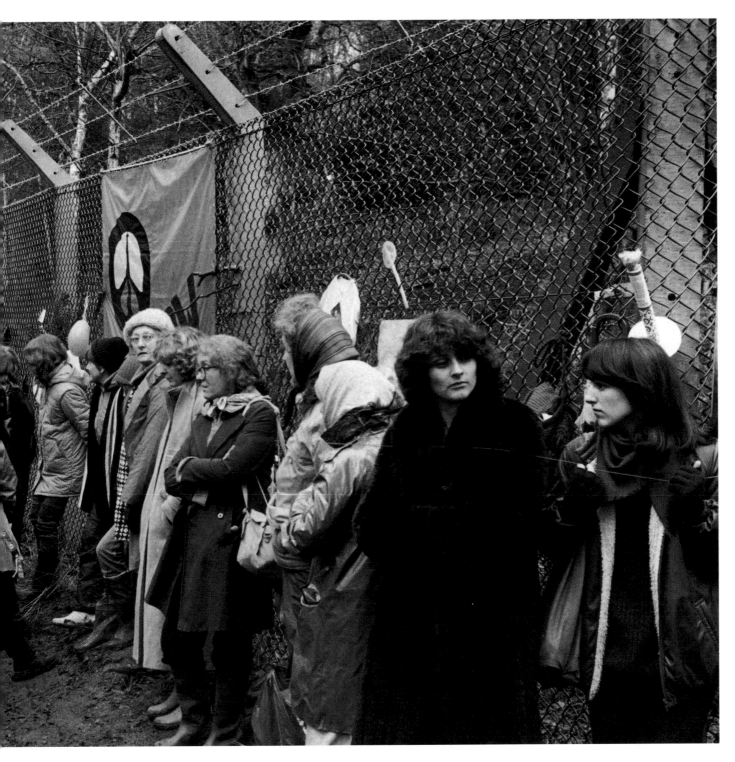

Gründe für politischen Protest waren nach dem Zweiten Weltkrieg nicht schwer zu finden. In der ganzen Welt setzten sich Menschen dafür ein, die Wale zu retten, die Umwelt zu retten, den gesamten Planeten zu retten. Sie überwachten Emissionen von Fabriken, Importe und Exporte, Atommüll, Luftverschmutzung, Lebensmittelzusätze und die Behandlung von Tieren. Sie blockierten die Zufahrten zu militärischen Anlagen, Elektrizitätswerken, Druckereien und Büros. Beeindruckend waren häufig ihre große Zahl, ihre Würde und ihre Entschlossenheit.

Mächtige Armeen bildeten sich, die sich nie bewaffneten. In Europa und den Vereinigten Staaten hofften Menschen, einen Verzicht auf die Bombe – und jeder wußte, welche Bombe gemeint war –, allein durch die große Zahl der Protestler zu erreichen. Vielleicht ist es ihnen ja gelungen,

obwohl es offiziell mit dem Zusammenbruch der Sowjetunion und dem Ende des Kalten Krieges begründet wird, weshalb man endlich zumindest einige Atombomben abgerüstet hat.

Greenpeace verfolgte ein ganz simples Ziel: die Welt zu retten. Sie glaubten an eine friedliche, aber direkte Konfrontation: sich an Parlamentsgebäuden abseilen, in Atombombentestgebiete segeln, sich Harpunisten auf Walfangschiffen ins Visier drängen. Sie schufen sich zahlreiche Freunde, aber auch Feinde, die mächtig und gefährlich genug waren, die *Rainbow Warrior,* eines der Greenpeace-Schiffe, zu versenken und zwei Besatzungsmitglieder zu töten.

Es gab auch Horden Unorganisierter – Menschen, die sich nur für kurze Zeit zusammentaten, solange die Sache, an die sie so leidenschaftlich glaubten, Schlagzeilen machte. Gerade-

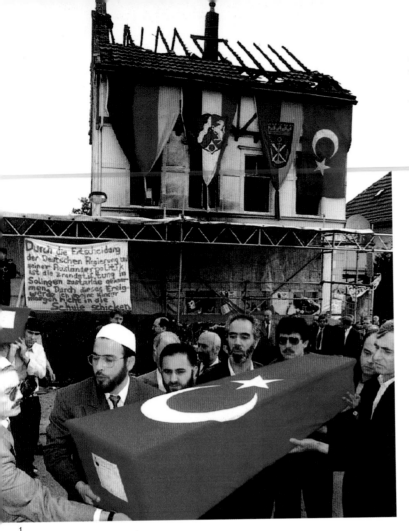

(1) In the small German town of Solingen the funeral takes place of a Turkish immigrant killed in a racially motivated arson attack in June 1993. (2) Another pyramid at the Louvre: fruit and vegetables piled up by French farmers angry at cheap Spanish imports, 1995.

(1) Die Beerdigung einer türkischen Einwandererin, die bei einem Brandanschlag in Solingen ums Leben kam, Juni 1993. (2) Noch eine Pyramide vor dem Louvre – diese hier ist aus Obst und Gemüse, das von französischen Bauern aus Protest gegen billige spanische Importe aufgeschichtet wurde, 1995.

(1) Juin 1993, funérailles d'un émigré turc mort dans un incendie criminel d'origine raciste à Solingen, une petite ville allemande.
(2) 1995, une deuxième pyramide au Louvre: fruits et légumes empilés par des agriculteurs en colère face aux importations meilleur marché en provenance de l'Espagne.

1

zu abenteuerliche Allianzen zwischen Vegetariern, Rentnern, Tierschützern und Arbeitslosen blockierten die Zufahrten zu Docks und Häfen, um den Export von lebenden Kälbern und anderem Vieh zu ächten. Und auf der anderen Seite des Kanals blockierten Bauern Häfen und Straßen, um den Import derselben Tiere zu verhindern – aus völlig anderen Gründen.

In manchen Fällen war unschwer zu erkennen, welche Seite die richtige war. Gruppen weißer Rassisten, die vom Bösen getrieben und von Leichtgläubigen unterstützt wurden, blieben in den meisten Ländern politische Randerscheinungen, obwohl man den gesunden Menschenverstand bei der Mehrheit einer Bevölkerung nie als selbstverständlich voraussetzen konnte. Die Opfer wechselten. In Deutschland waren es türkische Immigranten; in Frankreich Araber aus Nordafrika; in Großbritannien die Einwanderer aus Pakistan und Bangladesch; in den Vereinigten Staaten die Mexikaner, die bei Nacht heimlich über die Grenze nach Kalifornien kamen und am Tag wieder nach Mexiko abgeschoben wurden. In anderen Streitfragen war schwerer auszumachen, welche Gruppe von Demonstranten die besseren moralischen Gründe hatte – die Abtreibungsgegner oder die Befürworter des Rechts der Frauen auf eine eigene Entscheidung?

Im Herzen Mittelenglands belagerten Frauen aus der ganzen Welt den US-Luftwaffenstützpunkt Greenham Common und forderten, die Marschflugkörper abzuziehen, die dort bedrohlich stationiert, aber nie abgeschossen wurden. Dies war die wohl bestpublizierte Protestbewegung, da Befürworter wie Kritiker gleichermaßen von der Mischung aus Sanftheit (selbstgestrickten Dekorationen am Zaun) und

Gewalt (Einreißen desselben Zauns ein paar Tage später) des Protests fasziniert waren.

Bei den französische Bauern konnte man sich darauf verlassen, daß sie regelmäßig einen Anlaß fanden, Paris mit Traktoren zu blockieren, auf der Autobahn Lämmer als Brandopfer zu verbrennen oder in einem wunderbar phantasievollen Protest eine Pyramide aus Obst und Gemüse zu errichten, nur einen Kartoffelwurf von der berühmten Pyramide vor dem Louvre entfernt.

Sie alle marschierten in Demonstrationen und Gegendemonstrationen, um von der Fuchsjagd bis zur Atomenergie, von der persönlichen Verfolgung bis zum Krieg alles zu ächten. Sieg auf der ganzen Linie war kaum zu erreichen – das Beste, was die meisten erhoffen durften, waren ein kleiner Fortschritt, ein oder zwei Schlagzeilen und ein Bild auf einer Titelseite.

Au lendemain de la Seconde guerre mondiale, les grandes causes se multiplient. Partout dans le monde, des gens luttent pour sauver les baleines, l'environnement, voire la planète entière. Ils surveillent les décharges d'usines, les importations et les exportations, les déchets nucléaires, la pollution de l'air, les additifs alimentaires et le traitement des animaux. Ils encerclent des bases militaires et des centrales électriques, des imprimeries et des immeubles de bureaux. Ils impressionnent souvent par leur nombre, leur dignité et leur détermination.

De puissantes armées se forment sans qu'elles aient jamais à prendre les armes. En Europe et aux Etats-Unis, les partisans de la campagne contre la bombe atomique espérèrent remporter la victoire par le seul poids du nombre. Ils y sont peut-être parvenus mais on évoque plutôt l'effondrement de l'Union soviétique et la fin de la Guerre froide pour justifier le désarmement partiel de l'arsenal militaire.

Greenpeace a un seul objectif: sauver la planète. Ils croient en une confrontation à la fois pacifique et directe. Ils descendent en rappel les bâtiments des parlements, naviguent dans les zones d'essais nucléaires, se placent dans la trajectoire

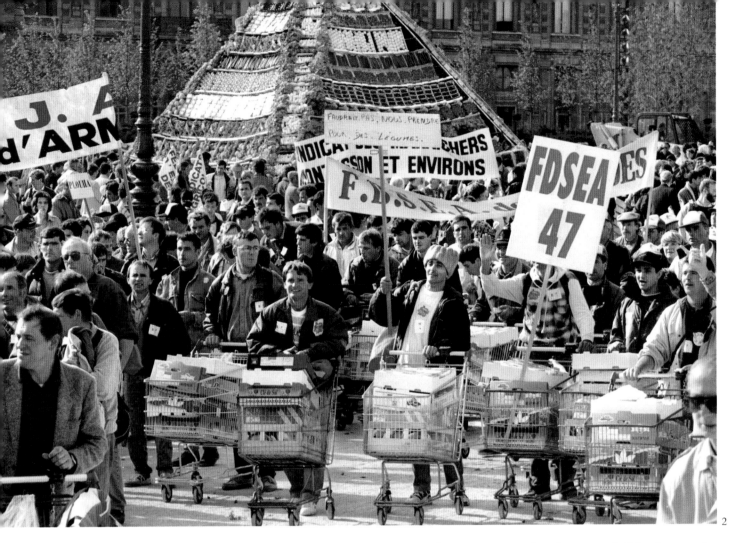

les harponneurs de baleines. Ils se font de nombreux amis mais aussi quelques ennemis, assez puissants et dangereux pour couler le *Rainbow Warrior*, un des bateaux de Greenpeace, et tuer deux membres de leur équipage.

Il y a aussi des hordes d'irréguliers en guenilles, des gens unis par une cause qu'ils défendent avec passion tant que celle-ci fait la une des journaux. Des alliances inattendues sont formées. Végétariens, retraités, défenseurs des animaux et chômeurs barrent ensemble l'accès aux chantiers navals et aux ports pour faire interdire l'exportation de veaux et autres bétails tandis que, de l'autre côté de la Manche et pour des raisons totalement opposées, des fermiers bloquent eux aussi l'entrée des ports et érigent des barricades sur les routes pour empêcher l'importation de ce même bétail.

Dans certains cas, on sait tout de suite qui a raison. Les groupes racistes blancs, qui sont influencés par des thèses malfaisantes et qui sont soutenus par des êtres crédules, restent généralement en marge de la politique, bien que le bon sens de la majorité ne doive jamais être tenu pour acquis. Chaque pays a ses victimes. En Allemagne, ce sont les émigrés turcs, en France, les Arabes d'Afrique du Nord, en Grande-Bretagne, les Pakistanais et les Bengalis. Aux Etats-Unis, ce sont les Mexicains qui traversent de nuit la frontière californienne et qui, le jour, sont reconduits de force au Mexique. Dans le cas de certaines causes, il est parfois plus difficile de décider qui des manifestants est moralement le plus fondé: ceux qui sont contre l'avortement ou ceux qui défendent le droit pour la femme de choisir?

A Greenham Common, dans le centre de l'Angleterre, des femmes venues du monde entier encerclèrent une base de l'armée de l'air américaine et exigé le renvoi des missiles de croisière qui étaient déployés sur le site de manière menaçante même s'ils ne furent jamais mis à feu. Ce fut un des mouvements de protestation les plus médiatiques car partisans comme opposants étaient subjugués par le mélange d'aménité (les barrières de tout le périmètre furent décorées avec des fils de laine) et de détermination des manifestantes (démolition de ces mêmes barrières quelques jours plus tard).

Quant aux agriculteurs français, on peut toujours compter sur eux pour défendre une cause et dresser un barrage de tracteurs aux portes de Paris, brûler des arrivages de veau sur une autoroute ou construire une pyramide de fruits et de légumes à quelques mètres de la célèbre pyramide du Louvre, une des manifestations les plus imaginatives qu'il y ait jamais eu.

Tous auront manifesté et contre-manifesté, que ce soit pour condamner la chasse au renard ou les armes nucléaires, les persécutions individuelles ou la guerre. Il est difficile de remporter une victoire complète. Mais, la plupart d'entre eux auront obtenu davantage que ce qu'ils n'avaient osé espérer: quelques progrès, la une des journaux et une photo en première page.

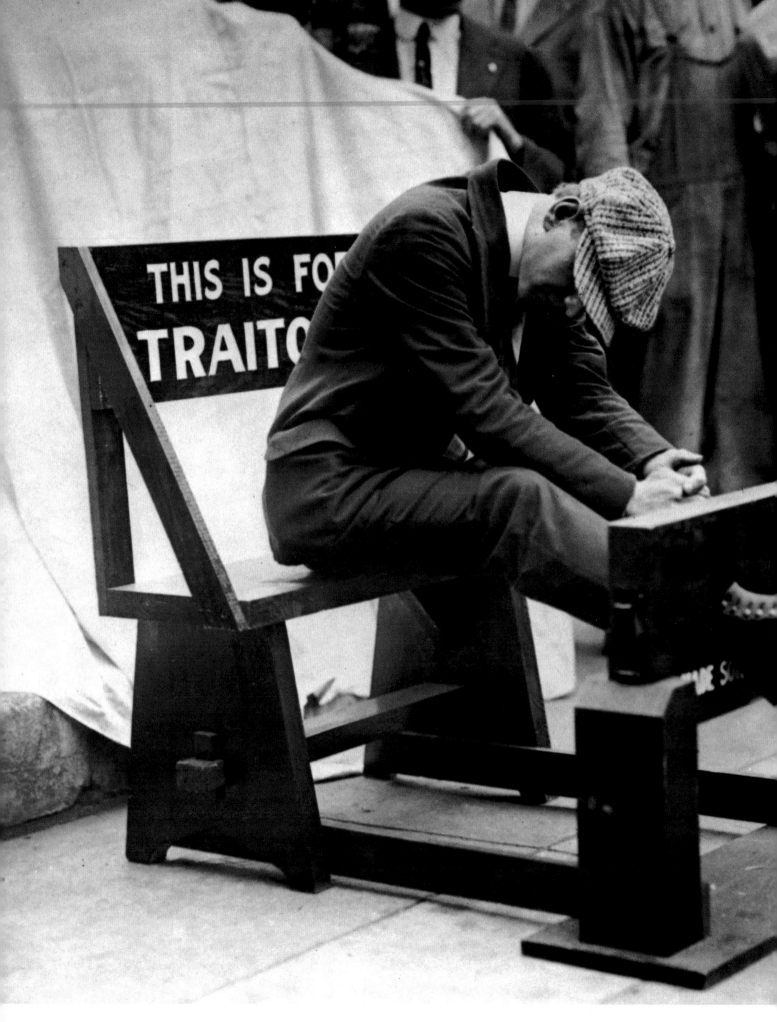

Conscientious Objectors

When conscription was introduced for the first time in Britain and the United States in the First World War, there were many who refused to join the armed forces for religious or moral reasons. They received short shrift from the authorities in both countries. Many were imprisoned; some were herded into labour camps. (1) Some 'Conchies' were publicly humiliated, as in the case of this American objector. (2) Others face the camera at Dyce Camp, Scotland, in the worst days of the fighting on the Western Front.

Wehrdienstverweigerer aus Gewissensgründen

Als im Ersten Weltkrieg zum ersten Mal in Großbritannien und den Vereinigten Staaten die Wehrpflicht eingeführt wurde, gab es viele, die den Wehrdienst aus religiösen oder moralischen Gründen verweigerten. In beiden Ländern machten die Behörden mit ihnen kurzen Prozeß. Viele kamen ins Gefängnis, einige wurden in Arbeitslager gesteckt. (1) »Conchies«, wie man die Wehrdienstverweigerer aus Gewissengründen nannte, wurden öffentlich gedemütigt wie dieser amerikanische Kriegsdienstgegner. (2) Einige schauen in Dyce Camp, Schottland, in die Kamera, während an der Westfront die schlimmsten Kämpfe toben.

Les objecteurs de conscience

La conscription devient obligatoire en Grande-Bretagne et aux Etats-Unis pendant la Première Guerre mondiale. Beaucoup d'hommes refusent de prendre l'uniforme pour des raisons religieuses ou morales et sont traités sans ménagement par les autorités de leur pays. Un grand nombre seront mis en prison, d'autres seront internés dans des camps de travail. (1) Les «Conchies» (objecteurs) sont parfois humiliés publiquement, comme c'est le cas de cet Américain. (2) Au camp de Dyce en Ecosse, ils défient l'objectif tandis que, sur le front occidental, se déroulent les pires combats.

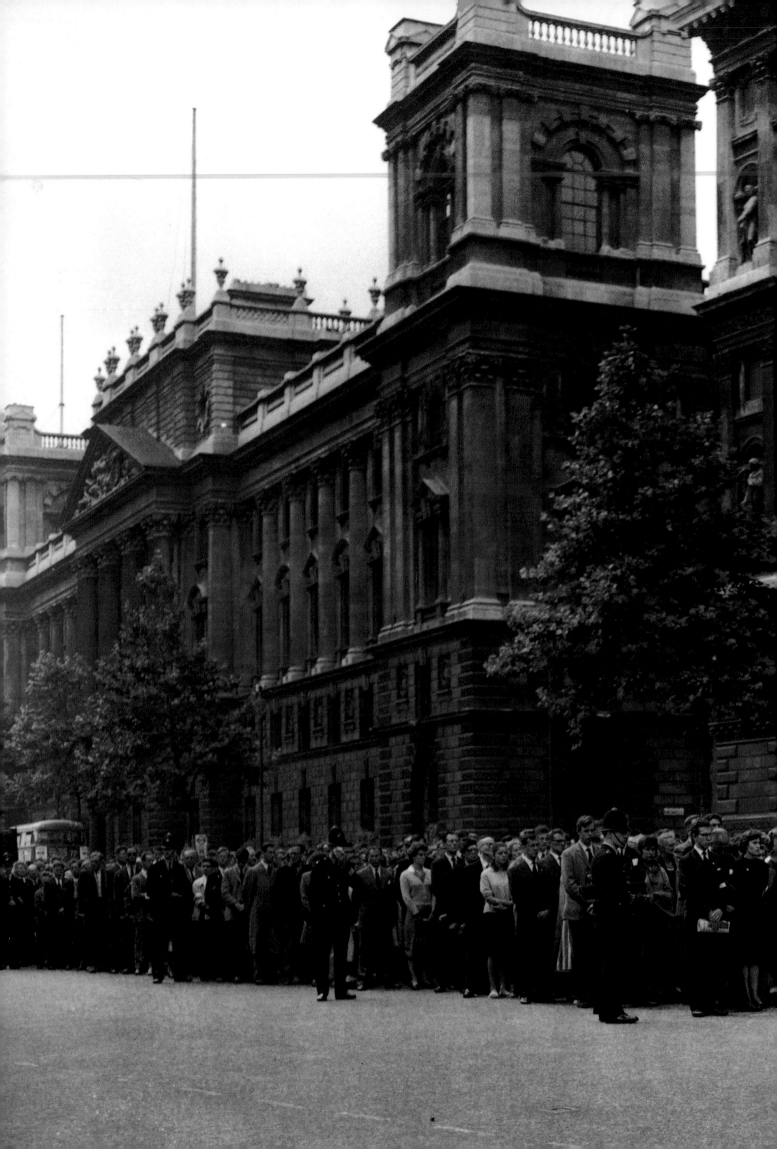

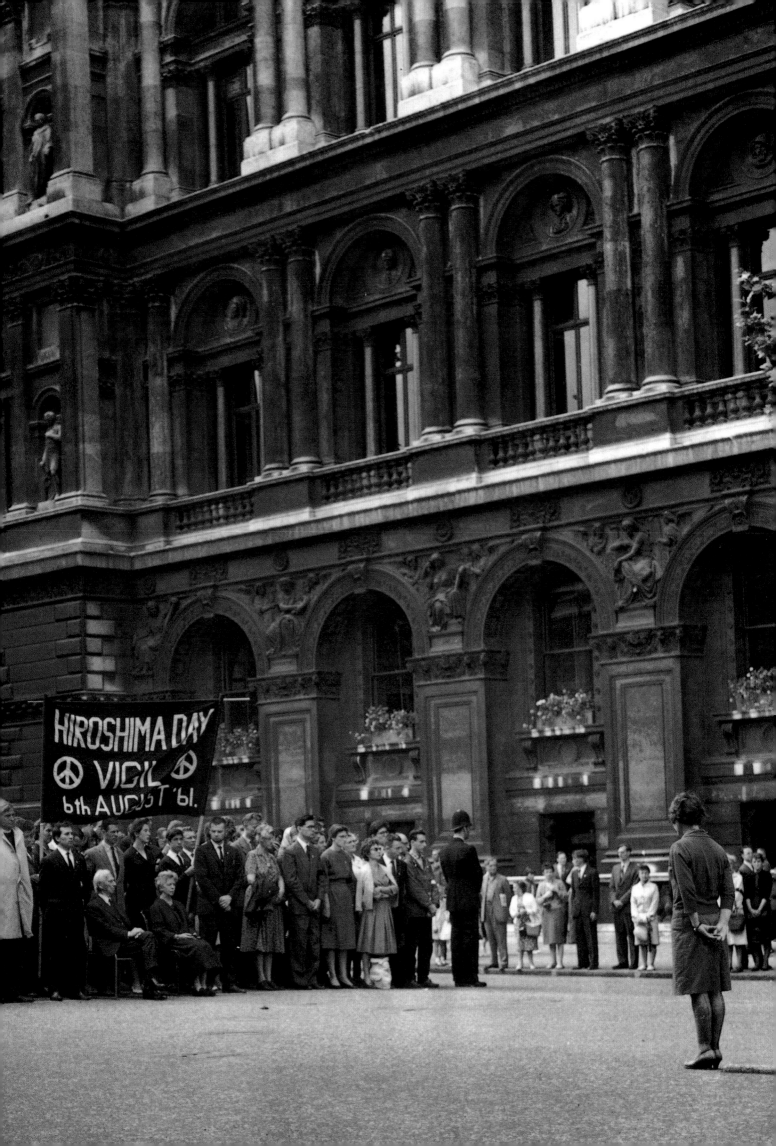

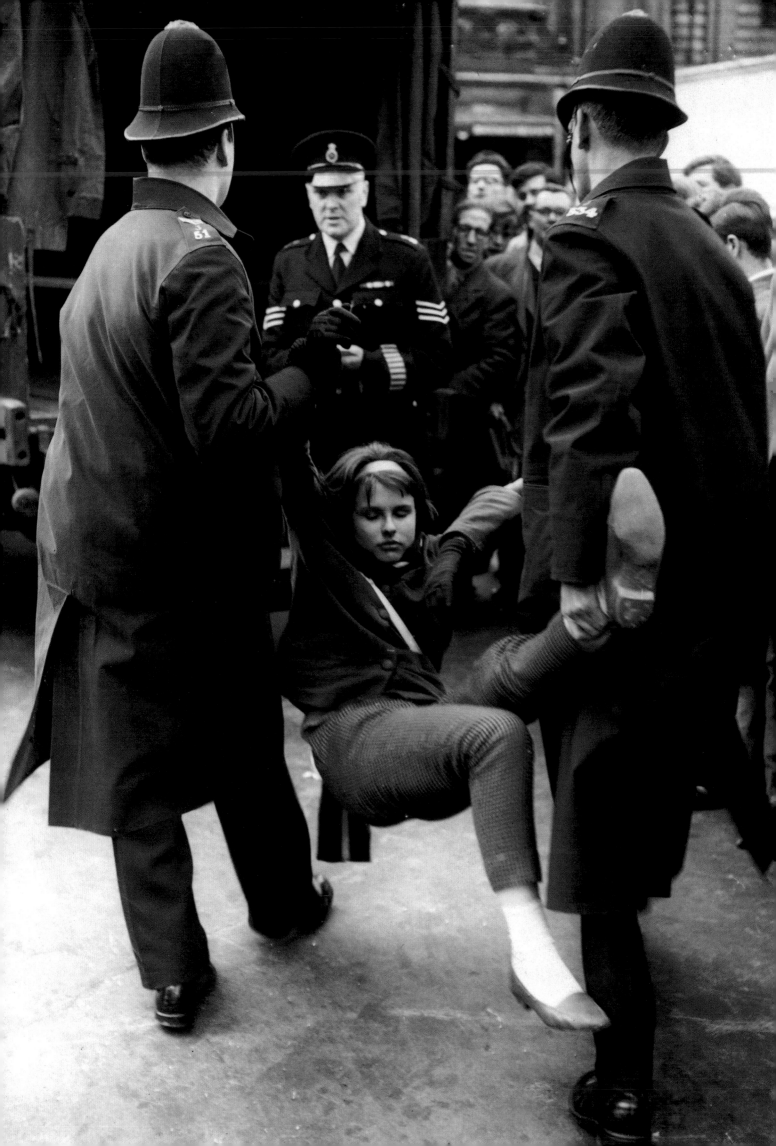

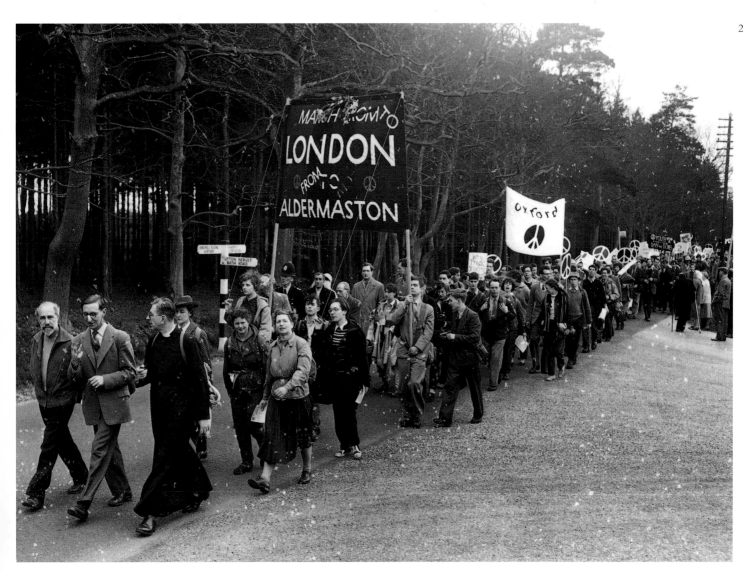

Campaign for Nuclear Disarmament

(Previous page) On the sixteenth anniversary of the Hiroshima bomb, members of CND hold a silent vigil in Whitehall, London. The seated couple are Bertrand Russell and his wife, Edith Finch, later imprisoned. (1) A young woman is removed from a protest in Parliament Square in March 1962. (2) The Government Atomic Research Centre at Aldermaston was for years the destination of annual CND marches. (3) The focus for the largest rallies was Trafalgar Square.

Demonstrationen für nukleare Abrüstung

(Vorige Doppelseite) Am 16. Jahrestag des Bombenabwurfs auf Hiroshima versammeln sich Mitglieder der englischen Anti-Atomwaffen-Bewegung CND zu einer schweigenden Demonstration in Whitehall, London. Das sitzende Paar sind Bertrand Russell und seine Frau Edith Finch, die später festgenommen wurde. (1) Bei einer Demonstration vor dem englischen Parlament wird eine junge Frau weggetragen, März 1962. (2) Das britische Atomforschungszentrum Aldermaston war jahrelang Zielpunkt des jährlichen CND-Marsches. (3) Der Trafalgar Square – Ort der größten Protestversammlungen.

La campagne pour le désarment nucléaire

(Page précédente) A l'occasion du seizième anniversaire de la bombe d'Hiroshima, des partisans de la CDN manifestent en silence à Whitehall, Londres. Le couple assis par terre est Bertrand Russell et sa femme, Edith Finch, qui sera par la suite emprisonnée. (1) Mars 1962 à Londres, jeune femme évacuée par la police lors d'une manifestation à Parliament Square. (2) Le Centre gouvernemental pour la recherche atomique d'Aldermaston sera pendant des années le lieu de rassemblement de la manifestation annuelle de la CDN. (3) Trafalgar Square est la place de ralliement de toutes les grandes manifestations.

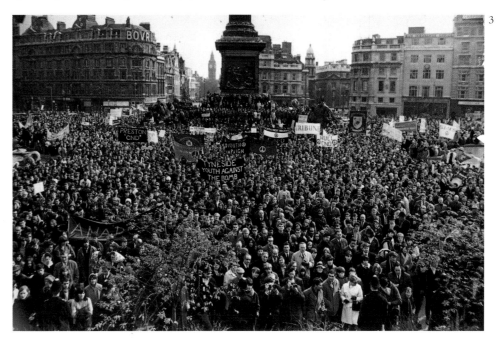

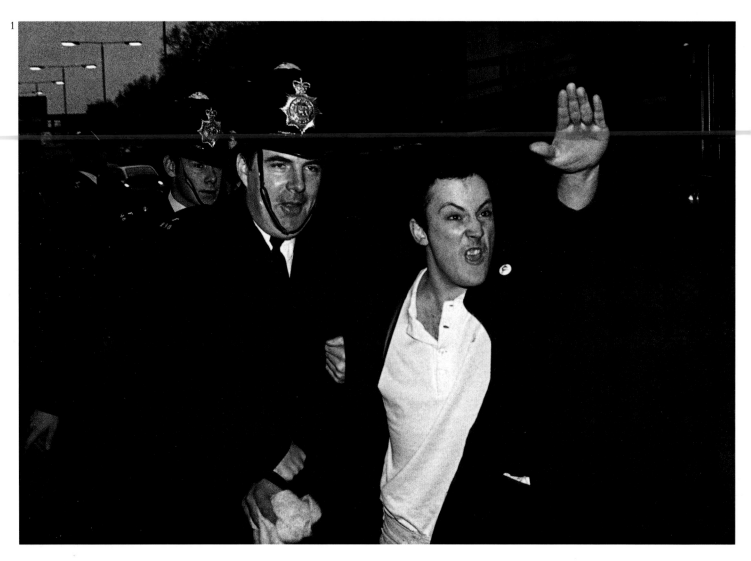

Right-wing Extremists

Not all protest was honourable. Whipped up by maverick politicians and right-wing newspapers – both of whom should have known better – there were those in many countries who were out-and-out racists. In Britain there were many such groups, some short-lived, all short-tempered, such as (1) the British Movement, (2) The National Front, and (3) the White Defence League. The aim was always the same, however – to preach violence and hatred towards black immigrants.

Rechtsradikale Extremisten

Nicht jeder Protest war ehrenwert. In vielen Ländern kam es zu Demonstrationen radikaler Rassisten – aufgepeitscht von politischen Außenseitern und rechtsextremen Zeitungen, die es eigentlich besser wissen mußten. England kannte einige solcher Gruppen – manche kurzlebig, alle voller Haß – wie die (1) *British Movement,* (2) die *National Front* oder (3) die *White Defence League.* Das Ziel war stets das gleiche – Gewalt und Haß gegen schwarze Einwanderer.

L'extrême droite

Toutes les manifestations ne sont pas honorables. Partout ou presque, des racistes fanatiques sont excités par des politiciens marginaux et des journaux d'extrême droite, qui auraient pourtant mieux à faire ailleurs. La Grande-Bretagne compte un grand nombre de ces groupes, certains ne durent pas mais tous sont violents, comme (1) Le Mouvement britannique, (2) Le Front National et (3) La Ligue pour la défense des blancs. Les intentions sont toujours les mêmes: prôner la violence et la haine à l'encontre des immigrés noirs.

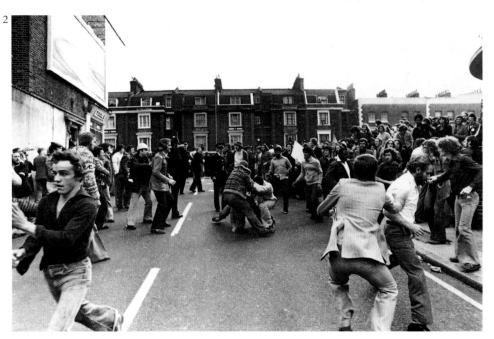

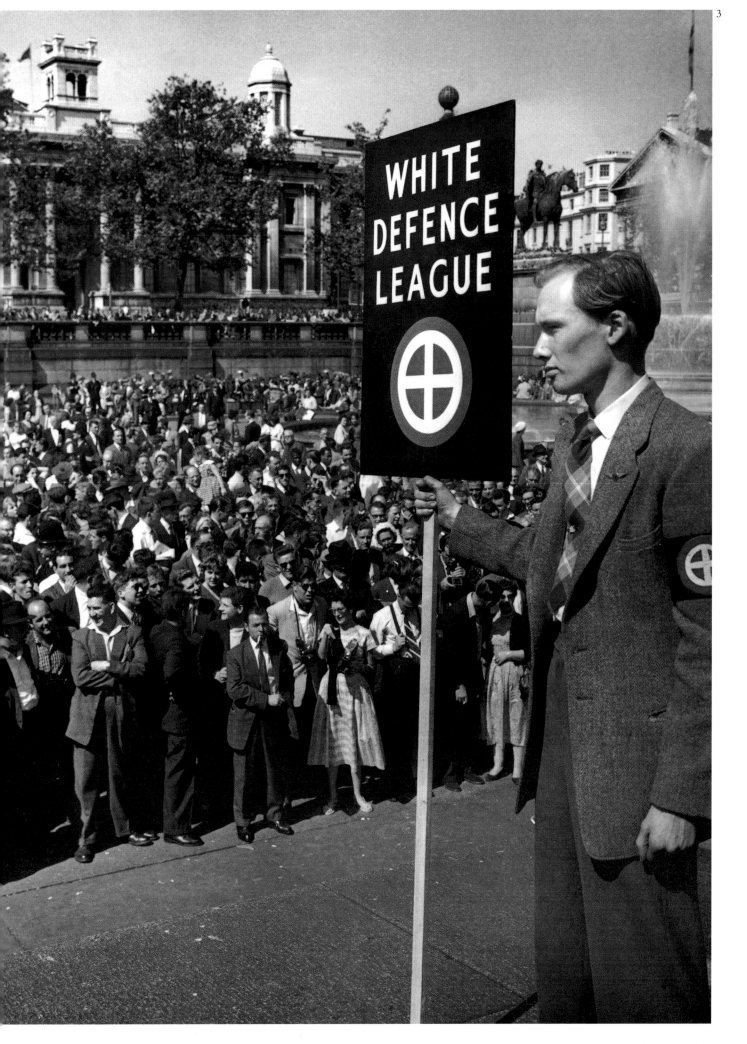

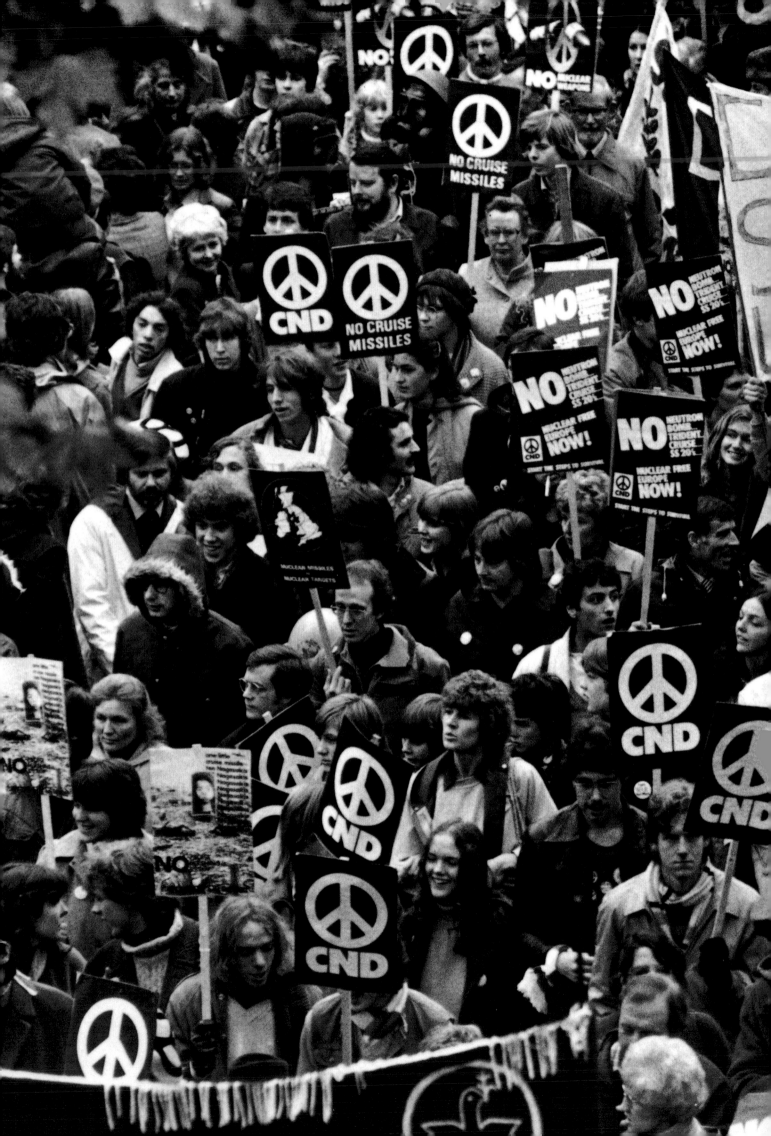

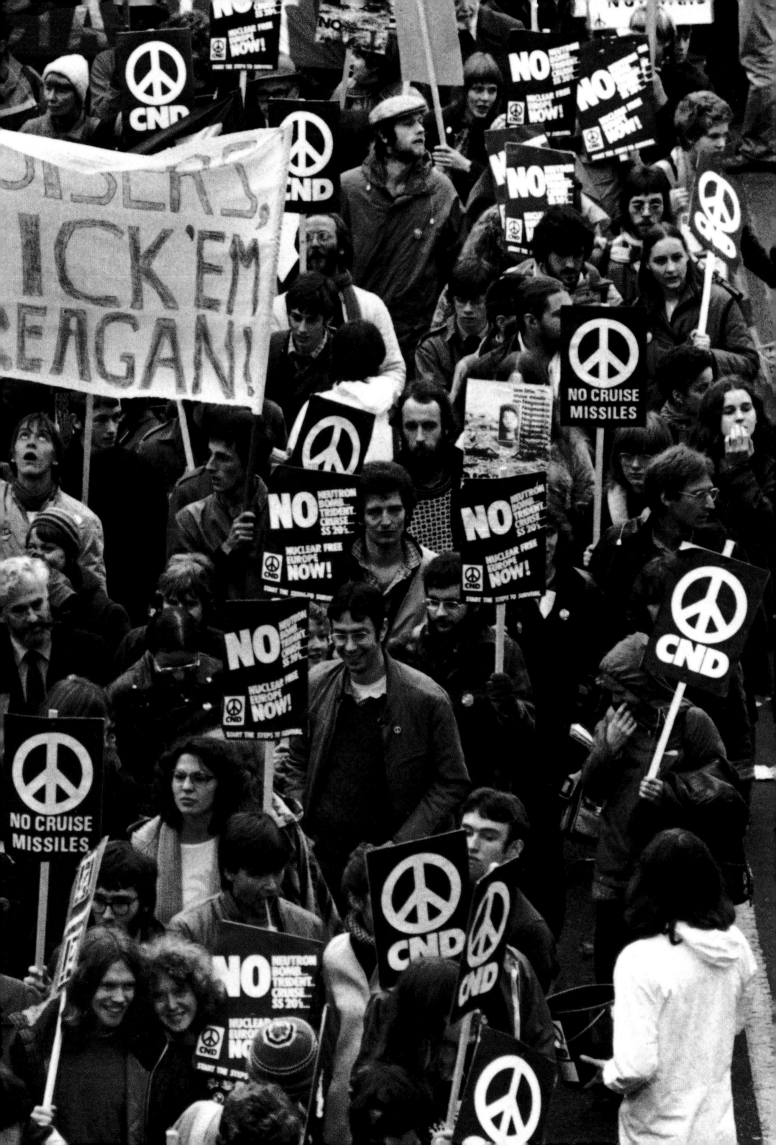

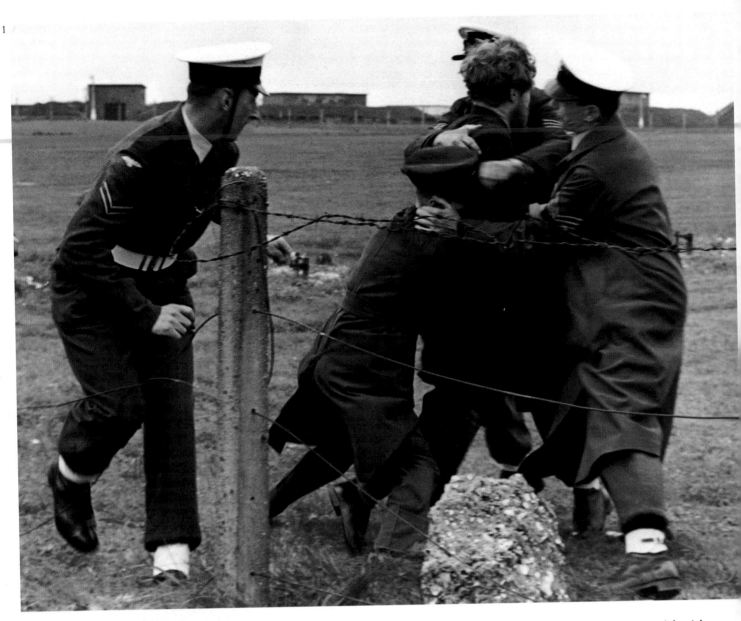

Anti-nuclear Protest

(Previous page) Again CND supporters gather in London – this time in 1987. For every nuclear bomb or missile in Britain there were always a thousand protesters. (1) In the 1960s the wires were easily cut – as at the RAF V-bomber base at Marham, Norfolk – or (2) scaled – as at Porton Down, the Government's biological warfare research centre. By the 1980s the protesters were more determined. (3) The most famous invasions were at the USAF cruise missile base at Greenham Common.

Anti-Atom-Protest

(Vorige Doppelseite) Wieder einmal versammeln sich CND-Anhänger in London – diesmal 1987. Auf jede Atombombe oder -rakete in England kamen immer etwa tausend Demonstranten. (1) In den sechziger Jahren schnitt man einfach Drahtzäune durch – wie auf dem britischen Luftwaffenstützpunkt von Marham, Norfolk – oder (2) kletterte darüber – wie in Porton Down, dem englischen Forschungszentrum für biologische Kriegsführung. Seit den achtziger Jahren verliefen die Proteste zielgerichteter. (3) Die berühmtesten »Invasionen« fanden auf dem amerikanischen Cruise-Missile-Stützpunkt Greenham Common statt.

Manfestation anti-nucléaire

(Page précédente) En 1987, des partisans de la CDN se réunissent une nouvelle fois à Londres. Plusieurs milliers de manifestants s réunissent chaque fois qu'une bombe ou missile nucléaire est déployée en Grande-Bretagne. (1) Dans les années 60, les fils de fer barbelés sont facilement sectionnés – comme sur la base des bombes V de l'armée de l'air britannique de Marham, dans le Norfolk – ou (2) escaladés – comme à Porto Down, Centre gouvernemental de recherch en armement biologique. Dans les années 80 les manifestants se montrent encore plus déterminés. (3) L'occupation la plus célèbre est celle de la base américaine de missiles de croisière, située à Greenham Common dans le centre de l'Angleterre.

Greenpeace

With a mixture of efficiency, imagination and courage, Greenpeace captured headlines in the 1980s and 1990s and made powerful enemies. (1) The *Rainbow Warrior* sinks in Auckland Harbour, New Zealand, April 1985, mined by French secret service agents after Greenpeace had announced their intention to disrupt French nuclear tests. (2) A demonstrator gives an optimistic 'Victory' sign after spraying 'Nukes, No' on a crane at Rokkasho, Japan. (3) French commandos prepare to board the new *Rainbow Warrior* inside Mururoa territorial waters in September 1995.

Greenpeace

Mit einer Mischung aus Effizienz, Phantasie und Mut machte Greenpeace in den achtziger und neunziger Jahren häufig Schlagzeilen in aller Welt und schuf sich mächtige Feinde. (1) Das Greenpeace-Schiff *Rainbow Warrior* sinkt im Hafen von Auckland, Neuseeland, April 1985. Französische Geheimdienstagenten hatten das Schiff vermint, nachdem Greenpeace öffentlich verkündet hatte, französische Atomtests im Pazifik stören zu wollen. (2) Ein Demon-strant macht optimistisch das »Victory«-Zeichen, nachdem er »Nukes, No« (Atomwaffen, Nein) in Rokkasho, Japan, auf einen Kran gesprüht hat. (3) Im September 1995 bereiten sich französische Kommandos darauf vor, die neue *Rainbow Warrior* in den Hoheitsgewässern von Mururoa zu entern.

Greenpeace

Dans les années 80 et 90, Greenpeace fait la une des journaux en alliant efficacité, imagination et courage et se fait des ennemis puissants. (1) Avril 1985, le *Rainbow Warrior* est coulé dans le port d'Auckland en Nouvelle-Zélande par les agents des servives secrets français. Greenpeace avait annoncé son intention d'entraver le déroulement des essais nucléaires français. (2) Un manifestant fait le V de la victoire après avoir sprayé «Non au nucléaire» sur une grue de Rokkasho au Japon. (3) Des commandos français se préparent à aborder le nouveau *Rainbow Warrior* qui a pénétré dans les eaux territoriales de Mururoa en septembre 1995.

The popular and traditional conception of the British 'bobby' was for a long time that of a cheerful, smiling and essentially unarmed servant of the people. It was never entirely accurate, but this line of London police and the crowds they held back in July 1922 seem happy enough with their respective roles.

Die beliebte und traditionelle Vorstellung vom britischen »Bobby« war lange Jahre die eines fröhlichen, lächelnden und immer unbewaffneten Dieners der Öffentlichkeit. Dieses Bild entsprach zwar nie völlig den Tatsachen, aber die hier fotografierte Reihe der Londoner Polizei und die von ihnen zurückgehaltenen Menschenmassen scheinen mit ihrer jeweiligen Rolle durchaus zufrieden zu sein.

L'image populaire et traditionnelle du «Bobby» anglais fut pendant longtemps celle d'un serviteur de l'Etat sympathique, souriant et, surtout, non armé. Cette image n'a jamais tout à fait correspondu à la réalité mais, ici en juillet 1922, chacun semble relativement satisfait de son rôle, d'un côté une rangée de policiers londoniens, de l'autre, la foule retenue en arrière.

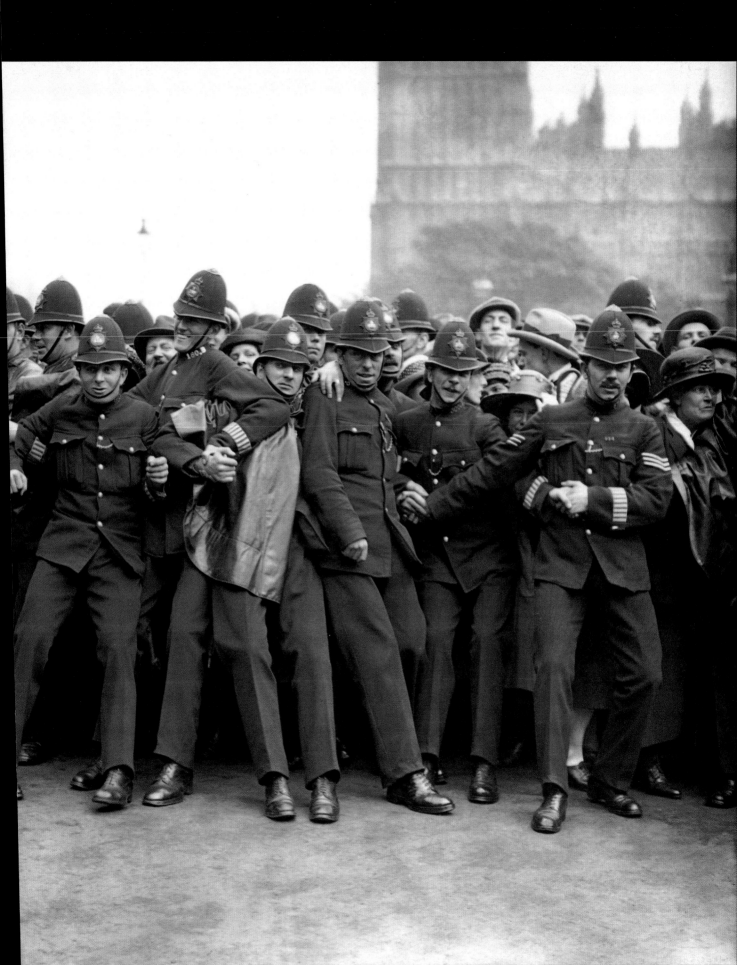

Policing the Protests

Only in fiction does it seem easy for any regime to keep control of a country. Police, military, National Guard or state troopers will almost certainly be better armed than any demonstrators, but the will to subdue a people is seldom as strong or as enduring as the will to protest. Battles may be won by troops firing tear gas or rubber bullets, but political wars are won by citizens carrying banners, shouting slogans, insisting on the right to be heard.

Whether they have been democratically elected or have forced their way to power, all governments believe that the process by which they rule should be unforced, unhurried and the product of their own free will. Initially it makes no difference to them if this right to rule is challenged by a terrorist bomb or by the mass of the people. The law decrees that the power of the state should not be opposed. If it is, order has to be restored by the forces of control.

But there will always be those on either side for whom confrontation is an essential part of the struggle, and who believe blood must be shed to validate a cause. To those in control, these people are 'troublemakers', or worse – unless, of course, they happen themselves to be members of the forces of law and order. To protesters, these people are heroes – unless, of course, they happen to be members of the forces of law and order. Perhaps it is fairer to regard law enforcers as neither heroes nor villains, but simply the paid agents of the state who are called upon to do some of its nastiest work: opposing, policing and sometimes attacking their civilian colleagues.

As time goes by, the forces of control are themselves increasingly in the firing line, caught by the camera as they patiently endure provocation or whirl into action, batons flailing, tempers flaring. Perhaps the camera itself has become a weapon of control. When cameras captured the events of Bloody Sunday in Derry in 1972, the pictures they took were flashed round the world. The forces of control, it seemed, had lost their own self-control. Something had to be done. Many would argue that those responsible for the killings were never brought to book: others would argue that, for a while at least, troops thought twice before pulling the trigger.

The list of killings and massacres that have stemmed from civil conflict is global and horrifyingly long: Hankow, Sharpeville, Peking, Kent State, Belfast, Prague, Budapest, Los Angeles, Santiago, Dublin, Berlin... the list goes on and on. No matter where in the world individuals wish to make their protest, there have always been huge forces ranged against them: not just armies and police forces, but secret bodies such as the American FBI and CIA, the Russian KGB and Cheka, the British SPG and MI6, and the French CRS.

At the Electric Auto-lite plant in Toledo, Ohio, in May 1934, strikers rejected a peace proposal amid scenes of violence when a National Guard officer and a civilian were wounded.

Vor der Electric-Auto-lite-Fabrik in Toledo, Ohio, weisen die Arbeiter ein Friedensangebot zurück, da bei gewalt-tätigen Ausschreitungen ein Offizier der Natio-nalgarde und ein Zivilist verwundet wurden, Mai 1934.

Mai 1934, à l'usine Electric Auto-lite de Toledo dans l'Etat de l'Ohio, rejet d'une proposition de paix par les grévistes alors qu'ont lieu des scènes de violence: un officier de la Garde Nationale et un civil seront blessés.

Telephones are tapped, underground groups infiltrated hidden cameras see and record every move. At the same time life becomes more complicated for those in control. The Czar's police never had to deal with hijacked jumbo jets motorway protesters, anti-abortion riots, hunt saboteurs football hooligans, or opponents of nuclear power. There may be moments of muttered gratitude from authority to those who have quelled a riot, but few people show any thanks to police or troops for keeping control. We are all much more concerned with finding culprits – whichever side they may be on.

There have been exceptions. When a lone policeman on horseback calmed the crowd at Wembley in 1923, a newspaper described him the next day as 'energetic, undaunted resourceful, at once decisive and good-tempered... whereve

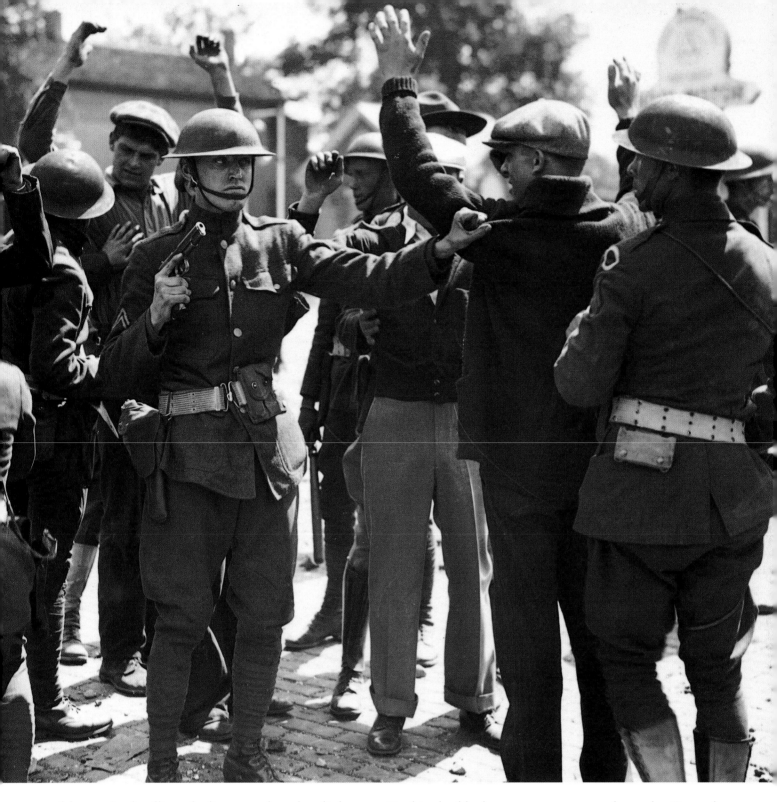

e appeared he received willing obedience, and made a little
asis of order in the general chaos'. It was a hard act to follow.
But,' the paper continued, 'he could not be everywhere at
nce…'

Perhaps there is something to learn from the story of
General Dyer, commander of the British troops in the
Holy City of Amritsar, India, in 1919. A large crowd gathered
ne April night in the Jallianwalla Bagh, an enclosed area
n that city. They were unarmed, but angry, whipped up in
pirit by Sikh nationalists who wished an end to British rule.
Dyer's troops fired into the crowd from point-blank range,
nd continued to fire for six minutes. At the end of that time
79 protesters had been killed, and 1500 wounded. To the
ikhs, Dyer was evil itself. To British imperialists, he was a
ero.

On his deathbed, some twenty years later, the General
murmured that all he wanted was to die 'and to know from my
Maker whether I did right or wrong'.

It is the perennial problem for those in control.

Nur in der Dichtung fällt es einem Staat leicht, ein Land
unter Kontrolle zu halten. Polizei, Militär, National-
garde oder Staatspolizei sind sicherlich besser bewaffnet als
alle Demonstranten, aber der Wille, ein Volk zu bändigen, ist
nur selten so stark oder so ausdauernd wie der Wille zum
Protest. Truppen mögen Kämpfe gewinnen, indem sie
Tränengas werfen oder Gummigeschosse abfeuern, aber
politische Kriege werden von Bürgern gewonnen, die
Transparente tragen, Parolen rufen und auf dem Recht
bestehen, gehört zu werden.

Ob demokratisch gewählt oder gewaltsam an die Macht gekommen: Alle Regierungen glauben, daß ihr Regieren ohne Zwang, ohne Drängen und als Produkt ihres freien Willens sich vollziehen sollte. Anfangs macht es für sie keinen Unterschied, ob dieses Recht zu regieren von einer terroristischen Bombe oder der Masse der Bevölkerung in Frage gestellt wird. Das Gesetz bestimmt, daß der Staatsgewalt kein Widerstand zu leisten sei. Falls dies doch geschieht, muß man die Ordnung mit Kontrollkräften wiederherstellen.

Dabei wird es auf beiden Seiten immer solche geben, für die Konfrontation ein wesentlicher Teil des Kampfes bedeutet und die glauben, es müsse Blut vergossen werden, um einer Sache Geltung zu verschaffen. Für die Machthaber sind solche Leute »Unruhestifter« oder Schlimmeres – wenn diese selbst nicht gerade zu den Gesetzes- und Ordnungshütern gehören. Und für die Demonstranten sind sie »Helden« - wenn diese nicht gerade zu den Gesetzes- und Ordnungshütern gehören. Angemessener wäre es vielleicht, die Gesetzeshüter weder als Helden noch als Bösewichte zu sehen, sondern schlicht als bezahlte Agenten des Staates, die dazu aufgerufen sind, einen Teil seiner schmutzigsten Aufgaben zu erledigen: nämlich ihren zivilen Kollegen Widerstand entgegenzusetzen, sie in Schach zu halten und manchmal auch anzugreifen.

Im Laufe der Zeit sind die Ordnungskräfte selbst zunehmend in die Schußlinie geraten, eingefangen von der Kamera, während sie geduldig Provokationen über sich ergehen lassen oder mit wirbelnden Schlagstöcken und hitzigen Gemütern in Aktion treten. Vielleicht ist nun die Kamera zu einem Kontrollinstrument geworden. Als Kameras 1972 die Ereignisse des »Blutigen Sonntags« in Derry festhielten, gingen die Aufnahmen in Windeseile um die ganze Welt. Die Kontrollkräfte hatten, wie es schien, ihre Selbstbeherrschung verloren. Es mußte etwas geschehen. Viele behaupteten, die Verantwortlichen des Massakers würden nie zur Rechenschaft gezogen, andere meinten, die Truppen würden es sich zumindest eine Zeitlang zweimal überlegen, ehe sie den Abzug betätigten.

Die Liste der Massaker und Todesopfer, die aus zivilen Konflikten hervorgingen, umfaßt die ganze Welt und ist erschreckend lang: Hankow, Sharpeville, Peking, Kent State, Belfast, Prag, Budapest, Los Angeles, Santiago, Dublin, Berlin … sie ließe sich noch endlos weiterführen. Ganz gleich, wo auf der Welt einzelne protestieren, immer gibt es ein gewaltiges Aufgebot, das gegen sie antritt: nicht nur Armeen und Polizeikräfte, sondern auch Geheimdienste wie das amerikanische FBI und der CIA, der russische KGB und die Tscheka, der britische SPG und das MI6 oder das französische CRS. Telefone werden angezapft, Untergrundgruppen infiltriert, versteckte Kameras beobachten jede Bewegung und halten sie fest.

Gleichzeitig gestaltet sich das Leben für die Herrschenden schwieriger. Die Polizei des Zaren mußte sich nie mit entführten Jumbo-Jets, Autobahnblockaden, Anti-Abtreibungs-Unruhen, Jagdsaboteuren, Fußballrowdies oder Atomkraftgegnern herumschlagen. Es mag durchaus einen gemurmelten Dank seitens der Obrigkeit für jene geben, die Unruhen erstickt haben, doch in der Bevölkerung zeigen sich nur wenige dankbar, daß Polizei oder Streitkräfte die Ordnung erhalten. Wir alle sind wesentlich mehr damit beschäftigt Schuldige zu finden – auf welcher Seite sie auch stehen mögen.

Es gab Ausnahmen. Als ein einzelner berittener Polizist 1923 die Menge im Wembley-Stadion beruhigte, beschrieb ihn am nächsten Tag eine Zeitung als »energisch, unerschrocken, findig, entschlossen und zugleich gutmütig… wo immer er auftauchte, folgte man ihm bereitwillig, und er schuf eine kleine Oase der Ruhe im allgemeinen Chaos.« Das ist schwer nachzuvollziehen. »Aber«, so fuhr der Artikel fort, »er konnte nicht überall gleichzeitig sein…«.

Vielleicht läßt sich ja aus der Geschichte von General Dyer etwas lernen, dem Kommandanten der britischen Truppen in der heiligen Stadt Amritsar, Indien, 1919. Eines Abends im April sammelte sich eine große Menschenmenge in Jallianwalla Bagh, einem eingefriedeten Bezirk der Stadt. Sie waren unbewaffnet, aber wütend, aufgeputscht von nationalistischen Sikhs, die der britischen Herrschaft ein Ende setzen wollten. Dyers Truppen feuerten sechs Minuten lang blindlings in die Menge, töteten 379 Demonstranten und verwundeten 1500. Für die Sikhs war Dyer der Teufel in Person. Für die britischen Imperialisten war er ein Held.

Als der General gut zwanzig Jahre später im Sterben lag, murmelte er, er wolle nur noch sterben und »von meinem Schöpfer wissen, ob ich richtig oder falsch gehandelt habe«.

Das ist das immerwährende Problem der Herrschenden.

C'est seulement dans les romans qu'il semble facile pour un régime de garder un pays sous contrôle. La police, la gendarmerie, la garde nationale ou l'armée seront en principe toujours mieux armées que n'importe quel manifestant, mais la volonté d'assujettir un peuple est rarement aussi forte ou aussi tenace que la volonté de manifester. Des batailles peuvent être gagnées par des soldats tirant des grenades lacrymogènes ou des balles en caoutchouc mais les guerres politiques sont gagnées par des citoyens portant des bannières, criant des slogans, revendiquant leur droit à se faire entendre.

Qu'ils aient été élus démocratiquement ou qu'ils aient forcé leur accès au pouvoir, tous les gouvernements admettent que l'exercice du pouvoir devrait être accompli sans recours à la force, sans précipitation et résulter de leur propre libre arbitre. Que le pouvoir soit défié par une bombe terroriste ou par une foule ne devrait, en principe, faire aucune différence. La loi décrète que l'autorité de l'Etat ne peut être contestée et que, si elle l'est, l'ordre doit être restauré par les forces dont dispose l'Etat.

Mais il y aura toujours, dans chaque camp, des hommes pour penser que la confrontation est un élément essentiel de la lutte et que le sang doit couler pour légitimer une cause. Pour le pouvoir, ces gens-là sont des «provocateurs» ou pire encore tant qu'ils ne sont pas eux-mêmes membres d'un service chargé de faire respecter l'ordre et la loi. Pour les manifestants

The heavy-handed tactics of the police towards the local community were thought to have been the impetus for the riots which broke out in Toxteth, Liverpool, in July 1981.

Das harte Vorgehen der Polizei gegen die Bewohner galt als Auslöser für die Unruhen, die im Juli 1981 im Liverpooler Viertel Toxteth ausbrachen.

Juillet 1981, l'attitude répressive de la police envers la communauté locale est certainement à l'origine des émeutes qui ont éclaté dans le quartier de Toxteth à Liverpool.

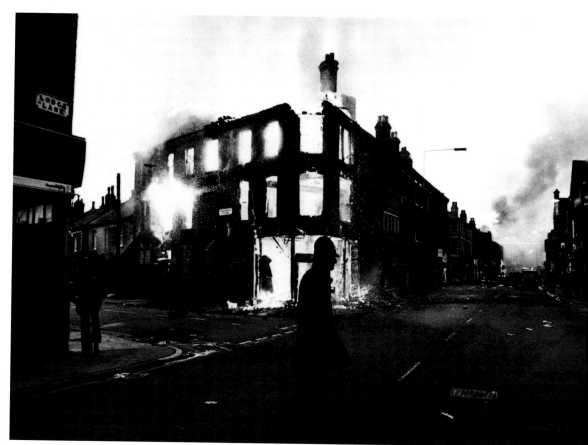

ces provocateurs sont des héros sauf s'ils sont des représentants de l'ordre et de la loi. Peut-être serait-il plus équitable de considérer les représentants de la loi non pas comme des héros ou des traîtres mais simplement comme des agents employés et payés par l'Etat, appelés à accomplir l'une des plus difficiles tâches qu'il soit: faire opposition, maintenir l'ordre et, parfois, charger ses camarades en civil.

A l'heure actuelle, les forces de l'ordre sont de plus en plus dans la ligne de mire, prises dans l'œil de l'objectif, que ce soit quand elles endurent avec patience les provocations ou qu'elles passent à l'action, matraques en l'air et nerfs à bout. L'objectif est peut-être devenu une arme de surveillance. En 1972 à Derry, les événements du Dimanche sanglant ont été photographiés et ces images ont fait le tour du monde. Les forces de l'ordre semblaient avoir perdu tout leur sang-froid. Il fallait en témoigner. Beaucoup affirmeront que les responsables du massacre n'ont jamais eu à rendre des comptes. Pour d'autres, pendant un certain temps au moins, les soldats ont réfléchi à deux fois avant d'appuyer sur la gachette.

La liste des tueries et massacres causés par des guerres civiles couvre la terre entière. Elle est horriblement longue: Hankow, Sharpeville, Pékin, Kent State, Belfast, Prague, Budapest, Los Angeles, Santiago, Dublin, Berlin... et interminable. Peu importe où dans le monde, chaque fois que des individus ont manifesté, il y a toujours eu des forces très importantes pour se dresser contre eux. Pas seulement des armées et des forces de police, mais aussi des agents secrets comme le FBI et la CIA américains, le KGB et la Tchéka russes, le SPG et le M16 britanniques et la DGSE ou les Renseignements Généraux français. Des téléphones sont mis sur écoute et des groupes clandestins infiltrés. Des caméras cachées épient et enregistrent tout ce qui bouge. Dans un même temps, la tâche des gouvernements devient plus difficile. La police du Tsar n'a jamais été confrontée à des détournements d'avion, des émeutes anti-avortements, des anti-chasseurs, des supporters de football déchaînés ou des opposants à l'énergie nucléaire. Rares sont ceux qui remercient la police ou l'armée pour maintenir l'ordre. Notre plus grand souci est toujours de pouvoir désigner des coupables, peu importe de quel côté ils se trouvent.

Il y a des exceptions. En 1923, un policier à cheval parvint à calmer la foule du stade de Wembley et, le lendemain, un journal en parla en ces termes: «Energique, sûr de lui, ingénieux, à la fois déterminé et jovial... peu importe où il allait, la foule lui obéissait naturellement et il sut créer un petit havre de paix dans le chaos général qui régnait». C'était une tâche difficile à accomplir. «Mais», poursuit le journal, «il ne pouvait pas être partout à la fois... »

Un soir d'avril 1919, une grande foule se réunit à Jallianwalla Bagh, un lieu fermé dans la ville. Ils avaient pour seules armes leur colère, les esprits ayant été échauffés par des Sikhs nationalistes qui réclamaient la fin de l'autorité britannique. Les soldats de Dyer tirèrent à bout portant sur la foule une première fois puis à nouveau pendant six minutes encore. A la fin de l'assaut, on compta 379 victimes parmi les manifestants et 1 500 blessés. Aux yeux des Sikhs, Dyer incarne le diable en personne. Pour les impérialistes britanniques, il fut un héros.

Sur son lit de mort, quelque vingt ans plus tard, le général murmura que tout ce qu'il souhaitait était la mort «savoir si, selon le Créateur, j'ai commis le bien ou le mal».

C'est l'éternel problème de ceux qui nous gouvernent.

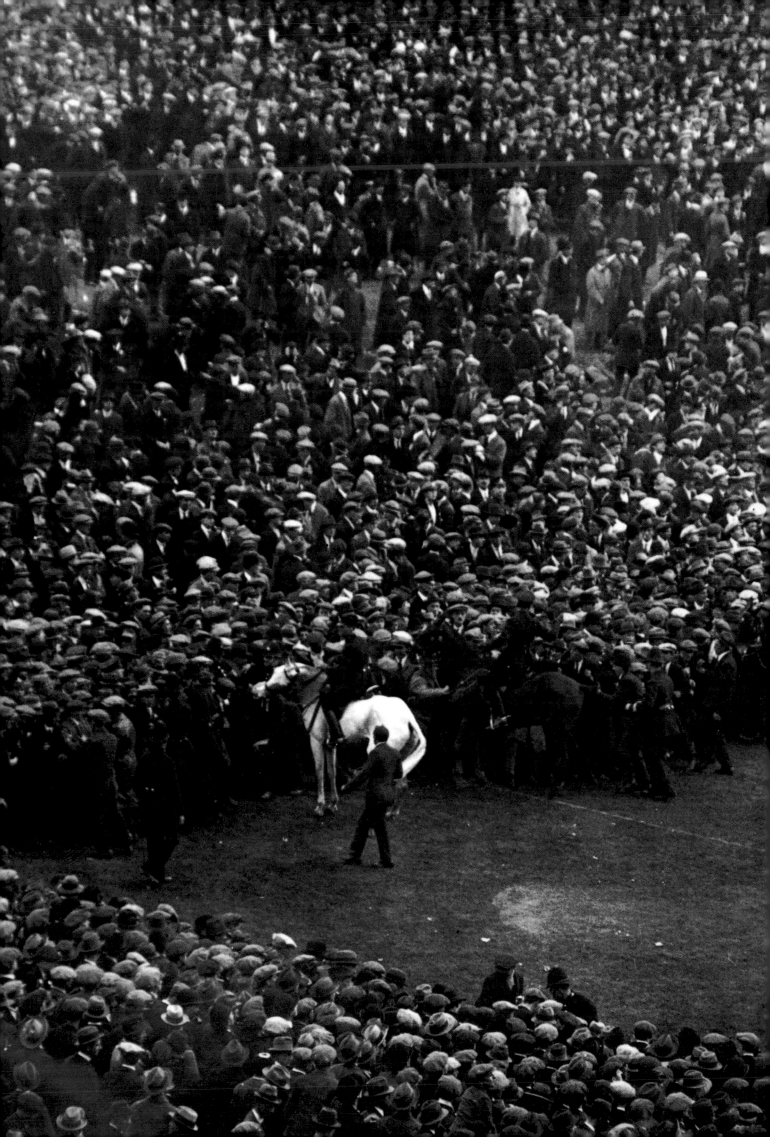

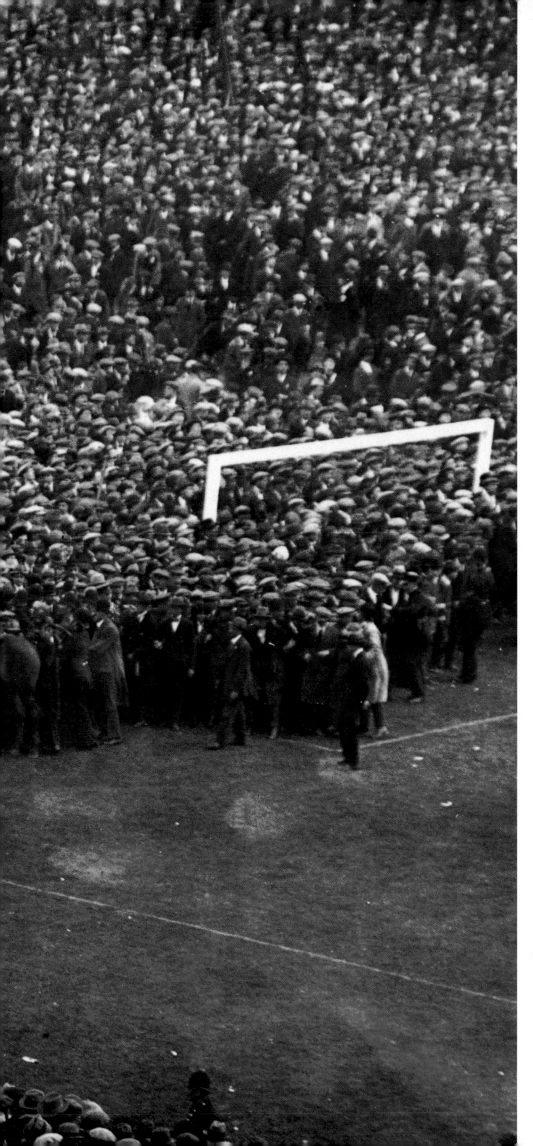

The Wembley White Horse

On 30 April 1923 the English FA Cup Final was played at Wembley Stadium for the first time. The ground capacity was reckoned to be 127,000, but over 200,000 people managed to gain entry. The crowd overflowed on to the pitch, and for an hour it looked as though the game would have to be abandoned. 'The foot police were whirled away like twigs in a spate,' reported the *Daily Mirror*, 'but one officer on a white charger won the unstinted admiration of the "gallery", and was often and deservedly cheered.' Eventually the game got under way, and Bolton Wanderers beat West Ham by two goals to nil.

Der Schimmel von Wembley

Am 30. April 1923 fand zum erstenmal das Endspiel um den Pokal des englischen Fußballverbandes im Wembley-Stadion statt. Schätzungen zufolge faßte das Stadion etwa 127 000 Zuschauer, aber über 200 000 Menschen gelang es, sich Zutritt zu verschaffen. Die Menge quoll bis auf das Spielfeld, und über eine Stunde lang sah es so aus, als müßte man das Spiel absagen. »Polizisten, die zu Fuß waren, wurden weggefegt wie Zweige im Hochwasser«, schrieb der *Daily Mirror,* »aber ein Beamter auf einem Schimmel errang sich die ungetrübte Bewunderung der Tribüne und erntete oft und verdientermaßen Jubelrufe.« Schließlich konnte das Spiel beginnen, und die Bolton Wanderers schlugen West Ham zwei zu null.

Le cheval blanc de Wembley

Le 30 avril 1923, la finale de la coupe anglaise de football se joue pour la première fois dans le stade de Wembley. Le nombre de places était limité à 127 000 mais plus de 200 000 personnes parvinrent à pénétrer dans l'enceinte du stade. La foule déborda sur le terrain et, pendant plus d'une heure, il fut question d'annuler la rencontre. «La police à pied était emportée par la foule comme des brindilles dans la tourmente», raconte le *Daily Mirror,* «mais un officier monté sur un cheval blanc gagna l'admiration sans réserve de la ‹galerie› et fut souvent, et à juste titre, applaudi». Le jeu put finalement commencer et l'équipe des Bolton Wanderers battit celle de West Ham par deux buts à zéro.

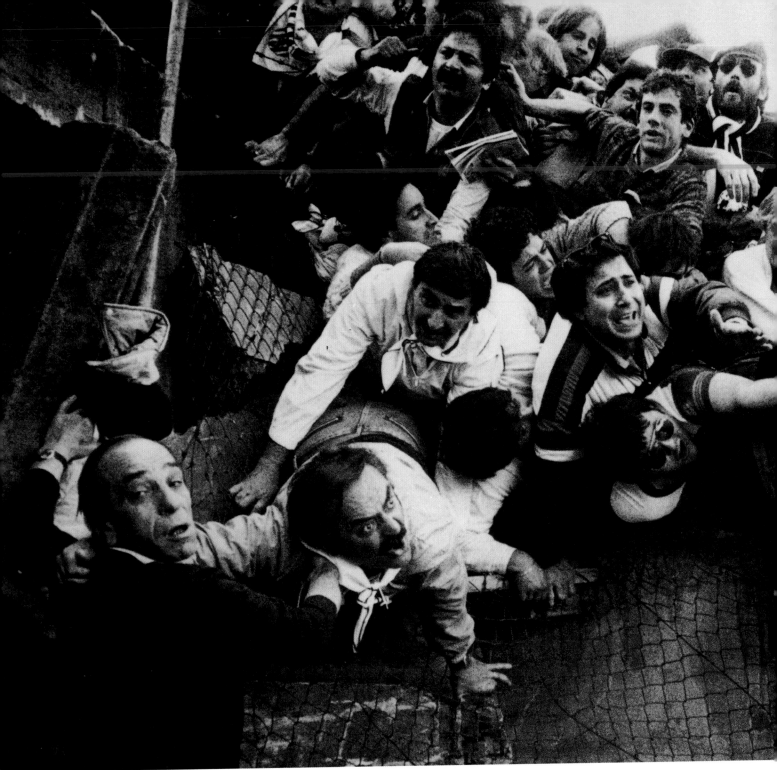

Sports Riots

Riots and disasters at football matches are not modern phenomena. It took 250 policemen to control a crowd at Hampden Park, Glasgow, in 1909. Thirty-three people were trampled to death at Burnden Park, Bolton, in 1946. (1) But the bloodbath of the Heysel disaster in May 1985 was perhaps the most terrible of all. Thirty-nine people were killed and 450 injured when Liverpool fans smashed down a flimsy fence that separated them from Juventus fans. (2) Local protest – Barnet vs Peterborough, May 1988. (3) Even cricket matches have been known to lead to violence – in Pakistan, India and (here) the West Indies.

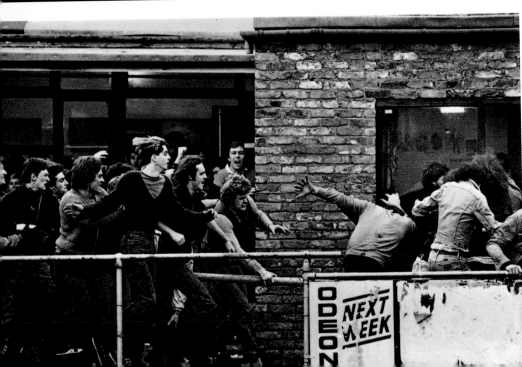

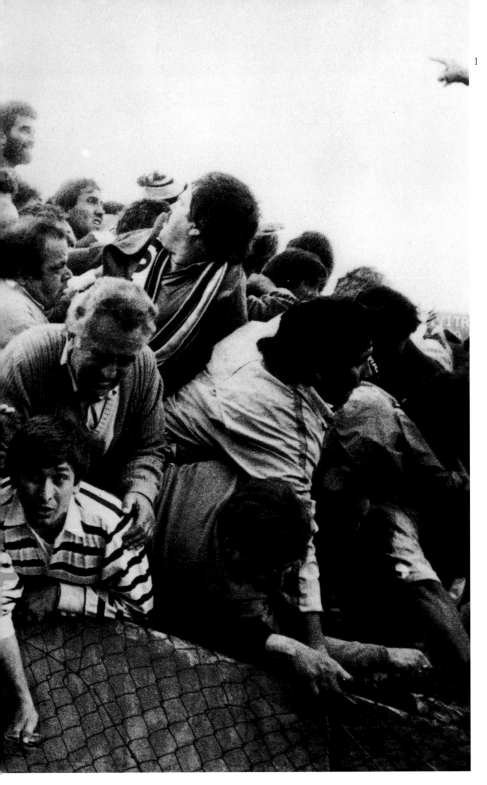

1

Le sport et les émeutes

Emeutes et catastrophes à l'occasion de matchs de football ne sont pas des phénomènes modernes. En 1909 au parc de Hampden à Glasgow, il faut 250 policiers pour maîtriser la foule. En 1946 à Bolton en Angleterre, 33 personnes sont piétinées au parc de Burnden. (1) Mais le bain de sang du Heysel en mai 1985 est sans doute la catastrophe la plus tragique. 39 personnes sont tuées et 450 blessées après que des supporters de Liverpool aient renversé les barrières qui les séparaient des supporters du Juventus. (2) Mai 1988, match régional: Barnet contre Peterborough. (3) Même les matchs de cricket sont le théâtre d'événements violents, au Pakistan, en Inde et (ici) aux Antilles britanniques.

3

Ausschreitungen bei Sportereignissen

Ausschreitungen und Katastrophen bei Fußballspielen sind kein modernes Phänomen. 1909 mußten 250 Polizisten eine Menge in Hampden Park, Glasgow, unter Kontrolle halten. 33 Menschen wurden 1946 in Burnden Park, Bolton, zu Tode getrampelt. (1) Doch das Blutbad im Heysel-Stadion im Mai 1985 war vielleicht der schrecklichste Zwischenfall von allen: 39 Menschen wurden getötet und 450 verletzt, als Liverpool-Fans den schwachen Zaun einrissen, der sie von den Juventus-Fans trennte. (2) Lokale Proteste – Barnet gegen Peterborough, Mai 1988. (3) Selbst Cricket-Spiele haben schon zu gewalttätigen Ausschreitungen geführt – in Pakistan, Indien und (hier) auf den Westindischen Inseln.

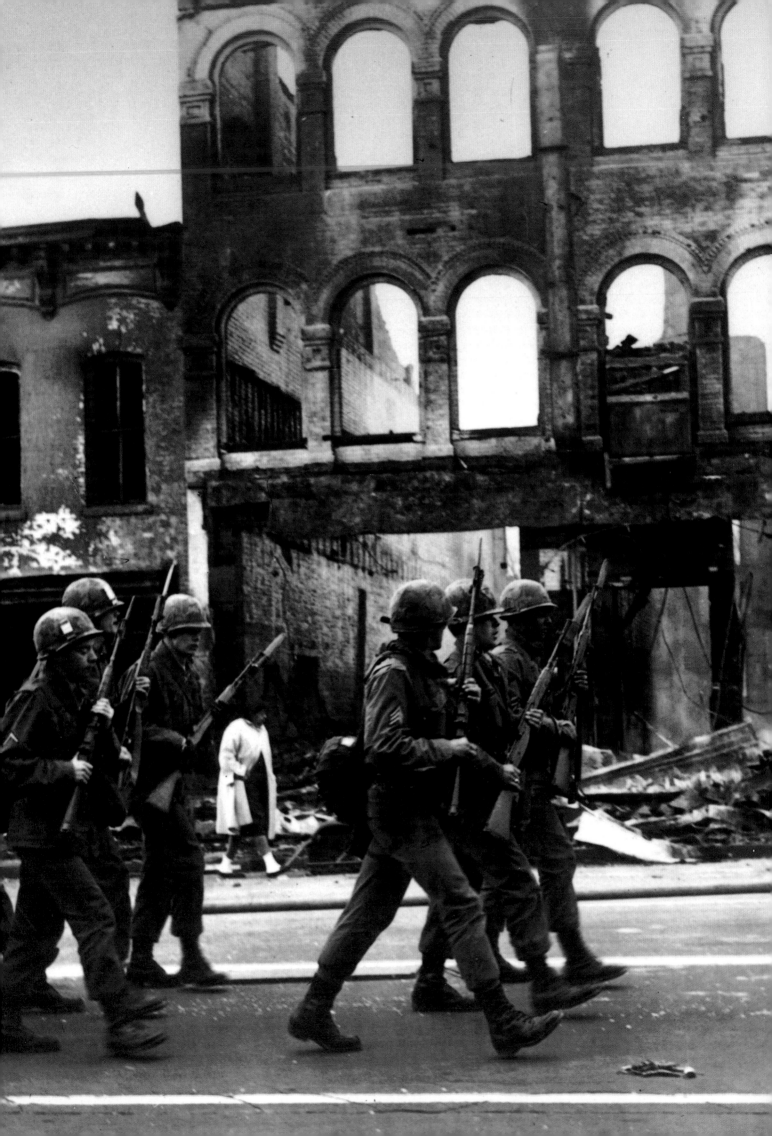

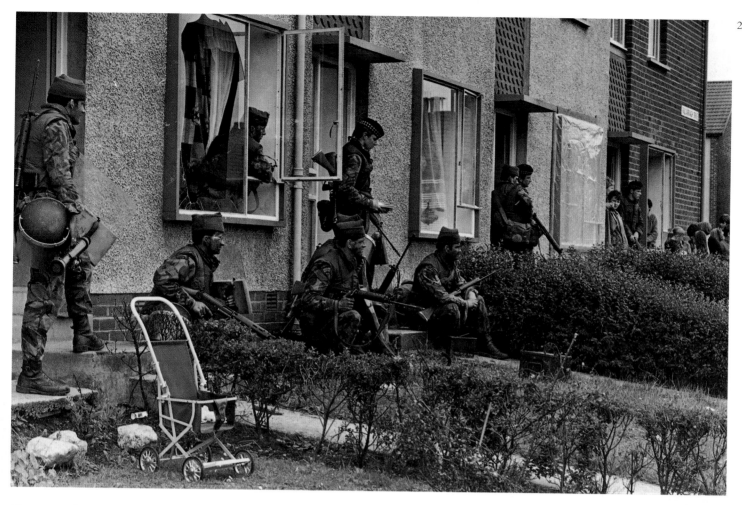

Troops on the Street

When all else fails, send in the troops.
(1) National Guardsmen patrol Washington DC in the riots that followed the assassination of Martin Luther King Jr, April 1968. Eight people were killed and many parts of the city were reduced to smouldering rubble. (2) British troops on a housing estate in Northern Ireland in July 1972, while residents look on. (3) The CRS clear the streets of Paris, June 1968. The worst of the troubles were over, order was returning to the city.

Truppen auf der Straße

Wenn alles andere versagt, entsendet Truppen. (1) Nationalgardisten patrouillieren in Washington, DC, während der Unruhen, die nach dem Attentat auf Martin Luther King jr. im April 1968 ausbrachen. Acht Menschen wurden getötet und große Teile der Stadt in Schutt und Asche gelegt. (2) Britische Truppen im Juli 1972 in einem Wohngebiet in Nordirland; Anwohner schauen zu. (3) Die Bereitschaftspolizei, CRS, räumt im Juni 1968 die Straßen von Paris. Die schlimmsten Unruhen waren vorüber, allmählich kehrte wieder Ruhe in der Stadt ein.

L'armée dans la rue

Quand tout le reste a échoué, il faut dépêcher l'armée. (1) Avril 1968, des membres de la Garde Nationale patrouillent dans Washington durant les émeutes suivant l'assassinat de Martin Luther King, Jr. Huit personnes sont tuées et plusieurs quartiers de la ville sont réduits en fumée. (2) Juillet 1972 en Irlande du Nord, des soldats britanniques en position dans un lotissement, sous l'œil des habitants. (3) Juin 1968 à Paris, des CRS dégagent les rues. Les émeutes les plus graves sont terminées. L'ordre est restauré dans la ville.

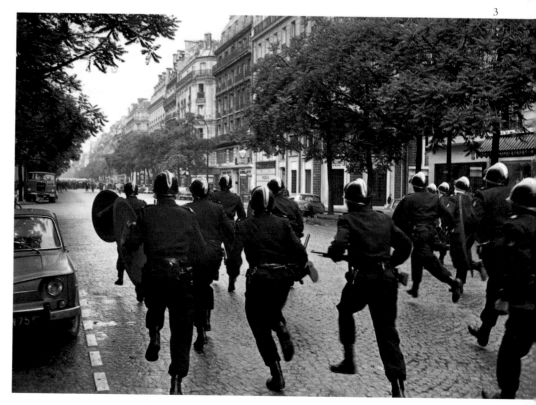

Vehicles (quick response)

In the mid 19th century it was said that the coming of the railway had made successful revolution more difficult in Europe, as it enabled police and troops to be moved quickly to wherever trouble occurred. At the end of the 20th century authorities have far more manoeuvrability at their disposal. (1) Federal troops patrol the streets of Detroit in a jeep in June 1943, when 29 people were killed in race riots. (2) Tanks and motor cycles form a road block in Milan during a raid against black marketeers. (3) An armoured truck speeds through a South African township in the 1980s.

Fahrzeuge (schnelle Reaktion)

Mitte des neunzehnten Jahrhunderts hieß es, die Entwicklung der Eisenbahn habe eine erfolgreiche Revolution in Europa schwieriger gemacht, da Polizei und Truppen schneller zu Unruheherden gelangen konnten. Ende des zwanzigsten Jahrhunderts verfügt die Obrigkeit über eine weitaus größere Mobilität. (1) Bundestruppen patrouillieren im Juni 1943 in einem Jeep durch die Straßen von Detroit, nachdem 29 Menschen bei Rassenunruhen getötet wurden. (2) Panzerfahrzeuge und Motorräder bilden eine Straßensperre in Mailand während der Unruhen gegen Schwarzmarkthändler. (3) Ein bewaffneter Lastwagen rast in den achtziger Jahren durch ein südafrikanisches Township.

Les véhicules (réaction rapide)

Au 19ᵉ siècle, on pensait que le rail rendrait tout succès de révolution plus difficile en Europe car policiers et soldats pourraient être dépêchés rapidement sur les lieux d'agitation. A la fin du 20ᵉ siècle, les autorités disposent de forces de manœuvre encore plus puissantes. (1) Juin 1943, des troupes fédérales patrouillent en jeep dans les rues de Détroit durant les émeutes raciales qui feront 29 morts. (2) Barrage de chars et de motos dans Milan pour arrêter les profiteurs du marché noir. (3) Années 80, un camion blindé traverse à grande vitesse un township en Afrique du Sud.

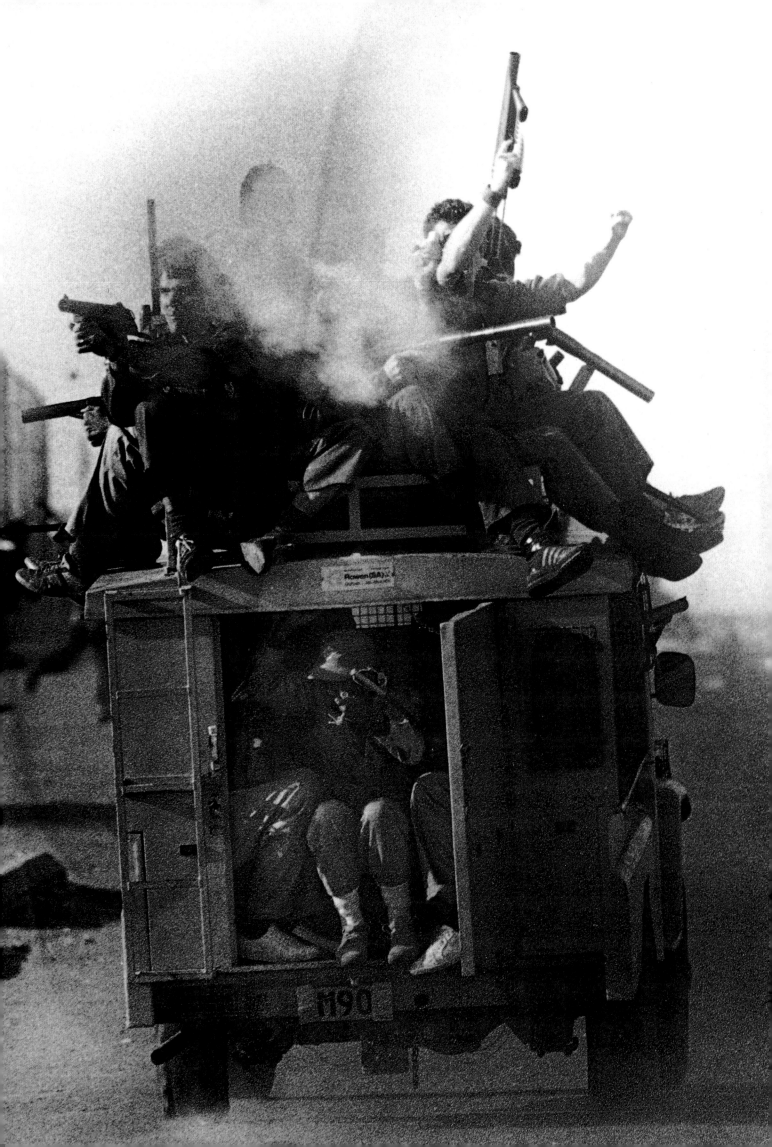

The Weapons of Order

The armoury available to authority for the control of civil disobedience has increased greatly over the last 150 years. The sabres that flashed in the hands of the dragoons on Bloody Sunday in November 1887, and the horses that carried them at the charge into Trafalgar Square, would be of little use now against Semtex and Molotov Cocktails. Nowadays not only troops and police are equipped with tear gas, rubber bullets, riot shields and water cannons, but also with the weapons of patience: psychology and negotiation. Had such modern methods been practised at the time, Peter the Painter and his fellow anarchists at the siege of Sidney Street in 1911 might well have been coaxed into submission – unless Winston Churchill had been the chief negotiator.

But no matter how well equipped and how swiftly transported – in armoured car or helicopter – those in authority have always to contend with the cunning imagination of the masses who rise up against them. When the first Russian tanks rumbled into Budapest in 1956, it was reported that extreme Hungarian nationalists stretched piano wire across the streets, decapitating the commanders who stood proud of their tank turrets.

Though the balance of power must always fall heavily on the side of the forces of law and order, the courage or fanaticism of some protesters occasionally tilts the balance back a little in their favour. Sacrificing one's life for a cause – whether as a Buddhist monk or a suicide bomber – is a weapon against which there can be little defence for the other side.

In the long run, perhaps the most powerful weapons of all are those that cannot be photographed – propaganda, rumour, and outright lies. When the United States entered the Second World War, Roosevelt, referring to the Nazis' burning of books, remarked that 'in this war we know books are weapons'. Those that control the media, the publicity of civil disobedience, are in an immensely strong position.

On Monday 13 September 1971, State Police stormed D-yard of Attica Prison, New York State. Twelve hundred prisoners were holding 38 hostages, mostly prison guards. A few of the prisoners were armed with knives. The police had guns, clubs and gas masks – essential as they drenched the prison yard in CS gas, the effect of which is to make victims' eyes and skin sting and make them feel they are about to suffocate.

In the attack ten hostages and 32 prisoners were killed. It was directed with gusto by Deputy Commissioner Walter Dunbar, who later reported that it had been necessary to use a great deal of force because the prisoners had begun cutting the throats of the hostages. 'But the thing that got us really upset was when we saw an inmate take young Officer Smith, take a knife, castrate him … well, we just had to go in.' This story was repeated *ad infinitum* all over the United States and was widely believed – it still is by many. It was completely untrue – the doctors who examined the victims of the attack repeatedly declared that there had been no mutilation of any bodies. At the time, truth didn't matter to the authorities – they wanted to win the war of words as well as the battle in the prison yard, and they did. The horror experienced by those who heard of this alleged outrage never really abated.

It's one thing to stave people's heads in with truncheons or batons: it's quite another to fill their heads with deliberately engendered misinformation.

Das Waffenarsenal, das den Behörden für die Kontrolle bürgerlichen Ungehorsams zur Verfügung steht, hat in den letzten 150 Jahren stark zugenommen. Die Säbel, die am »Blutigen Sonntag« im November 1887 in den Händen der britischen Dragoner aufblitzten, und die Pferde, die sie zu ihrem Angriff auf den Trafalgar Square trugen, hätten heute gegen Plastiksprengstoff und Molotowcocktails keine Chance

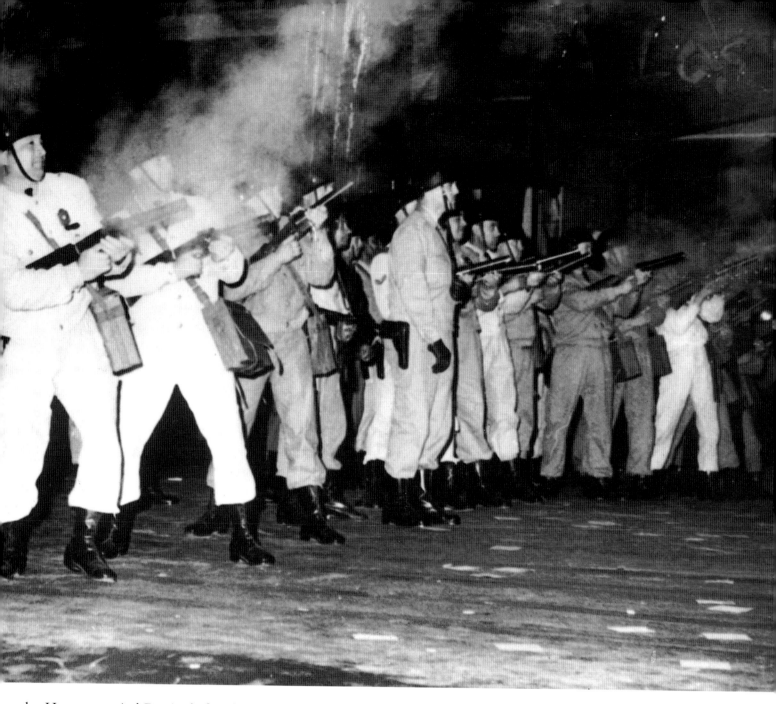

mehr. Heutzutage sind Bereitschaftspolizei und Armee nicht nur mit Tränengas, Gummikugeln, Schutzschilden und Wasserwerfern ausgerüstet, sondern auch mit den Waffen der Geduld – in Form von Psychologie und Verhandlungstaktiken. Mit solchen Methoden hätte man sogar »Peter the Painter« und seine Mitanarchisten bei der Belagerung der Sydney Street 1911 zur Aufgabe überreden können – wenn nicht Winston Churchill Verhandlungsführer gewesen wäre.

Aber selbst gut ausgerüstete und – in Panzerwagen oder Hubschraubern – schnell bewegliche Vertreter der Staatsgewalt tun sich immer schwer mit der raffinierten Phantasie der Massen, die sich gegen die Obrigkeit erheben. Als die ersten russischen Panzer 1956 in Budapest einrollten, sollen extreme ungarische Nationalisten Klaviersaiten über die Straßen gespannt haben, um die stolz in ihren offenen Panzerluken stehenden Kommandanten zu enthaupten.

Obwohl sich das Gleichgewicht der Kräfte auf Dauer jedesmal zugunsten der Ordnungsmacht verschiebt, neigen Mut oder Fanatismus mancher Demonstranten das Zünglein an der Waage immer wieder einmal zu deren Gunsten. Ob als

During demonstrations in Buenos Aires in October 1964 Argentinian police fire tear gas bombs at supporters of Juan Perón, still a potent force though he had been deposed nearly ten years before.

Während der Demonstrationen in Buenos Aires im Oktober 1964 feuert die argentinische Polizei Tränengasbomben auf die Anhänger von Juan Perón, der immer noch ein wichtiger Machtfaktor war, obwohl man ihn bereits zehn Jahre zuvor abgesetzt hatte.

Durant les manifestations d'octobre 1964 à Buenos Aires, la police argentine tire des grenades lacrymogènes sur les partisans de Juan Perón, une organisation encore puissante en dépit de la destitution de Perón quelque dix ans plus tôt.

buddhistischer Mönch oder als Kamikazeflieger – das Opfern des eigenen Lebens für ein bestimmtes Ziel ist eine Waffe, gegen die die andere Seite kaum eine Verteidigungsmöglichkeit besitzt.

Auf lange Sicht gesehen, sind die stärksten Waffen jedoch solche, die nicht fotografiert werden können – Propaganda, Gerüchte und Lügen. Als die Vereinigten Staaten in den

Tanks patrolled the streets of London in the General Strike of 1926, which lasted for nine days; it began when TUC members struck in sympathy with the miners, who refused to accept reduced wages.

Während des neuntägigen Generalstreiks 1926 patrouillieren Panzer durch die Straßen von London. Er begann, als Mitglieder der britischen Gewerkschafts- bewegung TUC aus Sympa- thie mit den Bergarbeitern streikten, die aus Protest gegen geringere Löhne die Arbeit niedergelegt hatten.

Les chars patrouillent dans les rues de Londres durant la grève générale de 1926 qui dura neuf jours. Elle commença lorsque des membres du TUC (fédération britannique des syndicats) firent grève pour soutenir les mineurs qui refusaient une baisse de leurs salaires.

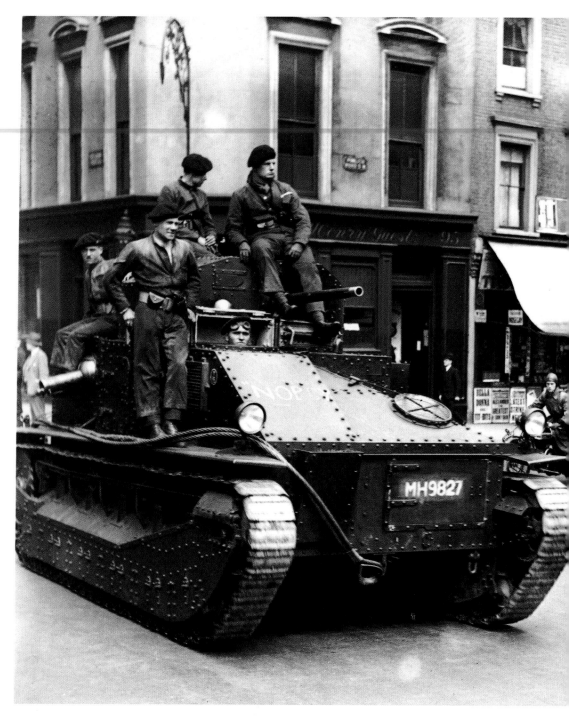

Zweiten Weltkrieg eintraten, sagte Präsident Roosevelt, mit Bezug auf die Bücherverbrennungen der Nazis: »Wir wissen, daß in diesem Krieg auch Bücher Waffen sind.« Wer die Medien und damit das Bekanntwerden von bürgerlichem Ungehorsam kontrolliert, hat eine extrem starke Position.

Am Montag, dem 13. September 1971, stürmte die Staats- polizei den D-Block des Attica-Gefängnisses im Staat New York. Dort hielten 1200 Gefangene 38 Geiseln gefangen, zu- meist Gefängniswärter. Einige Gefangene waren mit Messern bewaffnet. Die Polizei trug Gewehre, Schlagstöcke und Gasmasken – die sie auch benötigte, als das Gefängnis mit CS- Gas beschossen wurde, einem Reizgas, das bei seinen Opfern Augen- und Hautreizungen sowie Erstickungsanfälle auslöst.

Der darauffolgende Angriff, bei dem 10 Geiseln und 32 Gefangene ums Leben kamen, wurde mit Begeisterung von Deputy Commander Walter Dunbar geleitet, der später berich- tete, daß ein Vorgehen mit aller Härte nötig gewesen sein, weil

die Gefangenen damit begonnen hätten, den Geiseln die Keh- len durchzuschneiden. »Aber was uns wirklich rasend machte, war, daß wir sahen, wie ein Insasse den jungen Wärter Smith packte, sich ein Messer griff und ihn kastrierte ... wir mußten einfach eingreifen.« Diese Geschichte wurde überall in den USA endlos wiederholt und von vielen Menschen geglaubt – selbst heute noch. Dabei handelte es sich um eine glatte Lüge: Die Ärzte, die die Opfer untersuchten, erklärten wiederholt, daß keiner der Toten verstümmelt worden sei. Zu dieser Zeit spielte die Wahrheit für die Staatsgewalt keine Rolle. Sie woll- ten den Krieg der Worte ebenso gewinnen wie die Schlacht im Gefängnishof – und es gelang ihnen: Wer von dieser angeblichen Greueltat hörte, verlor seine Angst nie wieder.

Die Köpfe von Menschen mit Schlagstöcken oder Gummi- knüppeln einzuschlagen ist eine Sache – eine andere aber ist, sie mit falschen Informationen über andere Menschen zu füllen.

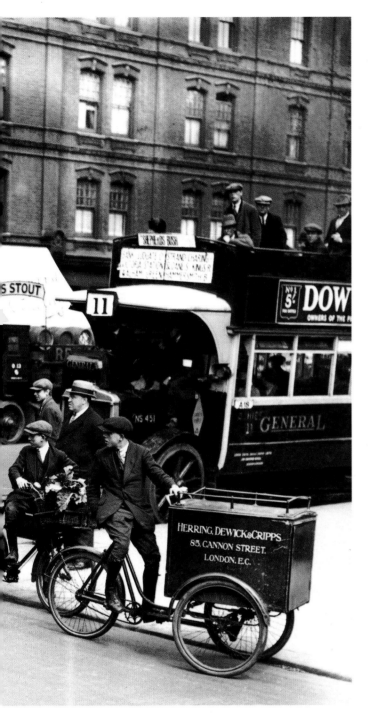

Au cours des 150 dernières années, l'arsenal dont disposent les autorités pour réprimer la désobéissance civile est devenu très sophistiqué. Les sabres dont se servit la police montée le fameux Dimanche sanglant de 1887 pour charger la foule à Trafalgar Square ne seraient guère utiles aujourd'hui face aux charges plastiques et aux cocktails Molotov. De nos jours, l'armée et la police n'emploient pas seulement des grenades lacrymogènes, des balles en caoutchouc, des boucliers anti-émeute et des canons à eau. Elles ont aussi recours aux armes de la patience: la psychologie et la négociation. Si de telles pratiques avaient existé en 1911, Pierre le Peintre et ses compères anarchistes qui occupaient une maison à Sidney Street auraient certainement accepté de se rendre, à moins que Winston Churchill ne fût le négociateur principal.

Mais peu importe que l'autorité en place soit bien équipée ou qu'elle se déplace rapidement, en voiture blindée ou par hélicoptère, elle est sans cesse confrontée à l'imagination et l'astuce des masses qui se soulèvent. On raconte qu'à l'arrivée des premiers chars russes dans Budapest en 1956, les extrémistes nationalistes hongrois ont tendu des cordes de piano à travers les rues, décapitant ainsi les commandants qui se tenaient fièrement debout dans les tourelles des chars.

Même si la balance des forces doit toujours pencher fortement du côté de la loi et de l'ordre, il arrive parfois que le courage ou le fanatisme de certains protestataires fasse pencher la balance en leur faveur. Le sacrifice de sa propre vie pour une cause, que ce soit l'acte d'un moine bouddhiste ou celui d'un commando-suicide, est une arme contre laquelle l'adversaire ne peut pas faire grand-chose.

En fin de compte, les armes les plus puissantes sont peut-être celles qui ne peuvent être photographiées: la propagande, les rumeurs et les mensonges de toutes pièces. Quand les Etats-Unis entrèrent dans la Seconde Guerre mondiale, Roosevelt déclara, en faisant référence aux autodafés des nazis, que «nous savons que, dans cette guerre, les livres sont des armes». Ceux qui contrôlent les médias – porte-parole de la désobéissance civile – occupent une position extrêmement puissante.

Le lundi 13 septembre 1971, la Police d'Etat américaine prit d'assaut la cour D de la prison d'Attica dans l'Etat de New York. Mille deux cents prisonniers retenaient 38 otages, des gardiens de prison pour la plupart. Quelques prisonniers étaient armés de couteaux. La police disposait de fusils et de matraques et portait des masques à gaz indispensables puisque du gaz C.S. avait été répandu dans la cour de la prison, gaz qui a pour effet de brûler les yeux et la peau des victimes et de les asphyxier presque totalement.

Au cours de l'attaque, dix otages et 32 prisonniers furent tués. Elle fut menée avec délectation par le commissaire adjoint Walter Dunbar qui, par la suite, expliqua qu'il avait été nécessaire de recourir à d'importantes forces armées car les prisonniers avaient commencé à couper la gorge des otages. «Mais, ce qui nous a vraiment bouleversé, ça a été quand un prisonnier a pris l'officier de police Smith et qu'il s'est emparé d'un couteau pour l'émasculer… c'est ça qui nous a décidé». Cette histoire fut répétée à l'infini à travers tous les Etats-Unis et fut généralement admise comme vraie. Aujourd'hui encore, un grand nombre de gens y croient. C'était totalement faux. Les docteurs qui examinèrent les victimes de l'assaut déclarèrent à maintes reprises qu'il n'y avait eu aucune mutilation des corps. Mais, à l'époque, la vérité importait peu aux autorités. Celles-ci voulaient gagner la guerre des mots et sortir victorieuse de l'assaut mené dans la cour de la prison, et réussirent. L'horreur que ressentirent ceux qui entendirent le récit du prétendu crime ne s'est jamais réellement dissipée.

C'est une chose de défoncer les crânes des gens avec des matraques ou des gourdins, c'en est une autre que de divulguer délibérément de fausses informations.

Riot Shields

The perfect riot shield has yet to be developed, whether used as a means of attack or defence. (1) A South Korean student delivers a flying kick at police shields in Seoul, during a demonstration demanding the resignation of President Kim Young-sam, April 1996. (2) Riot shields, Paris fashion – police get ready to defy the stone throwers in the heady days of May 1968. (3) British police shelter behind shields at the height of riots in Southall, London, April 1979.

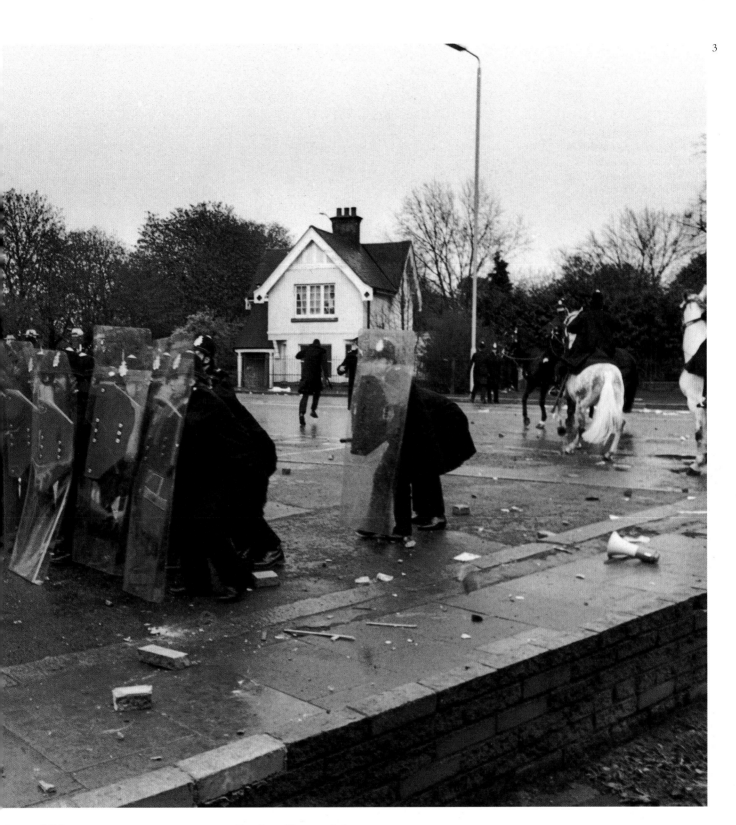

chutzschilde

er perfekte Schutzschild muß erst noch
1twickelt werden, ob als Angriffs- oder als
erteidigungswaffe. (1) Ein südkoreanischer
:udent springt in Seoul bei einer Demon-
ration, die den Rücktritt Präsident Kim
ung-Sams forderte, gegen Polizeischilde
1, April 1996. (2) Schutzschilde Pariser Art –
olizisten bei der Vorbereitung auf Steine-
erfer in den wilden Tagen des Mai 1968.
) Britische Polizisten suchen beim Höhe-
1nkt der Unruhen in Southall, London,
eckung hinter ihren Schilden, April 1979.

Les boucliers anti-émeute

Le parfait bouclier anti-émeute n'existe
toujours pas, que ce soit comme arme
d'attaque ou de défense. (1) Avril 1996 à
Séoul, un étudiant sud-coréen accomplit un
saut de karaté contre les boucliers de la police
lors d'une manifestation pour exiger la
démission du Président Kim Young-sam.
(2) Boucliers anti-émeute sur le modèle
français. Durant les chaudes journées de mai
68, des policiers se préparent à affronter des
jets de pierres. (3) Avril 1979 à Londres, la
police britannique s'abrite derrière des
boucliers au plus fort des émeutes de
Southall.

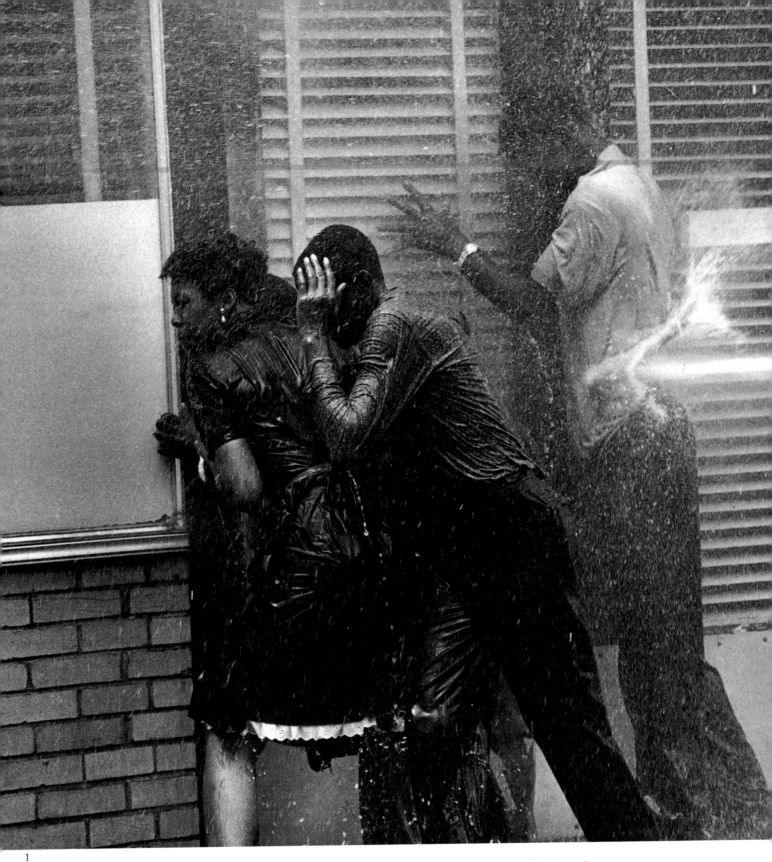

1

Water Cannon
High pressure water is not a particularly
new weapon, but it was originally used to
discomfort crowds and disperse them,
rather than (1) incapacitate them. (2) In
March 1952 police used trucks equipped
with fire hoses to break up protesters in
Trieste who were demanding that the city
be returned to Italy. At the time it was
occupied by Britain and the USA and the
subject of a dispute between Italy and
Yugoslavia. (3) Anti-NPD demonstrators are
held back by police water cannons in

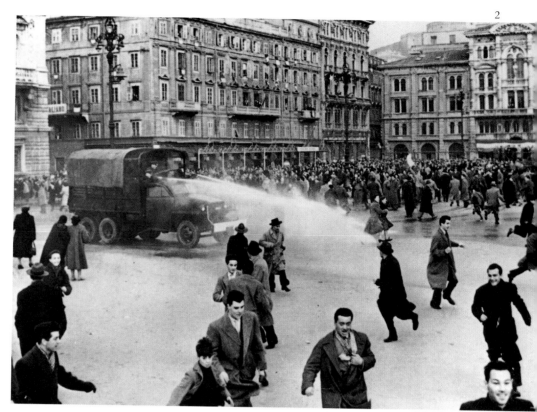

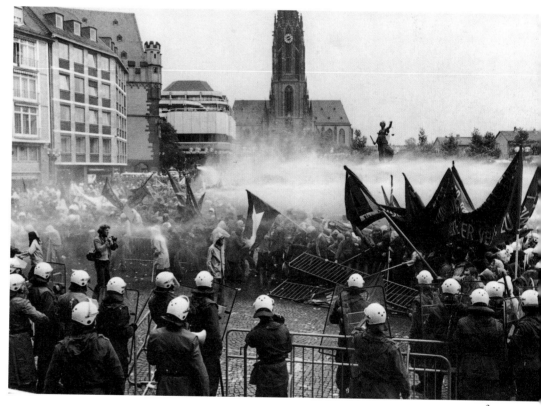

rankfurt, July 1978. The dry statue in the
background is of Justice.

Wasserwerfer

Hochdruckwasser als Waffe ist nicht sonder-
lich neu, wurde aber ursprünglich nur zur
Einschüchterung oder zum Zerstreuen einer
Menschenmenge eingesetzt und nicht, um
sie (1) handlungsunfähig zu machen.
(?) Im März 1952 setzte die Polizei feuer-
spritzenbewehrte Lastwagen ein, um eine
Demonstration in Triest aufzulösen, die die
Rückgabe der Stadt an Italien verlangte.

Damals stand sie unter britischer und ameri-
kanischer Besatzung und war Gegenstand
einer Auseinandersetzung zwischen Italien
und Jugoslawien. (3) Wasserwerfer der
Polizei halten in Frankfurt am Main Anti-
NPD-Demonstranten in Schach, Juli 1978.
Die trockene Statue im Hintergrund ist
Justitia.

Les canons à eau

L'eau à haute pression n'est pas une arme
vraiment nouvelle. Elle fut d'abord utilisée
pour incommoder et disperser les foules

plutôt que pour (1) les immobiliser sur place.
(2) Mars 1952 à Trieste, la police utilise des
camions équipés de tuyaux d'incendie pour
disperser les manifestants qui réclament le
rattachement de la ville à l'Italie. A cette
époque, Trieste était occupée par la Grande-
Bretagne et les Etats-Unis et faisait l'objet
d'une dispute entre l'Italie et la Yougoslavie.
(3) Juillet 1978 à Francfort, des manifestants
opposants au NPD (Parti national allemand)
sont empêchés d'avancer par les canons à eau
de la police. Au fond, on distingue la statue
de la Justice épargnée par les jets d'eau.

Tear gas

Nowadays tear gas usually comes in a canister packed with a bromide compound which induces temporary loss of sight due to an excessive flow of tears. (3) In the early days of tear gas, Chicago police fire cartridges at pickets during a strike at the Chicago Hardware Foundry Company in July 1938.

(1) Turkish recruits to the British Army in Cyprus practise firing tear gas guns in October 1955 – at the height of the Greek-Cypriot struggle for *Enosis*. (2) The quickness of the hand relieves the eye – a student from the San Andres State University in La Paz, Bolivia, returns a tear gas canister to riot police in November 1995.

Tränengas

Heute besteht Tränengas meist aus einer Bromidverbindung, die die Sehfähigkeit durch übermäßigen Tränenfluß vorübergehend beeinträchtigt. (3) In der Frühzeit des Tränengases schießt die Polizei von Chicago bei einem Streik in der Chicago Hardware Foundry Company mit Tränengaskartuschen auf Streikposten, Juli 1938. (1) Türkische Rekruten der britischen Armee in Zypern – auf dem Höhepunkt des griechisch-zypriotischen Kampfes für *Enosis* – üben im Oktober 1955 mit Tränengaskanonen. (2) Reaktionsschnelligkeit ist alles – ein Student der San-Andres-Universität in La Paz wirft eine Tränengasgranate in Richtung der Bereitschaftspolizei zurück, November 1995.

Le gaz lacrymogène

Aujourd'hui, le gaz lacrymogène se présente généralement sous la forme d'une grenade composée de bromure engendrant la perte momentanée de la vue due à une sécrétion excessive de larmes. (3) Juillet 1938, premiers emplois du gaz lacrymogène. La police de Chicago tire des cartouches sur les piquets de grève de la fabrique Chicago Hardware Foundry. (1) Octobre 1955, en plein conflit gréco-chypriote pour la conquête d'*Enosis,* des recrues turques enrôlées dans l'armée britannique s'exercent au tir de grenades lacrymogènes. (2) Sauvé des larmes par une main agile: novembre 1995 à La Paz en Bolivie, un étudiant de l'Université d'Etat San Andres relance une grenade lacrymogène du côté de la police anti-émeute.

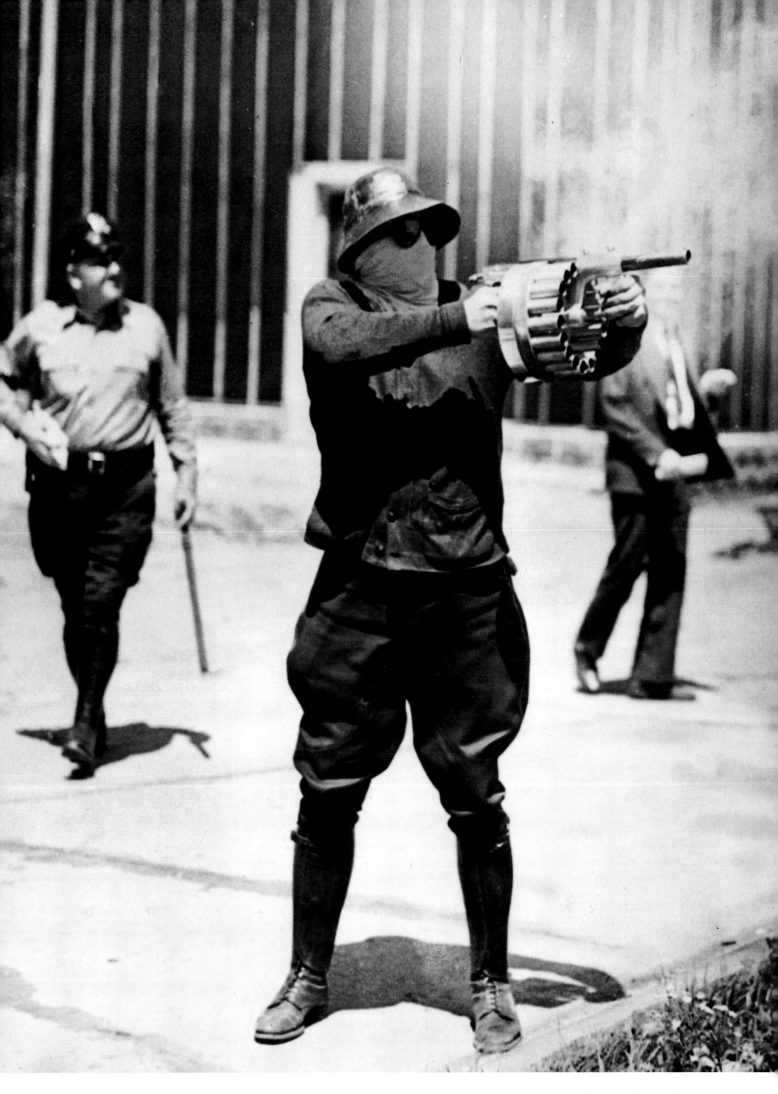

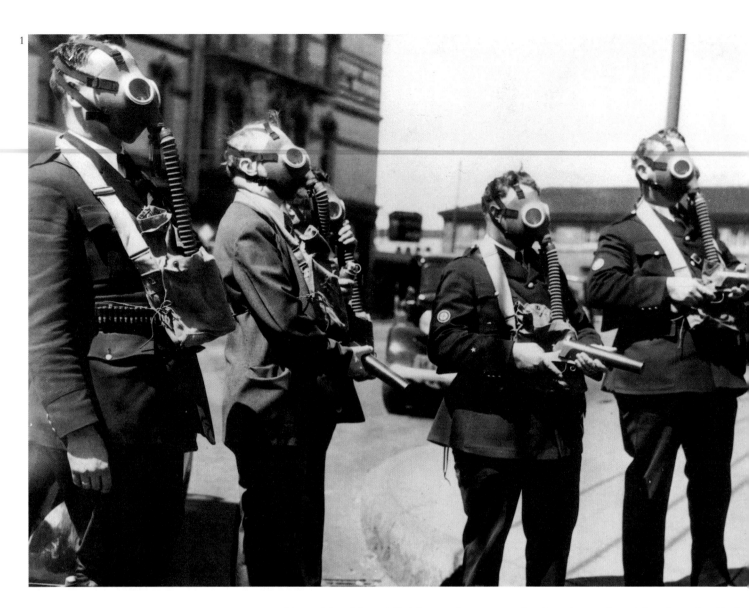

Masks
Usually police wear gas masks only as a defence against their own tear gas. (1) Police guard the San Francisco waterfront during the general strike in the Bay area in July 1934. (2) South African police advance in Cape Town, February 1986. (3) Members of the Mississippi Highway Patrol in July 1966, during the troubles that followed the murder of James Meredith, a civil rights worker. (4) Los Angeles police prepare for trouble on the eve of the trial of their colleagues accused of beating Rodney King, 1992.

Masken
Gewöhnlich tragen Polizisten Gasmasken nur als Schutz gegen ihr eigenes Tränengas. (1) Polizisten bewachen das Hafengebiet von San Francisco während des Generalstreiks in der Bucht im Juli 1934. (2) Südafrikanische Polizisten rücken in Kapstadt vor, Februar 1986. (3) Angehörige der Mississippi Highway Patrol im Juli 1966 während der Unruhen nach der Ermordung von James Meredith, einem Bürgerrechtler. (4) Die Polizei von Los Angeles bereitet sich am Vorabend des Prozesses gegen ihre Kollegen wegen der Mißhandlung von Rodney King auf Unruhen vor, 1992.

Les masques à gaz
En principe, la police se sert de masques à gaz uniquement pour se protéger des gaz lacrymogènes qu'elle utilise. (1) Juillet 1934, policiers montant la garde sur les quais pendant la grève générale du quartier de la Baie à San Francisco. (2) Février 1986, la police sud-africaine avance dans Cape Town. (3) Juillet 1966, des agents de la Patrouille autoroutière du Mississippi pendant les émeutes suivant le meurtre de James Meredith, un défenseur des droits civils. (4) 1992, la police de Los Angeles se prépare à d'éventuelles émeutes à la veille du procès des policiers accusés d'avoir roué de coups Rodney King.

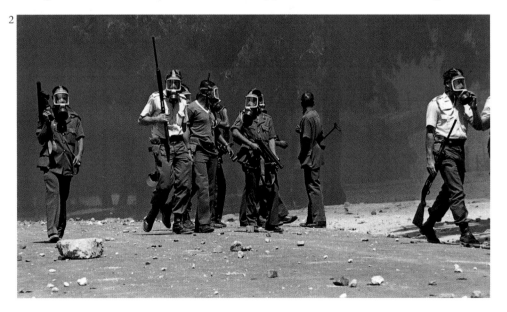

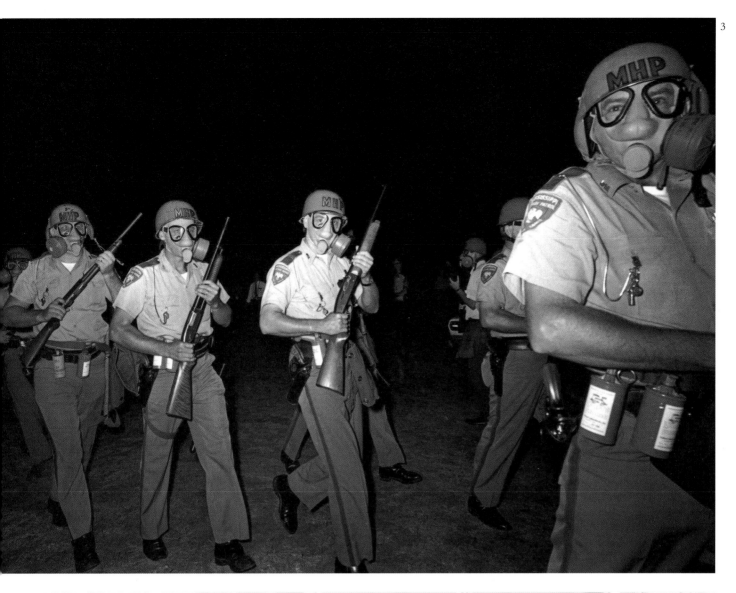

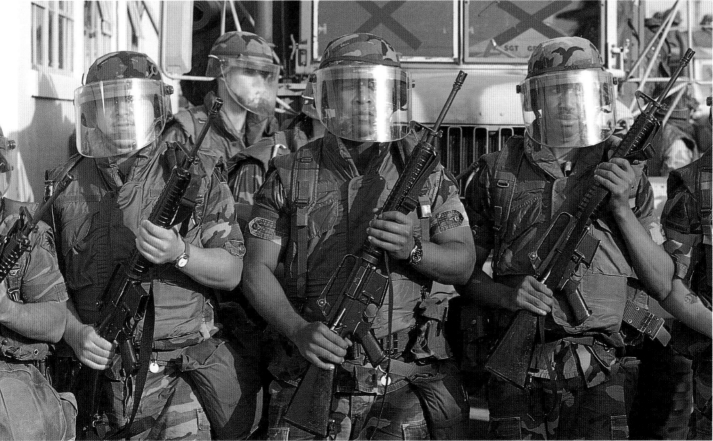

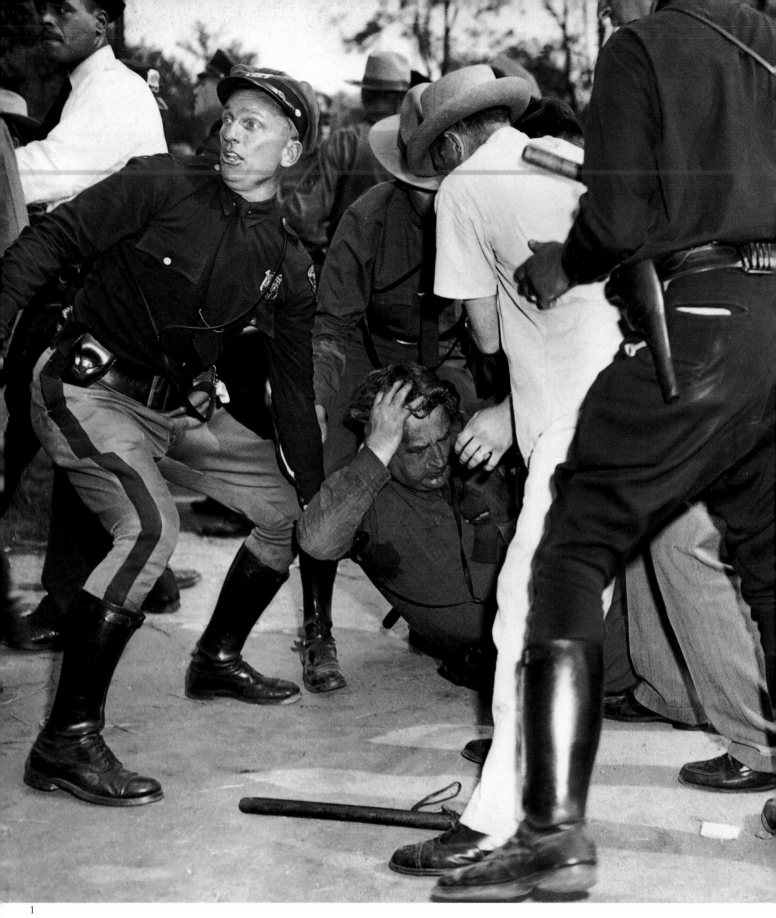

1

Truncheons and Batons

A riot stick is seldom a means of defence.
(1) A State Trooper slumps to the ground
after being hit by a rock. This picture was
taken during fighting over an attempt to hold
a Paul Robeson concert in Peekskill, New
York, in September 1949 – a time when
Robeson's politics made him an object of
hatred by many Americans. (2) Italian
demonstrators attack a Milan policeman in

April 1969, during a rally called by the
Communist party. (3) The British bobby
strikes out – at the Anti-Poll Tax
demonstration in Trafalgar Square, London
in March 1990.

Schlagstöcke

Ein Schlagstock ist selten ein Verteidigungs-
mittel. (1) Ein Staatspolizist sinkt nach einem
Steinwurftreffer zu Boden. Diese Aufnahme

entstand im September 1949 in Peekshill,
New York, bei dem Versuch, ein Konzert
des Sängers Paul Robeson durchzuführen,
der vielen Amerikaner wegen seiner politi-
schen Haltung verhaßt war. (2) Italienische
Demonstranten beim Angriff auf einen
Mailänder Polizisten im April 1969 während
einer Versammlung der Kommunistischen
Partei. (3) Der britische Bobby schlägt zu –
bei der Anti-Kopfsteuer-Demonstration

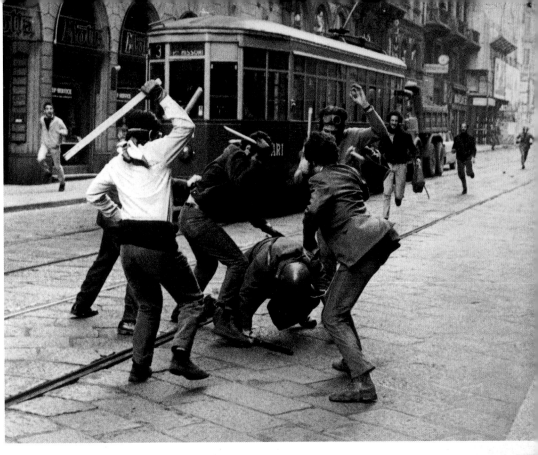

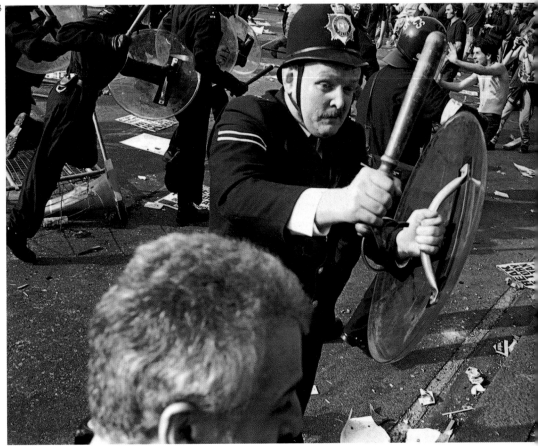

auf dem Trafalgar Square, London, im März 1990.

Les matraques et les gourdins

Un bâton anti-émeute est rarement utilisé pour se défendre. (1) Septembre 1949 à New York, un gendarme s'affaisse par terre après avoir été touché par une pierre. Ce cliché a été pris durant une bagarre pour empêcher la tenue d'un concert de Paul Robeson à Peekshill. A cette époque, sa politique l'avait rendu très impopulaire auprès d'un grand nombre d'Américains. (2) Avril 1969 à Milan, des manifestants attaquant un policier lors d'une marche organisée par le Parti communiste. (3) Mars 1990 à Londres, un Bobby anglais donne un coup de matraque lors d'une manifestation *Anti-Poll Tax* (anti-impôts locaux) à Trafalgar Square.

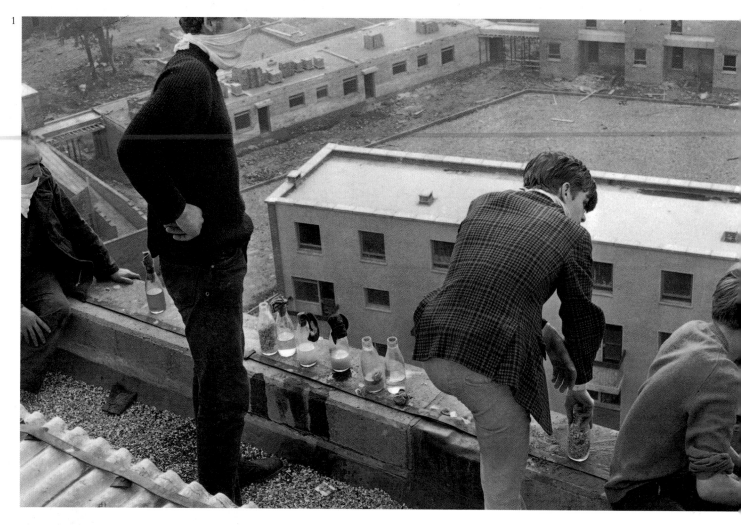

Molotov Cocktails

Named after the Soviet Foreign Minister in the Second World War, when Russian civilians had to improvise in their fight against German troops, the Molotov Cocktail is the simplest of home-made riot weapons – a glass bottle half filled with petrol, stuffed with a burning rag and hurled at police or troops. (1) Youths prepare their arsenal in Londonderry, August 1969, a period of intense rioting in Northern Ireland. (3) The arsenal is put to use in the battle of Bogside. (2) Masked Republicans attacking a British Army post in the South Armagh town of Crossmaglen, August 1995.

Molotowcocktails

Der Molotowcocktail, benannt nach dem sowjetischen Außenminister im Zweiten Weltkrieg, als russische Zivilisten im Kampf gegen die deutschen Truppen improvisieren mußten, ist die einfachste hausgemachte Waffe bei Aufständen – eine zur Hälfte mit Benzin gefüllte Glasflasche wird mit einem brennenden Stoffetzen verschlossen und gegen Polizei oder Truppen geschleudert. (1) Jugendliche bereiten ihr Arsenal vor; Londonderry, August 1969, eine Zeit heftiger Unruhen in Nordirland. (3) Das Arsenal wird in der Schlacht von Bogside eingesetzt. (2) Maskierte Republikaner greifen einen britischen Armeeposten in der Stadt Crossmaglen, County Armagh, an, August 1995.

Les cocktails Molotov

Du nom du ministre des Affaires étrangères de l'Union soviétique pendant la Seconde Guerre mondiale: les civils russes durent improviser dans leur combat contre les soldats allemands. Le cocktail Molotov est la plus simple des armes artisanales: une bouteille remplie à moitié d'essence et fourrée d'un bout de tissu en feu avant d'être lancée contre la police ou l'armée. (1) Août 1969 à Londonderry, des jeunes préparant leur arsenal pendant une période de violentes émeutes en Irlande du Nord. (3) Mise en service de cet arsenal au cours d'une bagarre à Bogside. (2) Août 1995 à Crossmaglen dans le comté d'Armagh, attaque d'un poste de l'armée britannique par des Républicains masqués.

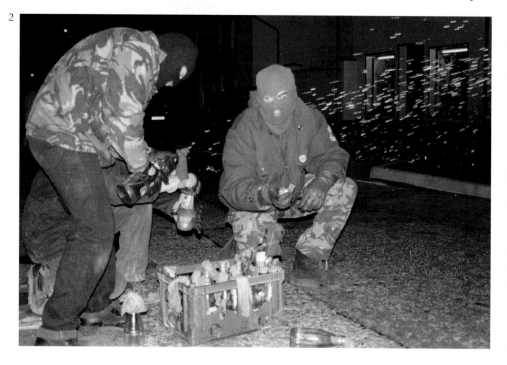

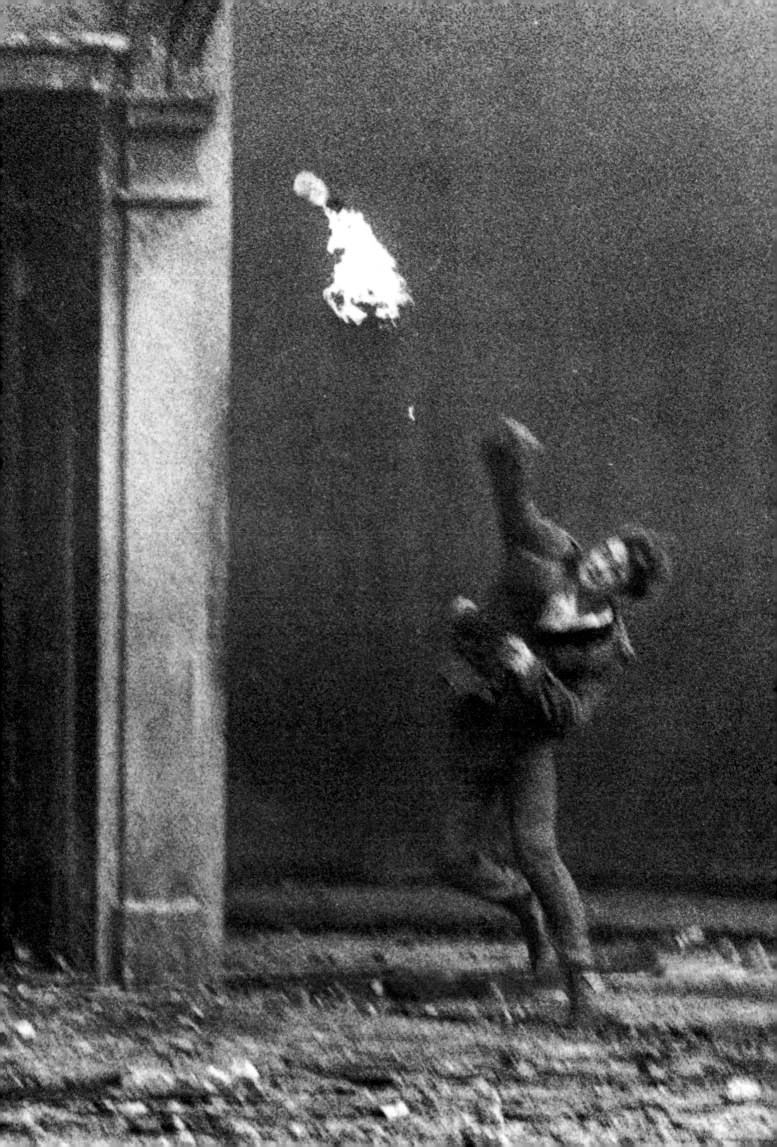

Index

Photographers' Index and Credits